www.wadsworth.com

wadsworth.com is the World Wide Web site for Wadsworth and is your direct source to dozens of online resources.

At *wadsworth.com* you can find out about supplements, demonstration software, and student resources. You can also send e-mail to many of our authors and preview new publications and exciting new technologies.

wadsworth.com

Changing the way the world learns®

From the Wadsworth Series in Production

Albarran, Alan B., *Management of Electronic Media*, 2nd Ed.

Alten, Stanley, *Audio in Media, 6th Ed.*

Armer, Alan A., *Writing the Screenplay, 2nd Ed.*

Craft, John, Frederic Leigh, and Donald Godfrey, *Electronic Media*

Eastman, Susan Tyler, and Douglas A. Ferguson, *Broadcast/Cable/Web Programming: Strategies and Practices, 6th Ed.*

Gross, Lynne S., and Larry W. Ward, *Electronic Moviemaking, 4th Ed.*

Hausman, Carl, Philip Benoit, and Lewis B. O'Donnell, *Modern Radio Production, 5th Ed.*

Hausman, Carl, Lewis B. O'Donnell, and Philip Benoit, *Announcing: Broadcast Communicating Today, 4th Ed.*

Hilliard, Robert L., *Writing for Television, Radio, and New Media, 7th Ed.*

Hilmes, Michele, *Only Connect: A Cultural History of Broadcasting in the United States*

Hilmes, Michele, *Connections: A Broadcast History Reader*

Kaminsky, Stuart, and Jeffrey Mahan, *American Television Genres*

MacDonald, J. Fred, *Blacks and White TV: African-Americans in Television Since 1948, 2nd Ed.*

MacDonald, J. Fred, *One Nation Under Television: The Rise and Decline of Network TV*

Mamer, Bruce, *Film Production Technique: Creating the Accomplished Image, 2nd Ed.*

Meeske, Milan D., *Copywriting for the Electronic Media, 3rd Ed.*

Viera, Dave, *Lighting for Film and Electronic Cinematography*

Zettl, Herbert, *Sight Sound Motion, 3rd Ed.*

Zettl, Herbert, *Television Production Handbook, 7th Ed.*

Zettl, Herbert, *Television Production Workbook, 7th Ed.*

Zettl, Herbert, *Video Basics, 3rd Ed.*

Zettl, Herbert, *Zettl's VideoLab 2.1*

Broadcast/Cable/Web Programming
Strategies and Practices Sixth Edition

Susan Tyler Eastman
Indiana University

Douglas A. Ferguson
College of Charleston

WADSWORTH
THOMSON LEARNING ™

Australia • Canada • Mexico • Singapore • Spain • United Kingdom • United States

WADSWORTH

THOMSON LEARNING

Radio-TV-Film Editor: Karen Austin
Assistant Editor: Nicole George
Editorial Assistant: Mele Alusa
Executive Marketing Manager: Stacey Purviance
Marketing Assistant: Neena Chandra
Publisher: Clark Baxter
Senior Project Manager: Cathy Linberg
Print/Media Buyer: Tandra Jorgensen
Permissions Editor: Robert Kauser
Production Service: Hal Lockwood, Penmarin Books
Cover Designer: Lisa Langhoff, One Good Dog Design
Compositor: ColorType, San Diego
Printer: R. R. Donnelley, Crawfordsville

This edition is dedicated to

REBECCA HAYDEN,

editor and friend extraordinaire.

Wadsworth/Thomson Learning
10 Davis Drive
Belmont, CA 94002-3098
USA

For more information about our products, contact us:
Thomson Learning Academic Resource Center
1-800-423-0563
www.wadsworth.com

International Headquarters
Thomson Learning
International Division
290 Harbor Drive, 2nd Floor
Stamford, CT 06902-7477
USA

UK/Europe/Middle East/South Africa
Thomson Learning
Berkshire House
168–173 High Holborn
London WC1V 7AA
United Kingdom

Asia
Thomson Learning
60 Albert Street, #15-01
Albert Complex
Singapore 189969

Canada
Nelson Thomson Learning
1120 Birchmount Road
Toronto, Ontario M1K 5G4

Library of Congress Cataloging-in-Publication Data

Eastman, Susan Tyler.
 Broadcast/cable/web programming : strategies and practices / Susan Tyler Eastman, Douglas A. Ferguson— 6th ed.
 p. cm.
 Rev. ed. of: Broadcast/cable programming. 5th ed. 1996.
 Includes bibliographical references and index.
 ISBN 0-534-51295-X
 1. Television programs—Planning. 2. Radio programs—Planning. 3. Cable television—Planning. I. Ferguson, Douglas A. II. Eastman, Susan Tyler. Broadcast/cable programming. III. Title.

PN1992.55.E18 2001
791.45′0236′0973—dc21 2001026889

Brief Contents

Detailed Contents

Preface

In the late 1970s, Lewis Klein and Sydney W. Head had the original inspiration that led to this book: They foresaw the need for a text on the strategies of programming in the television and radio industries to teach the upcoming generation of programmers. Their distinctive idea was that experienced professionals would contribute chapters because they could provide singular insights into what were then hidden-behind-the-scenes strategies and practices.

Lewis Klein and Sydney Head took their idea to Rebecca Hayden at Wadsworth Publishing Company, and in her inimitably wise way, she expressed optimism and gave the project the needed practical and logistical support. After adding a coeditor, the first edition appeared in 1981 under the title *Broadcast Programming: Strategies for Winning Television and Radio Audiences*, and it received a remarkable welcome in the academic community. The National Association of Television Program Executives (NATPE) supported the book by encouraging participation by influential programmers and by conducting a survey of program executives that was reported in the first edition. The book and its editors received a Broadcast Preceptor's Award from San Francisco State University for their signal contribution to the industry and academia.

As the book moved through six editions, the content expanded to include cable, new media, and the Internet, and now the title has become *Broadcast/Cable/Web Programming: Strategies and Practices*. The contributors have evolved into a mix of practitioners and scholars; in addition to the two editors/authors, 11 professionals and academics have contributed to the chapters in the current edition. Both editors want to extend their warmest thanks to these people and to previous contributors. Our most enduring authors, William J. Adams, Edward G. Aiken, John W. Fuller, and Jeffrey C. Reiss wrote for five editions; and William Adams and John Fuller are still with us in this most recent edition. Nick Alexander, John A. Haldi, Edd Routt, Squire Rushnell, Timothy P. Meyer, and John von Soosten contributed to four editions, and the last two of them continue to actively participate in this edition, we are grateful to say. These are the experts who have helped establish this book as the definitive programming text in colleges and universities around the world.

We also need to thank our most recent reviewers who pointed us clearly toward the needed changes, especially Thomas R. Lindlof at the University of Kentucky and Edward J. Carlin at Shippensburg State University. We also appreciate the efforts of our editor at Wadsworth Publishing Company, Cathy Linberg. In addition, we wish to thank the many others who wrote and reviewed, especially including four recent contributors— Jeffrey Bernstein, Dwight E. Brooks, David Sedman, and Jeffrey S. Wilkinson.

All the people we have mentioned have left distinctive stamps on the book and helped it maintain its ability to look into the future of the media business insofar as changing conditions

the impact of economics, ownership, regulations, and ethics on programming.

Chapter 2 introduces the major concepts of **program and audience ratings,** vital to understanding programming strategies. Many programming behaviors depend on assumptions about how ratings are collected and presented. In this chapter, the authors explain the qualitative and quantitative research tools of broadcasting and cable, showing how they can be put to use by programmers. The chapter focuses on national and local market ratings because they are the industry's primary method of program evaluation. Ratings are the agreed-on measure of success or failure, and as such, provide the means for setting advertising rates. Then, the authors describe the specialized tools of Internet audience measurement and show the ways in which they are equivalent to and different from traditional ratings measurements. Chapters 3, 4, 7, 10, and 11 supplement this discussion by disclosing specialized data-collection methods and reviewing the kinds of research and ratings reports used in particular parts of the industry. Chapter 2 provides a basic understanding of how the industry evaluates programs and audiences and lays the foundation for further exploration.

Chapter 3 deals with the all-important topic of **program syndication inside and outside the United States.** It begins by following the syndication process from initial production of a program to station purchase, tracing the roles of the major participants in the domestic syndication business. It then outlines the influences of international program syndication on this process. The author goes through the process of making a deal for a first-run or off-network program and the influence of station representative firms in helping their client stations purchase and schedule programs. The role of ratings in decision making about program purchase and scheduling is made clear, and many of the specialized research reports available to programmers and syndicators are explained. The mechanisms of negotiation, bidding, and pricing are described, along with methods of paying for programs. These concepts and practices are especially important to understanding broadcast television programming as it relates to the strategies and practices of network-affiliated stations. These ideas also influence the programmers of the broadcast and cable networks (and will soon influence web programmers as well).

The three chapters making up **Part One** reveal many of the vital components of programming strategies. They supply an overview of programming ideas and tools that will be useful for interpreting the more specialized chapters in the rest of the book.

affect the strategies and practices of programming. It is easy to claim that the future in the everchanging media business is unknowable, but with some prodding by the editors, for each new edition the authors managed to write in ways that remained applicable for five years or so into the future. This was a remarkable accomplishment, and we hope it continues into the present edition. The editor/authors wish to credit a great many people—only some of whom are acknowledged here—for their collective achievement.

Each time we do a new edition, my coauthors and I ask ourselves whether our subject matter is still what should be taught. Have new technologies come along that are so different in approaches and outcomes that traditional broadcast and cable programming strategies and practices are no longer relevant to the real world? The answer is threefold. First, current broadcasting is still the system that dominates all media, and students need to know how it works. Second, the current system will greatly influence the systems to come, just as print influenced radio, radio influenced television, and so on. Third, spelling out which influences will matter, which strategies will be copied, and which practices will become dinosaurs is the special contribution of this book. Our critics have inveighed against the "mechanical" approach to programming, saying that, behind all the words in this book, lies the hidden assumption that the practitioner who follows the stated guidelines will be successful. In response, we can agree that, at its highest levels, programming is part art, part science, and the art may be the most important part. At the station levels, where the competition may be fierce but the risks are relatively small, understanding and following the strategies and practices outlined in this book are probably the essential first steps to competence as a programmer—although innovation rarely hurts. In the emerging online industry, programming practices will alter greatly, evolving some exciting new strategies and innovative practices. Nonetheless, many media strategies will remain the same because they are driven by advertisers' needs. Moreover, the credible program-

mer will know where the lore of the field came from and be able to trace the ongoing process of changing assumptions and resulting practices.

In the five years since the fifth edition of this book, the assumptions and processes of programming have continued to evolve, especially under pressure from the Internet. Gigantic mergers among networks, program suppliers, cable operators, and telephone companies have altered the economics of the business. Additional broadcast television networks now compete for viewers, along with dozens of new cable networks, and the business has become increasingly global in all aspects. Digital compression, multiplexed satellite channels, and the arrival of high-definition television have transformed the processes of production, distribution, and reception. It is, however, the spread of daily Internet access in homes as well as businesses, accompanied by an immediate explosion in audio streaming and the first harbingers of streaming video, that has shaken up the traditional forces in the media business. Once again, predicting the media future challenges the most farsighted, and the eventual impact on programming of the changes that have already begun can only be guessed, but events so far have led to ten major changes for the sixth edition of *Broadcast/Cable/Web Programming:*

- The book's length has been shortened to 12 chapters, a practical amount for instruction in either quarters or semesters.

- A new element, promotion, has been added to the chapter by chapter focus on selection, scheduling, and evaluation.

- A more formal statement of the theory and model guiding the authors' thinking has been added to the first chapter, accompanied by basic descriptive information about the industry and about the viewing process to better meet the needs of teachers.

- A new chapter covering online video and audio programming has been added to reflect the dramatic changes already appearing in the industry.

- The topic of international syndication has been added to the chapter on domestic television syndication, and the subjects of wireless and satellite distribution have been added to the chapter on cable system programming.

- The topics of affiliate and independent television have been merged in a single chapter on television station programming to reflect the virtual disappearance of the unaffiliated station.

- The topics of network and syndicated radio have been spread into the chapters on music and information radio, reducing the total number of radio chapters but retaining essential content.

- The topics of basic and premium cable channels have been merged in a single chapter to better illustrate the workings of the industry and the interrelationships among cable program services.

- The sources listed at the end of each chapter now reveal a shift away from books and trade magazines to the web, in line with changing search practices.

- Finally, all chapters now close with sections on anticipated developments, spelling out "what

lies ahead" in terms of industry trends and audience behaviors.

Despite these changes, the fundamental approach to the subject of programming that characterized previous editions has been retained. The editors remain convinced that there are assumptions about viewing, listening, and online usage that lead to widespread adoption of strategic approaches to media programming. Although we would never belittle the importance of innovation and creativity in programming, we assert that the majority of programmers—and those who direct and work with programmers—need familiarity with current practices in order to be accepted as professionals and to accomplish the everyday tasks of programming stations, networks, and services. Nonetheless, prodigious inspiration, fantastic ingenuity, and great sagacity will be needed to cope with the enormous impact the Internet will undoubtedly have on the ways people access, consume, and utilize media in the coming decade, and we hope what is written here will be a catalyst for new programming strategies and practices.

Susan Tyler Eastman
Douglas A. Ferguson

PART ONE

Programming Resources and Constraints

American homes typically have three or more television sets and two or more VCRs or DVD players, and the sets are on about seven hours a day. Adults watch more than five hours of television daily and listen to nearly two hours of radio; children and teens watch television about three and a half hours daily, and teens consume five or more daily hours of radio. In addition, people who have computers use them an average of nearly two hours daily in the home (as well as in offices), and some of that use is to look at television-like programs and promotion for those programs, as well as to listen to radio stations. Thus, television, radio, and the Internet play crucial roles as sources of entertainment and information in the lives of Americans, and they have a tremendous impact on the culture and social practices. This book explains how programs get on the broadcast, cable/satellite, and online media, who makes them, why they are the way they are, and what limits operate on programmers and management. It reveals the strategies of network, station, and system programmers and describes common industry practices. Although the book zooms in on the strategies and practices used right now in the first decade of the twenty-first century, each chapter concludes with a section on what lies ahead—the trends and expected developments that will soon affect programmers.

Part One consists of three chapters covering a lot of territory very quickly. Their collective goal is to provide an extended framework for understanding the complexities of specific situations in subsequent chapters.

Chapter 1 introduces the major **concepts and vocabulary of programming strategy.** It lays the groundwork for conceptualizing the essential nature of the programming function. Despite the tremendous variety of programming situations in broadcasting and cable, all programmers face similar problems and approach them with similar strategies. Although online practices may differ in many respects, they generally derive from the audience's experience with traditional television. The common assumptions that underlie all programming behaviors can be understood by examining the programmer's options in light of the [?] of the field. Some constraints operating on programming decisions are beyond the programmer's immediate control; others leave room for exercise of the programmer's skills. In this chapter, the authors begin by defining programming in several ways, providing background on the industry, spelling out the theoretical model underlying the book's contents. Then they detail the range of skills and types of knowledge that programmers need, including some preliminary discussion

Chapter 1
A Framework for Programming Strategies

Douglas A. Ferguson and Susan Tyler Eastman

A GUIDE TO CHAPTER 1

In the media world, programming is the software that gives the hardware a reason for existing. Both are necessary for the system to work, but without programming no broadcasting or wired services would exist. Programmers sincerely believe that "content is king."

WHAT IS PROGRAMMING?

This chapter and the ones that follow introduce the realm of programming. Programming can describe either a *group of programs* on a radio station, television channel, or web site, as in "I really enjoy the programming on that new channel," or *the act of choosing and scheduling programs* on a broadcast station, subscribed channel, or the web, as in "I do most of the programming at this station."

Thus, programming can refer to an outcome or a process. *The processes of selecting, scheduling, promoting, and evaluating programs define the work of a programmer.* Whether designated a program director, program manager, or operations manager, the person's job will be to choose the programs that target the desired audience, then design a schedule for them, make sure they are effectively marketed, and then monitor the outcome.[1] If a station has weak programming, then the outcome may seem more important than the process. Such a station needs new programming, in the most tangible sense, because owners always seek large audiences for stations' advertisers. The new shows the programmers choose must appeal to more viewers (or listeners, in the case of radio, or users, in the case of web sites) than did the old shows.

Distribution of programming is a lot less important than one might believe, but a programmer should understand the different means for getting programs to the consumer. The basic distinction is *wired* versus *broadcast*. Wired communication takes place over a coaxial or fiber optic cable, which can come from a cable company or a telephone company (telco). Broadcast signals are typically transmitted over-the-air from radio (AM and FM) and television stations (VHF and UHF),

but the use of special high-frequency signals also fits the definition of broadcasting. A common example is *direct broadcasting,* referring to services that transmit programs from geostationary orbiting transmitters to small receiving dishes. These services are described in Chapter 8. Finally, content may be distributed over the Internet in audio and in streaming video (see Chapter 10).

The Process of Programming

Programming is not rocket science or brain surgery, but being successful at programming is still highly challenging. The primary goal in programming is to *maximize the size of an audience targeted by advertisers*. The only way to accomplish this goal is to satisfy the needs and wants of that audience.

In the case of **mass-appeal channels,** such as the major television networks and basic cable channels, programmers want as many viewers as possible. Ideally, the demographic characteristics popular with various advertisers will be well-represented in the total audience. In the case of specialty cable channels (called **niche networks**) such as the History Channel or Black Entertainment Television, the programmer may be more interested in pleasing the target audience than in expanding audience size. Of course, the larger the size of the target audience, the easier it is to make money.

All programmers must deal with certain limitations, most of them economic. Program resources are scarce. Good shows cost a lot of money. Unfortunately, bad shows are also expensive. Good or bad, each of the big four networks spends more than $100 billion annually on programs and rights to events, but audiences are scarce in terms of time and money. Viewers, listeners, and users are available to consume the media for only so many hours per day. In the case of television programming for which viewers pay a fee, there is a limit to how much they will spend before they start complaining to Congress about subscription fees.

Box 1.1 illustrates the not-always-happy relationship between television viewers and television program services as a tug of war, and similar pic-

1.1 TUG OF WAR

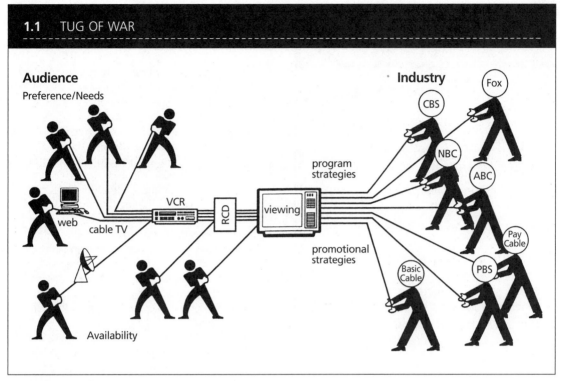

Art: Milt Hamburger

tures might be envisioned for radio and the web. What the cartoon suggests is that as audiences adopt new technologies, programmers must respond with new strategies for enticing and holding those audiences. Similarly, changing economic, regulatory, and social conditions usually result in acrimonious tensions between the sources of programs and their viewers, listeners, and users.

A step-by-step procedure for the process of programming would go something like this. First, choose programs that seem to meet the needs and wants of an audience. Second, organize those programs into a coherent schedule that flows from one program into the next. Third, market the programs to the appropriate audience. Finally, evaluate the results and make necessary adjustments. This is the basic recipe for cooking the perfect program schedule (see 1.2).

Programming Is Like Food

At its basic level, programming represents individual shows (programs) that people choose. The restaurant metaphor is a useful basis for understanding program choice. *TV Guide* is your menu. The channels are the restaurants. The shows are the food.

When people think about food, a seemingly endless combination of choices is available, but foods all come from a few groups: meat, grains, vegetables, dairy, and fruit. Similarly, programs originate in a few types or genres. The prime examples are situation comedies (sitcoms), dramas, news, talk, music, reality, sports, and movies.

Quality or quantity or convenience—which does one want? If people want good food without much wait, they can expect to pay more. If they want fast food at a low cost, they can expect lower quality. It is the same with programming.

1.2 RECIPE FOR SUCCESSFUL PROGRAMMING

1. Target a demographically desirable audience.
2. Choose appropriate programs for that audience.
3. Evaluate reasonable costs for program types and time slots.
4. Evaluate competition to determine scheduling strategy.
5. Make sure a program fits in with neighboring programs.
6. Employ talented performers who are liked by the public.
7. Hire producers/directors/writers with a record of success.
8. Deal with currently topical subject matter.
9. Emulate comparable high-rated series.

1.3 WHAT IS QUALITY?

Whenever the word *quality* is attached to programming, viewers think they know what that means. Do they? Quality often connotes strong production values (lavish sets, famous performers, riveting scriptwriting, technical achievement) and critical acclaim. Those who fight to save quality programs often see some substantial social value in such shows. So why is quality lacking in most television shows? Is it money, or could it be that the masses want circuses instead of high culture? Perhaps quality signifies only that a group of viewers finds some subjective value that is independent of objective criteria. If we cannot agree on what constitutes quality, does it really exist? Maybe those who use the phrase "quality television" really mean to say "programs that we really like."

Programmers are well-advised to be careful with the word *quality* as long as so little consensus exists about what it is. It might be better to strive toward shows that are popular (or critically acclaimed) by external standards, rather than programs that have intrinsic quality.

Program producers can deliver high quality if audiences are willing to wait for those special events or if viewers are willing to bear the cost (see 1.3). For the most part, broadcast programming follows the fast food analogy: plenty of food, low cost, but not a wide selection, and certainly not the quality you might desire. To paraphrase one of NBC's acclaimed programmers, Brandon Tartikoff, most television is a very good hamburger, but it's not truffles.[2]

Eating food requires no special skills, and neither does the consumption of media programming. Unlike books, where reading skills are required, consuming radio and television requires no intelligence at all. This may explain the snobbish disdain among some critics for entertainment and much of the information distributed over the electronic media.

Like the food in some restaurants, broadcast programming is continuously available from various sources. Just as restaurants may be national,

regional, or local, the distributors of media programs operate on three different levels. The *network* buys or produces programs to distribute over its affiliated stations (see Chapters 4 and 5). Program *syndicators* buy or produce shows to sell directly to stations or subscription channels (see Chapters 3, 8, and 9). Finally, each *local station* produces a few programs to meet the unique needs of its audience (see Chapters 6 and 7). And menus change when the audience doesn't like the food (see Chapter 2).

Thus, the stations, subscription channels, and online services are the restaurants, and the networks and studios are the wholesale suppliers. Rerun programs are the leftovers. With the exception of videotape rentals, the normal mode of dis-

affect the strategies and practices of programming. It is easy to claim that the future in the everchanging media business is unknowable, but with some prodding by the editors, for each new edition the authors managed to write in ways that remained applicable for five years or so into the future. This was a remarkable accomplishment, and we hope it continues into the present edition. The editor/ authors wish to credit a great many people—only some of whom are acknowledged here—for their collective achievement.

Each time we do a new edition, my coauthors and I ask ourselves whether our subject matter is still what should be taught. Have new technologies come along that are so different in approaches and outcomes that traditional broadcast and cable programming strategies and practices are no longer relevant to the real world? The answer is threefold. First, current broadcasting is still the system that dominates all media, and students need to know how it works. Second, the current system will greatly influence the systems to come, just as print influenced radio, radio influenced television, and so on. Third, spelling out which influences will matter, which strategies will be copied, and which practices will become dinosaurs is the special contribution of this book. Our critics have inveighed against the "mechanical" approach to programming, saying that, behind all the words in this book, lies the hidden assumption that the practitioner who follows the stated guidelines will be successful. In response, we can agree that, at its highest levels, programming is part art, part science, and the art may be the most important part. At the station levels, where the competition may be fierce but the risks are relatively small, understanding and following the strategies and practices outlined in this book are probably the essential first steps to competence as a programmer—although innovation rarely hurts. In the emerging online industry, programming practices will alter greatly, evolving some exciting new strategies and innovative practices. Nonetheless, many media strategies will remain the same because they are driven by advertisers' needs. Moreover, the credible program-

mer will know where the lore of the field came from and be able to trace the ongoing process of changing assumptions and resulting practices.

In the five years since the fifth edition of this book, the assumptions and processes of programming have continued to evolve, especially under pressure from the Internet. Gigantic mergers among networks, program suppliers, cable operators, and telephone companies have altered the economics of the business. Additional broadcast television networks now compete for viewers, along with dozens of new cable networks, and the business has become increasingly global in all aspects. Digital compression, multiplexed satellite channels, and the arrival of high-definition television have transformed the processes of production, distribution, and reception. It is, however, the spread of daily Internet access in homes as well as businesses, accompanied by an immediate explosion in audio streaming and the first harbingers of streaming video, that has shaken up the traditional forces in the media business. Once again, predicting the media future challenges the most farsighted, and the eventual impact on programming of the changes that have already begun can only be guessed, but events so far have led to ten major changes for the sixth edition of *Broadcast/Cable/Web Programming:*

- The book's length has been shortened to 12 chapters, a practical amount for instruction in either quarters or semesters.

- A new element, promotion, has been added to the chapter by chapter focus on selection, scheduling, and evaluation.

- A more formal statement of the theory and model guiding the authors' thinking has been added to the first chapter, accompanied by basic descriptive information about the industry and about the viewing process to better meet the needs of teachers.

- A new chapter covering online video and audio programming has been added to reflect the dramatic changes already appearing in the industry.

- The topic of international syndication has been added to the chapter on domestic television syndication, and the subjects of wireless and satellite distribution have been added to the chapter on cable system programming.
- The topics of affiliate and independent television have been merged in a single chapter on television station programming to reflect the virtual disappearance of the unaffiliated station.
- The topics of network and syndicated radio have been spread into the chapters on music and information radio, reducing the total number of radio chapters but retaining essential content.
- The topics of basic and premium cable channels have been merged in a single chapter to better illustrate the workings of the industry and the interrelationships among cable program services.
- The sources listed at the end of each chapter now reveal a shift away from books and trade magazines to the web, in line with changing search practices.
- Finally, all chapters now close with sections on anticipated developments, spelling out "what lies ahead" in terms of industry trends and audience behaviors.

Despite these changes, the fundamental approach to the subject of programming that characterized previous editions has been retained. The editors remain convinced that there are assumptions about viewing, listening, and online usage that lead to widespread adoption of strategic approaches to media programming. Although we would never belittle the importance of innovation and creativity in programming, we assert that the majority of programmers—and those who direct and work with programmers—need familiarity with current practices in order to be accepted as professionals and to accomplish the everyday tasks of programming stations, networks, and services. Nonetheless, prodigious inspiration, fantastic ingenuity, and great sagacity will be needed to cope with the enormous impact the Internet will undoubtedly have on the ways people access, consume, and utilize media in the coming decade, and we hope what is written here will be a catalyst for new programming strategies and practices.

Susan Tyler Eastman
Douglas A. Ferguson

PART ONE

Programming Resources and Constraints

American homes typically have three or more television sets and two or more VCRs or DVD players, and the sets are on about seven hours a day. Adults watch more than five hours of television daily and listen to nearly two hours of radio; children and teens watch television about three and a half hours daily, and teens consume five or more daily hours of radio. In addition, people who have computers use them an average of nearly two hours daily in the home (as well as in offices), and some of that use is to look at television-like programs and promotion for those programs, as well as to listen to radio stations. Thus, television, radio, and the Internet play crucial roles as sources of entertainment and information in the lives of Americans, and they have a tremendous impact on the culture and social practices. This book explains how programs get on the broadcast, cable/satellite, and online media, who makes them, why they are the way they are, and what limits operate on programmers and management. It reveals the strategies of network, station, and system programmers and describes common industry practices. Although the book zooms in on the strategies and practices used right now in the first decade of the twenty-first century, each chapter concludes with a section on what lies ahead—the trends and expected developments that will soon affect programmers.

Part One consists of three chapters covering a lot of territory very quickly. Their collective goal is to provide an extended framework for understanding the complexities of specific situations in subsequent chapters.

Chapter 1 introduces the major **concepts and vocabulary of programming strategy.** It lays the groundwork for conceptualizing the essential nature of the programming function. Despite the tremendous variety of programming situations in broadcasting and cable, all programmers face similar problems and approach them with similar strategies. Although online practices may differ in many respects, they generally derive from the audience's experience with traditional television. The common assumptions that underlie all programming behaviors can be understood by examining the programmer's options in light of the lore of the field. Some constraints operating on programming decisions are beyond the programmer's immediate control; others leave room for exercise of the programmer's skills. In this chapter, the authors begin by defining programming in several ways, providing background on the industry, and spelling out the theoretical model underlying this book's contents. Then they detail the range of skills and types of knowledge that programmers need, including some preliminary discussions of

the impact of economics, ownership, regulations, and ethics on programming.

Chapter 2 introduces the major concepts of **program and audience ratings,** vital to understanding programming strategies. Many programming behaviors depend on assumptions about how ratings are collected and presented. In this chapter, the authors explain the qualitative and quantitative research tools of broadcasting and cable, showing how they can be put to use by programmers. The chapter focuses on national and local market ratings because they are the industry's primary method of program evaluation. Ratings are the agreed-on measure of success or failure, and as such, provide the means for setting advertising rates. Then, the authors describe the specialized tools of Internet audience measurement and show the ways in which they are equivalent to and different from traditional ratings measurements. Chapters 3, 4, 7, 10, and 11 supplement this discussion by disclosing specialized data-collection methods and reviewing the kinds of research and ratings reports used in particular parts of the industry. Chapter 2 provides a basic understanding of how the industry evaluates programs and audiences and lays the foundation for further exploration.

Chapter 3 deals with the all-important topic of **program syndication inside and outside the United States.** It begins by following the syndication process from initial production of a program to station purchase, tracing the roles of the major participants in the domestic syndication business. It then outlines the influences of international program syndication on this process. The author goes through the process of making a deal for a first-run or off-network program and the influence of station representative firms in helping their client stations purchase and schedule programs. The role of ratings in decision making about program purchase and scheduling is made clear, and many of the specialized research reports available to programmers and syndicators are explained. The mechanisms of negotiation, bidding, and pricing are described, along with methods of paying for programs. These concepts and practices are especially important to understanding broadcast television programming as it relates to the strategies and practices of network-affiliated stations. These ideas also influence the programmers of the broadcast and cable networks (and will soon influence web programmers as well).

The three chapters making up **Part One** reveal many of the vital components of programming strategies. They supply an overview of programming ideas and tools that will be useful for interpreting the more specialized chapters in the rest of the book.

Chapter 1

A Framework for Programming Strategies

Douglas A. Ferguson and Susan Tyler Eastman

A GUIDE TO CHAPTER 1

In the media world, programming is the software that gives the hardware a reason for existing. Both are necessary for the system to work, but without programming no broadcasting or wired services would exist. Programmers sincerely believe that "content is king."

WHAT IS PROGRAMMING?

This chapter and the ones that follow introduce the realm of programming. Programming can describe either a *group of programs* on a radio station, television channel, or web site, as in "I really enjoy the programming on that new channel," or *the act of choosing and scheduling programs* on a broadcast station, subscribed channel, or the web, as in "I do most of the programming at this station."

Thus, programming can refer to an outcome or a process. *The processes of selecting, scheduling, promoting, and evaluating programs define the work of a programmer.* Whether designated a program director, program manager, or operations manager, the person's job will be to choose the programs that target the desired audience, then design a schedule for them, make sure they are effectively marketed, and then monitor the outcome.[1] If a station has weak programming, then the outcome may seem more important than the process. Such a station needs new programming, in the most tangible sense, because owners always seek large audiences for stations' advertisers. The new shows the programmers choose must appeal to more viewers (or listeners, in the case of radio, or users, in the case of web sites) than did the old shows.

Distribution of programming is a lot less important than one might believe, but a programmer should understand the different means for getting programs to the consumer. The basic distinction is *wired* versus *broadcast*. Wired communication takes place over a coaxial or fiber optic cable, which can come from a cable company or a telephone company (telco). Broadcast signals are typically transmitted over-the-air from radio (AM and FM) and television stations (VHF and UHF),

but the use of special high-frequency signals also fits the definition of broadcasting. A common example is *direct broadcasting,* referring to services that transmit programs from geostationary orbiting transmitters to small receiving dishes. These services are described in Chapter 8. Finally, content may be distributed over the Internet in audio and in streaming video (see Chapter 10).

The Process of Programming

Programming is not rocket science or brain surgery, but being successful at programming is still highly challenging. The primary goal in programming is to *maximize the size of an audience targeted by advertisers.* The only way to accomplish this goal is to satisfy the needs and wants of that audience.

In the case of **mass-appeal channels,** such as the major television networks and basic cable channels, programmers want as many viewers as possible. Ideally, the demographic characteristics popular with various advertisers will be well-represented in the total audience. In the case of specialty cable channels (called **niche networks**) such as the History Channel or Black Entertainment Television, the programmer may be more interested in pleasing the target audience than in expanding audience size. Of course, the larger the size of the target audience, the easier it is to make money.

All programmers must deal with certain limitations, most of them economic. Program resources are scarce. Good shows cost a lot of money. Unfortunately, bad shows are also expensive. Good or bad, each of the big four networks spends more than $100 billion annually on programs and rights to events, but audiences are scarce in terms of time and money. Viewers, listeners, and users are available to consume the media for only so many hours per day. In the case of television programming for which viewers pay a fee, there is a limit to how much they will spend before they start complaining to Congress about subscription fees.

Box 1.1 illustrates the not-always-happy relationship between television viewers and television program services as a tug of war, and similar pic-

1.1 TUG OF WAR

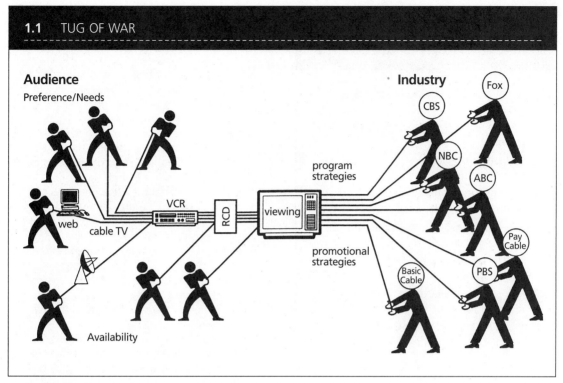

Art: Milt Hamburger

tures might be envisioned for radio and the web. What the cartoon suggests is that as audiences adopt new technologies, programmers must respond with new strategies for enticing and holding those audiences. Similarly, changing economic, regulatory, and social conditions usually result in acrimonious tensions between the sources of programs and their viewers, listeners, and users.

A step-by-step procedure for the process of programming would go something like this. First, choose programs that seem to meet the needs and wants of an audience. Second, organize those programs into a coherent schedule that flows from one program into the next. Third, market the programs to the appropriate audience. Finally, evaluate the results and make necessary adjustments. This is the basic recipe for cooking the perfect program schedule (see 1.2).

Programming Is Like Food

At its basic level, programming represents individual shows (programs) that people choose. The restaurant metaphor is a useful basis for understanding program choice. *TV Guide* is your menu. The channels are the restaurants. The shows are the food.

When people think about food, a seemingly endless combination of choices is available, but foods all come from a few groups: meat, grains, vegetables, dairy, and fruit. Similarly, programs originate in a few types or genres. The prime examples are situation comedies (sitcoms), dramas, news, talk, music, reality, sports, and movies.

Quality or quantity or convenience—which does one want? If people want good food without much wait, they can expect to pay more. If they want fast food at a low cost, they can expect lower quality. It is the same with programming.

1.2 RECIPE FOR SUCCESSFUL PROGRAMMING

1. Target a demographically desirable audience.
2. Choose appropriate programs for that audience.
3. Evaluate reasonable costs for program types and time slots.
4. Evaluate competition to determine scheduling strategy.
5. Make sure a program fits in with neighboring programs.
6. Employ talented performers who are liked by the public.
7. Hire producers/directors/writers with a record of success.
8. Deal with currently topical subject matter.
9. Emulate comparable high-rated series.

1.3 WHAT IS QUALITY?

Whenever the word *quality* is attached to programming, viewers think they know what that means. Do they? Quality often connotes strong production values (lavish sets, famous performers, riveting scriptwriting, technical achievement) and critical acclaim. Those who fight to save quality programs often see some substantial social value in such shows. So why is quality lacking in most television shows? Is it money, or could it be that the masses want circuses instead of high culture? Perhaps quality signifies only that a group of viewers finds some subjective value that is independent of objective criteria. If we cannot agree on what constitutes quality, does it really exist? Maybe those who use the phrase "quality television" really mean to say "programs that we really like."

Programmers are well-advised to be careful with the word *quality* as long as so little consensus exists about what it is. It might be better to strive toward shows that are popular (or critically acclaimed) by external standards, rather than programs that have intrinsic quality.

Program producers can deliver high quality if audiences are willing to wait for those special events or if viewers are willing to bear the cost (see 1.3). For the most part, broadcast programming follows the fast food analogy: plenty of food, low cost, but not a wide selection, and certainly not the quality you might desire. To paraphrase one of NBC's acclaimed programmers, Brandon Tartikoff, most television is a very good hamburger, but it's not truffles.[2]

Eating food requires no special skills, and neither does the consumption of media programming. Unlike books, where reading skills are required, consuming radio and television requires no intelligence at all. This may explain the snobbish disdain among some critics for entertainment and much of the information distributed over the electronic media.

Like the food in some restaurants, broadcast programming is continuously available from various sources. Just as restaurants may be national,

regional, or local, the distributors of media programs operate on three different levels. The *network* buys or produces programs to distribute over its affiliated stations (see Chapters 4 and 5). Program *syndicators* buy or produce shows to sell directly to stations or subscription channels (see Chapters 3, 8, and 9). Finally, each *local station* produces a few programs to meet the unique needs of its audience (see Chapters 6 and 7). And menus change when the audience doesn't like the food (see Chapter 2).

Thus, the stations, subscription channels, and online services are the restaurants, and the networks and studios are the wholesale suppliers. Rerun programs are the leftovers. With the exception of videotape rentals, the normal mode of dis-

tribution is home delivery. And how much gets eaten off the plate is how a show is rated.

Such an analogy, of course, can go only so far. Food is a necessity; entertainment probably is not. Food is a commodity; programming has a unique identity. French fries can be copied much more easily than *ER* or *Friends*.

How Programming Is Unique

If programming is not exactly like food or some other analogous product, what attributes make it distinct? How is programming unique?

Certainly, *ease of delivery* is key. What other product can be simultaneously delivered to nearly every consumer? Even so, there are still barriers to entry for budding suppliers. In theory, anyone can conceive an idea and sell it to a network or cable channel, but the distributors (broadcast and cable networks through their stations and systems) still exert a large measure of control over what programs are run. Yet, it is possible for some programmers to start small and build a national audience. Oprah Winfrey started at a small station doing a local talk show before achieving national television prominence and creating her own production company. Beginning with a web site is a likely path for many future entrepreneurs.

Reaching a national audience is becoming less difficult. Satellite dishes are proliferating, and a growing number of program suppliers are looking for additional program providers. Video rentals are another avenue for program suppliers, and the Internet's ability to stream audio and video programming—looking and sounding both the same and different from traditional programs—grows continuously.

Broadcast programming is also unique because there is *no direct cost* to the consumer for the most popular shows. Although cable and satellite programmers siphon away some of the most desired programs, the broadcast networks are able to provide very popular comedy and drama programs, along with top sporting events and live news coverage, absolutely free to the audience. The advertiser pays for the programs in exchange for the

commercials that are presented to the audience. Although the high cost of advertising is passed along to the consumer, the advertiser's ability to market products to huge audiences actually decreases the per-item cost of many products because of economies of scale. It usually costs more for producers to market products to a small number of people, thereby raising the price.

Why should radio or television programmers care how "free" the programs are to the receiver? In the case of broadcast programming, *the low cost of the programming to viewers is key to creating audiences large enough to sell to advertisers.* Contrary to popular belief, broadcasters are not in the business of creating programs; they are in the business of creating audiences that advertisers want to reach. Even in the case of cable/satellite channels and online sites, advertiser support is very important to programmers because costs are seldom borne entirely by subscriber or user fees.

Only such premium pay channels as HBO and Encore sell their programs directly to the audience. The television programs most watched by viewers are advertiser-supported. *Programming is a unique product in that it is used to lure the attention of consumers so advertisers can show those consumers commercial messages that help sell other products.* Programmers work only indirectly for the audience; *the primary customer is the advertiser*, without whom there would be few programs to see or hear.

What Does the Audience Want?

The most important part of programming is understanding the audience. What appeals to viewers or listeners or online users? Quite simply, audiences want to be entertained, and they want to be informed. These two elements comprise the whole of programming (see 1.4).

The demand for entertainment encompasses a mixture of comedy and drama. Narrative stories represent the norm. These stories have a beginning, a middle, and an end. Characters have goals resulting from a desire. Along the way, they encounter some form of conflict. In a comedy program, the conflict is a humorous situation that

The late Sydney W. Head was a frequent contributor to earlier editions of this textbook, and he had this to say about programming:

A popular fallacy holds that innumerable workable new program ideas and countless usable new scripts by embryonic writers await discovery and that only the perversity or shortsightedness of program executives keeps this treasure trove of new material off the air. But television executives hesitate to risk huge production costs on untried talents and untested ideas. Even when willing, the results rarely differ much because mass entertainment remains the goal. A national talent pool, even in a country the size of the United States (and even for superficial, imitative programming), is not infinitely large. It takes a certain unusual gift to create programs capable of holding the attention of millions of people hour by hour, day by day, week after week.

is resolved in a way that causes the audience to laugh. **Situation comedies (sitcoms)** usually appear in half-hour episodes. In a drama, the conflict results from a counterforce, often "the bad guys." Most dramas last an hour, occasionally longer. In the late 1990s, the reality format (*Survivor, Temptation Island, The Mole,* and sequels) resurfaced on the wave of game show formats (*Who Wants to Be a Millionaire?*), but both genres are cyclical and will submerge again when the fads wear off, resurfacing periodically as short-form programming. Comedies and dramas have had real staying power over the decades.

Comedies and dramas are composed of various ingredients that appeal to most audiences: engaging dialogue, attractive characters, romantic themes, nostalgia, suspense, and high emotion, to name a few. The audience for both types of entertainment shows are also interested in seeing or

hearing something novel, even if it is an old idea with a new twist (see 1.5).

Information programming is also driven by novelty and entertainment value. Viewers want fresh stories that promise something new. Critics can complain about the trivialization of information, but network and syndicated news and information programming with an entertainment approach (**infotainment**) attracts big audiences. Consider, for example, *60 Minutes, 20/20,* and *Entertainment Tonight.* Local stations' news broadcasts necessarily pay close attention to the lighter side of community events because there are fewer opportunities for hard news than on the national level.

When researchers study media behavior, they find that television and radio audiences look for different program types that can be classified in such genres as comedy, drama, sports, and news. Looking at the type of programs demanded by the audience is one way to study what people want, although it is not a perfect method. For example, some situation comedies have "serious" episodes that address social issues, and some dramas venture into comedy.

Adding to general misinformation about programming is the fact that viewers and listeners believe they are programming experts merely because they watch or listen. Most people who tune to a broadcast program feel that they could do a better job of choosing the shows and selecting the time slots. If that were really true, of course, there would be no need for a book on how to be a programmer. It may not be rocket science, but programming is a bit more difficult than it seems to many people.

THE LURE OF LORE

Everyone watches television, so nearly everyone professes to understand what programs ought to be like. Yet merely having preferences does not qualify a viewer—or a programmer—to make accurate decisions or judgments about program strategy. Because television viewing is so easy, the

1.5 UNCOVERING THE MYSTERY

Merely asking television audiences what they want is difficult. Many times viewers do not know what they want until they see it, and a short while later they tire of it and crave something new. Programmers must become accustomed to dealing with fickle audiences. The only refuge is to uncover the mystery of how the audience makes choices about what to watch.

The process whereby audience members make choices is seldom clear, but there are three basic approaches used by researchers to predicting choice. One way is to look at the uses and gratifications of media consumption. This approach frequently substitutes the self-reported attitudes of viewers for more concrete information on their actual behavior. A second way uses additional predictors of choice, such as market size, program length, awareness, cable/VCR/DVD/satellite penetration, and audience availability. Research findings in this area are equally unsatisfying or unusable, because really strong predictors, such as audience availability, are not usually controlled by the programmers (or the viewers).

The most promising way to predict choice is to study the actual content of programs. What is the most important element of the television or radio program? Some say it is the likability of the main characters. Others point to the compelling nature of the story or the format. Little research has been done in this area, perhaps because using structural predictors is easier than using content variables. In any case, studying programming as a serious topic is not easy. The networks and other program suppliers do not sponsor much theoretical research, although applied research (ratings) is a must. Ideas are tested, and pilots are tested (see Chapter 2), but programming seems to remain one big gamble where instinct is more important than science.

audience is confident that putting shows on is really simple. Just make good programs and schedule them where they do not conflict with other good shows. Never make any bad shows. What could be easier?

The professionals who work at the major broadcast and cable networks, along with their counterparts at the individual stations in each city, sometimes take a similarly simplistic stand. Always do this. Never do this. Give the people what they want. Or as NATPE's Dick Block preaches, "Find out what works, what doesn't work."

Out of this no-brainer philosophy has grown a garden of "rules" that the wisdom of experience has nurtured. Call it folklore or just "lore," many programmers believe that achieving success in television programming is a matter of avoiding common mistakes. Unfortunately, programming is much more complicated. But it is useful to examine some of the lore that has grown up around

programming. Certainly some of it may be good advice. Like most lore, however, the student of programming should be suspicious of universal truths.

First, there is the matter of *dead genres*. A **genre** is a type of program, such as a Western or a situation comedy. At various times in the history of programming, each genre has been declared dead, according to common wisdom. Family sitcoms were dead in 1982, they said—until *Cosby* went on the air. Game shows are dead, they said—until *Who Wants to Be a Millionaire?* came along. Reality shows such as *America's Funniest Home Videos* were very popular in the early 1990s, and then they said they were dead—until they came back a decade later in the form of *Survivor*.

Another example is the medical show. In the 1960s, the medical genre was hugely popular, with such hits as *Dr. Kildare* and *Ben Casey*. In the 1970s, the medical genre returned with *Medical*

Center and *Marcus Welby*, but with the exception of a moderate dent made by *St. Elsewhere*, the genre was comatose and presumed unworkable by the 1990s. In 1994, however, *ER* and *Chicago Hope* became very popular, and *ER* proved to be an enduring megahit. Perhaps genres are cyclical.

Second, program lore holds that there is a *formula approach* to building a successful show. For example, take a grizzled veteran in an action profession and pair that character with a young person—creating dual appeal—something for the older and younger viewers. Or hire a big-name star from the world of movies or music or sports. The problem with such recipes is that they lead to bland television. Moreover, all fans can name more programs fitting these formulas that got quickly canceled than shows that lasted on network television.

Third, program lore preaches that *certain formats always fail.* Anything with chimps. Science-fiction drama has never spawned a major network hit, not even *Star Trek* (although *X-Files* came close). Never bank on satire. The list goes on . . .

This chapter—indeed, the rest of this book—outlines what practitioners and scholars generally agree are the fundamentals of programming. These are the building blocks that programmers construct with. *Understanding* the sources of programs, the factors impacting audience size, and the aspects of technology, economics, ownership, and regulation that affect programming strategies and practices makes for competence in the field. Beyond them lies artistry—or magic.

STRUCTURAL CONSIDERATIONS

Programming can be seen as largely a matter of choosing materials and building a schedule. These two processes—followed by promotion and evaluation—are the essence of what a programmer does on a day-to-day basis. Choosing programs depends on circumstances that are closely linked to the source of the programming. Similarly, scheduling is greatly influenced by whether the type of channel that will carry it is broadcast, cable, home video, or online.

Sources of Programs

Four basic program sources exist for television and radio: **broadcast network** programs, **syndicated programs** (including feature films), **local programs** produced "in-house" by professionals, and **homemade,** the kinds of amateur video found on public access cable channels (see Chapter 8) and online (see Chapter 10). These compartments, however, are by no means watertight. Locally produced shows sometimes develop into hybrid blends of local production and syndication. Network entertainment programs "go into syndication" to stations after their initial plays on the national network. Network suppliers sometimes produce movies made specially for television (**made-for-TV movies**). Pay-television suppliers may produce made-for-pay movies and entertainment specials—by taping live performances on-location at concerts, at nightclubs, and in theaters. Live sports events crop up on both cable and broadcast network services and also as syndicated local/regional productions. And homemade programming on online channels has a local feel, but with worldwide distribution.

Network Programs

The national, full-service, interconnected network is broadcasting's distinctive contribution toward conservation of program resources. Newspapers shared news and features by means of news agencies and syndicates long before broadcasting began, but broadcasting introduced the elements of instantaneous national distribution and simultaneous programming. The nine national television networks (ABC, CBS, Fox, NBC, Pax, Telemundo, Univision, UPN, and WB) supply commercial broadcast programs by making or purchasing them. Nearly 225 cable program networks deliver the bulk of satellite and cable systems' content. Aside from news and news-related public affairs materials, the broadcast networks buy most of their programs from **studios** (some of which now own broadcast networks) and **independent production firms.** The tortuous route from program idea to finished, on-the-air network series is

described in Chapters 4 and 5 on network television. Each year, network programmers sift through thousands of initial proposals, shepherding them through successive levels of screening, ending up in the fall with many new programs for each network's new schedule. Outside authors write the scripts (which get modified by "the suits"), and production houses do the rest of the creative work.

Cable networks differ in major respects from broadcast television networks. In technical delivery, they are similar: In both cases a central headquarters assembles programs and distributes them nationwide, using orbiting satellites to reach individual broadcast stations or cable systems, but the financial and working relationships between broadcasting affiliates and their networks and between cable affiliates and their networks differ fundamentally. Cable systems depend almost totally on satellite-distributed programming to fill their channels, and because they have many channels, they deal with a hundred or so networks. The traditionally symbiotic relationship between each broadcast network and its 200 or so affiliates does not exist in the cable field. Most cable network programmers also have far less input into the creative aspect of programming than do their broadcast counterparts.

The great bulk of cable network programming comes from the same sources as broadcast programming—distributors of feature films and syndicated programs—and, indeed, much of it is old network programming, although this is rapidly changing. Pay and pay-per-view cable, of necessity, increasingly venture into their own production enterprises. The multiplication of splinter channels has greatly increased the difficulty of the programmer's task of attracting a large audience.

The traditional radio networks once offered by ABC, CBS, and NBC no longer qualify as full-service networks. Those that have not been sold now resemble syndicators, supplying features and program inserts such as newscasts (see Chapters 11 and 12). Conversely, some radio program syndicators supply stations via satellite with complete schedules of ready-to-air music in various established formats, much like the networks except

that stations now pay the networks. Formerly, the old radio networks paid the stations to compensate them for the loss of time to sell to generate advertising revenue, but that system is disintegrating.

Network programmers for public broadcasting face still a different situation. Originally designed as an alternative to the commercial system, **Public Broadcasting Service (PBS)** programming comes ready-made from the larger member stations specializing in production for the network, from small independent producers, and from foreign sources, notably the British Broadcasting Corporation, which now has its own satellite channel. (Even PBS has its own satellite channels that compete with its affiliates; see Chapter 7.) Foreign sources supply more elaborate productions than PBS can generally afford to commission domestically, costing PBS about one-tenth of what a similar program would if produced in the United States. **Coproduction,** sharing production costs by broadcasting organizations in different countries, accounts for an increasingly large proportion of national noncommercial programming and is being widely copied by the commercial studios and producers (see Chapter 3).

Syndicated Programs and Feature Films

Local broadcast programmers come into their own when they select syndicated programs for their individual stations. They draw upon these sources:

- **Off-network series:** programs that have reverted to their copyright owners after the network that first aired them has used up its contractual number of plays.

- **First-run syndicated series** and **specials:** programs packaged independently by producers and marketed directly to individual stations rather than being first seen as network shows; typical of such series are *Entertainment Tonight, Oprah,* and holiday specials.

- **Feature films:** movies made originally for theatrical exhibition.

Of all the program types, the feature film is the most in demand because of its popularity on so many

different delivery systems. The term **window**—borrowed from the world of space flight in which rockets can be launched only through certain time-space openings when conditions are just right—has been applied to the release sequence by which feature films reach their various markets. First, of course, comes the traditional window of theatrical release, either simultaneously in several thousand theaters throughout the country or in stages of "limited release." Next in the usual order of priority come releases through the windows of home video and pay-per-view cable, regular pay cable, broadcast networks, and finally, general broadcast and cable syndication. Prices for rentals decrease at each stage of release as products age and lose their timeliness.

Local Production

As Chapters 6 and 12 on station programming will show, local newscasts play an important role in broadcast station program strategies (even these programs, though locally produced, often contain a great deal of syndicated material as inserts). Aside from news, however, locally-produced material plays only a minor role as a program source. It is true that all-news, all-talk, and all-sports radio stations depend almost entirely on local production, but those formats cost so much to run and have such a specialized appeal that they remain few in number and exist only in the largest markets. Stations simply find syndicated material cheaper to obtain and easier to sell to advertisers. *Localism is more worshipped than practiced.*

Homemade

A few **cable systems** have undertaken competitive and highly professional local (often regionalized) news production, but most do not invest the kind of money in facilities and staff required for a competitive news department unless they have a cooperative arrangement with a broadcast TV station. Even though metropolitan cable franchises usually mandate one or more **access** channels for use by the general public, municipal agencies, and education, these sources account for only a tiny

fraction of cable system programming. Their channels tend to be filled with low-budget video of local city council and school board meetings, local debates, and home video shot by community members (see Chapter 8). Similarly, thousands of web sites have been created by individuals and filled with amateur attempts at text and video (or audio). Very little of this material reaches a wide audience.

The Uniqueness of Broadcast and Cable Scheduling

Of all the programmer's basic skills, perhaps **scheduling** comes closest to qualifying as uniquely a radio and television specialty. One critic has referred to broadcast television scheduling as an "arcane, crafty, and indeed, crucial" operation; another has said that "half a [network] program director's job is coming up with new shows; the other half, some would say the other 90 percent, is in knowing how to design a weekly schedule, in knowing where to put shows to attract maximum attention."[3]

Scheduling a station, cable system, or network is a singularly difficult process. It demands use of the principles of compatibility, habit formation, flow control, and resource conservation. Even with multichannel competition and the proliferation of remote controls, the audience for one show can influence adjacent programs. Furthermore, scheduling requires understanding one's own and one's competitors' coverage patterns, market, and audience demographics. Access commitments and owner policies complicate scheduling for cable channels. Cable programmers also have other problems: They have to weigh the claims of competing services for specific channel locations. VHF television stations, for example, much prefer a cable channel that matches their over-the-air channel number, and UHF stations would like a channel between 2 and 13 (there being no necessary relationship between the cable channel number a station occupies and its own assigned broadcast channel number). Stations particularly object to **repositioning,** moving them to higher

number cable channels, but cable operators prefer to give the choicest positions to the most popular (or most lucrative) services, whether they are broadcast or cable-only (especially the cable channels they own all or part of).

The Need for Promotion

The broadcast and cable networks forgo billions of dollars in advertising revenue in order to promote their programs on their own air. Every promotional spot takes up space/time that could be sold to an advertiser. Such promotion is essential to interest viewers (or listeners) in new programs and new episodes of continuing programs, and to retain audiences by making them feel satisfied with the program array. In addition, millions are spent in paid advertising of programs in guides, in other media, and in cooperative marketing endeavors with such stores as K-Mart or McDonald's, and by co-sponsoring concerts and sporting events to attract audiences to television and radio programs. The online world has also become a necessity for the networks. PBS, ABC, CBS, Fox, NBC, Pax, UPN, and WB have developed huge multimedia presences on the World Wide Web, and Univision, Telemundo, and the major studios and cable networks have followed suit. Television and radio enthusiasts can point-and-click their way through myriad home pages designed by the networks, their affiliates, the studios, the major cable channels, fan clubs, and even the program stars themselves. These are sophisticated promotional sites created to capture attention, generate buzz, and feed the fans' yearning for closer contact with programs and their stars. Most are sponsored by commercial interests. Not to be outdone, this textbook itself has a web site linked from *www.wadsworth.com* on the Internet.

To date, programming and promotion have generally been considered separate spheres at networks, stations, and services, often classified as "marketing" in the cable industry. The greatest of network programmers are as much known for the brilliance of their promotional strategies as for their program scheduling. Sylvester Weaver, for example, came up with the "spectacular," a kind of one-time-only program that would be virtually self-promoting because of its high visibility and uniqueness. Nonetheless, a great deal of airtime had to be devoted to telling the audience that a spectacular (nowadays called a **special**) was coming soon and that it was worth watching. Fred Silverman, another giant in network programming history, understood that how programs were promoted was as important as how they were scheduled. The devotion of immensely valuable airtime to program promotion each year on every network and station is clear evidence that the industry is convinced of the truism that *the best program without promotion has no audience*. If the audience doesn't know what day, what time, and what channel a program is on, the old viewers who miss the show will have a profound impact on the ratings; if new viewers don't see many exciting promos enticing them to watch a network's shows, that will also have a profound impact on ratings.

It is crucial to understand that just a ratings point or two stands between the number one and number three network in most years, and that promotion on and off the air is vital to maintaining and increasing standing in that elite group. The same situation occurs among cable networks and at the local level. Cable networks vie to be among the top ten (or top 25) but differ by only fractions of a ratings point. The slight advantage given by effective promotion can be the difference between making that top-list and falling to some lower grouping. Local stations often vary only minutely in popularity, and a great deal of newscast or format promotion can boost one station above its competitors.

Networks and stations are also concerned with their overall images. Increasingly, fostering positive images around the world has value in building audiences for exported programs and associated products (called **branding**). *Promotion, then, is one path through the labyrinth leading to high ratings and thus high revenue.*

THE ELEMENTS OF PROGRAMMING

The various strategies for selecting, scheduling, promoting, and evaluating programs are derived from a set of assumptions about audience behavior. In previous editions of this textbook, Sydney Head organized these strategies into various "themes," and this approach remains useful in spite of the changing media environment. These themes can be summarized as strategies capitalizing on these specific elements:

- Compatibility
- Habit formation
- Control of audience flow
- Conservation of program resources
- Breadth of appeal

These elements may seem old-fashioned in an era where dozens of channels compete for tiny slices of the universe of viewers, but the structural impact of the elements has not vanished. Judicious attention to the overall programming environment continues to be important to programmers who assemble schedules for program services, whether the channel is broadly based or tightly targeted.

Compatibility

Scheduling strategies take advantage of the fact that programs can be timed to coincide with what people do throughout the daily cycle of their lives. The continuous unfolding nature of radio and television allows programmers to schedule different kinds of program material, or similar program materials in different ways, in various **dayparts.** *They strive to make their programming compatible with the day's round of what most people do*—getting up in the morning and preparing for the day, driving to work, doing the morning household chores, breaking for lunch, enjoying an afternoon lull, the homecoming of the children after school, the accelerating tempo of home activities as the day draws to a close, relaxing

during early prime time, indulging in the more exclusively adult interests of later prime time, the late fringe hours, and the small hours of the morning. And, of course, compatibility calls for adaptation to the changed activity schedules of Saturdays and Sundays. Programmers speak of these strategies in terms of **dayparting**—scheduling different types of programs to match parts of the day known by such terms as **early fringe, prime time** and in the case of radio, **drivetime.**

Cable television's approach to compatibility has historically differed from broadcasting's approach. Because each broadcast station or network has traditionally had only a single channel at its disposal, broadcast programmers must plan compatibility strategies for what they judge to be the "typical" lifestyles of their audiences. Some broad-appeal cable services such as USA Network follow this same pattern, while other networks target very narrowly. Cable systems, however, accommodate many channels and usually devote some to atypical audiences, ignoring dayparts. They can cater to the night-shift worker with sports at 6 A.M., to the single-person household with movies at 6 P.M., to the teenager with round-the-clock videos, using a different channel to serve each interest. Two-thirds of cable subscribers receive at least 60 or more channels on their services, and direct satellite subscribers receive 100 or more channels.

Habit Formation

Compatibility strategies acquire even greater power because audience members form listening and watching habits. Scheduling programs for strict predictability (along with promotional efforts to make people aware of both the service as a whole and of individual programs) establishes tuning habits that eventually become automatic. Indeed, some people will go to extraordinary lengths to avoid missing the next episode in a favorite series. Programmers discovered this principle in the early days of radio when the *Amos 'n' Andy* habit became so strong that movie theaters in the 1930s shut down their pictures temporarily

and hooked radios into their sound systems at 7:15 P.M. when *Amos 'n' Andy* came on. About that time the fanatic loyalty of soap opera fans to their favorite series also became apparent, a loyalty still cultivated by today's televised serial dramas.

Ideally, habit formation calls for **stripping** programs—scheduling them Monday through Friday at the same time each day. To strip original prime-time programs, however, would require building up a backlog of these expensive shows, which would tie up far too much capital. Moreover, networks want maximum latitude for strategic maneuvers in the all-important prime-time schedule. If a broadcast network stripped its three prime-time hours with the same six half-hour shows each night, it would be left with only six pawns to move around in the scheduling chess game instead of the 22 or so pawns that weekly scheduling of programs of varying lengths makes possible.

When weekly prime-time network shows go into syndication, however, stations and cable systems schedule them daily, a strategy requiring a large number of episodes. A prime-time series has to have been on a network for four years (with the prospect of one more year) to accumulate enough episodes for a year's stripping in syndication (including a substantial number of reruns). Because few weekly shows survive five years of prime-time competition, the industry periodically faces a nagging shortage of quality off-network programs suitable for syndication. Fortunately, cable networks pick up shows that had short runs, but for lower licensing prices.

No one knows whether audiences find themselves more comfortable with the structured, compatible, predictable scheduling of traditional broadcasting than with a multitude of programming choices, however. Researchers investigating **channel repertoire** have often observed that when dozens or scores of options are available to listeners and viewers, most tune in to only a handful of the possible sources. For example, A.C. Nielsen surveys of homes with access to 60 or more television channels have consistently found that viewers watched only 13 of them for more

than one hour per week (but that number was only eight less than a decade ago). Recent research data on people's feelings about television (as compared with simple tuning data) suggest that the increased variety of programs and schedule options made possible by cable/satellite television and home video recording may be weakening viewing habits (see Chapter 2). Only about half of viewers (mostly women) choose in advance the programs they watch. Furthermore, active channel switching occurs more often in cable homes than in broadcast-only homes. Even so, some people may sometimes prefer to have only a limited number of choices. They find it confusing and wearying to sift through scores of options before settling on a program. *Broadcast scheduling, as a consequence of compatibility strategies and a tendency toward habit formation, preselects a varied sequence of listening and viewing experiences skillfully adapted to the desires and needs of a target audience.* People can then choose an entire service—an overall pattern (or "sound" in the case of radio) rather than individual programs. The food analogy would be opting out of a difficult set of menu selections (too many options) and deciding to eat a preset meal.

Control of Audience Flow

The assumption that audiences welcome, or at least tolerate, preselection of their programs most of the time accounts for strategies arising from the notion of **audience flow.** Even in a multichannel environment with dozens of choices, the next program in a sequence can capture the attention of the viewers of the previous program. At scheduling breaks, when one program comes to an end and another begins, programmers visualize audience members as flowing from one program to the next in any of three possible directions: They try to maximize the number that *flow through* to the next program on their own channel and the number that *flow in* from rival channels or home video, at the same time minimizing the number that *flow away* to competing channels or activities. Many strategies at all programming levels

hinge on this concept. Audience flow considerations dominate the strategies of the commercial networks and affiliates as well as their rivals, the cable networks and independent television stations (see 1.6). Blocking several similar comedies in adjacent time slots takes advantage of audience flow. **Counterprogramming** (simultaneously scheduling programs with differing appeals), in contrast, is crucial to the strategies of small-audience channels seeking to direct the flow away from competing channels to themselves.

Fortunately for programmers, many audience members remain afflicted by **tuning inertia.** Although dozens of options often exist in a cable or home satellite environment, *people tend to leave the channel selector alone unless stimulated into action by some forceful reason for change.* Many times, viewers are engaged in simultaneous activities that preclude a focused attention to what programs might be available on other channels. Moreover, programmers believe that children can be used as a kind of stalking horse: Adults will tend to leave the set tuned to whatever channel the children chose for an earlier program. Chapter 4 includes some of the common strategies for taking advantage of tuning inertia, such as lead-in/lead-out, tent-poles, hammocks, bridging, and seamless breaks.

The greater number of program options provided by subscription channels and the convenience of remote controls have lessened the effect of tuning inertia. Home video recording can defeat the idea of tuning entirely. Researchers recognize several ways the audience uses the remote control keypad to manipulate programming: **grazing,** hunting up and down the channels until one's attention is captured; **flipping,** changing back and forth between two channels; **zapping,** changing the channel or stopping a taping to avoid a commercial interruption; and **zipping,** fast-forwarding a recording to avoid commercials or to reach a more interesting point. Moreover, the VCR and DVD have undermined Saturday evening ratings for both broadcast and cable programmers: Huge numbers of viewers regularly rent DVDs or videocassettes on Saturday nights. Tuning

1.6 TELEVISION VERSUS BOOKS, NEWSPAPERS, AND MOVIES

Controlling audience flow becomes problematic because listeners and viewers have freedom of choice. Unlike the consumer faced with the limited decision of whether to buy a book, subscribe to a newspaper, or attend a movie, broadcasting, cable, and web consumers can choose instantaneously and repeatedly by switching back and forth among programs at will. Hence, the programmer cannot count on even the slight self-restraint that keeps a book buyer reading a book or a ticket buyer watching a movie so as not to waste the immediate investment. And, obviously, the polite social restraint that keeps a bored lecture audience seated does not inhibit radio and television audiences. Programmers have the job of holding the attention of a very tenuously committed audience. Its members take flight at the smallest provocation. Boredom or unintelligibility act like a sudden shot into a flock of birds.

inertia continues therefore as only a modest factor to consider in broadcast programming strategies.

Program flow is optional for some formats such as all-news radio and specialized subscription channels, which actually invite audience flow in and out. They aim not at keeping audiences continuously tuned in but constantly coming back. As a widely used all-news radio slogan goes, "Give us 22 minutes, and we'll give you the world." One cable news service promotes itself in variations of "Around the world in 30 minutes." The Weather Channel doesn't expect even weather buffs to watch for hours, just to return periodically.

In any case, the overall strategic lesson taught by the freedom-of-choice factor is that *programs must always please, entertain, and be easily understood.* Much elitist criticism of program quality arises simply because of the democratic nature of the medium. Critics point out that programs must

descend to the lowest common denominator of the audience they strive to attract. This fact need not mean the absence of program quality. After all, some programs aim at elite audiences among whom the lowest common denominator can be very high indeed.

Conservation of Program Resources

Radio and television notoriously burn up program materials faster than other media. This is an inevitable consequence of the continuousness attribute. That fact makes program conservation an essential strategy (see 1.7). Cable/satellite networks actively compete for channels on cable systems, suggesting an excess of programs. In fact, the reverse holds true. A high percentage of the programming on cable networks consists of repeats of the same items. The broadcast networks also repeat many programs in the form of **reruns.** Cable has stimulated production of new programs and program types, but on the whole cable heightens program scarcity rather than alleviating it. Cable makes parsimonious use of program resources all the more essential.

Frugality must be practiced at every level and in every aspect of programming. Consider how often audiences see or hear "the best of so-and-so," a compilation of bits and pieces from previous programs; flashback sequences within programs (especially in soap operas); news actualities broken into many segments and parceled out over a period of several hours or days; the annual return of past years' special-occasion programs; sports shows patched together out of stock footage; the weather report broken down into separate little packets labeled marine forecasts, shuttle-city weather, long-term forecast, weather update, aviation weather, and so on.

The enormous increase in demand for program materials created by the growth of cable television would be impossible to satisfy were it not that the multichannel medium lends itself to repeating programs much more liberally than does single-channel broadcasting. A pay-cable channel operates full time by scheduling fewer than 50 or so

1.7 RERUNS

Anyone doubting the difficulty of appealing to mass audiences need only consider the experience of the older media. Of 27,000 new books printed in one year, only 33 sold 100,000 or more copies; of 13,000 records copyrighted that year, only 185 music recordings went gold; of 205 feature film releases, only 11 grossed the amount of money reckoned as the minimum to break even. And yet audiences for these media are small compared to the nightly prime-time television audience.

Sometimes audience demands and conservation happily coincide, as when the appetite for a new hit song demands endless replays and innumerable arrangements. Eventually, however, obsolescence sets in, and the song becomes old hat. Radio and television are perhaps the most obvious examples of our throwaway society. Even the most massively popular and brilliantly successful program series eventually loses its freshness and goes into the limbo of the umpteenth rerun circuit.

new programs a month, mostly movies, and runs each film four to six times. Furthermore, movies first scheduled one month turn up again in the following months in still more reruns, which pay-cable programmers euphemistically call **encores.** As cable systems increase their capacity to 200 or more channels, frugality in sharing and repeating programs will become more essential. Even the basic cable channels rotate the showing of the same movies, based on the idea that the audience at 8 P.M. will be different from the audience at 1 A.M. A&E double-runs many of its prime-time programs, as does the American Movie Classics channel.

Programmers can also make creative use of low quality shows. Comedy Central and the Sci-Fi channel have featured old horror movies repackaged as *Mystery Science Theater 3000*. Repackaging

snippets of talk shows with humorous wrap-arounds, as in *Talk Soup* on the E! cable channel, is another example. A similar strategy is evident in scheduling programs such as *Soap Opera Digest*.

A major aspect of the programmer's job consists, then, of devising ingenious ways to get the maximum mileage out of each program item, to develop formats that require as little new material as possible for the next episode or program in the series, and to invent clever excuses for repeating old programs over and over. Any beginner can design a winning schedule for a single week; a professional has to plan for the attrition that inevitably sets in as weeks stretch into the indefinite future.

Breadth of Appeal

Stations and cable systems recoup their high capital investment and operating costs only by appealing to a wide range of audience interests. This statement might seem self-evident, yet initially some public broadcasters made a virtue out of ignoring "the numbers game," leaving the race for ratings to commercial broadcasters. But as Chapter 7 on national public television programming explains, this fundamentally unrealistic viewpoint has given way to the strategy of aiming for a high cumulative number of viewers rather than for high ratings for each individual program. This strategy coincides with that of cable television, whose many channels enable it to program to small audiences on some channels, counting on the cumulative reach of all its channels to bring in sufficient subscriptions to make a profit.

The difference between the two goals has been expressed in terms of **broadcasting** versus **narrowcasting.** Gene Jankowski, former president of the CBS/Broadcast Group, uses the terms *aggregation* and *disaggregation*, pointing out that the former deals with shared feelings and interests and the latter with highly personalized tastes and needs. Jankowski's terms take into account our complementary needs for belonging to the group while at the same time retaining our personal individualities.[4]

Only the national television broadcasting networks continue to "cast" their programs across the land from coast to coast with the aim of filling the entire landscape. Of course, no network expects to capture all the available viewers. A top-rated prime-time program draws only 25 percent of the potential audience, although extraordinary programs get up to three times that many viewers.

Nevertheless, *by any standard, audiences for prime-time broadcast television networks are enormous.* Although the audience shares of the broadcast networks have dropped from 90 percent of viewers to less than 60 percent in 2001 (for four networks),[5] a single program can still draw an audience so large it could fill a Broadway theater every night for a century. It is important to understand that a lowly rating of 10 still means more than 10 million people are watching a program. Such size can only be achieved by cutting across demographic lines and appealing to many different social groups. Network television can surmount differences of age, sex, education, and lifestyle that would ordinarily segregate people into many separate subaudiences.

A MODEL OF PROGRAMMING

The process of programming can be modeled in four major parts. First, programmers must *select* programs to go in a program lineup. Then, they must *schedule* them in an arrangement that maximizes the likelihood of their being viewed by the desired audience. Next, they must *promote* them to attract attention to new shows and new episodes of series and tell viewers where to find the shows. The outcome of these complex decision-making processes of selection, scheduling, and promotion ultimately determines the size and composition of the audience.

As shown in 1.8, however, the entire process is constantly modified by feedback from *evaluation*. Programmers must constantly appraise programs using ratings, hits, or other measures, interpreted by the honed instincts and experience of the programmer. Here, evaluation refers to the ongoing

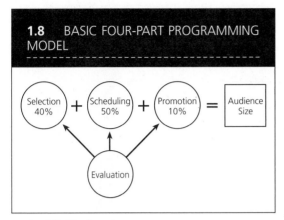

1.8 BASIC FOUR-PART PROGRAMMING MODEL

Selection 40% + Scheduling 50% + Promotion 10% = Audience Size

Evaluation

Art: Milt Hamburger

interpretation of quantitative information and qualitative judgment that results in revisions of show selections, changes in the scheduling of already selected programs, and modifications in the promotion of them. One important result of increased competition from cable and new broadcast networks, as well as the Internet, has been to drive the process of programming into constant flux. At local stations and at national and global networks, a static program lineup tends to lose ground, while ongoing refinements help to maintain and even increase audience size.

As the model shows, these authors have suggested the approximate proportions of influence for each of the three left-hand components on the resulting audience. The model shows that the selection component contributes roughly 40 percent to ratings, the scheduling component contributes about 50 percent, and the promotion component contributes about 10 percent. These proportions, however, vary widely for particular media and for particular programs and even at different times in history. Selection was probably much more important and promotion unimportant in the 1950s when the Big Three dominated television viewing. Increasing competition first from cable, then from more broadcast networks, and now from the Internet has altered the importance of the components to the television programming process.

In contrast, selection and scheduling are largely formulaic processes for popular all-music radio stations, while promotion becomes a more significant component in the determination of audience size and composition. On-air contests and games have a great deal to do with station popularity. For all-news radio and television, scheduling surfaces as the arena of competition and ongoing dynamism. For emerging Internet video channels, selection remains the key component.

If the model in 1.8 appears mechanistic, though, that is quite misleading. Even after a half century of concentrated attention, programming remains as much an art as a science. And nowhere is that more evident than in online programming. As the subsequent chapters reveal, at all stages the processes and the outcomes of programming are affected by the sparkle of insight, imagination, and inspiration.

Although some critics have decried the constant changes in television program lineups in the last decades, industry experience suggests that ongoing change is essential. Programmers tend to assume that audiences—especially the highly-desirable young adults—are fickle, have short attention spans, become easily bored, and follow fads. It may be that many program ideas (and songs) wear out and become stale more rapidly than in the past, partly resulting from clones, reruns, repeat plays of music, or web chat about a series or song. It may be that performers peak for a shorter time than in the past as a result of constant media attention. It may also be that programmers perceive their careers to depend on identifying and eliminating tiny flaws in program lineups and formats. Whatever the reason, ongoing feedback from the evaluation process is a critical component of the programming process. *The model in 1.8 illustrates the theory that industry decisions about selection, scheduling, and promotion, affected by ongoing evaluation that acts as a feedback loop, determine audience size.* It is important to understand that scholars and industry practitioners have studied parts of the programming process for decades. Some studies focus on the selection stage, others on the scheduling stage, others on

the promotion stage, and still others on the evaluation of ratings.

Selection

Figure 1.9 shows some of the many components affecting the selection stage for broadcast network television that are spelled out in the chapters on prime-time and non-prime-time programming (Chapters 4 and 5). They include the scarcity of top-notch writers, the high financial risk of markedly different program ideas, and escalating cost-per-episode for the on-screen and off-screen talent. For cable networks, the same factors are important to choosing programs, along with the need, usually, to target an underserved audience group. As significant as individual programs are, even more important is the overall composite that creates a "format" for the cable or radio channel. Additional factors affecting selection of programs for cable networks include differentiation from competing channels, relative cost compared to other program types, and the ability to capture space on local cable or satellite systems to reach an audience.

In radio and online music programming, enormous efforts go into choosing the songs to appeal to a particular demographic and psychographic group. Whether they are called music directors or programmers, the crucial task is to find and keep current the songs that the audience will tune in to hear.

Scheduling

It has been long understood that the size of the prime-time television audience is affected by the amount and type of competing programs, the amount of viewing inherited from preceding programs, and the compatibility between adjacent programs (see 1.10). The most studied of these elements, the amount of inherited viewing between adjacent programs, has been consistently shown to hover around 50 percent in prime time. This means that half of the viewers watching Program B on a channel already watched Program A

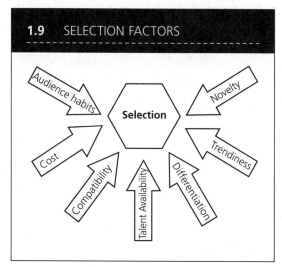

1.9 SELECTION FACTORS

Art: Milt Hamburger

on that channel. Program B's other viewers come from other channels or are newly tuned in for the evening. Inheritance, however, is known to be much lower between incompatible programs and between nonadjacent programs. Few of the viewers of a romantic drama would choose to stay tuned for a violent action program, for example. (One does wonder why USA Network scheduled *Walker, Texas Ranger* immediately before or after *JAG* for about two years.) Moreover, inheritance is certainly much lower outside of prime time except between two adjacent soap operas when it usually goes up. On the other hand, only 10 percent of television viewers are likely to flow from program to program in the morning daypart, because of other activities and obligations in daily lives—going to work, for example.

In radio, careful attention to each nuance of song rotation and news story rotation leads to ongoing scheduling adjustments. And similar attention to detail is required of online music and news programmers, but, as Chapter 10 explains, the frustratingly slow development and distribution of streaming video has put the focus on the technology and left little attention to devote to the niceties of Internet video scheduling.

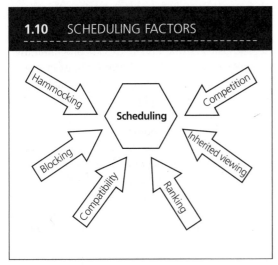

Art: Milt Hamburger

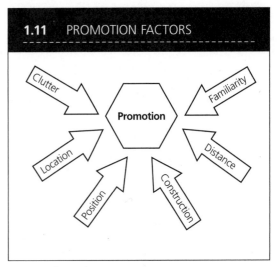

Art: Milt Hamburger

Promotion

The contributions of promotion to audience size and composition have only recently been the subject of quantitative research, but promotion's importance has long been recognized in the industry. Promotion serves both an informational and an enticement function. Figure 1.11 names some characteristics that impact the effectiveness of on-air spots—such as the location of promotional spots within a program, the position of those spots within breaks, the distance between the promotion and the promoted program (Next? Later tonight? Next week? Next month?), and the familiarity of the program to viewers or listeners. Such considerations as the physical environment of a message, the number of people reached, and the frequency of seeing or hearing the message also affect the efficacy of both on-air and print promotion.

Because promotion is the smallest of the three components in programming, and because it is the subject of another textbook by these same authors, promotion receives less attention in the chapters in this book than selection, scheduling, and evaluation. Nonetheless, it is the object of constant manipulation in the struggle to gain and hold ratings.

Evaluation

In 1.12, evaluation is shown as having a wide range of constituents, some directly related to program audiences and others of larger social scope. For example, the success of the competing programs affects a programmer's interpretation of ratings. A show with low ratings scheduled against a megahit on another channel might well be considered reasonably successful, whereas the same show in a less challenging location would be expected to perform much better in the ratings. Consider, for example, the inherent difficulty of trying to target men viewers on networks other than ABC on Monday nights during football season.

In addition, the programmers' specific assumptions about an audience's behavior and viewing or listening motivations affect how programs are selected, scheduled, and promoted. In one town, for example, factory workers start and end their jobs early, making afternoons a good time to program to them, whereas in another town, factories have varied schedules and less impact on the number of available afternoon viewers. Programmers' understanding of the impact and use of the newest technologies are also vital. Remote control use, for example, very much affects the

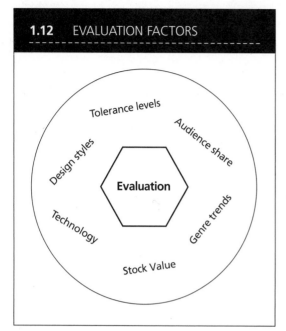

1.12 EVALUATION FACTORS

Tolerance levels

Design styles

Audience share

Evaluation

Technology

Genre trends

Stock Value

Source: Milt Hamburger

FIVE ISSUES FOR PROGRAMMERS

Beyond learning the nuts-and-bolts programming framework, the novice programmer must face several external issues that affect decision making. Five issues are outlined here, but their order is arbitrary. Distribution systems make all programming possible, so technological issues are considered first. Without money (economic issues), of course, there can be no widespread development of new technologies. From economics flows some kind of structure, creating ownership issues. Whenever corporations and economies get in the way of individual rights, governments create regulatory issues. Finally, the chapter discusses what is morally right about the work of a programmer (ethical issues). For example, does the end (ratings success) justify the means (pandering to viewers)?

Technology Issues

The ultimate effect of satellites, high-definition television (HDTV), and such technologies as compressed digital television and digital audio will be to lessen station dependence on traditional national networks for television (and radio) programming, both as sources of original material and for off-network syndicated material. HDTV is beginning to attract topnotch production talent. At the same time, the broadcast networks find themselves less able to invest in high-cost programming because of the audience's shift to satellite-distributed cable networks and digital home playback.

Contributing to this audience erosion is the increased difficulty of persuading affiliates to clear all requested time for network schedules. At one time the networks had considerable leverage over affiliates because the networks leased the coaxial-microwave relays that were the sole real-time program distribution system. Clearances were virtually automatic then. Now, however, satellite dishes, possessed by virtually all stations, give affiliates many alternate sources of instantaneous delivery at reasonable cost. All this encourages the emer-

processes of program selection and scheduling, and the growth of use of the Internet for music listening has altered the strategies of traditional broadcast radio stations. Other factors that programmers must constantly scope out are the trends in popularity of particular program genres, fads in star performers, styles in design and sound effects, and so on. The programmer's nearly unconscious awareness of what is going to become popular and his or her ability to capture it in programming decisions comprise much of what is meant by the creative side of programming.

In sum, the basic model is a simplified diagram that guided the approaches in subsequent chapters to specific programming situations. Collectively, the main model and its parts comprise a picture of the major components of the programming process, supplemented by many specific strategies in situations. These strategies, as well as the commonplace practices of programming—and the magical creative element—are the topic of this book.

gence of new program providers. Nonnetwork group owners will play a prominent role among them.

Another huge technological influence will be the convergence of computers, telephones, and television. There is little doubt that the various media will come together fairly soon in and out of the home. The merging of the Palm Pilot and its clones with cell phones and with Internet access signals the eventual arrival of portable digital web/television in the hand.

Economic Issues

There is a saying in business: "Good, fast, cheap—choose two." The idea that quality, speed, and price cannot occur at the same time is also true for programming. If most programming is like cheap fast food, then we should not be surprised that the quality is not high. The cost of extremely well-executed programming is high, if only because the cost of ordinary programming is so high. According to Gene Jankowski, former president of CBS:

Each network will review two thousand program ideas a year. About 250 of these will be judged good enough to go on into the script form. About thirty or forty of the scripts will move along into pilot production. About ten pilots will make it into series form. Perhaps two or three series will survive a second season or longer. Each year, program development costs $50 to $60 million. In other businesses it is known as Research and Development. In television it is called failure, or futility, or a wasteland.[6]

The high failure rate of television programs attracts constant attention in newspapers and magazines and in TV news and talk shows like *Entertainment Tonight*, but when television shows are compared to other sources of entertainment, such as movies, books, and Broadway plays, the TV failure rate does not seem so serious. The kinds of programs prevalent at any given time can be directly linked to economics. Some programs can be produced cheaply: soaps, game shows, talk shows, reality formats, and tabloid news. In each

case, there is little expense involved, because there is no need for top-name stars or sophisticated writing. These shows may not win many awards, but they create audience demand without incurring huge costs.

Economic issues also include the cost of waiting for a show to "grow" into its time slot. Considerable lore has evolved about several programs that had early low ratings and might never have become successful but which were, for various reasons, allowed to stay on the networks' schedules despite their ratings. For example, *The Dick Van Dyke Show* in the early 1960s was not popular at first and would never have survived today's cutthroat marketplace. Some shows seem to need incubation time to "find an audience." The award-winning *Hill Street Blues* was such a series. Some program producers feel that the audience never gets a chance to discover some shows because cancellations come too quickly. The programmer has to be realistic when millions of dollars are at stake. For every show that really needs more time to build, there are dozens more that were turkeys from the first day. Programmers can trust their hunches, or they can go with the ratings. Neither way is wrong or right, but very few programmers are fired for canceling a show too soon. If the program seems to be missing its audience (or vice versa), sometimes the wise decision is to try it on a different night or in a different time slot with a better lead-in and more promotion. If it fails there, it's time to admit defeat.

Finally, a situation can arise where a show is canceled even when it finishes among the top shows for the week. Anyone who remembers *The Single Guy* or *Jesse* will realize that some successful shows owe most of their success to the preceding program. If the lead-in show has a huge audience, even a precipitous falloff can leave a strong audience share for the weaker following program, but programmers want shows that maintain or build the audience shares from the preceding shows. Programs that "drop share" are canceled, regardless of high rankings.

Ownership Issues

To fully understand media programming, it is necessary to know who the major players are. The top 12 media companies are shown in 1.13. The major commercial television studios and producers are listed in 1.14. As this book went to press, only NBC was not aligned with a studio.

So many programs are produced by network-run or network-owning studios that difficult choices must be made about acquiring shows. According to an industry insider, a network with a strong show and a strong time slot should air its own product.[8] If the show is strong but the time slot is weak, it should sell to others (as Warner Brothers does with *Friends* to NBC). If the time slot is strong but the owned show is weak, it should buy better from others (as NBC does with the show on Thursdays at 9:30). If both the show and the time slot are weak, then the network should recycle its own library (as ABC does on Sundays at 7 P.M. with Disney movies).

Executives concerned with programming, as indeed with every other aspect of broadcasting cable, and web television, need constantly to update their knowledge of the rapidly evolving field and the rapidly increasing competition. The trade press provides one source of updates, but even more important are the many trade and professional associations that provide personal meetings, demonstrations, exhibits, seminars, and publications. Dozens of such associations bring practitioners together at conferences on every conceivable aspect of the media, all of which touch on programming in one way or another—conferences on advertising, copyright, education, engineering, finance, law, management, marketing, music, news, production, programs, promotion, research, and satellites, to name a few. Licensing groups provide the legal and economic environment that ensures that artists get paid royalties for their works. These associations, organizations, and groups are listed in 1.15, with more about the most important of all—to programmers: the **National Association of Television Program Executives (NATPE)** in 1.16.

1.13 THE PLAYERS

Top 12 Companies (plus owned programmers)	1999 Revenues (billions)
1. AOL-Time Warner (Turner, HBO, Warner Brothers)	$34.2
2. Walt Disney Company (CapCities ABC, ESPN)	$23.4
3. Vivendi-Universal (USA Networks, Universal, CANAL+)	$22.6
4. Viacom-CBS (Paramount, UPN, Infinity, MTV)	$20.3
5. Sony (Columbia-TriStar)	$16.9
6. News Corp. Ltd. (Fox)	$14.3
7. AT&T Broadband (TCI, MediaOne, Liberty Media)	$ 8.6
8. Comcast	$ 6.2
9. Tribune (Times Mirror)	$ 6.0
10. Cox	$ 6.0
11. General Electric (NBC)	$ 5.8
12. Gannett (*USA Today*)	$ 5.3

Source: *Broadcasting & Cable*, 28 August 2000.

Ownership affects the programmer at the lower levels of the hierarchy. Most broadcast stations and the larger cable systems belong to companies owning more than one station or system. The profitability of broadcast and cable investments attracts corporate buyers, who gain important economies of scale from multiple ownership. Because they can buy centrally in large quantities, they can get reduced prices for many kinds of purchases, including programs. FCC and Justice Department permissiveness also encourages the formation of multimedia companies and very large, diversified conglomerates, making group ownership the pattern of the industry. The AOL and Time-Warner merger signals the rise of the web to major-player stakes.

In broadcasting, the owner of two or more stations of a given type (AM, FM, TV) is called a **group owner,** while in cable television the owner of several systems is called a **multiple system**

1.14 THE PRODUCERS

The veteran movie and television producers, the traditional **Big Seven studios** of the Hollywood entertainment motion picture industry, are Sony (Columbia-TriStar), Walt Disney Studios (Buena Vista, Miramax, Touchstone), Paramount, MGM-UA, 20th Century Fox, Universal, and Warner Brothers—though a new studio, Dreamworks SKG, would have to be considered a top movie studio after the success of its summer 2000 movies, *Gladiator* and *Chicken Run.*

In addition, the independent production houses make Hollywood their base of operations. Among **independent producers,** Wolf/StudiosUSA, Carsey-Werner-Mandabach, WorldWide Pants, David E. Kelley, and Steven Bochco have been regular and prolific producers for the networks and the syndication market. Independents are sometimes acquired by large studios, as when New World bought Stephen Cannell Productions and Viacom/CBS purchased Spelling Entertainment and King World.

Consider the lineup for fall 2000. That year, prime-time network television consisted of 116 program series, 37 of them were new that season (16 dramas, 16 comedies, 2 new movie slots, and 3 reality-based shows). Of the 37, the networks themselves produced or co-owned 24 for airing on their own networks (or sometimes their competition). A total of 18 producers accounted for all program series, except for the feature film series. And the number of producers has dwindled over the years.[7]

In 1991, only five prime-time series were produced by the networks for themselves, compared to 76 shows in 2000. The repeal of financial interest and network syndication rules (fin-syn) has encouraged the networks to return to **vertical integration,** as also practiced by the cable companies. Production, distribution, and exhibition of a program are thus combined into a single company.

operator (MSO). About three-quarters of the nearly 1,300 commercial television stations are under group control (one-third are controlled by the top 25 groups), as are three-quarters of the 12,000 radio stations. In cable, the percentage is even higher, with more than 90 percent owned by an MSO (defined as owning three or more cable systems). The number of subscribers controlled by the top-ten MSOs grew from 73 to 84 percent between 1997 and 2000.

Group ownership of the right stations in the right markets can be remarkably profitable. ABC, CBS, Fox, and NBC's **owned-and-operated stations (O&Os)** constitute the most prominent group-owned constellations. Of the Big Three O&Os, those in each of the top three markets alone—WABC, WCBS, and WNBC in New York; KABC, KCBS, and KNBC in Los Angeles; WLS, WBBM, and WMAQ in Chicago—gross more revenue than any other groups. Fox, cur-

rently with the largest potential television reach, is owned by Rupert Murdoch, an international media magnate, and is linked with 20th Century Fox. The television network now has more than 220 affiliates, putting it slightly higher than the three traditional networks, which each have about 210 stations. Pax, Telemundo, Univision, UPN, and WB have far fewer affiliates. Box 1.17 spells out some of the advantages and disadvantages of group ownership.

Because broadcast stations have a legal obligation to serve their specific communities of license, group owners must necessarily give their outlets a certain amount of latitude in programming decisions, especially decisions that affect obligations to serve local community interests. Beyond that, broadcast group owners have no common method or standard for controlling programming at their stations. Most employ a headquarters executive to

1.15 THE ASSOCIATIONS

Here is a list of important organizations, along with the home page listings (when available) for the World Wide Web.

Major Industry Trade Associations
National Association of Broadcasters (NAB) *www.nab.org*
National Cable Television Association (NCTA) *www.ncta.org*
Radio-Television News Directors Association (RTNDA) *www.rtnda.org*

Programming Organizations
National Association of Television Program Executives (NATPE) *www.natpe.org*
Association of Local Television Stations (ALTV, formerly INTV) *www.altv.com*
Television Programmers' Conference (TVPC) *www.tvpc.org*
Community Broadcasters Association (CBA) *www.communitybroadcasters.com*
Alliance for Community Media (ACM) *www.alliancecm.org*
Media Communications Association (MCA), formerly, ITVA)

Music Licensing Groups
American Society of Composers, Authors, and Publishers (ASCAP) *www.ascap.com*
Broadcast Music Inc. (BMI) *www.bmi.com*
SESAC

Technical Societies
Society of Motion Picture and Television Engineers (SMPTE) *www.smpte.org*
Society of Broadcast Engineers *www.sbe.org*
International Radio & Television Society (IRTS) *www.irts.org*

Sales Organizations
Television Bureau of Advertising (TvB) *www.tvb.org*
Radio Advertising Bureau (RAB) *www.rab.com*
Cable-Television Advertising Bureau (CAB) *www.cabletvadbureau.com*
Cable & Telecommunications Association for Marketing (CTAM) *www.ctam.com*

oversee and coordinate programming functions with varying degrees of decentralization.

As for cable, the largest MSOs now focus more on adding subscribers to their existing systems than on adding new systems; some also have given slightly more autonomy to their local managers as they try to trim headquarters' budgets to reduce overhead. Nevertheless, cable group owners tend to centralize programming more than broadcasting groups do because cable has no special local responsibilities under federal law (as does broadcasting). Many of the largest MSOs also own several cable program networks, so they have a vested interest in distributing them to all the markets they reach, irrespective of local preferences.

Regulatory Issues

Radio and television, more than most businesses (including other media), must live within constraints imposed by national, state, and local statutes and administrative boards. Moreover, public opinion imposes its own limitations, even in the absence of government regulation. The most recent trend in media regulation has been to "let the marketplace decide" and remove the interference of government. Only a few rules

1.16 NATIONAL ASSOCIATION OF TELEVISION PROGRAM EXECUTIVES (NATPE)

When television programmers formed their own professional organization in 1962, they called themselves the National Association of Television Program Executives—tacitly acknowledging that membership would be dominated by general managers and other executives who play more important programming roles than those specifically designated as programmers. The broadcast station programming team is usually made up of the general manager, sales manager, and program manager. In cable organizations, the executive in charge of marketing plays a key management role and may be the one with the most influence on programming decisions. In recent years, the role of program manager at many network affiliates has diminished as higher-level staff members frequently make programming decisions.

Syndicators put programs on display nationally and internationally at a number of annual meetings and trade shows. For showcases, they rely especially on the annual conventions of the National Association of Television Program Executives (NATPE) and the National Cable Television Association (NCTA) held each spring.

At the annual NATPE conventions, hundreds of syndicators fight for the attention of television programming executives, offering a huge array of feature films (singly and in packages), made-for-TV movies, off-network series, first-run series, specials, miniseries, documentaries, docudramas, news services, game shows, cartoons, variety shows, soap operas, sports shows, concerts, talk shows, and so on. Trade publications carry lists of exhibitors and their

offerings at the time of the conventions. (Chapter 3 gives a selection of syndicators along with examples of their offerings.)

Europe has a similar annual program trade fair, MIP-TV. Formerly at that fair, the flow of commercial syndicated programming between the United States and other countries ran almost exclusively from the United States. Public broadcasting first whetted American viewers' appetites for foreign programs. And with such specialized cable services as The Discovery Channel featuring foreign documentaries and Bravo featuring foreign dramatic offerings, the international flow has become somewhat more reciprocal, although the United States is still much more often an exporter than an importer.

remain that programmers must know to avoid possible violations within their jurisdictions.

Fairness and Equal Opportunity

Both broadcast and local cable-originated programming must observe the rules governing appearances by candidates for political office (**equal time**) and station editorials. The equal-time rule for political candidates demands that broadcasters (not cable or satellite operators) provide equal opportunities for federal candidates, effectively preventing entertainers and news personnel from running for office while still remaining on their programs. Although the FCC has formally abandoned its specific Fairness Doctrine

concerning discussion of controversial issues of local importance, many managers continue to adhere to the basic fairness concepts as a matter of station policy. Day-to-day enforcement of such rules and policies devolves largely on the production staff in the course of operations, but programmers often articulate station policies regarding balance and stipulate compliance routines. Fairness looms large in talk radio and talk television, because the talk so often deals with controversial topics.

Monopoly

Traditionally, various rules have limited concentrations of media ownership, all of them aimed at

1.17 GROUP OWNERSHIP

The main programming advantages of group ownership are the cost savings in program purchases, equipment buys (such as computers, servers, and cameras), and service charges (such as by reps and consultants) that accrue from buying at wholesale, so to speak. Insofar as groups produce their own programs, they also save because production costs can be divided among the several stations in the group—a kind of built-in syndication factor. Moreover, group-produced programs increasingly are offered for sale to other stations in the general syndication market, constituting an added source of income for the group owners.

Group buys often give the member stations first crack at newly released syndicated programming as well as lower cost per station. Distributors of syndicated programs can afford such discounts because it costs them less in overhead to make sales trips to a single headquarters than to call individually on widely scattered stations, and the larger groups can deliver millions of households in a single sale.

Large group owners can also afford a type of negative competition called **warehousing.** This refers to the practice of snapping up desirable syndicated program offerings for which the group has no immediate need but which it would like to keep out of the hands of the competition by holding them on the shelf until useful later (see Chapter 3). Also, group executives have bird's-eye views of the national market that sometimes give them advance information, enabling them to bid on new programs before the competition even knows of their availability. For their part, producers often minimize the risk of investing in new series by delaying the start of production until at least one major group owner has made an advance commitment to buy a series. Many promising program proposals for first-run access time languish on the drawing boards for lack of an advance commitment to purchase.

The stations in the top four markets that are owned and operated by the national television networks exercise extraordinary power by virtue of their group-owned status. Each such O&O group reaches about one-fifth of the entire U.S. population of television households, making their collective decisions to buy syndicated programs cru-

ensuring diversity of information sources, in keeping with implicit First Amendment goals, although the recent trend has been to loosen the rules. Nonetheless, group owners of broadcast stations are particularly sensitive to regulatory compliance in this area because they have a high financial stake in compliance and, of course, are conspicuous targets susceptible to monopoly charges. In a way, cable franchises may be regarded as "natural monopolies," for it would normally seem uneconomic to duplicate cable installations (**overbuilds**). If monopoly is construed as denial of freedom of speech, though, then even the "natural monopolies" created by franchising one operator seem to violate the First Amendment.

Localism

The FCC has traditionally nudged broadcasters toward a modicum of **localism** in their program mixes. The FCC expects licensees to find out about local problems in a station's service area and to offer programs dealing with problems. The informal **ascertainment** requirement, which is a quarterly list of local issues and programming dealing with these issues that stations must place in their public files, is one approach to enforcing this requirement. In licensing and license renewals, the FCC gives preferential points for local ownership, owner participation in management, and program plans tailored to local needs. Cable operators are not licensed by the FCC and so have no such federal public-interest mandate, and

1.17 CONTINUED
- -

cial to the success of such programs. Thus, these few group-owned stations influence national programming trends for the entire syndicated program market.[9] So important to the success of programs is their exposure in the top markets that some syndication companies offer special inducements to get their wares on the prestigious prime access slots on network O&O stations. These inducements can take the form of attractively structured barter syndication deals or cash payments to ensure carriage. The latter type of deal, known as a **compensation incentive,** occurs primarily in New York, the country's premier market.

MSOs have much the same advantages as broadcast groups, however. Cable systems normally obtain licenses to carry entire

channels of cable programming (cable network services) rather than individual programs or program series. Thus, major MSOs, negotiating on behalf of hundreds of local cable systems, gain enormous leverage over program suppliers. Indeed, a cable network's very survival depends upon signing up one or more of the largest MSOs. By 1995, all but about 300,000 cable subscribers in America were served by systems owned by the top 100 cable MSOs, and the independence of the remaining small systems is threatened by the high cost of rebuilding to increase channel capacity.

Nongroup program directors (at the minority of independent stations and cable systems) enjoy more autonomy and can move more aggressively and rapidly than their group-

controlled counterparts. Group headquarters programmers and their sometimes extensive staffs impose an additional layer of bureaucracy that tends to slow down local decision making. Local program executives know their local markets best and can adapt programming strategies to specific needs and conditions. A group-acquired broadcast series or cable network that may be well-suited to a large market will not necessarily meet the needs of a small-market member of the group. When a huge MSO such as AT&T Broadband makes a purchase for hundreds of different systems, not every system will find the choice adapted ideally to its needs. Group ownership imposes some inflexibility as the price of its **economies of scale.**

as a result, cable programmers differ fundamentally in their programming outlook from broadcast programmers.

Increased competition for audiences now drives broadcasters and cable operators toward increased localism. In many cases, localism has boosted the financial return for those stations with a long, honorable history of community orientation. It is good business to serve the community, not merely a requirement.

Copyright

Except for news, most public affairs programs, and most local productions, all programs entail the payment of royalties to copyright owners. Programmers should understand how the **copyright**

royalty system works, how users of copyrighted material negotiate licenses from distributors to use them, and the limitations on program use that the copyright law entails.

Broadcast stations and networks usually obtain **blanket licenses** for music from copyright licensing organizations, which give licensees the right to unlimited plays of all the music in their catalogs (in programs, promos, or song play). For the rights to individual programs and films, users usually obtain licenses authorizing a limited number of performances (**plays**) over a stipulated time period. One of the programmer's arts is to schedule the repeat plays at strategic intervals to get the best mileage possible out of the product.

Stations and networks obtain **licenses** for the materials they broadcast, with fees calculated on the basis of their over-the-air coverage, but cable television systems introduced a new and exceedingly controversial element into copyright licensing: Importation of distant signals stretched the original single-market program license to include hundreds of unrelated markets all across the country—to the obvious detriment of copyright owners (the producers). The Copyright Law of 1976 tried to solve this problem by introducing the **compulsory licensing** of cable companies that retransmit television station signals. It provided retransmission compensation to the copyright owners in the form of a percentage of cable companies' revenues. The Cable Act of 1992 went further and insisted that cable systems receive **retransmission consent** from broadcast stations for their signals, which led some to believe that cable operators would finally pay for retransmission. The issue was largely resolved when most affiliates of major television networks made deals with cable operators for a second local cable channel in lieu of cash payment.

A related copyright matter, the **syndicated exclusivity rule,** often called **syndex,** gives television stations local protection from the competition of signals from distant stations (notably superstations) imported by cable systems. The rule is based on the long-held principle that a station licensed to broadcast a given syndicated program normally paid for exclusive rights to broadcast that program within its established market area. Cable's ability to import programs licensed for broadcast in distant markets (especially the superstations) undermines this market-specific definition of licensing and divides audiences. The rule requires cable systems to black out imported programs that duplicate the same programs broadcast locally. Most syndicators attempt to avoid selling their shows to superstations to make the shows "syndex-proof."

Lotteries, Fraud, Obscenity, Indecency

Federal laws forbid **lotteries,** fraud, and obscenity, and laws regarding them apply to locally originated cable as well as to broadcast programs. Shows that feature state-run lotteries are an exception to the rule. Programmers also need to be aware of special Communications Act provisions regarding fraudulent contests, **plugola,** and **payola. Indecency,** a specialized interpretation of obscenity laws, appears to apply only to broadcasting.

The 1984 Cable Act sets specific penalties for transmitting "any matter which is obscene or otherwise not protected by the Constitution" (Section 639). A subsequent Supreme Court decision affirmed that cable operators qualify for First Amendment protection of their speech freedom. This puts the heavy burden on those alleging obscenity of proving the unconstitutionality of material to which they object; in fact, several court decisions have overthrown too-inclusive obscenity provisions in municipal franchises. In practice, cable operators have greater freedom to offend the sensibilities of their more straitlaced viewers than do broadcasters, whose wider reach and dependence on the "public airwaves" (**electromagnetic spectrum**) make them more vulnerable to public pressure. Congress has shown some signs of tightening the restrictions on cable, however, including restrictions on nudity.

In a 1987 ruling, the FCC broadened the previous definition of prohibited words in broadcasting to cover indecency. That definition had been based on a 1973 case involving the notorious "seven dirty words" used by comedian George Carlin in a recorded comedy routine broadcast by WBAI-FM in New York. Responding to complaints about raunchy talk-radio hosts (**shock jocks**), the FCC has repeatedly advised broadcasters that censorable indecent language could include anything that "depicts or describes, in terms patently offensive as measured by contemporary community standards for the broadcast medium, sexual and excretory activities or organs." Raunchy radio content from Howard Stern led to a $1.7 million settlement by his syndicator to the FCC.

Nonetheless, the FCC has designated late night as a **safe harbor** for adult material. It is noteworthy that the commission used the words for the broadcast medium, implying that broadcasting should be treated differently from other

media, a concept out of keeping with much FCC-sponsored deregulation.

Libel

News, public affairs programs, and radio talk shows in particular run the risk of inviting libel suits. Because of their watchdog role and the protection afforded them by the First Amendment, the media enjoy immunity from punishment for libel resulting from honest errors in reporting and commentary on public figures. Due care must be taken, however, to avoid giving rise to charges of malice or "reckless disregard for the truth." Though the media have traditionally won most libel cases brought against them, in the early 1990s this trend was reversed, and juries awarded huge fines. Moreover, win or lose, it costs megadollars to defend cases in court. Managers responsible for news departments and radio talk shows need to be aware of libel pitfalls and to institute defensive routines. These defenses include issuing clear-cut guidelines, ensuring suitable review of editing, and taking care that promotional and other incidental material does not introduce libelous matter. To assist local programmers, the **National Association of Broadcasters (NAB)** has issued a videocassette that illustrates some of the common ways news programs inadvertently open themselves to libel suits.

Digital Must Carry

The transition to high-definition television over digital channels "loaned" to broadcasters is a major concern for broadcasters and cable operators alike. The FCC has been reluctant to require "must-carry" status for these new channels. The target year for the transition (2006) will likely be delayed. Digital signals must reach 85 percent of the country before the old analog channels will be shut down, and so far, the diffusion of digital receivers into the home has been slow.

Ethical Issues

Programmers continually wrestle with standards. It is not necessarily a question of freedom but of

taste. What is good taste? Like anything else, the definition depends on a consensus of the people who have to live with the definition.

Over a period of time, the erosion of public taste standards has mirrored the erosion of other aspects of public life (like manners). Viewers might be offended if television were the only culprit, but it is increasingly impractical to take a walk in the mall or go for a drive on the highway without being assaulted by someone's "free speech" in the form of a lewd T-shirt or scatological bumper sticker. In the process, the public consensus about "what is shocking" impinges on "what is good taste"; bad taste is precluded by definition. Some viewers will defend a program with violent or sexual content by saying, "You think Show A is bad. It's not nearly as bad as Show B." Show A becomes the standard, and Show B is the exception, until Show C comes along. Then Show B becomes the new standard, and Show C the new exception. The everwidening spiral may not be rapid, but there seems to be a steady broadening of what is acceptable. Programmers are caught between the expectations of one audience that wants "in your face" entertainment and the complaints from another audience that struggles to hold onto civility. A minority of producers (and their networks) go for shock value and try to lower the standards one small notch at a time. Like the drops of limestone slowly accumulating on the floor of a cavern until a stalagmite forms, the amount of impolite language and situations has grown into high peaks in some programs on evening television, especially late-night shows.

Not everyone agrees there is a problem with program standards. Here is a look at the arguments currently in vogue when the topic of ethical standards is discussed.

"It's just entertainment." The public derives its values from such institutions as family, schools, churches, and the mass media, but as the authority of families, schools, and churches declines, the content of radio and television programs takes on a larger role in the socialization of young people.

"*If you don't like it, turn it off.*" True, but I can turn off only my own television set. My neighbors' kids will still be intoxicated by the violence in afternoon children's programs. They will also learn that it's all right to be promiscuous from prime-time television and soap operas. The cultural values of a nation are not wired to my individual ability to shut off my set. If someone poisoned all the drinking water in my area, you might say, "If you don't like it, don't drink it." I guess I could buy bottled water.

"*Parents have the responsibility to monitor programming.*" This argument rarely comes from a parent, unless it's a parent who works as an executive at one of the broadcast networks. Anyone who thinks this will work is overly wishful. Children will see what they want to see if it is readily available at a friend's house, their daycare center, the mall, or other group viewing locations. One person who has some control over the ready availability of seamy programming is the programmer.

"*Censorship, even voluntary censorship, violates First Amendment rights.*" The Bill of Rights has ten amendments but somehow the first gets all the attention, perhaps because the media control what gets our attention. A lot of other freedoms are equally precious to the well-being of citizens, such as the right to a fair trial. The community standards of the present age would easily shock the framers of the Constitution.

The drinking water analogy is apt. If a very slow poison is released into the water supply that results in amoral, uninformed residents, then the culprits are those who work for the treatment plant. Likewise, those who choose and schedule programs for radio and television have the means to maintain some level of decency in the mass media.

How did things get so out of whack? When there were only three networks, the Standards and Practices Departments held a pretty tight rein, but when pay movies and cable came along, the competition for audiences heated up. Certainly, the most egregious examples of sex and violence come from movies, yet some viewers want still more uncut movies and more adult topics. The slow erosion of public behavior is also taking its

toll, but the amounts of sexual and violent content are merely surface issues. What matters are deeper concerns about how people in society learn to solve problems and get along in spite of differences.

Even though programmers have not always acted responsibly, the regulators have devised schemes to deal with unwanted content, including a device called the **V-chip.** This device is installed in every television set sold nowadays to automatically limit the amount of violence (or other unwanted content) children see. The presumption, of course, is that all TV sets in multiset households (85 percent of homes) are recently purchased, and that all parents remember to activate the device when they leave the room.

WHAT LIES AHEAD

In this new millennium, the landscape of broadcast and cable programming is undergoing a sea change. Merger mania has reached a crescendo with content giants devouring distribution giants, and vice versa. In the early 2000s, larger and larger deals occurred: AT&T bought TCI and MediaOne; AOL bought Time-Warner; and Fox bought the valuable Chris Craft stations. Changes came to the radio industry as well. **Cybercasting** now allows radio programmers to distribute materials directly to the consumer via a computer modem, bypassing local radio affiliates. Another development that may revolutionize mass communication is the growth of interactivity. Until now, audiences (whether they perceived themselves as active or passive) were receivers of most program content. Computer networking capabilities now being built into satellite television receivers and cable set-top converters have created "smart" machines. Before long, viewers with cable service will be able to web surf during commercial breaks on living-room television sets, or on streets and in their cars, using hand-held organizers via cell-like distribution systems.

Still, the most cataclysmic technological development for television may be the **digital video**

recorder **(DVR),** especially the two-tuner models. This device, sold under the brands TiVo, Replay, and UltimateTV, combines standard television viewing (and Internet access, in the case of UltimateTV) with a built-in hard-drive server. The user tells the DVR what his or her favorite shows are, and the device does the rest via a phone connection to a program database. The DVR detects the desired shows and digitally records them, up to about 20 hours, and because the storage is random-access, the viewer can start watching during any show while the recording continues, skipping commercials and perhaps catching up with the live action. Viewers can even watch live shows and pause the action for a phone call, resuming the program as stored on the server. Ad-supported network executives fear that viewers might thus record prime time (8 to 11 P.M.) and delay viewing until 8:20 (making that phone call to a friend) and then hit the skip button to avoid all the commercials, thereby "catching up" with the live programs at about the time that prime time ends. Or viewers might delay their viewing by a night and watch the shows (from different networks) in any order they choose, without rewinding or searching. This device will be integrated into every future set-top box, ushering in a new era of video-on-demand and personal control over scheduling to an extent never possible with the VCR. The easy elimination of commercial advertising is going to be the ultimate test for free over-the-air broadcasting.

A final word on the changing importance of scheduling: As more content moves to online video servers, the potential for viewers to create their own schedules increases. Although present generations may be comfortable with letting someone else package a programming service, no one can predict how enamored computer-savvy viewers will react to new streaming technologies. In 2000, a firestorm of controversy arose over Napster and Gnutella (see Chapter 10), services that allowed web surfers to download files stored on other web surfers' hard drives **(servers),** *without paying anyone!* The business model of selling content like audio CDs, which in turn influences

radio stations, may well evolve into an advertiser-supported system where content providers erect giant servers to supply video, audio, and interactive materials online, on demand. And Congress cannot readily legislate overseas services that connect American users who want to share their copyrighted materials with one another. Stay tuned.

The impact of technology on programming is being felt particularly by UHF and VHF television stations, where little has changed since 1948. Advances in digital television may provide these stations with a good deal more than **high-definition television (HDTV).** If stations begin delivering somewhat-improved signals to consumers in the traditional aspect ratio, occupying only a part of their allotted bandwidth (using what is called **standard-definition television [SDTV]),** they can use other parts of their wide bandwidth to offer several customized channels to less-than-mass audiences. There is growing debate on whether more channels per station, using the same frequency allocation, is better than more visual quality per channel.

Another force for change is economics. The most popular cable networks may not always be freely available on basic cable. MTV Europe moved its service off the basic tiers onto pay TV. This and other trends from the international programming arena may impinge on domestic practices of media companies. The growing importance of international markets cannot be discounted. Networks and studios reached out to less-developed nations with programming produced in the United States for several decades. So far, the influx of foreign-produced programming to U.S. TV sets (with the notable exception of PBS, A&E, and The Discovery Channel) has been a mere trickle, but that could easily change.

On the ethical side, it is clear that the programmer is responsible for media content, but it is less clear what the programmer's responsibility is. Is money all that matters? Will wealth be very enjoyable in a disintegrating society? What can one person do? Oprah Winfrey is one of the highest paid people in the media business, and she works very hard to keep her program "decent."

Drama and comedy in prime time need not pander to the low-brow viewer. As students of mass media, which is clearly one powerful influence on young people's lives, you can make a difference.

SOURCES

Auletta, Ken. M. *Three Blind Mice: How the Networks Lost Their Way*. New York: Random House, 1991.

Bellamy, Robert V., Jr., and Walker, James R. *Television and the Remote Control: Grazing on a Vast Wasteland*. New York: Guilford Press, 1996.

Dodd, Annabel Z. *The Essential Guide to Telecommunications*, 2nd ed. Upper Saddle River, NJ: Prentice-Hall, 2000.

Eastman, Susan Tyler, Ferguson, Douglas A., and Klein, Robert A. *Promotion and Marketing for Broadcasting, Cable, and the Web*, 4th ed. Boston: Focal Press, 2002.

Head, Sydney W., Spann, Thomas, and McGregor, Michael. *Broadcasting in America: A Survey of Electronic Media*, 9th ed. Boston: Houghton Mifflin, 2000.

Jankowski, Gene F., and Fuchs, Davis C. *Television Today and Tomorrow*. New York: Oxford, 1995.

Tartikoff, Brandon, and Leerhsen, Charles. *The Last Great Ride*. New York: Turtle Bay Books, 1992.

Tinker, Grant, and Rukeyser, Bud. *Tinker in Television: From General Sarnoff to General Electric*. New York: Simon & Schuster, 1994.

INFOTRAC COLLEGE EDITION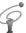

Consult InfoTrac College Edition using the password provided with this book. Use boldfaced terms as Key Words and section headings from this chapter for Subject searches.

NOTES

1. The kinds of programming covered in this book deal with electronically delivered materials, both digital and analog. The book does not deal directly with feature films projected in theaters, although companies that make feature films are responsible for much of the content of commercial and subscription television. Similarly, the book does not directly address the music industry that makes recorded music for compact disc or cassette, although these companies (usually owned by the same entertainment conglomerates that produce video programming) are responsible for much of the content of commercial radio.

2. Tartikoff, Brandon, and Leerhsen, Charles. *The Last Great Ride*. New York: Turtle Bay Books, 1992.

3. Read, William H. *America's Mass Media Merchants*. Baltimore, MD: Johns Hopkins University Press, 1976; Thomas Thompson, "The Crapshoot for Half a Billion: Fred Silverman Rolls the Dice," *Life*, 10 December 1971, pp. 46–48.

4. Jankowski, Gene F., and Fuchs, David C. *Television Today and Tomorrow*. New York: Oxford University Press, 1995, p. 25.

5. Some confusion exists about how to estimate the network share. Those who wish to demonstrate a large decline in network viewing will cling to the three-network (ABC, CBS, NBC) prime-time share, which has fallen below 55 percent on average. The four-network prime-time share—with Fox included—however, ranged around 63 percent, although network viewing always takes a big dive in summers.

6. Jankowski and Fuchs, p. 37.

7. This is compared to 75 total shows in 1987 without the Fox, United Paramount, and WB networks. There were 22 new shows in 1987, about half the number in 1995.

8. Wolzien, Tom. (23 February 2000). Media Merger Concepts, IRTS Faculty Seminar, New York.

9. Although O&O stations remain legally responsible for serving their individual local markets, they naturally also reflect the common goals and interests of their networks. As an example of a rather subtle network influence, consider the choice of the prime access program that serves as a lead-in to the start of the network's evening schedule. An ordinary affiliate (that is, one bound to its network only by contract rather than by the ties of ownership) can feel free to choose a program that serves its own best interests as a station. An O&O station, however, must choose a lead-in advantageous to the network program that follows, irrespective of its advantage to the station. O&O stations also must take great care in choosing and producing programs to protect the group image, especially in New York, where they live next door to company headquarters.

Chapter 2

Program and Audience Research

Douglas A. Ferguson
Timothy P. Meyer
Susan Tyler Eastman

A GUIDE TO CHAPTER 2

"How could those idiots cancel that show? It was my favorite. Why do they always get rid of the good stuff and keep all the junk?" Sound familiar? It should. Most people have, at one time or another, heard the news that a favorite television show has been canceled. The reason? Usually the one given is "low ratings," a way of saying that not enough people watched the program. Why are the ratings so important? Why do so many shows fail? Can't a network executive tell whether a show will succeed in the ratings? In this chapter we look at ratings and other forms of audience research and explain what they are, how they are used and misused, and why.[1] We will examine the industry's current program research practices and qualitative audience measurement techniques and then, because of their special position in industry economics, explain and interpret audience ratings.

DECISION-MAKING INFORMATION FOR PROGRAMMERS

Broadcast and cable programmers (and all the other advertising-supported media) are interested in one goal: *reaching the largest possible salable audience*. Programmers define audiences differently depending on particular circumstances, but regardless of definition, determining audience size is the paramount concern. The separations between program creation and presentation and reception by the audience mean that programmers must always guess who will be there and how many there will be, estimating how predictable and accurate those guesses are. Because networks and stations sell commercial time at dollar rates based on *predicted* audiences, it is no surprise that program and audience research is critical for the financial health of the broadcast and cable industries. Program and audience research, usually involving ratings, guides the process of selecting and scheduling programs to attract the desired audience and provide feedback on programming decisions.

The broadcast and cable industries use many research approaches to evaluate programs and

audiences, most of which fall into one of three groupings:

1. Qualitative and quantitative measures of the programs themselves
2. Qualitative and quantitative measures of audience preferences and reactions
3. Quantitative measures of audience size

Qualitative research tries to explain why people make specific program choices and what they think about those programs. Quantitative data, in the form of ratings and surveys, report what programs (and commercials, presumably) people are listening to or watching.

Programmers use qualitative information on programs to select and improve programs and to understand audiences' reactions to program content; qualitative audience data help explain people's reactions to programs. Quantitative audience data generally provide measures of the size and demographic composition of sets of viewers, listeners, or subscribers. Of all these findings, however, ratings are the major form of program evaluation, and they have the most influence on the other concerns of this book, program selection and scheduling.

In the late 1980s, a sweeping change occurred in the national television ratings—the shift by ratings companies from measuring people's viewing by diaries and simple passive meters to peoplemeters, a much more elaborate, interactive measurement process. **Peoplemeters** consist of a computer and an electronic, handheld device with which individuals signal when they are viewing. The "black box" computer sits on top of the television set, registering each viewer's presence (from the handheld device) and all channel selections; background demographic information (age and sex) on every viewer in the household is stored in its memory to be matched with the viewing information. Meters of either the active or passive type are now used in both the national ratings sample and in the major markets, but meters remain impractical for small markets because of their cost.

As some ratings wit once said, "There will always be diaries in Duluth."

Soon, **passive peoplemeters** will measure audiences without their active participation. Various ideas, ranging from wristwatch devices to intelligent pattern-recognition receivers atop the television receiver, have been developed to measure viewing with greater accuracy and less reliance on viewer participation. Although a reliable system had not gained popularity by 2001, Nielsen unveiled its A/P Meter peoplemeter in 1995 and tested a portable peoplemeter in 2000. The A/P system includes an advanced measuring system that can detect which programs are streaming through a digital frequency, rather than simply detecting the channel to which a set is tuned, as is done by the old peoplemeter system.

Another passive device was tested in 2001 by Pretesting Inc. The device (the size of a bracelet or keychain) is worn by a consumer in the home or car, where it records an inaudible (to the human ear) code that is recorded on a radio or TV commercial's sound track. The small device then sends a signal to a box the size of a paperback book. The device records only the fact that the person is in the location where the commercial was received (and not whether the user was asleep).

It will take a few years to judge the effectiveness and acceptance of new ratings methods, but no way of measuring audiences will ever be error-free or problem-free. We can only assess the competing methods and the measurement problems these practices create with an eye to their advantages and drawbacks.

PROGRAM TESTING

The enormous expense of producing television programs necessitates testing them before and during the actual production of a show. In addition, promotional announcements advertising programs are usually tested to gauge their effectiveness and ability to communicate a program's most attractive features.

Concept, Pilot, and Episode Testing

Concept testing is asking audiences whether they like the ideas for proposed programs. Producers generally conduct this type of test before a program has been offered to a broadcast or cable network. **Pilot testing** occurs when a network is considering purchase of a new series, and audiences are asked to react to the pilot episode. This process is described in detail in Chapter 4 on network prime-time programming. **Episode testing** occurs when a series is under way. Plot lines, the relative visibility of minor and major characters, the appeal of the settings, and so on can be tested to gauge audience preferences.

ASI Entertainment, based in Los Angeles, is one of the best-known companies conducting program tests (and tests of commercials). Traditionally, ASI researchers invite people into a testing theater to watch a television program, a film, or a commercial, asking them to rate it by pushing "positive" and "negative" buttons attached to their seats. Generally the participants are paid, often in products rather than cash, for taking part in the test. Computers monitor individual responses, producing a graph of the viewer's "votes" over time. These data are correlated with demographic and other information (**psychographics**) obtained via questionnaires from each participant (see 2.1).

Nielsen Media Research, which dominates the TV ratings business, is expanding into pilot testing. Nielsen's Paul Lindstrom, vice president, custom research sales and marketing, says the company is also "doing research on programs that are already on the air, experimenting quite a bit with the use of the metered sample," he says. "We've been examining minute-by-minute losses to evaluate when viewers switch away from programs."[2]

Concept and pilot testing stress general plot lines and main characters, seeking to discover if they are understood and appeal to a variety of people. Ongoing program testing focuses on more subtle evaluations of the voices, manners, style, and interactions of all characters. In fact, different actors and plot lines are sometimes used for

2.1 ASI THEATER TESTING

ASI research has been criticized for its unrepresentative audience samples, yet it remains a major contributor to network and movie studio program testing in America. ASI provides valuable data because its audiences are *consistent* from one time to the next. It has established norms from all its previous testing of programs, films, and commercials against which new findings are weighed. Given the many programs evaluated over past decades and the fact that few programs are really "new" in any significant way, how well a new show tests compared to others like it in past tests is use-ful information. The results are especially noteworthy when a program produces a negative or low evaluation because the average ASI audience evaluates programs positively. Not all pro-grams that test positively are successful when put on a net-work schedule (factors inde-pendent of the show's content have more influence on ratings), but very few of those that test negatively at ASI later succeed.

Frequently prime-time series that have slipped in the ratings are tested with live audiences to determine which aspects of the program, if any, can be manipu-lated to improve the popularity of the series. The testing instru-ments range from simple levers and buttons, such as those used in ASI theaters, to more contro-versial methods, such as gal-vanic skin response meters measuring respiration and per-spiration. Programmers seek aids in understanding the weak-nesses and strengths of a series performing below expectations. Sometimes the research sug-gests a change of characters or setting that revitalizes a pro-gram. (If research results are no help, the cynical programmer usually suggests adding a dog or a child.)

separate screenings to find out which cast and plot audiences prefer. Postproduction research can discover a poor program opening or difficulty in understanding the main theme of an episode.

Unfortunately, the theater environment can-not reflect at-home viewing conditions and is thus a less than ideal research method. It does, however, supply detailed data that can be matched to screen actions, adding fodder for programming decisions. In many test markets where insertion equipment is available, researchers send alternate versions of pilot programs (and commercials) to different cable homes and interview the viewers on their reactions. This necessitates producing alternate versions of a program, however, a huge expense not lightly undertaken.

A very popular method for program testing is using streaming video over the Internet to reach test audiences. Online data collection sim-plifies the research process and gets more accurate results. Participants can be recruited from far-reaching locations rather than just near New York or Los Angeles. It is not yet certain whether these newer methods will replace theater and cable testing. In the summer of 2000, the National In-Home TV Lab was created by ASI Entertain-ment, Nielsen Media Research, and TiVo. Under the cooperative venture, Nielsen designs a nation-ally representative sample and recruits the house-holds (separate from its television and Internet research samples), TiVo provides its server-based hardware to the selected homes, and ASI man-ages the TV Lab and conducts and reports the research findings.

Promotion Testing

Competition for audiences requires that most programmers continually produce effective pro-motional materials. Promotional spots advertise particular episodes of a series, special shows, movies, newscasts, or unique aspects of a station's or service's programming (images and identities).[3] These **promos** can be tested before they are aired

to find out whether they communicated what was intended.

Much of the testing being done uses *online audience samples*. Strategic Media Research (SMR), a research and marketing company that has specialized in radio, began testing TV promos online at the turn of the century. Clients include MTV, VH1, Comedy Central, Country Music Television, and The National Network. Some testing firms formerly conducted tests in shopping centers, intercepting people at random to invite them to view promos in return for cash or merchandise.

Promo evaluation sometimes includes group and theater testing, emphasizing such measures as *memorability, credibility,* and *persuasibility*. Demographic data are gathered and other questions are asked and associated with participants' opinions. Promo-copy testing has become a standard practice in the industry.

As multichannel television has moved closer to an online era, promotion testing is becoming far more important and more widely used. Menu-driven program selection (video on demand) will be more influenced by on-air promos and **barker channels** than by schedule-driven program selection.

QUALITATIVE AUDIENCE RESEARCH

In addition to program testing, which applies mostly to television programs and movies, stations use qualitative research to get audience reactions to program materials, personalities, and station or system image. Using focus groups is one such research method. Radio stations also use call-out research to test their programming, and network television and major-market stations make use of TvQs. Qualitative audience research is the most common phrase used in the industry to refer to all of these research techniques.

Focus Groups

One method of gathering information from a group of people is to conduct small group testing.

A **focus group** is a set of 10 or 12 people involved in a controlled discussion. A moderator leads a conversation on a predetermined topic, such as a music format or television newscast, and structures the discussion with a set of questions. Predetermined criteria guide group recruitment. Station management may want people who listen to country music or women aged 25 to 34, for example. Finding people who fit the predetermined criteria (**screening**) can be costly; more qualifications result in a greater turndown rate, increasing the price for screening. Assembling a typical focus group generally costs between $2,500 and $3,000, including the fee paid to each participant ($30 is the standard fee, although it is sometimes as high as $150 for individuals difficult to recruit, such as physicians and other professionals).

Focus group research is especially useful to elicit reactions to visual material and gain insight into subtle responses to televised characters and individuals. These small group discussions can be used to develop precise questions for later field surveys of a large sample of people. For example, researchers commonly use focus groups to evaluate whether a station has enough news, how people react to the newscasters, whether music is too soft or loud, whether personalities are perceived as interesting or friendly, and so on. The particular advantage of focus groups is that videotapes, newspaper ads, and recordings can be evaluated in the same session, providing immediate feedback while avoiding confusion in recall after a lapse of time.

Approximately 200,000 focus groups are conducted each year. The latest trend is to use Internet-based video-conferencing for focus group observers to save travel costs and allow more people to observe the groups during the session. For example, SMR's NetLinx service uses this technique to test new promos and programs. The biggest pitfall of high-tech focus groups is that many nonverbal behaviors are lost in the mediated setting.

Because of the small size of focus groups, research results cannot be generalized to the larger audience. Such a small number of people, reacting under completely artificial viewing or listening conditions, is only rarely representative of the

entire audience. Focused discussions can elicit some respondents' perceptions that would be overlooked by testing techniques such as survey questionnaires that are used with larger groups of people. Focus groups are especially suited to answering some of programmers' *why* questions in depth.

Music Research

Radio programmers want to know their audiences' opinions of different songs and different types of music. They need to know which songs are well liked and which ones no longer have audience approval (which songs are "burned out"). **Call-out research** is one popular, although controversial, method for discovering what listeners think about music selection.

Programmers conduct call-out research by selecting 5- to 15-second "hooks" from well-established songs and playing them for respondents over the telephone. A **hook** is a brief segment or musical phrase that captures the song's essence, frequently its theme or title. Programmers ask randomly selected respondents to rate 15 or 20 song hooks on a predetermined scale. Often a scale of one to ten is used, where one represents "don't like" and ten represents "like a lot." Call-out research indicates listeners' musical tastes at a given moment. When tied to the same songs for some time, it indicates song popularity but does not tell the programmer how often a particular song should be played. That remains the programmer's decision.

In the mid-1990s most research services began using computers to make the phone calls for call-out research. If stations perform call-out research frequently (and some use it every day), a track record for each song develops, and based on it the music programmer can decide whether to leave the song in the station's rotation or drop it.

Another popular method of testing music is **auditorium research.** Programmers invite 75 to 150 people to a location where they jointly listen to and rate a variety of songs. Instead of rating just 15 or 20 hooks, as in telephone research, auditorium tests involve 200 to 400 hooks. Like call-out research, the method tells which songs are liked and disliked at the moment but not how often they should be aired.

Music testing is expensive. Call-out research requires an investment in employees to make the calls as well as computer time to analyze the results. Auditorium tests involve recruiting costs and "co-op" money for participants (usually $20 to $35). Those stations lacking facilities and personnel for music testing can hire commercial firms specializing in such work.

Television Quotient Data (TvQs)

Television quotient data (TvQs) are used by many programmers to supplement Nielsen ratings. Nielsen provides information on how many people watched a program; TvQs measure the popularity and familiarity of a program and the performers in it (or in commercials). Marketing Evaluations/TvQ, Inc., has been collecting data with its 55,000-member households (The People Panel) for four decades. The Q-score service has expanded into seven services: TvQ, Cable Q, Performer Q, Cartoon Q, Product Q, Kids Product Q, and Sports Q. TvQ and Performer Q are the best-known measurements.

Bill Cosby, for example, had the highest performer Q-score in prime-time television, as of 2001, even though his score had slipped somewhat from the early 1990s. Noah Wyle, Anthony Edwards, Chuck Norris, Della Reese, and Roma Downey also scored high. Networks and programmers use TvQs as indicators of an actor's potential, assessing both *likability* and *recognition*. Some research companies make use of TvQs in computer programs that project the eventual success of a network program in syndication. Unlike ratings, these models consider how the people who watched *felt* about a show, not how many watched it.

RATINGS SERVICES

Ratings exert a powerful influence on the industry, from the decisions of syndicators and station representatives in programming as illustrated in

Chapter 3 to network television programming discussed in Chapters 4 and 5. Radio programmers also use ratings information to evaluate their market positions and convince advertisers to buy time (see Chapters 11 and 12). And ratings are used in public broadcasting and cable in specialized ways (see Chapters 7 and 8). In fact, all programmers use ratings in program decision making. Consequently, the rest of this chapter focuses on how programmers use and interpret ratings data.

Using audience ratings is not restricted to programming applications. In fact, ratings were originally intended to provide information for advertisers curious about audience size. Unsponsored programs, including presidential addresses and political programs, are unrated by Nielsen exactly because they do not carry advertising. Once the statistical reliability of ratings data became accepted, however, programmers began using these data to gauge the success of their decisions. As competition among networks and stations increased, ratings became the most important decision-making data in commercial broadcasting. Broadcast revenues, programs, stations, and individual careers depend on audience ratings. In the business of broadcasting, high ratings normally result in profits (and continuing careers). Broadcasting also has public service obligations and other aspirations and commitments, but on the purely economic side, a network or station will eliminate a program that receives low "numbers" if other, more viable options are available.

Cable and broadcast ratings cannot be compared directly because the potential audience viewing subscription channels is only 80 percent that of the commercial broadcast networks (68 percent cable and 12 percent satellite), and some of cable's programs are scheduled in rotating rather than one-time-only patterns. Therefore, in addition to using standard ratings numbers, cable programmers analyze ratings to determine audience reach—how many people over a period of time viewed a program or channel—much as public television programmers use ratings.

Articulating the power of audience ratings may sound crass to those who consider broadcasting an art form, but the reality is that ratings are the most important measure of commercial success. The efforts of most people involved in commercial broadcasting focus on achieving the *highest possible numbers*. Targeting more precisely defined audiences such as women 25 to 54 is an alternate approach for television networks and stations that cannot immediately achieve a number one position in the adults 18+ category.

Ratings affect television and radio programming and sales at stations and at networks; they affect independent producers, Hollywood studios, distributing companies, and advertisers and their agencies. Understanding the basics of the all-powerful numbers is essential in all of these businesses. Nearly all basic cable networks are advertiser-supported, and they need ratings information to convince advertising agencies to purchase time. The premium cable services such as HBO use their national ratings to convince local cable systems that their programs are watched and important to promoting the local system. High ratings, demonstrating television's widespread household penetration, also carry clout with Congress. Legislators generally use television to get elected and reelected, and politicians pay attention to their local broadcasters and the four largest national networks because they reach such enormous numbers of people. Increasingly, the major cable system operators have become influential because of their ability to reach certain types of audiences (especially upper socioeconomic levels) and the availability of low-cost time for political candidates on local cable channels.

Television Services

The most important distinction in television ratings is between *national* and *local* (also called *market*) ratings. A. C. Nielsen is the sole company in the United States producing nationally syndicated network audience measurements, although some of its clients are not too thrilled with the monopoly it has on data collection. Nielsen is also the sole company in the United States producing local station ratings for television (also leading to

some criticism about pricing). Other research firms collect and analyze television audience measurements of specialized types for only a portion of the country. Nielsen covers the entire country continuously for network ratings, using a separate sample of 5,000 households with people-meters. The four largest broadcast networks and the top-50 cable networks contract with Nielsen for this ratings service. Nielsen was purchased in 1998 for $2.8 billion by the Dutch company VNU, which also publishes SRDS, the leading advertising database. VNU also owns Scarborough Research and Billboard Publications.

Nielsen conducts four nationwide **sweeps** of all local television stations—November, February, May, and July—producing the most important local television reports (see 2.2). These market-by-market reports allow stations to compare themselves with the other stations in their market. A separate ratings book is published for each of the 211 markets in the country for each ratings period. These data are based on a mix of diaries and local tuning-sensors (old style passive meters) in the larger markets, diaries only in the smaller markets.[4] The metered markets operate on a sample of 400 to 500 homes that do not duplicate the national peoplemeter sample. One ratings point represented the viewing of 1,008,000 television households in 2001, and each household represented 2.61 people.[5]

A **ratings period** consists of four sequential weeks of data, reported week by week and averaged for the month. In addition to the four major nationwide television sweeps, large-market stations purchase ratings for as many as three more ratings periods (October, January, and March). Mid-sized and smaller television markets perhaps purchase one ratings book beyond the four sweeps. The stations in a market must contract with Nielsen for a ratings book, paying the cost of data collection, analysis, and reporting. In the very largest markets, stations pay as much as $1.5 million a year for ratings; in very small markets, however, the price may be as low as $10,000 annually. Other companies, such as advertising agencies, station representatives (reps), and syndicators, can subsequently purchase the network, cable, and local ratings books. It is important to understand that stations pay for ratings in their market, and the quality could be better if stations could afford to pay more (advertisers, agencies, and reps cover little of the cost). For example, samples could be larger and more representative, diaries could be more carefully double-checked, more call-backs could be made, and data analysis could be more reliable, but each of these steps would substantially increase the cost of ratings to the stations.

Normally, station programmers purchase only the books for their own market, but programmers dealing with groups of stations may purchase all 211 local market reports for the entire country or a subset of books for markets where they have stations or cable systems. These books can be used to cross-compare the performance of programs in different markets, at different times of day, with different lead-in shows, and so on. Subsequent chapters contain discussions about how ratings are used in specific sets of circumstances and point out specific weaknesses.

Network viewing estimates now come from a nationwide peoplemeter sample of 5,000 households with and without cable. To be included in Nielsen reports, at least 3 percent of viewer meters (or diaries in local reports) must record viewing of a cable service. This means that only the top 30 cable networks figure in most ratings calculations. Multiple-set households are counted only once in total television households (**TVHH**), even though the sum of the audiences to several programs telecast simultaneously may be bigger than the number of households said to be viewing at one time (**HUT**) because one household may tune to more than one program.

Radio Services

Only one company, Arbitron, provides quantitative local radio ratings. The consolidation of radio ownership in the late 1990s effectively drove out the need for competing services. Strategic Media Research converted its old Accuratings measurement (successor to Birch Ratings) into Accutrack, one of several similar services that qualitatively measure radio listening.

2.2 NIELSEN MEDIA RESEARCH

Headquartered in Northbrook, Illinois, Nielsen gathers and interprets data on a wide range of consumer products and services as well as television (no radio). Nielsen's network audience estimates are reported in the *Nielsen National TV Ratings* (often abbreviated NTI for the division that collects the data) twice-a-year summary books and in the abbreviated weekly booklets called *The Pocketpiece Report* (see Chapter 4 for a sample pocketpiece page). Besides the network-by-network ratings based on the audience for their affiliates, **pocketpieces** now include the collective ratings for independent television stations, superstations, national public broadcasting (PBS), basic cable networks, and premium cable networks, giving network programmers a handy tool for comparing the performance of the networks and their competitors. (Eventually, VCR and DVD viewing will be fully incorporated in these reports.) National viewing data are also reported in other forms described in Chapter 3, often combined with product purchase and usage data.

Nielsen also collects nightly ratings called **overnights** in the top 48 metered markets, publishing this information every morning for the benefit of network executives and purchasing stations. Overnights, because of the smaller samples used and the big-city nature of the viewers, are only indicators of what the network ratings probably will be when the six-month NTIs are

issued. But as more and more major markets are added to the overnight sample, the match between the overnight sample and the total sample comes much closer. As of 2001, more than 65 percent of U.S. TV homes were in the overnight sample.

Nielsen also measures local market television viewing. These reports are known as the Nielsen Station Index (NSIs) and published in *Viewers in Profile* for each market. These ratings books are purchased by most television stations and advertising agencies. Nielsen household samples are drawn from the most recent national census, and its ratings are *not* weighted (adjusted to fit national or local population percentages). NSI prepares county-by-county reports on television viewing, various reports for commercial time buyers, several reports for cable networks and system operators, and an online computer service for customized analysis of reach, frequency, and audience flow.

Nielsen also offers a tracking service called the ScanTrack National Electronic Household Panel. This national panel consists of about thirty thousand households who use handheld bar-code scanners to record all purchases, including prices, and whether each item was on sale. This information is then correlated with television viewing data derived from peoplemeters, plus magazine and newspaper data. Each household transmits all its media data (TV and print) weekly over phone lines to

Nielsen's center for data analysis. This service has enormous benefits for corporate brand managers and advertising agency media buyers.

Nielsen also has a service called Monitor-Plus, which uses computer-recognition technology to identify all commercials airing in the top 50 major markets. The Nielsen Station Index data is combined with the commercial data to provide minute-by-minute gross rating point measurement for each TV spot overall as well as being broken out by brand category and in comparison to competitors' spots. Monitor-Plus enables buyers and sellers to track advertising activity across 15 specific categories of media, including television, radio, and print.

The measurement of television audiences will eventually involve computer users as the convergence of media develops in the future. Nielsen partnered with I/Pro Form in 1995 to measure online audiences on the World Wide Web with a product named I/Pro Audit. In 1998, Nielsen announced a strategic alliance with NetRatings, Inc., a leader in Internet usage and advertising measurement. In March 1999, the companies launched Nielsen// Netratings, a service designed to provide high-quality information about the Internet. Nowadays, Nielsen uses two separate web addresses for its two divisions: Nielsen Media Research (*www.nielsenmedia.com*) and Nielsen//Netratings (*www.nielsen-netratings.com*).

A subsidiary of Ceridian, Arbitron rates radio audience size using diaries. Arbitron's *Radio Market Report* tracks both in-home and out-of-home listening (in cars, offices, and other places) for local radio stations in 278 markets (as of spring 2000). The data come from weekly diaries mailed to a sample of households in each market. The size of the sample depends on the past history of response in the market and how much data collection the stations are willing to pay for (larger samples cost more money).

Arbitron collects ratings for 48 weeks each year (called continuous radio measurement) in the larger markets and as few as 16 weeks in the smaller markets. It also offers county-by-county reports of radio listening, reports for 42 "custom survey areas," annual ratings for wired and unwired networks, Internet Listening Studies, and **Arbitron Information on Demand (AID),** a radio online computer service for diary research. Recent radio ratings from Arbitron are available at the *www. rronline.com* and *www.radiodigest.com* sites.

Radio's All Dimension Audience Research (RADAR), produced by Statistical Research, Inc. (SRI) in Westfield, New Jersey, reports on the performance of the *national* radio services. RADAR reports cover the size and demographics composition of about 26 major radio services, including those from the ABC Radio Networks, AMFM Radio Networks, American Urban Radio Networks, Premiere Radio Networks, Westwood One Radio Networks, and others. RADAR reports are published quarterly, based on analyses of 48 weeks of continuous measurement beginning at the end of August. Statistical Research, Inc., collects the data by telephone, and reports are issued in print and directly by computer. These are the only nationwide radio network ratings.

There has been pressure from programmers and advertisers for more information about an increasingly fragmented audience. The advent of cable and the larger audience shares captured by Fox and other new television networks created demand for an even more precise understanding of audience viewing habits. Thus, in local market reports, the ratings companies broke demographic information into smaller units (such as ten-year jumps for radio) and more useful categories for different groups of advertisers (both women 18–34 and women 25–49 are now included, for example, as well as similar subgroups of men, children, and teens).

In addition to local and national ratings reports, the largest companies offer a variety of customized reports covering narrower views of the audience (women 18–34 only or Hispanic women 25–54 or children, for example) and specialized programming, such as the Nielsen's analyses of syndicated program ratings, which are particularly useful to stations making program purchases. Chapters 3 and 6 make a special point of the importance of syndicated program reports, which are illustrated later in this chapter.

Online Radio and Video

Arbitron also collects listening information for more than 3,000 online radio stations and streaming media sites. InfoStream Webcast Ratings is broadcast-relevant audience measurement for the webcasting industry. The service is designed to bridge the gap between the top web sites, which are measured through panel-based surveys discussed later in this chapter, and streaming media channels and programs, which, until now, were unmeasured.

Measurement is important to webcasters because it enables them to legitimize a program service that reaches far beyond the usual geographic limits for a radio station. From the advertiser and advertising agency perspective, measurement provides advertisers with the data they need to make informed media buying decisions.

According to Arbitron, InfoStream helps webcasters manage the integration of broadcast media models with new Internet business and revenue opportunities by describing webcasting audiences in terms of traditional broadcast cume and time spent. InfoStream uses unique identifiers embedded within Windows Media Player and Real Player to measure cume instead of using IP addresses.

InfoStream is **server-side** measurement of streaming media, both audio and video, based on monthly estimates. That is, Arbitron collects the listening records (log files) directly from the computers from which the streams are served. Listeners on the web can choose from more than 3,000 (and growing) streaming media outlets. Unlike panel-based research with a limited sample size, server-side measurement has an advantage of huge sample sizes. It is almost census-based sampling, according to Arbitron. Even a lightly tuned channel or program can be measured using the server-side technique. Therefore, InfoStream users can be more confident that the changes they see from survey to survey are based on true changes in listening of viewing behavior versus changes caused by sampling error.

RATINGS TERMINOLOGY AND MEASUREMENT COMPUTATIONS

Nielsen collects television audience estimates by randomly selecting viewers from the 211 U.S. broadcast television markets. The number of markets varies slightly from year to year and has grown along with population increases. Nielsen calls the markets **Designated Market Areas (DMAs).** These areas are roughly equivalent to **Areas of Dominant Influence (ADIs)** as determined by Arbitron for measuring radio markets, although Arbitron no longer measures local television markets (except for a portable peoplemeter test in Philadelphia during 2000–01).

Survey Areas

For each market, Nielsen collects ratings data from more than just the DMA, as shown in 2.3. In the illustration, the smallest measurement unit is the **Metro Area,** the next largest is the local **DMA,** and the largest unit (not shown) is the **Nielsen Survey Index Area (NSI Area).** The NSI Area includes the DMA and the Metro area but also encompasses counties outside the DMA where viewing can be attributed to a station in

the DMA. These three geographical areas are described more fully next.

1. NSI Area

The NSI Area includes all counties measured in a ratings survey, including counties outside the DMA when substantial viewing of stations inside the DMA occurs in them—viewership is usually the result of carriage by cable systems. Rarely used by commercial television programmers, NSI Area figures show a station's total estimated reach or circulation. As indicated earlier, reach tells how many people have viewed or listened to a station in the past, and it therefore suggests how many could view or listen in the future. In cable, reach tells how many households subscribe to basic cable service. Reach is an important measure for radio, public television, cable, and online web sites. Another name for reach is cumulative audience, or **cume.**

2. DMA

Each county in the United States is assigned to only *one* DMA. When Arbitron measured local television ratings, Arbitron's ADIs and Nielsen's DMAs would occasionally differ in size because each company independently decided which counties belonged to the particular market. Generally, a DMA centers on a single city, such as Dayton or Denver or New York, but in some cases two or even three cities are linked in hyphenated markets, as in the Dallas–Ft. Worth and Springfield-Decatur-Champaign markets. All stations in these multiple markets reach most viewers, making the cities one television viewing market. Nielsen ranks each DMA according to the estimated number of television households within its counties. As of 2001, the top five DMAs in rank order were New York (with nearly seven million TV households), Los Angeles, Chicago, Philadelphia, and San Francisco.

3. Metro Areas

The third geographical area, the **Metro Survey Area (MSA)** in radio and **Metro Rating Area**

2.3 MAP OF A TELEVISION MARKET SURVEY AREA

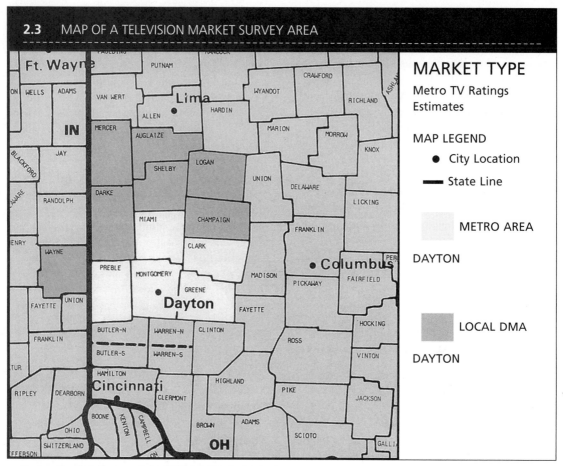

Source: Reprinted by permission of Nielsen Media Research.

(MRA) or simply "Metro" in television, is the smallest of the three survey areas and is the one most frequently used for radio programming. The Metro includes only a small number of counties closest to the home city of the DMA and consists of only a single, large county in some parts of the United States, especially in the west. Because competing big-city radio signals generally blanket the Metro, urban radio programmers use it to determine the success or failure of programming decisions. (Coverage patterns in outlying areas may vary too widely to compare.) The Metro represents the majority of the urban radio listeners, the bulk of office and store listening, and a large part of in-car listening. Altogether, more than

250 Metro areas are measured by Arbitron for radio listening. Radio stations on the fringe of the Metro area are more likely to refer to TSA/NSI area measures, and television programmers rarely use Metro ratings because no demographic breakouts are available.

To use any of these ratings services for programming decisions, programmers must understand how the estimates are produced. Using ratings without this knowledge is like trying to play chess without ever learning the rules. Pieces can be moved, but winning the game is unlikely. "Audiences count, but only in the way they are counted." The following subsections provide an overview of the basics of audience computations.

Ratings/Shares/HUTs

A **rating** is an estimate of the percentage of the total number of people or households in a population tuned to a specific station or network during a specific time period (daypart) such as morning drive or access. A **share** is an estimate of the percentage of people or households actually using radio or television and who are tuned to a specific station or network during a specific daypart. Ratings depend on a count of all receivers; shares on a count of all users. Shares are always bigger percentages than ratings for the same program or station because some people who could watch television (or listen to radio) are not watching (they are sleeping or playing or working).

Ratings are always a percentage estimate of an entire population, whether the **population** refers to all households in the country or all people 25 to 54 or all adults 12+ or all women 18 to 49. A share is always a percentage of those households or people in that population using the particular medium at a specific time. To restate, *shares always appear larger than ratings because they are based on a smaller sample of people*. Fewer people use television (or radio or cable) than could use it if all were at home, awake, and choosing television above other activities. Both estimates are percentages of an entire group, although the percent sign is often omitted.

Sales staffs use ratings to set advertising rates. Programmers generally use shares in decisions about programs because shares show how well a program does against its competition. Shares eliminate all the people who are not watching TV and show how many of those watching TV are tuned to a program or station. Programmers at broadcast networks and stations and cable services typically refer to their *shares of an actual audience*, not their percentage (ratings) of potential households, although newspaper articles often report ratings.

The combined ratings of all stations or networks during a particular daypart provide an estimate of the number of **households using television (HUTs)** or the **persons using television (PUTs)** or the **persons using radio (PURs).** HUTs, PUTs, and PURs are used to compute the shares for each station or network.

To illustrate these concepts, let's assume there are only four network television options in the United States and that Nielsen's 5,000 metered households indicate the following hypothetical data for prime time:

Network	Household Viewing
ABC	952
CBS	964
NBC	988
Fox	611
None	1,485
Total	5,000

The HUT level is .703 or 70.3 percent (3,515 / 5,000), calculated by adding households watching television and dividing by the total number of households with television (952 + 964 + 988 + 611 divided by 5,000 equals .703). The answer is changed from a decimal to a percent by multiplying by 100. A HUT of 70.3 means an estimated 70 percent of all households had a television set on at the time of the measurement. The individual ratings and shares for the four networks can now be calculated.

$$\text{RATING} = \frac{\text{Households Watching a Network}}{\text{Households with Receivers}}$$

$$\text{SHARE} = \frac{\text{Households Watching a Network}}{\text{Households Watching TV}}$$

Network	Ratings	Share
ABC	$\frac{952}{5000} = .190$ or 19%	$\frac{952}{3515} = .271$ or 27.1%
CBS	$\frac{964}{5000} = .193$ or 19.3%	$\frac{964}{3515} = .274$ or 27.4%
NBC	$\frac{988}{5000} = .198$ or 19.8%	$\frac{988}{3515} = .281$ or 28.1%
Fox	$\frac{611}{5000} = .122$ or 12.2%	$\frac{611}{3515} = .174$ or 17.4%

To calculate a rating, the number of households watching a network was divided by the total number of households having receivers. To calculate shares, the number of households watching ABC, for example, was divided by the total number of households watching television.

The individual ratings for all the stations in a market during a given daypart should approximately equal the HUT. Network programmers primarily use rating and share estimates to compare program audiences, but often they also will be interested in the specific number of persons in the audience. Ratings can be used to project to any particular population. For example, the data for the four networks listed produced these estimates for the entire United States (having a total population of about 101 million households).

Network	Rating	× Population	=	Population HH Estimate
ABC	.190	× 101 million	=	19,190,000
CBS	.193	× 101 million	=	19,493,000
NBC	.194	× 101 million	=	19,594,000
Fox	.122	× 101 million	=	12,322,000
	0.699 (or 69.9%)		=	70,599,000

The number 19,190,000 represents the 19+ million people estimated to be watching ABC (at this specific time). These calculations can be verified by multiplying the HUT, 69.9, by the total number of households: .699 × 101 million = 70,599,000, the total for the four networks.

Using part of a page from a Dayton Nielsen book (see 2.5), we can see how ratings and shares were computed for the local television stations WDTN, WHIO, and WKEF. To calculate the rating and share for WHIO, in this late afternoon example, Nielsen first analyzed diaries from a sample of households (HH) in the Dayton DMA. It then projected the sample returns to the DMA household population. Approximately 7 percent of the total diaries were tuned to WHIO from 3 P.M. to 5 P.M. If we assume that 7 percent of the diaries reflects 7 percent of the total households, the number of homes watching WHIO can then be calculated. An estimated 506,440 television

households in the Dayton DMA (this information is supplied on another page) produces a 7 rating for WHIO (35,450 / 506,440 = .07 or 7 percent). The share for WHIO was computed by using the HUT (see the H/P/T totals), which was 30 (percent). Thirty percent of 506,440 yields 151,932 HH, and when that figure is divided into WHIO's 35,450 HH, a share of 24 results.

Nielsen always rounds rating and share figures to the nearest whole number, making numbers easier to read but creating some interpretive problems. If you refer again to the 3 to 5 P.M. time period on the Nielsen report, you will see that WRGT and WPTD both have "1" ratings, but each station's share is different. We can compute more accurate ratings by manipulating the basic formula, usually written as:

$$\frac{\text{Rating}}{\text{HUT}} \times 100 = \text{SHARE}$$

The calculated value is multiplied by 100 to create whole numbers instead of decimals for shares and ratings. If we transpose to:

$$\text{RATING} = \frac{\text{Share} \times \text{HUT}}{100}$$

we can rate more accurately.

$$\text{WPTD Rating} \quad \frac{2 \times 30}{100} = 0.6$$

$$\text{WRGT Rating} \quad \frac{4 \times 30}{100} = 1.2$$

Keep in mind that all ratings and shares are percentages and must include decimal points for all calculations, although to make their reports easy to read, ratings companies do not print the decimals (see 2.4).

One final point concerning the 3 P.M. to 5 P.M. example is that the HUT/PUT/TOTAL line is 30, but if we add all the stations, the total rating is actually 21. The uncounted rating points means that 9 percent of the households in the DMA were viewing cable channels for which no one channel received a 1 rating. Individual shares for

all the stations should equal 100 percent when totaled, even if the tiny shares for cable viewing are unreportable.

PUTs/PURs

Ratings and shares for television generally represent households but occasionally refer to specific demographic groups such as women 18 to 49. Radio ratings always represent individuals or persons, and therefore, the term *persons using radio* (PUR) is used. *Persons using television* (PUT) is appropriate when calculations of individual viewers are made. Sales staffs and time buyers tend to be more interested in these calculations than programmers, and one of the big advantages of peoplemeters is that they supply individual person

as well as household data for the advertising industry.

AQH/Cume

Programmers use two very important computations in calculating ratings: **average quarter-hour (AQH)** audiences and **cumulative audience estimates (cume)**. Program audiences are typically measured in 15-minute intervals, hence "quarter-hour audience." Meters can, in fact, measure one-minute audiences (or even one-second audiences in comedy research, for example), but a person or household is counted in a quarter-hour if the television was turned on for a minimum of five minutes during the measurement period.

Although radio and television diaries also measure audience size in 15-minute intervals, TV programmers utilize these data in much larger units—by whole program or daypart. Quarter-hours are the particular concern of those who try to count fickle radio listeners. (Both time units may be too gross for measuring remote control grazers and radio button pushers.)

Cumulative audience measures are appropriate for small audiences that would not show up in rating/share measures. Cume measurements indicate the number of different people tuned in during a 15-minute (or longer) time period. Cume figures are always larger than AQH figures, which are averaged.

The basic difference between AQH and cume is that in the average quarter-hour calculation persons can be counted more than once in a total daypart. For instance, a person could tune to a station for five minutes, switch stations or tune out, and then tune back in to the original station during a later quarter-hour. This viewer would be counted twice in an AQH calculation, but not in an exclusive cume calculation because it counts only the number of different persons listening. Cume is considered to be the reach of a station because it tells you how many different persons were in the audience during a time period or daypart. It also reflects the growth or decay of an audience over time.

Public television and basic cable audiences are often too small for accurate measurement within one quarter-hour, but cumulative ratings over a longer period of time may reflect more substantial audiences. Cumes can also be calculated for a single program over several airings, a common pattern in public television and cable measurements, permitting programmers to estimate the total number of people who watched a program. Commercial broadcasting with its special interest in the number of people watching one commercial spot generally uses AQH ratings.

Reach and Frequency Analysis

Sales people most often use the concepts of *reach* and *frequency*. As we said earlier, **reach** refers to circulation or exposure—or the net size of the audience; **frequency** indicates the number of times a person was exposed to a particular advertising message (or program). A high frequency means exposure to a message several times and indicates the "holding power" of a station, network, or program. Programmers usually schedule several interesting programs in succession, trying to create audience flow and achieve a high frequency for advertisers among successive programs appealing to the same viewers.

TELEVISION MARKET REPORTS AND OTHER PROGRAMMING AIDS

Market reports (or "books") are divided into sections to allow programmers, sales people, and advertisers to examine an audience from many perspectives. In television, the major sections are: Daypart Audiences, Time Period Averages, and Program Averages.

Daypart Audience

The Daypart Audience section divides viewing into 29 dayparts, a highly useful format for analyzing a station's overall performance in specific time blocks. For instance, Monday through Friday noon to 6 P.M. provides a quick summary of the ratings and shares for all stations during dayparts. The page from a Nielsen book in 2.5 shows the crucial 4 P.M. to 6 P.M. period in the Dayton market toward the bottom.

Nielsen divides the viewers into 26 demographic (age and sex) classifications for both the DMA and the NSI station totals. For just one station, 754 ratings cells are required to fill out all 26 Nielsen people categories and 29 daypart categories for station totals alone. A single ratings book page contains an immense amount of data. Most programmers use computers to analyze data.

A look at 2.5 shows that WHIO-TV was the strongest station in the market in the early fringe daypart, with a 10 rating/26 share in the DMA and 10/27 in the Metro. It was very strong with both women 18 to 49 and men 18 to 49. No doubt this station's programmer was delighted because these demographics are very easy to sell to advertisers.

Programmers normally compare the current numbers to previous performances. **Tracking** a daypart shows how the station or program is doing over time. It is also important in selecting syndicated programs (see Chapters 3 and 6). Rarely will program decisions be based on only one book unless the numbers are very low and very credible, and no hope for improvement is in sight.

Time Period Averages

Television programmers are interested not only in broad dayparts but in quarter-hour or half-hour segments within them. This information, found in the Time Period Averages section of ratings books, is useful in determining a program's strength against the competition for a specific quarter-hour or half-hour. Managers of affiliates look here, for example, to see how their local newscast stacks up against its competitors. It also has an overview of access time and early fringe competition and shows lead-in and lead-out effects. Programmers use these data to analyze performance in time segments. (Sales people use these data to determine spot ratings.)

2.5 DAYPART RATINGS PAGE

DAYTON, OH

Daypart Summary

Column reference numbers (as printed): Metro HH (1,2); DMA Household — R T G (7), S H R (8), IN MKT SHR (9), SHARE TREND NOV '99 (10), JUL '99 (11), MAY '99 (12), FEB '99 (13); DMA Ratings — PERSONS 2+ (15), 12-24 (17), 12-34 (18), 18-34 (19), 18-49 (20), 21-49 (21), 25-54 (22), 35-54 (23), 35-64 (24), 50+ (25); WOMEN 18+ (26), 12-24 (27), 18-34 (28), 18-49 (29), 25-49 (31), 25-54 (32), WKG (34); MEN 18+ (35), 18-34 (36), 18-49 (37), 21-49 (38), 25-49 (39), 25-54 (40); TNS 12-17 (41); CHILD 2-11 (42), 6-11 (43); PERCENT DISTRIBUTION — MET (44), HOME DMA (45), ADJACENT DMA #1 (46), #2 (47), #3 (48); TV HH RATINGS IN ADJACENT DMA'S #1 (49), #2 (50), #3 (51).

MON.-FRI. NOON-3:00P

MR	MS	Station	DR	DS	InMkt	Nov	Jul	May	Feb	P2+	P12-24	P12-34	P18-34	P18-49	P21-49	P25-54	P35-54	P35-64	P50+	W18+	W12-24	W18-34	W18-49	W25-49	W25-54	WWKG	M18+	M18-34	M18-49	M21-49	M25-49	M25-54	TNS	Ch2-11	Ch6-11	MET	HomeDMA	A#1	A#2	A#3	T#1	T#2	T#3
<<		WBDT WPX			'																															84	94	5					
3	12	WDTN A	3	11	18	11	8	10	11	1	1	1	1	1	1	1	2	1	2	2	1	2	2	2	1	1	1									69	89	8					
11	43	WHIO C	11	41	68	39	38	39	40	5	2	3	4	4	4	4	7	5	10	9	3	6	6	6	6	4	3	2	1	1	1	2	1			60	83	13	3	1	1	4	
2	7	WKEF N	2	6	10	5	8	6	6	1	2	1	2	1	1	1	1	1	1	1	2	2	1	1	1	1	1	1	1	1						73	87	13					
<<		WKOI I																																									
<<		WPTD P																																		83	83	9					
<<		WRGT F				3	2	3	3													1				1										51	84	16					
<<		LMVC UP				NR	NR	NR																																			
1	4	WTBS IT	1	3		2	3	3	3								1			1				1	1		1																
1	2	AEN	1	3		2	2	NR	2																		1																
<<		ESPN				NR																																					
1	2	LIF	1	3		NR	NR	NR	NR											1		1			1																		
1	5	NIK	1	5		4	NR	3	3	1												1											3	1									
<<		TNT																																									
<<		USA																																									
25		H/P/T.*	26		16	25	27	22	27	13	9	10	12	10	11	11	16	12	21	20	12	16	15	14	15	10	9	7	6	6	5	6	5	7	4								

NOON-4:00P

MR	MS	Station	DR	DS	InMkt	Nov	Jul	May	Feb	P2+	P12-24	P12-34	P18-34	P18-49	P21-49	P25-54	P35-54	P35-64	P50+	W18+	W12-24	W18-34	W18-49	W25-49	W25-54	WWKG	M18+	M18-34	M18-49	M21-49	M25-49	M25-54	TNS	Ch2-11	Ch6-11	MET	HomeDMA	A#1	A#2	A#3	T#1	T#2	
<<		WBDT WPX																																			81	93	5				
3	13	WDTN A	3	12	20	11	9	12	13	1	1	1	1	1	1	1	2	1	2	3	2	3	2	2	2	1					1	1	1	1		67	87	10					
10	40	WHIO C	10	39	65	38	35	36	37	5	2	3	4	4	4	4	7	5	9	9	4	6	6	6	6	4	4	2	1	1	1	1				59	83	13	3	1	1	4	
2	7	WKEF N	2	6	10	6	7	6	6	1	1	1	1	1	1	1	1	1	1	1	1	2	1	1	1	1	1	1	1							68	83	17					
<<		WKOI I																																			74	74					
<<		WPTD P																																		82	83	13					
<<		WRGT F				3	2	3	3														1											1	1	56	89	11					
<<		LMVC UP				NR	NR	NR																																			
1	3	WTBS IT	1	3		2	3	3	3								1			1				1	1																		
1	2	AEN				2	NR																																				
<<		ESPN				NR																																					
1	2	LIF	1	2		NR	NR	NR	NR											1		1			1																		
1	5	NIK	1	5		4	NR	3	3	1																							3	2									
<<		TNT																																									
<<		USA																																									
25		H/P/T.*	26		15	25	27	23	27	13	10	10	12	11	11	11	16	12	21	20	14	16	15	15	15	10	9	7	6	6	5	6	7	8	6								

3:00P-5:00P →

MR	MS	Station	DR	DS	InMkt	Nov	Jul	May	Feb	P2+	P12-24	P12-34	P18-34	P18-49	P21-49	P25-54	P35-54	P35-64	P50+	W18+	W12-24	W18-34	W18-49	W25-49	W25-54	WWKG	M18+	M18-34	M18-49	M21-49	M25-49	M25-54	TNS	Ch2-11	Ch6-11	MET	HomeDMA	A#1	A#2	A#3	T#1	T#2	
<<		WBDT WPX					2	2																									1	2			63	92	5				
7	23	WDTN A	6	21	38	19	16	21	21	3	2	3	3	3	3	4	5	3	5	5	3	5	5	5	4	2	1	1	1	1	1	2		1	2	68	90	8					
7	25	WHIO C	7	24	43	27	21	24	25	3	3	3	4	3	3	3	5	3	6	6	6	6	5	5	5	4	2	2	1	1	1	1	1	1	1	60	82	14	2	1	2		
2	7	WKEF N	2	6	11	8	7	5	5	1	1	1	1	1	1	1	1	1	2	2	1	1	1	1	1	1	1	1	1	1	1	1				52	71	28					
<<		WKOI I																																			84	85					
1	3	WPTD P	1	2																													2	1		56	66	28					
1	3	WRGT F	1	4	6	3	2	4	2	1	1																						4	3		53	96	4					
<<		LMVC UP				NR	NR	NR																																			
1	3	WTBS IT	1	2		2	3	2	2								1	1		1				1																			
1	2	AEN	1	3			NR	2																																			
<<		ESPN				NR	2													1																							
1	3	NIK	1	3		3	NR	3	3	1																							3	2									
1	2	TNT				2																																					
<<		USA																																									
29		H/P/T.*	30		17	27	27	26	31	16	14	14	12	13	13	13	18	15	22	22	20	18	18	18	18	13	10	7	7	7	7	8	16	16	17								

4:00P-6:00P →

MR	MS	Station	DR	DS	InMkt	Nov	Jul	May	Feb	P2+	P12-24	P12-34	P18-34	P18-49	P21-49	P25-54	P35-54	P35-64	P50+	W18+	W12-24	W18-34	W18-49	W25-49	W25-54	WWKG	M18+	M18-34	M18-49	M21-49	M25-49	M25-54	TNS	Ch2-11	Ch6-11	MET	HomeDMA	A#1	A#2	A#3	T#1	
1	1	WBDT WPX	1	2	3		2				1																						1	2	2	56	93	4				
8	23	WDTN A	8	21	35	20	18	21	21	4	1	3	4	4	4	6	5	7	7	2	5	5	5	4	3	2	2	2	2	2	1	1	2	72	95	5						
10	27	WHIO C	10	26	42	25	26	27	28	5	3	4	5	4	4	5	7	6	10	8	4	5	6	5	5	4	5	4	3	3	3	4	1	1	2	64	87	10	1	1	1	
4	10	WKEF N	3	9	15	10	10	8	10	2	1	1	1	2	2	2	3	2	4	4	3	2	1	2	2	2	2	1	1	1	1	1	1	1	2	54	72	27				
<<		WKOI I																																			82	84				
1	3	WPTD P	1	3		3	2	2	4															1									3	2		48	63	31				
1	3	WRGT F	1	3	6	4	4	6	4	1	1		1		1					1	1	1										2	3	3	49	83	15					
<<		LMVC UP				NR	NR	NR																																		
1	2	WTBS IT	1	2		3	3	3	2	1	1						1	2	1	1	1	1							1				1		56							
1	2	AEN	1	3		2	3	NR	3				1	1	1	1	1	2	1	1	1	1																				
<<		ESPN				NR	1									1	1																									
1	2	LIF	1	2		NR	NR	NR	NR																								2	2								
1	2	NIK	1	2		2	NR	3	3																								2	2								
1	2	TNT																																								
1	2	USA	1	2		2	2									1																										
36		H/P/T.*	37		22	32	33	31	39	21	16	15	15	16	16	17	25	21	32	26	19	18	20	20	20	19	18	12	12	13	13	14	17	18	20							

Source: Reprinted by permission of Nielsen Media Research.

Averages for the whole week, Monday through Friday, are included in the Time Period Averages section along with most prime-time network programming because it varies from night to night. These figures show performance during a daypart or time period when all days are averaged together, crucial data when a programmer is looking at stripped programming in early fringe and prime-time access.

Program Audience

The last major section of a television ratings book, one television programmers most often use, is the Program Audience section. Rather than lumping a program into a daypart, this section breaks each daypart and program into 30-minute segments (and some 15-minute ones) to isolate individual programs on different days of the sweep weeks. The Program Audience section is considered the "pure programming" section because each program is analyzed individually here. It shows the titles of the shows and any scheduling variations from night to night. This allows programmers to examine ratings for their local news, say, night by night, and to eliminate the odd night when a sporting event, for example, cuts into the news time.

Look at the Program Averages data for Dayton at 7 P.M. in 2.6. The numbers are the DMA rating/share and Metro rating/share for all weekdays (AV5, average for Monday through Friday). Notice that in DMA measurements, WHIO dominates the competition with a 31 share for *Wheel of Fortune*. WDTN and WKEF (affiliated with ABC and NBC, respectively) have a 10 share and an 11 share with *Friends* and *Judge Judy*. The Fox affiliate WRGT came in third with an 8 share for *The Drew Carey Show*. This section permits analysis of individual programs without interference from ratings for adjacent programs.

In summary, the sections of a television book provide programmers with at least four different ways to evaluate station performance. Daypart Audience examines broad time periods without regard to specific programs. Time Period Averages provide programming data by quarter-hours and

half-hours on a daily basis and are useful in analyzing competitive performance. Finally, Program Averages information isolates the "pure program" data. Each section answers different questions, and television programmers use every section as their questions shift.

Nielsen also issues reports on specific demographic groups or types of programs or station market sizes in easy-to-use formats, and stations, reps, and ad agencies rely heavily on them. They also depend on other companies to reanalyze Nielsen's ratings data and to supplement them with other research. Of all these additional services, programmers find analyses of syndicated television programs the most valuable.

Syndicated Program Reports

Affiliates and independents rely on off-network and first-run syndicated programming to fill parts of their broadcast days. Because syndicated programs are expensive, however, station decision makers want to know about a program's past performance. Will a program perform well in their market? Will its ratings justify its cost? Reps and program consultants especially want this information because they advise station programmers. Projecting or estimating ratings success for a first-run product is an involved process that finally comes down to an educated guess. The potentials of off-network programs are somewhat easier to evaluate, but even here no hard-and-fast rules exist. Lead-in programs, local competition, and audience fads always influence ratings. Even the most successful network program may fail in syndication or perform below its network numbers at a given time or in a given market.

In making decisions about syndicated programs, Nielsen's *Report on Syndicated Programs* is helpful. (The major television rep firms also provide similar analyses in less bulky and unwieldy formats, such as the Comtrac report example featured in Chapter 3.) A page from the Nielsen analysis of *Friends* is shown in 2.7. At the top-right corner of the page, you will find the number of markets telecasting the program, the distributor, and other

2.6 PROGRAM AUDIENCE RATINGS PAGE

DAYTON, OH WK1 2/03-2/09 WK2 2/10-2/16 WK3 2/17-2/23 WK4 2/24-3/01

METRO HH RTG	SHR	STATION / DAY / PROGRAM	WK1	WK2	WK3	WK4	MW RTG	MW SHR	HUT	P 2+	P 18+	P 12-24	P 12-34	P 18-34	P 18-49	P 21-49	P 25-54	P 35-64	P 35-50	P 50+	W 18+	W 12-24	W 12-34	W 18-34	W 18-49	W 21-49	W 25-49	W 25-54	W 50+	WKG	M 18+	M 18-34	M 18-49	M 21-49	M 25-49	M 25-54	TNS 12-17	CH 2-11	CH 6-11	
3	1	*R.S.E. THRESHOLDS 25+%* (1 S.E.) 4 WK-AVG 50+%	9/2	9/2	9/2	9/2	2	1		2/1	2/1	8/2	7/2	4/2	4/1	3/1	2/1	3/1	3/1	2/1	3/1	12/3	12/3	5/1	6/2	6/2	5/1	4/1	5/1			3/1	13/4	6/1	6/2	6/2	5/1	14/4	11/3	15/4
		6:30PM																																						
<<		LMVC MON NWSCENTER 6	1	<<	<<	<<	<<		51																															
<<		TUE NWSCENTER 6	<<	<<	<<	<<	<<		48																															
<<		WED NWSCENTER 6	1	<<	<<	<<	<<		45																															
<<		THU NWSCENTER 6	<<	<<	<<	<<	<<		54																															
<<		FRI NWSCENTER 6	1	1	<<	<<	<<		47																															
<<		*AV5 NWSCENTER 6*	<<	<<	<<	<<	<<		49																															
<<		SAT MORE-GAME R			<<	<<			33																															
<<		SAT SAT NWSCNTR 6	<<	<<		<<			36																															
<<		SUN ANIML RSCUE R			<<	<<			39																															
<<		SUN CRIME STRIKE		<<		<<			41																															
<<		SUN SUN NWSCNTR 6	<<	<<		<<			48																															
		6:45PM																																						
4	9	WKEF SUN NBC-NWS SUN	5			5	9	51		2	2				1	1	2	3	2	5	2						1	5	2		2		1	1	1	2				
		7:00PM																																						
1	2	WBDT MON FRESH PRINCE	<<	1	1	1	1	52				1	1								2															2				
1	1	TUE FRESH PRINCE	1	<<	1	1	1	52	1	1		3	2	1	1						2	1	1	1	1	1				1	1	1			3	1	1			
1	2	WED FRESH PRINCE	1	1	2	1	2	49				1	1	1	1	1				1	1	1	1	1	1		1		1	1				2						
1	1	THU FRESH PRINCE	<<	<<	2	<<	1	58				1	1	1	1	1			1	2	1	1	1	1				1	1											
1	1	FRI FRESH PRINCE	<<	1	1	1	1	48				1								1														2						
1	2	*AV5 FRESH PRINCE*	<<	<<	1	1	1	52				1	1	1	1					1	1	1	1	1	1		1		1					2						
1	1	SAT NYPD BLUE 1	1	<<	1	<<		36				1	1	1					1																					
1	1	SUN 7TH HVN BEG-WB	1	<<	1	2	1	54	1	1	2	1	1	1	1	1		1	2	1	1	1	1	1	1		1	1	1	1	1	1		1						
5	10	WDTN MON FRIENDS	7	2	6	5	5/10	52		3	4	2	3	4	4	4	4	4	3		5	4	7	5	6	5	5	4	5	2	1	3	3	3	3	1	1	1		
4	9	TUE FRIENDS	8	4	2	5	5/9	52		3	3	6	4	4	5	4	3	3	2		4	6	7	5	4	3	2	4	3	2	2	2	3	2	2					
4	9	WED FRIENDS	6	4	5	4	5/10	49		2	3	5	3	3	2	2	3	3	2		3	4	6	3	3	2	2	3	4	2	2	2	1	2	3					
7	12	THU FRIENDS	6	4	4	6	5/10	58		4	4	4	4	5	4	5	4	4	3		5	6	6	5	5	3	4	4	5	4	4	4	4	4	3					
4	8	FRI FRIENDS	5	2	4	3	4/7	48		2	2	4	2	3	3	2	2	2	3		4	4	2	4	2	1	2	3	3	2	2	3	3	2	2	1	2	2		
5	10	*AV5 FRIENDS*	7	4	5	4	5/9	52		3	4	4	3	4	4	4	3	3	3		5	6	4	4	3	3	4	3	4	3	3	3	3	3	3	1		1		
2	4	SAT FRIENDS	3	1	1		1/4	35		1	1	1	1	1	1	1	1		1		2	3	2	2	2	1		2			1	1	1	1	1	1	1	1		
7	12	SUN ALL-BLOOPR-ABC				6	6/11	54	5	4	3	2	1	4	5	4	6	5		4	5	6	4	4	3	3	4	5	3		2				2	5	7			
7	14	SUN WONDRF-DSN-ABC		7	9	8	8/15	56	7	7	8	7	8	8	7	6	7	7	5		7	7	7	8	7	7	6	7	7	9	9	7	7	6	4	8	9	9		
4	9	*AV6 FRIENDS*				4	4/9		4	3	4	3	3	3	3	3	3	3	2		4	5	4	4	3	3	4	2	3	3	3	2	2	1	1	1				
16	31	WHIO MON WHEEL-FORTNE	18	15	13	16	16/30	52	9	12	4	3	4	5	5	7	15	11	23	13	4	6	6	6	7	24	9	10		10	4	4	4	4	6	1		1		
15	30	TUE WHEEL-FORTNE	20	13	18	11	15/30	52	9	12	4	5	6	6	7	7	14	10	21	13	4	6	6	6	7	24	7	10		10	4	4	4	4	6	1		1		
16	34	WED WHEEL-FORTNE	21	13	16	16	16/33	49	10	12	6	6	7	7	8	8	14	11	21	16	6	7	8	7	9	24	11	10		8	6	6	5	5	7	3	1	1		
18	31	THU WHEEL-FORTNE	21	17	14	18	18/30	58	11	14	3	5	6	7	7	10	17	14	26	16	4	5	7	8	11	29	11	12		7	6	6	6	6	9	2	1			
15	32	FRI WHEEL-FORTNE	20	13	15	15	15/31	48	8	11	3	4	4	5	6	13	9	20	13	3	5	5	6	5	7	25	9		8	6	5	5	5	7		1	2			
16	31	*AV5 WHEEL-FORTNE*	20	14	15	15	16/31	52	9	12	4	4	6	6	6	7	15	11	22	14	4	6	7	6	8	25	10	10		6	5	5	5	7	2	1	1			
9	25	SAT WHEEL-FORTNE W	11	9	5	9	9/24	35	5	6		2	3	3	3	8	5	12	8		2	3	3	3	5	5	12		4	1	4	5	2	3	3			3		
17	33	SUN 60 MINUTES-CBS	18	18	16	16	17/31	54	10	13	2	2	3	5	6	8	17	13	25	15	2	5	7	7	9	28	11	11	1	4	5	5	5	7	1		1			
6	11	WKEF MON JUDGE JUDY	6	3	6	6	5/10	52	3	4	2	2	1	2	2	5	4	7	5	2	2	3	3	2	3	9	5	3	1	1	1	1	1	2	2	1				
5	10	TUE JUDGE JUDY	4	4	5	6	5/9	52	4	4	1	2	1	2	2	4	4	6	4	3	2	2	2	4	7	5	2	1	2	2	2	2	1	1						
5	11	WED JUDGE JUDY	5	3	5	6	5/10	49	3	3	1	1	1	1	1	4	3	6	4	1	1	2	2	7	3	2	1	1	1	1	1	1	1							
6	11	THU JUDGE JUDY	6	5	7	7	6/10	58	4	4	1	2	1	1	2	2	5	4	7	5	1	1	3	3	3	8	4	1	1	1	1	1	1	2	1					
6	13	FRI JUDGE JUDY	4	5	5	7	5/11	48	3	4	1	1	1	2	2	5	4	6	5	1	1	3	3	3	8	4	2	1	1	1	1	1	2	1						
6	11	*AV5 JUDGE JUDY*	6	4	6	6	5/10	52	3	4	2	1	1	2	2	2	5	4	7	5	2	2	3	3	3	8	4	3	1	1	1	1	1	2	1	1				
1	2	SAT E.R.	1	<<	2	1	1	36	3	1								1	1	1						1	1	1												
7	13	SUN WR-AMZ VDO-NBC				5	5/10	57	4	4	4	4	3	3	2	3	3	5	4	8	3	3	1	1	5	2	4	6	3	4	4	3	3	4						
<<		WPTD MON NITE BSNSS RPT	<<	1	<<	<<	<<		52																															
<<		TUE NITE BSNSS RPT	<<	1	<<	<<	<<		52																															
<<		WED NITE BSNSS RPT			<<	<<	<<		49																															
<<		THU NITE BSNSS RPT	<<	1	<<	<<	<<		58																															
<<		FRI NITE BSNSS RPT	<<	1	<<	<<	<<		48																															
<<		*AV5 NITE BSNSS RPT*	<<	1	<<	<<	<<		52																															
2	5	SAT LAWRENCE WELK	3	2	1	<<	2	36	1	1					2		2	1								3	1	1												
4	7	WRGT MON DREW CAREY	3	3	5	2	3/6	52	2	2	1	3	2	2	3	1	2	1	1	2	3	2	2	2		1	2	3	3	3	4	3	4	2						
3	6	TUE DREW CAREY	3	2	3	3	3/5	52	2	2	2	2	2	3	2	1	2	1		2	2	2	2	2		1	2	2	3	3	4	3	1	1						
4	8	WED DREW CAREY	2	5	2	3	2/4	49	2	2	2	2	2	2	2	1	1	2	1	1	2	2	1		2	2	2	3	3	3	3	1	1							
5	8	THU DREW CAREY	4	5	3	4	4/7	58	3	4	4	4	4	3	3	1	1	2	4	5	3	4	3	1	1	3	4	3	4	4	4	4	2							
4	9	FRI DREW CAREY	4	3	4	2	3/7	48	2	3	4	4	3	3	3	1	1	2	4	2	2	2	1	1	3	4	4	4	4	4	4	1	1							
4	8	*AV5 DREW CAREY*	3	4	3	3	3/6	52	2	3	3	3	3	3	3	2	1	2	3	3	2	2	1	1	2	3	3	3	3	3	3	2	2							
2	7	SAT SEINFELD WK	3	2	1	2	2/8	35	1	2	1	1	1	1	1	1	2	1	2	1	1	2	1	1	1	3	2	1	1	1	1	1	1							
5	9	SUN FUTURAMA-FOX	4	5	4	2	4/7	53	3	3	5	4	4	4	4	2	3	1	2	1	4	3	4	4	3	1	3	3	4	4	4	3	4	3	1					
<<		LMVC MON P BENCHLY AMZN	<<	<<	1	<<	<<		54												1								1											
<<		TUE RELIC HUNTER	<<	<<	<<	<<	<<		52							1													1											
<<		WED EARTH-FC	<<	<<	1	<<	<<		49																															
<<		THU LOST WORLD	<<	<<	1	<<	<<		59																															
<<		FRI YOUR BIG BREAK	<<	<<	<<	<<	<<		49																															
<<		SAT WILD THINGS	<<		<<	<<			36																															
<<		SUN PARTY-FIVE R	<<	<<	1	<<	<<		54																															

Source: Reprinted by permission of Nielsen Media Research.

2.7 SYNDICATED PROGRAM REPORT PAGE ON FRIENDS

FRIENDS

30 MIN.

REPORT ON SYNDICATED PROGRAMS
NSI AVERAGE WEEK ESTIMATES
NOV 1999

MARKETS REPORTING	145
STATIONS REPORTING	148
TOTAL TV HH'S IN DMA'S	92,201,580
DMA % OF U.S.	91
EPISODES AVAILABLE	260
DIST: WARNER BROS. DOMESTIC TV DIST.	
TYPE: SITUATION COMEDY	

SUMMARY BY DAYPARTS

DMA HOUSEHOLD SHARES BY MARKET RANK

DAYPART	1-25 NO.OF DMA'S	1-25 % SHARE	26-50 NO.OF DMA'S	26-50 % SHARE	51-100 NO.OF DMA'S	51-100 % SHARE	101+ NO.OF DMA'S	101+ % SHARE	DAYPART	1-25 NO.OF DMA'S	1-25 % SHARE	26-50 NO.OF DMA'S	26-50 % SHARE	51-100 NO.OF DMA'S	51-100 % SHARE	101+ NO.OF DMA'S	101+ % SHARE
DAYTIME (M-F)†					1	6			POST PRIME (S-S)	17	9	10	10	13	11	6	
EARLY FRINGE (M-F)	21	10	16	9	21	10	41	3	WEEKEND DAYTIME(S&S)			1	5				
PRIME ACCESS (M-SAT)	10	9	14	9	29	11			WEEKEND PRE-PRIME(S&S)	17	8	11	7	12	5	40	2
PRIME (S-S)	11	6	3	5	3	9	46	1	AVG. ALL TELECASTS	25	9	25	9	48	10	47	2

TOTAL HOUSEHOLDS AND PERSONS

DAYPART	NO. OF MKT's	NO. OF DMA's	% U.S. TV	DMA HH AVG. QH RTG	SHR	TOTAL HHLDS (000)	WOMEN 18+ (000)	18+ V/CVH	18-49 (000)	18-49 V/CVH	25-54 (000)	25-54 V/CVH	MEN 18+ (000)	18+ V/CVH	18-49 (000)	18-49 V/CVH	TEENS 12-17 (000)	12-17 V/CVH	CHILDREN 2-11 (000)	2-11 V/CVH
DAYTIME (M-F)†	1	1		5	6	4	3	75	3	65	2	57	3	63	2	51				
EARLY FRINGE (M-F)	99	99	69	5	10	3965	2843	72	2416	61	1950	49	2081	52	1748	44	856	22	653	16
PRIME ACCESS (M-SAT)	53	53	37	5	10	2107	1517	72	1240	59	1023	49	1107	53	881	42	346	16	319	15
PRIME (S-S)	63	63	28	3	5	853	596	70	429	50	378	44	423	50	318	37	141	17	82	10
POST PRIME (S-S)	46	46	50	4	9	2328	1744	75	1423	61	1133	49	1190	51	972	42	286	12	90	4
WEEKEND DAYTIME(S&S)	1	1	1	2	5	14	10	70	10	70	10	70	10	66	10	66				
WEEKEND PRE-PRIME(S&S)	80	80	50	3	7	1763	1311	74	1071	61	840	48	862	49	679	39	272	15	320	18
TOTAL DAY	145	145				4764	3490		2869		2349		2480		2015		827		603	
AVG. ALL TELECASTS				4	9	34	25	73	25	71	17	49	18	52	14	43	6	18	4	13

| LINE 1 REPORTABLE STATIONS MARKET T.Z. ON AIR LINE 2 TOTAL DAY STATION CH. NET. DMA SHARE LINE 3 START NO. OF DAY TIME T/CS. LINE 4 LEAD-IN-PROGRAM | FOUR WEEK AVERAGE TIME PERIOD AUDIENCES (THIS PROGRAM vs. PRECEDING HALF HOUR) DESIGNATED MARKET AREA | | | | | | | | | | DMA % | | PROGRAM AUDIENCE SECTION (SYNDICATED PROGRAM ONLY) STATION TOTALS | | | | | | | | COMPETING FOUR WEEK AVERAGE TIME PERIOD AUDIENCES CORRESPONDING TIME PERIOD-3 HIGHEST COMPETING STATIONS | | DMA % |

	DMA % HH RTG	SHR	PERSONS SHARE % ‡ WOMEN 18+	18-49	25-54	MEN 18+	18-49	25-54	TNS 12-17	CHD 2-11	DMA % HH RTG	SHR	(000) VS V/CVH	TOTAL HHLD	TOTAL ADULTS	PERSONS (000) & V/100VH WOMEN 18+	18-49	25-54	MEN 18+	18-49	TEENS 12-17	CHILD 2-11	STATION	PROGRAM	DMA % HH RTG	SHR
	1	2	3 4	5	6	7	8	9	10		11	12	13	14		15	16	17	18	19	20	21			22	23
ALBANY-SCH-TROY EA 6 WNYT CH.13 N 16% M-F 7.30P 20T/C #ENT TONIGHT 30	7 13 7 14	12 17 14 16	17 11 16 10	16 7	14 9	14 5	15 1	7	7 13	(000) V/CVH	36 131	47 77	27 19 53	18 51	19 54	14 38	4 11	3 9	WTEN+ WRGB WXXA # WRGB WTEN+# WEWB	JEOPARDY FRASIER HOLLYWD SQUARS E.R EARTH-FC 3 STOOGES SA	15 28 7 13 4 6 1 12 1 9 <<					
SAT 1.00A 4T/C SAT NITE LIVE	1 11 5 37	4 48	5 54	6 50	38	50	43	21 30	1 11	(000) V/CVH	4 16	1 16	1 16	1 16				1 30								
MARKET AVG.									6 13	(000) V/CVH	30 129	39 76	23 16 52	15 50	16 53	11 38	3 11	3 9								
ALBANY, GA EA 5 ABSK CH. O I % M-F 6.30P 20T/C DREW CAREY	<< <<	1	1 1		1	1		1 1	<<	(000) V/CVH	1 114	1							WALB # WFXL WGVP #	NBC NITELY NWS EARLY EDTN NWS FAMILY MATTERS	28 54 2 3 <<					
M-F 7.00P 20T/C FRIENDS	<< <<	1	1 1		1	1	1	1 1	<<	(000) V/CVH	1	1							WALB WFXL # WGVP #	FRASIER LIVING SINGLE NEWLYWED GAME	11 21 6 11 1 3					
SAT 7.00P 4T/C E.R. B	<< <<	2 1	2 2	2					<<	(000) V/CVH	186	1 186							WALB WFXL #	PROFILER NYPD BLUE 1	6 14 3 7					
SUN 10.00P 4T/C #JACK&JILL-WB	<< 1	1 2	1 2	1	1		1		<<	(000) V/CVH	180	1							WGVP # WALB WFXL WGVP #	OUTER LIMITS NBC SUN-MOV FOX31 NW-10.00 OUTER LIMITS	1 2 13 23 2 4 1 1					
MARKET AVG.									<<	(000) V/CVH	1 106	1														
ALBUQ-SANTA FE MT 8 KASA CH. 2 F 8% M-F 5.30P 20T/C #HOME IMPROV MF	4 10 2 5	9 17 4 8	13 7 6 4	14 6	12 6	24 18	19 10	4 10	(000) V/CVH	26 111	28 70	18 15 58	12 46	10 41	9 36	8 32	10 41	KOAT+# KOB +# KRQE+	ABC-WORLD NWS NBC NITELY NWS CBS SW NWS-530	12 29 7 16 6 13						
M-F 6.00P 20T/C #FRIENDS	5 10 4 10	10 17 9 17	14 7 13 7	13 14	12 12	25 24	16 19	5 10	(000) V/CVH	29 125	37 75	22 19 65	16 54	15 50	13 44	8 26	10 34	KOAT+# KRQE+# KOB +	ACTN 7 NWS-6 JEOPARDY EYEWTNS NW-600	10 20 10 20 6 12						
SAT 6.00P 4T/C YOUR BIG BREAK	2 5 1 2	6 10 3	10 7 4 5	4 2	7 4	15 6	3 3	2 5	(000) V/CVH	12 130	16 89	11 9 72	9 71	5 41	4 36	3 23	1 11	KRQE+ KOB + KOAT+#	JEOPARDY-WKND EYEWITNESS NWS ACTN 7 NWS-6	6 14 5 13 5 13						
MARKET AVG.									4 9	(000) V/CVH	26 119	31 73	19 16 62	13 51	12 45	10 40	7 28	9 36								
ALEXANDRIA, LA CE 6 AAXN CH. O I % M-F 5.30P 20T/C DREW CAREY	<< <<	1 1	2 3		4				<<	(000) V/CVH	<<								KALB # KLAX # WNTZ	NBC NITELY NWS ABC-WORLD NWS MARTIN	26 55 3 5 1 3					
M-F 6.00P 20T/C FRIENDS	1 1 <<	1 1	3 2	1	4 4		1 1		1	(000) V/CVH	1 102								KALB WNTZ KLAX KALB	NWSCENTRAL 5 LIVING SINGLE 31 ACTION NEWS NWSCTRL 5 AT 6	27 49 4 7 3 5 15 26					
SAT 6.00P 4T/C										(000)																

Source: Reprinted by permission of Nielsen Media Research.

data such as the program type and the number of episodes available.

The second section provides overall ratings and share data by market rank and by daypart. The number of stations carrying *Friends* in both early fringe (99 DMA markets) and in prime access (53 DMA markets), presumably to appeal to young women in the late afternoon time period. *Friends* averaged a 5 rating and 10 share in both dayparts, higher than for any other daypart. This section shows which dayparts and market sizes a program has played most effectively in, quite useful information for programmers. Demographic data by daypart fill out the rest of this section.

The third section of the page shows a market breakout of specific stations carrying the syndicated *Friends*. The first market alphabetically, that carried the program, was Albany-Schenectady-Troy, where *Friends* ran at 7:30 P.M. on WNYT, an NBC affiliate on Channel 13, and it had a 7 DMA rating and a 13 DMA (M through F) share. In that market, *Friends* got lower ratings than *Jeopardy* (15/28) and tied with *Frasier*, but was higher than *Hollywood Squares* (4/6). *Friends* held most of its lead-in, *Entertainment Tonight*, which had a 7 rating and a 14 share. Programmers use this information to purchase or renew the show and to schedule it during a daypart with a lead-in that will make it maximally successful.

This third section also provides data on total persons viewing a program in key demographic groups. In Albany, N.Y., for example, *Friends* was viewed by 19,000 women 18 to 49 (representing 53 viewers per 100 homes using television), a slight increase over the lead-in. Unlike the *Syndicated Program Analysis* formerly produced by Arbitron, Nielsen's report does not show the demographic breakdown for competing stations. The programmer can, however, turn to the page for *Jeopardy* (not shown here) and see only 25,000 women 18 to 49 (representing 31 viewers per 100 homes using television). Because *Jeopardy* also has many more women 18+ than *Friends*, the programmer can deduce that *Jeopardy* skews toward older women who may not fit the advertisers' target.

Before purchasing a syndicated program, station programmers typically choose markets that are similar to their own in size and regional characteristics; they chart the performance of that program to determine its best daypart, its strength and weaknesses against specific competing programs, and its demographic appeal. The *Report on Syndicated Programs* enables programmers to estimate the likely performance of a syndicated program and to schedule it effectively in their lineup. If a program proves unsuitable (demographically or in terms of ratings projections), the analysis is helpful in targeting another program to meet a station's programming needs.

The *Report on Syndicated Programs* is limited to program data about syndicated programs already on the air. Quite often stations must decide whether to purchase a program before it is released in syndication (or even produced). This is particularly the case with **first-run syndicated** programs (never on a network) and popular **off-network** programs (often purchased before any station has tried them out). (The subject of purchasing **futures** on programs is covered in Chapters 6.) In the case of off-network programming, national and local data from the program network performance can be projected to the local market, although many markets differ substantially from the national market. Purchasing first-run syndicated programs is much riskier, though, because they lack both network and station track records.

Computerized Services

A ratings book represents only a fraction of the data available from Nielsen. The books exclude county of residence, zip code, specific viewing and listening patterns, and each individual diarist's reported age (in ratings books age is only group data such as women 18 to 34). A diary also tells what the diarist was watching at 5:45 P.M. before he/she began watching the 6 P.M. news. Nielsen stores this raw diary information on a secure web site that stations can examine by means of a computer. The information allows programmers to analyze nonstandard dayparts, specific groups of

zip codes, nonstandard demographics, county-by-county viewing, and audience flow patterns. In addition, sales staffs use the terminals to compute audience reach and frequency. If a programmer wants more information on selected programs on a market-by-market basis, Nielsen offers its *ProFile Ranking Report* (part of the Galaxy software) which provides detailed comparisons.

The management of any station, network, or cable service that subscribes to Nielsen (or Arbitron for radio) can personally review viewer or listener diaries. The main reason for inspecting diaries is to search for unexpected entries such as how listeners or viewers recorded the station's or service's name or call letters (or slogan or air personalities). Sometimes diarists name things differently than stations expect them to. A station can remedy incorrect attributions in subsequent ratings periods by submitting a limited number of different "nicknames" to Arbitron (or by changing a slogan if it is easily confused with a competitor's). Before computerized systems became available, firsthand diary reviews (usually by specialist companies located near the diary warehouses) were standard procedure after each ratings book was published. Computer tape now permits the information to be examined anywhere if the appropriate software is purchased.

Broadcast stations and cable services of all sizes routinely use microcomputers in all their operations, including programming. Television ratings and syndicated program reports are available on diskette or online. Local station programmers use computer software to schedule shows, print daily, weekly, and annual program logs, and keep track of competitors' program purchases in the same way that reps track purchases for many markets (see Chapter 3).

In addition, local programmers use microcomputers to keep track of local **program availabilities** (syndicated programs not yet under contract in their markets) and their own station's program inventory, including contract details, plays, and amortization schedule. Television programs are introduced, launched, bought, and withdrawn constantly. Keeping tabs on the daily changes in the program market involves constant record keeping based on information from the trade press and reports from reps and distributors. Only the largest stations and rep programmers have the resources to track this crucial programming information and keep timely records.

Third-party processors sell research reports on national and syndicated television programs, using Nielsen data. These services are based on the premise that raw information is less usable than processed information. For example, the Nielsen overnight ratings are analyzed by **WRAP,** a Windows ratings analysis program from Audience Analysis Inc. (AAI). The other prominent service (called **Snap**) is designed to analyze Nielsen data on syndicated program performance. Snap is sold to stations and syndicators by Snap Software (see Chapter 3). Both third-party processors compete with Nielsen itself, which markets similar products, using additional proprietary data. Nielsen's services, Profile and Navigator, compete with WRAP and Snap, and a third service, Galaxy, offers additional analysis. Nielsen also offers a software package (N-Power) that provides access to household and individual-level viewing.

TAPSCAN is a third-party processor of Arbitron radio ratings. Station program directors can create rankings (called **rankers**) of all radio stations in a market based on daypart or demographic criteria. For example, stations could be ranked on **exclusive cume,** which is a measure of listeners who listened *only* to a certain radio station and no other.

Strategic Media Research provides research capabilities via the Internet, where survey participants are recruited, screened, and invited to participate in a web survey that streams audio/video clips and then measures response immediately. Another product from SMR is Strategic & Tactical Audience Research (STAR), which is an annual program of weekly or biweekly music and perceptual tracking. The STAR program includes music research, customized perceptuals, and verbatim responses.

Scarborough Research provides a syndicated research service to newspapers, television stations,

radio stations, cable systems, Internet companies, advertisers, and agencies. Scarborough is a joint venture of The Arbitron Company and VNU Marketing Information. Scarborough provides a syndicated study to print and electronic media, new media companies, sports teams and leagues, agencies, advertisers, and yellow pages. Categories include local market consumer shopping patterns, demographics, media usage, and lifestyle activities.

Scarborough surveys more than 175,000 adults 18+ using a two-phase methodology. Phase I is the telephone interview and Phase II is a self-administered questionnaire and television diary. A total of 66 leading U.S. markets are measured. Every market has two six-month field periods each product year, eliminating any seasonal bias in the data and allowing users to account for new store openings and media changes.

One of Scarborough's premier products is called PRIME, composed of four separate reports: Profile, which compiles lifestyles and habits of a specific audience group; Crosstab, which classifies several audience groups at once for comparisons; Schedule Analysis, which combines various proposed schedules of media and cost for analysis; and Media Analysis, which collates media reach information into Cumulative (more than one spot or insertion minus duplication) or Ranker (average) reports, or graph mode (visually combines elements from either report).

Media Audit is a near competitor to the kinds of studies done by Scarborough, except that the former is accredited by the Media Ratings Council. Media Audit bills itself as a multimedia, qualitative audience survey covering about 450 target items for each rated media's audience. These qualitative data points cover things such as socioeconomic characteristics, lifestyles, business decision makers, product purchasing plans, retail shopping habits, travel history, supermarket shopping, stores shopped, products purchased, fast-food restaurants eaten in, soft drink consumption, brands purchased, health insurance coverage, leisure activities, banks used, credit cards used, and other selected consumer characteristics important to local media and advertisers.

Wimmer-Hudson Research & Development is known for its expertise in custom-designed telephone perceptual studies, music testing, interactive software, focus groups, micro/macro-market studies, the Persuasion Process seminar, and optical scanning data collection services. Box 2.8 shows a list of radio research companies.

RADIO REPORTS

Audiences for the approximately 12,000 radio stations in the United States are more fragmented than broadcast television audiences (although the spread of cable and satellite dishes is altering that condition for television). The largest radio markets such as Los Angeles have more than 80 stations, dividing the audience into tiny slivers per station. In general, *radio stations compare their share of the audience and their cumulative audience to that of other stations with similar formats in the same market.* The most popular stations use shares, and the least popular use cumulative audiences, although formats lending themselves to tuning in and out (such as all-news) use cumulative audience ratings even when they are popular. The top 100 radio markets correspond closely to television DMAs, but because some areas of the United States have radio but no television (largely in the west and south), the total number of radio markets (278) is larger than the 211 television DMAs.

Ratings books for radio are organized differently from those for television. An Arbitron radio ratings book contains Share Trends, followed by Demographic Breakouts, Daypart Averages, Cume Estimates, Hour-by-Hour Estimates, and a few smaller sections. The age and sex categories used in radio differ from those used for television because radio stations target their programming to more precisely defined demographic groups. Thus, age ranges for radio are smaller than those used in television, typically just ten years, as in 25 to 34. Most classification groups end in "4" for radio (24, 34, 44, 54, etc.); the groups used for television (18 to 49, 25 to 54, etc.) are broader, reflecting

2.8 THIRD-PARTY PROCESSORS AND CUSTOM RESEARCH COMPANIES
- -

Bedford Research	MJM Research	Roberts Communications (Market research and consulting)
BIA Consulting	Musicline (music research hooks)	
ComQuest (music research systems)	North Central Washington Research	J. R. Russ Programming and Research
Coleman Research	Nova Marketing Group	Shane Media Services
Critical Mass Media	Paragon Research	Strategic Media Research (Call-out, music tests, etc.)
Edison Research	Irwin Pollack's Radio Sales Intelligence	Tennecom Tomorrow
Mark Kassof & Co.		Wimmer-Hudson
Hooks Unlimited (music research hooks)	The Positioning Works	
	RadioResearch.Com	Source: *www.rronline.com*
Jacobs Media	RealCoverage.com (Coverage maps)	

the more heterogeneous nature of television audiences and thus television advertising sales.

Metro Audience Trends

The Metro Audience Trends section reports a station's Metro shares for five ratings books—the current survey and the previous four surveys—covering a period of about one year. These data show a station's share pattern (its "trend") over time for four separate demographic groups: 12+, 18 to 34, 25 to 54, and 35 to 64. A hypothetical example for the demographic category of Total Persons 12+ is shown in 2.9. A programmer can get a quick overview of all stations' performance in the market from the Metro Audience Trends section.

Consider the Monday to Sunday 6 A.M. to midnight period in 2.9 as an example. It shows that from spring 2000 to spring 2001, WCCC clearly led the market and continued to have climbing shares and cume ratings in the last book. WBBB was the number two station and had an upwardly trending cume. WDDD was at the bottom of the market with flat ratings. WAAA's 12+ share declined from 3.3 to 2.6, but the drop is less

than a full ratings point, and the station's cumulative rating remained at 10 percent of the market (near the bottom of the hypothetical market). Up and down data tell a program director that the music probably needs some fine-tuning in the Monday to Sunday 6 to 10 A.M. slot. WAAA's programmer needs to examine additional pages in the book, however, before making any major decision.

Demographic Breakouts

Pages from Arbitron's Specific Audience (2.10) and Listening Locations (2.11) sections illustrate different ways of displaying ratings and share data serving different purposes. Metro and TSA AQH ratings for several ten-year age groups broken out by gender (and Men 18+ and Women 18+), with Persons 12+ and Teens 12 to 17 listed separately, are presented in 2.10. In 2.11, Metro AQH population estimates are detailed for three different places people hear radio (At Home, In-Car, and Other) for drivetime and three other time periods. These data are reported separately for Persons 12+, Men 18+, and Women 18+ (2.10 shows only Men 18+). These Specific Audience and Lis-

2.9 METRO AUDIENCE TRENDS PAGE

	MONDAY - SUNDAY 6AM - MID					WEEKEND 6AM - MID				
	Spring 00	Summer 00	Fall 00	Winter 01	Spring 01	Spring 00	Summer 00	Fall 00	Winter 01	Spring 01
WAAA										
SHARE	3.3	3.7	**	3.2	2.6	3.0	3.7	**	2.9	2.1
AQH(00)	168	187	**	163	133	128	163	**	125	96
CUME RTG	10.7	11.6	**	10.8	10.0	5.9	5.9	**	6.2	5.1
WBBB										
SHARE	3.6	3.7	**	3.5	4.4	3.0	3.2	**	3.0	3.4
AQH(00)	183	187	**	179	228	128	143	**	129	150
CUME RTG	11.7	11.1	**	11.6	13.2	5.6	6.4	**	5.8	6.8
+ WCCC										
SHARE	8.0	7.6	**	7.8	9.4	7.5	7.0	**	7.8	9.5
AQH(00)	404	385	**	395	488	324	315	**	331	426
CUME RTG	16.7	14.9	**	15.7	17.1	10.4	9.5	**	10.0	11.1
WDDD										
SHARE	2.5	2.7	**	2.1	2.3	3.2	3.4	**	2.3	2.5
AQH(00)	124	140	**	108	120	136	150	**	97	112
CUME RTG	7.4	8.4	**	6.4	7.1	4.7	5.5	**	4.3	4.7

Footnote Symbols: ** Station(s) not reported this survey.
+ Station(s) reported with different call letters in prior surveys - see Page 5B.

Metro Audience Trends

Source: Arbitron Ratings Co., used with permission.

tening Locations data help programmers see which dayparts draw which audience subgroups and where listeners most use the station. In combination with other information provided in an Arbitron book, they suggest how different programming (or additional promotion) can improve audience composition (and therefore saleability).

Arbitron also reports an hour-by-hour analysis that includes ten demographic groups by AQH for the Metro area. A programmer can track a station's performance hour-by-hour from 5 A.M. to 1 A.M. to isolate particularly strong or weak hours during the broadcast day. Other sections of the Arbitron radio book include Exclusive Audience and Cume Duplication, both of which help radio programmers understand how listeners use radio.

Arbitron radio data also come on diskette or online in a format called Arbitrend, which reflects the continuously measured markets and contains demographics. Programmers for music radio stations can also purchase (or write) software to accomplish most of the tedious work involved in developing a station's music playlist.

(See Chapter 11 on creating music wheels.) One widely used software program on the market accounts for 50 different characteristics of a song in selecting its position and rotation.

Time-Spent-Listening

Programmers are rarely content with the bare facts reported by Arbitron (or Nielsen in the case of television), so they use all these various ratings to make many different computations. For example, radio programmers generally want to know how long their audience listens to their station, known as **time-spent-listening (TSL).** TSL is computed by multiplying the number of quarter-hours in a daypart times the rating and dividing by the cumulative audience.

To illustrate, assume we have the Los Angeles Arbitron Radio Market Report and want to compute the 18+ TSL for KABC-AM. We can pull the AQH and cume from the book to produce the TSL. The TSL for adults 18+ for this station,

2.10	ARBITRON'S SPECIFIC AUDIENCE PAGE

AQH (00) — Specific Audience

	Persons 12+	Men 18+	Men 18-24	Men 25-34	Men 35-44	Men 45-54	Men 55-64	Women 18+	Women 18-24	Women 25-34	Women 35-44	Women 45-54	Women 55-64	Teens 12-17
WAAA														
METRO	174	55	8	15	21	8		112	28	35	30	6	12	7
TSA	186	55	8	15	21	8		124	39	35	31	6	12	7
WBBB														
METRO	322	142	18	68	43		6	177	39	69	41	13	9	3
TSA	370	167	18	78	56	1	6	200	42	87	42	13	9	3
+ WCCC														
METRO	636	269	12	23	36	47	59	366	22	19	51	44	88	1
TSA	667	281	12	23	36	53	60	385	22	27	51	46	95	1
WDDD														
METRO	135	55	9	8	18	4	8	69	5	11	19	7	13	11
TSA	135	55	9	8	18	4	8	69	5	11	19	7	13	11
WEEE														
METRO														
TSA														

Footnote Symbols: * Audience estimates adjusted for actual broadcast schedule.
+ Station(s) reported with different call letters in prior surveys - see Page 5B.

Source: Arbitron Ratings Co., used with permission.

Monday to Sunday, 6 A.M. to midnight, is calculated using the following formula:

$$TSL = \frac{AQH\ in\ Time\ Period \times AQH\ Audience}{Cume\ Audience}$$

$$AQH\ in\ Time\ Period = 504*$$
$$AQH\ Audience = 872\ (00)**$$
$$Cume\ Audience = 9{,}875\ (00)$$

$$TSL = \frac{504 \times 872}{9875} = 39.9$$

*There are 504 quarter-hours from 6 A.M. to Midnight, Mon.–Sun.
**Zeros indicate that these numbers are in thousands, i.e., 87,200.

Therefore, the programmer concludes that the average length of listening to KABC for an adult 18+ is 39.9 quarter-hours during a given week, 6 A.M. to midnight. A high TSL indicates that people (who listen) are listening for long periods of time, not that a lot of listening goes on. TSL refers only to the amount of listening by those who do listen. Television programmers also calculate time-spent-viewing using the same formula.

Turnover

Turnover indexes the rate at which an audience changes, or turns over, during a time period. Turnover is calculated by dividing the cumulative audience by a quarter-hour rating:

$$Turnover = \frac{Cume\ Households\ or\ Persons}{AQH\ Households\ or\ Persons}$$

A low turnover rate indicates a loyal audience, and high turnover means a station lacks "holding power." *Television stations expect more turnover than radio stations and go after greater reach.* Turnover is calculated for public broadcasting and cable as well as for commercial radio and television. Tracking the amount of turnover over time on a graph provides a quick clue to changes in audience listening or viewing patterns for an individual station or service.

2.11 LISTENING LOCATIONS

	METRO AQH (00)											
	MONDAY- FRIDAY COMBINED DRIVE			MONDAY - FRIDAY 10AM - 3PM			WEEKEND 10AM - 7PM			MONDAY - SUNDAY 6AM - MID		
	At Home	In - Car	Other	At Home	In - Car	Other	At Home	In - Car	Other	At Home	In - Car	Other
WAAA	18	26	13	9	27	21	12	8	6	14	18	11
%	31	46	23	16	47	37	46	31	23	33	42	25
WBBB	36	43	57	27	31	92	25	17	18	30	27	43
%	26	32	42	18	21	61	42	28	30	30	27	43
WCCC	129	49	77	122	33	140	118	29	14	114	34	56
%	51	19	30	41	11	48	73	18	9	56	17	27
+ WDDD	29	26	7	19	22	6	22	10	4	24	17	5
%	47	42	11	40	47	13	61	28	11	52	37	11

Footnote Symbols: * Audience estimates adjusted for actual broadcast schedule.
 + Station(s) reported with different call letters in prior surveys - see Page 5B.

Source: Arbitron Ratings Co., used with permission.

CABLE RATINGS

Nielsen reports cable network ratings data separate from broadcast network data for the larger basic and premium cable services (in addition to cumulative totals for all basic and pay networks within the *Pocketpieces* and *NSI Reports*). More than 65 percent of its 5,000 peoplemeter sample are cable subscribers, and Nielsen issues its *Cable National Audience Demographics Report* covering the national audiences for the largest services drawn from peoplemeter data.

In general, the introduction of peoplemeters has benefited cable services far more than most broadcast stations. Viewers tend to fill in diaries at the week's end, losing track of where VCR recordings came from and forgetting the names of the many (relatively new) cable networks, so the more familiar-sounding networks tend to get undeserved diary entries and consequently high ratings. Peoplemeters, however, record the exact channel viewed, the length of viewing (as do traditional passive meters), and the composition of the audience. Many smaller local markets, however, continue to be measured with diaries or diaries plus passive meters.

On the local market level, individual cable networks are included in Nielsen's *Cable Activity Report* when they achieve a 3 percent share of audience (and pay the cost of data analysis and reporting). Nielsen measures cable service audiences along with broadcast station audiences in the all-market sweeps (using diaries or meters or both). Cable lineups differ from franchise to franchise within one market, however, and accurate tracking of channel attributions ("I watched Channel 3") has been difficult. For example, the Washington, D.C., area has about 30 cable franchises, which place the dozens of cable networks (and some broadcast TV stations) on widely differing channel numbers. In consequence, ratings for the smaller services have not been stable even within a single market. Even though the Nielsen metered markets (covering more than 60 percent of all U.S. viewing) will eventually migrate to the A/P or PPM meters that read codes embedded in the programs by the producers, there will always be less-reliable diary measurements in the smaller markets.

To qualify for inclusion in the standard television sweep reports, a cable service must reach 20 percent of net weekly circulation. In other words, 20 percent of the market's television households

must view it for at least five minutes during the survey week. In the first year of reporting (1982), only HBO, WTBS-TV (the former Superstation, now the TBS cable network), Showtime, and ESPN qualified. A decade later, however, nearly all of the top 20 largest cable networks qualified in most markets, including A & E, Cinemax, The Discovery Channel, ESPN, The Movie Channel, CNN, USA, The Family Channel, MTV, The Nashville Network, Lifetime, Nickelodeon, C-SPAN, and TNT. Other cable services such as WGN and WWOR easily qualify in some regions of the country. Cable networks appearing on only some of a market's systems, however, have more difficulty meeting the minimum viewing level, even when they are regularly watched by the cable subscribers able to receive them.

Although each cable MSO and network purchases cable ratings from Nielsen, they are also interested in research that identifies their most-likely customers. Two services, Claritas and Looking Glass, offer detailed demographic and behavioral information in annual reports. Claritas is the dominant company with its PRIZM (Potential Rating in Zipped Markets) report, which combines zip code information with Nielsen data, information from local governments, magazine subscription lists, automobile registrations, and other data sources. Such **geodemographic** information groups population segments by lifestyle.

Arbitron competes with Nielsen, using two techniques: Set-Top Solutions (STS) and the Portable People Meter (PPM). STS collects viewer information directly from the cable converter box. The PPM, as described later in this chapter, collects information from a pager-sized device carried by the viewer. Arbitron also offers three services to cable operators and networks: Scarborough, RetailDirect, and RetailDirect Lite. These services provide qualitative media and market consumer behavior information.

Premium Services

Pay movie services have special measurement problems. Movies, the largest element in their programming, appear in repeating and rotating patterns to attract large cumulative audiences for each feature. This contrasts with the broadcast television pattern of scheduling a movie or series episode only once in prime time (typically) and seeking the largest possible audience for that one showing.

Indeed, viewers shift the times they watch pay cable so much more than they do broadcast television (by recording movies at home) that it becomes problematic to use the same measurement criteria. (See Chapters 8 and 9 on program evaluation and audience measurement.) Moreover, the total number of pay households is relatively small for all services except HBO, although nearly half of all television households take one or more pay services. And the large number of basic and pay-cable television networks split up the ratings much as radio stations do in major markets. Cable programmers use the ratings information available to them to judge individual program popularity and channel popularity, but as yet cable networks win only specific time periods in competition with broadcasters. Frequently, however, the cumulative audiences for all showings of a top-notch movie on HBO equal the size of a television network's audience. Although pay-cable movies usually draw small audiences, original programming like *The Sopranos* attracts critical acclaim, Emmy Awards, and stronger viewing levels.

Nielsen publishes a quarterly *Pay Cable Report* and a comprehensive *Video Cassette Recorder Usage Study*, which can help pay cable programmers make sense of reported viewing. The Nielsen Homevideo Index, as contrasted with the Nielsen Station Index, provides many additional specialized reports for cable programmers.

Cable Penetration Measures

Using figures supplied by Nielsen and the industry itself, the industry regularly updates cable statistics, reporting how many households have access to cable at the present time, called **homes passed (HP).** As of 2000, more than 96 percent of U.S. households were passed by cable wires; that is,

people in 96 percent of homes/apartments *could* subscribe to cable if they wanted to. **Cable penetration** is the percentage of television households actually subscribing to basic cable service (shown as household penetration in 2.12), which was about 68 percent in 2000. Actually, the total penetration of the cable networks had passed 80 percent by 2001, thanks to other multichannel distributors like DTH satellites, but the ratings services have continued to report merely cable-only penetration.

In 2.12, the number of pay-cable subscribers (minus DTH satellite subscriptions) appears as a total 48.4 million homes, or about 48 percent of all television households. Another important figure to the industry is *pay as a percentage of basic cable subscribers*, because those are the homes actually able to sign up. Dividing 48.4 by 68.7 (million) from the data in 2.12 results in about 70 percent of basic cable subscribers who took one or more pay channels. This is down from 82.8 percent in 1995, which may be why the percentage is no longer included in the summary from the trade organization NCTA.

Like radio, cable services are also concerned with audience turnover. In cable, **churn** is the ratio of disconnecting subscribers to newly connecting cable subscribers (the number of **disconnects** divided by the number of **new connects**). The problems associated with a high rate of churn are described in Chapter 8.

Because the audiences for some advertiser-supported networks are too small (at any one time) to show in Nielsen ratings books, a number of basic cable networks estimate their audiences on the basis of customized research that adjusts the size of the universe of homes to match cable penetration in the markets the cable network already reaches. Direct comparisons of such customized cable ratings to ordinary ratings can lead to confusion because nonsubscribers are not counted. Especially for narrowly targeted cable services, advertisers want detailed demographic breakouts, necessitating expensive customized cable research at the local level.

2.12 2000 CABLE SUMMARY REPORT	
Total Subscribers	68,690,390
Homes Passed	96,600,000
Total Systems	11,197
Household Penetration (universe = 100.8 million)	68.1%
Pay-Cable Households	48,400,000

Source: *www.ncta.com*, July 2000

ONLINE RESEARCH SERVICES

Due at least in part to the growing interrelationships between the Internet and the traditional cable/home satellite/broadcast media, it is not surprising that Nielsen would handle Internet audience measurement. Nielsen//Netratings is one of two major competitors, the other being Media Metrix, the web's oldest rating service. Both use samples of home and at-work web surfers to monitor and estimate usage patterns.

Although cable and home satellite delivery systems have had a huge impact on audience behaviors, this impact pales in comparison to the profound and sweeping effects of the Internet. How and why people use the web, what they use it for, and how these things affect other traditional or "old" media are topics worthy of comment and explanation. There are many important consequences for programming in cable, broadcast television, and cable and broadcast radio. Many of these consequences are still in the very early stages. How they will actually emerge is yet to be determined, but some trends, however, can be gauged with some fairly high accuracy. Others remain highly speculative. The situation for audiences is extremely dynamic, almost volatile in many respects.

Chapter 10 provides a discussion of what the online ratings show about audience behavior. For example, **time-spent-online (TSO)** was about

9.5 hours per week for the average Internet user in 2000. The methods and terminology for measurement of online computer use are quite a bit different from broadcast and multichannel measurement.

Web Tracking Services

Nielsen//Netratings publishes regular reports that include five sections: Audience Summary, Audience Profile, Daily/Hourly Traffic, Average Usage, and AOL Service Usage. Audience Summary reports give a comprehensive profile of the entire web audience, including **unique audience** (average number of different people who visit a site on each day during the course of the month), page views, audience demographics, frequency, and time-spent information. Audience Profile shows demographics for the total U.S. Internet population, which include composition, number of sessions per period, average-time-spent per session, and average pages viewed per session.

Daily/Hourly Traffic breaks down the Audience Profile Report data by specific day and hour. Average Usage includes statistics on the number of sessions, pages viewed, pages visited per session, time spent per session, and duration of a page viewed. AOL Audience Report shows average time spent and audience demographics for use within the AOL service.

The Nielsen//Netratings audience tracking software has several advantages over other approaches, which are key to delivering the most accurate and useful information. It is highly accurate because it "sits in the datastream," which allows an unobstructed log of all web activity. This unique audience tracking technology has the ability to automatically measure the viewing and clicking of ad banners (**bannertrack**), e-commerce activity (**commercetrack**), page views cached (i.e., stored) by the browser program (**cachetrack**), and page loading times. The tracking is unobtrusive to users to limit bias and requires the absolute minimum in company intervention once installed. Software updates are also wholly automatic.

The other leading web tracking service is Media Metrix, which produces four reports: Digital Media Report (DMR), Q-Metrix, Source/Loss Report, and Trend Report. Digital Media Report (DMR) covers all Internet and digital media (e.g., e-mail) audience usage including properties such as AOL, PointCast, and Juno. Measures reported include unique visitors, reach, usage day per person, minutes per usage day and month, and age and gender composition. **Q-Metrix** supplies proprietary data on the personal lifestyles, media consumption habits, product consumption patterns, and buying behaviors of Internet users. This data is linked with Media Metrix's metered user statistics to provide consumer behavior analysis. The **Source/Loss Report** maps traffic flow into and out of a web site, and the **Trend Report** measures change over time.

In addition to Nielsen//Netratings and Media Metrix, other services "audit" server-based information supplied by web sites. I/Pro offers its I/Audit service, and Audit Bureau of Circulation (the same ABC that audits newspaper and magazine circulation) provides a service called the ABC Interactive Web Site Activity Audit Report.

Methodology

Media Metrix uses its own patented metering methodology, which *continuously* captures actual usage data from randomly recruited, representative samples of tens-of-thousands of people in homes and businesses around the world (excluding college labs, cyber cafes, airports, hotel business centers, public libraries, and schools K–12). The meter is a software application that works with the PC operating system to passively monitor all user activity in real time—click-by-click, page-by-page, and minute-by-minute, measuring only those users who visit the Internet at least one day per month.

Unduplicated audience (cume, or reach) is calculated by adding all at-home users to all at-work users, and subtracting all users who use *both* locations. Only the base-page **URL (Universal Resource Locator,** or page address) is counted, even if other files and items are associated with it.

Media Metrix keeps track of each time the computer is turned on or turned off, when the machine is on, and whether a user is actively using the machine by recording whenever keyboard or mouse activity take place. Sixty seconds after keyboard or mouse activity ceases, the machine is declared to be "idle." Viewing time is not credited when the machine is in the idle state. As soon as a user moves the mouse or presses a key, the meter resumes accumulating viewing credit to the page or application.

When the computer first boots up, the user must select his or her name from the list of registered users and press OK. After 30 minutes of "idle" time, the meter presents its user identification screen again, to ensure that a change in user is captured. If, at any time, users change, it is a simple matter of clicking the meter's icon to recall the user identification screen. The meter applies viewing credit to only one application or program at a time. If the user is using a word-processing application, for example, while his or her browser is in the background downloading web pages, the word-processing application receives viewing credit—not the browser.

The meter also has the ability to record additional detail on demand, such as specific activity within applications. One of the applications for which Media Metrix captures additional information, for example, is AOL. Specifically, the meter records the content of the AOL parent and child window titles. The meter records step-by-step action through the AOL application.

Whenever a page from the World Wide Web is displayed in a browser, the meter records the full URL. The Media Metrix Meter records the name and details of each file coming into the PC over a network connection. The meter also records information about each graphic file, banner ad, sound file (wav, mid, mp3), streaming media, and so on.

Once or twice per year, a certain percentage of respondents is asked to complete a qualitative questionnaire to more fully describe their lifestyle beyond the key demographic data. Household-level demographics are updated annually, by asking a representative from the household to visit a web site and update the profile. Additionally, twice per year, a portion of the sample is provided with "scanning" software, which scans the PC to record the technical configuration and to log which software programs are installed.

Online Ratings Terminology

Page views (also known as **page impressions**) are usually defined as a combination of one or more online files presented to a viewer as a single document as a result of a single request received by the server. **Visits** are series of interactions by a visitor with a site without 30 consecutive minutes of inactivity.

ABC Interactive Audits focus on advertising, with such variables as ad display, ad download, ad impression, ad impressions ratio, ad request, and click/ad interaction. For programmers, it is important to understand that the advertising banners are not separate from the content; they are somewhat like having a changing billboard in a live sporting event. There is no flow, no break, and no need to zip or zap. The key measurement in e-commerce is the **click-through,** defined as the result of "clicking on" an advertisement that links to the advertiser's web site or another page within the web site (exclusive of nonqualifying activity and internal users).

Different web tracking services use slightly different terminology. In the key five variables, Media Metrix estimates a site's (1) unique visitors (the number of different people visiting the property in a 30-day period); (2) reach (percentage of projected individuals who visited a designated web site or category among the total number of projected individuals using the World Wide Web during a given reporting period); (3) average usage days per user; (4) average unique pages per user per day and month; and (5) average minutes spent per person per page, per day, and per month. Media Metrix's measure of unique pages counts the number of different URLs visited by a person on a particular day. For example, a user viewing a stock-price page who hits the "refresh" button

repeatedly throughout the day will be counted as a single unique page for the day.

In its top 25 and top 50 lists, Media Metrix identifies locations by their domain names. Some web sites, however, are not reflected properly by a single domain name but are defined by a collection of domain names. These web sites are noted with an asterisk, and the definitions are listed on the Media Metrix web site.

Nielsen//Netratings has similar terminology, covering three critical areas: site activity (sites visited, URLs within a site visited, duration of visits, duration and frequency of sessions), advertising activity (actual ad banners viewed, advertisers, sites the ads ran on, and ads clicked on), and user profile (age, gender, marital status, education, occupation, income, and ethnicity).

Matching

One attempt to combine traditional media content of print or TV and related Internet sites occurred when NBC Television Network collaborated with DigitalConvergence.com to provide technology that allowed viewers to link their personal computers with TV programming and advertising during NBC's 2000 Olympics, its national election coverage, and its fall 2000 network television season. This technological alliance let advertisers track consumers interested in their products and to tailor online information accordingly. This project was part of the ongoing efforts to match certain types of viewers with specific brands of various products and services, enabling advertisers to communicate directly with these potential customers and not waste resources on those consumers for whom the brand is either irrelevant or not the preferred one. The question of how effective (and how welcome) the process will be over the long-term is not resolved, but it is clear that advertisers continue seeking greater efficiency in their expenditure of advertising dollars. The inefficient network model requires advertisers to pay for many audience members who have no specific interest in the brand being ad-

vertised, and the Internet provides the opportunity to move to a new model.

RATINGS LIMITATIONS

Although many broadcast and cable (and web) programmers are aware of the limitations of ratings (and user counts), in practice these limitations are rarely considered. This does not result from ignorance or carelessness so much as from the pressure to do daily business using some yardstick. Programmers, program syndicators, sales staffs, station reps, and advertising agencies all deal with the same numbers. In any one broadcast market, all participants—those buying and selling programs, those selling and buying time—refer to the same sets of numbers (Nielsen reports in TV, Arbitron in radio), and they have done so for decades. The "numbers" for any single market usually show a consistent pattern that makes sense in general to those who know local history (such as changes in power, formats, and ownership). Although broadcasters and the ratings companies know that the "numbers" are imperfect, they remain the industry standard. In practice the numbers are perceived as "facts," not estimates.

Occasionally a gross error will require a ratings company to reissue a book, but for the most part, small statistical inequities are simply overlooked. To eliminate as much error as possible, the major ratings companies use advisory boards that suggest how to improve the ratings estimates. Because a change in ratings methodology always means additional costs passed on to broadcasters, the rate of improvement will continue to be conservative now that the shift to peoplemeters has been accomplished.

The major limitations of broadcast and cable ratings can be briefly summarized. Readers interested in further information should consult the references listed at the end of this chapter. (Until use of the Internet grows considerably, the problem of limited use overwhelms all other methodological considerations.) The following six practical

and theoretical problems limit the validity, reliability, significance, and generalizability of broadcast and cable ratings data.

1. Sample Size

Although each ratings company attempts to reach a sample that represents the population distribution geographically (by age, sex, income, and so on), a shortfall occasionally occurs in a market. Such shortfalls are in fact routine in radio market ratings, and also occur, although less frequently, in television market ratings. In these instances, certain demographic groups have to be weighted to adjust for the lack of people in the sample (such as too few men between 25 and 49).

Weighting by large amounts makes the estimates less reliable. The amount of unreliability is related to the (unknown) differences in responses between those who did respond in the sample and those who did not cooperate or bother to comply with all of the procedures. An expected return rate of 100 diaries from teenagers, for example, with an actual return rate of 20, should create strong skepticism about how representative the 20 are. The 80 who did not respond would undoubtedly represent this segment of the audience better and more accurately, but because their media usage is not known, the ratings services use the 20 responses and compound the error by assigning a weight of 5 to each of the 20 responses (to calculate the number of respondents in this age group as a proportional part of the total sample). Although weighting is a scientifically acceptable and perfectly valid procedure, it assumes that those responses being weighted closely represent those responses that are missing (see 2.13 for more on sampling errors). In our hypothetical example, the responses of too few individuals represent too many other people/households.

Sample size is the one limitation that comes to most people's minds when they hear about how ratings are compiled. The typical "person on the street" response is: "How can a few thousand people be used to measure what millions of people watch or listen to?" They are mistaken; the sample sizes used by the ratings companies are not the major problem. **Representativeness** by those selected for the sample is.

2. Lack of Representation

The major ratings companies refuse to sample from group living quarters such as college dormitories, bars, hotels, motels, hospitals, nursing homes, military barracks, and so on. The problem with measuring such viewing is that the number of individuals viewing varies, sometimes greatly, making it nearly impossible to determine how many diaries or peoplemeter buttons need to be provided. They also fail to measure office, workplace, and country club viewing, and watching battery-operated TV sets on beaches and at sporting events (there are more than ten million portable units in the United States). The ratings services argue that such viewing accounts for only a small percentage of total national television viewing and is therefore not worth pursuing (that is, not cost-effective for broadcasters to pay to measure). In 1998 Nielsen Media Research estimated that 25.7 million adults watched an average of 5.6 hours of television in out-of-home locations each week. Some of the most common out-of-home locations include college/second homes (34 percent), work (23 percent), and hotel/motels (19 percent).

TV programs and some radio formats that appeal to narrow demographic segments go uncounted in calculating the ratings. Estimates for *Late Night with Conan O'Brien*, for example, indicate that as much as one-fifth of the actual audience goes uncounted by Nielsen's ratings largely because of the exclusion of the types of locations where many people watch the program (college dorms and bars). Also, cable services such as ESPN, watched in nearly every bar in the country, suffer from the omission of group audiences. The wide popularity of sports bars in recent years (with multiple TV screens) adds substantially to the inaccuracy of samples used to measure sports viewing. Small wonder that Arbitron and Nielsen began testing a portable peoplemeter in 2001.

2.13 STANDARD ERROR

The concept of **standard error** is not a ratings limitation but rather part of a mathematical model whose use reduces some of the problems associated with rating procedures. In practice, however, very few people using audience ratings ever take standard error into consideration. The "numbers" are seen as factual; sampling errors and other errors or weaknesses in research methodology are not considered in any way.

In essence, using the standard error model compensates for the fact that ratings are produced from a sample of people, not a complete count of an entire population. Whenever researchers project sample findings into the general population from which that sample was drawn, some error necessarily occurs. A standard error figure establishes the range around a given estimate within which the actual number probably falls. The range suggests how high or how low the actual number may be. The formula for standard error is:

$$SE = \sqrt{\frac{p(100 - p)}{n}}$$

where SE = standard error

p = audience estimate expressed as a rating

n = sample size

For example, suppose that a random sample of 1,200 people produces a rating of 20. The standard error associated with this rating is computed as:

$$SE = \sqrt{\frac{20(100 - 20)}{1200}}$$

$$= \sqrt{\frac{20(80)}{1200}}$$

$$= \sqrt{1.33}$$

$$= 1.15$$

A rating of 20 therefore has a standard error of plus or minus 1.15 points—meaning that the actual rating could be anywhere from a low of 18.8 to a high of 21.1.

Another difficulty in calculating error is determining how confident we want to be of the results. It is possible to be very confident (with a 95 percent probability of being right) or somewhat confident (with only a 65 percent probability of being right). Nielsen ratings are generally calculated to the lesser standard. Most social science research uses the higher standard. Nielsen includes standard error formulas in all their ratings books for those wishing to calculate error in specific ratings and shares, but of course printing the range for each rating/share would make ratings books unusable. Nonetheless, the range is the most accurate version of each rating or share, given its database, which may itself introduce a great deal more error.

3. Ethnic Representation

Data for ethnic groups are among the most hotly debated aspects of broadcast and cable audience estimates. Ratings companies have long grappled with the difficulty of getting randomly selected minority households to cooperate with the ratings company by filling out a diary or having a meter installed. Companies have gone to great lengths and expense to provide a more adequate and representative sample of both Hispanics/Latinos and African Americans.

Critics argue that those minorities who agree to go along with prescribed procedures are much more like white sample participants and are atypical of the ethnic group they are intended to represent. Thus, a participating black family may not be like the vast majority of black families in a given viewing area. Many minorities understandably remain apathetic to the needs of ratings companies, even though financial incentives are offered. *Ethnic populations are undoubtedly undercounted, and those who are counted are often unrep-*

resentative of their ethnic groups. Because no standard of "truth" exists by which to compare samples to an entire ethnic group, ratings companies and advertising agencies inevitably use the numbers in front of them to make decisions.

Nielsen does identify African-American and Hispanic audiences in its local market rating reports, but the information in some markets is limited to penetration, counting their presence in the same table as multi-set, cable, VCR, and DVD homes. At the national level, however, Nielsen's monthly reports have an added 20 African-American demographic categories. Primarily to serve Univision and Telemundo, Nielsen started a national Hispanic Television Index (NHTI) in 1992. For markets with a significant Hispanic population, Nielsen offers local ratings in its Hispanic Station Index (NHSI).

4. Cooperation

All ratings companies use accurate and statistically correct sampling procedures: People/households are selected at random to represent (within a small margin of error) the population from which they were drawn. For representativeness to occur in practice, however, the people/households originally selected must cooperate when the ratings company invites their participation. In the past, when Nielsen used the passive TV set meters (before peoplemeters were developed), cooperation was not an overwhelming problem. Since the late 1980s, cooperation rates for allowing the installation of the peoplemeter technology by Nielsen have steadily declined to alarmingly low levels. Studies have reported one-half to two-thirds refusal rates for peoplemeter installations among those contacted in original random samples. Refusal rates were highest among ethnic minorities and younger adult males.

In the area of diary cooperation, sharp declines were also reported in the same studies. Nielsen diary response rates for the November sweeps had gone from about 43 percent in the early 1990s to around 28 percent by 2000. Arbitron diary response rates have gone from 40 percent in 1995 to 35 percent in 1999. Again, participation differs

among key demographic and lifestyle groups. Ratings for children and teens are most problematic. Moreover, long-term cooperation from all viewers continues to be a problem. Using a diary requires participants' willingness to train themselves to fill it out as they view or listen and to learn how to fill it out correctly. Peoplemeters require pushing buttons every fifteen minutes as on-screen reminders interrupt viewing. They also require the householder to assign spare buttons to casual guests.

One possible solution is the development of passive or portable peoplemeters. Nielsen has been testing passive peoplemeters for many years. Arbitron announced plans in 2000 to use a new pager-sized **portable peoplemeter (PPM),** for which it has struck a strategic alliance with its one-time nemesis, Nielsen. The PPM, which must be recharged daily, sends the embedded codes of audio, radio, and TV programs to Arbitron for tabulation of broadcast and cable usage. This device was still in the test phase in 2002, and Arbitron planned to roll it out in the United States when the process finally seemed to be working efficiently and effectively. Until the technology of such ratings devices improves and is demonstrated as effective and appealing to audience participants in the selected sample, the problems inherent with the present system remain and pose major obstacles for interpretation of what audiences are actually listening to or watching.

Whenever cooperation rates are low, for whatever reason, the participating sample probably differs from those who declined. *Those who cooperate typically demonstrate a highly favorable view of the medium and generally use it more often than those who refuse to cooperate.* Refusals may indicate a lack of interest in the medium or, at the least, too light a use to warrant learning a fairly complicated but infrequently applied process. It is easy to visualize a single person or a young, childless couple who says to the ratings company, "No thanks, I'm (we're) almost never home. I (we) hardly ever watch TV at all." Thus, those who view more or use the medium more are probably over-represented in the sample, resulting in correspondingly inflated

viewing estimates and unrealistic measures of the total television audience's preferences. Of all the limitations on ratings, cooperation remains one of the two most significant and persistent problems.

5. Definition of Viewing/Listening/Visiting

No one seems to be even remotely certain of precisely what it means to "view" television or "listen" to radio. It sounds so simple on the surface, but consider this: For those using peoplemeters to be counted as "viewers," household members must activate the computer with the handheld device only while in the room where the television set is on. At regular intervals, viewers are reminded of the need to "log in" with the meter by pointing their handheld device at the TV set. In all systems, the sole criterion for being a viewer is *being in the room*. Viewers can very easily be reading magazines, talking, thinking, playing a game—in short, paying little or no attention to the picture or sound—but are still counted as viewers. Conversely, a viewer might be in a nearby room doing a menial task and listening intently to a program's sound. This person is normally not counted as a viewer. Being there may or may not constitute "viewing." What the ratings services measure, therefore, are potential viewers with the option of letting television (or radio) occupy their attention. To date, no commercial techniques measure viewing as a function of the attention paid to what is on or to the way that content is used.

Among radio audiences, the parallel problem is no uniform definition (or no definition at all) of what it means to "listen" to radio. When in someone else's car on the way to school or work while this person has the radio on, should the passenger be counted as a "listener" to station WXXX? How about offices where a radio station plays in the background while people work—? Are they "listening"? Is the music or information what each person would have chosen had they been able to select the station? Moreover, what does "listening" mean? If a person is paying attention to other things and has the radio on for background noise or a kind of companionship, should that person "count" as a listener?

As for what it means to "visit" a web site, the absence of key, universally agreed-upon definitions poses inherent interpretation problems when trying to understand what the numbers mean or represent. In this instance, the problem centers on defining what it means to "use" a web site, a parallel to what it means to "view" television. To be counted as a site visitor, does one merely have to access the site to be counted or, perhaps more importantly, should that person count the same as someone who, while at the site, goes to other options or pages that are components of the site? Other questions that will need to be answered include: What exactly does someone look at when at the site? For how long does the user look at a particular item or the site generally? Why are *none* of the options available accessed? Why *are* one or more available options accessed? *As hard as it is to come up with a valid definition of what constitutes "viewing" television, it seems easy in comparison to defining what goes on with a user while at a web site.*

Both television and radio ratings are plagued by the industry's unwillingness to provide a standardized, widely agreed upon definition of viewing and listening, and now the problem is extended to the online world. So long as the advertising industry remained satisfied with the ratings numbers generated for TV and radio, there was little reason for concern. As Nielsen moved to peoplemeters, however, and as media choices proliferated rapidly through cable and satellite-delivered media services, the reported numbers showed progressive shrinkage. Advertisers began to ask what was "going on," and the broadcast and cable industries began to scramble for explanations. Broadcasting and cable have continued to point the finger of blame toward the ratings services, questioning their methods and the validity of the numbers they report. Lost in all the ongoing measurement arguments is the crux of the problem—no one knows what the ratings services are supposed to be measuring in the first place. This debate has no satisfactory means of resolution until basic definitions are standardized.

6. Station Tampering

A continuing problem for ratings is that sometimes stations attempt to influence the outcome of the ratings by running contests during the measurement period. Arbitron and Nielsen place warnings on the cover of their ratings books advising users of stations' questionable ethics. Of course, there is a grey area: Was the promotional activity (called **hyping** or **hypoing**) really a normal contest or one designed to boost (hypo) the ratings?

Warning labels are especially ineffective for the advertising industry when the agencies get their numbers from computer tapes or online services. There is no "book" on which a warning can appear. The problem of hyping has grown in recent years, with some local newscasts promoting huge cash giveaways. Many industry experts predict that year-round measurement, abolishing sweeps periods, will eventually solve the hyping problem.

7. Device Limitations

Not everyone has faith in the reliability of peoplemeters. After thirty years of depending on one ratings system, Nielsen's abrupt change in 1987 from passive meters and diary-based national television ratings to peoplemeters created an uproar. The shift happened all in one year, and many in the industry felt unprepared with so much at stake. One objection to peoplemeters centers on what happens when the handheld devices are not correctly operated. When mistakes are made, as is inevitable, viewing is invalidated and not counted in the ratings. Given the high likelihood that people will have occasional mechanical difficulties and that children and teens will "fool around" with the meter, much legitimate viewing may be lost. Nielsen argues the necessity of omitting figures where the device was misused, claiming that such inclusions would produce unrealistic figures. Nielsen further claims that in a national sample of 5,000 households, occasional omissions have only a negligible impact on ratings. What do you think?

Another peoplemeter problem occurs with *sample composition*. The issues previously discussed concerning who chooses to become part of the sample and who refuses and why are worsened, not resolved, by peoplemeters. Nielsen's own studies show that *peoplemeter cooperators differ from noncooperators in that the former are younger, more urban, and have smaller families* (they may also differ in other unreported ways). Older people and those living in rural areas are underrepresented in the peoplemeter sample, in part because of many people's reluctance to learn to use "another new technology." It is, however, recognized that Nielsen's previous national sample overrepresented older viewers and that post-1987 sample composition more accurately represents the country's overall population.

A third limitation centers on a new form of resistance to allowing Nielsen to install the peoplemeter hardware. Installing the older passive meter involved little or no hassle for participants. Peoplemeters, however, require a substantial amount of wiring and hole drilling. For many people, allowing workers into their homes to do such work is an intolerable intrusion. And, of course, if households allowing the installation do so in part because they are eager to be part of the television sample, they do not represent the overall population, probably producing inflated viewing estimates and distortions in program preferences.

A fourth and final device-related limitation occurs because *peoplemeters transform generally passive viewers into active viewers*. Every time a participant enters the television room or leaves, the handheld device must be activated. Such behavior involves more conscious decisions to view, what to view, and when to stop viewing than does usual television behavior. Research shows that most viewing gets done with little self-awareness on the viewer's part. Now, viewers with peoplemeters must actively record their behavior, and the results are probably atypical viewing. Nielsen maintains that peoplemeter users rapidly become accustomed to them, and "normal" viewing habits soon return, similar to the way viewers become accustomed to using **remote control devices** (handheld channel changers).

Problems with sample, hardware, and the unnatural state of "active" viewing necessitated by use of handheld controls have prompted Nielsen to forge ahead with passive peoplemeters. These are electronic devices equipped with infrared sensors that identify people present in the room and record that information along with the tuned program. These new peoplemeters may overcome the "activity" criticism, but testing shows that many people object to the new process, feeling that the camera that recorded their presence in the room spied on them. The other substantial limitations, unfortunately, also remain.

Whether a ratings system uses peoplemeters, infrared sensors recording the presence of viewers in a room, diaries, the old audimeters, portable devices, or some yet-to-be-developed variation on these methods, ratings remain *estimates* of audience preferences, always subject to a certain undetermined margin of error (this margin may be quite small or very large, but it is unknown with certainty). Previously, the media industry's temporary solution was to examine more than one set of numbers. Considering numbers from multiple sources and multiple methods is a stopgap while awaiting a more valid measuring system. When all the numbers from different sources agree, confidence in their accuracy rises. When there are variations, programmers and advertisers are left in the uncomfortable quandary of deciding which numbers to trust, and which numbers to use. Some television programs and radio formats will not receive a completely fair rating regardless of which system is used—or even from a combination of measures. Children's and very light adult viewing will probably always remain uncertain.

FUTURE CHALLENGES

As the broadcast/cable and online/interactive worlds collide, one can expect many changes in the years to come. Traditional measurement services will have to improve in order to measure smaller and smaller audiences. Fortunately, technology to embed a "signature" into all forms of media content has been established. Devices to track audience behavior are likely to solve the counting problem, if only the issue of what is to be counted could be decided (with sufficient agreement among the parties concerned!).

Television networks and stations remain uncertain about how to use the Internet to increase over-the-air and cable viewership. So far, it seems that if a TV show is already popular or becomes popular, web sites featuring such programs also enjoy popularity. For example, the reality shows that burst into public awareness in 2000 and 2001 —*Survivor, Temptation Island, The Mole*—have been responsible for dramatic increases in visits to the ABC, CBS, and Fox web sites. Other popular shows, especially those with strong fad appeal to younger audience members, have also experienced huge responses from viewers wanting to know more about the show or its characters/actors.

The main benefit of increasing traffic to a hit show's web site is that other programs can be promoted beyond the hit show that brought the users there in the first place. Links to other shows that might catch a user's eye can build interest in these shows. At least, that is the conventional wisdom on the importance of a hit show on a web site. Whether this actually works in any measurable, systematic way has yet to be determined by valid research investigations.

Perhaps the most important question is whether a network or station web site can be used to help attract new viewers to an existing show or to a new show before it airs or as it begins its first network run. If web site visitors have their curiosity piqued by creative, cleverly designed banners or links and then, having learned more about a new program, some might—it is hoped—make a point to watch the show. Would subsequent changes in the web site's content get users/viewers to return to the web site and continue to watch the program? Thus, the web site might stimulate TV viewing, and TV viewing might, in turn, stimulate more web site use. It is not clear whether web sites can be successfully employed to attract, interest, and then maintain an audience. Future

research will be needed to look for connections between web site visits for particular shows and corresponding changes in the ratings for these shows. How to effectively use a web site to reach and affect viewers will remain a mystery—until the difference between watching TV and using a computer is finally erased.

SOURCES

Anderson, James A., and Meyer, Timothy P. *Mediated Communication: A Social Action Perspective*. Newbury Park, CA: Sage, 1988.

Audience Research Sourcebook. Washington, DC: National Association of Broadcasters, 1991.

Greenbaum, Thomas L. *The Handbook for Focus Group Research*, 2nd ed. Thousand Oaks, CA: Sage, 1998.

www.gavin.com

www.nielsenmedia.com/whatratingsmean

Nielsen Media Research. *Your Guide to Reports & Services: How to Use the Local Market Book and Other Special Reports*. New York: Nielsen Station Index, 1999.

R&R Ratings Report. Los Angeles, CA: Radio & Records, Inc., semiannual special reports.

Webster, James, Phalen, Patricia F., and Lichty, Lawrence W. *Ratings Analysis: The Theory and Practice of Audience Research*. Hillsdale, NJ: Erlbaum, 2000.

Wimmer, Roger D., and Dominick, Joseph R. *Mass Media Research: An Introduction*, 6th ed. Belmont, CA: Wadsworth, 1999.

INFOTRAC COLLEGE EDITION

Consult InfoTrac College Edition using the password provided with this book. Use boldfaced terms as Key Words and section headings from this chapter for Subject searches.

NOTES

1. The word *ratings* had a clear meaning for much of the history of broadcasting until the introduction of content ratings in the late 1990s. Content ratings serve as labels to adults who supervise the viewing of children. As the motion picture industry did in the late 1960s, the television industry bowed to government pressure and began putting program content ratings on shows in the late 1990s. This chapter deals with ratings in the traditional sense of audience measurement, not content labeling.

2. Kira Green, "TV's Test Pilots," *Broadcasting & Cable*, 17 July 2000, p. 52–54.

3. For more on this topic, see Eastman, Susan Tyler, Ferguson, Douglas A., and Klein, Robert A., eds. *Promotion and Marketing for Broadcasting, Cable, and the Web*, 4th ed. Boston: Focal Press, 2002.

4. In January 2000, Nielsen adopted local peoplemeters for measuring in Boston, the first such market in the U.S. Remembering the dislocations caused by the national switch to peoplemeters, the Boston managers were not pleased.

5. The number of households varies annually, and the number of people varies according to census reports. These estimates are from Nielsen Media Research.

Chapter 3

Domestic and International Syndication

John von Soosten

The programs seen on hometown television stations usually get there by one of four routes: *network, paid, local,* or *syndicated.* The six biggest television networks, ABC, CBS, Fox, NBC, UPN, and WB, supply **network programs** for which stations receive compensation payments; these programs usually air simultaneously on all affiliates of the network. Stations also receive money from program suppliers to air **paid programs,** often in low-viewership time periods; these shows include paid religion (for example, the *700 Club*), paid political programs, and *infomercials* (such as how to make a fortune in real estate or beauty tips from a celebrity).[1] Stations sometimes create their own **local programs,** such as news, talk shows, or public affairs programs, for which they assume all costs.

This chapter deals with the fourth type of program, **syndicated programs,** which are series, specials, and motion pictures sold to individual stations for exclusive showing for a limited time. A program may be distributed by satellite, especially if the subject matter is timely, or on tape. The local television station licenses a syndicated program from a **syndicator,** a national company that similarly licenses the same program to other stations in other markets (but not others in the same market). The program probably will not air simultaneously in all markets. It probably will not air in all markets, and it probably will not air solely on affiliates of any single network or solely on independent stations. Hence, the program is said to be *syndicated.*

Although some programs may be licensed to national cable networks (which often precludes sale to local television stations), the term *syndication* applies only to broadcasting. Although I focus on broadcast television in this chapter, most of the principles and considerations discussed here apply equally to **cable syndication.** The topic of **radio syndication** is discussed in Chapters 11 and 12 and **noncommercial syndication** in Chapter 7.

THE SYNDICATION CHAIN

The syndication chain reaches from the producer through various intermediaries to the station, and it begins with the program itself. Programs for syndication arise in one of three ways:

- If the program was originally created exclusively for syndication and has not previously aired in any other venue, it is said to be **first-run;** it is a program that was created for **first-run syndication.** Foreign programs produced for airing in other countries and later placed into domestic U.S. syndication are usually considered first-run because they have not previously been seen in this country. The rare program made for syndication that later gets sold to a cable or broadcast network is called *off-syndication.*

- Programs that were originally created for one of the broadcast networks that are subsequently sold in syndication are called **off-network** programs. Programs that were created for the national cable networks are also included in the off-network category. (As the number of such programs put into syndication increases, a separate *off-cable* designation may develop.)

- The third category consists of **feature films,** including **theatricals** (made originally for exhibition in movie theaters) and **made-for-TV/made-for-cable** or **movie-of-the-week (MOW)** films. MOWs may be off-network/cable or first-run in syndication.

Unlike off-network shows, which are sold for a number of years with a certain number of runs per episode, first-run programs are generally sold in syndication for one or two years at a time with a predetermined number of weeks of original programs and repeat programs. For example, a 52-week deal might include 39 weeks of original programs (195 shows) and 13 weeks of repeats (65 of the original 195 shows). Each year or two, the contract is renewed (often at a higher price). Fresh episodes are then produced.

3.1 SAMPLES OF SYNDICATED
PROGRAM TYPES

Off-Network: *Friends, Frasier, Everybody Loves Raymond, The Drew Carey Show, Spin City, King of the Hill, Moesha, Nash Bridges*, Ally McBeal*, The Practice**

First-Run: *The Oprah Winfrey Show, Ricki Lake, Entertainment Tonight, Star Trek: The Next Generation, Jeopardy, Wheel of Fortune*

Feature Films: Nearly any movie title once it leaves the movie theaters except recent movies still playing on pay-per-view, pay cable, basic cable, or network before they go into syndication

*Note that off-network shows may run simultaneously with new episodes on the broadcast network and reruns or multiplexed episodes on cable networks and in off-network syndication.

These three types of programs are illustrated in 3.1. First-run and off-network programs may also be categorized according to **program type.** Although several systems for classifying programs exist, syndicators and programmers commonly use eight easily recognized categories:

- **Situation comedies.** Most **sitcoms** are off-network (for example, *Friends, Spin City, Suddenly Susan, Everybody Loves Raymond, Clueless*), although, in the past, some have been created for first-run syndication, such as some episodes of *Mama's Family* and all episodes of *Small Wonder.*

- **Dramas.** These may either be off-network (*Ally McBeal*) or first-run (*Star Trek: The Next Generation*) and may include **action-adventure** (*Nash Bridges, Baywatch Hawaii*) and **dramatic** (*The Practice, Dawson's Creek, The X-Files*) shows. Although these shows are mostly one hour long, some are half-hours.

- **Talk.** Generally these are first-run, one-hour shows. They include *The Oprah Winfrey Show, The Ricki Lake Show, The Rosie O'Donnell Show, The Jerry Springer Show,* and others.

- **Magazine.** Most commonly half-hour, first-run programs, these include *Entertainment Tonight, Access Hollywood, Inside Edition,* and *Extra.* This category also includes the weekend editions of the same programs: *Entertainment Tonight Weekend,* for example.

- **Reality.** This category is a catchall comprised mostly of first-run half-hours (although the occasional first-run hour creeps in) including **reality shows** (*Martha Stewart Living, Real TV*), **court shows** (*The People's Court, Judge Judy, Divorce Court*), **comedy shows** (stand-up comedy routines), **music shows** (videos, dance music), and **comedy-based shows** (*America's Dumbest Criminals*).

- **Games.** These half-hour, first-run shows include "pure" game shows (*Jeopardy, Wheel of Fortune*), celebrity-driven, humor-based shows where the entertainment value is more important than the game itself (*Hollywood Squares*), and "gamedies" (*The Newlywed Game/Dating Game Hour*), which combine a game with humor.

- **Children's.** Once dominated by syndicated programs, children's programming is now provided to stations primarily by the networks, principally Kids WB! and Fox Kid's Network. Cable networks, especially Nickelodeon and Cartoon Network, have also become a major force for reaching kid viewers. Stations still use some syndicated programming designed for children in non-network time periods on both weekdays and weekends. Whether provided by the networks or acquired through syndication, children's programs fall into several basic categories: **animation** (*Pokèmon, Sabrina the Animated Series, 101 Dalmatians: The Animated Series, Disney's Hercules*), **live action** (*Mighty Morphin Power Rangers*), **reality** (*Bill Nye the Science Guy*) and **theatrical cartoons** (*Bugs Bunny, Tom and Jerry*).

- **Weeklies:** This category includes virtually all the aforementioned program types, but the shows are first-run and designed for broadcast once or twice a week, generally on Saturdays or Sundays (*Xena: Warrior Princess, The George Michael Sports Machine, WWF Shotgun Saturday Night*). After several years of weekly runs, some of these shows may amass enough episodes to be played Monday through Friday (*Star Trek: The Next Generation, Baywatch*).

The syndication chain involves both direct participants—one or more producers and financial backers; a distributor; and the buyer, a broadcast television station, cable network, or foreign network—and indirect participants, who include programmers at the national station representative firms.

The Producer and Production Company

Many people think of producers as cigar-smoking, fast-talking, jewelry-bedecked guys "taking meetings" by the pool. A few may fit this description, but most would not stand out in a crowd. Actually, the producer is the person who coordinates the diverse elements that constitute a television program. Producers (or executive producers) oversee on-air talent, directors, writers, technical crew, line producers, production managers, production assistants, and researchers. Producers often deal with talent agents, personal managers, union officials, the press, and lawyers. They are answerable for everything: the program concept, program content, the tone or mood of the program, and the overall production. If a program is not delivering satisfactory ratings, its producer is responsible for "fixing" or improving it. The producer is also responsible for delivering the program on time and on or under budget and is directly accountable for contacts with the production company and syndicator that financed the program.

A production company finances and produces television programs, hiring the producer and the staff and possibly proposing program ideas or financing producers who bring in the ideas. Based on a pilot or merely a written presentation, the production company sells programs directly to broadcast or cable networks or, alternatively, strikes a deal with a syndication company to distribute (syndicate) its programs to individual television stations. Sometimes the production company is the syndicator itself and distributes the programs it has created.

The decision to begin production of a new program depends on whether a broadcast or cable network is interested in the idea and advances development funds (see Chapters 4 and 5) or whether the program is suitable for domestic and foreign syndication. U.S. cable and sales to foreign television networks are an important **after-market** for off-network programs and theatrical movies.[2] However, hour-long dramatic shows have only modest syndication potential even after network airing (for example, *Melrose Place*), but comedy has always been a gold mine, although most programmers insist that sitcoms must have young adult and youth appeal to succeed in syndication. *Network carriage is important in giving a program high visibility, but syndication is where the profits lie.*

The Syndicator

Although some syndicators produce programs and others merely handle programs produced by different companies, all syndicators (also called *distributors*) supply programming to local stations on a market-by-market basis throughout the nation. Unlike ABC, CBS, Fox, NBC, UPN, WB, Telemundo, and Univision, syndicators do not have a single "affiliate" in any particular market. (The parent companies of ABC, CBS, Fox, UPN, WB, and the Spanish-language networks also operate syndication companies as separate entities.) Instead, syndicators can and often do sell their programming to any and all stations in a market. Depending on the kind of programs offered by the syndicator, certain stations in a market may be more frequent customers than other stations. For example, some affiliates build programming blocks

3.2 PROGRAM SYNDICATORS

Syndicators	Programs
Baruch Entertainment	Movies, specials
Buena Vista Television	*Home Improvement, Live with Regis and Kelly,* Disney's *Honey I Shrunk the Kids, Roger Ebert & the Movies,* Disney movies
Carsey-Werner-Mandabach Distribution	*3rd Rock from the Sun, Cosby, Roseanne, That 70's Show*
CBS Enterprises	*Martha Stewart Living, Pensacola: Wings of Gold, Bob Vila's Home Again, The George Michael Sports Machine*
CF Entertainment	*American Athlete, Every Woman*
Columbia Tristar Television	*Seinfeld, Mad About You, The Nanny, Ricki Lake, Married . . . with Children, Designing Women, Barney Miller, Facts of Life, 227, Who's the Boss?* movies
DLT Entertainment Ltd.	*Benny Hill, Three's Company, Too Close for Comfort*
Grandolph Juravic Entertainment	Weekly programs
Hearst-Argyle Television Productions	*Your New House, Living Better, Rebecca's Garden*
Hearst Entertainment Distribution	*B. Smith with Style, Popular Mechanics for Kids,* movies, cartoons
King World Productions	*The Oprah Winfrey Show, Wheel of Fortune, Jeopardy, Hollywood Squares*
Litton Syndications	*Jack Hanna's Animal Adventures, P. Allen Smith Gardens*
MG/Perin	*Jim Fowler's Life in the Wild,* specials
MGM Worldwide TV Group	*National Enquirer TV, The Outer Limits, In the Heat of the Night,* movies
Muller Media	Movies, specials
New Line Television	*Nancy Drew/Hardy Boys Mysteries,* movies
October Moon Television	*Real World,* first run series, movies

around game shows, others around talk shows. Fox, WB, UPN, and Spanish-language stations are more likely to air movies and children's animated programs. Although the syndicator may have more than one customer in a market, only one station is licensed to carry any particular program at a time. Thus, one station may buy syndicated reruns of *Married . . . with Children* from Columbia Tristar Television Distribution, while another station may buy the rights to *Seinfeld,* also from Columbia. And a third station may purchase *Ricki Lake* from Columbia. Each station will have the exclusive right in its local market to all episodes of the series it bought during the term of the license.

The United States has dozens of domestic syndication companies, and there are scores of others worldwide. Most of the major and medium-sized domestic program syndicators and their hottest properties in the early-2000s are presented in 3.2. Off-network hits such as *The Drew Carey Show* and *Everybody Loves Raymond* average as high as $2 to $3 million an episode in combined syndicated revenue (for all stations). Of the two dozen or so firms listed in 3.2, six companies command more than three-quarters of the domestic syndication business: Buena Vista, Columbia Tristar, Paramount, Studios USA, 20th Century Fox, and Warner Brothers.

Syndicators "sell" (license for a fee, hence **license fee**) the telecast rights to a program to the local station for a certain term and for a set number of plays. The syndicator or the producer of the program continues to own the rights to the

3.2 CONTINUED

Syndicators	Programs
Paramount Distribution	*Entertainment Tonight, Judge Judy, The Montel Williams Show, Spin City, Frasier, Cheers, Family Ties, Happy Days, Nash Bridges, Matlock, Star Trek, Star Trek: The Next Generation,* movies
Pearson Television	*Baywatch Hawaii, Family Feud,* movies
The Program Exchange	*Garfield and Friends, Dennis the Menace, Bosom Buddies, Dear John, Webster*
Promark Television Syndication	*Travel Travel, PC4U, Sportsweek,* specials
Raycom Sports	*ACC Basketball, Big 12 Conference Football, Pac 10 Conference Football,* specials
SFM Entertainment	Movies, specials, documentaries, animated specials
Studios USA	*Jerry Springer Show, Sally, Maury, Xena: Warrior Princess, Coach, Gimme a Break, Rockford Files, The A-Team,* movies
Telepictures Distribution	*ER, Family Matters, Fresh Prince of Bel-Air, The Jamie Foxx Show, This Old House, WCW Pro wrestling,* movies
Tribune Entertainment Company	*Beastmaster,* Gene Roddenberry's *Earth: Final Conflict, Soul Train,* movies, specials
20th Century Fox Television	*Ally McBeal, The Practice, Dharma & Greg, Divorce Court, X-Files, The Simpsons, M*A*S*H, Cops, Doogie Howser M.D.,* movies
Unapix Entertainment	*Great Minds, Record Breakers*
Warner Brothers Domestic Television	*The Drew Carey Show, Friends, Full House, Hangin' with Mr. Cooper, Murphy Brown, The Rosie O'Donnell Show, Jenny Jones, People's Court, Access Hollywood, Extra,* movies
Western International Syndication	*It's Showtime at the Apollo,* action series, specials
World Wrestling Federation	*WWF Metal, WWF Jakked, WWF Shotgun, WWF Shotgun Saturday Night*

show. Some syndicators create, produce, and distribute their own programming while others merely distribute (for a commission) programs created and produced by others. Additionally, some syndicators increase their revenues by selling national barter time (advertising spots) within programs. The syndicator licenses ("sells" or leases) the program to a station for a specific term or period of time. During the license term, the syndicator grants the station the *exclusive* right to broadcast the program. At the end of the license term, the broadcast rights revert to the syndicator, who may now license the program all over again to any station in the market.

The syndicator's client is the local television station in the person of the general manager or the program director (also called program man-

ager, director of programming, or other similar titles). The general manager is responsible for the overall station operation, including programming, sales, news, engineering, legal matters, business affairs, promotion, public affairs, traffic, network relations, and labor relations. Because programs are what viewers watch and advertisers buy commercial time in, and because of the considerable cost of purchasing programs, the general manager usually gets involved in most programming decisions. In fact, some important program purchasing or scheduling decisions may bypass the general manager and are made by corporate management or station owners.

The **program director** is the station executive primarily responsible for developing the program schedule, establishing a relationship and conducting

business with the syndicator, managing the station's program inventory, dealing with viewers and community interest groups, and generally implementing and overseeing the station's programming policies. The program director is also responsible for any non-news local programming the station produces, including talk shows, magazines, children's shows, sporting events, and the like. The program director usually works closely with the station's promotion and production departments.

The Rep

The outside party involved in the syndication chain is the **rep programmer,** who works for the national sales representative firm that sells national advertising time for the station. The rep programmer acts as an ally for and consultant to the station. Blair, HRP, Katz, MMT, Petry, Telerep— these names can be seen in trade publication articles, in advertisements, on research materials, in directories, and even on television station letterheads[3]—all these companies (and several smaller companies) are **station representatives,** national sales organizations selling commercial airtime on behalf of local market television stations.

Although the station representative is primarily a sales organization, reps provide additional services to client stations including *marketing support, sales research, promotion advice,* and *programming consultation.* Through these support services, the reps help client stations improve their programming performance in terms of audience delivery, which will in turn lead to increased advertising rates and, presumably, increased profitability for the station and the rep. (Although revenues may go up, profitability for the station sometimes does not because of increased programming, operating, and other expenses.) Usually, no additional fee is charged for support services; they are included in the rep's sales commission (see 3.3). The six major rep firms have programming staffs that work with programmers at client stations to shape and guide the stations' programming schedules. Rep programmers provide ratings

3.3 THE NATIONAL SALES REP

Reps sell commercial airtime on local client stations to national spot advertisers. As the advertising agency represents the advertiser in buying commercial time, the station rep represents its client station in selling the time. Local stations of whatever sort sell commercial time to local merchants and other advertisers within the market, and all commercial stations employ a local sales force for this purpose. It is not economically feasible for a single station to employ a sales force to sell commercial time to *national* advertisers, however; there are far too many advertisers and advertising agencies in too many cities to be covered by a station's sales force. That's where the rep comes in. Reps employ sales people in many cities on behalf of the local station to sell to advertisers in those cities. (Several reps have offices in more than 20 cities.) Because reps sell on behalf of many stations, they can maintain sales forces of hundreds of people, selling on behalf of dozens of stations. The largest station representatives have client stations in as many as 200 markets. The rep receives a negotiable commission from its client stations for the commercial time the rep sells. As a rule of thumb, a 10 percent commission rate is the industry norm, but because of the competitive nature of the rep business, such considerations as the overall state of the economy and market size may cause the commission rate to vary widely. Larger market stations and stations owned by large group broadcasters often pay only single-digit commission rates to their representative. Conversely, smaller market stations generally pay a higher commission rate, because the dollar volume is considerably less than in large markets.

information that may support or call into question information syndicators supply, and they advise client stations on the programs that will attract the most viewers in the demographic groups

advertisers desire most to reach. At the same time, rep programmers must consider each station's programming philosophy, the mores of the community, and the quality of each program.

One of the rep's most important functions is to regularly disseminate generic national research information and market-specific research to client stations. Most reps maintain close contact with all the big networks (ABC, CBS, Fox, NBC, UPN, and WB), enabling them to supply an affiliate with competitive information regarding the other networks. Reps also publish ratings summaries and analyses of new programs, and they provide exhaustive ratings information after each rating sweep period. Because of their national overview of programming and their own experience and that of their colleagues, rep programmers can often look at programming decisions from a perspective not available to a local station's general manager or program director.

PROGRAM ACQUISITION

Syndication is the arena in which most programmers expend much of their energies—and with good reason. *For most stations, the money spent annually to acquire syndicated television shows is their single largest expense.* The station that buys a syndicated program that turns out to be a dud, or the station that overpays for a syndicated show, may be in financial trouble for years to come. And the station that makes several such mistakes (not uncommon) has serious problems.

The rep provides the station management with programming advice supported by research and experience-based opinion. The general manager and the program director get recommendations from their rep on which shows should be acquired, along with a rationale for the acquisition and recommendations on the program's placement in the station's lineup. Although reps spend most of their time dealing with syndicated programming and therefore work closely with syndicators, reps do *not* work for the syndicators. The rep works for

the stations; rep firms are paid commissions by client stations based on advertising sales.

Both the station program director and the rep programmer spend many hours meeting with syndicators, listening to sales pitches and watching videocassettes or DVDs of sales pitches, research information, excerpts of the program, or actual pilots. In the pitch, the syndicator tries to convince the programmer of the program's merits and that the program, if scheduled on the station, will improve the station's ratings. Although the reps do not actually purchase the program, and although the syndicator must still pitch the station programmers directly, a rep's positive recommendation to the station paves the way for the syndicator when he or she contacts the station. Most syndicators maintain close and frequent contact with the station program director and the reps. They inform reps of ratings successes, changes in sales strategy, purchases of the program by leading stations or station groups, and any other information the syndicator feels may win support from the rep. Syndicators often try to enlist the rep's support for a show in a specific time period on a specific station the rep represents. Frequently, syndicators inform reps of programs during their developmental stages, often as trial balloons to gauge the rep's reaction prior to beginning a sales campaign or shooting a pilot of a program.

Syndicator contacts with reps do not replace contact between syndicator and station. Rather, syndicators take a calculated risk with reps to gain support for a program. If a rep dislikes the show or does not feel it suits a station's needs, the rep's advice to the station can damage the syndicator's efforts.[4] Many stations have refused to buy syndicated shows because their reps did not endorse them.

Scheduling Strategies

When a television station acquires a program from a syndicator, its managers generally have a pretty good idea of how they will use the show. Frequently, they look not only for a program that meets their needs but also for one that fits certain

scheduling and business deal criteria. As discussed in Chapter 1, several scheduling strategies are widely accepted. These include:

- **Stripping.** Syndicated series can be scheduled daily or weekly. Programs that run daily in the same time period Monday through Friday are said to be stripped. In the case of off-network programs, 65 episodes (three network seasons) are generally considered the minimum for stripping, allowing 13 weeks of Monday to Friday stripping in syndication before a station repeats an episode. Between 100 and 150 episodes are considered optimum for stripping, while 200 or more episodes can be a financial and scheduling burden to a station. First-run daily programs are created specifically for stripping. Producers will generally shoot 195 original episodes (39 weeks) a year, with 65 episodes (13 weeks) repeated. Some first-run strip shows will be produced fresh every day (260 episodes over 52 weeks), as in the case of magazine shows.

- **Audience flow.** As a general strategy, programmers try to schedule successive shows in a sequence that maximizes the number of viewers staying tuned to the station from one program to the next. The shows flow from one to the next, with each building on its predecessor. The lead-in and lead-out shows are carefully selected to be compatible with a program in any given time period. Theoretically, the audience flows with the shows. Additional audience may flow into the program from other stations and from new viewers just turning on their television sets. Thus, audience flow is a combination of (1) *retention* of existing audience from lead-in, (2) *dial switching* from other stations, and (3) attraction of *new tune-in* viewers.

- **Counterprogramming.** This tactic refers to scheduling programs that are different in type and audience appeal from those carried by the competition at the same time. For example, within one market at 4 P.M. Monday through Friday, affiliate WAAA might schedule a talk show, affiliate WBBB might carry a game show, affiliate WCCC might carry a situation com-

edy, and independent WDDD might carry children's animation; thus, all stations are counterprogramming each other. In another example, within one market at 10 P.M. EST, while all three affiliates are carrying network entertainment programs, the independent might schedule news, and while the three affiliates carry late evening news at 11 P.M., the independent might counter (go against) with situation comedies.

Deal Points

When the syndicator approaches the station or rep programmer, he or she outlines the terms and conditions of the offering. Most deals include the following deal points or terms:

- **Title.** In the case of programs entering syndication after a network run, the syndication title may be different from the network version. Thus, *Happy Days* became *Happy Days Again* in syndication. Sometimes the title of a first-run program is changed from the time the program is marketed to the time it starts airing, often in an attempt to entice more people to watch the show.

- **Description of the program.** This includes whether it is first-run or off-network, the story line or premise, and other pertinent information.

- **Cast, host, or other participants.** Big-name or emerging talent is often a draw. If additional episodes of a series are planned, notice of long-term contracts with the talent has value.

- **Duration.** The program may be 30, 60, or 90 minutes long, or another length entirely.

- **Number of episodes.** This point includes original episodes and repeats. Sometimes a minimum and maximum number of episodes are offered.

- **Number of runs.** The syndicator indicates the maximum number of times the station may air (**run**) each episode.

- **Start and end dates.** Programs are sold for specific lengths of time, such as six months, one year, three-and-one-half years, five years, or seven years. They may be sold months or years in advance of the start date (**futures**).

- **Commercial format.** Each show is sold with a fixed number of commercial spots. For example, a typical half-hour program might be formatted for (1) *six-and-a-half internal commercial minutes* (in other words, thirteen 30-second units) in two breaks of two minutes each and one break of two-and-a-half minutes within the program plus (2) an *endbreak* (external) following the program, typically of 92 seconds.

- **Price.** The cash price may be stated as either a per episode fee (which is one inclusive amount for all runs of a single episode) or as a weekly fee (a fixed amount regardless of the number of times each episode is ultimately shown).

- **Payment method.** Programs are sold for cash, for barter, or for cash-plus-barter.

- **Down payment.** In cash or cash-plus-barter deals, the syndicator might request a down payment (typically 10 to 20 percent) when the contract is signed, which is sometimes several years before the station receives the rights to the show.

- **Payout.** Cash the station still owes to the syndicator (after the down payment) must be paid when the program begins to air. Typically, the balance is paid in installments over the life of the contract, similar to mortgage or auto loan payments.

A Pitch

Using the hypothetical syndication offering of the equally hypothetical off-network *The Bill Smith Show* as an example, let's look more closely at the syndicator sales pitch to a station.

About 9:30 one morning, the telephone rings in the office of the program director at a medium-sized market independent station on the East Coast. The caller is a Los Angeles–based syndication salesperson (calling at 6:30 A.M. Pacific time from his home) with whom the programmer has developed a professional friendship/relationship. After a minute or so of how's-your-family chatting and two or three minutes of exchanging trade gossip ("Did you hear Jane Green is out as general manager of WBBB? Do you know who's going to replace her?"), the syndicator tells the programmer that he's coming to the market next week and would like a few minutes to tell the program director about his company's latest offering, *The Bill Smith Show*. And how about lunch too? The programmer agrees to see the syndicator the following Tuesday at 11 A.M., followed by lunch.

Tuesday morning arrives, and so does the syndicator, shortly before the appointed 11 A.M. There's amiable conversation about the syndicator's rough flight east; the hot, rainy, humid weather the city has been experiencing for a week; and the good weather the syndicator has left behind in Los Angeles. The salesman asks about the sale of one of his competitors' off-network programs, trying to ferret out competitive information. The program director asks about the status of one of the syndicator's somewhat shaky first-run programs, to which the syndicator replies that the program is stronger than ever but, after a few minutes of verbal fencing, acknowledges it is still not performing up to expectations. Finally, at about 11:10, the pitch begins.

The syndicator removes a glossy, expensively printed, full-color sales brochure from his briefcase. Bill Smith's smiling face and the title of his show are on the cover. The salesman guides the program director through the first few pages, elaborating on the printed descriptions of the show's plot, characters, and leading stars. He makes reference to the show's "outstanding" network history, "the best since *Home Improvement* or *Seinfeld*," he claims, but he offers no research to support his assertions. (That will come later in the video presentation.) The program director takes the following notes:

TITLE: *The Bill Smith Show*

DESCRIPTION: Off-network sitcom about a zany recluse and the lovable neighbors in his apartment building

CAST: John Jones as the zany but sensitive Bill Smith; Jane Doe as Bill's amorous neighbor Helga; Max Brown as the bumbling building superintendent Sam

DURATION: 30 minutes

The syndication salesman suggests that the program director watch a 15-minute video presentation. As they watch, the programmer sees a succession of hilarious *Bill Smith Show* highlights, followed by clips of several tender, emotional scenes designed to show John Jones's acting range as Bill Smith. Although *The Bill Smith Show* has been on network television for two years, the producer of the tape is taking no chances that the programmer may not have seen the show. The presentation's producer has also put together many of the show's more memorable or funnier scenes, hoping to create a highly favorable impression of the show.

Now the focus of the tape shifts to the program's network performance. The presentation shows that *The Bill Smith Show* has taken a previously moribund time period on the network and has increased the network's household audience share in the time period by 50 percent over the previous occupant's performance, despite a weak lead-in program and strong competition from the other networks. In fact, in its first season, *Bill Smith* had single-handedly taken the network from a weak third place to a strong second place. As a result, the network moved *The Bill Smith Show* in its second season to a different night and time, where the results have been similarly impressive. The research focuses on similar gains made by the show in women 18 to 34, 18 to 49 and 25 to 54, children 2 to 11, and teen demographics. It omits all mention of male viewers older than age 17.

In the tape's final minutes, the enthusiastic announcer stresses the usefulness of *The Bill Smith Show* in syndication as a lead-in to an affiliate's early newscast (typically 5 P.M. or 6 P.M.) or an independent station's 6 to 8 P.M. schedule. The tape also compares the show's writing, cast of characters, and network performance to such perceived network and syndication successes as *Seinfeld, Cosby, Friends, Cheers,* and *Home Improvement.* The tape ends with several additional hilarious scenes and the syndication company's logo.

Now the syndicator hands the programmer a packet containing research studies. Much of the research mirrors the information shown in the video presentation, but it is more detailed. A copy of last week's overnight ratings in the metered markets is included showing that *Bill Smith* finished in first place for the fourth week in a row. The programmer and syndicator discuss the research data. The programmer questions the obvious omission of data for the male demographics, which he deduces is one of the show's weaknesses. The syndicator claims that lack of male appeal is not a shortcoming because the time periods in which the program will play in syndication have relatively few male viewers available, and because women and children control the television set anyhow. The programmer continues to question the point; the syndicator uses his laptop to show research data demonstrating that *The Bill Smith Show,* does, indeed, have male appeal. Still unable to completely satisfy the program director, the syndicator promises to have his company's research director provide additional information to show that males also like the program. And so it goes for about half an hour, with the program director questioning research data and making counterarguments based on his own research. Finally, the program director is satisfied that the syndicator's research is generally accurate—as far as it goes.

Now the discussion turns to the deal itself. In a presentation punctuated by frequent questions and requests for elaboration, the syndicator outlines the rest of the offering. The program director takes notes of the deal points:

PROGRAM TYPE: Off-network situation comedy

EPISODES: Minimum of 96, maximum of 168 if the program runs seven years on network

RUNS: 6

YEARS: 3 to 5 (depending on number of episodes produced)

START DATE: Fall 2004

FORMAT: Cut for 6½ minutes

PAYMENT: Cash

DOWN PAYMENT: 10 percent

PAYOUT: 36 equal monthly installments

ASKING PRICE: $12,500 per episode for the first five network years plus an additional 10 percent per episode beginning with the sixth production season (if the show runs that long on the network) with a maximum of eight production years

In a similar pitch to a rep, the asking price usually is not discussed because the syndicator is pitching the rep on all markets at one time and would prefer to quote the price directly to the customers, the stations. Finally, the syndicator has made all his points, and the program director has asked all his questions. It's now time for lunch. (Most syndicator meetings do not involve lunch, but when they do, it's a chance for less formal discussion of the program and other issues.) The programmer and the syndicator go to a nearby restaurant for lunch. During the meal, the syndicator suggests specific spots in the station's schedule where the show might fit and tries to get a reaction from the program director. The programmer plays it close to the vest.

Eventually the discussion turns to other topics. The programmer and syndicator touch on renewals of one older show. They discuss the syndication company's plans for future first-run shows. At one point, the salesman says he'll be back in town in a few weeks with a new package of 30 movies his company is about to offer. The program director manages to pry out of him three "typical" titles, probably the three most popular films in the package.

Finally lunch is over. The syndicator goes to his next appointment at another station in town, and the program director returns to the office, possibly for another meeting with another syndicator.

Syndicator/Rep Rules

The relationship between syndicators and reps is generally friendly and mutually dependent. The syndicators need the reps' support in client markets; the reps need to get programming information from the syndicators. Yet the relationship must also be guarded. Because the reps are agents of their client stations, they must maintain their independence from the distributors with an impartiality befitting the trust placed in them by the stations.

Therefore, certain unwritten rules govern the relationship between syndicator and station rep. Reps rarely make blanket program recommendations, and they do not endorse any particular program or syndicator. Although reps often support or oppose a particular genre or programming trend, they are generally quick to point out that not every station in every market necessarily can be included in their assessment. Few programs will appeal equally in every market, and the stations' competitive needs differ greatly from market to market.

Another unwritten rule is that rep programmers do not supply syndicators with privileged client-rep information. As an extension of the station, the rep programmer does not want to supply information to syndicators that would help the syndicator negotiate against the station. Privileged information includes prices the station would be prepared to pay for programs, prices it already paid for other programs, other programs the station is considering purchasing, its future plans and strategies, contract expiration dates, and any other information that might harm the station's negotiating position; however, syndicators frequently provide such information to the reps.

RATINGS CONSULTATION

Station general managers and program managers talk regularly with their national reps. Rep programmers and station sales management and research directors are also in contact, albeit less frequently (most stations do not even have a research department). The rep programmer occasionally meets clients, either by visiting the station or when station personnel travel to New York to meet with rep sales management and with advertising agencies. Most general managers/program directors and reps endeavor to meet at the annual conventions of **NATPE** (National Association of Television Program Executives), the **NAB** (National Association of Broadcasters), and at network affiliate meetings.

A good working relationship between station and rep programmer is important. Consultation is not a one-way process; a rep does not presume to be an all-knowing authority dispensing wisdom from a skyscraper in New York. The consultation a rep programmer provides is a give-and-take exchange of ideas. Just as the rep has a national perspective, enabling him or her to draw upon experiences in other markets, the station programmer generally knows his or her market, local viewers' attitudes and lifestyles, and the station's successes and failures over the years better than almost anybody else.

Key Questions

Station management and rep programmers must consider some key questions as they work together:

- How well is the station's current schedule performing?
- Has there been audience growth, slippage, or stagnation since the previous ratings report? Since the same period a year ago? Two years ago?
- What audience demographics are the advertisers and the station and rep's sales departments seeking? Is current programming adequately delivering those demos?

- Are older shows exhibiting signs of age?
- Has the competition made schedule changes that have hurt or helped the client station?
- Does the client own programs that can be used to replace weak programs, or must the client consider purchasing new programs for weak spots?

Generally, a station seeks audience growth over previous ratings books. Of course, for one or two stations to experience audience growth, other stations in the market must lose audience. The rep programmer seeks to help the station stem audience erosion and create growth instead.

Reps also help station programmers analyze the most recent ratings report. Both parties look for trouble spots. If a program is **downtrending** (shown a loss of audience from several previous ratings periods), the programmers may decide to move it to a different, perhaps less competitive, time period. Or they may decide to take the show off the air entirely, replacing it with another program. Sometimes a once-successful but downtrending program can be **rested** or "put on hiatus," perhaps three months minimum to a year maximum, or for a part of the year, such as the summer. When the program returns to the air from hiatus, it often recaptures much of its previous strength and may run successfully for several more years.

The programmers may also note that a certain daypart is in trouble. A wholesale revision of that part of the schedule may be in order. They may need to rethink a station's programming strategy to decide if current programming is still viable or if the station should switch to another genre. For example, if a two-hour off-network action-drama block is not working, should the station switch to sitcoms or talk shows? A change of this magnitude is often quite difficult to accomplish, for the station usually has contractual commitments to run current programming into the future. Also, most viable programs of other genres are probably already running on other stations in the market. It is usually easier to rearrange the order of the existing shows to see if a different sequence will

attract a larger audience. It is also easier to replace a single show than an entire schedule block.

Although household ratings are an important indicator of a program's relative performance, programmers are primarily concerned with audience demographics. Though there are dozens of demographic groupings, the most important demos are women 18 to 34 years old (W18–34), women 18 to 49 (W18–49), women 25 to 54 (W25–54), men 18 to 34 (M18–34), men 18 to 49 (M18–49), men 25 to 54 (M25–54), teenagers (T12–17), and children (K2–11). Generally, these are the demographic groups most desired by advertisers and therefore the target audiences of most programs.

Although most programs probably don't appeal equally to all of these groups, programmers try to schedule shows that reach at least several of these demos at times of the day when those people are available to watch television. Even if a program is not number one or two in household rating and share, a strong performance in a salable demographic may make the program acceptable despite the household rating. For example, the program may be number two or three in household rating/share but may have very strong appeal to young women, making it number one in the market in women 18 to 34 and women 18 to 49. These groups are attractive demographics for many advertisers. Thus, the program might be acceptable for the station's needs despite its lower household ratings performance.

In another example, the program might be the third-rated show in its time period, but may have exhibited significant ratings growth over previous ratings books. Therefore, the programmers may decide to leave the program in place because it is **uptrending** rather than **downtrending.** They may decide instead to change the lead-in show to try to deliver more audience to the target show. They may also decide to promote the show more to build audience.

A key issue in all these decisions is that *programming is usually purchased far in advance of its actual start date*. In the autumn of any year, stations are already planning for the following September, even though the current season has barely begun.

Successful first-run shows are often renewed for several years into the future. Off-network programs are frequently sold two or three years before they become available to stations in syndication. Once purchased, the station is committed to paying the agreed-upon license fee to the syndicator regardless of the program's subsequent network or syndication performance. Not uncommonly, a once-popular network program will fade in popularity in the two or three years between its syndication sale and its premiere in syndication. Although the station may be stuck with a program of lesser value than originally perceived, the syndicator does not waive or offer to drop the license fee. A deal is a deal. Conversely, some network shows increase in popularity as they continue to run, meaning that the station that bought early may pay a smaller license fee than if the program had been purchased a year or two later when its popularity was greater. Reps and their client stations thoroughly research, analyze, and plan acquisitions carefully to purchase wisely.

Research Data

Much station/rep consulting time is spent preparing information, researching program performance, and formulating programming strategy. Ratings information from Nielsen Media Research is the basis for much of this thought. (Until early 1994, similar information was available from The Arbitron Company; Arbitron now only measures radio listenership.) Station, syndicator, and rep programmers and salespeople regularly use Nielsen NSI data published quarterly in VIP ratings books (see below) to make programming decisions, to sell syndicated shows, and to sell advertising time. The syndicators and reps also have available to them additional Nielsen ratings information not generally purchased by stations because of its cost. These reports include:

- **NSI.** The *Nielsen Station Index* is the system used to measure viewership in local designated market areas (DMAs), including local commercial and public broadcast stations, and viewership of some national cable networks,

superstations, and spill-in stations from adjacent markets.

- **VIP.** Nielsen's *Viewers in Profile* report is the bible of local television stations, the infamous "book" by which stations (and sometimes careers) live and die. Most commercial TV stations subscribe to this report, for it is the basis for the advertising rates the stations charge. All advertising agencies, syndication companies, and station reps get this report as well. Using NSI data, the VIP books show viewership over specific four-week periods (the "sweeps") in quarterly reports (November, February, May, July) in 211 markets and in October, January, and March in selected large markets. The information is broken down for dayparts, programs, and individual quarter hours. Ratings and shares are shown for households and key demographic groupings based on age and gender. There is also a section that tabulates viewership as thousands of people rather than as rating or share. The data is shown as a four-week average and is also broken out for the four individual weeks of the ratings period. Both program averages (showing data for only a single program as a single number for the entire length of the show) and time period averages (which may include two or more programs in the same time period during the four weeks and which is broken down by quarter hour or half hour) are provided.

- **ROSP.** Nielsen's *Report on Syndicated Programs* provides a complete record of all syndicated programs. The ROSP aids in the selection, evaluation, and comparison of syndicated program performance.

- **NSS Pocketpiece.** Nielsen's *National Syndication Service* weekly report provides national audience estimates for barter programs distributed by subscribing syndicators or occasional networks, including barter specials, syndicated sporting events, and barter movie packages. It is small enough to fit into a man's suit jacket pocket (hence the name) or a woman's purse, making it handy on sales calls.

- **NTI.** *Nielsen Television Index*, based on people-meters, provides daily ratings performance on a national basis for all network programs, including household and demographic audience estimates. The NTI ratings are also available as a weekly pocketpiece.

- **Galaxy Explorer.** Nielsen's overnight NTI service provides national household ratings and shares and HUT levels.

- **Galaxy Navigator.** Similar to Galaxy Explorer, Nielsen's Galaxy Navigator provides household ratings and shares and HUT levels for the individual local metered (overnight) markets.

- **Galaxy Profile.** A PC-based analysis tool that the client can use to manipulate Nielsen data.

- **NAD.** Nielsen's *National Audience Demographics Report* provides comprehensive estimates of viewership across a wide range of audience-demographic categories. The *NTI NAD* is published monthly in two volumes and provides national network program viewership information. The *NSS NAD* is a monthly book providing similar data for syndicated programming. *CNAD* is a quarterly report of cable network viewership. Unlike the other NAD reports, *CNAD* does not provide data on individual programs; it provides viewing estimates only for time periods and dayparts.

- **PTR.** Nielsen's quarterly *Persons Tracking Report* tracks program performance in terms of household audiences and viewers per 1,000 viewing households. The PTR includes "specials."

- **HTR.** Nielsen's quarterly *Household Tracking Report* tracks program performance by individual network within half-hour time periods.

- **NCAR.** Nielsen's quarterly *Cable Activity Report* compares all basic cable, pay cable, and broadcast audience levels.

- **NSI Report on PBS Program Audiences.** Viewership of public television in each of the major ratings sweeps periods (November, February, May, July) is reported as national averages.

3.4 COMTRAC SHEETS FOR SEINFELD

SEINFELD

Nielsen Ratings RANK MARKET STATION	DAYS TELECAST	START TIME	Feb 99 LI HH SH SH	May 99 LI HH SH SH	Nov 99 LI HH SH SH	LEAD-IN PROGRAM	HH SH	February 2000 HH HH %CHG W1 W2 M3 SH RT FB99 SH SH SH	LEAD-OUT PROGRAM	HH SH	HIGHEST COMPETING PROGRAM	Feb 00 LI HH W1 SH SH SH	2nd HIGHEST COMPETING PROGRAM	Feb 00 LI HH W1 SH SH SH		
001 NEW YORK WPIX 11	W	MTWTF..	7:30P	11 8f	10 8f	10 10	FRIENDS	10 11 7	37 15 14 17	VARIOUS	10	WABC WHEEL-FORTNE	23 22 15	WNBC ACCESS HOLLYWD	10 10 9	
002 LOS ANGELES KTLA 5	W	MTWTF..	7:30P	12 14	12 13	12 11	FRIENDS	12 11 7	-22 12 11 13	VARIOUS	9	KABC WHEEL-FORTNE	17 14 7	KTTV SIMPSONS	8 11 11	
003 CHICAGO WFLD 32	F	MTWTF..	6:30P	16 16	17 16	15 14	SIMPSONS B	15 12 7	-25 12 12 20	VARIOUS	10	WLS WHEEL-FORTNE	19 25 16	WBBM ENT TONIGHT 30	10 10 9	
004 PHILADELPHIA WTXF 29	F	MTWTF..	7:30P	10 14	11 13	11 10	SIMPSONS B	12 12 7	-15 14 12 18	VARIOUS	9	WPVI WHEEL-FORTNE	26 24 15	WCAU ACCESS HOLLYWD	8 10 11	
005 SAN FRANCISCO-OAK KTVU 2	F	MTWTF..	7:00P	11 11	11 11	8 9	HOME IMPROV MF	8 9 5	-31 11 12 14	FAMILY FEUD	8	KGO JEOPARDY	14 19 15	KRON FRASIER	14 13 13	
006 BOSTON (MANCHEST WSBK 38	U	MTWTF..	7:00P	12 12	12 10	11 11	JUDGE JUDY B	12 10 6	-17 13 11 18	FRASIER	8	WHDH WHEEL-FORTNE	16 16 9	WCVB INSIDE EDITION	15 14 12	
007 DALLAS-FT. WORTH KDFW 4	F	MTWTF..	6:30P	9 12	8 12	9 10	FOX4NEWS AT 6	9 11 7	-9 11 12 17	VARIOUS	10	WFAA WHEEL-FORTNE	20 21 15	KXAS INSIDE EDITION	12 15 14	
008 WASHINGTON, DC (H WTTG 5	F	MTWTF..	7:30P	15 16	13 14	11 11	FRIENDS	12 13 8	-19 15 15 17	VARIOUS	9	WJLA JEOPARDY	18 20 16	WUSA ENT TONIGHT 30	15 16 17	
009 DETROIT WWJ 62	C	MTWTF..	11:00P	10 5c	10 4	10 6	VARIOUS	9 8 5	60 11 11 10	D LETTRMAN-CBS	9	WDIV NW 4 NT8EAT	26 26 26	WXYZ 11PM NWS UPDTE	17 20 16	
010 ATLANTA WATL 36	W	MTWTF..	10:00P	10 12	10 10	8 8	VARIOUS	7 8 5	-34 9 7 10	FRIENDS	8	WXIA VARIOUS	13 17 19	WSB VARIOUS	18 17 15	
011 HOUSTON KHWB 39	W	MTWTF..	10:00P	0 0	0 0	7 9	REAL TV	6 10 6	--- 11 9 10	FRIENDS	13	KTRK EYEWIT NWS-10	15 18 14	KHOU 11 NEWS-10	14 15 12	
012 SEATTLE-TACOMA KSTW 11	U	MTWTF..	7:30P	8 9	8 8	7 8	DREW CAREY	9 11 6	22 12 11 15	VARIOUS	9	KOMO JEOPARDY	20 22 16	KCPQ SIMPSONS	12 11 15	
013 TAMPA-ST. PETE (S WTOG 44	U	MTWTF..	7:30P	10 11	11 12	9 10	FRIENDS	10 11 7	0 17 12 18	VARIOUS	7	WTSP JEOPARDY	23 20 9	WFLA EXTRA	15 13 10	
014 MINNEAPOLIS-ST. P WFTC+ 29	F	MTWTF..	6:00P	14 10	16 10	13 8	SIMPSONS	16 9 5	-10 9 9 14	3RD ROCK MF2	7	WCCO+ 4 NEWS-6PM	24 26 12	KARE KARE11NWS-6	15 16 22	
015 CLEVELAND WOIO 19	C	MTWTF..	7:00P	6 11	8 9	9 10	CBS EVE NWS	7 9 5	-19 9 10 14	FRASIER	11	WEWS WHEEL-FORTNE	20 22 15	WKYC NBC NITELY NWS	10 14 10	
016 MIAMI-FT. LAUDERD WBZL 39	W	MTWTF..	7:00P	10 9g	9 9g	9 9	SIMPSONS	8 7 5	-23 8 8 11	VARIOUS	10	WPLG WHEEL-FORTNE	14 20 12	WSVN INSIDE EDITION	10 9 7	
017 PHOENIX KPHO 5	C	MTWTF..	10:15P	12 11c	11 10c	11 11c	SEINFELD	11 12 7	9 11 12 13	D LETTRMAN-CBS	9	KPNX+ TONITE SHW-NBC	24 21 22	KSAZ MASH	10 10 9	
018 DENVER KDVR+ 31	F	MTWTF..	6:30P	13 14	13 12	12 15	DREW CAREY	10 15 9	7 19 17 23	VARIOUS	10	KMGH WHEEL-FORTNE	9 14 5	KUSA ENT TONIGHT 30	12 13 17	
019 SACRAMNTO-STKTON- KTXL 40	F	MTWTF..	7:30P	9 10	8 9	7 9	DREW CAREY	8 10 6	0 11 11 16	VARIOUS	9	KXTV WHEEL-FORTNE	16 13 11	KOVR VARIOUS	11 11 8	
020 PITTSBURGH WPGH 53	F	MTWTF..	7:30P	9 10	8 10	6 6d	DREW CAREY	7 7 5	-30 9 7 10	VARIOUS	9	WPXI WHEEL-FORTNE	22 20 11	WTAE ENT TONIGHT 30	15 18 19	
021 ST. LOUIS KPLR 11	W	MTWTF..	10:00P	8 15	11 16	9 15	FRIENDS	10 16 10	6 23 19 19	DREW CAREY	14	KSDK NWS CH5-10P	30 27 25	KMOV CH 4 NEWS-10	19 22 17	
022 ORLANDO-DAYTONA B WKCF 18	W	MTWTF..	7:30P	11 11	11 10	11 11	FRIENDS	12 12 8	9 19 16 20	VARIOUS	7	WFTV WHEEL-FORTNE	22 23 13	WKMG FRASIER	9 10 12	
023 PORTLAND, OR KPTV 12	U	MTWTF..	7:30P	8 7k	6 5k	4 8	MAD ABOUT YOU	4 7 4	0 10 10 13	VARIOUS	5	KATU WHEEL-FORTNE	20 17 10	KPDX SPIN CITY-ABC	22 17 18	
024 BALTIMORE WBFF 45	F	MTWTF..	7:00P	9 9	9 10	9 10	FRASIER	9 11 6	22 17 14 15	DREW CAREY	5	WJZ CBS EVE NWS	18 16 11	WBAL INSIDE EDITION	18 14 12	
025 SAN DIEGO KUSI 51	I	MTWTF..	9:00P	6 5n	5 5n	5 5n	FAMILY FEUD	5 5 3	0 4 4 5	FRASIER	6	KNSD VARIOUS	17 17 18	KGTV VARIOUS	15 14 14	
026 INDIANAPOLIS WTTV+ 4	W	MTWTF..	7:30P	12 11	11 11	8 9	3RD ROCK MF	7 9 4	-37 9 8 12	DREW CAREY	6	WISH WHEEL-FORTNE	17 18 11	WTHR EXTRA	14 14 14	
027 HARTFORD & NEW HA WTIC 61	F	MTWTF..	7:00P	7 10	7 10	6 8	FRASIER	7 9 6	-10 14 10 16	FRIENDS	9	WTNH JEOPARDY	14 17 13	WFSB INSIDE EDITION	20 15 9	
028 CHARLOTTE WJZY 46	U	MTWTF..	6:30P	6 5d	6 5b	5 7	GRACE-FIRE MF	4 7 4	0 9 6 12	DREW CAREY	6	WSOC ABC-WORLD NWS	28 23 13	WBTV WBTV NWS-600P	20 16 11	
029 RALEIGH-DURHAM (F WRAZ 50	F	MTWTF..	7:30P	3 6	6 4	4 5	PARENT HOOD	3 5 3	-11 5 4 5	NEWSRADIO	4	WTVD JEOPARDY	18 20 15	WRAL INSIDE EDITION	22 17 11	
030 NASHVILLE WZTV 17	F	MTWTF..	6:30P	9 10f	7 8f	7 8f	FRASIER	7 8 5	-20 11 9 10	VARIOUS	7	WSMV SCENE AT 6	23 20 14	WKRN WHEEL-FORTNE	16 16 14	
031 KANSAS CITY KCTV 5	C	MTWTF..	11:30P	8 13	9 12	9 13	D LETTRMAN-CBS	14 17 5	30 23 23 19	MARRIED-CHLDRN	14	WDAF MASH	14 12 17	KMBC ENT TONIGHT 30	11 10 11	
032 CINCINNATI WSTR 64	W	MTWTF..	7:30P	9 12	8 10	9 10	DREW CAREY	10 11 7	-9 15 12 18	VARIOUS	7	WCPO JEOPARDY	19 18 10	WKRC ENT TONIGHT 30	11 15 11	
		WSTR 64	W, T..	11:30P	11 9	9 9e	7 7b	ANGEL-WB	7 6 4	-25 4 4 10	VARIOUS	4	WKRC 60 MIN(CBS WED	18 18 17	WCPO SPIN CITY-ABC	22 17 18
033 MILWAUKEE WVTV 18	W	MTWTF..	11:00P	9 9	9 9e	7 9	FRIENDS	9 7 5	-10 12 11 13	VARIOUS	5	WTMJ WHEEL-FORTNE	21 19 15	WISN ENT TONIGHT 30	14 16 20	
034 COLUMBUS, OH WSYX 6	A	MTWTF..	11:30P	14 14	12 14	13 15	NEWSCENTER-11P	13 14 6	0 19 19 17	ABC-NITELINE	12	WBNS D LETTRMAN-CBS	16 26 18	WCMH TONITE SHW-NBC	23 16 17	
035 GREENVLL-SPART-AS WHNS 21	F	MTWTF..	7:30P	8 9	9 10	10 11	FRIENDS	11 9 5	0 13 11 11	VARIOUS	6	WLOS JEOPARDY	22 23 17	WYFF INSIDE EDITION	13 13 13	
036 SALT LAKE CITY KSTU+ 13	F	MTWTF..	6:30P	16 15	14 15	16 17	SIMPSONS	17 17 9	0 17 14 15	VARIOUS	11	KTVX WHEEL-FORTNE	15 16 16	KUTV+ ENT TONIGHT 30	13 15 17	
037 SAN ANTONIO KABB 29	F	MTWTF..	10:30P	11 15	10 14	9 14	SIMPSONS	9 14 8	-7 16 13 14	FRASIER	15	KENS FRIENDS	22 19 19	KSAT INSIDE EDITION	22 18 16	
038 GRAND RAPIDS-KALM WOMI 17	F	MTWTF..	7:30P	11 11	7 7	10 9	DREW CAREY	11 12 6	9 15 12 19	VARIOUS	8	WWMT JEOPARDY	22 23 17	WOOD FRIENDS	13 13 13	
039 BIRMINGHAM (ANN A WBRC 6	F	MTWTF..	9:30P	16 12j	16 12j	16 12	FOX6 NWS AT 9P	18 12 8	0 10 10 9	FOX 6 NW AT 10	16	WVTM VARIOUS	14 15 19	WBMA+ VARIOUS	12 13 10	
040 MEMPHIS WPTY 24	A	MTWTF..	6:30P	5 6	6 7	5 6	ABC 24 NEWS	5 3 -17 7 6		VARIOUS	6	WMC WHEEL-FORTNE	30 27 18	WREG ENT TONIGHT 30	15 18 15	
		WPTY 24	A, .WT..	7:30P	8 8p	8 8a	9 100	WHOSE LINE-ABC	6 4 -25 7 6		3 DREW C\MILLNR-	10	WKNG CITY-AN\DIAGNOS	15 15 14	NMC JESSE-NBC	17 14 13
041 NEW ORLEANS WVUE 8	F	MTWTF..	6:30P	9 11	8 11	10 10	FOX 8 NWS AT 6	9 8 5	-28 7 8 12	VARIOUS	9	WWL WHEEL-FORTNE	31 31 23	WDSU ENT TONIGHT 30	11 11 13	
042 NORFOLK-PORTSMTH- WTKR 3	C	MTWTF..	7:00P	15 11	11 11	11 11	CBS EVE NWS	10 11 7	0 11 11 16	HOME IMPROV MF	9	WGNT JUDGE J BROWN	18 17 16	WAVY WHEEL-FORTNE	24 22 16	
043 WEST PALM BEACH-F WFLX 29	F	MTWTF..	7:00P	9 10f	8 10f	7 8f	FRASIER	8 10 6	0 15 12 18	DREW CAREY	9	WPBF WHEEL-FORTNE	10 19 11	WPTV EXTRA	22 14 14	
044 BUFFALO WUTV 29	F	MTWTF..	10:00P	8 9	7 6	7 8	VARIOUS	7 10 6	11 14 11 13	FRASIER	9	WGRZ VARIOUS	15 24 24	WKBW VARIOUS	19 17 15	
045 OKLAHOMA CITY KWTV 9	C	MTWTF..	11:30P	10 12	10 13	9 12	D LETTRMAN-CBS	12 12 4	-8 19 13 26	C KILBORN-CBS	8	KFOR EXTRA \C O'BRI	16 12 9	KOCB MAD AB\CAROLIN	12 9 13	
046 HARRISBURG-LNCSTR WPMT 43	F	MTWTF..	7:00P	6 8	9 12	10 12	FRASIER	11 12 6	50 15 13 20	DREW CAREY	10	WHTM WHEEL-FORTNE	4 19 11	WGAL ENT TONIGHT 30	10 31 15 14	
047 GREENSBORO-H.POIN WGHP 8	F	MTWTF..	7:30P	12 13	13 14	13 14	FRASIER	14 15 9	0 18 15 19	DREW CAREY	11	WFMY JEOPARDY	25 21 11	WXII ENT TONIGHT 30	16 16 15	
048 LOUISVILLE WDRB 41	F	MTWTF..	11:00P	13 13	12 13	11 11	FOX NWS AT 10	10 6	42 13 11 12	MASH	14	WAVE WAVE NWS-11P	20 26 18	WHAS WHAS NWS 11	16 20 14	
049 ALBUQUERQUE-SANTA KOB+ 4	N	MTWTF..	11:30P	17 14f	21 16f	20 12	TONITE SHW-NBC	27 16 2	14 14 15 19	C O'BRIEN-NBC	16	KRQE+ JUDGE JUDY	11 9 5	KASA BLIND DATE	5 6 10	
050 PROVIDENCE-NEW BE WLNE 6	A	MTWTF..	7:30P	7 9g	8 8g	8 7	FRIENDS	8 5 -12 10 9 13		VARIOUS	13	WJAR ENT TONIGHT 30	17 16 16	WPRI JEOPARDY	18 16 14	
051 WILKES BARRE-SCRA WBRE 28	N	MTWTF..	7:30P	16 20	17 20	18 20	EYEWIT NWS-LV5	18 20 10	0 24 24 27	EYEWIT NWS-6	16	WNEP FRASIER	35 25 31	WYOU 22 ACT NWS-530	7 10 13	
052 JACKSONVILLE WAWS 30	F	MTWTF..	7:00P	9 10	9 10	10 10	MAD ABOUT YOU	7 9 6	-10 11 9 14	3RD ROCK MF	8	WJXT FRASIER	25 18 17	WTLV WHEEL-FORTNE	15 15 10	
053 LAS VEGAS KVMB 21	W	MTWTF..	7:00P	7 5	7 4	5 6	DREW CAREY B	6 4 -15 8 7 9		DREW CAREY	7	KLAS ENT TONIGHT 30	19 18 13	KVBC WHEEL-FORTNE	14 12 14	
054 FRESNO-VISALIA KSEE 24	N	MTWTF..	7:30P	4 8	3 8	6 4	ACCESS HOLLYWD	6 7 4	-13 8 7 8	VARIOUS	12	KFSN WHEEL-FORTNE	15 18 9	KMPH FRASIER	19 15 14	
055 ALBANY-SCHENECTAD WXXA 23	F	MTWTF..	7:30P	8 9	7 9	6 10	FOX23 NWS-630P	5 11 6	22 11 11 19	HOLLYWD SQUARS	7	WTEN WHEEL-FORTNE	19 26 13	WNYT ENT TONIGHT 30	23 16 18	
056 DAYTON WRGT 45	F	MTWTF..	7:30P	9 10	9 10f	8 10	DREW CAREY	9 5 -10 11 9 14		VARIOUS	7	WHIO ENT TONIGHT 30	31 21 21	WDTN JEOPARDY	9 14 13	
057 LITTLE ROCK-PINE KLRT 16	F	MTWTF..	6:30P	5 6f	5 6f	5 6	HOME IMPR MF B	7 10 6	66 16 12 15	VARIOUS	8	KATV WHEEL-FORTNE	30 32 22	KARK ENT TONIGHT 30	15 17 14	
058 TULSA KOKI 23	F	MTWTF..	6:30P	5 6f	5 6f	5 6	HOME IMPROV MF	9 7 -13 13 15		ROSEANNE	8	KTUL FRASIER	30 29 33	KOTV D LETTRMAN-CBS	27 16 17	

a. 2GUYS-PZZA-ABC b. ANGEL-\ROSWELL c. D LETTRMAN-CBS d. DREW CAREY B e. FELICI\CHARMED f. FRASIER g. FRIENDS h. GRACE-FRE MF B i. HOME IMPROV MF j. JEOPARDY
k. MAD ABOUT YOU l. MAD ABT YOU B m. MASH n. MATLOCK o. VARIOUS p. VENG UNLMT-ABC

HH = HOUSEHOLDS	W1 = WOMEN 18-49	W2 = WOMEN 25-54	M3 = MEN 25-54	LI = LEAD-IN	LO = LEAD-OUT	RT = DMA RATINGS	SH = DMA SHARE	%CHG = DMA SHARE

SNAPTRAC: SNAP SOFTWARE 1999

Source: From *COMTRAC Syndicated Program Performance* (Vol. 2), May 2000. Used by permission.

- **NHTI.** The *Nielsen Hispanic Television Index Report* evaluates Spanish-language television viewing using the same methodology as the company's other national television reports; however, the data are gathered by people-meters from a separate sample of randomly selected Hispanic households.

- **Network Programs by DMA.** Nielsen's reports provide audience information by station within each DMA (market) for network programs.

In addition to these reports, which may also be purchased by syndicators, major station groups, and large-market stations, Nielsen can prepare special research reports exclusively for an individual station or tailored for a group of stations such as a rep firm's client list. With the advent of personal computers, the station reps themselves now provide much customized research formerly only available at significant cost from Nielsen. One example of such customized ratings research is the Katz Comtrac system, which has become an industry-standard research tool because it provides easy-to-use comprehensive overviews of station and program performances (see 3.4). The Comtrac reports were originally computed and printed by Nielsen on its mainframe computers; now Katz prepares the reports in-house for its clients on its

own PCs more quickly and at significantly lower cost. In the near future, Katz plans to cease publication of printed reports and to send all the data to its client television stations on CD-ROMs. The stations would then analyze the data on their own computers, printing the individual reports in which they are interested.

Katz's first page for *Seinfeld* (one of several pages that cover all markets) tracks the show's shares in syndication in a condensed format. It shows which stations in which markets purchased *Seinfeld* and when they scheduled it. Then it lists the shares for the time period performance in the three previous ratings books (February '99, May '99, and November '99 in this example), also telling what kind of lead-in it had and the lead-in's shares. (In some cases *Seinfeld* was not the program in the time period in previous ratings surveys; the performance of the previous programs in the time period is shown. The previous program is indicated by a small letter next to the share number, and the title is in the footnote at the bottom of the page. For example, in New York the small letter *f* indicates *Frasier* ran in the time period in February '99 and May '99; *Seinfeld* was the November '99 program, because there is no small letter next to the number.) Next the Comtrac report shows *Seinfeld*'s current lead-in and shares in each market, and then *Seinfeld*'s own shares and ratings (including some abbreviated demographics; see the footnote for definitions of the demos) and its lead-out. Finally, the Katz Comtrac page shows *Seinfeld*'s two main competing programs in each market and their audience shares.

Computers for Program Analysis

Syndicators, major-market stations, and rep programming departments have invested heavily in high-end personal computer (PC) systems with large storage capabilities, with good reason. The PC has given programmers the ability to create sophisticated research tools for programming (see 3.5). PCs enable syndicator and rep researchers to quickly and thoroughly analyze and configure Nielsen ratings data. The complete Nielsen data

3.5 SNAP AND WRAP (AND PROFILE, TOO)

Many syndicators and most reps use the Snap system, an acronym standing for **Syndication/ Network Audience Processor,** which they license from Snap Software, the computer software company that developed the application. WRAP is a competing software system with very similar performance features to Snap. From Audience Analysis, Inc., WRAP stands for Windows Ratings Analysis Program. And Nielsen has its own system, Galaxy Profile, which works much the same as Snap and WRAP. All three software programs are installed on the clients' PCs, and Nielsen data is furnished to the clients on CD-ROMs by the respective software vendor. Snap, WRAP, and Profile allow syndicators and reps to rearrange Nielsen data from various ratings periods into easy-to-read summaries. Using the software, a syndicator or rep programmer can analyze individual programs, individual markets, multiple market performance of individual programs, time period trends, or program trends. Such elements as program or time period ratings history, lead-ins, lead-outs, competition, and up to 16 demographic groups can be manipulated simultaneously. Losses or gains can be shown as percentage changes. Perhaps most important, the user can set all the parameters. Usually, the information can be retrieved and printed within seconds, although preliminary data gathering and file creation may take several minutes. Nonetheless, retrieving the same amount of data from printed ratings books often takes hours, if not weeks. Some of the more obscure demographics are not printed in ratings books at all.

tapes for all markets in each rating sweep can be loaded into a computer and then transformed into customized research data. Syndicators use this data to sell programs; reps use it to help stations analyze their problem programs and potential

acquisitions. Syndication sales people and station rep programmers frequently take laptops with them when visiting stations to present and analyze the data. For example, PCs can quickly present ratings and share analyses of the target program, lead-in and lead-out, competitive programming, and same time period programming from the most recent ratings sweep period as well as historical data from earlier ratings sweeps. The computer can show this data in any of more than 100 different demographic categories. It can also show percentage gain/loss as well as actual numbers of viewers. And it can do all of this in a matter of seconds, providing instant in-depth research that used to take hours or even days with yellow pads and pencils, not to mention eyestrain and headaches.

PCs have also enabled programmers to create useful visuals in the form of pie charts, bar graphs, and line graphs. For example, audience flow from one program to the next can be graphically illustrated in audience flowcharts (see 3.6). Bar graphs can show, for each station in a market, the amount of audience the target program retained from the lead-in program, the amount of audience tuning into the program from other stations, the new audience turning on their televisions, the amount of audience lost to other stations, and the number of sets turned off from each station in the market.

Station program directors and reps also use personal computers as information storage/retrieval systems. For example, a PC can list for any given market all programs in syndication, the name of the syndicator, cash or barter terms, number of episodes, runs, years, start date in syndication, and most important, the call letters of the station in the market owning the syndication rights to the program, with a blank space indicating that the program is unsold and therefore available.

THE DECISION PROCESS

The syndicator has visited the station and made his or her pitch to either the general manager or the program manager or both. The rep has consulted with the station, providing research support combined with experience and judgment resulting in a recommendation regarding the program the syndicator is selling. The station and the rep have analyzed the terms of the deal, and the programmers now must determine how they might utilize the program, if at all.

Each programming decision is different from any other. Each show is different; each deal is different. Markets and competitive situations differ; corporate philosophies and needs not only differ but may also change over time. The personalities and opinions of the syndicator, the station general manager, program director, and rep programmer all enter into the decision. Although innumerable permutations and combinations exist, the basics of the decision-making process involve an assessment of need and an analysis of selection options.

Determining Need

Perhaps the most important part of making any programming decision is establishing whether a program is needed and determining whether the program in question is the best choice to meet that need. Sometimes this task is easy. The need may be quite obvious. For example, a first-run program that many stations carry may fail to attract a large enough national audience and be canceled by its syndicator. It needs to be replaced on all the stations carrying it. In another example, despite increased promotion and a strong lead-in, a particular program on a given station continues to downtrend in several successive books and from year-ago performance in the time period. It needs to be replaced.

At other times the need may be less obvious. A show may perform reasonably well but show no audience growth and finish second or third in the time period. Should it be replaced? Will a replacement show perform as well, better, or not as well?

When a syndicator is pitching a station, he or she tries to identify or create a need for the station to buy the particular program being offered. Although the syndicator's assessment that an existing program should be replaced may be correct,

3.6 KATZ AUDIENCE FLOWCHART

PROBE *PLANNING*

AUDIENCE FLOW ANALYSIS

RETENTION	SWITCHING

The left side of the example shows each station's ¼hr. lead-in to its 6 o'clock program as well as the amount of new audience coming into the time period.

Follow the different shadings from the left side of the example over to the right in order to see how much lead-in audience was retained by each station. WAAA held on to 34,000 households from the 50,000 that were viewing the People's Court lead-in. These 34,000 households represent 67% of the People's Court audience or 38% of the total households viewing WAAA's News Center 6.

Follow the individual shadings in each 6-6:15 PM program back to the left side of the example (5:45-6PM) to see where each portion of a program's audience originated. For WAAA's News Center 6, 6,000 Households or 77% of its total audience switched from WBBB's M.A.S.H, 3,000 Households or 4% switched from WCCC's movie and 6,000 or 7% switched from WDDD's Soap.

STA. TOT. - HOUSEHOLDS
JULY -NIELSEN

6.00PM

M-F, 5:45PM - 6:00PM

M-F, 6:00PM- 6:15PM

SHARE OF NEW TUNE-IN

This shading is the amount of households which had not had their sets turned on from 5:45-6PM but are now viewing. The 40,000 new tune-in viewers now watching WAAA's News Center 6 represent 56% of all new households just tuning-in or 44% of the total households now viewing News Center 6.

PEOPLE'S COURT

WAAA 50,000

NWS CENTER 6 (RETAINED - 67%; SHAR OF NEW TUNE-I - 56%)
34 6 3 6 40
38% 7% 4% 7% 44%
49,000

MASH

WBBB 54,000

ACTION NWS 6 (RETAINED - 48%; SHAR OF NEW TUNE-I - 25%)
26 6 5 18
46% 11% 2% 9% 37%
58,000

MOVIE

WCCC 4,000

NWS 6 (RETAINED - 9%; SHAR OF NEW TUNE-I - 0%)
2
83%
2,000

SOAP

WDDD 24,000

13 NWS EARLY (RETAINED - 57%; SHAR OF NEW TUNE-I - 18%)
14 3 6 3 13
35% 7% 16% 8% 34%
38,000

OTHER 14,000

6 1 4
18,000

NEW AUDIENCE

71,000

TUNE OUT

5 2 2
18,000

The audience that had been tuned to WAAA from 5:45-6PM but is no longer viewing that station from 6-6:15PM have either been tuned to another station or turned their sets off. This includes:
— 6,000 Households now viewing WBBB's Action News 6, representing 11% of the total Action News 6 audience.
— 3,000 Households now viewing WCCC's 13 News Early, representing 7% of the total 13 News Early audience.
— 3,000 Households now coming from other station's outside the market.
— 5,000 that have turned their television sets off.

Source: Katz Television Group, reprinted by permission.

he or she is looking at it strictly from the perspective of selling a program in the market. The syndicator's need to sell a particular show may not be the same as the station's degree of need (if any) to replace an existing program.

The station and rep programmers approach the determination of need by first looking at the performance of the existing schedule and identifying trouble spots, including individual programs and entire dayparts. For example, three out of the four programs from 4 to 6 P.M. may be performing quite well, but one may be a weak link and therefore a candidate for replacement. In another situation, the entire 4 to 6 P.M. schedule might be performing poorly and need to be replaced, perhaps including a switch from one program type to another, such as from talk shows to reality and magazine shows.

Selection Options

Once a need to replace a program has been established, a replacement must be selected. Programmers have four basic options at this point. Think baseball, for the alternatives are analogous in both television and baseball:

- **Do nothing at all.** If the station or baseball team is trailing, it's sometimes best to leave the lineup unchanged, hoping for an improved performance or a mistake by the competition. Sometimes there's no alternative, because the bench strength is either depleted or no better than the current players and no stronger players or programs can be substituted.

- **Change the batting (or programming) lineup.** Swap the lead-off hitter with the cleanup batter, or swap a morning program with an afternoon show, or reverse the order of the two access shows. (There are many more examples.)

- **Go to the bench** for a pinch hitter or go to the inventory of programs "on the shelf" (already owned by the station but not currently on the schedule) for a replacement show.

- **Hire a new player** or buy a new show.

Let's look at each area in greater detail.

1. Do Nothing

Although a time period may be in trouble, sometimes nothing can be done to improve the situation. The station may not own any suitable replacement shows. Other shows already on the air might be swapped, but the station and rep programmers might feel such a swap would hurt another daypart (perhaps a more important daypart) or that the other program might not be competitive in the target time period. Then, too, potential replacement shows available from syndicators may be perceived as no improvement over existing programming, or they might be too expensive. Often, increasing promotion can help the show "grow." Finally, the programmers may decide to leave the schedule intact as it may take time for viewers to "find" the show and form a

3.7 EXAMPLE OF A SWAP ALTERNATIVE

The Oprah Winfrey Show premiered in syndication in September 1986. It was positioned by its syndicator as a morning program (9 to 11 A.M.), meaning a reasonably low risk and low purchase price to stations, because morning HUT levels are low. After *Oprah's* dramatic and very strong ratings performance in the November 1986 and February 1987 ratings books, many stations moved the program to the more important and more lucrative early fringe (3 to 6 P.M.) daypart to improve their afternoon performance. *Oprah* quickly became a dominant early fringe program, vastly improving the time period performance of many stations and increasing audience flow into affiliate early newscasts. In some cases, the program *Oprah* replaced was merely moved to the morning time period previously occupied by *Oprah*. In other situations, stations had to purchase a replacement morning show to fill *Oprah's* vacated time period.

viewing habit. The rep may research the performance of the program in other markets to see whether the program is exhibiting growth. Sometimes the only choice is to do nothing at all.

2. Swap Shows

The second alternative is to change the batting order. Generally, the station and rep programmers look first at the station's entire program schedule to see if the solution might be as simple as swapping time periods for two or more shows already on the air. Often a program originally purchased for one time period can improve an entirely different time period when moved. See 3.7 for an example.

In most cases, syndicators are delighted when a station moves a show from a lower HUT level time period to a time period with higher HUTs. *A higher HUT level means a higher rating, even if*

share stays the same or drops slightly. For syndicators selling barter time in a program, higher ratings in individual markets contribute to a higher national rating, which translates into higher rates charged by the syndicator to the barter advertiser.

For a station, however, such a move may also mean paying higher license fees to the syndicator. In the case of first-run programs, syndicators often make **tier** or **step deals** with stations. At the time the deal is made, stations and syndicators agree on price levels for different dayparts with higher prices for dayparts with higher HUT/PUT levels, which have more potential viewers available. One price is agreed upon for morning time periods, a higher price for early fringe, and perhaps a still higher price for access. Four-tier agreements, which may also include late night, are not uncommon. Moving a program from one daypart to another triggers a change in license fee. It is to the station's advantage to negotiate a step deal to avoid a potentially expensive program playing in a low-revenue time period.

Step deals are relatively rare for off-network programming, which generally has a single license fee level priced by the syndicator that is based on the revenue potential of the daypart in which it is presumed the program will play. Thus, when a station buys an off-network sitcom or hour-long action-adventure show for access or early fringe, the price the station pays remains the same over the life of the contract. If the show is a ratings failure in access or early fringe and must be moved to a less lucrative morning or late-night time period, the station's financial obligation to the syndicator remains unchanged. Thus, a station can find itself with a very expensive "morning program," a daypart of significantly lower revenue potential than early fringe or access (meaning that the program may cost the station far more than the time period can generate in advertising income).

If the station buys an expensive off-network show that later moves to a time period with lower HUT levels, the station may experience some discomfort in its bottom line (low profitability or a loss), but the consequences are generally not disastrous. If, however, the station buys several expensive shows that do not perform and must be moved to time periods with lower advertising rates, the economic impact can be quite serious. Because of the relatively long license terms of off-network shows (typically three to four years), a station may not recover for years when several such "mistakes" are made.

3. Substitute Shows

The third alternative is to go to the bench for a pinch hitter. Programmers have a responsibility to manage existing product and at the same time remain competitive. It's not always necessary to spend more money to buy a new program. Sometimes the station already owns the solution to a problem. A simple swap of programs already on the air may not be the best answer. A station with strong bench strength may have enough programs "in the dugout" to replace a failing show in a competitive manner. Corporate accountants like this sort of solution because it does not add to a station's expenses, and it uses existing product that must be paid for whether or not it airs.

The station and rep programmers look at the strengths and weaknesses of the shows on the shelf, which generally have aired before. They must ask some questions at this point. How well did they work? Have they been rested long enough to return at their previous performance level, and if not, is that reduced level still superior to the current program's performance? Are the shows dated? Will they look "old"? Are the potential replacement shows suitable for the time period? Are they compatible with the other programs in the daypart? Are they competitive? Are they cost-effective? Do they appeal to the available demographic?

4. Buy New Shows

If the first three solutions have been examined and rejected, the programmers at the station and the rep generally consider purchasing a program. Because an added expense is involved whenever a purchase is made, the programmers must determine whether a new program will be superior to

an existing show, and if so, will it be strong enough to offset the additional cost?

Although expense is a consideration in any programming decision, programmers and corporate and station management should always keep in mind one very important factor: *They must keep the station competitive.* Remember, their job is to deliver the largest mass audience with the strongest demographics. Although they must always keep an eye on the bottom line and therefore program in a cost-effective manner, a false economy will result from trying to avoid expense if the result would be to lose even more revenue. If ratings decline, eventually revenue will also decline.

Instead, programmers must balance expense against returns, determining the ratings potential and projected revenue in deciding whether a new purchase is practical and, if so, how much the station can afford. The rep's research can help project the future performance of a program, whether it is already on a station's schedule or is to be a future acquisition. Anticipated performance plays a large role in determining the purchase price.

CALCULATING REVENUE POTENTIAL

Based on a program's ratings and the sales department's estimate of **cost per point** (the number of dollars advertising agencies or advertisers are willing to pay for each rating point the station delivers), the programmers can determine the amount of money the station can pay for a show. It works like this. *A rating point equals 1 percent of the television households in a market.* If there are 500,000 television households in market A, a rating point represents 5,000 households. A show that receives a 15 rating in market A would deliver 75,000 households (5,000 households per rating point × 15 rating points = 75,000 HH).

Advertising agencies pay a certain amount for each thousand households, called **cost per thousand (CPM).** Let's say the agency assigns a $5 CPM. A 15 rating in market A would be valued at $375 for a 30-second commercial ($5 CPM

multiplied by 5,000 households per rating point divided by 1,000 equals $25/point multiplied by 15 rating equals $375).

Let's say the station is considering a half-hour, off-network sitcom cut for six commercial minutes and sold with six available runs over four years. Six commercial minutes in each episode translates to twelve 30-second spots per day. Revenue potential is calculated by multiplying the projected rate per spot at the anticipated rating by the number of commercials to give a gross revenue potential. The gross is now netted down (reduced) to allow for commissions paid by the station to salespeople, reps, and advertising agencies. At a 15 percent commission rate, the station nets 85 percent of the gross. The net is now netted down again to a projected **sellout rate** (the number of spots actually sold over the course of a year is generally less than the number available). Most stations use a conservative 80 percent sellout rate for planning purposes; if they actually sell more than 80 percent of the available time, that's all to the good, and to the bottom line. This final revenue figure is called the **net net.** The calculation per episode would look like this:

$ 375	rate per 30-second commercial
× 12	30-second commercials
$4,500	gross per day
× .85	net revenue level (after 15% commission)
$3,825	net per day
× .80	sellout rate
$3,060	net per day

The $3,060 is the daily income the station can expect to generate during the current year for each run of the program.

To compute what the show would generate when it goes on the air, the station and rep sales managers inform programmers of the potential rate for all future years the show will be available. A typical increase in cost per point from year to year might run from as low as 3 percent to as high as 12 percent depending on inflation and local

3.8 CALCULATION OF REVENUE PER EPISODE

$5.00 current CPM	*Year 1:* Runs 1 & 2 of each episode in access at 15 rating.
× 1.05 (5% increase estimate)	
$5.25 CPM next year	
× 1.07 (7% increase estimate)	*Year 2:* Runs 3 & 4 of each episode in early fringe at 8 rating.
$5.62 CPM Year 1 of show	
× 1.06 (6% increase estimate)	*Year 3:* Runs 5 & 6 of each episode late night at 5 rating.
$5.96 CPM Year 2 of show	
× 1.08 (8% increase estimate)	
$6.44 CPM Year 3 of show	

YEAR 1		YEAR 2		YEAR 3	
$5.62	CPM	$5.96	CPM	$6.44	CPM
X 5000	households	X 5000	households	X 5000	households
1000		1000		1000	
$28.10	cost per point	$29.80	cost per point	$32.20	cost per point
X 15	rating	X 8	rating	X 5	rating
$421.50	rate	$238.40	rate	$161.00	rate
X 12	commercials	X 12	commercials	X 12	commercials
$5,058.00	Gross	$2,860.80	Gross	$1,932.00	Gross
X .85	Net revenue	X .85	Net revenue	X .85	Net revenue
$4,299.30	Net	$2,431.68	Net	$1,642.20	Net
X .80	Sellout	X .80	Sellout	X .80	Sellout
$3,439.44	**Net Net per run**	$1,945.34	**Net Net per run**	$1,313.76	**Net Net per run**

market economy. Using figures supplied by sales, programmers use this formula to project the net net revenue potential of the program over the life of the show. In this calculation, they also revise the rate based on the show's ratings delivery. A program that produces a 15 rating in its first run might be moved by its fifth and sixth runs (as it can be expected to weaken as it is repeated) to a time period with lower HUT levels, such as late night, and may generate only a 5 rating. Therefore, although CPMs are increasing, the lower rating will bring down the spot rate, lowering the revenue potential for the program in that run.

Let's look at a simplified example of the complete calculation. We'll assume the program is available two years from now. There will be 130 episodes, six runs each (780 total runs) over four years. The station plans to trigger the episodes as soon as the contract starts, running five episodes a week for three years, with no hiatus, until all 780 runs are exhausted. Coincidentally, this will take exactly three years (5 days/week multiplied by 52 weeks equals 260 days per year divided into 780 total runs equals 3 years).

The various calculations of the revenue potential for each individual episode are shown in 3.8.

The percentage rate increases are estimated by sales. This year and next year are the two years between the time the station buys the show and the time it goes on the air. Years 1, 2, and 3 are the years in which all runs will be taken. The years are not necessarily calendar years; generally they begin in September with the start of the new season or the program's availability date.

Now that we've figured the revenue potential per run of each episode as shown in 3.8, it's easy, based on projected usage, to compute the total revenue potential for each episode over the life of the contract.

Run 1, Year 1	$3,439.44
Run 2, Year 1	3,439.44
Run 3, Year 2	1,945.34
Run 4, Year 2	1,945.34
Run 5, Year 3	1,313.76
Run 6, Year 3	1,313.76
Total net net revenue per episode	$13,397.08

But we're not quite done. Now, let's figure how much the station can pay per episode. Stations assign percentage ranges in three areas: program purchase cost, operating expense, and profit. Program purchase cost may run as low as 20 to 30 percent of total revenue for an affiliate, which gets most of its programming from the network, to as high as 50 percent for an independent, which must purchase or create all of its programming. Let's use a median figure of 40 percent for our example.

With a total revenue projection of $13,397.08 per episode, the station using a 40 percent program cost figure would estimate the price per episode at $5,358.83. Because nobody figures so closely (that is, to the exact dollar), a range of $5,000 to $5,500 per episode would be a reasonable working figure. Multiplying these figures by 130 available episodes would establish a total investment of $650,000 to $715,000 for the program. The station would certainly try to negotiate a lower cost for the show but might be willing to go higher, even considerably higher, depending on how badly the station needed the program or if it per-

ceived that the show was important to the station's image (to viewers and advertisers) and to its competitive position.

Unfortunately for the station, syndicators perform the same calculations. They generally quote a purchase price significantly higher than the station wishes to pay. In our example, knowing that the station could expect to make as much as $20,000 in the access time period if all six runs of each episode ran in access, but not knowing that the station might plan to take some runs in early fringe and late night, the syndicator might ask $10,000 to $15,000 per episode. The station might want to pay $3,000 to $4,000 but expect to pay $5,000 to $6,000 per episode and go as high as $7,500 if it really needed the show.

Obviously, the two parties have to reach a middle ground or the show will either be sold to another station in the market or go unsold to any station. And now the fun begins—negotiation.

Negotiation

Syndicators sell most programs to stations through good old-fashioned negotiation. Generally, the syndication company "opens a market" by pitching the program to all stations in the market. The pitch will be the same to every station in the terms and conditions of the deal (episodes, runs, years, availability date, price, barter split, payment terms) but may differ subjectively depending on the stations' perceived needs, strengths, weaknesses, and programming philosophy. The syndicator will try to determine or create a need at each station with the hope that several will make an offer. In this ideal situation, the syndicator will be able to select which station receives the show based on the following considerations:

- Highest purchase price offered (if cash or cash-plus-barter)
- Size of down payment
- Length of payout
- Ability to make payments
- Best time period (particularly important for shows containing barter time)

- Strength of station
- Most compatible adjacent programming

Often the syndicator receives no offers initially but may have one or two stations as possible prospects. Negotiations may continue for weeks or even months, with syndicator and station each making concessions. The station may consider paying a higher price than originally planned or may agree to also purchase another program. The syndicator may lower the asking price or may increase the number of runs and years. The station may raise the down payment, and the syndicator may allow the station to pay out over more time. Negotiation is basic horse trading.

Bidding

Some syndicators of hit off-network programs have sold their programs by confidential bid to the highest bidder in the market rather than through negotiation. In 1986–87, Viacom sold the megahit *The Cosby Show* at megaprices, shattering records in all markets. Shortly thereafter, Columbia Pictures Television sold *Who's the Boss?* at astronomical prices, in some cases eclipsing even *Cosby's* prices. Both *Cosby* and *Boss* were bid rather than negotiated.[5]

Here is how bids work. The syndicator opens half a dozen or so markets in a week. Each station receives a complete pitch, including research data, terms, and conditions. Financial terms are *omitted* during the pitch. After several days, when all stations have been pitched, the syndicator faxes all stations simultaneously, revealing the syndicator's lowest acceptable price and certain other financial details. Stations are given a few days, perhaps 72 or 96 hours, to bid on the program. Bids from each station in the same market are due simultaneously so that no station has a time advantage over another. The syndicator analyzes the bid price, the amount of down payment offered, and other financial terms to determine the highest bidder. The highest bidder wins the program, pure and relatively simple.

The rep programmer usually becomes involved in advising client stations during the bidding process. Syndicators notify the reps of the markets coming up for bid, and the reps immediately notify their respective client stations. The reps provide their usual research analyses of the program's performance, coupled with their subjective views of how well the show will play in syndication and in the client's lineup. The reps advise the stations whether or not to bid. The reps frequently project the rating and help clients determine the amount of the bid if a bid is to be made.

Perhaps most important, the reps track **reserve** (asking) **prices** and reported or estimated selling prices in other markets. The rep programmer informs the client of these pricing trends to help the station determine a **bidding price** based on previously paid prices in similar markets. The rep also informs the client of down payment percentages and payout terms in other markets, serving as a guide to successful bidding.

Bidding is a fairly simple, clear-cut procedure for syndicator and station alike. There is no messy, drawn-out negotiation. The syndicator makes only one trip to the market, not repeat visits over many weeks or months. The sale can be accomplished quickly if there is a bidder at an acceptable price. Competition between stations is established, often turning into a frenzied escalation of prices by stations reaching ever deeper into their piggy banks to be sure they acquire the must-have program. And the syndicator generally achieves prices far in excess of the amounts that might be realized through negotiation. *But bidding works only for the must-have shows that are truly megahits.* An atmosphere of anticipation has to preexist, and stations have to have a strong desire to own the program.

Stations generally dislike bidding. It often forces them to pay more than they normally would. In a negotiation, station management usually gets a feel for the degree of competing interest and the syndicator's minimum selling price. In a bidding war, stations get little sense of the competition for the show. A station may be the only bidder, in which case it bids against itself. It may also bid

substantially more than any other bidder, a waste of money. In this situation, each station works in the dark, which can be unsettling. However, stations realize that if they want to be in the ball game for a bid show, the syndicator not only owns the bat and ball but also makes the rules.

PAYMENT

Payment for programming takes one of three basic forms: *cash, barter,* or *cash-plus-barter*. Payout arrangements vary and are usually negotiated.

Cash and Amortization

Cash license fees are paid as money (rather than in airtime, as with barter). In most cases, cash deals are like house mortgages or auto loans. An initial down payment is generally made at the time the contract is signed, followed by installment payments over a set period of time. The down payment is generally a comparatively small portion of the total contract amount, perhaps 10 or 15 percent. The remaining payments are triggered when the station begins using the program, or at a mutually agreed-upon date, either of which may be a month or two or several years after the contract is signed. If the contract is for a relatively short amount of time or a low purchase price, the payments will be made over a short period of time. A one-year deal may have 12 equal monthly payments, and a six-month deal may be paid in only two or three installments; however, a five-year contract may be paid out over three years in 36 equal monthly payments, beginning when the contract is triggered. No payments would be due in years four or five of the contract.

When stations buy programs for cash, whether negotiated or bid, they pay out the cash to the syndicator on an agreed upon schedule, but they allocate the cost of the program against their operating budget via an amortization schedule. **Amortization** is an accounting principle wherein the total cost the program is allocated as an operating budget expense on a regular (monthly) basis

over all or a portion of the term of the license. Thus, stations control and apportion operating expenses to maintain a profit margin. Amortization does not affect the syndicator or the amount paid to the syndicator (payout).

Depending on the intended method of airing the program, amortization may be taken at regular weekly or monthly intervals or as the runs are actually used. In the case of programs intended to be played week-in, week-out without hiatus (such as most first-run and some off-network shows), amortization is taken every week or month without exception. This allows a station to predict its ongoing program costs, but it does not allow the station to avoid those costs should it remove the program from its schedule.

Alternatively, for most off-network shows and feature films, the show/movie is expensed (amortized) as runs are taken of the individual episodes or titles. The amount amortized each week/month will vary depending on the number of runs used. If a station must reduce operating expenses, it can do so by **resting** (placing on hiatus) a program or running less expensive movie titles. Conversely, in a period of strong revenues, a station can **play off** (run) more expensive shows or movies. In this manner, a station can control its operating costs to a degree. If, however, a station does not play off all the episodes before the end of the contract, it may find itself with unamortized dollars that have to be expensed. Thus, amortization can be a double-edged sword, and the programming executive has to be a bit of an accountant as well as a creative programmer.

Amortization Schedules

Amortization schedules differ from station to station, depending on corporate policy. Some stations use different schedules for different program types or planned usages. The two most widely used amortization schedules are *straight-line* and *declining-value*.

Straight-line amortization places an equal value on each run of each episode. If a program cost a station $10,000 per episode for five runs of

each episode, straight-line amortization would be computed by dividing the five runs into the $10,000 cost per episode, yielding an amortized cost per run of $2,000 (20 percent of the purchase price, in this case). If the station had negotiated more runs at the same per episode license fee, the cost per run would decline. For example, had the station purchased eight runs for $10,000, the straight-line amortized cost would be $1,250 per run. The lower amortized cost would reduce the station's operating budget by $750 each time the show is run. On a five-day-a-week strip over 52 weeks (260 runs in a year), the $750-per-run savings would total $195,000, a sizable amount. (You can see why it is important to negotiate well and get as many runs as possible.) The station would still pay the syndicator the full $10,000 per episode, multiplied by the total number of episodes.

With **declining-value amortization,** each run of an episode is assigned a different value on the premise that the value of each episode diminishes each time it airs. Thus, the first run may be expensed at a higher percentage of total cost than is the second run, and the second run may be expensed higher than the third run, and so forth. A typical declining-value amortization schedule for five runs of a program might look like this:

First run	40 percent
Second run	30 percent
Third run	20 percent
Fourth run	10 percent
Fifth run	0 percent

If we compared the same program under straight-line and declining-value amortization systems, operating expenses would be as follows:

	Straight-line	Declining-value
First run	$ 2,000 (20%)	$ 4,000 (40%)
Second run	2,000 (20%)	3,000 (30%)
Third run	2,000 (20%)	2,000 (20%)
Fourth run	2,000 (20%)	1,000 (10%)
Fifth run	2,000 (20%)	0 (0%)
Total	$10,000 per episode	$10,000 per episode

In both schemes, the total amortized amount over the five runs is the full per episode cost of the program. In the straight-line method, the station expenses each run (or "charges" itself) equally, even though the show's performance may decline as more runs are taken of each episode. An advantage of this method is that the initial run or runs are comparatively inexpensive, especially if the show performs well. A disadvantage is that the final run is just as expensive as the first run, even though the show's popularity may have faded and the ratings declined.

Under the declining-value method, the bulk of the amortization is taken on the initial runs, when the ratings would presumably be at their highest. Relatively few dollars would remain to be expensed in the final runs. In this example, 70 percent of the program's cost is taken in the first two runs under the declining-value system, but only 40 percent is taken for the same two runs straight-lined. If the show falls apart in the ratings after two or three runs, the station using the declining-value method has most of its financial obligation behind it, but the station using straight-line amortization has the bulk of the expense still to come. In the example, using declining-value amortizes all the expense of each episode over the first four runs. Because stations sometimes fail to use all the available runs of a program, the fifth run at no charge can be quite helpful to a station. If the run is not taken, there is no charge against the show as there would be in the straight-line system. (Not all declining-value amortization schedules provide free runs; some companies place some value even on the final run, which serves to reduce the expense on the earlier runs, at least slightly.)

The straight-line system is frequently used to amortize first-run shows that are expensed on a weekly basis and generally run no more than twice per episode. *The declining-value system is often used for off-network programs and feature films* that are generally expensed on a per-run basis and are sold with five to ten runs per episode or film.

Finally, amortization is only an internal allocation of dollars against usage. It does not change

the payout of the license fee to the syndicator. The program may be fully run and amortized before payout is completed, or the station may continue taking runs of the show for years after the payout to the syndicator is complete, with the amortization of the episodes allowing the expense against the operating budget to be delayed until the programs are actually run. When all episodes are fully amortized and all payments made to the syndicator, the final dollars expensed in both amortization and payout will be identical.

Barter and Cash-Plus-Barter

The second payment method is **barter.** Barter is a fairly simple payment system. The station agrees to run national commercials sold by the syndicator in return for the right to air the program. No money changes hands. The syndicator makes all of its money from the sale of commercials to national advertisers, and the station gives up some of the commercial time it or its rep would have had to sell.

Cash-plus-barter means exactly what the name suggests. Part of the license fee is paid in cash, albeit a lower cash license fee than if the show were sold for straight cash, and part of the license fee is given by the station to the syndicator as commercial time, which the syndicator sells to national advertisers. A typical cash-plus-barter deal for a half-hour show might be a cash license fee plus one minute of commercial time (1:00 national) for the syndicator, with the station retaining five-and-a-half minutes (5:30 local) for its own sale.

Barter can be both a blessing and a curse. On the plus side, barter can be a way of reducing cash expense at a station. In some cases, especially for untried and unproven first-run shows, stations may be more willing to give up commercial airtime than to spend money. If a syndicator takes three minutes of commercial time within a half-hour show and the station receives three minutes, the syndicator has received 50 percent of the available commercial time, and the station retains 50 percent. As you saw earlier, stations generally

figure 30 to 50 percent of their revenue goes to programming expense, so barter may seem expensive. But because stations are rarely 100 percent sold out and may average only an 80 to 90 percent sellout over a year, the barter time the station gives up really represents only 30 to 40 percent of revenue potential.

Because most syndicated programs today contain some barter time, barter can be problematic. Some stations embrace barter so they don't have to spend real money. Others dislike it because commitments to many shows with heavy barter loads means significantly less time for the station to sell, hence less revenue. A typical barter deal could result in as much as half of the commercial inventory not being available to the station to sell. Also, they may not want to give their time to a third party to sell, often at lower rates than the station itself is charging because the syndicator is selling many markets as a package.

Regardless of a station's feelings regarding barter, it has no choice whether to pay cash or give up barter airtime for a show. The syndicator determines the payment terms, not the station. The station's only option is whether to run the program. If it doesn't like the terms, it doesn't have to clear the show.

Barter and cash-plus-barter are used primarily for the sale of first-run programs and the first syndication cycle of off-network programs because barter is an effective way for syndicators to maximize revenues to fully cover production and distribution costs. Producing first-run shows is generally expensive, and stations are often unwilling to pay sufficiently high license fees for untried first-run programs. The syndicator's other choice is to cover production and distribution costs by bartering a program. By combining cash payment and several barter commercials a day in the first syndication cycle of an off-network program, the syndicator can maximize revenue while allowing the station to spend less actual money than if the program were sold for cash only. Older off-network sitcoms, action hours, and dramas are generally sold for straight cash with no barter because production costs have

already been covered and demand for these programs is less.

Even though clearance in every market in the country is the goal, the syndicator must clear (sell the show to) stations in enough markets to represent at least 70 to 80 percent of all U.S. television households. Based on this minimum figure, the syndicator projects a national rating and, using a national cost per point, determines a rate for each 30-second commercial. The syndicator then attempts to sell all the national time in the show to national advertisers at, or as close as possible to, the determined rate. The syndicator tries to clear the show in the strongest time periods on the strongest stations to achieve the highest rating. The ratings from all markets clearing the show are averaged to produce a national rating that will, it is hoped, equal or exceed the projected rating. If the syndicator can get the 70 to 80 percent national clearance, sell all the spots at or near rate card, and deliver the rating promised to advertisers, the syndicator will make money, and the show will stay on the air. If not, the syndicator will likely lose money, and the show may not be renewed.

Although no standardized ratio of national-to-local commercial time exists, half-hour shows typically range from two minutes national/four minutes local (generally expressed as 2:00N/4:00L) to as much as 3:30N/3:30L. Hour-long shows typically contain from 5:00N/7:00L to as much as 9:00N/5:00L. A one-hour cash-plus-barter program would typically be cut from 2:00N/12:00L to 3:30N/10:30L, plus the cash payment. The amount of national barter time the syndicator can withhold depends on the perceived demand for and strength of the program and the ability of the syndicator's station sales force.[6]

CABLE AND SYNDICATION

Syndication is the distribution of programs through a syndicator (distributor) to many users, typically broadcast stations. This process is analogous to a newspaper syndicate that distributes national columns ("Ann Landers") or comic strips ("Peanuts") to hundreds of newspapers. Thus, syndication technically does not include cable networks, and "cable syndication" is a seeming contradiction in terms.

On the other hand, broadcast syndicators have found cable networks to be a ready and growing market for programs. Therefore, the syndication division of a company often also sells to national cable networks, sometimes in conjunction with syndication sales of the same program. Instead of sending a large sales force to call on three to eight stations in each of 211 local markets to sell a program in syndication, that same program might be sold to a national cable network in a single deal. Sometimes the cable price may approach what might be made in broadcast syndication. Also, sales staff salaries and travel expenses would be saved.

More recent and vintage off-network programs, not to mention new and continuing first-run programs, are available than can be fit into traditional broadcast station schedules. The huge supply of programs and reduced demand have created a cable aftermarket. Some cable networks program their schedules much as independent broadcast television stations once did, stripping off-network shows (for example, USA's *Walker Texas Ranger*, *Nash Bridges*, and *JAG*) and vintage programs (Nickelodeon/Nick at Nite's *I Love Lucy*, *Bewitched*, and *The Mary Tyler Moore Show*). Others buy failed network or syndicated programs at appealingly low prices, because these shows either don't have enough episodes for syndication or have already failed in syndication. The cable network can make an opportunistic purchase and program the shows effectively for their needs. (Examples include the 13 episodes of *New Fantasy Island* that failed on ABC and the failed 22 syndicated episodes each of *Highlander: The Raven* and *The Crow: Stairway to Heaven*. All three programs were snatched up at bargain basement prices by the Sci-Fi Channel, which considered the shows fresh and relatively unseen, a cheap way to fill hour-long time slots.) Syndicators also find basic cable a competitive marketplace for feature films

after their pay-cable and network exposure and before broadcast syndication.

To maximize revenue potential for network programs, a recent trend has been to sell off-network rights simultaneously to both traditional broadcast stations and cable networks. Although the types of deals may be limited only by the imagination and creativity of the sellers and buyers, perhaps the most common arrangement has become a single weekly run on a television station followed by a Monday through Friday strip run on a cable network. A popular and long-running program might also run simultaneously on different venues: (1) on the original broadcast network with newly produced episodes for the network, (2) weekly repeats from previous seasons on local television stations once a week, and (3) the same weekly repeats on a cable network as a strip (*Nash Bridges* is an example).

Yet another arrangement is simultaneous run of brand new episodes on both a broadcast network and a cable network. For example, from the beginning of its network run, *Law and Order Special Victims Unit* ran on the NBC television network with a repeat play several days later on the USA cable network.

In still another arrangement, a program may be created for a basic cable network and simultaneous first-run syndication. For example, *The Invisible Man* was created with this idea in mind, taking its first run on the Sci-Fi Channel followed by a first-run syndication appearance of the same episode two weeks later on broadcast television stations in syndication.

Certain shows created expressly for cable have later found their way into broadcast syndication. Some programs made the transition to broadcast television directly (without being reshot), as in *Brothers*, whereas others were produced anew for syndication (*Double Dare*) or even network airing (Fox's *It's Garry Shandling's Show*).

Inevitably, *the once-rigid relationships of syndication, broadcast television, and cable will continue to evolve with new and evermore innovative marketing schemes.* Just when everybody thinks they understand how the business works, someone invents a better (or at least different) mousetrap.

INTERNATIONAL MARKETPLACE

From the earliest days of television syndication through the late 1990s, the international syndication marketplace was fairly predictable and understandable. A program created in one country for domestic syndication, network, or cable might also be sold in other countries, thus extending the revenue potential for the program. The basic syndication "rules" were pretty much the same in international syndication as in domestic. Then, as the twenty-first century approached, something entirely unforeseen happened: A totally new and exciting arena opened up, producing vast new creative and sales potential. Although the traditional international syndication market is still very active and important, new programming and marketing concepts are changing the face of the international marketplace. Let's look first at the traditional, tried-and-true international syndication realm.

Just as American syndicators have found multiple program sales opportunities in this country in network, syndication, and cable, they have also extended the revenue potential of programs through syndication in international markets. Although most American television programs are produced in English, foreign broadcasters and cable networks find American programming very attractive. There is a worldwide appetite for things American (Mickey Mouse, Coca Cola, and McDonald's hamburgers, to name but a few); people in other nations also love American television shows and movies. Thus many, but certainly not all, American television programs find life in other countries. Often they are dubbed into another language. They may also be aired in English, either with or without subtitles, depending in part on the level of English spoken by citizens of a particular country and by the expense of dubbing or subtitling. Even within the same country, some broadcasters may opt to dub, while others may

choose to subtitle, and still others may air the program in its original language. Though policies among companies may differ for various reasons, often it is the expense of dubbing that is the determining factor. It's interesting to note that programs for young children are almost always dubbed: They can't read yet!

In many ways, the syndication process in the international marketplace is very similar to the domestic sales effort. Salespeople visit stations and cable networks in cities throughout foreign countries. A domestic salesperson may go on the road for several days in the southwestern United States, traveling from Dallas to Albuquerque to Lubbock. Conversely, the international syndicator may go on a sales trip of several weeks, ranging throughout the Pacific Rim, from Hong Kong to Tokyo to Fiji to Samoa. Although a domestic syndicator's biggest cultural problems may be regional accents and local food, the international salesperson may encounter language barriers and different customs. Many certainly find this makes their job both more challenging and more interesting.

As in this country, programs are sold for various combinations of cash and barter time. The amounts of cash involved, however, are generally substantially less. The production costs of a program are usually recouped in the United States through sales to broadcast networks, local television stations, and cable networks. International sales become the icing on the cake.

In some instances, especially for first-run syndicated shows, the program is created with American and international partners **cofinancing** the production and distribution costs and then splitting the revenue. For example, an American company may team with French and Australian partners. Generally, each coproduction partner retains the rights to their own country or territory. The American partner may retain North American rights, the French company rights to France and Europe, and the Australian producer rights throughout the Pacific Rim. Rights in Asia, South America, and Africa might be sold to an entirely separate company. The divvying up of

rights often depends on the individual clout of the production partners and how much they are contributing to the production, including both money and facilities.

The program may even be shot in one of the partner countries such as Australia, and may use talent and production crews from one or more of the countries represented. Sometimes this is done to meet national employment quotas or for nationalistic pride, but more frequently the purpose is to lower production costs. In the United States, we enjoy a high standard of living; we also have high labor and other production costs. Although shooting a series in a country such as Australia may sound exotic, it is usually done primarily with an eye on the bottom line.

Unlike program production in the United States, when shows are produced in other countries for airing in those countries or in the international marketplace, the producers must generally conform to various quotas. Often a country will require that certain percentages of the people employed for the production of a program be citizens of that country. This extends from the stars and other on-camera talent to the behind-the-scenes people, including producers, writers, technicians, wardrobe people, stagehands, secretaries, and even drivers.

Quotas of a different sort must also be considered. Many countries regulate the percentage of a program schedule that must originate within that country, leaving the remaining portion of the schedule that may be made up of programs produced in other countries. For example, the European Union is very restrictive regarding the amount of programming that must contain European content. Furthermore, within a single European country, certain percentages must be created within that nation. In France, for example, not only must a certain percentage of the programs carried on the French network Canal+ be European, but some must also be produced in France. Within Europe, quotas are the same among all European countries, but quotas may be significantly different in other areas of the world.

In the United States, there are no restrictions or quotas whatever regarding either national program origination or employment. American producers are subject only to U.S. labor laws regarding noncitizens.

When a program is produced by or taped in several countries, quotas become even trickier. And when a syndicator attempts to sell foreign-produced programs to customers in another country, that nation's employment and content quotas must be considered. This is one of the reasons why fewer and fewer American prime-time series are finding their way onto other nations' television screens.

For years, most programming went in one direction: from the United States to other countries. Relatively little programming flowed from other nations into the United States. American dramatic and action shows generally sold best in other countries. Although car crashes, whodunits, and prime-time soaps seem to have universal appeal, comedy shows often didn't fare as well. What's a knee slapper or rib tickler in one part of the globe may not seem so funny in other areas. American movies have also been popular in other countries.

During the 1980s and 1990s, the Hollywood studios increasingly made **output deals** in which substantial amounts of programming from a studio were sold in advance in other countries. This helped to finance the production costs of the shows and to give relative assurance that a program actually would be produced. Some people have dubbed this period the Golden Age of Export.

The birth of new broadcast and cable networks in the United States and throughout the world in the 1980s and 1990s created a tremendous demand for fresh programming. The rise of the Fox network had tremendous impact not only in the United States, but also around the world. Fox programs such as *Beverly Hills 90210* and *The Simpsons* became so popular in other countries that they became **global brands,** much like Nike and Microsoft. Many American cable networks have also become global brands. MTV has cable networks in many areas of the world programmed

in the languages of the local countries. The Discovery Channel is also global, with localized programming in Africa, Asia, Europe, Latin America, and the Middle East as well as individual countries, including Australia, Brazil, Canada, Germany, Italy, and India. E!, Fox Kids, and TNT are also seen in many countries. And CNN is the original worldwide network, viewed around the globe since the 1980s.

Global branding has become commonplace in broadcast and cable circles. Often branding goes beyond an individual program or character. Nickelodeon, for example, has created branded blocks of programming both for its own international services and for sale to other companies in countries where Nick does not have its own operations. Nickelodeon provides not only several hours of the programs themselves, but also interstitial materials such as promos and IDs. As a further extension of branding and its image, Nickelodeon also licenses ancillary rights and services. Included are product licensing and merchandising (toys and games), video and audio products (CDs, videocassettes, and DVDs), and publishing rights (books and magazines). Like many other companies, Nickelodeon believes its trademark is valuable, and it carefully guards the environment in which its programming and image are presented around the world.

As communications shrink the world, programs and program concepts are becoming both more global and more utilized. For example, Nickelodeon created *Rugrats* as a U.S. cable program. The show has since been aired around the world. In Great Britain alone, *Rugrats* can be seen on the BBC (the British Broadcasting Corporation's terrestrial broadcast network), Nick UK (basic cable and direct broadcast satellite), and Nick Replay (digital TV). With an eye to the future, when Nickelodeon develops programs or acquires program rights, their programmers attempt to do so for all Nickelodeon venues (Nick US, Nick UK, Nick Australia, etc.). Such strategy is not unique to Nickelodeon; indeed, many multinational companies employ the same approach.

As the twentieth century drew to a close, an extremely significant change occurred in the international marketplace. With deregulation and a single monetary standard sweeping Europe, there was a simultaneous desire for strong locally-produced programming coupled with an ability to export such programming. As a result, **format programming** emerged as a dominant trend. (Formatting is essentially the same as franchising.)

To understand format programming, think of *Wheel of Fortune* and *Who Wants to Be a Millionaire?* Both programs were created in one country (*Wheel* by producer Merv Griffin and syndicator King World Productions in the United States, *Millionaire* by producer Michael Davies and the BBC in England). In each case, the format is licensed to broadcasters in other countries. Many of the production elements (scripts, music, scenery design, sound effects, questions, etc.) are provided by the program creators, but local hosts and contestants are used in each country. Scripts are tailored to local interests, habits, and language (the American word *cookie* would be changed to *biscuit* in England, for example). In some cases, actual video portions of the program may be supplied. (For its preschool program *Blues Clues*, Nickelodeon provided all the animation; the various international broadcasters then chromakeyed their own local live actors over the animation.) Perhaps most important, the shows are produced in the local languages. Thus, *Wheel* has its own British Pat Sajak and Vanna White, and the British host of *Millionaire* was replaced by Regis Philbin in this country. Both shows air in Japan with Japanese hosts, in France with French hosts, and so forth.

Format programming has tremendously affected international syndication. What had been pretty much a one-way flow of programs from the United States to other countries has been abruptly changed. *Product flow from Europe to the United States and other countries is now the largest ever.* This phenomenon has resulted in vast new creative and sales potential.

WHAT LIES AHEAD FOR BROADCAST SYNDICATION

Broadcast syndication is a rapidly changing business. Headlines in trade publications frequently herald new and innovative syndication deals. Although it is speculative at best to imagine how the industry might look by the next century, several scenarios are plausible.

1. **Innovative deal structuring.** As the financial stakes get higher and competition becomes more fierce, syndicators and stations alike will become more and more creative in their deal making. Syndicators will make offers more attractive to stations while simultaneously finding new ways to increase revenue to their own bottom line. This may involve barter, payout, additional daily or weekend runs, sharing use with cable, cofinancing with station groups, hiatus periods, and ancillary revenue sources. Deal structure will be limited only by the ingenuity of the participants and will be driven by the need to maximize profits for both syndicators and stations.

2. **Cost control.** Stations and syndicators are continually striving to manage costs. The days of heady economic growth and comfortable profits between the 1970s and early 1990s seem only a pleasant memory in the early 2000s. In the wake of new competition from cable and the softening of the world economy, costs must be controlled. Therefore, whether in deal making, station operation, or expansion of facilities or staffs, broadcasters and syndicators alike share a common goal: the need for efficiency, streamlining, mutually beneficial dealing, and utilizing all assets. With FCC regulations allowing increased station ownership by single broadcasting companies, and with mergers of many syndicators, cost controls become ever more important, even as the programming deals are becoming bigger.

3. **Consortiums/coproduction/coventures.** All these terms mean much the same thing: Station

groups and syndicators are increasingly finding new and exciting ways to work together as partners. Spurred by tough economic times and the need to control costs, station groups and syndicators can share costs and risks and, perhaps, profits. Station groups will continue to join forces with one another in noncompeting markets to develop and launch first-run programs to meet specific station needs. Increasingly, syndicators will join in these coventures. Because stations will hold an equity position in some shows, these shows will probably gain some extra promotion and perhaps be given a longer time on the air to prove themselves. In other words, coproduced shows will get a good shot at succeeding (if the audience likes them!).

4. **Cable.** Increasingly, programs created for original telecast via one delivery system are finding their way to another: over-the-air to cable and vice versa; network to either broadcast syndication or cable; cable to syndication; cable to foreign; foreign to domestic syndication. These crisscrossing paths already exist, and the separation of network/syndication/cable is now blurring. In fact, the broadcast networks routinely promote their cable programs on network shows airing on local affiliates; talent is frequently utilized for both network and cable telecasts. As cable has grown and solidified its economic base, syndicators have played to that strength. This trend should accelerate. Now cable and broadcast, traditional adversaries, have formed coventures that will benefit both. Just as politics make strange bedfellows, so too do the economic needs of the television industry.

5. **Increasing role of reps.** Programmers at station representative firms will play an even greater role in the syndication process. As costs escalate and programming decisions become riskier, the rep programmer's expertise becomes more valuable. To control costs, many stations have eliminated the program director position and are using rep programmers instead. This trend is likely to continue.

6. **Increasing role of networks.** With the demise of the FCC's financial and syndication rules, the networks have become actively involved with the production of syndicated shows. Many expect the prime access period (7 P.M. to 8 P.M. EST) to attract more off-network programs now that the Prime-Time Access Rule (PTAR) is long gone. First-run game shows and magazine formats have outlived their protected existence in the top 50 markets. Increased competition for hit off-network programs will affect the price for these shows.

Just as the children and teenagers of the 1950s and 1960s grew up watching *I Love Lucy*, *The Flintstones*, and *The Brady Bunch*, so too the next generation found enduring favorites in *The Cosby Show*, *The Simpsons*, and *Married . . . with Children*. Television shows are valuable assets that can enjoy a long economic lifespan. Old favorites in broadcast syndication continue to play and play and play. And the needs of cable have extended the life of many seemingly lesser programs. The Peter Allen song holds especially true for syndication: "Everything old is new again!"

The key players in the domestic syndication process remain the syndicators (distributors) who license syndicated programs to local television stations and cable networks. Station general managers or program directors have to negotiate with the syndicators in competition with other stations in the same market for the local-market broadcast license to a show, and rep programmers continue to have a crucial role in advising client stations on programming decisions. The Internet has rapidly become the newest challenge for broadcasters, syndicators, and networks. Although the World Wide Web offers great opportunity for extending program and product reach and for promoting a program or an entire brand, it also has created huge challenges—even threats. Decisions must be made on how to sell a program on the Internet, how to charge, and how to protect a copyright. Once a program or portion of a program is on the Internet, it essentially becomes

available to any person or company in the entire world. The owners of the program and the copyright to the content need to figure out how to protect their interests, financial and otherwise. Producers usually make programs because of their enormous revenue potential from domestic and international syndication, and the syndication process involves hundreds of millions of dollars annually across the United States. The rise of the Internet potentially challenges all these assumptions. Broadcasters' and syndicators' need to contain costs has led to trends such as innovative deal structuring, coproducing and coventuring, cable syndicating, and larger roles for rep programmers, and the international programming marketplace has now become a major force in television programming.

SOURCES

Broadcasting & Cable, weekly.

Brotman, Stuart N. *Broadcasters Can Negotiate Anything*. Washington, DC: National Association of Broadcasters, 1988.

Getting What You Bargained For: A Broadcaster's Guide to Contracts & Leases. Washington, DC: National Association of Broadcasters, 1989.

Variety, weekly.

Webster, James G., Phalen, Patricia F., and Lichty, Lawrence W. *Ratings Analysis: The Theory and Practice of Audience Research*. Mahwah, NJ: Lawrence Erlbaum, 2000.

INFOTRAC COLLEGE EDITION

Consult InfoTrac College Edition using the password provided with this book. Use boldfaced terms as Key Words and section headings from this chapter for Subject searches.

NOTES

1. When is an infomercial not a television program? Apparently the issue is complicated. In the dispute between Leeza Gibbons and Paramount, it was debated whether her infomercial was a television program, a commercial, or a hybrid. Gibbons contended that her contract with Paramount allowed her to do commercials but not other television programs without the studio's permission. Paramount contended that her infomercial was a program, presented in a talk show format. Regardless of the actual outcome of that case, the status of infomercials is still unclear.

2. A few shows move the other direction. The game show *Remote Control* went from cable to broadcast syndication, the first of a new stream of programs for the syndication market.

3. Cox Broadcasting, which already owns two television station rep firms, TeleRep and Harrington Righter & Parsons, acquired yet a third, MMT Sales, Inc., in 1995. TeleRep has annual billings of about $1 billion. MMT bills around $300 million annually, and HRP is at about the $450 million mark. Also in 1995, the number three rep firm, Petry Television, negotiated to purchase the number four rep firm, Blair Television. Blair bills about $650 million, and Petry approximately $1 billion. These two deals are yet another step in the consolidation of TV rep firms that began in 1992 when Katz started it all by acquiring Seltel. See *Broadcasting & Cable*, 18 September 1995, p. 11.

4. Avoiding an in-person pitch to reps generally has the advantage, in cases where the rep is negative toward the program, of minimizing the strength of the rep's recommendation to stations. Opinions tend to be stronger about shows that have been evaluated firsthand. Reps eventually see pilots or sample tapes of all shows their client stations are interested in, but delay sometimes works to the temporary advantage of the syndicator.

5. By the early 1990s, stations had become more cautious about bidding because of competition for off-network shows from cable networks, some of which had big bucks to spend.

6. Barter splits may vary widely, even among essentially similar programs. For example, *Jerry Springer, Oprah,* and *Jenny Jones* are all cash-plus-barter, one-hour talk show strips, but the national/local barter splits are quite different, with *Jenny Jones*'s syndicator having considerably more national time to sell than *Jerry Springer*'s distribution company: *Jerry Springer* 2:30N/12:00L; *Oprah* 3:00N/11:00L; *Jenny Jones* 3:30N/10:30L.

PART TWO

Broadcast Television Strategies

The second section of the book focuses on traditional broadcast television, although the broadcasting business is changing almost beyond recognition. There are now nine competing broadcast networks, and the owners of the Big Three face unprecedented threats to their profitability in every aspect of the business. Even the once-firm borders between networks and stations are blurring to a degree unimaginable just a decade ago, just as the territories of networks and syndicators have become overlapping. Many independent stations, who were once "also rans" in programming, have now leaped high in audience appeal as they took on big budget programs from new broadcast networks and top syndicators, creating serious competition for affiliates of the traditional Big Three. Many ABC, CBS, and NBC station managers find it hard to shake off the expectations arising from their long histories of dominating in virtually all time periods in their markets. While vertical integration in the industry has intensified, creating concern about limitations on the number and kind of voices that can now be heard, within the broadcast community, group owners are proving to be powerful challenges to network domination of programming. Companies such as Tribune Broadcasting, the Sinclair Group, and Chris Craft control so many stations that they can determine the success or failure of original syndicated shows, and group preemptions of network shows profoundly affect their ratings.

Nonetheless, because network television continues to attract audiences in the tens of millions in prime time, and its visibility focuses public attention on its strengths and weaknesses, **Part Two** contains fours chapters focusing on network and station programming.

Chapter 4 deals with traditional **network prime-time programming.** It explains the assumptions behind the target audiences chosen by the networks, the decision-making processes that influence the renewal of programs, and the selection of new programs. It details the primary scheduling strategies that have guided prime-time program placement for decades, and emphasizes the rising role of program promotion on the air, in print, and online. The chapter looks at changes in the popularity (and cost) of various program formats over time and compares the programming styles of the major four networks.

Chapter 5 shifts to **nonprime-time programming,** the content airing outside of the prime hours. It outlines the overall strategies for scheduling programs in the morning, afternoon, and late evening hours, and then examines the special role of sports programming on television. The chapter details

the content, production processes, scheduling strategies, and promotional tactics for soap operas, game shows, news and other informational programs, children's programs, and talk and other late-night entertainment, concluding with predictions for changes in the coming years.

Chapter 6 discusses programming from the station perspective, looking in turn at the needs and strategies of affiliates of the traditional Big Three, at affiliates of Fox, and at affiliates of the newer broadcast networks. It covers the sources of programs, what needs the networks and syndicators fill, the special role of local evening and late-night newscasts, and the pressures coming from changing ratings measurements.

The last chapter in this section, **Chapter 7,** turns to **public broadcasting.** It contrasts the philosophy of noncommercial networks and stations with those of their commercial counterparts, spelling out the model PBS and its member stations have adopted. Then the chapter outlines the respective responsibilities of the network and the stations, compares the major kinds of noncommercial stations, and tells where programs come from, along with the limitations that underwriters place on their production and use. The authors look at noncommercial network scheduling strategies and changed attitudes toward audience ratings.

These four chapters in **Part Two** reveal the ways that broadcasters apply the essential concepts of selection, scheduling, evaluation, and promotion in the traditional programming situations.

Chapter 4

Prime-Time Network Entertainment Programming

William J. Adams
Susan Tyler Eastman

A GUIDE TO CHAPTER 4

As the new millennium began, broadcast network television turned 53 and found itself facing an enormous number of mid-life crises. Nothing demonstrated this better than the February sweeps of 2000. Coming up to that period, the Disney Company, owner of ABC and ESPN, and Time Warner, the nation's second-largest cable system, were locked in a fight over which Disney-owned cable networks would be carried by Time Warner, where the channels would be placed, and the amount of compensation that would be paid. Time Warner wanted to control the placement of the channels and reduce the fees it paid for retransmission rights; Disney's leverage was the threat to look elsewhere for carriage of its popular programming. With no agreement in sight, Time Warner took the radical step of pulling ABC affiliates off of its systems in major markets during the critical February sweeps month. Disney ran to the FCC screaming foul. *Broadcasting & Cable* magazine declared it a public relations fiasco for both companies. Time Warner eventually backed down as negotiations were renewed, but not before it had demonstrated a crucial fact unthinkable even a few years earlier: *Cable had become more important to the major broadcast networks than the networks were to cable.* The situation also demonstrated that, although the major broadcast networks had not yet become only minor players, they were also not the major concern of their giant corporate parents.

VERTICAL INTEGRATION

During the 1990s, in the face of declining broadcast audience shares, increased competition, and declining revenues, the FCC began relaxing many of the rules governing broadcast television. This included repealing the financial interest rules that had limited the amount of time networks could fill, preventing broadcast networks from owning shows, and stopping them from participating in profits from syndication. The FCC also relaxed ownership rules, changing from a simple number system to a percentage of the total audience. Suddenly, companies could buy enough stations to reach close to 40 percent of the nation's population with no interference from the FCC. Further relaxations removed the rules preventing newspapers from owning broadcast stations in their own markets. As a result, the buying frenzy that followed caused station prices to skyrocket and created unprecedented instability in affiliations as both networks and other giant communications companies bought new stations or negotiated deals with more powerful ones in markets all across the country. By the turn of the century, 26 companies owned almost 50 percent of all television stations in the United States, and all three major broadcast networks had changed hands.

By 2000, *Broadcast & Cable* magazine listed nine broadcast networks (although only four had enough affiliates to be truly considered nationwide broadcast systems). Moreover, virtually all over-the-air stations were affiliated with one of the networks. The independent broadcast station had all but disappeared, and so had independent networks: All were corporately owned. The Disney/ Time Warner fight epitomized the changed relationships. Disney—owner of theme parks, distribution companies, production facilities, and cable networks, also owned ABC, which in turn owned local stations and cable networks such as ESPN— was going head-to-head with the new AOL Time Warner, owner of the America Online web service, a publishing empire, cable distribution systems, cable networks, local television stations, production facilities, motion picture distribution, and the WB broadcast network—in an epic battle to dominate the entertainment business.

Although ABC and WB are probably the most visible portions of those giant corporations, they are far from the most profitable. Indeed, ESPN actually produces more profits for Disney than ABC does. This is not unusual. MTV produces more profits for Viacom than CBS does, and NBC is not the most profitable part of GE.[1] In short, the broadcast networks are merely parts of much larger companies. In another about-face, NBC, which in the early days of television was forced by the FCC to sell off its second network, is now a principal owner of the Pax network, and CBS is a principle

owner of UPN. The two remaining networks of the nine listed by *Broadcasting & Cable*, Telemundo and Univision, are Spanish-language systems which, like Pax, combine over-the-air-stations and cable systems for their distribution.

Corporate Control

In an unstable climate, how network programmers react and what they decide to offer can be the difference between network failure and survival. At the same time, being vertically owned limits what they can do. For example, increasingly networks feel the pressure to program with series owned by the parent company. During the 2000–01 season, for instance, both CBS and ABC either owned outright or co-owned all but one of the new series each offered in the fall. Further, CBS had a direct link to half of the programs UPN offered. NBC, with no corporate production facilities other than those owned by NBC itself (principally news), nonetheless either owned or co-owned 60 percent of the new programs appearing on the network, about the same percentages that Fox and WB owned of their schedules.[2] Having such control over their programs reverses 50 years of network programming practice.

Problems arise for a network when business decisions made by the parent corporation fail to adequately consider their impact on the television network. For example, in the early days of UPN, the network encouraged joint affiliations with many Fox stations. Because neither Fox nor UPN filled the full 22 hours available in prime time, shared affiliations tended to work well and had the full support of Fox. At one point, however, UPN's corporate headquarters decided against sharing audiences and demanded that stations go with only one of the two networks. Much to corporate surprise, virtually all stations chose the much more powerful Fox, dooming UPN to permanent last place status among broadcast networks. By 2001, UPN was again seeking out some joint affiliations.

Another example of poor corporate decision making occurred during the 1999–00 season on the WB network. WB had made strong inroads

into prime time with such popular youth series as *Buffy the Vampire Slayer* and *Dawson's Creek*. Then, Time Warner's corporate headquarters suddenly pulled the WB affiliation from Chicago's superstation, WGN. Because WGN was the primary distributor of the network to cable and direct satellite systems, huge audiences were lost. Time Warner announced that the move had been made to protect its affiliates from competition, but that reasoning rang hollow when the company immediately set up its own WB Cable Network. The move revealed an attempt to claim all cable and satellite revenues for Time Warner. Much to the surprise of the parent company, apparently, gaining space on cable and satellite systems for the new network proved difficult. As a result, WB's prime-time ratings fell 20 percent in a matter of weeks and did not recover. One has to wonder what the network programmers thought of the parent company, but in the next season, they showed they weren't all that bright either when they announced the solution to WB's problem was more sitcoms.[3] The audience can be forgiven for holding its collective head and thinking less than complimentary thoughts about all involved.

Diminishing Audiences

As 4.1 shows, American broadcast network ratings have been gradually falling over the last two decades. Indeed, the average rating for each of the Big Three in 2000 was less than half what it was two decades earlier. Because the audience was being split many more ways, the total accounted for by all six rated networks dropped from 54.2 percent of households to merely 37.6 percent by the year 2000 (see 4.1). Although, the amounts reported for Fox, WB, and UPN might look small to the uninitiated, each point represented a percentage of the 101 million television households in America. Thus, a 2.7 rating means 2.7 million households (with an average of 2.3 people viewing), attracting 6 to 7 million people at one time. This is sufficient for many advertisers and still better than the typical less-than-one ratings point most cable networks earn.

4.1	AVERAGE NETWORK RATING FROM SEPTEMBER TO MAY, 1980 TO 2000					
Year	ABC	CBS	NBC	Fox	WB	UPN
1980–81	18.0	19.0	17.2			
1981–82	17.7	18.5	15.2			
1982–83	16.6	17.7	14.5			
1983–84	16.2	16.8	14.5			
1984–85	15.0	16.5	15.8			
1985–86	14.3	16.0	17.1			
1986–87	13.6	15.4	17.1			
1987–88	12.7	13.4	15.4			
1988–89	12.6	12.3	15.4			
1989–90	12.9	12.1	14.5			
1990–91	12.0	11.7	12.5	6.1		
1991–92	12.2	13.8	12.3	8.0		
1992–93	12.1	12.9	12.0	8.1		
1993–94	12.1	11.7	10.3	7.1		
1994–95	11.7	10.8	11.5	7.1	1.9	4.1
1995–96	10.5	9.6	11.6	7.3	2.4	3.1
1996–97	9.2	9.6	10.5	7.7	2.6	3.2
1997–98	8.4	9.7	10.2	7.1	3.1	2.8
1998–99	8.1	9.0	8.9	7.0	3.2	2.0
1999–00	9.3	8.6	8.5	5.9	2.6	2.7
2000–01	8.4	8.6	8.0	6.1	2.5	2.4

Note: The Fox network started broadcasting before 1990, but for the first few years its ratings were not reported in the trade press.

Prime Hours

Of the approximately 28,000 hours the nine commercial networks program yearly, about one-fifth is singled out for special critical attention—the nearly 170 hours of prime-time programming each week. That figure, multiplied by 52 weeks, equals about 8,840 hours of prime-time network programs a year provided collectively by ABC, CBS, NBC, Fox, Pax, Telemundo, Univision, UPN, and WB. Audience ratings throughout the day are important to the networks, of course, but ratings in the prime-time hours are absolutely vital. A failure in prime-time programming may take years to remedy.

The 22 prime-time hours—from 8 P.M. to 11 P.M. (EST) six days each week and from 7 P.M. to 11 P.M. on Sundays—constitute the center ring for all networks, the arena in which their mettle is tested. Fox programs 15 hours on seven nights of the week, competing head-to-head with the older networks. UPN and WB each program about 13 hours of prime-time on six nights each week. Pax, Telemundo, and Univision run full 22-hour packages, but most of the Pax schedule is off-network reruns, and much of the Spanish-language schedules contain syndicated Mexican and South American programs. Nevertheless, Univision beats all competition in some markets.

Prime-time programs are the most vulnerable part of the network's schedule because low ratings in these valuable hours lead to devastating losses in advertising revenue. By 2002, the networks

could charge more than $600,000 for a 30-second spot in a top-rated series like *Friends*, while a bottom-rated series like the UPN's *Malcolm & Eddie* raised only about $20,000 per spot. Even among the Big Four (the Big Three plus Fox), a bottom-rated show could pull only $70,000 or so per spot. *Both advertisers and networks expect the highest return from prime-time hours.* Indeed, with production costs for an average hour of (non-news/reality) prime time running around $4 million, anything less would seldom be tolerated.

IDEAL DEMOGRAPHICS

Some advertisers are interested mainly in tonnage —the sheer, raw size of an audience, as measured by the ratings for a program. This scattershot approach, aiming at all ages and both sexes, best suits advertisers of soaps, foods, over-the-counter drugs, and other general-use products. The ability to deliver such an audience in the tens of millions is broadcasting's greatest strength. Even in the present market, a company would have to buy almost a dozen cable networks to equal the audience numbers they can get with one of the Big Four broadcasters. Some advertisers, however, prefer targeting a specific segment of the audience by its **demographics** (age, sex, education, and so on).

General demographic measurements have been part of broadcast ratings since the 1960s, but, in the early 1970s, Paul Klein of NBC, with the support of Mike Dann of CBS, introduced the concept of **ideal demographics,** the theory that all prime-time programming should aim at one young female consumer segment of the audience. This ideal segment, the programmers claimed, both controls most consumer purchasing and succumbs most easily to televised advertising messages.[4] This shift toward a younger, more urban audience deliberately aimed network programming at the major population centers, closer to the coverage area of the network owned-and-operated stations, and further away from the more thinly-populated rural markets where the networks had no direct ownership interests. It was also a blatant attempt

to apply the principles of mass audience, which the networks were so good at, to the concepts of a targeted appeal.

The network heads of research continue to claim the same group of viewers (the single largest group) as the audience ideal; the group simply aged as the baby-boom generation grew older. By 2002, it consisted of urban women 25 to 49 (all races). Critics, however, argue that there are more people in the other demographic divisions than in the so-called ideal group, so any network or advertising campaign concentrating solely on this ideal demographic would miss more audience than it would attract. Indeed, an excessive emphasis on youthful female viewers in the past may have contributed to the erosion of broadcast network audiences and certainly has produced a programming "gender gap" between male and female viewers. Research suggests that targeting the ideal group led to a decline in program variety and fostered much complaint about the "sameness" of programs on the major networks. Moreover, the basic assumption, that younger women control shopping, can be challenged by a trip to any supermarket.

In contrast, the newer broadcast networks have built their appeal by focusing on other audience groups. Originally, the Fox network deliberately targeted younger males that the other networks were ignoring and was quite successful. WB also went after younger males and females, while Telemundo and Univision identified themselves with a particular ethnic/language group. Most cable networks also go after alternate audiences by programming for demographic niches.

An alternative to demographic targeting is **psychographic** or lifestyle targeting, which aims at audiences defined by their likes/dislikes, political and social attitudes, hobbies, consumption habits, and so on, but gathering psychographic information was extremely expensive. Moreover, the results were often difficult to interpret and generalize. In the 1980s, marketing firms began matching easily-gathered demographic information to product purchasing data (from bar code scans) to identify distinct lifestyle divisions. By the turn of the century, the widespread use of in-store discount cards had

taken this approach a step further by providing purchasing information about individual families (at the modest cost of a small discount on some items).

The widespread popularity of marketing tools drawing on such marketing data helped force the broadcast networks to switch from the traditional rating methods to peoplemeters in 1987. As explained in Chapter 2, the peoplemeter is designed to keep track of an individual's television viewing (as did the legendary "black box" passive meter patented by Nielsen) while also recording the viewer's demographics, which the black box did not capture. However, distrust for the data's accuracy has proven to be a serious problem. As a result, many companies have turned to the simpler approach of targeting specific audiences they wish to reach based on perceived appeal of program content. This practice has allowed low-rated networks like WB to charge premium prices for such shows as *Buffy the Vampire Slayer* or *Dawson's Creek,* but the major broadcast networks, with their general appeal and focus on programming for the ideal demographic group, have not tapped into this trend. It seems ideally suited to cable's more narrowly defined audience system. As a result, industry experts predict that by 2005 cable advertising revenues will be greater than broadcasting revenues.

Least Objectionable Programming

Unfortunately, aside from their ability to attract viewers, the *quality* of programs has rarely seriously concerned most advertisers—at least not enough to affect their practices. There are notable exceptions. A select roster of advertisers (Kraft, Hallmark, IBM, and Xerox, for example) has insisted on prestigious programs as vehicles for their advertisements and therefore has tended to sponsor entire programs, rather than merely buy participating spots. Also, during the 2000–01 season, some sponsors pulled their advertisements from the syndicated *Dr. Laura* show in response to protests from gay and liberal groups who objected to her message. More commonly, though, most advertisers care little about program quality or message, merely seeking vehicles for reaching appropriate markets for their products.

Indeed, some advertising studies have suggested overly strong audience support for a program may actually be undesirable, because excessive program loyalty may interfere with the advertising message. Prime-time network television traditionally strives to provide the largest possible audience (overall or within a demographic group), not necessarily the most satisfied audience. Many programmers believe that prime-time series that generate strong reactions among viewers may in fact split the audience into two groups: those who "love" and those who "hate" a show. A show that generates only moderate liking, but is hated by no one, may get the biggest audiences.

NBC programmer Paul Klein called this idea the theory of **least objectionable programming (LOP).** He assumed that viewers of the networks would choose the program that created the least outcry among others in the room, whether anyone actually liked the program or not. LOP has continued to be a major consideration in network prime-time programming into the twenty-first century. The difficulty with the theory is that it presumes a limited number of program options for viewers. When there are many alternatives, programs that generate little real loyalty may lead to long-term erosion as unserved groups eventually go elsewhere. Once that happens, it is extremely difficult to pull them back, and it has meant that many programs that were failures for the Big Four networks actually worked successfully on cable or on the smaller broadcast networks.

Modern technology now provides most Americans with the possibility of hundreds of television or Internet channels. Moreover, virtually all homes have VCRs or DVD players and remote controls. Under conditions of vastly increased program supply, prime-time programmers face the difficult task of satisfying advertisers' demands for large, well-defined audiences and viewers' demands for programs they really want to see. Although the least objectionable program theory becomes progressively untenable as viewing options increase, nonetheless, the major networks have stubbornly clung to the theory, aiming nearly all programs at the so-called "ideal group."

Audience Flow

Aside from a program's demographics, the networks look for **audience flow** from program to program. As explained previously, each network hopes to capture and hold the largest possible adult audience, especially from 8 P.M. until midnight or later. Network strategies are usually directed at achieving **flow-through** from program to program within prime time. Network executives claim that on average, five out of every ten points in a lead-in program's ratings will flow through to the succeeding program (that is, much of its audience will continue to watch), although this factor grows weaker as the number of program options increase and as the hour gets later. Flow continues to be commonly produced by placing programs with similar appeals or story lines one right after another, although the remote control makes flow-through difficult to achieve.

Appointment Viewing

For decades, scholars have argued about how people watch television. For most of the last 50 years, practitioners assumed people passively watched television—not programs. In short, when they had time, viewers tuned in and then looked for something to watch. About a decade ago, some researchers began contending that people planned their viewing around specific programs designed either to continue the mood they were in or to change a bad mood. This latter view proved to be a hard sell in an industry that had long dismissed the idea of program loyalty in all but a few cases. For example, everyone recognizes that many soap opera viewers actively plan their activities so they can watch their favorite afternoon programs—that is, **appointment viewing.** But, experts argued, this happened only rarely in prime time, only perhaps with such megahits as *Seinfeld,* live sporting events, or occasionally, with a highly touted miniseries. As the network rating slid downward, however, more researchers began looking at program preference, and they found that viewers develop strong mental images of when their favorite programs are on and tune in with those programs in mind. This understanding intensified the amount and type of

on-air promotion in order to create and manipulate such mental images, and simultaneously it led to renewed interest in creating programs that spur appointment viewing—that is, shows that are so special that viewers plan their time around them.

However, most viewers do not change other plans to watch even their favorite television programs. They find great comfort in knowing the series will still be there next week or that one can get missed episodes in rerun. The VCR and DVR have also profoundly changed people's views of when they have to watch, and **time shifting** of favorite programs is now a common practice. Such changing viewing behaviors make the successful selection and scheduling of mass-audience programs increasingly difficult for programmers.

RATINGS

Regardless of whether an advertiser wants sheer tonnage or a specific audience segment, commercial spot costs depend mainly on the absolute ratings (total estimated audience) of the programs in which the commercials occur. A television advertiser, in contrast to an advertiser on a formatted radio station, must pay for all viewers, whether or not they fall within the desired target audience. *Estimated program ratings are the major determinant of the cost of a commercial spot.*

Ratings, however, lack precision. As pointed out previously, network ratings *estimate* the number of viewers on the basis of viewing by 5,000 cooperating families representing 101 million television households. It is very unlikely that estimates are exactly right. In fact, statisticians sometimes claim that no substantial difference exists between the fifth-rated and thirtieth-rated shows in prime time; the differences in their ratings could result from nothing more than inevitable sampling errors. Because advertisers (and ad agencies) have agreed to base the price of a commercial spot on the absolute ratings numbers, however, they ignore their inability to measure small differences. A program such as *Dharma & Greg* with a rating of about 10 and a $315,000 per spot advertising price will

generate millions of dollars more in revenue over the course of a season than a program such as *Will & Grace* with a rating of about 9 and a spot price of $225,000, even though the difference in ratings between the two is statistically meaningless.

The treatment of ratings as absolute numbers by both advertisers and networks has led to fights over unmeasurable fractions of a rating point and demands for more measurements, produced more often. These demands have led to ratings being reported in a number of different ways. For prime-time programming, the most common of these are the sweeps, overnights, Pocketpieces, and MNA reports.

Sweeps and Overnights

Four times each year (November, February, May, and July) a highly controversial rating event occurs —the **sweeps.** Nielsen Media Research uses a diary system (and mixed diaries and meters in some markets) to gather ratings, shares, and demographic information for local television stations and a growing number of cable networks. The results of sweeps ratings, particularly the November and February periods when audience viewing levels are at their highest, directly affect the rates these cable networks and local stations (including network-affiliated and network owned-and-operated stations) charge for advertising time.

The stations, therefore, demand that the networks display their highest-quality merchandise during the sweeps periods to attract the largest possible audiences and maximize ad revenues. The practice of **stunting** (the deliberate shuffling or preempting of the regular schedule for specials, adding celebrity guests and extraordinary hype) makes the four sweeps periods, especially November and February, highly competitive and, at the same time, not always the most valid indicators of a network's or station's real strength.

As described previously, national ratings take several different forms. Aside from the sweeps, the **overnights** (available in some 52 cities by 2002, representing 67 percent of the public) are the most avidly monitored of ratings data. Overnights, gathered through a set of peoplemeters located in

major cities, take into account only the non-Spanish broadcast networks (although overnight information drawn from a national peoplemeter sample is available for purchase for about a dozen major cable networks). The overnight ratings are used to monitor overall urban audience reaction to such "program doctoring" as changes in casts, character emphases, and plot lines. The overnights also indicate immediately whether a new program has "taken off" and captured a sizable audience in the urban markets. Advertising agencies also use the overnight numbers to make predictions about specific shows that then become the basis of ratings expectations (and sales rates).

For example, when *Ally McBeal* first started, it was predicted to get a *share* of 9 but actually got a 15, thus making it a hit, even though its *ratings* were not high compared to those of many other new series. Continued low ratings in the overnights during the first few weeks of a newly introduced program's run spells cancellation unless the ratings show a hint of growth—or unless the program is expected to have stronger appeal to a specific audience. *JAG* was canceled by NBC but picked up and run successfully by CBS, which argued that it had a strong rural and male appeal not represented in the city-based overnight ratings.

Sometimes international appeal is a factor in letting a show build an audience. For example, *Third Watch* was only a moderate rating success for NBC, losing every week to *Touched by an Angel* and almost every week to *The Simpsons*, but it showed strong international potential and offered a racially diversified cast during a year with little other racial diversity in prime time. Thus, *Third Watch* was renewed while higher-rated series were canceled. Other series, such as *West Wing*, were only moderate rating performers but generated strong critical and special interest appeal and thus remained on the schedule. Such cases demonstrate the inability of programmers to ascertain a program's appeal to a particular audience despite the predictions and expectations of advertisers and the availability of network ratings data. Yet, agency predictions have tremendous power. For example, during the 1999–00 season, advertisers predicted

4.2 ADVERTISING DECISIONS

In the early days of television, companies owned the programs they placed their advertisements in, but in the late 1950s that changed. Now there is little direct connection between the advertisers and the media. Decisions are usually made by advertising agencies acting for companies. They base their decisions mainly on ratings and demographics; however, about 80 percent of the advertising in prime-time television is actually purchased in late spring and early summer before the season begins. This process is called **upfront buying** and determines the economic health of the television networks for the next year. However, as the buying is done in May or June and the shows don't actually air until September or October, there are no real ratings, shares, or demographic numbers available at the time of purchase. Decisions are made on the basis of what the network is willing to guarantee and how well the agencies predict a program will do. If the network's guarantees are not met, as was the case with the WB Network during the 1999–00 season, the network must run make-good advertisements for free until the promised number of rating points is met. If the numbers are better than the guarantee, the advertiser gets a bargain. Therefore, agencies are always looking for shows they feel will do better than the networks think, and the networks are not willing to hold onto any show that is doing worse than their guarantee.

The question is, how good are the predictions? Although network guarantees are considered proprietary information and thus seldom released to the public, agency predictions are often released (even though the formulas used to obtain those predictions are closely guarded secrets). The following list shows 20 programs, 10 established and 10 new, for the 1999–00 season. The first number shows what agencies predicted the program would get four months before it actually went on the air, back in May 1999, and the second number shows the actual share of the audience it received averaged over the entire season. As these results show, agency predictions are usually very close but often overestimates. The rare cases of underestimations are the plums for advertisers.

Established Series	Predicted Share	Actual Share	New Series	Predicted Share	Actual Share
ER	29	27	Stark Raving Mad	20	17
Friends	25	22	Once and Again	13	14
JAG	16	15	Judging Amy	13	17
Jesse	20	18	Ladies Man	12	12
Walker, Texas Ranger	16	15	The West Wing	13	14
Nash Bridges	16	13	Third Watch	11	11
Diagnosis Murder	14	14	Malcolm in the Middle	8	14
Ally McBeal	14	12	Freaks & Geeks	9	8
NYPD Blues	15	18	Harsh Realm	8	6
Dharma & Greg	14	16	Now & Again	11	11

Secret Agent Man would get barely a 2 share. As a result, the series was canceled without airing even one episode. Who knows, given a chance, the audience might have turned to it as they did to *Who Wants to Be a Millionaire?* and the summer surprise hit *Survivor*. On the other hand, the same agency experts predicted that *Stark Raving Mad* would be the highest-rated new series of that season. It did not live up to that prediction. See 4.2 for further discussion of this issue.

4.3 SAMPLE POCKETPIECE PAGE

A-16
NATIONAL *NielsenTV* AUDIENCE ESTIMATES EVE.SUN. NOV.5, 2000

TIME	7:00	7:15	7:30	7:45	8:00	8:15	8:30	8:45	9:00	9:15	9:30	9:45	10:00	10:15	10:30	10:45	11:00	11:15
HUT	61.0	62.2	63.6	65.1	66.7	68.5	69.1	70.2	70.9	71.1	70.3	69.5	66.0	62.7	59.9	57.3	51.3	46.3

ABC TV — WONDERFUL WORLD OF DISNEY / THE GROWING PAINS MOVIE — MILLIONAIRE-SUN — PRACTICE, THE

HHLD AUDIENCE% & (000)	9.2	9,350							12.5	12,810			12.5	12,780				
TA%, AVG. AUD. 1/2 HR %	17.9	8.2*		9.0*		9.4*		10.0*	17.4	12.0*		13.1*	16.2	12.3*		12.7*		
SHARE AUDIENCE %	14	13*		14*		14*		14*	18	17*		19*	20	19*		22*		
AVG. AUD. BY 1/4 HR %	8.0	8.4	8.9	9.0	9.4	9.4	9.6	11.5	12.4	12.9	13.4	12.4	12.2	12.5	12.9			

CBS TV — (1) — 60 MINUTES (7:25-8:25)(PAE) — TOUCHED BY AN ANGEL (8:26-9:25)(PAE) — CBS SUNDAY MOVIE / JACKIE KENNEDY ONASSIS, PT. 1 (9:25-11:25)(PAE)

HHLD AUDIENCE% & (000)		11.4	11,610			9.4	9,590			8.0	8,200							
TA%, AVG. AUD. 1/2 HR %		18.4		11.0*		14.2		9.0*		13.9		8.1*		8.1*		8.2*		7.7*
SHARE AUDIENCE %		17		17*		13		13*		13		12*		12*		14*		15*
AVG. AUD. BY 1/4 HR	14.5	10.0	10.6	11.5	12.4	9.3	8.7	9.2	10.0	7.9	7.9	8.2	8.1	8.1	8.1	8.3	7.8	7.6

NBC TV — DATELINE SUN-7PM — ED — SNL PRESIDENTIAL BASH '00

HHLD AUDIENCE% & (000)	6.3	6,450			6.9	7,060			9.9	10,150								
TA%, AVG. AUD. 1/2 HR %	11.2	6.1*		6.5*	10.6	6.4*		7.4*	19.9	11.0*		10.5*		9.8*		8.5*		
SHARE AUDIENCE %	10	10*		10*	10	9*		11*	15	15*		15*		15*		14*		
AVG. AUD. BY 1/4 HR %	5.9	6.3	6.8	6.3	6.4	6.4	7.0	7.8	10.9	11.0	10.6	10.5	10.2	9.3	8.7	8.3		

FOX TV — FUTURAMA-SUN (7:00-7:20) (B)(PAE) / KING OF THE HILL / SIMPSONS / MALCOLM IN THE MIDDLE / X-FILES

HHLD AUDIENCE% & (000)	3.6	3,640	6.6	6,750	9.2	9,380	9.0	9,210	9.5	9,670								
TA%, AVG. AUD. 1/2 HR %	4.0		7.7		10.8		10.5		11.6	9.4*		9.6*						
SHARE AUDIENCE %	6		10		14		13		13	13*		14*						
AVG. AUD. BY 1/4 HR %	3.5	3.8	6.3	6.9	8.6	9.7	8.9	9.1	9.3	9.5	9.6	9.5						

WB TV — JAMIE FOXX SHOW, THE - WB / PJS - WB / STEVE HARVEY SHOW, THE-WB / HYPE - WB / NIKKI - WB / GROSSE POINTE - WB

HHLD AUDIENCE% & (000)	2.1	2,170	2.0	2,000	2.4	2,480	2.1	2,140	2.2	2,210	1.8	1,880
TA%, AVG. AUD. 1/2 HR %	2.6		2.4		2.9		2.7		2.7		2.3	
SHARE AUDIENCE %	3		3		4		3		3		3	
AVG. AUD. BY 1/4 HR %	2.0	2.2	2.0	1.9	2.2	2.6	2.2	2.0	2.1	2.2	1.9	1.8

UPN TV

HHLD AUDIENCE% & (000)	
TA%, AVG. AUD. 1/2 HR %	
SHARE AUDIENCE %	
AVG. AUD. BY 1/4 HR %	

PAX TV — ENCNTRS W/THE UNEXPL ENC (R) / IT'S A MIRACLE ENC (R) / PAX BIG EVENT SUNDAY / THE STORY OF ESTHER / SCARECROW & MRS KING-WKD (11:00-12:00)(R)

HHLD AUDIENCE% & (000)	0.8	790			0.9	870			0.9	960							0.4	380
TA%, AVG. AUD. 1/2 HR %	1.2	0.7*		0.8*	1.6	0.8*		0.9*	1.7	0.8*		0.9*		1.0*		1.0*	0.6	0.4*
SHARE AUDIENCE %	1	1*		1*	1	1*		1*	1	1*		1*		2*		2*	1	1*
AVG. AUD. BY 1/4 HR %	0.7	0.8	0.8	0.9	0.8	0.9	0.8	0.9	0.8	0.8	0.9	1.0	1.0	1.0	1.0	0.4	0.3^	

U.S. TV Households: 102,200,000
(1) CBS NFL NATIONAL VARIOUS TEAMS AND TIMES.CBS.(MULTI SEGMENT)(PAE)

For explanation of symbols, See page B.

Pocketpieces, MNA Reports, and the National Syndication Index

The ratings report traditionally of greatest interest to the *creative* community is published every other week in a small booklet known as *The Nielsen Pocketpiece*. It comes from the 5,000 national peoplemeter households selected to match census demographic guidelines for the entire country. Though this information is published only every other week, these data are available to Nielsen subscribers through a computer data bank on a next-day basis. This data bank provides, upon request, data not only for the nine major broadcast networks but also for about a dozen of the major cable networks. Normally, cable ratings appear only in a separate cable report that provides cumulative rather than per-episode ratings. These cumulative numbers cannot be compared to the broadcast numbers.

At present, Nielsen is handling almost 1,300 computer requests for these data each month, indicating that this service may eventually replace or diminish the importance of the overnights. These data include ratings/shares and the all-

important demographics for both prime time and daytime, plus general information such as average ratings by program type, number of sets in use by days and by dayparts, comparison of television usage between the current season and the one preceding, and other details. Unlike the urban nature of the overnights, the Pocketpiece provides estimates for the entire nation. The rating and share information is also widely available each week to the public through such publications as *Variety* and *Broadcasting & Cable* (see 4.3 for a sample Pocketpiece page).

Programmers also find Nielsen's Multi-Network Area Report (MNA) very useful. The statistics in the MNA cover the 70 leading population centers in the country. The 70 markets represent about two-thirds of total television homes nationally, and MNA measurements are compiled from this two-thirds of the national Nielsen sample. The networks use MNA reports to compare the performance of the major networks without the distortion caused by one- and two-affiliate markets included in the national Nielsen reports (although few now exist). MNA reports include the so-essential demographic breakouts.

Though traditionally of limited interest to the national networks, the National Syndication Index, described previously, is of major importance to group owners. Published yearly, it lists all syndicated shows on a market by market basis. Few syndicated series have national penetration equal to network programs, and, as a result always look worse in the national ratings. This market by market approach, however, shows how each series did against specific competition and in specific dayparts. It therefore provides a more realistic picture of how syndicated programs did and is considered the bible for local stations and group O&Os when doing their own programming.

NETWORK SEASONS

The entire process of prime-time programming breaks down into three major phases: *deciding to keep or cancel already scheduled series, developing and*

choosing new programs from the ideas proposed for the coming season, and *scheduling the entire group*. To understand program evaluation, selection, and scheduling, the changing concept of a season needs to be spelled out.

From the 1950s to the present, the main viewing year has periodically expanded or contracted until it now consists of about 40 weeks, usually running from late September (or in 2000 because of the Olympics, in early October) to the end of May. The remaining 12 weeks (off-season) occur in summer. By the early 1970s, high per-episode costs had cut back the typical number of episodes produced for a series to 32 for a 32-week season (later just 30 weeks long). Further cost increases combined with a high mortality rate forced an end to that pattern, decreasing episode orders for renewed series to 26 in the late 1980s, falling to 20 or 22 episodes in the early 1990s. Nowadays, networks tend to order just six episodes at a time, although occasional 22-episode guaranties are given to capture a high-profile producer or star. In the mid-1990s, however, a problem became apparent: The reduced-length season no longer covered the May sweeps, but these sweeps were increasingly important to affiliated stations and expensive for the networks. In consequence, the Big Four broadcasters restretched the season to 40 weeks, although the number of episodes they ordered did not increase. As a result, networks have to find a great deal of "fill," which has further destabilized the prime-time schedule.

The networks now contract for just six to ten episodes of new shows, and contracts say "cancelable any time." To fill out some of the 40 weeks of the regular ratings season, another ten new episodes may be ordered. As the network license fee gives the right to two showings of each episode for the one payment, and the networks need to get their money's worth out of every episode, reruns begin early, often scheduled at the end of the first season in December (no ratings then) or between the February and May sweeps. Traditionally, weaker episodes were rerun in summers, but the extended season has resulted in reruns of nearly all episodes during the main viewing year, with

episodes of quickly-canceled series saved for summers. Specials, sports, miniseries, and limited-run tryouts fill the remaining weeks of the regular season. However, the definition of a "special" has become extremely loose. For example, during a recent season, specials included rejected pilots, such fluff shows as ABC's *21 Hottest Stars Under 21* and so-called "news specials" that were indistinguishable from the regular news magazines and reality shows.

Beginning in the late 1980s, the networks have used the tactic of taking popular series off the air for six to eight weeks to try out new series in strong prime-time slots. March, April, sometimes August, and now the summer months have become tryout months for **limited series** (generally four to six episodes). This off-and-on method of scheduling allows the networks to test a new program under the best possible conditions while preserving original episodes of the most popular series for the May sweeps. WB added a new variation to this practice by scheduling two series for the same time slot (i.e., **shared time slots**). During the 2000–01 season, WB carried 11 weeks of *Felicity*, followed by 13 weeks of *Jack & Jill*, and then another 11 weeks of *Felicity*. In a variant, ABC scheduled *Once and Again* for Tuesday night until the end of the football season. The series then moved to Monday night and *NYPD Blue* took over the Tuesday slot.

Whether these scheduling methods improve a new series' chances for long-term success is debatable. New shows usually get highly inflated ratings while in a popular show's time slot, but these ratings seldom hold up when the new show moves into its much weaker permanent slot. Even if the program significantly improves ratings for the permanent slot, the numbers seldom look as good as in the tryout weeks, and the common result is quick cancellation. At present, the jury is still out on shared time slots, although they were used successfully in the 1950s, and **checkerboarding** (rotating weekly among two or three shows in the same time slot) had some success in the 1980s with a rotation of *Columbo*, *McCloud*, and *McMillan*.

In truth, *the majority of new series are aired in limited-run experiments*. The majority of new programs tried by ABC, CBS, NBC, and Fox run less than eight weeks. UPN, WB, Pax, Telemundo, and Univision tend to leave new series on for a full season, but some programmers argue that this stems not from a different philosophy but from a lack of the money required to constantly develop replacements.

Another new twist to network scheduling patterns is the practice of airing top-rated or very cheap programs more than once a week, called **doubling.** Although doubling-up had been tried in the late 1960s with such programs as *Batman* and *Peyton Place*, it was dropped until Fox began double showings of *Cops* and *The Simpsons* in the mid-1990s, usually placing two episodes back-to-back. The other networks, with very few truly successful series to offer, quickly picked up on the idea with double-scheduling of *Home Improvement*, *Frasier*, and *The Drew Carey Show* for a few weeks. Many experts are concerned by the practice. They attribute ratings declines to program overuse because viewers burn out on story ideas and characters.

Beginning in the mid-1990s, NBC surpassed its competitors by scheduling *Dateline NBC* three times a week (**tripling**) and eventually five nights a week by 2000 (**stripping**). ABC and CBS tried to follow with multiple episodes of *60 Minutes, 48 Hours, Primetime,* and *20/20*, but quickly backed off to once or twice a week when the new versions did worse than expected in the ratings, despite original shows being produced for each night. For other genres, however, no extra episodes were ordered to fill the extra time, forcing a program quickly into reruns. During the 2000–01 season, ABC surprised the industry by scheduling *Who Wants to Be A Millionaire?* five nights a week in prime time. Although the show proved to be enormously popular, many programmers predicted that its heavy use would result in a rapid burnout. In truth, ABC had little choice that year. The network's first-place finish in the 1999–00 season had been a direct result of the popularity of that one show, and it had few strong pilots or other program options suited to capitalizing on the show's unexpected strength in the following season.

Fall Premieres

Traditionally, the networks premiered their new series during a much-publicized week in late September. However, the **premiere week** slowly spread out. By 1994, "premiere week" actually lasted from late August to November, and series debuted in scattershot fashion, usually throughout September and October (and occasionally as early as August or as late as November). This spreading out keeps new programs from getting lost in the rush, gives viewers maximum opportunity to sample each new network show, and accommodates interruptions caused by baseball playoffs, the World Series, and other major events such as a late Olympics. In fact, spreading out "premiere week" has had the effect of diminishing the excitement associated with a new season and, in fact, reduced the sampling of new shows. For example, viewers who find an appealing show at a certain hour in early September are unlikely to check out new shows when they debut some weeks later at the same hour.

In addition, a large number of new network programs, particularly replacement shows, begin their runs in January or February, thus creating a **second season** on the networks. By late fall each year, the fate of most prime-time programs already on the air has become clear. Holiday specials usually preempt those destined for cancellation or restructuring, while more popular series go into reruns and special holiday episodes. By January or February the networks are ready to launch their second season—with almost the same amount of promotion and ballyhoo as are accorded the new season premieres in September or October. Nonetheless, they then promptly preempt the new schedule to promote and run special programming for the February sweeps. As a result, it is hard to argue that there are clear seasons any longer. Rather, network programming has become a round of constant changes. As a strategy, this is called the **continuous season** approach.

Many programmers now believe *mid-year starts are actually better than the traditional first season rush*, as the audience is at its peak and has more realistic expectations following the fall's original episodes than just after a long summer of reruns. As a result,

some of the networks' strongest new shows are now held as replacement series. The initial scheduling of programs such as *Coach*, *The Simpsons*, and *Malcolm in the Middle* were examples of the mid-year replacement strategy. By 2000, Fox was announcing series in May that it had no intention of airing until mid-year (January).

Summer Schedules

Traditionally, in spite of the sweeps held in May and July, the summer was exempt from the ratings race (although networks often hold new episodes for use in May or plan dramatic, cliff-hanger endings during that month). Summer has been an arena for reruns (often of weak series episodes or episodes of quickly canceled series that were paid for but never used) and episodes of never-scheduled shows or reruns of canceled series.

In the late 1980s, the networks began using March and April, as well as summer, for testing new program ideas in short runs and airing rejected pilots that did not make the fall schedule. (Previously, these pilots would never have been seen by anyone outside the network programming department.) The Big Three's neglect of the summers had made them a gold mine for the pay-movie networks and smaller broadcast networks. Moreover, by the 1990s, not only were network ratings down, but the costs for program development were so high networks could no longer absorb the expense of the development stages for new shows that never reached air. Running pilots as made-for-TV movies, summer specials, and short-run tests of series helped recoup much of their investment. This practice accelerated, partly to recover development costs, partly to counteract audience losses to other broadcast and cable networks, and partly to satisfy affiliated stations worried about the extreme ratings drop during the July sweeps.

Fox further complicated the picture when it discovered that summer was a good time to get people to sample series they did not normally watch. The network was able to build an audience for several of its regular series by continuing original episodes into summer, supported by promotional

campaigns (such as NBC's "New to you") that emphasized the fact that "if you hadn't seen it, the program was new to you." To take advantage of the potential for discovering its shows, Fox began heavily promoting its reruns as a "second chance to see what you had been missing." This strategy was sufficiently successful to force the other three networks to pay more attention to their summer schedules. By 2001, most networks scheduled at least one or two new series during the summer, although none seemed intended to continue during the main season.

Even when a summer series outperforms expectations, it has seldom been picked up. Programmers generally write these offerings off before they ever go on the air. As a result, a show must break all records to get attention from programmers who have already moved on to next season's planning. *Survivor,* which ran only during the summer of 2000, was such a surprise megahit, and it spawned several **clones** (lookalike shows) for the subsequent season (*Temptation Island, the Mole,* and *Survivor II*) because it quickly attracted young adult viewers to CBS, a network young people had rarely watched in large numbers. With the advent of original **summer schedules** and the promotion of reruns as original programming for people who normally watched the competition, the July ratings books took on more importance as a measure of network and pay-cable pull and as a limited vehicle for pre-fall testing.

PROGRAM RENEWAL

Evaluation of on-air shows goes on all year. The final decision on whether to return a program to the schedule the following fall is usually made between March and May because the networks showcase their fall lineups at their annual affiliates meetings during those months. Last-minute changes, however, occur right up to the opening guns in the fall. *The critical times for new programs starting in September are the four or five weeks at the beginning of the fall season (September/October) and the November sweeps.* Typically, programs surviving the waves of cancellation at these times and lasting into January or February are safe until April (when preemptions of soon-to-be-canceled shows occur).

Program Lifespan and License Contracts

The average **lifespan** of popular prime-time series has declined steadily over time. In the 1950s and 1960s, such shows as *The Ed Sullivan Show, Gunsmoke, What's My Line,* and *The Wonderful World of Disney* endured for more than 20 years. These records for longevity will probably never be matched again in prime time—with the sole exception of *60 Minutes.* By 1980, a program lifespan of ten years was regarded as a phenomenon. By the 1990s, five years was an outstanding run for a successful series, and that remains the standard today.

Several factors account for this shortened lifespan:

- The increased sophistication or, some argue, the shortened attention span of the viewing audience

- The constant media coverage of television shows and stars (as in *Entertainment Tonight*), wearing out each episode and series idea quickly

- The practice of syndicating a series while it continues its network run or other overuse while on the network

- The scarcity of outstanding program forms and fresh, top-rated production and writing talent, as well as a network propensity for formulaic series, which leads to a great deal of copying and very low levels of originality

- The high cost of renewing writers, directors, and actors after an initial contract expires

- The loss of actors because they become bored or move on to other projects

- A general lack of variety in prime-time programming resulting in a sameness that causes even the best ideas to wear out faster

The shortened lifespan of prime-time series especially reflects the complexity of program license

contracts that generally run for five to seven years. When a series first makes it to the air, the network controls the contractual situation and usually requires several concessions from the producer. At this time, the producer commonly has to sign over such rights as creative control, spinoff rights, limitations on syndication, and scheduling control. The producer also agrees to a specific licensing fee for the run of the five-year contract, regardless of the program's success (after all, most shows fail). Typically, this licensing fee is substantially less than actual production costs and makes no concession for sharing the profits should the program become a hit.

Producers practice **deficit financing** (paying more to produce a series than the network pays in license fees) because the potential profit from off-network syndication can run into the hundreds of millions of dollars. After the 1971 **prime-time access rule** barred the networks from taking a share of the syndication profits, all three networks demanded that the producers shoulder a larger portion of the production cost. The networks argued that because only the producers get syndication profits they should also accept more of the risk involved in prime-time production. The repeal of the financial interest and syndication section of the rule a couple of decades later did not alter this network position regarding new series. Instead, it added a demand from the networks for **joint ownership** of product (meaning the network and the producer would share profits from syndication). When a script idea is first proposed, its producer is in no position to argue with this type of network reasoning. After all, the idea is worth nothing until it gets on the air, and cable is still very limited in the amount it spends on original productions, although that is increasing as quickly as cable revenues go up.

At the end of the first contractual period, normally five years, the tables are turned. Now the producer enjoys the advantage. The series has a **track record** and enough episodes in the can for syndicating as a stripped show. In short, because the producers no longer need the network as much as it needs them, producers may demand the return of many of the concessions granted in the original contract. Moreover, a hit series' stars, directors, and other executives now seek much larger salaries and concessions. *Friends* illustrated this dilemma when the stars each demanded $1 million an episode (although they finally settled for only $750,000), thus pushing the cost of production to $4.5 million per-episode even before any other salaries or production costs were added. Under such renewal conditions, a network can often profit by dropping a popular show with a marked-up price in favor of an untried newcomer, or by replacing a popular star with a newcomer, as ABC did with *NYPD Blue*. NBC did bite the bullet, however, with megahit *ER*, paying $13 million per episode for one year just to keep this centerpiece for its Thursday night schedule.

Pivotal Numbers

Of the three phases of planning a fall schedule—*evaluation, selection, and scheduling*—choosing which programs already on the air will continue and which will be pulled (renewals and cancellations) is perhaps the easiest decision. The decisions are based squarely on the network's **profit margin**—in essence, subtracting cost per episode from advertising revenue. *Normally, revenue is directly related to ratings.* Until the 1980s, a weeknight rating below 20 (or an audience share of less than 30) almost always resulted in a program's cancellation on any network. But because of steady network audience erosion, by 2001 the Big Three's numbers had dropped to a *minimum weekday prime-time rating of 7 and a share of 12.* These numbers will sink even further if the broadcast networks' share of viewers continues to decline.

Entertainment programs stalling in the bottom third of the Nielsens are usually canceled as soon as possible, while programs in the top third are usually renewed. The most difficult decisions for network programmers involve programs in the middle third—*the borderline cases*—or programs that:

- Show signs of fatigue but are still holding their own
- Are only just beginning to slide in the ratings

4.4 TIME SLOT RATINGS

The history of ratings for the time slot a program fills may be the strongest measure of how that program will perform. After all, a "history" takes into account such factors as the competition, the leads in and out on all channels, the network's myths and policies, and the public's viewing habits and expectations. The reality is that more than 80 percent of the series scheduled in new time slots (new or moved shows) do not alter either the ratings or the ranking for their slots significantly. This means that a series placed in a top-rated time slot probably will be a top-rated series, and conversely, a series placed in a weak position will be weak. The majority of the remaining shows get lower ratings than their time slot averaged in the previous season. This means that when a series does change the historical pattern, the change is usually for the worse. Chances are less than 5 percent that a program will significantly improve the ratings for the time slot even at the generally accepted 68 percent level (one standard deviation rather than the two normally used in research).

Low-rated shows are subject to a widely accepted condition called **double jeopardy.** According to this idea, low-rated shows have both low exposure and little chance of getting more exposure. This is because popular programs are both chosen by more people, and those viewers are more committed to the shows. Thus, unpopular programs suffer from increasingly fewer and less-committed viewers.

Obviously the best scheduling ploy would be to place every series in an already strong position, an impossibility. The slots open to programmers are usually ones where previous programs failed. In the last 20 or so years, more than half of all new shows have been scheduled in prime-time slots that already ranked in the bottom third of the ratings, and most were also in slots ranked third compared to the competition. Clearly, *the strength of a time slot should be considered when the decision is made to hold or cancel a series.*

This, however, has not usually been the case at the networks: *In practice, a program's rank and absolute rating overrule expectations for a time slot.* As a result,

a series with an 11 rating would usually be held, while a series with a 6 would be canceled, even if that 11 represented a loss of several points (by comparison to the lead-in program or the previous program in that slot) while the 6 represented a gain. Because there is only a small chance that a series will significantly improve the ratings for a time slot, considering ranking and absolute rating appears to be self-defeating in the long run. Because the majority of available slots are going to be weak in any case, wisdom suggests holding onto series that improve the numbers and slowly rebuilding holes in the schedule would be sound practices. Because a short replacement series is very unlikely to do any better and is expensive to develop, common sense would also seem to advocate holding onto new programs longer to give them time to build audiences. After all, *Seinfeld* only generated ratings of 11 and 12 during its first year, losing badly to *Home Improvement.* Nonetheless, the pattern of the three major networks has been "decide quickly" and "cancel fast."

- Are highly rated but draw the wrong demographics
- Have low ratings but high profit margins (as is often the case with news or people-participation series)
- Produce strong critical approval

Occasionally, the personal preferences of a top network executive, the reaction from critics, letter writing campaigns, or advertiser support may influence a decision, but the prevailing view is that cancellations had far better come too soon and too often than too late. Oddly enough, replacement series almost never do any better than the

original program in the ratings (see 4.4) and push development prices even higher. This may be one of the reasons that large group owners increasingly pressure networks to hold onto problematic shows. Group owners can affect these decisions, as can direct participation from large sponsors. As the millennium turned, some sponsors were again entering into deals with producers to pre-buy certain shows for the entire season. Such a pre-buy would certainly affect a cancellation decision.

Although audience protests about the cancellation of *Its Like, You Know* or the moving of *Frasier* might be annoying, of far greater concern to network programmers was a new willingness by producers to defy the networks and keep canceled shows in production or to move them to other networks. Some canceled series were subsequently offered in original syndication (first-run) as direct competition for prime-time network programs. The first rebels surfaced in the early 1970s when *Lawrence Welk* refused to be canceled and when *The Muppet Show* went into production even after all three major networks had turned the series down. By the 1990s, such series as *Baywatch* were coming back to haunt network executives. The success of other series such as *JAG* on a competing network were even more annoying, as the network that had lost the show couldn't argue the new success was because of lower standards (as was often the case in original syndication).

Worse yet, by the 1990s some producers had stopped offering their new ideas to the traditional broadcast networks, choosing instead to offer their series to cable. The networks might have considered such programs as *Tek War* and *First Wave*, but they went straight to cable. Even more new series went directly to original syndication, leaving all profits and control with the producer. Indeed, by 2002 there was a mild glut in original prime-time shows for local stations, including such series as *Beastmaster, Xena: Warrior Princess, The Outer Limits, Star Gate SG1, Baywatch Hawaii, Total Recall 2070,* and *Earth, Final Conflict.* In many cases, these programs (*Xena,* for example) were produced outside the United States to lower production costs. Many also did better in the ratings

than off-network series, further eroding the networks' dominance and challenging U.S. production houses, meanwhile raising serious questions about the networks' programming emphases. Much of original programming is now created from an international perspective for selling to the entire world at once. Indeed, in startling contrast to past decades, many first-run syndicators consider any money made in the United States as pure profit. As explained in Chapter 3, international syndication rights cover production costs.

Program Costs

In addition to ratings, profits left after subtracting licensing costs from advertising revenues influence program cancellations. Two prime-time programs of the same length, on the same network, with identical ratings will, ideally, produce identical amounts of revenue for that network. If, however, one of them has slightly higher per-episode licensing costs (say, $625,000 versus $600,000), over the length of a season that difference may reduce net profit by a half-million dollars. Generally, the number of commercial minutes remain the same for each program, although the networks have begun experimenting with slipping extra commercials into some series. It is clear that the program with the higher licensing cost will be canceled before the lower-cost series.

In recent years, the networks have scheduled more of program genres with low production costs —witness the number of news magazines in prime time. It was also reflected in the huge publicity push for reality programs that occurred in 2000–01. Listening to the media, one would think such programs as ABC's *Member of the Band,* which followed a group of young hopefuls trying to get into a band, or MTV's *The Real World,* were pulling in huge numbers. In truth, MTV offerings seldom got even a 2 rating, and the number of hits to reality sites on the web (often used as a justification for such series as *Big Brother*) were minimal when compared to the number of people required to make a network sitcom or drama successful. (A million hits to a web site is nothing compared to

ten million viewers week after week.) Although even network reality offerings rarely get out of the bottom third of the ratings, the genre is very cheap to produce, so one unexpected hit like *Survivor* has led programmers to promote "the new reality shows" as the next great thing on television even without long-term numbers to back up the claim.

License fees vary with cost factors such as costumes, special effects, sets, stunt work, the amount of location versus studio shooting, cast size, the producer's and star's reputations, the program's track record, and so on. At present, one of the biggest cost factors of all is how a program is produced from a technical standpoint. According to information provide by NATPE, producing a program on film runs about $4,000 per five minutes of product (not including any other costs such as cast and other salaries). Tape is less expensive, but still around half that cost. Producing the program digitally—using a digital camera and the computer for editing, special effects, and so on—runs about $7,000 for 45 minutes of high-definition product, and that includes transferring back to analog for distribution. *This enormous cost differential—about one-fifth—drove the high-definition revolution in Hollywood.* The broadcast networks themselves have only given the change lip service, and by 2001, still had not agreed on a single format for HDTV broadcasting although they were very close to the FCC-mandated switch-over date.

By 2000, sitcoms, movies, and news/reality programs filled 67 percent of the prime-time schedule. If crime dramas are also included (but not programs about lawyers like *The Practice*), these four genres occupy 80 percent of all prime-time hours.

The traditional other option, movies, although expensive, fills large amounts of time and is therefore useful for plugging temporary night-long holes in the schedule until more sitcoms and reality-based series can be developed. Movie nights can also be used to test pilots done as **made-for-TV movies,** thus saving on the costs of development. As a result, there are many movie nights, but they come and go very quickly.

News/documentary and reality-based formats are still by far the cheapest to produce; most are produced **in-house** and make use of material provided for free by the audience or by the network news divisions when not preparing the nightly newscasts. A news magazine program such as *60 Minutes* or *20/20* can run virtually forever. Reality-based shows, such as *America's Funniest Home Videos, Survival,* and *Unsolved Mysteries,* are also relatively cheap to make and tend to do well in the ratings, at least initially. Nonetheless, reality-based shows usually have only a short network lifespan and no life at all in off-network syndication.

Advertising rates did not keep up with production cost rises in the late 1980s, as 4.5 shows, and network profits declined drastically, although the networks introduced severe cost-cutting measures, including huge cutbacks in personnel and departmental budgets. Though ad rates went up again in the late 1990s, both network news departments and Standards and Practices Departments were hit hard by economy measures. All three major networks also began selling off such subsidiary businesses as recording and publishing. Eventually, the networks themselves were sold. As another money-making idea, CBS was the first network to add one or two extra commercial spots to some of its most highly rated programs, in essence, letting ratings influence the amount of time devoted to commercials. By 2000, extra spots were being added to many programs, in and out of prime time.[5]

NEW PROGRAM SELECTION

Phase two in planning a new fall season—selection and development of new program ideas—poses more difficult problems than ongoing program evaluation. The four networks consider as many as 6,000 new submissions every year. These submissions vary in form from single-page outlines to completed scripts. Decision makers favor ideas resembling previous or presently successful shows. They even quietly agree that almost all so-called original successes are in fact patterned after long-forgotten programs. For the 2000–01 season, for example, NBC was bragging about their move toward new and daring ideas such as *Titans,* described

4.5 ADVERTISING RATES

Advertising rates, the amount paid for a 30-second spot, vary a great deal from one program to the next and from year to year. The traditional rule has been to charge whatever the market will bear. Costs are figured on how much is being paid per rating point. Each point now equals more than a million homes. In the late 1980s, it appeared that costs had finally gone too high, as large blocks of time went unsold, but that trend reversed itself in the 1990s. Since 1995, in spite of a large increase in the amount advertisers had to pay per rating point, all available time was selling out. The following table shows how the average cost per point has changed since 1972.

Year	Title	Cost per 30-Second Spot	Cost per Point
1972	Bonanza	$ 26,000	$ 1,670
1980	M*A*S*H	$150,000	$ 5,840
	Dallas	$145,000	$ 4,200
1987	Cosby Show	$369,000	$13,275
	Cheers	$307,000	$11,290
1992	Murphy Brown	$310,000	$12,255
	Roseanne	$290,000	$ 9,390
1994	Seinfeld	$390,000	$19,310
	Home Improvement	$350,000	$17,950
1995	Seinfeld	$490,000	$24,260
	Home Improvement	$475,000	$24,360
1997	The X-Files	$275,000	$26,190
	Walker, Texas Ranger	$155,000	$16,489
1999	Friends	$510,000	$37,778
	The Practice	$250,000	$21,368
2000	Frasier	$466,000	$46,140
	The West Wing	$183,000	$16,195

Sources: *Advertising Age, Broadcasting & Cable,* and *Variety.*

as a "quirky yarn about a big city lawyer returning to his hometown in Ohio." No one at the network seemed to notice this was the same plot as *Providence* or *Judging Amy*. But then, none of the other networks were more original.

Concepts

By the turn of the century, most new development was coming from the parent companies themselves or production houses they either had an interest in or owned outright. Nonetheless, the four major networks continue to invite submissions from es-

tablished **independent producers** who enjoy substantial track records, such as Carsey-Warner-Mandabach, David E. Kelley, and Witt/Thomas Productions. The major studios, the big independent production companies, and experienced individual writer/producers are still sought out, even in the face of vertical integration, if some of their prior output ranks high in recent ratings. These companies or individuals have already demonstrated that they have financial stability and the know-how required for dealing with network pressures and red tape. It is a given that long-established organizations have the most successful writers under

contract and have the clout to hire exceptional talents, making their submissions more persuasive than those from less-experienced sources. Big advertisers such as Pepsi and Procter & Gamble have also begun backing the development of a few television series to gain more control over the types and content of programs offered.

Many program concepts are dismissed out of hand; others are read and reread, only to be shelved temporarily. A few, usually variations on present hits or programs linked to top stars or producers, get a favorable nod with dispatch. Big names such as Bette Midler and Oscar-winner Geena Davis get contracts, and then series are developed around them. Decision makers look for a program with **staying power**—that elusive combination of elements that makes a series continue to fascinate viewers over several years of new episodes using the same basic characters and situations (exemplified by *Diagnosis Murder* and *Frasier*).

Network programmers often look for ideas that closely resemble current hits. For example, *Roseanne's* early success spawned a rush to propose stand-up comedians in sitcom roles based on their routines, and the O. J. Simpson trial led to a half dozen attempts at courtroom dramas during the 1995–96 season. Truly original ideas tend to be ignored or given very short runs in weak time slots, and then canceled.[6]

Most new program ideas are for half-hour comedies or reality-based series. Concepts for one-hour dramas are far fewer. Half-hour sitcoms target the desirable demographic groups of young people and women 25 to 49 and, if successful, usually hit the syndication jackpot. Reality-based series, though rarely successful in syndication, are cheap to produce and fill a great deal of time. Consequently, the networks tend to order, and producers tend to propose, pilots for these two types of programs more readily than other types. The potential for international syndication is beginning to alter this practice, however. Interestingly, sitcoms seldom work internationally—they are too topical and their idiom is too American—while one-hour dramas are proving very successful. Joint deals between producers, networks, and international

distributors have made the rather expensive hour-long programs very profitable again. Because the networks now own an interest in these shows and, thus, a share of the profits both from the network run and from syndication, hour-long dramas have made a comeback in recent years.

Of the thousands of submissions that land on the networks' desks, roughly six hundred are chosen for further development at network expense. At this point, the parties sign a **step deal,** a contract providing development funds in stages to the producer, setting a fee schedule for the duration of the contract, and giving the network creative control over the proposed program. The networks also get **first refusal rights,** preventing the producer from taking the idea to anyone else until the network has actually turned down the show. This provision allows a network to hold onto an idea for years. In short, if the network is unwilling to air a program but is also concerned that some other network might, it can permanently shelve the idea. First refusal means that as long as a network doesn't actually say no, the producer can't talk to another network about the program.

Scripts

As a rule, step deals authorize scripts or, in some cases, expanded **treatments**. The approved concepts often take first form as special programs, made-for-TV movies, test characters in established shows, or miniseries. If a concept was submitted initially in script form, a rewrite may be ordered with specific recommendations for changes in concept, plot, or cast (and even new writers). Until recently, ABC traditionally supported many more program ideas at this stage than CBS, NBC, or Fox, but ratings shifts have led CBS and NBC to allot more money to develop new program ideas. Fox and WB have been more daring and more willing to hold onto new programs, but that seems to be changing as they increase the amount of time they fill and move closer to the Big Three in the ratings.

Before authorizing a pilot, the program executive will first order one or more **full scripts.** In the early days of television, certain program ideas

received immediate pilot funding and even guaranteed places on schedules, but such decisions usually depended on the use of a mega-star personality or big-name participation in the production. Nowadays, a network typically pays about $50,000 for a half-hour comedy script and $70,000 for a one-hour drama script. Exceptional (read *successful*) writers demand much higher prices. Before a pilot reaches production, a second or even third script for a proposed series may be called for to test the versatility of the series' idea.

Pilots

A **pilot** is a sample or prototype production of a series under consideration. Pilots afford programmers an opportunity to preview audience reaction to a property. Each of the four biggest networks order between 45 and 50 pilots to fill just over a dozen anticipated gaps in their new season lineup. Of course, such new networks as UPN and WB use fewer. Once a network decides to film or tape a pilot, it draws up a budget and advances start-up money to the producer. The budget and advance may be regarded as the third major step in the program development process. Half-hour pilots cost from $1.5 million to $3 million, depending on things like sets, costumes, special effects, and so on, with one-hour dramas costing more than twice that amount. Pilot production costs are generally higher than costs for regular season shows, because new sets have to be built, crews assembled, and start-up costs paid.

The very practice of "piloting" creates an artificial situation. More money, more time, and more writing effort go into a pilot than into subsequent episodes of the series. All the people involved do their very best, trying to make the pilot irresistible to network decision makers. The producer often pulls out all the stops and spends more money than the network agreed to pay, making up the extra expense out of the company's own resources.

Because of its incredible expense and abysmal success rate, the pilot system has been denounced by Fox and many producers. Fox uses five- to ten-minute presentation films in place of full-blown

pilots for many shows, but this radical idea has met strong resistance from traditional broadcasters. Nowadays, about 130 pilots are produced annually to fill the three- to five-dozen newly opened slots on the four main networks each year. Many of these pilots are done as made-for-TV movies, which can be played on regular movie nights and sold internationally as parts of movie packages, thus recouping the investment even if the series idea is not picked up. Series failing to make the final selection list for the fall season are held in reserve in anticipation of the inevitable cancellations. The networks also "short order" backup series from some of the pilots. They authorize production of four to six episodes and order additional scripts to be ready in case a backup show is successful. For a visualization of this process, see 4.6.

Most contracts require delivery in early spring. When received, pilots are tested on special audiences as described previously. Although pilot-testing research is admittedly inconclusive, it exerts considerable influence. The pilots are also repeatedly screened by committees of programming experts. The decision to select a pilot for a series may take into consideration:

- Current viewer preferences as indicated by ratings
- Costs
- Resemblance between the proposed program and concepts that worked well in the past
- Projected series' ability to deliver the targeted demographics for that network and its advertisers
- Types of programs the competing networks air on nights when the new series might be scheduled

Of secondary weight but also relevant to a judgment are:

- The reputation of the producer and writers
- The appeal of the series' performers (the talent)
- The availability of an appropriate time period
- The compatibility of the program with returning shows
- The longevity of the concept

4.6 THE PROGRAM DEVELOPMENT PROCESS

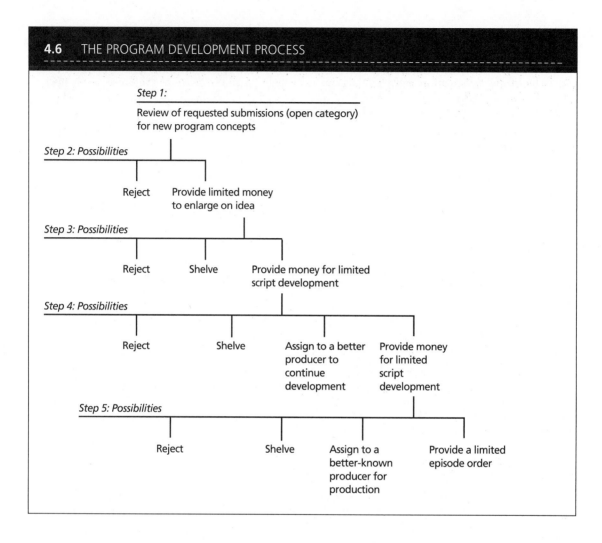

Step 1:

Review of requested submissions (open category)
for new program concepts

Step 2: Possibilities

Reject Provide limited money
to enlarge on idea

Step 3: Possibilities

Reject Shelve Provide money for limited
script development

Step 4: Possibilities

Reject Shelve Assign to a better
producer to
continue
development Provide money
for limited
script
development

Step 5: Possibilities

Reject Shelve Assign to a
better-known
producer for
production Provide a limited
episode order

Finally, increasingly relevant are:

- The quantity and type of countries that might buy the show in syndication
- The viability of inviting international production houses to share the initial expenses

Major considerations for programmers now include whether first-world countries will buy the show and whether it has very wide appeal that crosses cultural divides. Of equal importance is whether international production houses can be brought in to share expenses. All these 12 considerations and others are juggled by the chief programmer.

If a pilot passes final muster and gets into the network's prime-time lineup, subsequent half-hour episodes will usually cost about $1 million, and one-hour episodes about $2 million to $3 million. Anchor shows such as *Friends* and *Everybody Loves Raymond* broke all the rules. Programming costs vary a great deal because each property differs as to the number and size of cast, sets, and salaries paid. In addition, high demand for the product pushes the cost up. Made-for-TV movies cost from $4 million to $6 million, depending on ingredients; miniseries such as *Arabian Nights*, *Leprechauns*, and *Jason and the Argonauts* cost $30 million and up but, unlike most made-for-TV movies, they

sometimes provide a motion picture for eventual theatrical distribution (especially abroad) or a boxed video set for direct sale to the public.

Typical License Fees	
30-minute sitcom	$1 million
60-minute drama	$2 to $3 million
2-hour movie	$4 to $6 million
Miniseries	$30 million

SCHEDULING STRATEGIES

Ten strategies dominate prime-time scheduling: lead-off, lead-in, hammocking, blocking, tentpoling, bridging, counterprogramming, blunting, stunting, and seamlessness.

1. Lead-off. All schedulers use the strategy of beginning an evening with an especially strong program. Known as the **lead-off,** this first prime-time network show sets the tone for the entire evening. It is believed that this maneuver can win or lose a whole night and thus affect the ratings performance of a full week. Programmers believe the network winning the ratings for the first hour of prime time also usually wins the entire night.

A strong lead-off is considered so important that the major networks routinely move popular established series into the 8 P.M. (EST) positions on every weeknight. This is done even if it means raiding, and thus weakening, strong nights to get the proven shows for lead-offs. A classic example occurred in 2000 when ABC used *Who Wants to Be a Millionaire?* to shore up weak Tuesday and Wednesday night lineups.

2. Lead-in. Closely related to the lead-off, the **lead-in** strategy places a strong series before a weaker (or any new) series to give it a jump start. Theoretically, the strong lead-in carries part of its audience over to the next program. A new series following a strong lead-in has a modestly better chance of survival compared to a new series with no lead-in or a weak lead-in. To get a strong lead-in, the networks often shift strong series to new nights or times. No show is safe in any schedule

position. *M*A*S*H,* for example, occupied almost a dozen different time slots during its long run.

3. Hammocking. Although scheduling strategies can help bolster weak programs, it is obviously easier to build a strong schedule from a strong foundation than from a weak one. Moving one of a pair of established series to the next later half hour and inserting a promising new program in the middle time slot can take advantage of audience flow from the lead-in program to the rescheduled familiar program, automatically providing viewers for the intervening program. This strategy is known as **hammocking** the new series —in other words, a possible audience sag in the middle will be offset by the solid support fore and aft (also called a **sandwich,** with the new show as the filling). ABC, for example, used *Dharma & Greg* and *Once and Again* to create a space (a hammock) for *Geena* in 2000–01, and NBC used the opening created by moving *Frasier* to make a hammock for *The Steven Weber Show* between *Friends* and *Will & Grace.*

4. Blocking. The networks also use **block programming,** placing a new program within a set of similar dramas or sitcoms filling an entire evening, a venerable and respected practice. The risk with this strategy is that the new comedy may lack the staying power of its "protectors" and damage the program that follows. *Programmers, however, believe that surrounding a newcomer with strong, established programs of the same type ensures the best possible opportunity for it to rate as high as the established hits.*

The theory of **blocking** is that an audience tuning in for one situation comedy will stay for a second, a third, and a fourth situation comedy— if of the same general type. The first show in a group usually aims at young viewers or the general family audience. Each ensuing series then targets a slightly older audience, thus taking advantage of the fact that as children go to bed and teenagers go out or do homework, the average age of the audience goes up. Blocking works best during the first two hours of prime time but typically loses effectiveness later in the evening.

Examples of blocking (also called **stacking**) are easy to find in prime-time schedules every year on all three networks. During the 2000–01 season, for instance, CBS formed a crime block on Friday nights with *The Fugitive,* followed by *C.S.I.,* followed by *Nash Bridges.* In the same season, ABC formed a game block on Thursday with *Whose Line Is It Anyway?,* followed by *Who Wants to Be a Millionaire?* NBC, in turn, built its own comedy block on Thursday starting with *Friends,* followed by *The Steven Weber Show,* followed by *Will & Grace,* and ending with *Just Shoot Me.* During the 1970s and 1980s, most of the highest-rated nights were built using the stacking strategy, including the most effective grouping of all—*The Cosby Show, Family Ties, Cheers,* and *Night Court* on NBC.

5. Tent-poling. Instead of splitting up successful adjacencies to insert an unproven show, in many seasons ABC and NBC turn to **tent-poling,** an alternative to hammocking. Each network focuses on a central, strong show on weak evenings, hoping to use that show to anchor the ones before and after it. This strategy (also called anchoring a night) is particularly useful when a network has a shortage of successful programs and consequently cannot employ hammocking. This was the basis for NBC's move of *Frasier* to Tuesday night. It was hoped it would hold up *The Michael Richards Show, Tucker,* and *DAG.*

6. Bridging. The bridging strategy is not as common in commercial broadcasting as the others but has been useful to public broadcasting and such cable networks as TBS and HBO. **Bridging** has three aspects: One such aspect is the regular use of long-form programs (one and a half hours or more) that start during the access hour and continue into prime time, thus running past the broadcast networks' lead-offs and interrupting their strategy when viewers later switch channels. HBO, for example, often schedules a hit movie starting at 7 or even 7:30 P.M. (EST) to bridge the start of network prime time.

The second aspect of bridging involves starting and ending programs at odd times, thus causing them to run past the starting and stopping points

for shows on other networks. This creates a bridge over the competing programs, which keeps viewers from switching to other channels because they have missed the beginnings of the other shows. For example, TBS regularly starts its programs at five minutes after the hour. As a result, TBS viewers are forced either to watch the next TBS show or tune into another program late.

CBS also used the bridging strategy successfully in its Sunday night lineup. The network regularly ran Sunday football games (or other sports) beyond the hour point, thus throwing the rest of the night off by about ten minutes. This meant that the huge audience that watched *60 Minutes* was stuck with CBS for the rest of the night. NBC also does this regularly with their Sunday afternoon sports broadcast. The alternatives for viewers are to leave a CBS or NBC show before it is over or to tune in to the competition late.

A third variation on this strategy involves scheduling half-hour shows against hour-long shows on the competing networks. By placing a strong show like *Friends* first, the audience is forced to watch the weaker *Steven Weber* or tune into the middle of hour-long programs on the other networks. The risk is that viewers may go to cable or put in a tape or DVD.

7. Counterprogramming. The networks also schedule programs to pull viewers away from their competitors by offering something of completely different appeal than the other shows, a strategy called **counterprogramming.** For many years, for example, CBS successfully countered the strong, action-and-youth-oriented series offered by ABC and NBC on Sunday nights with *Touched By an Angel,* a series providing continuity for the older, more sophisticated viewers tuning in to *60 Minutes* while appealing as well to viewers with strong traditional values. Much of WB's success was credited to counterprogramming with such series as *Buffy the Vampire Slayer* and *Dawson's Creek,* which targeted underserved segments of the audience at hours when the other two networks were attracting advertisers' most-desired demographics. Perhaps best known of all, ABC has successfully counterprogrammed all other broadcast and cable net-

works on Monday nights for years with its *Monday Night Football.*

In many ways, counterprogramming challenges the ideal demographics approach. Counterprogramming relies on finding a large, ignored group of viewers and scheduling a program for them. Most other strategies are intended to hold viewers who are already watching (**flow strategies**); counterprogramming *interrupts flow* to gain different viewers. This characteristic is believed to make counterprogramming an effective scheduling option, especially for the network facing a super-hit program on another network. However, the effectiveness of counterprogramming relates to the number of options available to viewers: The greater the number of competing shows, the less effective counterprogramming becomes.

8. Blunting. Networks that choose to match the competition by scheduling a show with *identical* appeal are **blunting** the competition. For example, in the 2000–01 season, NBC carried *Law & Order: SVU* and CBS carried *Nash Bridges* (just as ABC carried *20/20* and CBS carried *48 Hours*), in each case effectively splitting the number of viewers of one demographic group (though often not in half because one show will prove more popular than the other). If two networks are already blunting each other, a third network that counterprograms often gets higher ratings than either of the other two networks. In other words, the two networks running similar programs split part of the audience, while the counterprogram, in theory, gets everyone who likes the program plus all those who dislike the genre that is being blunted on the other two channels.

9. Stunting. The art of scheduling also includes maneuvers called *stunting,* a term taken from the defensive plays used in professional football. **Stunting** includes scheduling specials, adding guest stars, having unusual series promotion, shifting a half-hour series to long form, and otherwise altering the regular program schedule at the last minute. Beginning in the late 1970s, the networks adopted the practice of deliberately making last-minute changes in their schedules to catch rival networks off guard. These moves were calculated and planned well ahead of time but kept secret until the last possible moment. Such moves are intended to blunt the effects of competitors' programs. Generally these maneuvers are one-time-only, because their high cost cannot be sustained over a long period.

Scheduling hit films, using big-name stars for their publicity value, and altering a series' format for a single evening are common attention-getting stunts. *The Drew Carey Show* has provided a number of classic examples such as doing the sitcom as a musical or the now famous April Fools' Day episodes that ask viewers to "find what is wrong." Such stunts have high promotional value and can attract much larger than usual audiences. Of course, the following week, the schedule goes back to normal, so these efforts generate sampling but rarely create long-term improvements in series ratings. Creating unusual program **crossovers**—that is, using story lines and characters that involve more than one show—is a related stunt that affects ratings only so long as the crossover continues. One example occurred when a story was started on *Ally McBeal* and finished on *The Practice.*

CBS used another form of stunting when it paid more than $4 billion for rights to sporting events (including Major League Baseball) during the 1990s. This proved to be a financial disaster. Although the network expected to lose money most years, they hoped that the rewards from promoting CBS shows during the World Series and championship games would be more than worth the cost. Those hopes proved fruitless, and CBS lost tens of millions of dollars. Investing in popular but unprofitable specials to promote other network shows remains a popular form of stunting, however. The Olympics are a perfect example. NBC acknowledged that the $1.25 billion (plus production costs) it paid for the 2000 Summer Games and the 2002 Winter Games would have far exceeded revenues had the games been broadcast only on NBC. Using its cable networks in a multichannel setup was one part of the solution, but the main element in financial success was that advertisers bought time on both channels as a package. When ABC, after almost two decades, pulled out of the bidding for the Kentucky Derby,

arguing it was no longer possible to make money on the broadcast, NBC jumped in and paid what was asked. Indeed, the importance of sports for stunting had reached a stage where the amount paid only for the rights to professional football during the 2000–01 season surpassed the money paid for the collective rights to football, baseball, basketball, and college sports just the year before.

10. Seamlessness. In the 1990s the networks turned to a new strategy intended to accelerate the flow between programs. First NBC, followed by the other networks, eliminated the breaks between key programs (*Seinfeld* to *Frasier*, for example). Because viewers normally make most use of their remote controls in the two minutes or so that has traditionally occurred between programs, running the end of one program right up against the start of the next avoids the opportunity for remote use. This is called a **seamless transition,** and its goal is to keep viewers watching whatever network they began with.

In another twist, ABC (soon copied by the other networks) instructed producers to cut out all long title and credit sequences and to begin every program with an up-tempo, attention-getting sequence. (Titles may appear later in a program after viewers have, presumably, been hooked.) At the end of programs, all networks have experimented with split screens and squeezed credits to allow some program action (or "bloopers") in part of the screen to hold viewers' attention right into the next program (or very close to it).

Though these ten scheduling tactics are now used with more than 80 percent of the prime-time schedule, there is little reason to assume they have any large impact on viewing. Most were developed at a time when there was little competition and when few people had remote controls. Today, there is little reluctance on the part of the audience to change channels, and there is no lack of places to go. Nonetheless, most experts believe that well-defined and executed application of these programming strategies helps the broadcast networks hold onto significant portions of the viewership.

Schedule Churn

Stunting has resulted in a continual shifting of prime-time schedules, called **scheduling churn.** The number of series introduced or moved into new time slots during each month from 1971–72 to the 2000–01 seasons is shown in 4.7. The September/January figures represent the traditional first- and second-season starting points. Therefore, series introduced in other months represent changes in the schedule that took place while the season was in progress. The chart shows the schedule churn caused by moving established series into new time slots (program shifting) and the introduction of new programs (replacements, requiring the cancellation of old programs). Included are figures for the first and second seasons only (32 weeks, excluding summers), because they represent the networks' main programming efforts. (Here the term *churn* refers to the continual shifting of programs within the network schedule and should not be confused with subscriber churn as it is used in the cable and pay-television industries.)

The September 1980 and 1981 figures and the 1988 figures reflect the effects of strikes that delayed the start of those seasons. For other years, however, there is very little explanation for the high levels of churn. Indeed, the table shows only part of the picture. It shows only actual changes in the schedule. It does not show preemptions, which are now common. It also does not show the relatively new practice of running four to six weeks with no regularly scheduled series (just filler) as happens when one program is canceled before another is ready to take its place.

Industry expert Tim Brooks, author of *The Complete Directory of Prime Time Network and Cable TV Shows*, blamed much of this churn on "panic."[7] He pointed out that ratings had been declining since the mid-1970s but that the decline was not steady. Rather, ratings would drop, then stabilize for a few years. When this happened, programmers would proclaim success, claiming they now had control of the problem (and then continue doing exactly what they had been doing). These periods of stability were related to specific programs that, for a time, according to Brooks,

4.7 PRIME-TIME CHURN: TIME SHIFTS AND NEW PROGRAM INTRODUCTIONS FROM 1971 TO 2000

Season	Sept.	Oct.	Nov.	Dec.r	Jan.	Feb.y	March	April	Total	Percentage Outside of Sept./Jan.
1971–72	24	—	3	3	14	—	—	—	44	14%
1972–73	19	—	—	3	13	1	—	—	36	11%
1973–74	20	—	1	—	20	2	2	—	45	11%
1974–75	25	2	—	3	13	3	6	1	53	28%
1975–76	29	4	7	6	17	1	4	—	68	32%
1976–77	20	—	15	4	21	6	10	—	76	46%
1977–78	22	7	2	12	13	8	7	12	83	58%
1978–79	25	5	11	1	20	14	19	4	99	55%
1979–80	24	8	2	16	11	2	25	8	96	64%
1980–81	7	4	8	10	13	6	13	8	69	71%
1981–82	6	13	15	4	13	5	18	20	94	80%
1982–83	15	10	2	—	12	10	20	9	78	65%
1983–84	16	5	4	11	17	3	19	5	80	59%
1984–85	21	7	4	10	12	2	14	12	82	62%
1985–86	22	2	5	6	13	5	15	12	80	56%
1986–87	26	2	17	2	11	8	23	8	97	62%
1987–88	30	8	7	15	13	6	17	7	104	58%
1988–89	4	19	8	6	18	7	10	19	92	75%
1989–90	36	4	8	8	13	7	12	21	109	55%
1990–91	32	3	13	5	17	8	17	17	112	56%
1991–92	40	9	11	7	11	8	9	18	113	55%
1992–93	38	3	10	10	12	15	22	17	127	61%
1993–94	29	19	8	6	11	7	5	12	97	59%
1994–95	33	12	7	7	22	6	13	21	121	55%
1995–96	59	11	18	7	12	5	22	15	149	52%
1996–97	43	14	4	4	20	11	23	15	134	53%
1997–98	44	20	12	9	27	10	26	18	166	57%
1998–99	27	34	6	14	20	3	21	16	141	74%
1999–00	39	17	19	8	25	9	14	15	146	56%
2000–01	19	31	10	8	21	12	24	10	135	70%

Source: *Variety* and *TV Guide* listings, prepared by William J. Adams, Kansas State University. The Fox network is included in the figures beginning in 1989. Movies, sports, and specials are not included.

brought in big audiences. During the 1980s, it was *Cosby*; then in the mid-1990s it was *Roseanne* and *Home Improvement*. Later the numbers again stabi-lized when *ER* and *Seinfeld* became hits. When one of these shows slid downward, though, the overall ratings for that network went into a "free

fall." When this happens, as it inevitably does, programmers panic. Instead of changing the practices that seem to be driving the audiences away, they do more of them. For example, when ratings began another free fall in 1997, programmers went into a schedule shuffling frenzy.

Examination of all 52 weeks during the 1998–99 seasons revealed an ugly picture.[8] WB changed its schedule 34 times. Because it had only 14 programs in prime time and didn't actually cancel or add to this number, the extent of its programming instability is obvious, but not extraordinary. Even UPN moved its ten shows around 28 times. Astonishingly, ABC, running 24 series, made 64 changes, while NBC changed its 29 series 62 times. CBS was relatively conservative with only 47 changes in its 25 series lineup, while Fox changed its 16 programs 30 times. With the Big Four, these changes also included the cancellation and addition of new programs. But 25 percent of the moves involved nothing more than putting a program back into the time slot it had been moved from, often just four or six weeks earlier. It is hard not to agree with Brooks that this constant motion represents panic.

A program that a network wants to get rid of can be canceled outright or **manipulated** (time shifted or churned) until its ratings fall. Manipulation sometimes makes good public-relations sense when a show is critically successful or widely popular, although not quite popular enough among the desired demographic group (some critics have suggested that this was the problem with *Brooklyn Bridge*). Examination of the results of program churn show that *an individual program's ratings almost always fall when it is moved two out of three weeks* (especially when moved in the second season). Studies also show that a new series that has improved upon the time slot it was originally given always fails if it is moved. Other prime candidates for excessive schedule manipulation include programs with higher than average production costs that would cause managerial problems if abruptly canceled (because they are supported by a highly placed executive or advertiser). Many believe that the 1995 shift of *Murder, She Wrote* on CBS from Sunday to Thursday was a clear ex-

ample of this type of move. Once low ratings or even a downward trend is achieved, network programmers can point to the numbers to justify cancellation (on the few occasions when some justification seems useful). During an apparent panic, however, programs are moved for no apparent reason. Just showing the company something is being done seems to be the only real programming strategy at such times.

Cancellations

To attract and hold young viewers in large numbers, the Big Four now introduce nearly five dozen new programs to their prime-time schedules each year. Discounting movies and specials, at present the networks collectively offer an average of 40 new programs, adding to the average of 80 established ones returning to the air each fall. Which new entries will beat the odds and survive this critical sweepstakes each year is the key question. *Typically, nearly 70 percent overall* (75 percent in the 1990s) *of new series fall by the wayside.* Some are pulled within a few weeks; others may last until early spring if a network believes that too few viewers sampled them in the fall. Some are kept on the schedule only until their replacements are readied.

New programs have a higher cancellation rate than programs overall because the latter includes the few hits that go on from year to year. The long-term average failure rate for all three networks exceeds 68 percent. The network enjoying the highest overall ratings naturally cuts the fewest programs, and conversely, the one with the lowest average ratings scissors its schedule most drastically. What the network in the middle does varies from year to year.

PROMOTION'S ROLE

All nine networks use **on-air promotion** to introduce new programs. Beginning as early as mid-July and continuing through November (after especially heavy season-opening salvos), networks

intensify promotion of their programs and their overall image. In addition, networks use **print promotion,** especially television guides and newspaper listings to catalog offerings for particular evenings. For a long time, *TV Guide* magazine was so important to network television that programmers sometimes delayed schedule changes so that the changes could make *TV Guide's* deadline for affiliate program listings. The promotional value of *TV Guide* is essential both locally and nationally, although its format is becoming more unwieldy as the magazine seeks to incorporate more and more program services.

On-air promotional announcements play a pivotal role in the ratings success of a program. Not until a program is safely past the rocks and shoals of its first several airings (or until it becomes clear that nothing can help to get it past these early trials) does promotion let up. In the fall, on-air **promos** plug every program scheduled to appear in a season lineup. Weak or doubtful offerings needing extra stimulus get extra exposure, at least until the network gives up. Extensive on-air program promotion continues year-round, with extra efforts devoted to sweeps periods. New slogans and symbols extol the virtues of overall network offerings and accompany all promotional announcements. In recent years it has also become common for the networks to join with major stores, such as K-Mart, to promote the new season. Although studies have suggested that effective on-air promotion may affect as much as 10 or even 20 percent of prime-time ratings,[9] much of the remaining ratings must be attributed to the appeal of the program. Nonetheless, promotion in print, on the air, and on the web is the primary way networks invite viewers to try out programs. It is also the way that the networks convince viewers to associate a program with a particular network. It is little help to Fox if most diary keepers think *Ally McBeal* is on ABC.

CHANGING FORMAT EMPHASES

The kinds of **formats** dominating evening schedules have altered over time. One change is the increased use of *specials*—a term encompassing one-time entertainment programs, major sporting events, and more rarely, major news documentaries. Other changes are the growth in use of reality shows and news magazines. Nonetheless, to minimize risk, networks continue to rely on the traditional winners: situation comedies, dramas, and movies.

Sitcoms and Crime Dramas

Situation comedies and dramas focusing on crime have a long history in network television, stretching back to such shows as *The Life of Riley* and *Dragnet* in the early 1950s through *Frasier* and *C.S.I.* From 1971 to 1991, more than 375 sitcoms and 160 crime dramas were tried because these two formats:

- Were inexpensive to produce (initially)
- Attracted sizable audiences
- Attracted the ideal demographics

The cost of sitcoms and crime shows has gradually escalated, though, until they cost more than most other formats. As a result, the crime drama began to morph into the reality show. Situation comedies, however, remain a dominant feature of prime-time television. Although examples of top-rated shows in both of these types are easy to find, their overall success rate has declined steadily.

Situation comedies fall into two main types: family-based comedies like *The Nanny, The Hughleys,* and *Malcolm in the Middle,* or occupational comedies like *Just Shoot Me, Spin City,* and *Frasier.* Together, these two types account for more than three-quarters of all situation comedies offered over the last 20 years. More unusual sitcom formats, such as *Friends, The Simpsons,* or *Futurama,* occasionally turn up, but only in limited numbers and with very few attempts to copy them even when they succeed in the ratings. **Crime dramas** slowly changed from private citizen do-gooders like *Magnum P.I.* to gritty police dramas like *NYPD Blue.* The mid-1990s also saw the return of courtroom dramas, often in connection with a police

show, as was the case with *Law and Order*, or on their own as with *Family Law* and *Judging Amy*.

Specials

Of the approximately 700 specials each year, more than 500 have been entertainment specials for adults, such as the Garth Brooks specials, or for children, such as the Charlie Brown Christmas specials. About 100 each year are sports specials, including the Super Bowl and World Series games. The remaining 100 divide among dramatic specials and news specials, including interviews such as those by Barbara Walters and occasional documentaries.

Entertainment specials often attract superstars (such as Dustin Hoffman and Katharine Hepburn) whose regular motion picture work or performing schedule (or health) prevents them from participating in series programs. Star-studded specials can invigorate a schedule, encourage major advertiser participation, provide unusual promotional opportunities, and generate high ratings and critical approval.

Because of their popularity, the number of specials steadily increased each season, peaking at the end of the 1970s with the beginning of the economic recession. In the 1980s, specials changed format: Increasingly they became long-form episodes of regularly scheduled series, presented in their usual time slot. For example, the record-breaking final episode of M*A*S*H (amassing an extraordinary 77 share) was an extended episode of the existing series, as was the final episode of *Seinfeld*. Since the early 1980s, one-fifth of the five hundred or so entertainment specials each year have been in fact long-form episodes of regularly scheduled series. Theoretically, network programmers are awake to the possibility that too many specials differing sharply from the regular programming might interrupt carefully nurtured viewing habits beyond repair—hence, the trend toward long-form episodes of regularly scheduled series. Such shows also have the advantage of being relatively inexpensive to produce and promote, and they also take advantage of existing audiences, thus reducing risk.

Nowadays, network prime-time sports consist of ABC's *Monday Night Football* and playoffs and championships in the major sports, as well as special events such as the Olympics. Although the networks carry a great deal of football, basketball, baseball, tennis, and golf, most is relegated to the weekends and specials. Univision and Telemundo carry soccer and some other sports, and UPN has been successful with *WWF Smackdown*, but most soccer, wrestling, and other sports command prime time on cable, not on the broadcast networks. Big sporting events do bring prestige to the network, are popular with affiliates, and fill out advertising packages by delivering men viewers of all ages.

Magazines and Reality Shows

The long-term ratings success of *60 Minutes* on CBS led ABC and NBC to imitate it with such **magazine series** as *20/20*, *Primetime*, and *Dateline NBC*, and CBS to create *48 Hours*. Success also encouraged the development of so-called reality-based programming such as *America's Funniest Videos*, *Unsolved Mysteries*, *America's Most Wanted*, and *Rescue 911*. Such programs cost less than half the average for entertainment series, and some can readily be aired on successive nights or doubled up to fill holes in the schedule. Non-news reality shows are especially useful for capturing surfers who can tune in in the middle of these segmented programs and still understand what is happening. Reality-based series usually generate high initial ratings, however, that fall quickly as the show enters its second or third season. As already noted, such programming has no potential for off-network syndication. A boom in the 1990s occurred because reality-based shows, like news magazines, are very cheap to produce and promote, appealing to the networks in tough economic times. Programs like *America's Most Wanted* and *Unsolved Mysteries* became a way to hold down production costs, and recent efforts combined it with the game show genre in such programs as *Survivor* and *Member of the Band*.

Movies

Three types of productions regarded as movies fill prime time on the broadcast television networks: (1) **theatrical feature films,** those made originally for release in theaters; (2) **made-for-TV movies,** similar to feature films but made specifically for network television airing in a two-hour format containing commercial breaks; and (3) **miniseries,** multipart films made especially for broadcast airing in several installments. All three types share these major advantages for the networks:

- They fill large amounts of time with material that usually generates high ratings.

- They make it possible to air topical or controversial material deemed inappropriate for regularly scheduled network series.

- They permit showcasing actors and actresses who would otherwise never be seen on television.

The popularity of superstars such as Tom Cruise, Robert Redford, and Julia Roberts can be tapped by showing their movies. Many other stars, such as Dustin Hoffman, Gary Oldman, or Diana Ross, such producers as Martin Scorsese and such writers as John Mortimer (*Tea with Mussolini*), who would never agree to work in a TV series, are happy to be showcased on a miniseries or made-for-TV movie.

The three kinds of movies also share one major disadvantage—exceptionally high cost for the networks. Miniseries are typically the most expensive, and theatrical movies the second-most costly. Both are more risky in ratings than made-for-TV movies, but all three remain widely popular because they fill big chunks of time.

Theatrical Movies

The theatrical film or motion picture has been a mainstay of prime-time programming since the mid-1960s, but cutbacks in Hollywood production during the late 1960s and early 1970s caused severe shortages of features. At that time, many critics predicted a phase-out of theatrical films in television prime time. The 1980s, however, saw a re-vitalization of Hollywood film making. In 1980 only 120 theatrical motion pictures were made, but by 1985 the number had risen to 320, and by 1991 it hit about 400. At present almost 600 films are released each year, reflecting four fundamental changes in the motion picture business—changes in release dates, the addition of sequels, expanded content targeting, and changes in release cycles.

Instead of the traditional head-to-head summer/winter release schedule, in the 1980s Hollywood studios began juggling **release dates,** providing a continuous flow of new films into the market (thereby lessening the effects of strong competition from other movies). For example, *Mission Impossible II, X-Men, Big Momma, Gladiator, Dinosaur,* and *Shanghai Noon*—all major productions for the summer of 2000—would have been released at the same time in the old days, causing the inevitable box-office casualties that major studios once considered a normal part of competition. The new strategy separates the release of these big films by a few weeks, allowing each movie to dominate entertainment news during its initial week, a period crucial to theater owners, who demand immediate success (or they pull the film). This strategy also had the unexpected advantage of increasing movie attendance steadily throughout the late 1980s and 1990s.

During the last decade, Hollywood also began investing heavily in **sequels** such as *Star Wars II–VI, Rocky II–V, Flintstones II,* and so on. Such sequels benefit from built-in audience interest and involvement with the characters as well as from self-perpetuating promotion and reduced production costs. Some films, such as *Back to the Future II–BTTF III,* were filmed at the same time for separate, sequential release. The television networks often like to license sequels for showing during sweeps months because they need relatively little promotion compared to made-for-TV movies and miniseries. The problems are that they also cost more than made-for-TV movies and may have already burned out with the audience if most television viewers have already seen them and are not interested in seeing them again with advertising interrupting every few minutes.

In spite of endless complaints about the quality of movies today, a comparison of film subject matter in the 1950s and 1960s with that at present reveals much greater diversity in film topics today. Today's motion picture subjects have **expanded content targeting,** with topics that range from period adventures such as *The Patriot* and *Gladiator* (a remake of *Fall of the Roman Empire)* to such old-fashioned romances as *I Dream of Africa*, to Shakespeare in the form of an updated *Hamlet, Titus,* and *Love's Labour's Lost*. Sophisticated comedies like Woody Allen's *Small Time Crooks* were balanced by such action movies as *The Perfect Storm* and mysteries like *Frequency*. Children's shows range from the combined animation/live action of *Rocky and Bullwinkle* to the claymation *Chicken Run*. Even a few controversial social-topic films pop up, such as the more politically correct version of *Shaft*. By increasing the diversity in subject matter, Hollywood has learned to thrive on a variety of audiences instead of narrowly targeting teenage moviegoers. Producers now design some films to appeal to a broad audience base (12 to 44 years), while others deliberately target smaller, more selective audiences, knowing that the multiplex theater systems allow groups to split up and go where they want. Family members no longer have to decide on just one film. Some producers even film two versions of controversial scenes—one for theaters in Europe and a second to meet U.S. television standards. These changes have made more feature films useful to the television networks.

Perhaps most important of all to television, theatrical motion-picture producers modernized their **release cycles** over the last two decades. Movies continue to be released first to theaters, but when box-office receipts begin to fall off (often in a couple of weeks), a movie is usually shelved for several months, then **rereleased** for a second theatrical run. About six months after the final theatrical release, movies now appear in the videocassette and DVD market, first primarily for rental (at a high price), then several months later at a much lower price for sale to collectors. In the meantime, the movie may have appeared on **pay-per-view** television. At about the time video-

4.8 COMPARATIVE FLOW IN REVENUES FOR MOTION PICTURES AND BROADCAST TELEVISION

Motion Picture	Step	Television
Theatrical release	1	Network run
Merchandising of related products	2	Merchandising of related products
Pay-cable and international release	3	International release (and possible rebroadcast on company-owned cable network)
Video release for rental	4	Video release (or re-cut as movie for cable or international market)
Second theatrical run (discount houses)	5	Off-network syndication—exclusive rights
Network release and lower-priced video release	6	Off-network syndication—non-exclusive rights
Non-pay cable release	7	
Local station sale	8	

cassette and DVD movies go down in price, they are licensed to the **pay-cable networks.** After a pay-cable run, they are offered to the broadcast networks; then, after a couple of years, they become available to affiliates and independent stations.

During all of this time, many movies also make money from the side business of merchandising. Figure 4.8 spells out the usual steps in revenue flow for movies and television programs. Movie producers license companies to make dolls, lunch boxes, clothes, CD versions of the music, movie posters, collections of stills, art work or planning materials from productions, and so on, all of which can be sold. In some cases, such as *Star Wars*, side merchandising produces more money than the box office does. As a result of all of these steps, big bud-

get movie productions, as well as smaller limited audience films, have become highly profitable.

This model is becoming important to television producers as well. Indeed, the syndicators of programs like *Xena* produce entire catalogs of merchandise. Many also now release video collections at the end of each season and don't even go into production without first lining up several different countries to run the series. PBS has also made extraordinary moves in this direction, selling everything from videos and CDs to T-shirts. They have also formed many international deals to sell programs overseas. Seeking multiple revenue streams, broadcast television is just now beginning to copy this pattern. For example, the failed CBS series *Space Rangers* was re-cut into three movies that were sold around the world, re-shown on pay-per-view, and sold as a video set.

Foreign release of U.S. television programs has expanded enormously, allowing television programs (as American films had done for years) to derive huge sums from foreign markets, often surpassing income from the domestic market. Agreements among producers and distributors, primarily with England and Australia, for wider distribution of foreign-made films in the American market also increased competition—to the advantage of some television programmers. Although the broadcast networks have been very reluctant to encourage foreign productions, original syndication has followed the motion-picture model and now is heavily involved in foreign production.

Motion pictures pose other problems for the broadcast networks. Their popularity on network television is unpredictable. *Star Wars*, for example, got lower ratings than a competing made-for-TV movie. Also, many theatrical films contain violence or sexual content that must be removed before broadcast television airing. Several scenes had to be shortened and lines redubbed before *Risky Business* met network continuity standards for prime-time broadcast. Editing such films as *Born on the Fourth of July* for television often destroys the flow of a film and may anger viewers. Moreover, the networks now compete with pay cable and with original syndication for the top theatrical

films, driving the price for such movies up. Films that reach cable viewers before the networks can show them often exhaust the mass audience's interest, resulting in fewer such films being aired on network television. The theatrical film, even if it became available in unlimited supply, would not be a panacea for the shortage of network programming.

Made-for-TV Movies

Many viewers and critics bewail the disappearance of the **dramatic anthology** format, sets of single-episode television plays presented in an unconnected series. In reality, however, the anthology format went through a style change and returned as the **made-for-TV movie.** During the 1955–56 season, the very peak of the anthology era, dramatic anthologies made up about 526 hours of prime time. In 1989–90, a peak year, 624 made-for-TV movies aired in prime time (not including those made for cable). The best of these movies compare favorably with the best of the dramatic anthologies of the earlier era. For example, *A Message from Holly, The Silence of Adultery,* and *In a Child's Name* were made-for-TV movies of the highest caliber, filling the equivalent role in programming fare.

In the later 1970s, the made-for-TV movie replaced the pilot as the major method for testing new series ideas. Programs such as *Walker, Texas Ranger* and *Providence* succeeded as television movies before becoming series. Made-for-TV movies as pilots have four distinct advantages:

- They can be profitable.
- They can target a desired demographic group.
- Audiences and affiliates like them.
- They have syndication potential.

Such pilots pay their way whether or not the concept ever becomes a series. Even when such a series later fails, the networks usually have made a healthy profit on the made-for-TV movie's initial run and on the normal advertising revenues from the run of the weekly series. Moreover, the made-for-TV movie has the advantage of being made to

order to fit within a network's existing schedule. It can target a specific audience to maintain a night's flow and avoid the disruptions that theatrical movies often cause.

As a result, the made-for-TV movie pilot has become very popular with networks, affiliates, and, fortuitously, with audiences. The ratings for some of these films equal and even surpass those for feature films shown on television. All of the top-10 movies shown on network television during 1999–00, for example, were made-for-TV movies. They also have an **aftermarket** (one or more revenue streams after the network airing): Although such films now average $5 million to make (some as high as $10 million), such movies often command high prices in syndication and sell well as videocassettes and DVDs. Many have been sold as theatrical films in foreign markets. This flexibility, their popularity, their precise targeting, and revenue advantages over regular video pilots, and the fact that the average made-for-TV movie costs half the license fee of the average Hollywood theatrical movie, have established this format firmly in the economics of network television.

Miniseries

The success of specials and limited series on PBS's *Masterpiece Theater* led the commercial networks into the production of multipart series presented in three to six episodes on successive nights or in successive weeks. Called **miniseries,** they run for as long as ten or more hours. The best known of recent miniseries include *10th Kingdom, Cleopatra,* and *Arabian Nights.*

Miniseries typically begin and end on Sunday nights, the night of maximum viewing. Shorter miniseries tend to be scheduled on sequential nights, while longer series, such as *North and South, Books 1 and 2,* stretch over two weeks, skipping the evenings on which the network has its most popular programs. These extreme long forms, however, have become very rare. Because of their exceedingly high cost, averaging $30 million to $40 million each, miniseries are usually created only for sweeps periods.[10]

By the 1980s the costs for **long-form miniseries** (ten hours or more) had skyrocketed to the point that the 30-hour *War and Remembrance* was estimated to cost more than $100 million. At the same time, ratings for such long-form series dropped sharply, losing tens of millions of dollars without bolstering the network's overall ratings position. As a result, in the late 1980s the networks switched from long-form to **short-form miniseries** (four to six hours). Shorter series such as *Tom Clancy's Op Center, Million Dollar Babies,* and *The Burden of Proof* reduced the networks' financial risks and limited the damage that failures could cause to the overall ratings.

The success of *Lonesome Dove* singlehandedly pulled CBS out of its 1989 rating doldrums, however, clearly showing that the traditional long form can still be a major factor in network rating strategies. Networks also value the prestige that comes from successful long-form miniseries such as *North and South* and *Love and War,* and when planning the next year's special schedule, some concepts always sound like winners. Consequently, even though the long form may be limited to one or two projects a season, both short-form and long-form miniseries are here to stay because of:

- Blockbuster ratings
- Prestige
- Critical acclaim
- Series potential

By the 1990s the network had also changed the way long-form miniseries were presented. Instead of making one program that ran ten to 24 hours on successive nights, the networks turned to series that filled as much time, but that could be separated into several made-for-TV movies and shown at the rate of one every month or two. This strategy worked well with the reintroduction of the old favorites like *Murder She Wrote* as limited series.

A multistep profit system, designed like the one used for motion pictures, made the miniseries more popular than ever by 2000. This was especially true for such high-level fantasy concepts as *Merlin, Alice in Wonderland,* and the Romeo and

Juliet takeoff *Leprechauns*. Not only did these miniseries gain high ratings on the networks, but they sold well internationally and as videotape and DVD sets offered during the original showing on the network. NBC also began the practice of a delayed repeat about one week later on its cable networks, thus producing another round of advertising revenues. Even such critical and audience disasters as *Noah's Ark* (which left many wondering if the writers and producer had ever read the book and provided late-night comedians with material for weeks) proved to be big money makers.

NETWORK DECISION MAKING

Few program decisions precipitate as much controversy as cancellation of programs. Because commercial television is first of all a business, with tens of thousands of stockholders and hundreds of millions of dollars committed for advertising, the networks' overriding aim is to attract the largest possible audience in the ideal demographic range at all times. Networks always aim at the number one position. Traditionally, ratings have been considered the most influential prime-time programming variable, and the networks make many controversial decisions each year based on these numbers. This often results in (1) canceling programs favored by millions of viewers, (2) countering strong shows by scheduling competing strong shows, (3) preempting popular series to insert special programs, and (4) falling back on reruns late in the season when audience levels begin to drop off.

However, the type of program, the ranking compared to the competition, the size of production fees, and the target demographic group may be as important as the ratings in cancellation decisions. New situation comedies and reality-based series are more likely to be held than other kinds of series producing equivalent ratings. Also, series with low production fees are more likely to be held than more expensive programs, and finally, series that appeal to the network's concept of "proper demographics" and some would now argue "political correctness" may be held even when ratings are low.

The Critics

Critical approval and the extraordinary promotional opportunity that public acclaim provides also figure in decisions to cancel or hold low-rated new programs. Acclaim usually has some effect only in the absence of other rating successes. The kudos for *Hill Street Blues*, for example, bolstered NBC's image at a time when it was sorely in need of prestige, persuading programmers to stick with the show even in the face of low ratings. The fact that Grant Tinker was both head of NBC programming and producer of *Hill Street Blues* may also have been a contributing factor. Even so, under Tinker's direction, slow starters such as *Mama's Family*, *Cheers*, and *St. Elsewhere*, which might well have been canceled during Fred Silverman's earlier NBC tenure or Brandon Tartikoff's later time, remained in the prime-time schedule. The same connection between critical acclaim and patience even in the face of low ratings can be seen for the low-rated *Party of Five* on Fox and the moderately rated *West Wing* on NBC. Sometimes the networks decide to go along with the critics, at least until something with better numbers comes along.

Despite such exceptions, the industry depends almost totally on *early ratings* to determine a show's fate, because the major advertising agencies use these figures as the primary basis for buying network time. As of 2001, a single rating point translated into more than one million homes (1 percent of 101,000,000 total households). Over the course of a year, a single point more than the competing networks represents more than $40 million in network pretax profits. Small wonder then that ratings rule the networks, public irritation with the process notwithstanding.

The Censors

The broadcast **Standards and Practices Department,** a behind-the-scenes group, exercises total authority over all network programming. Cynically and often angrily called "censors," the department acts as policeman and judge for all questions concerning acceptability of material for broadcast.

It often finds itself walking a thin line between offending viewers or advertisers and destroying imaginative programming that may pull in high ratings. It decides between the imaginative and the objectionable. Members of the department read submitted scripts; attend every rehearsal, filming, or taping; and often preview the final products before they are aired. If, in the department's judgment, a program fails to conform to network standards in matters of language or taste, it can insist on changes. Only an appeal by the chairman or president of the company can overturn its decisions.

Over the years, the department's criteria for acceptability have changed. In the early 1920s, one of the hottest issues was whether such a personal and perhaps obscene product as toothpaste should be allowed to advertise over the radio airwaves. By 1983 the hottest question was whether NBC's censors would permit a new series, *Bay City Blues,* to air a locker-room scene that included nude men photographed, as the producer put it, "tastefully from the back." By the mid-1980s, child abuse, abortion, and homosexuality were the problematic topics, while the 1990s brought the thorny questions of AIDS, condoms, obscene language, and, as always, how explicitly sex could be shown. By 2002, there was a new concern about violence and such difficult issues as drinking and smoking.

The Standards and Practices Department decides acceptability on a show-by-show basis. While decisions may seem arbitrary, the censors normally follow certain guidelines. For example, a program's perceived audience is an important factor. A show appealing to children will be regulated much more heavily than one aimed at adults and scheduled later. The program's daypart is also a major consideration. Traditionally, the censors have been much easier on series run during the morning or early afternoon (most notably, the soap operas) than on programs run during prime time. They are also much easier on programs that run after 10 in prime time. Also, censors tend to be more liberal with specials, miniseries, and made-for-TV movies than with regular weekly series.

During the mid-1980s, broadcast Standards and Practices Departments increasingly found themselves fighting organized audience objections to what some perceived as an overly permissive network attitude toward sex. Indeed, content analyses of TV programs showed that the sexual intercourse mentioned on television occurred mostly outside of marriage as a result of one-night stands and that abstinence was depicted as a physical impossibility, a sign of mental illness, or, as shown on one *Beverly Hills 90210* episode, a sign of homosexuality. In 1994–95, *NYPD Blue* broke new ground by showing more nudity than ever before and more graphic sex scenes, resulting in many affiliates refusing to air the series. Feminists, religious fundamentalists, and other groups denounced this portrayal of sex without love or consequences. In 2000, *God, the Devil and Bob* outraged religious groups with what many saw as a direct insult to religion. During the same year, some producers, gay groups, and other liberal organizations were demanding even more graphic and controversial portrayals of sex in prime time, and the NAACP was demanding more minorities in major roles.

Cost-cutting measures at the networks were also resulting in fewer "network censors" to go around, and producers had learned a trick to get objectionable scenes into prime-time series: Producers would write "worse" scenes than they hoped to shoot, knowing the censors would object, leaving the producers to "compromise" by submitting the version of the scene that had been planned from the start. Standards and Practices executives often gave in to this ploy. Worse yet, there were times they did not object to the original script, forcing the producer to do the scene or admit they had never planned to in the first place. As a result, prime-time television continues to push hard at the evolving bounds of good taste. A new element was added, however, when government required the V-chip in television sets, which in turn required ratings of shows on the amounts of violence and sexual content to allow parents to lock out shows with certain rankings. Nonetheless, the networks now battle advertisers more than the producers or the public over content standards.

WHAT LIES AHEAD: RISK AND REWARD

Supposedly, the three major networks prowl for the breakthrough idea—the program that will be different but not so different as to turn away audiences. *The Cosby Show* was one such show in 1984–85, as was *ALF* in 1986. *Married . . . with Children* astonished viewers in 1987, *Roseanne* made a splash in 1988, *Friends* reintroduced the buddy sitcom in 1995, and *Malcolm in the Middle* suggested an entirely new idea for the family sitcom in 1999. The biggest change of course was the rebirth of the prime-time game show with *Who Wants to Be a Millionaire?* in 2000—after an absence of nearly 40 years. Such shows, however, are rare and the exception to the rule.

In recent years, all four networks have had entire seasons without a single new hit. In truth, network programmers can only guess what the next hit will be and why it succeeds. A program failure is easier to analyze. It can result from the wrong time period, the wrong concept, the wrong writing, the wrong casting, poor execution of a good idea, poor execution of a bad idea, overwhelming competition, the wrong night of the week, and a dozen other factors. Conversely, success is very hard to analyze or copy.

Although the actual cost of production has gone down dramatically through the use of digital technology and computer-produced effects, other factors have canceled out the savings and caused the full cost of production to continue to skyrocket. Some of those factors are directly related to programming decisions and seem to be the opposite of what many would naturally assume would happen. For example, the inability of programmers to produce successful shows has actually caused the price of production to go up. With so few true hits, programmers seem willing to pay almost anything to keep a successful program, as demonstrated by the incredible amounts paid to renew such series as *ER* and *Friends*. The networks are also locked in bidding wars for top specials and sporting events, again, causing the prices to go

through the ceiling. In a strange type of domino effect, however, as the top price levels have gone up, directors, writers, actors, and people in all other branches of production have also demanded more. As a result, costs at all levels have gone up even as ratings have gone down.

At the same time, the incredible failure rates have resulted in an insatiable demand for replacement series. It is not at all uncommon at this point for up to half of new prime-time series to fail within six weeks. These shows have to be replaced, and, because development is the most expensive phase of production, this constant demand for new series has sent development costs out of sight. As these new programs virtually never do better than the original series, one would presume, just consider the economics, that programmers would leave new series alone for at least a year to see if they could build audiences. The continual hope for that one elusive program that will break the trend, however, produces a type of feeding frenzy in which no programmer is willing to deviate from this destructive cycle.

Another unusual factor affecting program costs actually began as a money-saving move back in the 1970s. At that time, the assumption that people watch television and not programs meant that variety was of very little importance. As a result, the major networks concentrated new programming into a limited number of genres. By the mid-1970s, two of those genres, situation comedies and crime dramas, occupied more than half of the prime time schedule. At the time these were two of the cheapest forms of programming to produce that could still draw an audience. By the mid-1980s, variety even within these two formats had all but disappeared, resulting in widely-recognized standard formulas for programs in both genres. By 2001, crime dramas had been reduced in favor of reality programs, but the level of variety had continued to decline until three types of programming occupied more than 80 percent of prime time.

Initially, it would seem the concentration on this limited variety was done to reduce cost, but the effect was exactly the opposite. In truth, there are only a limited number of producers, writers,

directors, and so on who do these genres well. As all major networks began bidding for these same people, the cost for the formats went up dramatically, until by the late-1990s, situation comedies and crime series cost more to produce than science fiction and westerns (traditionally, the most expensive forms of programming). This indeed may be why the networks have moved so strongly toward reality and news programs, the least expensive types of programming to produce at the moment. Reality programming now seems to be following the same pattern as situation comedy and crime, however, because the cost for such series as *Survivor* and *Who Wants to Be a Millionaire?* have doubled and even tripled within a single year.

Playing it safe with formats known to satisfy audiences is a normal reaction on the part of network executives. Considering the high stakes involved, most program executives naturally resist any program that can be described as a trailblazer until they have nothing to lose. Those programmers who dare to depart from the formulas, however, may occasionally enjoy the fruits of such standout hits as *The X-Files*. Indeed, the current rate of program failure suggests that the unusual might be less risky than sticking to copies of old series. Given the rapid turnover in network presidents and vice-presidents of programming during the 1990s, however, iron nerves are required to allow a really new idea to remain on the schedule long enough to attract a significant following.

Predicting the future of any medium is a risky undertaking at best. Nonetheless, there are certain trends that are strong enough to suggest some aspects of broadcasting in the future. A 30-year pattern in programming practices, combined with a seeming inability of programmers to challenge the precepts of traditional lore, suggests that broadcast audiences will continue to decline while cable audiences will increase. Eventually, then, broadcast networks and the more popular cable networks will resemble each other in average ratings. The outcome will mean further increases in original production for cable and decreases in production for broadcasters (combined with heavy reliance on

repeats), making the Big Four look more like the cable television of the 1990s.

As ratings and compensation continue to fall, eventually large, nonnetwork group owners may decide they can do better on their own. It would be natural for such group owners to either increase their participation in original syndication production for their own systems or to buy into production houses directly, thus in essence, becoming networks themselves. Such a scenario suggests that the future American broadcasting system will more closely resemble the system that presently exists in such countries as Japan, rather than what is now familiar. In short, there would be more networks, but fewer affiliates. That is to say, the networks would be doing their own production, which is then distributed through stations that they also own as part of a much larger entertainment wing of a giant corporation. Such a scenario implies that the amount of choice for viewers would go up even as true national networked distribution goes down. In short, such companies would not be able to reach 98 percent of the country as is now the case with ABC, CBS, and NBC. It is possible, however, to envision a situation in which group owners would produce their own programming and then syndicate it to other group owners, or form a system not unlike the old Mutual Broadcasting organization in which each group owner produced a few shows that were then shared with other group owners in order to put together a full schedule. Regardless of which vision of the future occurs, there is one thing common to all of them: *The power of the big broadcast networks to control information and entertainment will continue to decline, and the division between broadcasting and cable will continue to blur as the companies buy into one another and begin to mirror each other and make greater use of the Internet.* Indeed, the mixed broadcast/cable/online model now used by Pax, The WB, and Univision may be the future of the business. In any case, one thing is clear, the next 50 years will bear little resemblance to the last 50 years.

SOURCES

Auletta, Ken. *Three Blind Mice: How the TV Networks Lost Their Way.* New York: Random House, 1991.

Croteau, David and Hoynes, William. *Media/Society: Industries, Images, and Audiences.* California: Sage Publications, 2000.

Fowles, Jib. *The Case for Television Violence.* California: Sage Publications, 2000.

Goldenson, Leonard H., with Wolf, Marvin J. *Beating the Odds: The Untold Story Behind the Rise of ABC: The Stars, Struggles, and Egos that Transformed Network Television by the Man Who Made It Happen.* New York: Scribners, 1991.

Paisner, Daniel. *Horizontal Hold: The Making and Breaking of a Network Television Pilot.* New York: Birch Lane Press, 1992.

Tartikoff, Brandon and Leerhsen, Charles. *The Last Great Ride.* New York: Turtle Bay Books, 1992.

Thompson, Robert J. *Adventures on Prime Time: The Television Programs of Stephen J. Cannell.* Westport, CT: Praeger, 1990.

Tinker, Grant and Rukeyser, Bud. *Tinker in Television: From General Sarnoff to General Electric.* New York: Simon & Schuster, 1994.

Variety. Weekly trade newspaper of the television and film industry.

www.ABC.com

www.CBS.com

www.Fox.com

www.NBC.com

www.PAC.com

www.TELEMUNDO.com

www.UNIVISION.com

www.UPN.com

www.WB.com

INFOTRAC COLLEGE EDITION

Consult InfoTrac College Edition using the password provided with this book. Use boldfaced terms as Key Words and section headings from this chapter for Subject searches.

NOTES

1. Mathews, R. The economics of programming: Cable nets a huge force in media giants' earnings. *Cable World,* 13 October 1997, pp. 17–31.

2. Schlosser, J. and McClellan, S. Moneyphilia. *Broadcasting & Cable,* 22 May 2000, pp. 16–20.

3. The WB wants laughs. *Broadcasting & Cable,* 22 May 2000, p. 31.

4. Klein, P. Programming. In S. Morganstern (ed.), *Inside the TV Business.* New York: Sterling, 1979.

5. Many of the networks' financial problems came from unwise investments during the 1970s and from debt built up during attempted takeovers during the 1980s. As a result, the Big Three networks entered the 1990s in the worst economic condition in their history, causing them to move cautiously and resulting in their takeovers by larger companies; however, the downward trends of the 1980s were only a temporary condition. By the mid-1990s, from a revenue point of view, the broadcast networks were stronger than ever. Still, they continued to program with extreme caution, relying on theories developed in the late 1960s and computerized testing.

6. In Prime-time network speculators: the fall guys. *Broadcasting,* 1 April 1991, p. 35–41. The head of programming for CBS pointed to two examples where originality had led to unwise cancellation decisions: *The Flash,* for example, a 1990–91 series, might still be running and a major international hit had the network had held onto it; he also suggested that the successful syndication of *Forever Knight* implied that its network cancellation was a mistake. Few other network executives have been willing to admit specific errors, but indications from cable suggest that Fox may have erred by canceling the low-rated *Brisco County,* which had developed a strong cult following. Normally, such shows have so few episodes in the can that they do not come back to haunt programmers.

7. McAdams, Deborah D. Tim Brooks: Television's number man. *Broadcasting & Cable,* 15 May 2000, pp. 34–36.

8. Author's analysis of Nielsen ratings from weeks 1 through 52. 5 October 1998 through 27 September 1999. *Broadcasting & Cable.*

9. Eastman, S. T., and Bolls, P. D. Structure and content in promotion research. In S. T. Eastman (ed.), *Research in Media Promotion.* Mahwah, NJ: Lawrence Erlbaum Associates, 2000, pp. 55–100.

10. Both *Roots* (1975) and *The Thorn Birds* (1983) were produced at enormous cost, and both gained unusually large audiences and high revenue. *The Thorn Birds*, for example, averaged a 41 rating and an extraordinary 59 share, making it the second-highest rated miniseries, just behind *Roots* (average 66 share over eight consecutive nights). Aside from winning high ratings and beating the competition, the networks derived considerable prestige and critical acclaim from these programs, which helped to justify the heavy investment. Some miniseries, such as *Rich Man, Poor Man* and *How the West Was Won*, have been turned into regular series, further reducing the financial risk involved.

Chapter 5

Nonprime-Time Network Television Programming

James R. Walker
Robert V. Bellamy, Jr.

A GUIDE TO CHAPTER 5

For the popular press, prime-time television is the big time television. Much of national and local coverage of television focuses on evening programs. Critical reviews, star interviews, and Nielsen ratings for the top prime-time programs are readily available. Because prime-time is the subject of such intense reporting, one might think the rest of the day is insignificant. Not true. Afternoon soap operas and late-night comedy are frequently the most provocative and—significantly for the networks—most profitable shows on television. The difference between what a program costs to produce and its advertising revenue is its profit. Because nonprime-time programs are often inexpensive to produce, their ratings can be relatively modest and still produce large profits for the networks. In addition, nonprime-time audiences are less demographically diverse, making it easier for advertisers to target their commercials to consumers most interested in their products. This means less advertising waste (commercials directed to wrong viewers) than in prime-time with its larger but more diverse audiences.

Nonprime-time viewers are often more loyal to their programs than prime-time viewers. Many football fans plan their whole week around Saturday college and Sunday professional games, and the network programmer who preempts a soap opera for a special program will receive an avalanche of unpleasant letters and phone calls. For millions of Americans, the network evening news is a daily information ritual.

Networks generating the largest advertising revenues have the most nonprime-time programming. Programmers cannot ignore the non-evening programs because there are many more hours to program than in prime-time. More than any other type of programming, the nonprime hours distinguish the oldest broadcast networks (ABC, CBS, NBC) from their more recent competitors. The long established presence of the Big Three in virtually all nonprime dayparts provides them with substantially more commercial availabilities to sell to advertisers. In the first half of 1999, ABC, CBS, and NBC each sold between 26,500 and 28,100 minutes of commercials, nearly four times as many

minutes as Fox, the most active of the other English-language networks.

The primary reason for this vast disparity in the networks' most basic product, advertising availabilities, is that the newer networks take a different approach to nonprime-time programming. With the important exceptions of sports on Fox and children's programming on both Fox and WB, new networks have not competed successfully in nonprime time. Instead of challenging long-running programs in early morning, daytime, and late night, new networks have tried to capture sports fans who will readily switch networks to watch favorite teams and players, or they have gone after children who do not have the viewing loyalties of adults. NBC's investment in Pax and Viacom's (owner of UPN) purchase of CBS have given these newer networks important nonprime-time alliances. The Spanish-language networks, Telemundo and Univision, in contrast, fill many of the nonprime hours successfully with talk shows and **telenovelas** (television novels similar to soap operas, but with a definite ending after some months or years).

NONPRIME-TIME DAYPARTS

Nonprime-time is a broad term encompassing all the programming dayparts other than prime-time. The broadcast television networks program some or all of the following dayparts (reflected in Eastern/Pacific times) with several genres (types) of programming:

Weekday Programming

Overnight	2:05 A.M.–6 A.M.	News
Early morning	6 A.M.–9 A.M.	Magazine
Daytime	10 A.M.–4 P.M.	Soaps/Game Shows
Early fringe	4 P.M.–6 P.M.	Children's
Early evening	6:30 P.M.–7 P.M.	News
Late night	11:35 P.M.–2:05 A.M.	Talk/News

Weekend Programming

Weekend mornings	8 A.M.–1 P.M.	Children's/Information
Weekend afternoons	1 P.M.–7 P.M.	Sports
Weekend late-night	11 P.M.–1 A.M.	Comedy/Music

5.1 LONGEST RUNNING NETWORK SERIES

Nonprime-time series are among the longest running programs in TV history. Only one of the top 15 series, *Walt Disney*, had its entire run in prime time; all others are nonprime-time series.

Top 15 Longest Running Programs in Network TV History as of 2000	Years
1. *Meet the Press*, NBC (premiered 1947)	53
2. *The Guiding Light*, CBS (premiered 1952)	48
3. *The Today Show*, NBC (premiered 1952)	48
4. *Face the Nation*, CBS (premiered 1954)	46
5. *The Tonight Show*, NBC (premiered 1954)	46
6. *As the World Turns*, CBS (premiered 1956)	44
7. *ABC's Wide World of Sports*, ABC (premiered 1961)	39
8. *Search for Tomorrow*, CBS, NBC (1952–87)	35
9. *Walt Disney*, ABC, NBC, CBS (1954–83; 1986–90)	34*
10. *General Hospital*, ABC (premiered 1963)	37
11. *CBS Evening News*, CBS (premiered as 30-minute series,[1] 1963)	37
12. *NBC Nightly News*, NBC (premiered as 30-minute series,[1] 1963)	37*
13. *The Price Is Right*, NBC, ABC, CBS (1956–65,[2] returned 1972)	37
14. *Another World*, NBC (premiered 1964–99)	35
15. *Days of Our Lives*, NBC (premiered 1965)	35

Notes: *Series title varies; [1]ABC, CBS, and NBC have each had regularly scheduled newscasts prior to the 1950s; [2]*Price Is Right* had a concurrent prime-time run from 1956 to 1964 and two brief runs on prime-time in 1986 and 1993.

The audience level in nonprime-time dayparts is considerably smaller than that of prime time. All nonprime-time dayparts, however, contribute competitively and economically to the network's performance. There is big money in daytime programming.

Programming executives responsible for nonprime-time dayparts are as dedicated to competing for available viewers as are their prime-time counterparts. In prime-time programming, the "war" is fought night after night and measured in daily ratings gains or losses. Although daily ratings are important to shows in nonprime time, the battle is to get viewers into the habit of watching weekday nonprime-time programs every day or from week to week. Of the 15 longest running network series, 14 are nonprime-time series (see 5.1).

In prime time, ratings average about 10.0 with a vast range from 1.3 to 20.0 between the bottom-rated and top-rated network shows. This huge variation means sharp differences in the advertising rates and profit ratios for the network. In nonprime-time programming, the average is about 2.5 with a range, for daytime soap operas, from 1.9 to 6.3, quite a different ballgame. Although the revenues generated are more modest, the risks are also more modest. Programmers use a low-risk approach in building their schedules.

In a **low-risk programming strategy,** programmers concede that blockbuster ratings and their accompanying high advertising rates are virtually

impossible to attain. They take a more conservative approach, which limits production costs and uses tried and true formats. In addition, developing a schedule using a different series each weekday would be far too expensive. Thus, weekday programming is **stripped** (the same programs are scheduled on Monday through Friday at the same time). *Stripping allows viewers to build ongoing loyalty to a series while lowering the financial risks involved in program development.* To program effectively in nonprime time, the networks must assess the available audience in a particular daypart. To do this, programmers examine HUT levels, clearances, potential advertisers, and likely demographics of audience members.

SCHEDULING STRATEGIES

Obtaining and scheduling programming in nonprime time presents a unique set of challenges for programmers. Weekday programming is stripped five days a week, and a single program is usually part of a block of programs of the same type. For example, daytime soap operas are usually scheduled in a block and late-night talk shows are usually followed by a second or even third talk show. The programmer wants to build two types of audience flow: **flow-through** from the first program to the second one in the daypart and **flow across** the weekdays from one day to the next. Flow-through is usually accomplished by using block programming, the scheduling of same genre (type) of program over a daypart. Flow across the weekdays is promoted by stripping the program in the same time slot each weekday and by using such program genres as soap operas, where the program's narrative structure connects each episode with the next day's. For news, talk, and magazine programs, the program's anchor or host promotes continuity from one day to the next.

Weekend programming is scheduled like primetime with one episode per week at the same time from week to week. Viewers return each week to get programming that is less available on networks during the rest of the week, such as sports, cutting edge comedy, music, or extended news interviews. For example, fans of a particular NFL team will religiously tune in every Sunday afternoon to see their local favorites.

HUT Levels

HUT levels are around 60 percent in prime time, while nonprime-time levels can be less than 10 percent. Because so few homes are using their televisions, the potential ratings and advertising revenue are limited. But the opportunity to create a winning franchise for a time period does not suffer. Even small audiences have value to advertisers. In fact, many clients cannot afford to advertise in prime time, so creative programming targeted to the "right" small audience is often very attractive to these sponsors. Weekends are a good example. Viewers who tune in on the weekend have a different mindset than prime time viewers. They often want more movies or sports than they have time to watch during prime-time. *Larger chunks of leisure time can offset the smaller HUT levels: Viewers wind up spending more time watching television, despite their smaller numbers.*

The Struggle for Clearance

Nonprime-time and prime-time also differ in their affiliate clearances. When a network schedules a program, an affiliated station has three options: It can **clear the program** (air it when scheduled by the network), it can decide not to clear it (**preemption**), or it can ask permission to air the program at a later time (**delayed carriage**). Both preemption and delayed carriage, especially by major market stations, hurt the network's national ratings because they reduce the potential audience for the program. The networks frequently petition the FCC to raise the percentage of U.S. households they can reach with their owned and operated stations (now at 35 percent) to help increase clearances of network programming especially in nonprime time. Their high rate of preemption and delayed carriage is one reason why public television's ratings appear so low. Although most affiliates clear about 90 percent of their network's

total schedule, the percentage in nonprime time, especially daytime, Sunday morning, overnight, and late night, is substantially lower.

In a surprising move after nearly 50 years of substantial daytime programming, NBC (which ranked third in daytime programming throughout the 1980s and early 1990s) decided to scale back its daytime schedule because of low **clearances.** When NBC first offered *The Other Side*, a daytime talk show, it received only a 61 percent clearance rate; almost 40 percent of NBC's affiliates decided to schedule syndicated series instead. Recently, NBC began to develop new daytime game shows in an effort to recapture some of this daytime given back to affiliates. When CBS premiered the talk show *The Late Late Show* featuring Tom Snyder in mid-season, the "live" clearance rate was 30 percent. In this case, the network's affiliates decided either to preempt or, more commonly, delay the show. Low clearance rates were a major factor in the low ratings this show received in its premiere season.

Besides eroding its potential audience, preemption and delayed carriage disrupt the scheduling strategies used to promote audience flow from one program to another. For example, an ABC affiliate that carries *Nightline* following the local newscast provides a stream of viewers who are looking for information. When *Nightline* is delayed to allow the affiliate to carry a sitcom, some of the potential audience goes to bed. The delayed *Nightline* is less likely to attract a large audience when it follows comedy rather than news.

Advertisers and Demographics

A network determines which segment of the available audience it will target, mindful of its competitors' programming and influenced to some degree by advertiser support for its programming. The network programmer's task is to put together a schedule of programs that will, at the lowest possible cost:

- Attract the most desirable demographic groups
- Maximize audience flow-through

- Build viewer loyalty
- Capture the largest possible audience

One big difference between the major dayparts is that audiences during nonprime-time dayparts are more homogenous (similar in demographic composition) than prime-time audiences. Typically, the three networks schedule the same program type head-to-head, which creates fierce competition (all soaps, all talk, all games, all soft news, and so on). When selecting the shows for a particular daypart, the networks give primary consideration to these elements:

- Demographics of available audiences
- Competitive counterprogramming opportunities
- Economic viability

Indirect influences on programming practices also come into play. Daytime programs rely on drug and food companies for advertising revenue. Hence, programmers are wary of scripts or interview programs that tackle subjects such as tampering with painkillers or rat hairs in cereal. *Daytime programming is in much closer touch with its advertising messages than prime-time* for several reasons. First, daytime programs contain *more commercial minutes per hour*. Second, because many programs were once both sponsored and produced by advertisers, there is a *tradition of sensitivity to advertiser needs*. Finally, *two major companies, General Foods and Procter & Gamble, dominate the advertising time in daytime*, and networks cannot afford to offend them.

Genres of Nonprime-Time Programming

There are seven key genres of nonprime programming: (1) sports, (2) daytime soap operas (including telenovelas), (3) game shows, (4) news, (5) children's programming, (6) talk shows, and (7) comedy/music programming. Most of these program types are identified with particular dayparts: sports with weekend afternoons, soaps and game shows with daytime, children's programming with early fringe and Saturday morning, talk

shows with weekday late night, and comedy/music with late nights on Friday and Saturday. Different strategies and practices associate with each genre of programming, as well as different levels of cost, and the development processes for new shows vary considerably.

SPORTS

Weekend afternoons (1 to 7 P.M.) on the broadcast networks are dominated by live sports coverage. *Sports are one of the most important forms of programming in television.* One of the chief reasons for sports' popularity is their ability consistently to attract an audience of young men who are extremely difficult to attract with other types of regularly scheduled programming. In addition, sports provide a much-valued location for zap-proof advertising and promotion. Sports telecasts are brimming with opportunities for the insertion of ads and promotional spots and announcements that cannot be avoided by the viewer unless she or he also avoids (misses) part of the action. Sports also are one of the programming forms that provide excellent branding opportunities for networks, such as "NBC—The Home of the Olympics," "Fox NFL Sunday," and so forth.

The network's sports division is responsible for acquiring the rights to games and events and for producing the telecasts. It must work closely with the programming division because of the complexities associated with live sporting events, including overtime pay and weather-related cancellations. The networks' sports divisions work directly with the sports leagues to guarantee that start times occur when the majority of viewers can watch. Because many sporting events do not attract a prime-time-sized audience, they are often scheduled so as not to interfere with prime-time entertainment programs. This noninterference with prime time has become less of a concern in recent years because of the rising popularity and value of most sports. For example, the late afternoon NFL (National Football League) games and even postgame programs regularly run into prime time and

often contribute to high prime-time ratings. With only a few exceptions (e.g., *ABC's NFL Monday Night Football*), however, the broadcast networks confine regular-season team sports coverage to weekend afternoon and early evening time slots.

Sports Programming in a Multichannel Environment

Although sports are not the low-cost programming option they were in the early days of television, *programming costs are always relative in television.* Although CBS claimed to lose millions of dollars on sports rights in the early and mid-1990s, the network more recently spent enormous sums to regain a piece of the NFL Sunday afternoon package and to renew its NCAA Men's Basketball Tournament coverage. This was after the network's prestige was seriously damaged by its 1994 loss of the NFL to the less-established Fox network. Fox used the NFL and later MLB (Major League Baseball) and the NHL (National Hockey League) to establish itself as a legitimate member of the Big Four to both viewers and the financial community. One result of Fox's new leverage was its ability to upgrade affiliates in several markets, mainly at the expense of CBS. The question of cost, then, involves more than simply the profit or loss made from the ratio of program costs to advertising revenues: *Losing major sports can undermine the legitimacy and degrade the financial value of a network.*

Cable has also had a large effect on sports programming. Networks such as ESPN, ESPN2, and the regional Fox Sports Nets exist only because of their sports coverage. Their saturation coverage has raised the profile and value of sports on television, even as they drain ratings from broadcast networks. The lessening of sports ratings (see 5.2) is offset somewhat by the increased value of sports as one of the few programming types that can attract an audience valued by advertisers in the face of ever-increasing television and entertainment options.

In addition, the ongoing economic consolidation of the media industry has allowed broadcast networks to partner with cable networks to share

5.2 BIG FOUR REGULAR-SEASON NIELSEN RATINGS

	1995	1996	1997	1998	1999
MLB	5.7	2.7	2.7	3.6	2.9
NFL	12.9	12.2	11.5	11.3	11.4
	1995–96	1996–97	1997–98	1998–99	1999–00
NBA	5.0	4.7	4.6	4.3	3.4
NHL	2.1	1.9	1.4	1.4	1.3

Source: Sports on the tube. *Street & Smith's SportsBusiness Journal,* 5 June 2000, p. 54.

rights to sports programming. The most prominent examples are Disney's ownership of both ABC and the ESPN networks, which share the National Hockey League, and the Fox/Fox Sports Net combination, which shares Major League Baseball. There are also shared rights arrangements among separate companies where early rounds of team playoffs and golf and tennis matches appear on cable networks, with later rounds shifting to networks. The split of National Basketball Association (NBA) rights between TNT/TBS and NBC is an example of leveraging of the value of sports television.

The sports anthology program, exemplified by ABC's long-running *Wide World of Sports,* has been a casualty of the recent changes in sports television. The minor sports that were typically covered by anthologies have, for the most part, benefited from the explosion in sports by gaining individual contracts on broadcast or cable (NASCAR, WNBA, soccer). The "a little something for everybody" approach is less viable as a means of keeping a program audience in the multichannel environment because it virtually encourages channel changing. Despite the demise of regularly scheduled sports anthologies on the networks, the *Wide World of Sports* brand continues to exist as an umbrella title for minor event coverage, such as the Tour de France, the name of a sports entertainment attraction at Walt Disney World, and a programming promotion segment of the ABC web site.

Non-Live Event Sports Programming

Non-live event sports programming on the networks today generally consists of (1) pregame & postgame programs and (2) sports-league-produced programming for children and young adults. After the success of CBS's *The NFL Today* in the 1970s, broadcast and cable networks have developed similar shows for other sports. *These wrap-around shows help networks to more fully brand programming blocks and expand the programming hours devoted to sports without additional rights fees.* In addition, powerful sports entities can demand sports-league-produced programming. For example, the NBA forced NBC to schedule *NBA Inside Stuff,* a youth-oriented feature magazine about the league, as a condition of its contract with the league. Similar programming is scheduled for the other major team sports.

Rights Fees and Ratings

Figure 5.3 shows the rights fees, as of July 2000, for major sports. These fees include the rights to playoffs, all-star games, and championship series that are often scheduled in prime time as well as weekend daytime. These figures are even more staggering considering the vast growth of rights fees in the 1990s. For example, the NFL has increased its rights fees by a factor of about 4.5 in the decade, while the NBA fees have grown even

5.3 MAJOR SPORTS TELEVISION RIGHTS

League	Networks	Contract Term	Contract Amount
NFL	Fox	8 years	$4.4 billion
	CBS	8 years	$4.0 billion
	ABC	8 years	$4.4 billion
	ESPN	8 years	$4.8 billion
NBA	NBC	4 years	$1.75 billion
	Turner Sports (TBS/TNT)	4 years	$890 million
MLB	Fox	4 years	$575 million
	NBC	4 years	$400 million
	ESPN	4 years	$440 million
	Fox/Liberty cable	4 years	$172 million
NHL	ABC	5 years	$600 million
PGA	ABC, CBS, NBC, ESPN	4 years	$650 million
NCAA Men's Basketball Tournament	CBS	11 years	$6.0 billion

Source: Broadcast rights. Fox Sports web site, 2000. *foxsports.com/business/resources/broadcast.*

faster. The escalation of fees is likely to continue as MLB, among others, seems virtually certain to increase their national television money by a large percentage in the near future.

Comparing 5.2 and 5.3 provides the best evidence that increased rights fees do not reflect increased household ratings. The Big Four sports leagues have had, at best, stagnant ratings and, in the case of MLB and the NHL, significant declines. Despite these numbers, sports telecasts, with their desirable audience, their ability to break through a cluttered television landscape, and their power to increase network prestige, will continue to be a key part of network television schedules.

DAYTIME SOAP OPERAS AND GAME SHOWS

Daytime programming (9 A.M. to 4 P.M.) is one of the most lucrative dayparts for television networks. Its profit margin often challenges that of prime

time because the cost-per-program in daytime is substantially less. *The money needed to pay for one hour of prime-time drama will cover the costs of a week's worth of daytime soap operas.* Because viewer loyalties are strong and developing new programs is difficult, however, newer networks have been reluctant to develop daytime programming. Currently, only ABC, CBS, and NBC of the major English-language networks have a substantial stake in daytime programs Monday through Friday. The two Spanish-language networks also have a major presence in daytime with telenovelas airing during several hours of their Monday through Friday schedule.

In addition to lower programming costs, there are more commercial availabilities in daytime. In November 1999, networks scheduled about 21 minutes of nonprogram material (commercials, promos, public service announcements, and so on) per hour compared to 16 and ¾ minutes in prime time. Although daytime audiences are much smaller than prime time, daytime programming

5.4 NETWORK FEED OF DAYTIME PROGRAMMING (CBS)

	Eastern Time	Central & Pacific Time
The Price Is Right	11:00 A.M.–noon	10:00–11:00 A.M.
LOCAL TIME*	noon–12:30 P.M.	—
The Young and the Restless	12:30–1:30 P.M.	11:00 A.M.–noon
LOCAL TIME*	—	noon–12:30 P.M.
The Bold and the Beautiful	1:30–2:00 P.M.	12:30–1:00 P.M.

Note: *Local time is the time that the local affiliate runs local programming, usually news.

fills more hours per day than prime time, and each hour provides more commercial slots. It is not a coincidence that the networks with the largest share of the broadcast network advertising pie (NBC 31.1 percent, ABC 25.3 percent, CBS 21.6 percent compared to 22 percent for the other four English-language networks combined) have a substantial and long-standing presence in daytime. Daytime is especially important to CBS, the ratings leader in the daypart for more than ten years. CBS's daytime strength has helped offset the weaker appeal of its older prime-time audience to advertisers.

Daytime profits help networks offset extraordinary program investments in other dayparts. Loss leader programming as top dramas and situation comedies with enormous talent costs, ambitious prime-time miniseries, sports programming with huge rights fees, and expensive breaking news coverage, often cost more than the advertising revenue they generate.

The primary genre on network daytime schedules is the soap opera, although networks offer the occasional talk or game shows. Daytime programmers face enormous competition from cable television, locally produced programming, and syndicated programming. In the fourth quarter of 1999, the number of viewers of the 26 syndicated daytime programs surpassed those for the 14 network daytime programs for the first time, although the average rating of network programs (3.4) was substantially higher than for syndicated shows (2.5).

For example, a network talk show might face competition for a similar audience from a dedicated talk cable network, a locally produced talk show, and a variety of syndicated talk shows an affiliate, or a competing network show. One reason that soap operas have performed better than any genre in daytime network television is their scarcity in syndication and cable.

Daytime programmers do have some distinct challenges. In particular, they must face time zone complexities, the potential for audience erosion, and competition from dedicated cable services and syndication.

Time Zone Complexities

Time zone complexities disrupt daytime schedules. Consider scheduling for a 1 P.M. Eastern time zone soap opera. Its noon start-time in the Central time zone would interfere with the schedules of those affiliates who program a noon newscast. Networks have to schedule multiple feeds of some soap operas to make it easier for their affiliates to schedule them and, therefore, maximize clearances. This explains why *The Young and the Restless* is an afternoon show in the Eastern time zone but a morning show in the Central and Pacific time zones (see 5.4).

Daytime television seems to have the most potential for audience erosion. Compared to the 1950s and 1960s, the number of viewers who are at home in the daytime has decreased, because

many more women work and because children stay at childcare centers rather than at home. The networks had additional worries when younger viewers (ages 18 to 34 and 18 to 49) declined further for each of the networks between 1993 and 1995. Cable/satellite networks, home video, video games, and the Internet may be responsible for the decline.

Soap Operas

Developing popular soap operas has been the key to success in daytime network television.[1] Soap operas build loyal constituencies that last for decades, as viewers follow a set of compelling characters nearly every weekday. Networks develop this habitual viewing by **stripping** daytime soaps at the same time slot five days a week. As a result, the broadcast networks have had even more motivation to shift most sports to prime time or weekends, while both networks and local stations use **character-generated crawls** (written across the lower or upper third of the screen) to alert viewers of major news developments or severe weather without interrupting shows.

The soap opera viewer is an active viewer, seeking information from the Internet, soap telephone services, newspaper columns, and publications such as *Soap Opera Digest*. Networks reinforce this information seeking by offering show-specific chat rooms and plot summaries on their web sites. Viewers are determined to see their favorite soaps: Daily activities are planned to make time for soaps, and episodes are **time-shifted** (recorded on a VCR or DVR) when necessary. In network daytime viewing, all ten of the most time-shifted programs are soap operas.

A hit soap opera is a cash cow for its network. Production and talent costs are considerably less than for prime-time programming. Soaps are shot primarily in studios on videotape with multiple cameras and receive far less costly post-production editing and sound "sweetening." Typically, the producers, directors, writers, and actors hired for soaps produce five hours of programming a week, compared to 30 minutes for a prime-time sitcom.

5.5 NETWORK SOAP OPERA RATINGS, WEEK OF JUNE 19, 2000		
CBS	*The Young and the Restless*	6.3
CBS	*The Bold and the Beautiful*	4.6
ABC	*General Hospital*	4.1
NBC	*Days of Our Lives*	4.0
CBS	*As the World Turns*	3.7
CBS	*Guiding Light*	3.7
ABC	*All My Children*	3.6
ABC	*One Life to Live*	3.5
NBC	*Passions*	2.0
ABC	*Port Charles*	1.9

Source: Soap Opera Central. www.amcpages.com/soapcentral/ratings

Despite the lower costs, CBS's highly rated soap *The Young and the Restless* does better at making a profit and delivering its target audience, women 18 to 49, than many of the network's prime-time offerings.

Both ABC and CBS have strong daytime line-ups featuring many long-running soap operas (see 5.5), while NBC has curtailed its lineup to two daytime dramas. Soap viewing is highly predictable; viewers watch their favorite programs nearly every day. This habituated viewing means that established soaps are rarely canceled and rarely created. Instead of a new season appearing each year as it does in prime time, a few new soaps may appear each decade and sometimes not even then. In the last decade, the broadcast networks developed only three new daytime soaps: NBC's *Passions* and *Sunset Beach*, and ABC's *Port Charles*, a spin-off of *General Hospital*. Although rarely cancelled or developed, soap operas do change. As characters and viewers age, producers and writers must introduce new characters to entice a new generation of viewers. Established leads yield to younger actors, and they in turn fade in the glow of the next generation of daytime stars. Changing characters also reflect the changing characteristics of viewers. The last two decades have seen a sub-

stantial rise in the number of minority soap opera characters, reflecting demographic shifts in the U.S. population.

Development

Establishing a new soap opera demands a long-term commitment. It takes years to achieve audience identification with new characters in their fictional affairs. Development begins with an independent producer providing the network programmer with a basic concept for a new series. If it seems promising, the network will commission a **treatment,** sometimes called a *bible,* analyzing each of the characters and their interrelationships and describing the settings in which the drama will unfold. For a treatment, the writers receive development dollars or seed money. The final step is to commission one or more scripts, advancing more funds to pay writers. The entire development process can take one to two years and an investment of thousands or even millions of dollars.

Usually, several development projects are abandoned each season; only a few have ever made it to the daytime schedule. Once a network picks up a soap opera, however, **casting** begins. Casting the appropriate, charismatic actor for each role is crucial to a soap's success. To this end, CBS, ABC, and NBC maintain their own casting directors to work with producers.

Most network television is videotaped or filmed on the west coast, where producers contend they can produce programs for less money than in New York. This is due, in part, to the more favorable weather conditions for exterior shooting. Soap operas, however, continue to be taped in New York because much of the shooting is interior and the Broadway theater provides a large pool of actors who are available during daytime shoots. Young actors in the New York area vie for soap roles because a bit part can bring high visibility and a decade of financial security. And soap taping schedules leave plenty of time for stage and screen acting jobs.

The international market has become a lucrative secondary outlet for American soaps. Many soaps incorporate plot sequences that take place overseas to appeal to specific foreign markets. Networks are also developing cable outlets for their off-network daytime and prime-time soaps. In 2000, Disney/ABC launched SoapNet, a cable/satellite network featuring reruns of its weekday soaps.

Game Shows

From the 1950s until the 1990s, game shows were a profitable mainstay of network daytime programming. Typically, several episodes of a game show are taped in a single day, and these shows use the same sets and props for years. In exchange for on-air announcements, advertisers provide the prizes awarded to contestants. Usually, only the host gets a big salary, and production costs are low.

Networks seldom invest in a game show pilot because they cannot recoup any of their investment by airing them as they sometimes do with prime-time pilots. Usually, a game show producer presents a **concept,** and if the network likes the idea, it commissions a **run-through.** The producer then rehearses the show's actors and participants, and network executives are invited to see the run-through. At this stage, a network may commission a **semipilot,** allowing the producer to videotape various versions of the game show with a studio audience and with appropriate production elements such as music. This approach avoids the expense of an elaborate set.

Games began disappearing from the network lineups because of competition from first-run syndicated game shows (including *Jeopardy* and *Wheel of Fortune*), from cable/satellite networks dedicating some or all (Game Show Network) of their schedules to game shows, and, most recently, from network prime-time big money game shows (*Greed, Twenty-One, Who Wants to Be a Millionaire?*). As of 2002, *The Price Is Right,* hosted by Bob Barker with a 30-year run on CBS, was the only broadcast network game show scheduled in nonprime time. Spurred by the success of prime-time game shows, NBC, which offers the fewest hours of daytime programming, is developing pilots for several new game shows that may be scheduled for the 2002 or 2003 television seasons.

WEEKDAY NEWS AND INFORMATION

In addition to their own intense competition, the Big Three networks face increasing competition from strong local stations in major markets in the early daypart. Local stations in markets including New York, Miami, Chicago, and Washington are producing their own early newscast and magazine programs. Because of their strong local emphases, these competing shows have garnered strong ratings against network offerings.

If network programs are to remain strong competitors in the major markets in the morning dayparts, they must adjust to the changing environment. Because they cannot compete for local appeal, the network morning shows must continue to interview the most important national/ international news and entertainment figures and send their popular personalities to exotic locales or the sites of national news events.

Early Newscasts

All three networks provide an early newscast Monday through Friday. The networks hope to bolster their 7 A.M. programming by getting flow-through from these programs; however, they also realize that many affiliates produce their own morning news shows. Therefore, they try to accommodate affiliates with multiple feeds of these early newscasts. They all have beginning and end points at the top and bottom of each hour. Hence, an affiliate can "dump out" or join a morning newscast after 30 or 60 minutes.

Morning Magazines

The networks compete head to head with **magazine format** programs between 7 and 9 A.M. *The Today Show, Good Morning America,* and a CBS challenger, under a variety of titles, have contested this time period for several decades. In 2000, NBC extended its *The Today Show* program into the 9 A.M. to 10 A.M. time slot. These morning magazines provide news headlines, weather forecasts, and interviews ranging from soft entertainment to hard news. Because they resemble print publications, they are called *magazines.* Like print magazines, they contain a series of feature articles and a table of contents (**billboard**) at the beginning informing viewers of what will be on that day, and are bound together with a common cover and title.

The magazine format is especially suited to the early morning daypart when most viewers do not watch for extended periods of time. As they ready themselves for the day ahead, they catch short glimpses of television. The segmented magazine format allows viewers to watch for short periods of time and still see complete segments. News and weather updates allow viewers to start their day with useful information. These national magazines include local breaks when affiliates air brief local news, weather, or traffic updates.

Morning magazines are a valuable promotional tool for the network's prime-time offerings. For instance, when a network has scheduled a prime-time miniseries, the hosts of the morning magazine interview the stars or appear on the set of the miniseries. Correspondents from prime-time news magazines (*20/20, Dateline*) frequently make guest appearances on their network's morning shows to promote features on that night's program. Conversely, prime-time programs can help boost the ratings of morning magazines. For example, CBS's *The Early Show*'s ratings increased when it began to capitalize on the success of the network's prime-time *Survivor* series.

In August 1999, NBC News' *The Today Show* was the highest-rated morning news program with a 4.7 rating, ABC News's *Good Morning America* was second with a 3.4 rating, and CBS's *This Morning,* to be replaced soon by *The Early Show,* was third with a 2.0 rating (see 5.6).

To some extent, the relative popularity of the leading morning magazine shows is connected to the night-before ratings (**tuning inertia**). If NBC is the number one network, the television set is often switched off at night with the channel position on NBC, and a disproportionate number of viewers turn on their sets and see morning programming from NBC. Similarly, ABC has an ad-

5.6 THE MORNING MAGAZINE SHOWS

The Today Show on NBC

NBC pioneered the magazine format with the 1952 premiere of *The Today Show.* Over the years viewers have become very attached to the personalities associated with *The Today Show.* Popular *Today* personalities have included Dave Garroway (its original host), John Chancellor, Hugh Downs, Barbara Walters, Tom Brokaw, Jane Pauley, Willard Scott, and Bryant Gumbel. Each of these *The Today Show* hosts and regulars had a long run, bringing stability and familiarity to the program. These are essential ingredients for ratings success in a daypart where viewers' behavior becomes routine, as most people start each of their weekdays in much the same manner. *The Today Show's* ratings dip, which took place in the early 1990s, has been attributed mostly to revolving hosts following the departure of Jane Pauley. *The Today Show* successfully rebounded in the mid-1990s with a new generation of morning stars, Katie Couric and Matt Lauer.

ABC's Good Morning America

Like the newer networks of today, ABC did not offer any network service until 11 A.M., prior to 1975. Then, it began to compete more vigorously in other dayparts, including prime time, even though its small station lineup of **primary affiliates** at the time compared unfavorably with NBC's and CBS's.

ABC challenged the well-established *The Today Show* when it introduced *AM America,* aiming for a younger early morning audience. ABC believed that its target audience, women 18 to 49, were less habituated viewers than the over-50 age group, drawn in large numbers to *The Today Show,* and would sample the new program. Also, women 18 to 49 were the demographic group most desired by advertisers. By 1980 the re-titled *Good Morning America* had moved into first place overall in the ratings. Since then, NBC and ABC have alternated for the top ratings position, and the time period remains competitive. Currently, *Good Morning America* is second to *The Today Show,* but ABC has moved popular prime-time reporter Diane Sawyer to a cohost slot and invested $75 million in a new studio, to be used primarily by the program, complete with *The Today Show*–like windows showing adoring fans.

CBS's The Early Show

CBS has languished in third place in the morning news ratings since the mid-1970s. As the third place network, it has tried over and over to innovate in hopes of improving its low ratings. Over its nearly five decades in this time slot, CBS has tried 27 different combinations of hosts and a multitude of different titles and approaches. In the mid-1990s, CBS's *This Morning* was produced regularly in front of a live audience with the second hour devoted to a single topic or guest. The producers were trying to revitalize the show and to stimulate enthusiasm like that generated on the set of such morning talk shows as *Live with Regis and Kelly.* In 1996 CBS completely revamped its morning news show, but its ratings remained low. In November 1999, CBS replaced *This Morning* with *The Early Show* cohosted by former *The Today Show* star Bryant Gumbel and onetime ABC correspondent Jane Clayson from a new $30 million studio in the General Motors Corporation building in New York. Although initial ratings have been disappointing, CBS continues to work on solving its decades-old early-morning problem.

vantage when its shows win the ratings the night before. CBS has never had much success in the morning and probably does not benefit much from tuning inertia.

The ratings competition between the networks for early morning viewers is always intense, but the stakes are even higher during the sweeps ratings periods. To make the shows more attractive,

the cast and crew often travel to exotic locations during the ratings period. The cost of remote productions is higher, but they often return higher ratings and create a promotional hook to tempt audiences. During one sweeps period, CBS's *This Morning* scheduled an entire week inside the studios of *Late Night with David Letterman* while *Late Night* was in London. This provided cross-promotion between both shows.

Evening News

Although ratings have declined, the evening newscasts are the centerpieces of the ABC, CBS, and NBC television news organizations. Along with daytime and late-night programming, evening newscasts help to distinguish these full service networks from their more recent competitors (Fox, WB, UPN, Pax), enhancing their brand identification. The advertising revenue generated by these news programs is substantial. For example, *NBC's Nightly News* has annual revenues of about $200 million dollars. Evening newscasts also give the broadcast networks prestige as major players in national and international politics. Evening newscasts originally provided a service to affiliates, most of which had very limited, if any, news operations. CBS and NBC introduced the nightly, 15-minute newscast to network television in 1948, and by the 1960s, the newscasts had expanded to 30 minutes. Although modest by today's standards, the expenses incurred by a network news operation during those early years were often far more than the income derived from advertising on the newscasts.

Evening newscasts face difficult competition from cable news networks and the Internet news services. There is no need for busy viewers to wait until 6:30 or 7 P.M. for a network newscast as 24-hour news channels (CNN, Headline News, MSNBC, Fox News Channel) and news web sites sponsored by newspapers, television/radio stations, wire services, and the networks themselves have proliferated. In addition, local affiliate newscasts compete with the networks for national and sometimes international stories by producing high-quality coverage with on-the-spot video via satellite.

Thus, *network news may not remain a staple of nonprime-time programming if current trends persist.* By the mid-1990s less than half of the American adult public (only 42 percent) regularly watched network evening TV news broadcasts, down from 60 percent just a few years earlier. Also, network, local, and CNN news audiences slipped the most in viewers younger than 30, perhaps because younger adults are more likely to seek news from newer alternatives, such as cable or the Internet. This demographic trend suggests that audiences for evening newscasts may continue to decline.

Despite increased competition and lower ratings, network newscasts are still important promotional tools. Affiliates benefit because the networks promote the evening's prime-time schedule during commercial breaks. Just as with early morning magazine programs, the network's news division can promote other news programming within the newscast. For example, ABC promotes *Nightline* within its nightly newscast, while each of the networks generally incorporate promotion for their own news magazines (CBS's *48 Hours*, NBC's *Dateline*, ABC's *20/20*).

Time zone differences present a challenge to both the programming department and the news department. The solution has been a multiple-feed schedule. The first feed of a network newscast is generally 6:30 to 7 P.M. Eastern time. Because some affiliates delay this newscast and the time would be inappropriate for the Mountain and Pacific time zones, a second feed is scheduled for 7 to 7:30 P.M. EST, and a third from 6 to 6:30 P.M. Pacific time. Breaking or updated news stories can be inserted into the later feeds.

Because most network newscast elements (news gathering, scheduling, and technology) are about the same, *news personalities become critical in winning the ratings competition* (see 5.7). Reporters and, especially, news anchors are the keys to higher ratings. News anchors who can connect with other members of the news team and the audience are highly rewarded by their networks. Currently, all three networks feature long-running anchors (Dan Rather, Tom Brokaw, and Peter Jennings) producing a very stable period in which ratings for the

5.7 THE EVENING NEWSCASTS

NBC Nightly News

NBC first offered a regular nightly newscast in 1949, the *Camel News Caravan* with John Cameron Swayze. Swayze was not an experienced journalist and eventually was replaced by Chet Huntley and veteran reporter David Brinkley in 1956. The renamed newscast, *The Huntley-Brinkley Report,* was a ratings hit, becoming the top-rated news program in the late 1950s and for most of the 1960s. When Huntley retired in the 1970s, NBC retitled the show the *NBC Nightly News.* With NBC's news ratings declining in the late 1970s and early 1980s, Tom Brokaw was moved from *The Today Show* to the *Nightly News* anchor position in 1982. As NBC has added cable networks (CNBC, MSNBC), the *Nightly News* has become a source of programming material for these newer news/talk outlets. *Nightly News'* stories are frequently the major focus of evening programming on these cable networks, and archived *Nightly News* reports have been repackaged to provide new programming for its cable partners.

CBS Evening News

Walter Cronkite anchored the *CBS Evening News* from 1962 until his retirement in 1981. In times of crisis, more people tuned in to Cronkite than to any other newscaster. During the 1970s, polls repeatedly showed Cronkite as the most trusted source of news. Dan Rather took over the helm of *CBS Evening News* upon Cronkite's retirement. Rather's credentials as a highly experienced journalist would have meant little if his chemistry had not matched that of his predecessor. Even though the ratings of *CBS Evening News* declined after Cronkite's retirement, Rather continued to dominate the evening news ratings until the late 1980s when the reign of ABC's Peter Jennings began. In June 1993 CBS decided to pair Rather with veteran reporter and weekend anchor Connie Chung. The combination did not work out, and ratings did not improve. Two years later, Chung was demoted from the anchor desk, and the president of CBS News was fired.

ABC's World News Tonight

ABC has been airing nightly newscasts since 1953, but for three decades it failed to pose a serious news threat to CBS and NBC. In 1977, in a bold move, ABC appointed the head of ABC Sports, Roone Arledge, to supervise both its news and sports divisions. Arledge had made ABC the number one network sports organization with his unconventional strategies—introducing offbeat sporting events and building up the dramatic aspects of sports competition. During his tenure as head of news, ABC assembled a team of highly respected journalists, including Peter Jennings, Sam Donaldson, Diane Sawyer, Ted Koppel, and David Brinkley, temporarily catapulting ABC into the lead in the evening news ratings. Some observers credit anchorperson Peter Jennings with the success of *World News Tonight,* as he actively serves as executive editor and writes (or rewrites) many of the stories.

three newscasts have been nearly equal. Networks risk alienating regular viewers by changing any of these anchors, but they also risk losing the next generation news viewers to cable, if younger personalities are not developed. Prime-time news breaks, vacation replacements, and weekend newscasts often are the training ground for new anchors and reporters.

Because their anchors have remained the same since the 1980s, the networks have tried to distinguish the three newscasts from each other and from cable by creating segments within the newscasts. CBS's daily "American Dream," NBC's "Fleecing of America," ABC's ongoing "21st Century Lives" and "It's Your Money" provide hooks for promotional announcements. Viewers may make a link between "American Dream" and a

particular network; the networks hope they might even get into the habit of watching a particular network for a favorite segment or follow up for more information on the network's news web site.

Late-Night News: *Nightline*

In November 1979, ABC news seized on the American viewing audience's fascination with the Iran hostage crisis and began a late-night newscast to summarize the major events of the day. The show evolved into *Nightline*, an in-depth news program hosted by Ted Koppel. Counterprogramming the network and syndicated talk shows, *Nightline* draws a loyal, upscale audience. The series' ratings tend to rise sharply depending on national crises, wars, and disasters that may erupt on any given day. Although the program is typically a half hour in length, it sometimes expands for extremely important stories. On those evenings, *Nightline* can obliterate all the competing programs. Such events as the Oklahoma City bombing incident, the Colorado high school shootings, and the Clinton impeachment triggered upward spikes in the ratings. Even when major events are not taking place, *Nightline* has become a solid ratings performer (4.8 rating during the May 2000 sweep besting both *Late Night* and *The Tonight Show*). The key to its success has been its vigorous campaign to have the show cleared live in most TV markets. In summer 1999 *Nightline* expanded its franchise to prime time, offering eight specials focused on major changes in society.

Overnight News

The overnight time period (2:05 to 6 A.M.) has the lowest viewership of any daypart. Be it second-shift workers, nursing mothers, bottle-feeding fathers, or insomniacs, however, there is some viewership left in overnight, although the competition in overnight is not as spirited as in other dayparts. Unlike prime-time, where HUT levels are around 60 percent, overnight HUT levels are just 10 percent. Given the relatively low number of viewers, the potential ratings for individual overnight programs are also quite low. Some affili-

ated stations sign off in the overnight hours, leading to lower clearance rates that further reduce ratings. Therefore, in the overnight time period, a 1.0 rating is considered very strong.

Given the low ratings and the low HUT levels, one might wonder why a network would bother to schedule any programming overnight. Even with 16 minutes of commercial time per hour, the entire daypart is worth only a few million dollars to each broadcast network. If the network can keep costs below the advertising revenue in the daypart and promote forthcoming shows, however, the effort is worthwhile because the risk is low. In addition, overnight news gives network affiliates programming at no cost to sustain their broadcast signal 24 hours a day.

ABC's *World News Now* and CBS's *Up to the Minute* are the traditional overnight news series, although their names have changed over the years. These shows compete against syndicated news programming offered to local stations by CNN Headline News, and Conus. Each network does what it can to keep the costs of production low. *Up to the Minute* was one of the first network news services to provide video stories **on demand** over the Internet, now common practice for television news organizations. Following their overnight programming, each network offers early newscasts starting at 4:30 A.M. that lead into and provide updates for their local affiliates' news programming. These early morning news efforts are followed by the networks' morning news magazines: *The Today Show*, *Good Morning America*, and *The Early Show*.

Limited testing of **value-added** programming, such as talk shows with product selling and extra runs of programming, has been attempted in the overnight daypart. News continues to dominate the time period for the networks, however, vying with cable's movies and rerun entertainment series.

WEEKEND NEWS AND INFORMATION

Although weekday news and information programs receive the most attention, weekend programs in-

clude some of the longest running series in television. In addition, weekend news and information slots allow networks to extend successful program brands (i.e., *The Today Show, Good Morning America*) into new hours.

Weekend Magazines

CBS and NBC have opted to program weekend morning magazines. NBC airs *Today* on both Saturday and Sunday. CBS offers a Saturday version of *The Early Show* and *Sunday Morning,* a 90-minute program reviewing news of the past week and surveying the world of fine art, music, science, and Americana. *Sunday Morning,* with host Charles Osgood, has been a fixture on CBS for more than 20 years and delivers a surprisingly solid rating (3.2 rating/11 share) for the time period. These weekend shows allow network news divisions to utilize veteran news staff members while also developing and experimenting with new talent on the air.

The addition of the Fox Children's Network (and later WB and UPN) all but knocked NBC into the basement in what had been a three-network race for children's audiences. NBC decided that it would counterprogram Saturday morning, dropping two hours of animation in favor of *Saturday Today.*

Sunday News Interviews

ABC, CBS, and NBC have traditionally aired public affairs interview programs on Sunday mornings and Fox has joined them. The format usually consists of a panel of journalists interviewing recent newsmakers about current issues and events. These shows have a longevity rare in modern television: NBC's *Meet the Press* began in 1947, and CBS's *Face the Nation* began in 1954. *Meet the Press* is network television's longest running program. ABC inaugurated its own public affairs show, *Issues and Answers* in 1960, which was replaced by *This Week with David Brinkley* in 1981. After Brinkley's retirement, the title was shortened to *This Week,* and Sam Donaldson and Cokie Roberts now host it. *Meet the Press* draws the largest audience with a 3.4 rating, followed by *This Week* with

a 2.4 rating, and *Face the Nation* with a 2.1 rating. *Fox News Sunday,* which is allied with the Fox News cable channel, joined the competition in the 1990s.

Although these news interviews do not attract large audiences, they remain on the air for a number of key reasons. First, all three of these programs have become *important news events* in and of themselves. Elected officials and reporters appear on them, have a chance to express themselves at length on important issues, and watch these programs avidly. Their words on Sunday morning television often become Sunday night's and Monday morning's news. This is especially important because Sunday is usually a slow news day. Second, *they attract a desirable upscale audience* and, as a result, prestigious advertisers are drawn to the shows.

Despite attractive attributes, many stations are hesitant to clear these relatively low-rated programs on weekends. Affiliates can make more money carrying infomercials or paid religious programming. To provide affiliates with more flexibility, multiple feeds of the programs are scheduled. CBS's *Face the Nation* is fed at 10:30 and 11:30 A.M. Eastern time and 4 P.M. Pacific time, giving affiliates plenty of scheduling options, yet many still refuse to clear the time.

CHILDREN'S PROGRAMMING

Children's television programming best illustrates the massive industry changes coming from the proliferation of program outlets. Figures 5.8 and 5.9 provide clear evidence of this change. Because a child's brand loyalty is to the program and not to the network, an upstart network such as WB can leverage its *Pokémon* program in several time spots, making it the number one network in both weekdays and the traditional Saturday morning children's block.

The strong position of Nickelodeon, a basic cable network, is further evidence that children are major users of newer television services. Although second, at the moment, to WB, Nickelodeon, formerly the highest-rated children's

5.8 TOP 10 BROADCAST AND CABLE PROGRAMS, SATURDAY A.M.

Children 2 to 11	Network	Rating/Share
1. *Pokémon* (10 A.M.)	WB	7.0/25
2. *Rugrats*	Nickelodeon	5.1/19
3. *Pokémon* (8:30 A.M.)	WB	5.0/24
4. *Pokémon* (11 A.M.)	WB	4.9/20
5. *SpongeBob SquarePants*	Nickelodeon	4.7/18
6. *Disney's One Saturday Morning*	ABC	4.3/16
7. *Men in Black*	WB	4.2/16
8. *Hey Arnold*	Nickelodeon	4.1/16
9. *Batman Beyond*	WB	4.0/16
10. *Digimon*	Fox	4.0/15
11. *NASCAR Racers*	Fox	4.0/15

Source: Top 10 broadcast, cable shows, Saturday morning. *Electronic Media,* 6 March 2000, p. 36.

5.9 TOP CHILDREN'S (2–11) NETWORKS

Saturday Morning		Weekdays	
1. Kids' WB	4.0/18	1. Kids' WB	2.4/15
2. Nickelodeon	3.8/17	2. Nickelodeon	2.3/16
3. ABC	2.8/13	3. Fox Kids	1.9/11
4. Fox Kids	2.8/12	4. UPN	1.2/9
5. UPN	1.8/9	5. Cartoon Network	1.0/7
6. Cartoon Network	1.6/7	6. Disney Channel	0.7/5
7. Disney Channel	1.6/7		
8. NBC	0.8/3		
9. CBS	0.7/4		

Source: Top kids networks. *Electronic Media,* 6 March 2000, p. 36.

network, is still well ahead of the Big Four. Unlike prime time and most other dayparts where cable, WB, and UPN ratings are substantially lower than the Big Four, the children's television universe is topsy-turvy, with the newer providers in positions of dominance (see 5.9). Whether this is an aberration of childhood or a sign of television's future is difficult to ascertain. However, *network children's programmers clearly operate in a more competitive environment than their counterparts in other dayparts.*

Programmers must also consider several other factors specific to children's programming. First, federal rules mandate minimum amounts of prosocial and educational programming (see 5.10). Although such rules are often perceived as vague and easily satisfied, programmers in other dayparts do not face these content specific rules.

Second, children's programming is very much fad-driven: Children's interests are fickle and change quickly. Chances are very good that the *Pokémon* phenomenon will have faded in a very few years and will have been replaced by the next big thing. *Scooby Doo, Power Rangers,* and *Teenage Mutant Ninja Turtles* have all had their days in the ratings' sunshine.

Third, children's television is often an excellent example of the **synergy** so heralded when corporations merge. The most popular programs are used to market a dizzying array of toys, games, clothing, fast food, snacks, videos, and motion pictures. One has only to walk through the various children's sections of a major store to see how popular children's programs become strong franchises for marketing a vast array of products.

Production and Development Issues

The development process for animation is different from that of prime-time programs. Development of an animated children's series begins about 12 months before telecast, with pickups of new series exercised in February or March to allow producers six to seven months to complete an order for a September airing. The first stage is a **concept**

5.10 CHILDREN'S PROGRAMMING REQUIREMENTS

The FCC has long studied children's television programming. The public, including special interest groups and parents, have stated their concerns about kidvid. Three main issues regarding children's television programming are: overcommercialization of children's programming; separation of program content from the commercials; and lack of educational programming options.

Overcommercialization

In 1990, Congress passed the Children's Television Act, requiring the FCC to impose advertising limits on children's programming of up to 10.5 minutes on weekends and 12 minutes during the week.

Separation of Program Content and Commercials

A second limitation on commercialization concerns the content of commercials within a show. The Children's Television Act restricted the use of host-based commercials. A host-based commercial is one that features a character from a particular children's series giving the advertiser's message. A number of commercials featured the Mighty Morphin Power Rangers. Host-based commercials, or those featuring the Power Rangers or

products with the Power Rangers, are not to be shown during the airing of *Mighty Morphin Power Rangers* or within 90 seconds before or after the program. If the commercials were to air, then the entire program would be considered a "program-length commercial" and, therefore, exceed the maximum advertising time for one hour of children's programming, a clever stratagem to force stations to exhibit some sensitivity to children's vulnerabilities. The prohibition on host-based commercials is aimed at decreasing the confusion a young child likely has in distinguishing a commercial from the show's content. Even before the Children's Television Act, networks (as well as syndicators and broadcasters) placed interrupters or bumpers to separate the program from the commercials, despite research findings that young children remain confused nevertheless.

Lack of Educational Programming

The Children's Television Act also required broadcasters to air educational and informational children's programming. At license renewal time, the FCC is required to consider whether the television station has served the edu-

cational and informational needs of children. Broadcasters are now obligated to air programs serving a child's cognitive/intellectual or social/emotional needs. However, the FCC has not specified the number of hours or the actual series that would satisfy the Act.

After the Children's Television Act was in place, the FCC cited statistics showing that educational programming on the networks had actually fallen from 11 hours a week in 1980 to just five hours by the early 1990s. The Commission reacted to these findings by adopting new rules in August 1996 designed to strengthen the existing Act. Chief among these were those that:

- Defined "core" programs as those regularly scheduled on a weekly basis, broadcast between 7 A.M. and 10 P.M., at least 30 minutes in length, that would "generally would have serving the educational and information needs of children as a significant purpose".

- Established a guideline for a minimum three hours per week of core programming per television station.

- Adopted new public information initiatives to supply information to parents.

pitched to the network programmers. The next steps are the **outline,** which describes the characters and the setting, and the **artwork,** which provides the sketches of the characters in several

poses and costumes. If a project passes these stages, the next step is to order one or more scripts, which usually go through many drafts before final acceptance.

Pilot programs are rarely commissioned for cartoons because of the long production time and high costs. The usual contract for a season of animated programs to be aired weekly specifies production of only 13 episodes. The network generally schedules each episode four times during the first season.

The development process for live action is similar to that of animation, but it substitutes a **casting tape** for the artwork. In hopes of lowering per-episode production costs or of targeting a slightly older target audience, some networks choose live-action programs.

The large number of repeats that networks can employ offsets the high cost of children's animated programming to a large degree. Popular children's programs can have each episode broadcast dozens of times over a period of years (even less time on cable). Unlike most programs, which lose substantial audience share with repeats, children's programs are less affected by repeats, because the audience changes frequently with a new generation of youngsters to discover every old program. In addition, children generally enjoy program reruns more than adults do.

Weekend Mornings

The days of the multihour cartoon block on the Big Three are over. The competition from the newer networks and cable have spurred each of the major networks to schedule weekend versions of their respective weekday morning news and feature programs (*The Today Show, Good Morning America, The Early Show*) in what was once exclusively the domain of cartoons.

The Big Three are also narrowing their target audiences. For example, NBC has abandoned animation and programs for younger children, scheduling several low-cost taped sitcoms aimed at young teenagers (**tweens**) and branded as "TNBC." The most popular of these tween sitcoms was the high school comedy *Saved by the Bell,* which was replaced in 2001 by *Hang Time* and *City Guys.*

Disney's purchase of ABC led to another type of corporate synergy. The network's Saturday morning children's schedule has been branded

Disney's *One Saturday Morning* and features programs previously aired in weekday syndication as *The Disney Afternoon*. Not surprisingly, popular Disney animated theatrical films, such as *Aladdin* and *The Lion King,* provided the inspiration for many of the programs in the block.

Similarly, Viacom's acquisition of CBS resulted in the cable channel Nickelodeon, owned by Viacom, becoming the programmer of CBS's Saturday morning children's block. CBS now uses the name Nick, Jr., the title once used by Nickelodeon for its weekday morning schedule. This is another example of the **multinetwork synergy** so highly valued by the ever-consolidating media industries.

As 5.9 shows, in children's programming, the dominant broadcast networks are WB and Fox at the present, both of which air a traditional Saturday morning slate of action-oriented animated series, under the aegis of Kids' WB and Fox Kids. UPN, following a model once used by ABC, schedules a two-hour slate of children's programming on Sunday mornings with no competition from the other broadcast networks. Included are such popular programs as *The X-Men* and *Spiderman,* based on Marvel Comics characters that also appear in syndication on weekdays.

Another example of the influence of children's cable networks on broadcast children's programming is the development of program blocks (Kids' WB, Fox Kids, and TNBC) that are promoted as separate children's networks just like Nickelodeon or The Disney Channel. Even the term *kids* that Nickelodeon uses to designate its children's audience has now become ubiquitous in children's television.

Weekdays

The Big Three abandoned children's programming on weekdays more than a generation ago. Until the 1990s and the creation of new networks, children's syndication developed into a large business supplying independent stations and some affiliates with much popular programming. In most markets independent stations "owned" the weekday children's audience in both the early morning (approx-

imately 6 to 9 A.M.) and late afternoon/early fringe (3 to 6 P.M.). As most of these independents became affiliates of newer networks, these broadcast networks have capitalized on their affiliates' power to reach children by developing new national programming blocks. Today, both Fox and The WB compete in afternoon time spots and with programming genres not seen on the other commercial broadcast networks. Fox recently abandoned its one-hour early morning block, making Kids' WB the sole network provider of children's programming in that daypart. The weekday lineup also offers an effective way for The WB and Fox to promote their respective Saturday children's programming.

The children's television market is strong, vital, and particularly important to the newer broadcast networks that have carved out a substantial niche in the genre, but even with their recent ratings problems, the Big Three are likely to maintain a Saturday morning presence through coventures and with more careful targeting of young viewers. In addition, the FCC and Congress would likely object to a complete abandonment of children's programming by a network. Although always affected by economic cycles and the fickleness of the audience, children's programming is likely to remain popular, because it can be linked to other entertainment media, including motion pictures, video games, and the Internet.

TALK SHOWS

The studio-based talk show is a prime example of low-risk programming. Its minimal start-up and ongoing production costs make it a perfect format for both the low-budget realms of daytime and late-night television.

Daytime Talk

The talk show has been used to fill hour-long gaps in a network's daytime schedule and potentially reach the desirable 25 to 54 female audience. Further, if a talk show host connects with the audience, a series can attract very loyal followers who will watch daily. With studios and equipment almost always available, talk shows are one of the most easily instituted and adaptable of genres. Indeed, the outstanding success of such syndicated talk as *Oprah, Jerry Springer,* and *Rosie O'Donnell* has stolen the genre away from the broadcast networks. The networks have not succeeded in creating popular daytime talk shows, partly because of the dominance of other network formats that have been immensely popular in past decades. In the 1980s when *Donahue, Oprah,* and *Geraldo* were redefining the daytime talk show, the networks stuck with their successful soap operas and game shows during daytime, losing the programming initiative to their syndicated competitors. Currently, the only English-language network daytime talk show is ABC's *The View* with its unique five-cohost format. Both Telemundo and Univision, however, rely on popular talk shows such as *Padre Alberto* and *Cristina* to fill substantial parts of their daytime schedules.

Late-Night Talk/Variety

Despite its near disappearance in daytime, the network genre with the greatest longevity in the late-night time period is the talk show. NBC airs three consecutive talk shows (*The Tonight Show with Jay Leno, Late Night with Conan O'Brien,* and *Later*) in the late-night period; CBS airs two talk shows (*Late Night with David Letterman* and *Late Late Show with Craig Kilbourn*), while ABC competes with *Politically Incorrect* following *Nightline* (see 5.11). Both ABC and Fox have tried several times to develop competing talk shows, but ABC has been more successful with movies and action series than with late-night talk.

As in prime-time series development (see Chapter 4), pilots are often produced for nighttime talk shows. Producers test a variety of elements prior to a talk show's release in attempts to gauge a show's potential. Commonly examined are the sets, the band, the sidekick, and the pacing of the show, but of course the key is the appeal of the host. When a network signs a major star to a talk show contract, the network may decide to

5.11 THE LATE-NIGHT MERRY-GO-ROUND

The Tonight Show was the first late-night network program. The show has been the model of stability with only four regular hosts in five decades: Steve Allen, Jack Paar, Johnny Carson, and Jay Leno. Johnny Carson, the host of *The Tonight Show* from 1962 to 1992, was such a mammoth ratings success that the network added a one-hour show following *Tonight*, *The Tomorrow Show* with host Tom Snyder, which ran from 1973 to 1982.

After guest hosting frequently for Carson, David Letterman was given his own daytime show on NBC in the 1980s. Because of low clearances and low ratings, his program lasted only four months. NBC thought Letterman's offbeat style might better suit late-night audiences, and it replaced Snyder's program with *Late Night with David Letterman.* Letterman developed a cult following among young viewers, particularly college students, who made up a large portion of the show's audience.

Letterman's show attracted an especially desirable target audience with little fall-off toward the end of the program, and to capitalize on the potential viewership, NBC added another half hour to its late night lineup in

1988. The show, *Later,* was originally hosted by NBC sportscaster Bob Costas. When Carson retired in 1992, NBC had to decide who would replace him. Of its two final candidates, the network chose stand-up comic and frequent guest host Jay Leno over Letterman. Because *Tonight's* audience aged dramatically toward the end of Carson's reign, Leno retained the opening monologue that Carson had made famous, but changed the show's style, band, and routine to draw a younger audience. Leno's musical guests were selected with careful attention to the younger target audience.

CBS, which was struggling in third place in late night, decided to take a gamble on David Letterman after he left NBC. The new *Late Show with David Letterman* gave CBS an instant ratings success in late night. Following *Late Show's* success, the network lured Tom Snyder away from his cable talk show on CNBC and gave him his own program, *The Late Late Show,* following Letterman. After Snyder retired, CBS hired Craig Kilbourn, former host of Comedy Central's news spoof *The Daily Show.* Prior to acquiring the services of Letterman, CBS had

run original dramas in late night to counterprogram against talk shows. From 1986 to 1989 and from 1990 to 1994, a number of different series were scheduled. Eventually, these programs proved too costly (averaging about $850,000 an episode by the 1990s), so CBS signed Letterman. The CBS shows, although expensive to produce, had production budgets slightly less than their prime-time drama counterparts. The primary reason for this was that most series were shot in Canada or other countries to avoid the costs associated with U.S. labor unions. Also, these shows were generally coproduction deals with other countries. Hence, the shows were cofinanced with another country and broadcast in other countries. In fact, alternate, steamier versions of the series were generally shot and produced for the European market.

Fox had three notable late-night talk show failures prior to withdrawing from the daypart. Their talk shows, *The Late Show Starring Joan Rivers* (1986–87), *The Wilton-North Report* (1987–88), and *The Chevy Chase Show* (1993) did not draw significant audiences away from competing talk shows.[2]

economize by producing **rehearsal shows** rather than a full scale pilot.

Late-night shows often travel to remote locations. In one sweeps week, for instance, the New York–based *Late Show* traveled to Los Angeles;

ironically, California-based *The Tonight Show* traveled that same week to New York. Such remote locations become promotable events, and the competition is fierce. After an initial lead over *The Tonight Show,* Letterman continues to trail Leno.

The late-night talk show has some of the same benefits of the morning talk show. The talk show can promote network offerings by booking same-network guests. A well-known celebrity appearing in a forthcoming NBC made-for-TV movie can make a timely appearance on *The Tonight Show* and promote the show's exact airdate and airtime. During the 1994 Winter Olympics, CBS's *Late Show* featured nightly reports from the site of the Olympics, for which CBS had the exclusive broadcast rights.

LATE-NIGHT WEEKEND ENTERTAINMENT

Late-night (11 P.M. to 1 A.M.) weekend programmers generally attempt to reach viewers 18 to 34 years old. Networks face competition from a variety of sources in the late-night weekend daypart. First of all, on any given Saturday night, many in the desired target audience have other things to do than watch television. Second, cable and syndicated programs capture substantial audiences. As a result, networks have tried a number of unique programs on Friday and Saturday nights to reach young adults, including comedy, news, and music formats. With only a handful of exceptions, however, they have been unsuccessful, so affiliates fill late-night weekend time with syndicated fare and infomercials.

SNL and Its Offspring

One of the rare successes in network late-night weekend programming history is NBC's *Saturday Night Live*. Debuting on NBC in 1975, *SNL* was an innovative 90-minute comedy/variety program airing at 11:30 P.M. on Saturdays. Previously, NBC had scheduled reruns of *The Tonight Show* in this time period. *Saturday Night Live* features regular cast members and a different guest star host each week. Ratings are typically between 6.0 and 7.0 for new episodes: a huge rating for a time period where HUT levels are low. Many former cast members have become famous film and prime-

time television stars, including Chevy Chase, Jane Curtin, Mike Myers, Bill Murray, John Belushi, Eddie Murphy, Dana Carvey, and Adam Sandler. Producing a fresh 90-minute sketch-driven comedy is demanding; to give cast and writers a rest, NBC has offered some specials and a variety of packaged, thematic best-of-*SNL* shows. During the crucial November, February, and May sweeps ratings periods, however, first-run shows generally air each week.

As is the case with most successful series, *SNL* has had its imitators over the years, the most obvious being ABC's *Fridays* in the early 1980s. At present *SNL* has direct competition from two other comedy entertainment programs, *Mad TV* and *The Howard Stern Radio Show. Mad TV*, which premiered in 1995, is similar to *SNL*. It uses a repertory company of young comedians performing comedy sketches, including popular culture satires and recurring character bits. The one-hour program starts at 11 P.M., one half hour earlier than *SNL*, allowing it to **counterprogram** the local news on NBC affiliates. This enables *MAD TV* to capture viewers interested in comedy before *SNL* takes the stage. Despite this advantage, *MAD TV* trails *SNL* with an average rating of 4.5.

The Howard Stern Radio Show was a one-hour TV program consisting of videotaped segments of Stern's popular nationally-syndicated morning radio program, interspersed with short advertising parodies. In 1998, it went head-to-head at 11:30 with *SNL* on most of the CBS owned-and-operated stations as well as many other stations. *Stern* is an example of a hybrid network/syndicated program. Produced by CBS, which owns Infinity Broadcasting, the radio group owner that produces and syndicates Stern's radio program, *The Howard Stern Radio Show* was offered to all CBS stations. Unlike a traditional network program, however, the program was offered by Eyemark, a syndication company also controlled by CBS. The result is that *Stern* was not considered a true network program and had relatively limited clearances lowering its national ratings. After premiering with a 2.7 rating, the program had ratings as low as 0.9. Its ratings also suffered because the show is

essentially the same as the *Stern* program that airs weeknights on basic cable's E! Entertainment Television. The raunchy and controversial nature of the program kept CBS from marketing the show more aggressively to its affiliates, and then when its ratings died in 2000, relegated it to E!

At present, the only other late-night weekend entertainment program on network television is NBC's *Friday Night*, a 1:35 A.M. Saturday program that combines stand-up comedy and music with entertainment news. NBC previously aired two long-running music-based programs in this time slot: *The Midnight Special* (1973–81), which predated *Saturday Night Live* and demonstrated the viability of programming aimed at young late-night viewers, and *Friday Night Videos* (1983–92). Although viewing levels are very low in this time period, *Friday Night*'s clearly defined target audience had appeal for certain advertisers.

WHAT LIES AHEAD FOR NONPRIME TIME

Significant viewing shifts in nonprime time seem more difficult to achieve in early morning and daytime programming than in prime time. Only in rare cases has a network been able to dislodge an established viewing habit. Competition from basic cable services, pay-cable channels, and videocassette and DVD recordings has decreased the number of available viewers during all time periods, making the task of network programming even more arduous. Two general themes for the future have emerged.

First, for each of the **newer networks** (Fox, WB, UPN, Pax, Telemundo, Univision) *the key to competing for the advertising dollars in network television is to increase their presence in nonprime-time hours.* Fox aggressively expanded its weekend programming in the 1990s, especially sports programming, and has been very successful in gaining new affiliates, viewers, and advertisers. WB and UPN initially concentrated their programming efforts on prime time, but both have expanded to weekend mornings; and WB began weekday morning

programming in 1996 and afternoon programming in 1997. The recent purchase of CBS by Viacom, UPN's owner, has reduced the need for UPN to expand, because CBS is well established in nonprime-time hours. In addition, NBC's purchase of a substantial interest in Pax may limit this new network's growth in nonprime time. Since the FCC now allows companies to own two broadcast stations in the same market, other network combinations may occur, but both Fox and WB are likely to expand their programming efforts in nonprime-time dayparts with the goal of becoming full-service operations.

Second, the transformation of the Warner Brothers' syndicated afternoon of children's programming into a network-delivered schedule of programming for the Kids' WB network *demonstrates the blurring of the network and syndicated television business.* Relaxation of the financial interest and syndication rules (see Chapters 1 and 3) allowed networks to establish themselves as program suppliers to affiliates and nonaffiliates. By the mid-1990s, NBC owned all of its Saturday morning properties. This allowed the network to sell its series to any station in the United States and overseas. Increasingly, broadcast networks are both programmers and active syndicators both domestically and internationally.

Nonprime-time dayparts continue to be more profitable than prime time because program costs are much lower and the time span is longer. *Gaining enough affiliate clearances to achieve success is the key problem for the networks in nonprime-time dayparts.* Programmers try to put together schedules that will be watched habitually week after week. The relatively staid programming strategies associated with daily programming have paid off over the past decades. In the short term, sports, newscasts, magazines, talk shows, children's programming, and soap operas will continue to be the predominate nonprime-time genres. It is difficult to make long-term forecasts for nonprime time, however, because of the changing nature of the syndicated market, and the increased competition from cable, emerging networks, and streaming video from Internet sources.

Sports and late-night programming will also continue to be crucial to the success of network efforts in nonprime-time. *The most reliable predictor of the overall importance of a particular daypart is access to a well-defined and underserved target audience*, even more so than HUT levels. Advertisers may reach older and female audiences through prime-time shows (as well as soaps), but nonprime time is crucial for reaching the very young and male audiences. This is why several newer networks have first programmed sports or children's shows outside of prime-time hours. New corporate combinations (NBC/Pax, CBS/UPN) among network owners herald increases in duplicate airings or reruns, not more original programming. These combinations may also reduce the need for newer networks to expand into more nonprime-time dayparts.

SOURCES

Bellamy, Jr., Robert V. The evolving television sports marketplace. In L. A. Wenner (ed.), *MediaSport*. London: Routledge, 1998, pp. 73–87.

Broadcast rights. Fox Sports web site, 2000. *foxsports.com/business/resources/broadcast*

Carter, B. *Late Shift*. New York: Hyperion, 1994.

Children's educational television. Federal Communications Commission web site, 2000. *svartitoss.fcc.gov:8080/prod/kidvid/prod/kidvid.htm*.

Frank, Reuven. *Out of Thin Air: The Brief Wonderful Life of Network News*. New York: Simon & Schuster, 1991.

Gunther, Marc. *The House that Roone Built: The Inside Story of ABC News*. Boston: Little Brown, 1994.

Kessler, Judy. *Inside Today: The Battle for the Morning*. New York: Villard Books, 1992.

Shapiro, Mitchell E. *Television Network Weekend Programming, 1959–1990*. Jefferson, NC: McFarland, 1992.

abcnews.go.com

cbsnews.cbs.com

www.msnbc.com/news

www.nbc.com

www.soapcentral.com/soapcentral/index.html

INFOTRAC COLLEGE EDITION

Consult InfoTrac College Edition using the password provided with this book. Use boldfaced terms as Key Words and section headings from this chapter for Subject searches.

NOTES

1. For more information about soap operas and their audiences, see Carol Traynor Williams, Soap Opera, *National Forum* 74, fall 1994, pp. 18–21; Robert C. Allen, ed., *To Be Continued . . . Soap Operas Around the World*. New York: Routledge, 1995; and for a history of the soap opera, Marilyn J. Matelski, *The Soap Opera Evolution: America's Enduring Romance with Daytime Drama*. Jefferson, NC: McFarland, 1988.

2. *Arsenio Hall* was a syndicated program that aired successfully for a brief time in the early 1990s on many Fox affiliates.

Television Station Programming

Robert B. Affe

A GUIDE TO CHAPTER 6

6.1 PROGRAMMING SOURCES

ISSUES	Network	Syndication	News/Local
Technology	Distribution: bypass affiliates in future via cable, satellite, Internet	Digital distribution: by server, not satellite; cheaper, more secure	Digital channels: more potential for local programs
Regulatory	Ownership: limits include some multi-network ownership	Deregulation: weakens independents as source of program supply	Station ownership consolidates: small groups sell, local commitment weakens
Economic	Station purchases: increase profits and leverage over affiliates	Networks produce or coproduce own programs for syndication: Independents squeezed	News expands: local production declines. Net compensation under review
Brand-Building	Branding: emphasis on more national brand-identity	Brand-synergy: studios consolidate suppliers under own operations	More local cable: local news still important asset. Local identity declines in favor of national brand identity

Broadcast television—that is, free over-the-air television—is in the throes of its most convulsive changes since its first appearance on the American home screens in the 1940s. On all levels—technological, regulatory, economic, and brand-building—broadcast television is racing toward a maturity that is breathtaking to its viewers and gut-wrenching to its participants. And after decades of enormous profitability, the stations have begun to wonder if they have a future at all.

SOURCES OF TELEVISION PROGRAMS

Television programs come from three main sources—networks, syndicators, or local station production—and are enormously affected by the changes swirling around the industry. Stations used to be thought of as two distinct kinds: affiliates and independents. Although the term **independent station** is still used, it now refers to stations that operated in the three-network world before 1995.

With the rise of such new networks as Fox, UPN, The WB, and Pax, and the strengthening of the Spanish-language, religious, and home-shopping networks, and the subsequent affiliation of virtually all former independents, it now makes little sense to refer to any stations as "independent." In 1996, even the Association of Independent Television Stations (INTV) voted to change its name to the **Association of Local Television Stations (ALTV)** and positioned the organization as a group of stations *not* associated with the Big Three: ABC, CBS, and NBC. With the newer networks gaining audience share against the Big Three, the name *independent* now refers more to attitude than to any real independence from television's dominant economic and structural system.

The relationships among the competing entities and the issues that are important to each part of the industry are visualized in 6.1. Bear in mind that there often are no hard-and-fast divisions among the issues; they are usually interrelated, and their causes, remedies, and consequences are not always readily apparent.

NETWORK PROGRAMMING

In television, the station-network relationship is modeled on the pattern established in the days of radio. Companies that owned more than one station, such as RCA and CBS, quickly realized how **program-intensive** the broadcasting industry is: Programs get used up, and new (or better) ones are constantly needed. Station owners recognized the need to develop a consistent supply of programs for their stations, and it was a short step to the decision to send the programs to all of the stations in the group. In markets in which they did not own stations, the networks found plenty of customers, and in exchange for the programming, the networks kept the majority of commercial advertising time within the program for themselves, allowing their local partners to retain the rest of the commercial time.

The company owning the programs is called the **network;** the local partner is termed the **affiliate.** As long as the network-owned stations needed programming, sharing the programs with affiliates was a means of generating ad revenue and subsidizing the cost of expensive program production. Thus, an affiliate is a *local* television station that contracts with a network to broadcast the network's national program service on an exclusive basis, and a network is a company that provides a simultaneous national program service for up to 22 hours per week in prime time. *In practice, the major television networks provide about half the programming in an affiliate's total weekly schedule.*

For nearly four decades, network television was virtually the *only* successful form of television. As technology, national affluence, and the resulting increase in leisure time created a demand for more entertainment and information products, competing forms of television-related industries developed, including:

- Independent broadcast television
- Cable networks (basic and premium)
- Superstations (WWOR, WGN—a hybrid of independent broadcast and cable)

- Home video
- Satellite (direct broadcast television)
- Cable pay-per-view
- Digital local signals
- Internet-delivered video, text, voice, data

The Big Three

At the apex of their supremacy and profitability, in the late 1970s, the Big Three—CBS, NBC, ABC—generated more than 90 percent of all prime-time viewing. By the early 2000s, their share of network prime viewing had slipped beneath 45 percent. Although the alternative forms of video entertainment, in the aggregate, have chipped away at the networks' near-monopoly of television, commercial network television continues to remain the best vehicle for mass advertising in America. The newer broadcast networks, the cable networks, and Internet web sites attract higher concentrations of narrowly-targeted audiences, but they cannot come close to contesting the networks for delivery of mass audiences.

Every day, the Big Three distribute approximately 12 hours of programs to their affiliates, which otherwise would be hard-pressed to obtain sufficient quality programming to stay on the air 24 hours a day. CBS, NBC, and ABC each have more than 211 affiliated stations, including about a dozen or so owned-and-operated stations in the largest markets.

Fox-Hunting

The cozy three-way balance that operated for four decades was upended in 1994, when the insurgent Fox network successfully raided many traditional affiliate rosters, especially those of CBS, soon achieving near-parity with the traditional networks. The Big Three rapidly became the Big Four. Fox's affiliates were a lineup of formerly independent stations, usually the highest-rated independents in their respective markets, but still inferior in audience share and revenue to their competitors, the affiliates. In addition, most of the Fox affiliates

lacked newscasts. Owner Rupert Murdoch soon put them on notice that his affiliates would have local news—or lose their affiliation. Fox forced itself into the inner sanctum of the industry just by reaching seven nights of prime-time programming in 1992, and topped that achievement by outbidding CBS for the broadcast rights to NFL football starting with the 1994 season. When Fox secured the NFL rights, the CBS affiliates suddenly saw the immediate threat of loss of loyal viewers, irreplaceable revenue, and an unmatched platform for promoting network programming. The impact of the NFL deal shook the underpinnings between networks and their affiliates (particularly those of CBS, whose executives opened their eyes to the advantages of switching their allegiance to Fox).

Before 1994, affiliation switches were rare; viewers, broadcasters, and networks basked in the security of loyal, long-term relationships. When Fox announced a series of affiliation switches in major markets, it unleashed a flurry of activity, breaking a logjam and causing a downstream realignment of affiliates in nearly every large market in which the Big Three networks did not already own stations. In Philadelphia, Boston, Detroit, Dallas, Atlanta, Cleveland, Seattle, Tampa, Miami, Phoenix, and many other markets—nearly one-quarter of the U.S. population—long-term affiliation relationships were broken up, and Fox substantially upgraded its affiliate lineup. By doing so, it achieved station **parity** in network television (reaching equal numbers of households via roughly the same number of affiliates).

CBS was severely wounded by the raid on its affiliates. The network lost decades-long relationships in large markets and had to spend scores of millions of dollars in advertising, promotion, and publicity, introducing viewers in many markets to the local channel that was the new home of CBS. The costs were more than monetary; in many cases they were a slap to the prestige of the "Tiffany Network." In Detroit, for example, CBS lost its Channel 2 affiliate to Fox and had to decamp down the dial to Channel 62. (It was not exactly in the spectrum with police and fire calls, but it was close, from CBS's perspective.) In Miami,

CBS lost its traditional position on Channel 4 and moved to Channel 6, which had a serious signal-reception problem in half the market. In Atlanta, CBS lost Channel 5 and moved to Channel 46. CBS was staggered by the Fox raid, and it took years for the network to recover.[1]

The New Networks

In 1995, two new networks debuted in the same week. The WB, owned principally by the Warner Brothers movie studio, and UPN, originally owned by Paramount and Chris-Craft (and temporarily called The Paramount Network), now by Viacom, owner of CBS (with a puzzling part-ownership by Murdoch who purchased the Chris-Craft stations in 2000) . These so-called "netlets,"[2] or little networks, do not offer the full programming slate of the traditional networks. Instead, WB and UPN focus on the heart of a station's schedule, the prime-time hours, adding young-adult-**skewing** programming and children's animation on weekdays and weekend mornings. The new networks patterned their **roll out** on the model devised by Fox in its early years, introducing one or two nights of prime-time programming per year. The new networks, emphatically WB, have announced that it is not in their game plan to compete for ratings with the Big Four across all dayparts. They will program only in areas in which they can be competitive, which means primarily prime time. Even Fox does not program three hours of prime per night, unlike the Big Three. Fox programs two hours, then expects its affiliates to air late news at 10 P.M. (9 P.M. Central time), to get the jump on the other network's affiliate late newscasts.

One of the major benefits of the WB and UPN affiliations is that they, as well as Fox, give a network-quality look to their affiliated stations, which were predominantly independent stations before the networks came into being in 1995. As much as any other factor, by their guerrilla style of picking off targeted network audiences, the UPN and WB networks contribute to the blurring of identities between affiliates and the former independents. Independents used to be characterized

6.2 AFFILIATION AGREEMENT

Television affiliation agreements differ for each network but in general contain the following elements:

1. The affiliate has first call on all network programs.

2. Acceptance (clearance) or rejection of network programming must be made within four weeks of receipt of order, usually three weeks before the program airs. This is to meet the deadlines of program listing services, such as *TV Guide,* or the companies providing program schedules to the local newspaper or cable program guide, as well as for the purpose of compiling data to justify advertising buys. Presidential press conferences, general news conferences, and news specials require a minimum of 72 hours' clearance. Finally, breaking news stories, such as Senate hearings and fast-breaking domestic or international stories of great import, could require same-day

notification and clearance. Controversial episodes of entertainment series or movies are reflagged by the network at least five weeks in advance so that the affiliate may screen and decide whether to clear the program. Upon receiving a program rejection, the network has the right to offer the rejected program to another television station in the same market.

3. The network's obligation to deliver the programs is subject to the network's ability to make arrangements satisfactory to affiliates for such delivery (via satellite or shipment of videotape).

4. The network agrees to pay the affiliate on the basis of an established affiliated-station's network rate. This rate is based on a station's audience position (share of the market), size of the market, and the station's contribution to the total network audience. The contract between network and affiliate was tradi-

tionally renegotiated every two or three years, but the term can be for one year, and some of the recent agreements, echoing the Fox network's aggressive affiliate raids, have been for as long as ten years.

5. Payment for each network commercial program broadcast over the affiliated station during "live time" is based on a percentage formula. Early evening and prime-time programs are clearly the most profitable to the affiliate because the networks gain the largest gross audiences during those dayparts.

6. The network can reduce the affiliated station's network rates if market conditions change (after at least 30 days' notice, in which case the broadcaster can terminate the affiliation relationship within a predetermined time period). The networks retain staffs to reevaluate rates—recommending varied compensation rates in different time pe-

by a "local" look ("local" used pejoratively in this case), with prime-time programming consisting of old movies and even older syndicated product. Today, it is virtually impossible to distinguish between the two former classes of stations in network prime time.

More networks have arisen to fill in the space beneath the Big Four and Little Two (WB and UPN). Paxson Communications launched its Paxnet service in 1998, concentrating on family-friendly programming. Because of the enormous financial and operational burdens, in 1999 the network joined NBC, who uses the service as a

second tier, with repeats of NBC programs and extended news coverage as the meat of the revamped Pax. Other important networks are the two major Spanish-language services, Univision and Telemundo. In markets with high Spanish-speaking presence, Univision and Telemundo often outdraw English-language competitors and are a growing force in the national advertising market.

The Network-Affiliate Relationship

Each party to an affiliation makes specific promises to the other party; the legal document binding

6.2 CONTINUED

riods to get a better clearance pattern from their affiliates.

7. The network agrees to make compensation payments with reasonable promptness within a monthly accounting period.

8. The broadcaster agrees to submit reports related to broadcasting network program. These reports are in the form of affidavits, also called performance reports or usage reports.

9. The Federal Communications Commission (FCC) rules originally fixed the term of an agreement to two years, with prescribed periods during the agreement when either party may notify the other of termination, but network-affiliate agreements no longer have such a restriction. If each party concurs, the agreement is renewed automatically for another multiyear cycle.

10. If a broadcaster wants to transfer its license to another party, the network can decide whether to transfer the affiliation agreement.

11. The agreement also lists the technical conditions under which the affiliate will carry the network programs (when a broadcast standard signal arrives to ensure picture quality, for example). Clipping (cutting off the beginning or ends of a program or commercial), reselling (including permitting noncommercial stations to re-air network programs), or altering any of the content of network programs is expressly prohibited.

12: The rights of the broadcaster, derived from the Communications Act of 1934, also are itemized: (a) the broadcaster can refuse or reject any network program that is reasonably unsatisfactory or unsuitable or contrary to the public interest; and (b) the broadcaster has the right to substitute programs in lieu of the network's if the substitution is considered in the broadcaster's opinion of greater local or national importance. The network, in turn, has the right to substitute or cancel a program as it deems necessary.

13. The network must inform the broadcaster of any money, service, or consideration it accepted in the preparation of network programs in accordance with Section 317 of the Communications Act of 1934, which requires this disclosure.

14. The network also agrees to indemnify the broadcaster from and against all claims, damages, liabilities, costs, and expenses arising out of broadcasting network programs that result in alleged libel, slander, defamation, invasion of privacy, or a violation or infringement of copyright, literary, or dramatic rights involved in programs the network furnished.

both parties is called an **affiliation agreement.** The most salient points of a standard agreement are to be found in 6.2.

To summarize, the network agrees to provide its program service to the affiliate on an exclusive basis. **Exclusive** means that only one station in each market may broadcast the network's programs. Further, the network will pay the affiliates a negotiated fee for broadcasting its programs. This fee is called **network compensation,** or just plain **comp.** Network compensation can easily exceed one million dollars per station in the larger markets. Ironically, comp is more important to stations in the smaller markets, where it can represent up to 10 percent of total revenues and spell the difference between profit or loss for the affiliate.[3]

In return, the affiliate promises to broadcast the programs as delivered by the network and to allow the network to retain about three-quarters of the commercial time within each network program. *The exchange of local commercial airtime for network programming is the justification and foundation for the entire network-affiliate relationship.* This is the central idea of the network/affiliate relationship. For example, in the practice of commercial television, one variable in a station's profit formula is the

number of commercials it can air. Although a network program usually generates a higher rating than a locally-produced one (and thus carries a higher commercial rate), the number of commercials the affiliate can air is only about one-quarter the number of total ads in a given program; small variations in that "about" can mean a lot of money to the station.

The commercial breaks for the local station are called **station breaks** or **adjacencies.** In a half-hour program, the affiliate's commercials come at the end of the program; the network's commercials fall within the more desirable real estate—within the program itself. In an hour program, half the affiliate's commercials fall at the end of the program, half within, and, again, all the network's commercials occur within the program. Thus, hour programs have more value to stations, ratings being equal, because some of the "within spots" can sell at higher rates.

Tension between a network and its affiliate governs the entire relationship. In the network-affiliate detente, each party thinks that the other is getting the upper hand in the deal: Networks believe that the affiliates are reaping windfalls from obtaining high-quality and commercially-attractive network programs *plus* receiving compensation. In contrast, affiliates grouse that networks are hogging most of the commercial **inventory** during network programming as well as piggybacking on the affiliate's success and reputation in the market for news and local programming. These arguments raged back and forth for decades, indicating that the relationships were roughly equal in strength. Of course, in markets where the affiliate is competitively superior (because of strong news performance or such outside factors as signal strength or lack of strong competitors in the market), its resentment of the network is correspondingly higher than in a market in which the affiliate is weak.

In truth, networks and affiliates need each other. *Each party trades what it has for what it needs: The network needs local affiliates to gain access to the market, and affiliates need the economies-of-scale that enable the network to provide the big-budget*

6.3 PROGRAMMING AS A COMMODITY

Throughout the early years, when television was struggling, there were underlying scarcities: The number of stations was limited, commercial inventory was perforce in demand, and program suppliers were few. The result of these scarcities drove programming and advertising costs upward. Today, there is a free-for-all in the markets. The result is a commoditization of programs and the value of commercial time. The industry is struggling to come to grips with this new fact of life. As a result, economies-of-scale are becoming more critical, leading to the centripetal forces of consolidation. Large companies are brand-building through acquisition and development. Smaller companies, unable to compete with the behemoths, are selling out to them. This gravitational force is working its way through all media, not just television. This is a sure sign of a maturing industry.

entertainment/sports/news programming that affiliates would otherwise be unable to produce on their own.

The Profits in the Business

In the shorthand of the television trade press, it is often reported that a network made or lost money. That is a largely inaccurate way to report the fortunes of a broadcasting company. It is important to remember that network television is a *program service;* in other words, it is an *expense.* Network service is not designed to maximize profit. Recall that the network-affiliate structure was built to subsidize the expensive budgets of producing programs for the network's owned stations (see 6.3). The *real* money is made at the network-owned stations. This is why the networks continue to beef up their roster of owned-stations and aggressively lobby Washington to raise the limits on ownership.

STATION DAYPARTS

A **daypart** is a span of time during the day. The best-known daypart, of course, is prime time. Although it might seem an arbitrary division, the assignment of hours of the 24-hour day into dayparts generally reflects the presumed lifestyles and viewing patterns of the typical American viewing household. These are the generally accepted dayparts and their time periods:

6 to 9 A.M.	Early morning
9 to 12 noon	Morning
12 noon to 4 P.M.	Afternoon

(Note: 9 A.M. to 4 P.M. is also referred to as "daytime.")

4 to 7 P.M.	Early fringe
7 to 8 P.M.	Prime access
8 to 11 P.M.	Prime time
11 to 11:35 P.M.	Late fringe
11:35 to 2 A.M.	Late night
2 to 6 A.M.	Overnight

These dayparts are standard for Eastern and Pacific time zones. In Central and Mountain time zones, the dayparts change slightly: Essentially, prime time starts an hour earlier and ends an hour earlier, and early fringe, access, and late fringe move an hour to accommodate prime time:

4 to 6 P.M.	Early fringe
6 to 7 P.M.	Prime access
7 to 10 P.M.	Prime time
10 to 10:35 P.M.	Late fringe

Although necessarily subjective, the division of the day into dayparts does indeed reflect large portions of most people's lives. For example, most people awaken in the morning between 6 and 9 A.M. (corresponding to the **early morning** daypart), get off to work or school by 9 A.M. (start of **daytime**), and return home in the afternoon between 4 and 6 P.M. (**early fringe**). About two-thirds of American households watch television during the evening, peaking around 9 P.M. (**prime time**). Between 10 and 11 P.M., viewing levels

begin tapering off, then drop precipitously after 11 P.M. (**late fringe**).

It is necessary that broadcasters and advertisers agree on these dayparts, established by the Nielsen Media Research company, in order to conduct the multibillion-dollar business of setting advertising rates and selling commercial time at America's more than one thousand commercial television stations. In addition to configuring advertising expenditures and revenue, the dayparts also set the boundaries for the programming strategies that capture the time, money, and effort of broadcasting producers and executives.

Programming from the Network

The Big Three networks generally supply programs for approximately 12 hours per day, across many dayparts, and across the two main categories of program formats: information (regularly-scheduled newscasts, specials, live coverage, documentaries, public affairs) and entertainment (dramas, comedies, movies, talk, game shows, sports, children's, and other specialty formats). See also Chapters 4 and 5 for more on specific programs and network strategies.

Early Morning (6 to 9 A.M.)

Before their network morning news programs, affiliates often air their own local newscasts. If the station cannot afford to produce news, it can acquire syndicated news or business programs. Although stations get the benefit of compatible programming to network news, they will lose some of the inventory to barter.

The 7 to 9 A.M. time period has traditionally been a network preserve, in which a long-form newscast is softened with interviews and features. CBS affiliates have had the most anguish in this daypart because their network has had only indifferent success over the years with its many morning efforts. Its affiliates obviously want their network to succeed, but they cannot wait indefinitely for it to do so, thus lack of clearance exacerbates the

network's problems. Unlike in the early days of television, a Big Three affiliate now can finish worse than third in the ratings. CBS affiliates usually preempt the network in whole or part in early morning, scheduling syndicated programming more attractive to the eventual audience of their 9 A.M. women-oriented programming. In contrast to the other networks, the Fox network delegates the daypart to its affiliates, the largest of which counterprogram the affiliates with local news programs, occasionally beating one or more of the traditional networks at their own news and talk game. In smaller markets, the smaller networks program entertainment opposite network morning news, predominantly sitcoms and cartoons. This is an effective strategy, too: Let the three networks fight for the same news audience and instead concentrate on the non-news-viewing adults or children.

Stations that do not have network news on their schedule tend to program blocks of off-network dramas or sitcoms, or children's programs as a clear alternative to network news. The latest trend is to schedule first-run programming, like telecasts of talk shows, as the clearest alternative to news.

Morning
(9 A.M. to 12 noon)

The Big Three networks do not program the entire daypart; they each fluctuate between providing one and two hours. Affiliates fill out the schedule with a combination of syndicated talk and game shows, sitcoms, and dramas, ideally blending in with network programs. In the largest markets, affiliates sometimes produce their own programs. The attrition rate for network morning programs is high; but an intriguing characteristic of network daytime is that if a new program can hang on for a couple of years and attract a loyal audience, a kind of video inertia takes over, and the program stays on the air seemingly indefinitely. *The Price Is Right* has been on the CBS daytime schedule since the 1970s. Viewers during daytime tend to be homemakers, senior citizens, students, and shift workers. Although they have large blocks of time to watch

programs, they are not fully engaged with the programs. So producers structure their programs to enable viewers to enter, leave, and return a daytime program easily. That's why game shows have lots of noise and require minimal levels of sustained concentration and why soap opera plots proceed so slowly.

Talk programs are a mainstay of daytime program schedules. The mortality rate of such syndication programs is high: 80 percent of all syndication programs that make it to broadcast do not make it to year two. But once a program has established itself as a popular favorite, it can stay on the air for almost as long as the distributor wants. *Live with Regis and Kathie Lee* enjoyed a successful 12-year run, and even survived the loss of Kathie Lee Gifford, becoming *Live with Regis and Kelly*. The right talk show can pull large numbers of viewers into the next program.

Talk shows run the emotional gamut from light-content interviews with celebrity guests to an exploitative treatment of guests' troubled psyches or relationships, where personal and interrogatory confrontations delight or repel viewers. Research has shown that there is a vicarious appeal to these exploitative programs: Viewers at home, no matter how troubled their own personal circumstances, feel relieved that at least they are not as pitiful as the people they are watching on television.

Why are talk shows so prevalent in television syndication? The major reason is *cost* or, more accurately, lack of cost. Like late-night network programs, daytime talk in syndication is relatively inexpensive to produce, and once the fixed costs are laid in, the incremental costs are minimal. The low cost threshold makes it easier for the program's producers to adjust the content, if ratings or research testing indicate that popularity has fallen among the viewers.

Afternoon
(12 noon to 4 P.M.)

Except for a midday break for local news, the afternoon daypart is the Mother Lode for soap operas (network executives get irritated when "the soaps"

are referred to as such, preferring to have them called "daytime dramas").[4] Needless to say, this is the most stable daypart for viewers, networks, and advertisers, and affiliates of the Big Three need only sell the time.

Syndicated talk shows work well for stations without network soap operas. Another popular daytime program category is court shows, in which a real or ersatz judge hears disputes and rules upon them. The appeal of programs like *Judge Judy* is twofold: First, the personality or character of the magistrate is entertaining and, second, the actions and reactions of the litigants are heartrending, or comical, or just plain irritating. In any case, for societal good or ill, it makes for compelling television.

Lest one conclude that all first-run television in daytime is devoted to exploiting the dark or voyeuristic side of human nature, there are more lighthearted categories of programs: game shows and relationship shows. Game shows are traditional and quintessential daytime television fare. They are suitable for all viewers: The content is mostly question and answer, viewers can play along at home—and feel superior when the contestants muff an easy question. To keep the pace of the game interesting, game shows are usually one half hour in length. Research has shown that the best companion program to round out the hour is another game show. That is why so many game shows are found together in a one-hour block. Even though technology has ramped up the production values of game shows, the elements remain unchanged: question/answer format, relatively low skill level, vicarious viewer participation, and a clear payoff or disappointment. None of life's ambiguities for game shows; every game produces a winner or a loser.

Relationship shows can be dramatic or lighthearted. If serious, they are found in the format of talk shows, in which the underlying issues of the relationship are explored. If entertainment, often they are found as game or comedy shows, in which couples of long or brief acquaintance answer questions about each other. There is a legacy of syndicated relationship shows: *The Dating Game, The Newlywed Game,* and *The Love Connection* all draw upon people's interests in the love lives of others.

Early Fringe (4 to 7 P.M./4 to 6 P.M. Central)

Most of the networks do not generally program early fringe. They leave the time period for local stations to fill with syndicated programs or local news. The only exception is the daily half-hour network news, which used to be broadcast during the first half hour of prime access, 7 P.M./6 P.M. central.[5] Because of the high potential revenue available to entertainment programs in access, affiliates successfully pressured networks to send the network news down the line in early fringe, 6:30 P.M./5:30 P.M. central.

A station can make more money in early fringe than in prime time, with a judicious combination of programs. Viewing levels, while not as high as prime, still are high, on average two-thirds of prime viewing. During winter months, especially, viewing spikes upward once darkness falls.

Early fringe gives stations all kinds of creative opportunities to put together the strongest possible combination of local and syndicated programs. Stations generally fall into two categories when it comes to scheduling early fringe. News stations run news-compatible programs around their newscasts. These programs might be female-oriented talk shows such as *Oprah* or *Jenny Jones*, or court shows, such as *Judge Judy, Judge Joe Brown,* or *People's Court. Oprah* is the number one talk show in syndication. She is scheduled with devastating effect in many markets at 4 P.M., and her program funnels viewers into the news. Her ratings prevent competing stations from getting traction in the late afternoon. Only when an equally strong personality comes to the television screen, like a *Judge Judy,* does *Oprah* get challenged.

If a station decides not to program news opposite its competitors' newscasts, the station usually chooses to program blatantly in the opposite direction. When a station takes such a course, it

is called **counterprogramming.** Stations with no news in early fringe generally run a program category diametrically opposite news—comedy. These stations are generally not the Big Three affiliates: They are Fox affiliates or stations affiliated with the netlets of The WB or the Paramount Network, or completely independent. Not having news, their audiences are younger.

The strategic response of these stations is to match their program offerings to those viewers available, starting in the afternoon around 3 P.M., either with animated cartoons or other young-skewing fare. This technique is called **aging an audience.** Sitcoms might appear in the next hour or two, certainly by 5 P.M., when the traditional affiliates air news. Younger-skewing sitcoms (*Moesha, Sabrina, the Teenage Witch*) might give way to slightly older sitcoms (*Home Improvement*), then come the strongest sitcoms on the station's schedule, in access (*Friends, Drew Carey, Seinfeld, Everybody Loves Raymond*). Whether a station is programming network, syndicated, or news/local, it wants to retain as many of its viewers as possible through the daypart. As explained in Chapter 1, this is called program **flow:** It is a strategy of scheduling programs similar enough in appeal that current viewers will stay with the next program as new viewers tune in. As the audience composition changes during the day, the program lineup changes along with it.

Flow is not as critical a concept as it once was. Before cable brought multiple channels to the home screen, and before ubiquitous remote control handsets made channel changing a push-button procedure, station programming executives obsessed over the idea of program flow. In the days of three or four channels and no remote controls, it was vital to keep the viewers in their seats and not off the sofa changing the channel, because the station might lose them for the rest of the evening. Today, with scores of channels available and the ability to change channels as easy as pushing a button, viewers can surf channels at whim. Flow is less critical a strategy than it once was, and the notion of customer-retention now takes place in an infinitely more challenging universe.

Stations with news have a predicament: They run news in early fringe, but not during every half hour in the daypart. Yet they want programs that are compatible to the newscast and provide some measure of flow. That is why magazine shows like *Inside Edition* are so prevalent. They are news-light, first-run, new telecasts every day. The downside to magazine programs is that their ratings are generally not as strong as the best comedies. The upside is that, unlike sitcoms in syndication, which can be expensive and risky, magazine programs are plentiful, which means the purchase price is not exorbitant. Too, the magazine format does not change radically over the years, which means advertisers and viewers will not receive any unhappy surprises. In short, for the news affiliate, it is best to have the highest-performing syndicated program even if it is a comedy, but if price or risk-averseness is a major consideration, a strong magazine program can meet the objectives of the station as well.

Prime Access
(7 to 8 P.M./6 to 7 P.M. Central)

Networks do not program the time period since the creation of this daypart in 1970. Access is the second-highest revenue time period on most affiliates. A handful of first-run syndicated shows (*Wheel of Fortune, Jeopardy, Entertainment Tonight, Inside Edition*) have dominated the ratings in this time period for many years. As a result, new shows have a tough time breaking through. Demographics play a key role in selecting programs, especially for stations that cannot buy the top show, but can counterprogram to a different advertising target (e.g., men 18 to 49). For example, the rankings shown in 6.4 demonstrate that *Seinfeld* was tied for seventh place in overall households, but ranked first among target men.

Prime Time
(8 to 11 P.M./7 to 10 P.M. Central)

This is the marquee time period for the networks. Viewing levels are highest, prestige is highest, revenue is highest, but because of the expense of ac-

6.4 ACCESS PROGRAMMING, MAY 2000

KTVG PROGRAMMING RESEARCH
May 2000 SWEEP
NSI SYNDICATED PROGRAM RANKINGS

AFFILIATE/ACCESS/Top 100 Markets

RANK	PROGRAM	# OCC	HH R/S	M99 T.P.S	% CHG	W18-49 RNK	SHR	M99 T.P.S	% CHG	W25-54 RNK	SHR	M99 T.P.S	% CHG	M18-54 RNK	SHR	M99 T.P.S	% CHG	M25-54 RNK	SHR	M99 T.P.S	% CHG
1	WHEEL	96	11 / 22	23	-4%	3	13	14	-7%	1	15	16	-6%	3	10	11	-9%	3	11	12	-8%
2	JEOPARDY	62	10 / 19	21	-10%	4	12	14	-14%	4	14	15	-7%	3	10	12	-17%	3	11	12	-8%
3	E.T.	74	6 / 13	12	+8%	2	14	13	+8%	1	15	14	+7%	4	9	9	-	4	10	10	-
3	INSIDE EDITION	21	6 / 13	14	-7%	5	11	11	-	5	12	13	-8%	9	8	9	-11%	6	10	10	-
5	FRASIER	20	6 / 11	11	-	6	11	10	+10%	3	12	12	-	3	10	10	-	3	11	11	-
5	FRIENDS	21	5 / 11	13	-15%	1	17	17	-	1	15	16	-6%	2	14	13	+8%	2	13	13	-
7	EXTRA	26	5 / 10	11	-9%	8	10	9	+11%	7	11	10	+10%	12	7	8	-12%	11	8	8	-
7	JUDGE JUDY	9	5 / 10	10	-	9	9	11	-18%	7	11	11	-	7	8	10	-20%	8	9	10	-10%
7	SEINFELD	21	5 / 10	11	-9%	6	11	12	-8%	7	11	13	-15%	1	15	15	-	1	15	15	-
10	REAL TV	9	4 / 9	11	-18%	11	8	10	-20%	13	8	10	-20%	9	8	10	-20%	11	8	11	-27%
10	HOLLYWOOD SQUARES	53	4 / 9	10	-10%	11	8	10	-20%	10	9	11	-18%	14	6	8	-25%	13	7	9	-22%
12	HOME IMPROVEMENT	11	4 / 8	10	-20%	14	7	12	-42%	13	8	12	-33%	6	9	11	-18%	8	9	11	-18%
13	ACCESS HOLLYWOOD	14	5 / 7	7	-	11	8	7	+14%	10	9	8	+13%	12	7	4	+75%	13	7	6	+40%
13	DREW CAREY	11	3 / 7	9	-22%	9	9	11	-18%	10	9	11	-18%	6	9	9	-	8	9	10	-10%

Source: NSI Snap, May 2000. 5 or more occurrences in the daypart.
New programs this season in bold.
6/20/00

Source: *www.katz-media.com/tvprog/v16n5/aff-access.gif*. From *COMTRAC Syndicated Program Performance* (Vol. II), May 2000. Used by permission.

quiring first-class productions, profit margins are higher in other dayparts. As the most visible of network-supplied dayparts, affiliates preempt carefully, only with cause.

Syndication is in retreat in prime time because former-independents have affiliated with one of the netlets. The growth of Fox, UPN, and The WB networks has removed hundreds of potential program-hungry stations from the syndication market in prime. Formerly, there was an insatiable demand for movies and off-network product. Much of this studio-produced product today has been bought by the cable networks, which in many cases are owned by the studios themselves. The smaller stations left to themselves to program in prime will have to share this product with cable.

Late Fringe
(11 to 11:35 P.M./10 to 10:35 P.M. Central)
Reflecting lifestyles, HUT levels start dropping precipitously around 11 P.M./10 P.M. Central. Networks, after three hours of prime program-

ming, take a rest and throw the time period back to their affiliates, who generally program news. Not everyone wants to watch news before going to sleep, or perhaps some viewers watched an earlier newscast. These viewers are likely customers for the many kinds of syndicated entertainment programs available.

Stations not airing news run a menu of syndicated programs, positioned to appeal to viewers uninterested in news programs: sitcoms, evening (second) runs of daytime talk programs, and relationship shows. Late fringe is a strong time period for non-network stations; the strongest ones often outperform local affiliate news. Fox stations have spent the last several years delving deeply and expensively into the comedy syndication marketplace; so have other non-news stations.

With the rise in popularity of talk shows, another effective programming move has been to schedule a repeat telecast of talk shows in late night, for working people who cannot watch during the day. *Oprah,* for example, is rerun late at night

in several large markets, including New York, Los Angeles, Chicago, and Philadelphia.

For the programming executive, one advantage of late fringe over early fringe is that an elusive viewer is reachable in late fringe—men. Males watch less television than women or children, both in terms of amounts watched and kinds of programs viewed. Young men, in particular, are more likely to watch narrow categories of broadcast programs: sports, some action-oriented movies, and. . . . more sports. In late night, however, men are available, and they do watch comedies and risqué, first-run late-night programs.

Late Night
(11:35 to 2 A.M./10:35 to 2 A.M.)

This daypart has become stable, and affiliates generally clear their network's programming: Leno's program is Los Angeles–oriented, Letterman's is in New York, and ABC covers the newsbeat with *Nightline*. Most affiliates of the Big Three are relatively happy because these programs may attract larger audiences than they would lure with first-run or off-network syndicated programs. Moreover, the program content is not as restricted as it is in prime time, because of the lack of a children's audience at such a late hour.

Late night is an ideal time period to experiment with offbeat syndication ideas. Expectations are not very high; there are men available, and if a program is a hit, it can make money in the daypart, perhaps even be moved to a more revenue sensitive daypart.

Overnight
(2 A.M. to 6 A.M.)

Networks do not program entertainment overnight because HUT levels are too low to justify production and distribution costs (exceptions are described in Chapter 5). Thus, overnight becomes an arena for second and third reruns of syndicated programs and movies purchased by the stations.

Although HUT levels are at their lowest levels, stations cannot afford to completely ignore this daypart. First, in our 24-hour world, there are *some*

viewers available at all times. Advertisers can still be found to buy commercial time, even if at very low rates. (These spots are not unaffectionately called "a-dollar-a-holler.")

Second, if the station signs off the air, the local cable company might use the now-empty channel space to carry a service with content that might alienate the broadcaster's regular viewers when they turn the television on the next day. Third, if a station signs off, the few viewers who were watching will turn to another channel. When they turn the set on again, it will be on a different channel. Why invite customers to sample a competitor? There is enough noncash programming, combined with old movies, to fill up the overnight schedule. All else failing, another format ideally suited for late night is that of the infamous program category known as **infomercials.**

Weekend Programming

On Saturday and Sunday, networks adjust their programming to attract a group of viewers who are light network viewers during the week: men, and of course, sports programming dominates the screen on weekends. Broadcast advertisers are willing to pay a premium rate to attract men, who watch little of prime view, but account disproportionately for large-item (autos, financial services, sporting equipment) and specialty (alcohol, men's personal care) purchases. Even with relatively low HUTS, affiliates find their adjacencies in top network sports events enormously valuable.

Preemptions

Occasionally, an affiliate might decide not to air a network program. This is called **network preemption,** which might occur for a number of reasons:

- A local news emergency might require live coverage.
- The station might decide to air a program it produced on its own: a local parade, local news special, and so on.
- The content of the network program might be deemed inappropriate for local viewers.

- For commercial reasons, a station might preempt the network in order to keep all the advertising time and revenue for itself.

Usually, when an affiliate preempts the network, it will reschedule the program to another time period (called **delayed carriage**), but will lose the compensation for the program. If the affiliate will not **clear** the program at all, the network will offer it to another station in the market. The networks keep careful track of the number of preemptions each affiliate makes, which can be a powerful bargaining chip at the time of affiliation agreement renewal and when adjustments in compensation are requested.

It is important to note that networks are not licensed by the FCC—stations are—and the affiliate must keep an eye on its next license renewal by offering programming in the public interest. Sometimes the affiliate will contest its network's complaints about preemptions, on the grounds that the substitute program served the community's interests and made the affiliate a stronger station in the market. This is a compelling argument to use when a network repeat episode is preempted in favor of a news special about education in the locality; it is a plausible argument when a network is preempted in favor of a championship game in which a local college team is playing; and it is a weak argument if the network is preempted in favor of a syndicated entertainment program, broadcast solely for the purpose of selling more commercials to make a quarterly budget.

SYNDICATED PROGRAMMING

If a network can be considered a wholesale supplier of programs, then syndication is a retail source. Stations fill nonnetwork time primarily with syndicated fare, which comes in two kinds: programs formerly aired by one of the nine networks or new programs never aired on a network. See Chapter 3 for a detailed discussion of the syndication process.

The Prime-Time Access Rule

In an attempt to encourage stations to live up to their "public service" mandate and, not incidentally, make the network-affiliate relationship more balanced, in 1970 the FCC issued a regulation chopping off one hour of prime-time television per night. (Until then, network prime had started at 7 P.M./6 P.M. Central and aired for four hours.) The 7 to 8 P.M. hour was dubbed **prime-access time,** and the regulation was called **the prime-time access rule (PTAR).** Under PTAR, the commission limited affiliates to three hours nightly of network programming and prohibited stations in the largest 50 markets from airing any off-network syndication in prime access. (An exception was made for network news programs: They would not count toward the three hours. A second exception was made for Sundays because, at the time, the networks aired family-oriented programming on the most heavily viewed night of the week, reasoning that seems silly today.) The FCC naively imagined that the 7 to 8 P.M. time period would be occupied by local productions, public affairs shows, and more local news.

Instead, the "rule of unintended consequences" applied. Rather than produce more (low-rated) public affairs programs, local stations realized that they had just been handed a great gift. They could now run syndicated programs (so long as they were not of the off-network variety) in what was formerly prime-time territory, and they got to keep *all* the extra commercial inventory and the revenue that went with it! Although PTAR was repealed in 1995, it is highly unlikely that the networks will get their lost hour back. Access is the highest viewed nonnetwork time period during the day, and stations generate too much commercial revenue to acquiesce in returning the time to the network. Now that off-network reruns can air in access in any market, the increase in potential programs has driven prices down for both off-network and first-run, and local stations make even more money.

Off-Network Syndication

When a program debuts on network television, all eyes are watching: The viewers look to see if they like the new show and want to continue watching; the network executives look to see if the program's ratings are secure, so that their jobs will also be; the advertisers look to see if their commercials are persuading viewers to buy their products; and the program's producers look to see if their new network program will have a sufficiently long network run to live on in syndication.

After a program has been on the network for about two years, the producer has a clear idea how popular the program is among viewers (by the ratings) and how popular the program is at the network (by the time period and the number of times the program has been moved or preempted). The producer, now wearing his syndicator's hat, will make in-person inquiries of stations, soliciting their opinions of the program and trying to determine their level of interest. At some point during the second or third network season, the syndication process begins for the program. Sales presentations are made at each station in a market (see Chapter 3), follow-ups are made at the corporate level, and hard-bargaining ensues. Unlike other properties for which a price can be established (like land, or automobiles, or even for personal services), there is *no inherent value* to any given television program. Ultimately, the market value of a program is set by the price at which the buyer's offer and the seller's take-price overlap. In adjoining markets of similar size, with similar demographic profiles, the same program can sell at wildly varying prices.

The contract is an exercise in simple mathematics. The syndicator sells the exclusive right to air the program in one of two ways—on a weekly license basis or on a per-episode basis.

1. Weekly license. The most-popular, current style of syndication. The station pays a weekly rate for the program (paid monthly), which is satellite-fed to the station. There is **barter** advertising in the program, and the station has no say in the scheduling of individual episodes.

2. Per episode. The older method, in which the station enjoys more control over the management of the program. As long as the syndicator gets paid (monthly), it does not care whether the station airs the program every day, twice a day, or not at all (called **resting** or **shelving**). There is generally no barter in this method. The station contracts for a determined number of telecasts over a stated period of time.

In either case, when the program is sold in syndication, it goes into the marketplace upward of two years before its actual entry into syndication. For example, when *Friends* launched on the NBC network in 1994, it was an immediate hit. The owners of the program, Warner Brothers, opened the market for syndication sales of *Friends* in 1996, for debut in syndication in 1998. From that date and on to whenever the end of its network run occurs, *Friends* will be on both the network and in syndication. A megahit program might be on a network for as many as eight years; in network seasons four through eight the program is simultaneously in syndication. As each network year ends, those episodes fold into the syndication contract, adding to the number that the local station has to air, as 6.5 explains.

While a program is on the network, the station benefits from having the syndicated version in three ways:

- *National exposure.* The networks spent heavily to promote the program on the network and publicized it in the rest of the media. The name recognition rubs off on the syndicated version of the program.

- *New episodes.* Every year the station gets the rights to the previous season's network episodes, broadcast only twice, so many viewers haven't seen them—at least not often.

- *Advertiser access.* Advertisers know and respect network programs. When programs are too expensive on the network, advertisers can buy spots at the local level.

For stations, syndicated programs pose both opportunities and perils. On the opportunity side,

6.5 SYNDICATION CONTRACTS

Calendar Year	Network Season	Number of Episodes	Syndication Season	Number of Episodes
1994	1	22	—	
1995	2	22	—	
1996	3	22	—	—
1997	4	22	—	—
1998	5	22	1	88 (from first 4 net years)
1999	6	22	2	110 (plus 22 from net year 5)
2000	7	22	3	132 (plus 22 from net year 6)
2001	8	22	4	154 (plus 22 from net year 7)
2002	—	—	5	176 (plus 22 from net year 8)
2003	—	—	6	176 (no new episodes)

the big benefit is the commercial inventory. After the station exchanges three-quarters of its potential commercials for the right to receive network programs, it still has a 90-second station-break for sale. In off-network syndication ("off-net," for short), the station keeps most of the commercial time, generating more revenue. Another benefit lies in brand-building for the station. In syndication, a station can pick and choose among available programs, building the best lineup it can construct. With a network, a station is stuck with the program the network schedules. A third benefit exists in the afternoon lead-in to local evening news. A station can acquire programs that will be more complimentary to its high-profile afternoon and evening news programs than a network might provide. Finally, stations can use syndicated programs to cater to local tastes. *Networks have to program for a national audience or audiences reached by their owned-stations, which tend to be in the largest markets. The syndication marketplace makes available programs that might be a better fit for regional or market tastes.*

At the same time, there are perils in not having network programming. First and biggest is the cost of programs. Whatever their other disadvantages, network programs do not create an out-of-pocket cost to the station. If a station buys a

syndicated program, conversely, it bears the entire financial risk of that decision. If a network program fails, the network will eventually replace it. If a syndicated program fails, the station is still obligated for all the costs of the program throughout the contract period.

Second, the station has to promote each costly program it buys, using up cash and some of that immensely valuable spot real estate. Network programs have national exposure and national publicity, to the downstream benefit of local stations. On a network schedule, a given program is aired on the same day, at the same time, everywhere. *ER* is on every NBC affiliate on Thursdays, at 10 P.M./9 P.M. Central, for example. In contrast, syndicated programs are on the air at different times everywhere. A station cannot rely on a national network advertising campaign and must bear the burden of promoting the program locally. The syndicators do, indeed, participate in and contribute to promotional efforts, but a great deal is left to the station, especially with older programs. Another risk lies in the absence of exclusivity. Once a program is on a network, it seldom moves to another network. A local affiliate can be confident that a hit network program will be on its station for the length of its run. In contrast, a syndicated program is under the control of

the syndicator. Once the contract period is over, the syndicator can move the program to another station, and there is little loyalty to stations in the syndication business.

Movies

Like all other forms of programming, movies have felt the influence of technology and new market economics. When cable networks—both general interest (e.g., USA, TBS) and movie-specific (AMC, HBO), both free and pay—started operations, they proved to have an even more insatiable appetite for movie product than broadcasters (see Chapter 9). As a result, the cable networks forced their way into the buying process, offering prices that were so attractive that they pushed ahead of local stations in the exhibition sequence. By the time a local broadcast station can air a syndicated movie, it is often exhausted from overexposure. As a result, a once-valuable program franchise has been co-opted by bigger and deeper-pocketed cable competitors. Today it is highly unusual to discover a movie on local television that one has not had many opportunities to see elsewhere.

Infomercials

Program-length commercials called **infomercials** sell everything under the sun—from kitchen appliances, fund-raising appeals, weight-loss programs, real-estate seminars to self-improvement courses. They are a part of syndicated programming that station executives avoid talking about. The executives have been pilloried in the industry, and the content parodied from *Saturday Night Live* to *The Simpsons*. Such programs usually have the particular advantage of being paid for in advance, however, and thus they provide quick cash to stations. No station brags about airing these programs, but at the end of a budget period, a station can preempt a program in a low-rated time period and sell the time period to an infomercial provider for a rate far in excess of what the station could otherwise generate in revenue.

How can the infomercial provider afford to pay such a premium rate? The success of an infomercial depends not on its rating, but the so-called **response rate,** the number of persons who call the toll-free number and sign up for a service or order the merchandise. Great numbers of infomercials pop up at odd hours, evidence that television continues to be the world's most influential advertising medium.

Syndication Economics

Just as videotape technology energized the off-network syndication business, satellite technology played a key role in establishing the **first-run syndication business,** which refers to original programs sold on a market-by-market basis. When the cost of leasing time on satellite transponders fell because of the increased number of satellites and through technological efficiencies, programs that were formerly shipped via a ground carrier in large, bulky film reels or in heavy videotape boxes began being transmitted by satellite. No longer were networks the only "same-day" program service.

The first syndicated program to take advantage of satellite technology in a systematic way was Paramount's *Entertainment Tonight.* It become the grandparent of a generation of programs combining scheduling flexibility with network-like timeliness. Called **magazine programs** (detractors call them **tabloids**), such shows as *Access Hollywood, Inside Edition, Extra,* and *Hard Copy* have the look and pace of news with the content-light format of celebrity talk shows.

Daily magazine programs have greater appeal to advertisers than off-network reruns. With the advantage of short segments similar to newscasts (in which ads easily fit), the access magazine shows tend to be watched by audiences with younger—and thus more favorable—demographics than regular newscasts, making the format doubly attractive to advertisers. Syndicators withhold some of the commercial time for themselves (barter programs), and, like their station customers, sell the time to a national advertiser. The problem, for stations, is that syndicators can sell this program

time at a cheaper national rate than the local station can to the same advertiser. This fact of economics threatens to undercut the stability of station advertising profitability. Only if an advertiser does not want to make a national buy, and is content to pay a higher rate for a spot buy, does the local station have an advantage over the syndicator's advertising division.

This system works out well for the syndicator. Under the older form of syndication, the seller was paid in installments. Each month another payment would arrive from the station. The syndicator was not paid until, in effect, the station was first "paid" by its advertisers. With barter, the syndicator cuts out the middlemen, the stations, and goes directly to the advertisers, which accelerates receipt of their revenues. And, the syndicator is still being paid, on a weekly-basis, by the station for the weekly license fee. The syndicator now has two streams of revenue. *Today, most first-run and off-network programs are sold with a barter component, increasing the difficulty of the station business.*

NEWS AND LOCAL PROGRAMMING

Television, as was the case with its parent technology, radio, began as a local business. Limited by both technology and the financial/organizational constraints of an infant industry, early television was predominantly a *live, local* medium. The early days of television were experimental, thrilling, agonizing, and just plain wacky.[6]

The U.S. Congress passed the Communications Act of 1934, establishing the Federal Communications Commission as broadcasting's regulatory and licensing agency. This enabling legislation authorized the Commission to regulate broadcasting "in the public interest, convenience, and necessity." Historically, the FCC has given broad latitude to stations in the programming area to meet their statutory obligations, although the epicenter of a station's mandate has always been service to the public. The surest path to public service has

been through news and local programming. This sub-section examines why television news is so prevalent and its prospects for the future.

Television News versus "Real" News

One of the most enduring criticisms of television news is that it is not "real news," that television news is somehow counterfeit when compared to print journalism. Although some of these observations have some validity, television does not operate in a vacuum: It is a captive of its technological, regulatory, economic, and competitive environments.

Many complaints about contemporary television journalism begin with the cliché, "Edward R. Murrow would be spinning in his grave if he saw television's coverage today of [such-and-such a news story]." Then the critic often goes on to offer what Murrow's opinion *would* have been, if he were still alive to give it. Interestingly, Murrow himself clearly recognized the distinctiveness and limitations of the new medium, and said, in effect, "Television news is a combination of show business, advertising, and news."[7]

Television journalism, being so invasive in our lives, is often compared on an apples-to-apples basis with print journalism, which is unfair to both. Newspapers have been regularly published in America for nearly 300 years, television for about 50.

The Role of Newscasts

Newspapers give a minority of their product to news. This so-called **newshole** amounts to no more than 20 percent of newspaper space; the rest of the paper is devoted to advertising. Television, though criticized for its excessive commercial interruptions, offers about 75 percent of its product to news-related content, 25 percent to advertising.

In addition, technology affects the two businesses in different ways. Newspapers and magazines are printed on tight, regular schedules, but in an emergency can delay a press run. In contrast, television has zero tolerance for delays. Television

cannot stop the clock in response to a just-breaking story. The 10 P.M. news must go on at 10 P.M., not 10:10, or 10:01. In covering a breaking story, this immediacy requires television to perform many of its news-editing functions in full public view.

The third difference between video and print journalism is that print lends itself to consumer self-editing more than video. If a person buys a newspaper and wants to learn what tomorrow's weather will be, but has no interest in a big national story, all that person has to do is skip past the front page and turn immediately to the weather section of the newspaper. That same person, as a television viewer, wishing to know the forecast and having no interest in the lead story, must sit through the first half of the newscast before hearing the weather report. Put another way, print is selective in nature, video is sequential.

The Benefits of News

In addition to the obvious community benefits of having news content on the air, news programming serves the commercial objectives of a broadcaster quite well, in the following six ways:

1. Risk Mitigation. When a station buys a syndicated program, the result of that purchase can be a hit, a dud, or anything in between. Admittedly, no station sets out to deliberately buy a failure. No matter: *Regardless of the ratings performance of the program, the station must honor its contract and continue to pay the broadcast license fee.* News programs, in comparison, are rarely abject failures and can nearly always be resuscitated if they stumble.

2. Exclusivity of Product. No competitor can steal a station's newscast or copy the name of the newscast. The names, faces, and personalities of the on-air talent are exclusive to the station, too.

3. Brand-Building. The newscast's content and production values can be styled so as to match the station's desired market identity, built through its mosaic of network programming, syndicated programming, news/local programming, and other community exposure. Affiliates that are number

one in news generally are number one in their markets in prime-time as well. How much of their news ratings are attributable to their network's appeal in prime-time, and how much of the prime ratings can be linked to the affiliate's news success is debatable; what is *not* debatable is that *local news and prime-time success are linked.* As stated in the beginning of this chapter, the fortunes of the network and the affiliate in a market are indissoluble, even if the two parties have conflicting interests.

4. Customization of Product. In response to market forces beyond their immediate control—such as time-of-day, competing programs, changing tastes—the station can alter its newscast's content and format. For example, the news can be modified to offer more or less hard news, or more coverage of features, such as health or personal finance issues, or the weather report can be moved earlier or later in the program. If those changes do not work, they can be changed back or other changes put into place. No network or syndicated program can offer such a luxury.

5. Cost Containment. Any locally produced telecast can be a costly project. News is particularly expensive, because of the kind and amount of sophisticated news-gathering electronic equipment, on-air talent, newscast sets, number of behind-the-scenes producers, editors, and so on. The so-called entry cost is high, but these costs can be accurately estimated and budgeted, unlike the syndicated market, where the price of a new program can change drastically from year to year. In addition to budgeting reliability, the costs of adding an *additional* newscast are incrementally small; most of the expenses are fixed and therefore already committed to. Adding another half hour of news in some cases might require only an additional news crew, consisting of a reporter and photographer.

6. Revenue Enhancement. News programs can be enormously profitable for stations.

Unlike the limited local inventory in network and syndicated programs, the station keeps its entire newscast sales inventory and, if budgetary needs

require, can expand that inventory by adding commercial time to its newscast. (See section on late fringe following for an example of how the multiplier effect of adding just one commercial break benefits a station over the course of a year.) Second, advertisers might object to their product's commercial placed during a controversial network or syndicated program; these programs are said to be on an advertiser's **hit list.** Newscasts, fortunately, are usually not hit-listed, and a larger universe of potential advertisers is available for the sales department to approach. A third revenue benefit is that the advertising community regards news as the most prestigious category of television programming. An image-conscious company that might reject the idea of advertising in an entertainment program might consider advertising in news as an acceptable alternative. Often, once a company discovers how effective television advertising is, the advertising target is expanded to other programs and dayparts. Stations use their newscasts as bait, as a means of enticing new or reluctant potential clients to advertise on television.

The Separation of News from Local Programming

The diet of early television lineups was laden with locally produced programs. Many of these regularly scheduled programs were hosted. Interview programs, movies, how-to instructionals, and children's programs featured local live talent (not unlike Krusty the Klown from *The Simpsons*). Oftentimes the hosts were station employees who had other jobs at the station during the day.

Over time, television news asserted its power, influence, and advertising strength over other forms of local programming, which were increasingly pushed into the background.[8] Newscasts were not merely a commercially advantageous form of programming; as long as news fulfilled most of a station's vague public service obligations, the financial drawbacks of local programming became even more obvious to management. Today, locally produced programming is a faint echo of the early glory days of television.

There are two categories of local programs: regularly scheduled programs (mostly produced out of the news department, such as public affairs discussion programs and weekend sports wrap-ups) and special event programs (ballgames and parades). Local programs still exist, to a limited degree— in the largest markets or for special events (Philadelphia's Mummers' Parade on New Year's Day, coverage of the Boston Marathon, and so forth), but local programs no longer drive station programming. Even in the largest markets, locally produced, regularly scheduled programs are limited: KCBS airs *Woman 2 Woman* weekdays at 4 P.M., and WCVB has had *Chronicle* at 7:30 P.M. for many years. The exceptions are glaring in their rarity.

For group-owned stations, local production can be a laboratory, a means of field-testing programming before a launch in syndication. For instance, Oprah Winfrey hosted a local talk show on WLS-TV Chicago, before her program went to national syndication in 1986. At the other end of the personality spectrum, Howard Stern had a test-run on local television in New York (WWOR-TV), years before his program went to national syndication in the late 1990s.

Local programming has four main liabilities. They are primarily related to its labor and cost structure:

1. Labor-intensive. In contrast to the physical simplicity of airing a network or syndicated program (which can require—at most—one or two technicians to supervise master control and videotape machines), a local program can require as many as dozens of personnel, working over weeks or months to plan, produce, and edit the program.

2. Cost-intensive. Budgeting is complex for a local production: There must be an accounting for talent fees, production crew, equipment, insurance, storage, construction, rentals, and all other related expenses of the production, to be borne by the station. To keep the production's on-air quality competitive with network and syndicated programming, the show's budget must not skimp. Although television is said to be a "forgiving" medium for production quality, the local program

would defeat its own purposes if it looked amateurish. Occasionally, some of the production's costs can be recouped if the station syndicates the program to other stations. The most frequent example of this occurs when a sporting event is syndicated to a regional cluster of stations.

3. Advertising considerations. If the local program is a one-time-only telecast, it might be difficult to find advertisers willing to buy time in it. Advertising agencies desire predictability; they want to have some pretelecast notion of the kind of program they are buying, and some realistic estimation of what the program's ratings will be in order to justify the advertising buy to their client. Unless the production is a regularly scheduled program or a local traditional event, the advertiser might shy away. This is particularly true with national advertisers, who generally will not sponsor an unknown, local program. Local advertisers, however, are more likely to support a local program, as their advertising is less ratings-sensitive than national businesses. Local businesses can measure advertising success by other factors, sometimes as basic as the increased number of telephone calls or customer traffic at the stores. The priorities of national advertisers do not lend themselves to calibrating their advertising so anecdotally.

4. Promotion. Unlike network or syndicated programs, local programs are promoted by the station or its agents only. There is no ancillary promotion from national media coverage of the program or event and no other producer or distribution partner to subsidize publicity of the program. Heavy promotion of such a local production, especially if it meets with sales department resistance, is dangerous; it could result in a disproportionate stationwide effort for a minimal revenue return.

News on Television, by Daypart
Early Morning: 5 to 9 A.M.

5 to 7 A.M. In response to the lifestyle evolution in American households toward more working couples, the day is starting earlier, and ending later. Although HUT levels are modest at dawn,

most people who are awake before 7 A.M. are awake for a reason: They are preparing to go to work or school. These are likely candidates for news: viewers who are working adults, disproportionately commuters, and therefore having attractive psychographic qualities of employment, income, education, and purchasing habits. The news content is bread-and-butter: updated stories from overnight, previews of the day's news, with lots of weather, traffic, and school-closing reports. Viewers cannot commit to watching for long periods of time, so the information is repeated, with updates several times throughout the hour. In fact, viewers "listen" to the morning news as much as watch it—while getting dressed, making breakfast, getting schoolchildren out the door. The video product is treated as background sound, much like radio. Local newscasts piggyback on viewer awareness of *The Today Show, Good Morning America,* and CBS's *The Early Show* programs at 7 A.M., in order to lure viewers to their locally oriented product earlier in the morning. Local news starts as early at 5 A.M. in the largest and most traffic-congested markets, although most markets start at 5:30 or 6 A.M.

7 to 9 A.M. In many large markets, Fox affiliates, blazing their own trail as they often do, compete head-on with the networks' morning news programs by offering the distinctly Fox approach of locally oriented news against the more national approach of the networks. The Fox philosophy is that competing with the near-exact news product of their competitors is futile, that the international/national/Washington/New York orientation of the networks is redundant, and that the viewers are underserved by local news in the morning.

Morning/Afternoon: 9 A.M. to 3 P.M.
Between the time that working adults leave home for the office and the time they return in the early evening, there is little demand for news from the at-home viewers. The only broadcast news is at the noon hour; it is another legacy from radio days, when factory- and office-work were more rigorously scheduled, and workers had an hour or half

hour for lunch at noon. In addition to reporting on that morning's news stories, the midday news serves to promote the station's other programming, particularly the late afternoon newscasts.

Early Fringe/Access: 4 to 8 P.M./4 to 7 P.M. Central

Industry research has consistently demonstrated that the best lead-in program for a newscast is . . . more news! This is intuitive: Viewers who are predisposed toward watching any one newscast are interested in news and therefore more likely to watch an additional newscast than would a non-news viewer. The results of this research happily match the budgetary facts-of-life for news production: that it is expensive to start a news operation, relatively cheap to expand it. Over the last ten years or so at the Big Three and Fox affiliates, newscasts have pushed out expensive and unpredictable syndicated programs in the larger markets at 5 and 5:30 P.M. In the largest markets—New York, Los Angeles, Chicago, and Philadelphia among them—newscasts start as early at 4 P.M. or 4:30 P.M., pushing syndication programs even earlier, or off the schedule entirely.

The most protean programs insofar as content, newscasts vary their content over the course of this daypart. The earlier afternoon newscasts tend to be lighter on news, with an emphasis on features and afternoon rush-hour coverage. As the afternoon wanes into early evening, and more paycheck-earners return home, the news becomes harder-edged, with more news content and less fluff.

Prime Time: 8 to 11 P.M./7 to 10 P.M. Central

There *is* local news in prime-time. Fox does not program three hours of prime time per night, unlike its Big Three competitors. Instead, Fox offers only two hours of network service during the first two hours of prime, then expects its affiliates to air local news. This is not simply a bold counterprogramming move (news against three entertainment choices), but Fox affiliates get a one-hour jump on the affiliate's local late newscasts, as well; many early rising viewers cannot stay awake until 11 P.M./10 P.M. Central to watch affiliate news.

Fox's strategy is a carryover from its forebears; the Metromedia station group was independently programmed and ran successful newscasts at 10 P.M./ 9 P.M. Central. (In fact, the Washington station, WTTG-TV, often was the late news leader in the market.)

Many independent stations follow the same course as Fox. If a station has the wherewithal to mount only one newscast, it will do so during the last hour of prime. All of the advantages of newscasts come together at 10 P.M./9 P.M. Central:

- Counterprogramming the networks
- Opportunity to get a one-hour jump on the affiliates' local news
- Access to diffident or broadcast-wary advertisers
- Exercise of public service requirements
- High-ratings track record in the time period
- High-visibility time period to display station identity

Late Fringe: 11 to 11:35 P.M./ 10 to 10:35 P.M. Central

Late fringe is another example of the interconnectedness of the network-affiliate relationship. The local affiliate relies on the network to provide good ratings during prime in order that its local newscast enjoys a good lead-in for its late fringe news. Similarly, the network relies upon the affiliate's local strength to deliver strong lead-in ratings to prime. Even though news viewing for any given station is acknowledged to be a form of habit, viewers do not always act like they are "supposed to"; local affiliate late-news ratings can spike up or head downward, depending on the network lead-in.

With three hours of prime-time programming as a lead-in, late fringe is a key ratings and revenue daypart for an affiliate. In the early days of television, late news was regarded as little more than an update of the early fringe newscasts, but in recent years, with the advent of the 24-hour newscycle and cost-efficiencies in news-production technology, late news programs are regarded as distinct profit centers.

As a revenue-enhancement technique, affiliates of the Big Three networks in late fringe stretch their newscasts to 35 minutes. The purpose was to create another commercial break.[9] *Going to all that trouble to add just one more commercial break might not sound like a dramatic addition, but over the course of one year, the arithmetic compounds into large multiples.* If four commercials are placed in that extra pod, times five days during the week, times 52 weeks a year, that translates into 1,040 extra commercials in a year. If a small-market station charges only $200 for a commercial, adding just one more break to late news results in $208,000 additional gross revenue in one year. If a large-market station charges $2,000 for a commercial, adding that break means $2,080,000 gross in a year—with virtually no additional costs to generate that revenue!

Late Night: 11:35 P.M. to 2 A.M./ 10:35 P.M. to 2 A.M. Central

Between midnight and daybreak, little locally produced news exists. If stations want news overnight, they either clear the overnight services offered by ABC (*World News Now*) or CBS (*Up to the Minute*), or go into the syndication marketplace to broadcast, for example, CNN's broadcast service or specialized newscasts offered by other program vendors. Financial newscasts are becoming increasingly popular, given the universal viewer interest in the subject of money, and the advertiser-attraction that such viewers represent.

RATINGS

Local television audience measurement has been changing in recent years. Audience fragmentation makes it more difficult for Nielsen to accurately measure the size of evershrinking viewer populations. Too many channels split the viewing too many ways. Station managers worry that the ratings will not continue to accurately reflect viewing.

For example, Nielsen started rolling out its peoplemeter in local metered markets in the early 2000s, starting with Boston. Station managers remember when Nielsen moved the national sample from old-style meters to peoplemeters: Viewing of traditional shows went down. The big broadcast networks lost audience share and the small cable networks picked up total viewers and target demographics. Local stations in a dominant position in their markets worry about suffering the same fate because of more up-to-date metered measurement techniques.

As described in Chapters 2 and 3, the local market reports from Nielsen are analyzed by stations using programs like Snap and by station reps (e.g., Katz). An example was shown previously in 6.3 of a display format that helps station programmers figure out relative rankings of syndicated shows as compared to local programming, like news. The data in 6.6 describe the relative strength of different shows commonly used by stations to lead-in to local news.

STATION PROMOTION

The station's two constituencies, viewers and advertisers, need to be continually reminded of the existence of station programs. Although the promotion manager is ultimately responsible for the promotion, advertising, and publicity of the schedule, the programmer's intimate knowledge of program audiences and viewing behavior is invaluable in designing the optimum placement of on-air promotional announcements.

On-Air Promotion of Programs

Among all the media available to publicize a lineup, the station's own air time is the most effective for reach- and cost-efficiency. The station's loyal viewers can easily be located in the market —they are already watching the channel! The station can then put to good use its unsold advertising time for scheduling on-air promos. So as not to become stampeded by a sales manager's pressure to preempt important promos in place of last-minute, cheap commercials, stations will often reserve a place for a promo, called a **fixed spot.** Very generally speaking, these fixed spots should be the

6.6 NEWS LEAD-INS

MAY '00	W18-49 Shr	W25-54 Shr	M18-49 Shr	M25-54 Shr
OPRAH (93)	24	26	10	11
NEWS	17	20	15	17
% Change	-29%	-23%	+50%	+55%
ROSIE (48)	21	21	10	10
NEWS	13	15	12	13
% Change	-38%	-29%	+20%	+30%
J. JUDY (26)	15	16	15	16
NEWS	13	15	12	14
% Change	-13%	-6%	-20%	-12%

Source: www.katz-media.com/tvprog/v16n5/NSIMAY00.htm.

equivalent of a 30-second spot in each network hour, or 30-second in each half hour of syndicated programs. A promo might be dedicated to one program, or two or more programs. The latter is called a combination spot, or "combo."

The trend in the last several years has been toward fewer on-air promos. With many former-independents aligning with new networks, an increasing amount prime-time commercial inventory is now committed for network commercial time. Moreover, post-prime news programs demand priority in promotion. Also, the rampant ownership consolidation in the last several years has compelled corporate owners to eschew the long-term strategy of brand-building in favor of running more commercials to meet short-term financial targets. (This is not an editorial comment on the relative value of one strategy over another, just an observation of corporate behavior.)

Having said all that, the fundamental principles apply. The most practical way to design an on-air promotion strategy is to remember that "like goes to like." *In other words, similar programs or programs with similar audiences should be promoted toward each other.* The trade name for this technique is **cross-promotion.** The station sets its on-air promotion priorities according to two criteria:

the potential profitability of the program and the importance of the program to the station's overall branding strategy.

One category of programs generally fits both criteria: local news. Local news is one of the station's most significant profit centers. The local-production aspects of local newscasts make this program genre amazingly customizable in content, audience appeal, and commercial format. News programs remind viewers of other news programs, thus it makes sense for the 7 A.M. network news to contain a promo for the station's local noon news. The noon news likely will promote the next news program at 5 P.M. The early fringe newscast will promote the next newscast, and during prime time, there will likely be several reminders to "stay tuned for the late news."

There are two general categories of promos: topical and image. A *topical* spot will be a promo about a specific story: the update on the day's biggest trial, or a live shot of a traffic accident accompanied by a promise of coverage of the wreckers hauling away the vehicles during the next newscast. A topical promo is timely and story-specific. An *image* spot, in contrast, creates in the viewer's mind a general impression of the news product's overall identity. Typical image spots

might be quickly-edited scenes of anchors in action, interviewing people out in the field, hectoring unwilling sources on the telephone to spill the beans, racing to the news-set with their hot story just in time for the beginning of the program (irrespective of whether this is what they actually do, it is supposed to create positive images of experienced, professional journalists).

Topicals and image spots are also the norm for nonnews program promotion. After the news promos are scheduled, the remaining promo time is allocated according to station needs. Most often, the lion's share of promos belongs to the highest-revenue-producing programs, for example, those programs scheduled during early fringe. Lastly, those programs on "next," will usually get a promo, as a vestige of the time when the forces of program flow were stronger than they are today.

Promotion in Other Media

Outside media—radio, newspapers, billboards—traditionally occupied a large proportion of the station's advertising efforts. Over the last several years, however, the downstream effects of deregulation have created many unintended consequences. Here is one example: Ownership of media has concentrated on a market-by-market basis to the point where media costs have skyrocketed. For example, before the Telecommunications Act of 1996 became law, a company could not own more than one (two, if grandfathered) radio stations in a market. If an average-sized market had 20 or 30 stations, advertising rates were competitive, and advertisers could make cost-efficient, and frequent, radio buys. Today, however, when companies can own up to eight radio stations in a market, radio ad rates are too aggressive for television stations to replicate the same kind of radio campaigns seen just a few short years ago.

Cable, too, is starting to price itself out of the broadcast advertising market, particularly in those markets with a heavy concentration of ownership or an aggressive **interconnect** (electronic connection among a consortium of separately owned cable companies). Although the price per commercial is attractively low, the number of viewers per cable program is still so low that the ratio of viewer-per-program drives the cost-per-viewer price uncompetitively upward. *In short, television is a victim of its own attractiveness as an advertising vehicle. Compared to other media, television remains the most cost-efficient buy.*

WHAT LIES AHEAD FOR STATIONS

Predicting the future of the local television station business is difficult. On one hand, the technology is moving away from program source scarcity to program source abundance. On the other, media corporations are deriving their best profit margins from local affiliates.

The number one threat to over-the-air broadcasters (as well as advertising-supported subscription television) comes from technology that frees the viewer from program schedules: **digital video recorders (DVRs)** and, to a lesser extent, **video-on-demand.** Although the real impact of these technologies is just arriving and not likely to harm broadcast revenues in the short run, the timetable will be swift—certainly damage will be occurring no later than 2006. The loss of control of programming spells the loss of commercial breaks as they presently exist, because DVRs allow viewers to "skip 30" seconds. Unlike the VCR and DVD, which are largely auxiliary devices that viewers may or may not choose to use, the DVR will intrude more on the viewing process because it enhances the viewing of *live or real-time* programming. It is very likely that the set-top boxes used by 80 percent of U.S. viewers will soon incorporate DVR functionality, suggesting that DVR use will not be tied to the slow diffusion that usually occurs with a new technology. The timing of the latest generation of set-top boxes will likely accommodate the rapid introduction of set-top storage.

On the other hand, given the way VCRs get used in homes, it is clear that the American audience will not want to read any instructions, learn any sequences or steps, or wait for their TV set's operating system to boot-up. Manufacturers had

better use **firmware** (instant-on software) and automatic downloadable updates, because research shows that television viewers still want to relax. The safe money says that new technologies should bend over backward to accommodate Jerry Springer fans, so they won't need to know about bandwidths or protocols—they'll just swim in the digital stream without understanding it. All of this is predicated on effective design of remote controls and very smart set-top boxes, of course.

The Future of News on Television

News will continue to be a mainstay of television programming. Not only is it an advertiser-friendly franchise, but also a station can mold its newscasts to blend into a market identity derived from its network/syndicated/local programming. Increasingly-sophisticated and miniaturized technologies give an individual station production quality and time-responsiveness that were unimaginable only a few short years ago.

The main challenge is competition: not just at the local level, where competitors are expanding and upgrading their news product, but also from competing industries: Cable networks are jumping into the news business as well. What is particularly grating to affiliates is that some of these news networks are owned by their own network partners!

One of the viewer benefits (albeit indirectly) arising out of the massive cable system consolidations of the 1990s is that many cable systems in large markets now offer around-the-clock local news channels of their own; to varying degrees, these local news channels are like mini-CNNs. They represent a serious threat to the dominance of broadcast: The local cable channels are placed on low channel positions nearby broadcast channels, can cover ongoing local stories as they unfold during the day whereas broadcasters usually are forced to wait until their regularly scheduled newscast, and can undercut the relatively high advertising rates of newscasts by offering both lower spot rates and quantity discounts to local advertisers.

Use of the Internet for news programming offers the ultimate of both extremes: global instantaneous distribution and individualized news product for the consumer. At present, the web's news capability rests largely in conveying news that is previously generated for television or print, and then adapted for the Internet. Until computers are as easy to use and as plentiful as television sets, media true programming competition among technologies is not at hand. The ultimate question will be whether the Internet will be a standalone industry, or whether already existing industries will be able to co-op or adapt to the advantages the web offers, without losing their own brand-identities. At this writing the Internet is not generating profits for its participants, but profits and competitive advantages are too potentially enormous to be ignored.

Digital Television

By 2006, every television station in America is supposed to give up its long-held channel position and migrate to a new channel in the UHF band.[10] Why? The FCC in the 1990s responded to technological developments (and the entreaties of the consumer electronics manufacturing industry) by mandating that television broadcasters must broadcast using compression technologies that will permit high-definition television. Companies are now spending millions of dollars per station to purchase and assemble the new generation electronic equipment required to transmit a high-definition signal. Consumers, too, will have to replace their conventional television receivers.[11]

One of the characteristics of a high-definition signal is clarity. HDTV signals will be transmitted digitally, with no signal attenuation (loss) as they move from network-to-station- to-transmitter-link-to-transmitter-to-local-cable-system/satellite to home antennas. The program picture will be demonstrably superior to the current analog method of transmission, with a clarity and definition replicating that of a feature film in a movie theater.

The second characteristic of a high-definition signal is a wider bandwidth. To broadcast in high definition, a station must use the equivalent of six analog channels. If, however, a program were

not produced in high definition, or if the station chooses not to broadcast in high definition, the station, in effect, has up to five more channels. The problem is that there is not enough network or syndicated programming to go around, and the station will need to purchase, produce, or barter some kind of program service to occupy the new channels. Stations will be faced with a daunting range of choices of how to manage their new frequency space. These include:

- Broadcasting in high definition
- Reselling the channels to another programmer
- Offering a specialized service, such as an all-weather service, all traffic service, all news-service, or all-classified ad service

Interestingly, a technology with similar capabilities was available 25 years ago. It was called multi-point distribution service (MDS), and it functioned as a form of wireless cable, as it still does today in a few cities. It is interesting to speculate what would have happened had the right vision-ary come along to quash the fledgling cable and satellite industries. Most of the visionaries then were in cable.

The Shifting Power Balance

The historic balance of power between networks and affiliates is changing, tipping in favor of the networks. First, the networks are buying more sta-tions, weakening the influence of affiliates in the largest markets. As of this writing, the FCC allows a broadcasting company to own stations reaching 35 percent of the country. The formula is not as straightforward as it is often stated and, in prac-tice, a company can own stations covering more than the 35 percent limitation. Even that figure is under intense lobbying pressure. Rupert Murdoch's purchase of the Chris-Craft UPN stations in major markets forced a challenge to the rule in 2001.

Second, network compensation is under the strongest attack in history, and at some point in the future will dissolve. Third, the networks are distributing their programs along other technolo-gies—cable networks, satellite, the Internet—and are no longer restricted to sending their programs exclusively down a single pipeline to their affili-ates. Affiliates will have to share network resources with network-owned cable networks. Network prime-time, the most visible indicator of network health, is heading toward a more disciplined cost-containment structure, including network-owned productions and prime-time newscasts.

Fourth, affiliates are no longer the exclusive gatekeepers to their markets. Their former monop-oly of access to the viewer is fading: Cable, satel-lite, and the Internet are all removing the bricks and mortar in the wall of local exclusivity. Fifth, broadcasting has traditionally been a free service. The American consumer, however, is increasingly accustomed to paying for television, through monthly fees for cable, satellite, and Internet service. The increasing affluence of America is making it even easier to wean Americans away from their free television.

Smaller companies that own stations in mar-kets with network-owned stations, but do not produce programs themselves, will face heavy leverage. They will sell out to the larger com-panies. The traditional local orientation of broad-casting will flicker, to be rekindled by industries that have economies-of-scale on their sides: cable and the Internet. They will provide not only local but personally-customized entertainment and news content to consumers. Broadcasting will stay around because it is universal and free, which is in the nation's interest. It is still a highly profitable business. Free television, however, will have to re-sign itself to no longer being the biggest float in the television parade. The television industry is ma-turing, and the original business model of distant-networks/local affiliates is disappearing. Now, the program producers, through cable, satellite, and the web, have direct access to the consumer.

Competition has always been around (see 6.7). At one time, every programmer knew who the competition was and knew what they were doing. Now, video entertainment is global, instanta-neous, and customizable in a way unimaginable just one generation ago. Local stations were once

6.7 A LITTLE HISTORY AND A NEW ENVIRONMENT FOR LOCAL TELEVISION

Not so very long ago, most cities had only three affiliates, perhaps one independent, and one public broadcasting station. Commercial stations did not want to lose any viewers, because that would mean losing them to one of only two or three competitors. A philosophy of programming called "least objectionable programming" developed, in which it was believed that viewers, faced with only three or four choices, would watch anything, so long as they did not find it blatantly objectionable. Consequently, the content of television programs became bland and noncontroversial.[12]

The objections that television's critics made were centered on the prevalence of homey, schmaltzy, family comedies on the air, and that seemingly *every* comedy had adorable children, a dog, a homemaker mom, and a dad who went to the office each morning to perform some vague administrative duties. No domestic problem was so intractable that it could be not be remedied by the parent—or a solution offered by a child—by the end of the program. Networks fought over the great middle ground of what they thought American tastes were.[13]

The occasional program that strayed even slightly from the strict formula generated headlines even if, in retrospect, they were relatively tame. *All in the Family* and *Laugh-In*, debuting in the late 1960s, provoked sizzling controversy, even though there was no profanity, violence, or sex. In today's climate, these two programs would probably not be deemed edgy enough to make it to a network schedule.

When dozens of new channels appeared on cable during the early 1980s, the American viewer responded. The new channels did not need to copy the three networks; instead they offered specialized program services that took away the networks' long-held viewers in little slices.

These program services came in every category. For example, in news, when previously a news-hungry viewer had to wait until evening to watch a half-hour of network news—when the three networks aired their news at the same time—now the viewer could tune in to CNN or Headline News, 24 hours a day. For sports, instead of waiting until the last few minutes of the local news program to see just a few scores and highlights, a viewer can get an hour's worth of all scores and highlights on ESPN. Weather reports 24 hours a day, all-day financial information, old movies . . . the choices came gushing out of the cable.[14]

That was the first generation. The next step was the addition of second and third channels in the format. Cable was fragmenting itself, just as it fragmented broadcast. The networks were now surrounded by cable choices in their broadcast service. Their response was to enter the cable business, recognizing that the phase of broadcast's fat days as a high-margin, innovative television service were drawing to an end. The big money today is in owning the cable networks. Ninety-seven percent of American homes have access to cable, and nearly all the rest have access to satellite. The networks are gingerly tiptoeing around this issue. In the first place, broadcasting still delivers the largest single audience of any television service, even if it is less profitable than it once was. Secondly, there is a very important public policy argument that television should have some kind of universal service, so that all Americans have access to the same general body of information and communications.

the gatekeepers; now they are just one group among many (see 6.8). To survive they must recognize and adapt themselves to those niches in which they can be competitive. The introduction of new news industries does not automatically mean that existing ones will be killed off. Despite the fears of media Cassandras who prognosticate the end of broadcasting, history tells us otherwise: Television did not kill off the movie industry, FM radio did not eliminate AM, cable did not elimi-

6.8 IS AFFILIATION ANACHRONISTIC?

The network-affiliation arrangement was historically a hybrid, a means to get national programming to the locality. National and local programming squeezed through the same station. The lack of an alternative technology forced the marriage with the networks and affiliates: Technology today liberates the networks to bypass the affiliates at will and program directly to viewers through their cable networks and, ultimately, via satellite. Many observers expect the Internet to be the next dominant form of video distribution.

nate local broadcast, and satellite-delivered television did not defeat cable. Instead, each industry had to adapt itself to the new challenge.

Generations ago, visionaries foretold the day when television would become the equivalent of a "video jukebox." That day has arrived. Broadcasters must face that challenge, and how they respond will determine whether broadcasting will either fade into mediocrity or transform itself into a new Golden Age of Television.

SOURCES

www.broadcastingcable.com
www.electronicmedia.com
www.variety.com
www.adage.com
www.mediaweek.com
www.katz-media.com
www.hollywoodreporter.com
www.abc.com
www.cbs.com
www.nbc.com

www.Foxnetwork.com
www.warnerbros.com
www.upn.com
www.fcc.gov

INFOTRAC COLLEGE EDITION

Consult InfoTrac College Edition using the password provided with this book. Use boldfaced terms as Key Words and section headings from this chapter for Subject searches.

NOTES

1. This disproportionate amount of discussion of Fox's raid is indicative of the disruption that Fox caused in the relatively calm network landscape. It was as if a starter's gun had fired, and all networks and affiliates scrambled for new partners. Murdoch's audacity created turbulence, which distracted his competitors, thus leveling the playing field for him. The raid gave Fox a chance to be sampled by new viewers and, not incidentally, to deeply wound a major competitor. If there was any doubt about Murdoch's intentions when he started his network in the 1980s, it was now clear that the game was being played for keeps from then on.

2. The trade periodical *Variety* is renowned for creating new words for the industry. The term *netlet* was one such neologism. Others are *flix* or *pix,* meaning movies; *exex* or *helmers* for executives; *biz* for business, specifically show business; *ayem* for morning (A.M.), and so on. The practice was started as a breezy means of compressing as much information into a headline as possible. The most famous *Variety*-speak headline was printed in the 1930s, when rural-oriented movies had a weak box office season. *Variety* headlined: *Stix Nix Hix Pix.*

3. CBS, which inaugurated the concept of compensation, took the lead in trying to dismantle it during the early 1990s. After having lost many affiliates to Fox in 1994–95, CBS, NBC, and ABC moderated their stance toward compensation. At present, the relationships between affiliates and their networks are too volatile to predict the future of compensation.

4. Television fun fact: Western programs on radio were termed *horse operas,* not because oats were advertised, but in tribute to the role of soap opera advertising dollars in building the networks.

5. News is a money-loser for networks. Budgets for production, talent, and the overhead of maintaining many news bureaus are gargantuan, but the prestige value of being number one in news spills over beneficially into other network programming endeavors. (Additionally, news budgets can be spread over into early morning newscasts and, increasingly, prime time.) Network evening-news ratings have been damaged by the rise of CNN, MSNBC, Fox News, and web 24-hour news services. Consumers/viewers correctly reason, "Why wait until evening for the news, when I can have it right now?" Consequently, news viewership on broadcast has not only declined, but demographically it has become older, poorer, and more downscale, thus less attractive to advertisers. News, however, is a prestige part of network programming, and it will likely stay indefinitely. In the last few years, the network news divisions have tinkered with their content, changing the focus from harder-edged international/political stories with remote personal consequences, to more individualized issues as health, education, and personal finance coverage.

6. For an unsurpassed anthology of hilarious, believe-it-or-not stories of television during its first decades, read *The Box: An Oral History of Television 1920–1960* by Jeff Kisseloff (Viking Press, 1995).

7. Murrow (1908–65) was one of the earliest broadcast journalists to achieve notoriety and , later, celebrity. Murrow joined CBS in 1935, then was promoted to the European Bureau in 1937. He is most remembered for his on-scene reporting of harrowing Nazi air raids over in London during World War II. Morrow moved to television after the war. His on-screen news career notched highs with his award-winning documentary series *See It Now*, and lows (he hosted *Person-to-Person*, an early personality-interview program, during which Murrow often looked physically pained to be interviewing celebrities rather than newsmakers).

8. For the rest of this chapter, "local programming" refers to local productions, *exclusive* of news.

9. The commercial break is also called a **pod;** a 2½-minute break has room for four commercials of 30 sec-

onds each and another 30 seconds for promotion. The four slots these commercials occupy in the break are termed **positions.**

10. The change is already under way. Many stations are transmitting on their traditional channels and on their new channels simultaneously. All the stations broadcasting on the VHF band (channels 2–13) will be moved to the UHF band (channels 14–69), and the VHF frequencies will be returned to the FCC for reassignment to another transmission use.

11. As a stopgap measure, consumers will not be compelled to buy a new receiver costing thousands of dollars; a converter, costing between one hundred and two hundred dollars, can be used to substitute.

12. The most controversial opinion on the noncontroversial nature of television was uttered by an early FCC Chairman, Newton Minnow, who called network television programming, "a vast wasteland."

13. The best analogy to what the networks were trying to achieve is to be found in politics. Where there are only two political parties, they each usually contest for the middle, where the greatest number of voters are found. If one party gets too far from the middle, they concede the valuable middle ground to their opponent. In countries with many parties, the best way for a new party to make itself known is by becoming strident or radical, easily distinguishing itself from all the others. It doesn't matter if the radical party turns off a block of voters, because the party does not need a majority. All the party has to do is maximize its potential core of voters; the party's opponents will be siphoned off to many other parties, not just one. In politics, as in television, or any consumer choice, multiple choices produce fragmentation, choice, and instability. A lack of choice generally produces stability, little impetus to innovation, and ultimately, stagnation.

14. Cable picked off the children's audience, too. Nickelodeon beat all commercial networks in children's ratings in the 1999–00 and 2001–02 seasons.

Chapter 7

Public Television Programming

John W. Fuller
Douglas A. Ferguson

Public television, its mission, and its public service objectives occupy a unique position in American broadcasting. Contrary to broadcast development in nearly every other country in the world, public service broadcasting in the United States developed long after the commercial system was in place. This fact has had an immense effect on the general public's attitude toward American public television programming and on public broadcasters' self-definition.

The public debates whether public television programs are even necessary and whether they should occupy the time and attention of the nation's communications policymakers in the Congress, the executive branch, and the Federal Communications Commission. Opponents of public broadcasting argue that the advent of such distribution developments as large-capacity cable systems, direct satellite broadcasting, multipoint distribution systems, videotapes, digital versatile discs, and so on obviate the need for public television. Proponents counter that the marketplace fails to provide the specialized programming that public television offers and that any belief that emerging technologies will be different from existing media is unfounded. Marketplace critics also state that only public television programming has special audience services for children, the elderly, and ethnic minorities.

PROGRAM PHILOSOPHY

The debate over programming content has persisted within the industry since public television began. For stations, the debate centers on the meaning of **noncommercial educational broadcasting,** which is what the Communications Act of 1934 and the Federal Communications Commission call public television's program service. Noncommercial service came into existence in 1952 when educational interests lobbied the FCC into creating a special class of reserved channels within the television allocations exclusively dedicated to "educational television."

One argument defines *educational* in the narrow sense of *instructional*. From that viewpoint public television (PTV) should teach—it should direct its programs to school and college classrooms and to out-of-classroom students. The last thing PTV should do is to compete for commercial television's mass audience. Others define *educational* in a *broader sense*. They want to reach out to viewers of all kinds and generate mass support for the public television service. This group perceives "instructional" television as a duty that sometimes must be performed, but their devotion goes to the wide range of programming the public has come to think of as public television.

The Carnegie Commission on Educational Television introduced the term *public television* in 1967. The commission convinced many in government and broadcasting that the struggling new service had to generate wider support than it had in its fledgling years. One of the impediments to such support, the Commission felt, was the word *educational,* which gave the service an unpopular image. They suggested *public television* as a more neutral term. Thus, a distinction has grown up between **instructional television (ITV)**[1] and **public television (PTV).**

Lacking a truly national definition for public television's program service, a public television station's programmer must deal with the unresolved, internal questions of what it means to be a noncommercial educational broadcasting service. The PTV programmer must come to grips with a station's particular program philosophy. Philosophies vary widely from one station to the next, but two common themes persist: being educational and being noncommercial. These terms imply that *public television must directly serve "the people"; it must be educational and different from commercial television.* One of the implications of such a fundamental difference is that public television programming need not pursue the largest possible audience at whatever cost to programming. Public broadcasting has a special mission to serve audiences that would otherwise be neglected because they are too small to interest commercial broadcasting.[2] This difference in outlook has great

programming significance. It means that the public station programmer is relieved of one of the most relentless constraints limiting a commercial programmer's freedom of choice.

At the same time, public television cannot cater only to the smallest groups with the most esoteric tastes in the community. Broadcasting is still a mass medium, whether commercial or noncommercial, and can justify occupying a broadcast channel and the considerable expense of broadcast facilities only if it reaches relatively large numbers of people. Public broadcasting achieves this goal cumulatively by reaching many small groups, which add up to a respectably large cumulative total in the course of a week (about 55 percent of U.S. television households).

THE NETWORK MODEL

Programming the national **Public Broadcasting Service (PBS)** is a little like trying to prepare a universally acclaimed gourmet meal. The trouble is that a committee of 171 plans the menu, and the people who pay the grocery bills want to be sure the meal is served with due regard for their images. Some people coming to the dinner table want the meal to be enjoyable and fun; others want the experience to be uplifting and enlightening; still others insist that the eating be instructive; and the seafood and chicken cooks want to be sure the audience comes away with a better understanding of the problems of life underwater and in the coop.[3]

The analogies are not farfetched. A board of 35 appointed and elected representatives of its member stations governs the Public Broadcasting Service on three-year terms. The board is expected to serve 171 public television licensees operating 347 public stations all over the country and in such remote areas as Guam, American Samoa, and Bethel, Alaska.

Because PBS produces no programming, it uses a host of program suppliers and tries to promote and schedule their programs effectively. In addition, constituencies ranging from independent producers to minority groups constantly pressure public television to meet their special needs. And, of course, the program funders have their own agendas too.

In *commercial* television, programming and money flow *from* network headquarters *to* affiliates. Production is centrally controlled and distributed on a one-way line to affiliates, who are paid to push the network button and transmit what the network feeds. Most of the economic incentives favor affiliate cooperation with the network, placing tremendous programming power in network hands.

In *public* television, money flows the opposite way. Instead of being paid as loyal affiliates, member stations *pay* PBS, which in turn supplies them with programs sufficient to fill prime time and many daytime hours. Stations pay membership dues to cover PBS's operational budget and, entirely separately, fees to cover part of the program costs. PBS is both a network and a membership organization responsible for developing, maintaining, and promoting a schedule of programs while also providing services to its dues-paying members. A station's remaining broadcast hours are typically filled with leased syndicated fare (movies; off-network reruns; made-for-syndication series, mostly British; and instructional programs for local schools), local productions, and programs supplied by regional public television networks.

Four regional networks also serve the eastern, southern, central, and western sections of the United States; one, the Eastern Educational Network, formed the Interregional Program Service in 1980 to distribute its programs nationally. Now renamed American Program Service, it serves a large group of stations in all regions, functioning as a second major public television distributor.[4] The relationship between the regional networks and PBS is complementary: *Member stations pay the regional network*, and it then delivers programs to them during off hours via satellite for local taping and scheduling, more like syndicators. PBS, however, delivers its programs in a *prearranged schedule*. An entire week of daytime PBS programming in 2000 appears in 7.1, covering the hours from 6:30 A.M. to 8 P.M.

7.1 2000 PBS DAYTIME PROGRAMMING

| | SUNDAYS | MONDAYS – FRIDAYS | | SATURDAYS |
		PACKAGED (w/interstitial)	UNPACKAGED (w/o interstitial)	
6:30		Between the Lions	Sesame Street	
7:00	Caillou	Barney & Friends	Arthur	
	Clifford the Big Red Dog	Zoboomafoo	Clifford the Big Red Dog	
8:00	Sesame Street	Sesame Street	Dragon Tales	PBS Kids Bookworm Bunch
			Caillou	
9:00	Barney & Friends	Mister Rogers	Barney & Friends	
	Teletubbies	Teletubbies	Zoboomafoo	
10:00	Dragon Tales	Dragon Tales	Teletubbies	
	Wimzie's House	Arthur	Sesame Street	
11:00	Zoboomafoo	Caillou	Sesame Street	
	Arthur	Clifford the Big Red Dog	Between the Lions	Regina's Vegetarian Table
12:00	Between the Lions	Noddy	Dragon Tales	Baking with Julia
	Adventures from the Book of Virtues	Dragon Tales	Arthur	The Victory Garden
1:00	Zoom	Teletubbies	Mister Rogers' Neighborhood	This Amazing World
	Theodore Tugboat	Caillou	Teletubbies	This Old House
2:00	Tots TV	Sesame Street	Noddy	The New Yankee Workshop
			Reading Rainbow	Hometime
3:00		Arthur	Wishbone	The Woodwright's Shop
		Clifford the Big Red Dog	Zoom	Handyma'am with Beverly DeJulio
4:00		Zoom	Zoboomafoo	
		Wishbone	Arthur	
5:00		Reading Rainbow	Clifford the Big Red Dog	
		Barney & Friends	Dragon Tales	
6:00		Zoboomafoo	Caillou	In the Mix
		Between the Lions	Barney & Friends	
7:00	Wishbone		Arthur	
	Adventures from the Book of Virtues		Zoom	

Reprinted by permission of PBS.

Station Scheduling Autonomy

Much clout rests with the stations. They spend their revenues as they see fit, expecting to be treated fairly and with the deference due any consumer. PBS, as a consequence, has a limited ability to get stations to agree on program scheduling. Citing the principle of "localism" as public television's community service bedrock, station managers display considerable scheduling independence, ostensibly to make room for station-produced or acquired programs thought to meet some local need.

After the nationwide satellite system was phased in (1978) and as low-cost recording equipment became available in the 1970s, stations carried the PBS schedule less and less frequently as originally programmed. Until a networking agreement was worked out with the stations, no two station program schedules were remotely alike. National promotion, publicity, and advertising placement were, if not impossible, extremely difficult to achieve. Nor were corporate **underwriters** pleased at the scheduling irregularity from one market to the next.

The Carriage Agreements

Implementing a networking "common carriage" agreement in October 1979 partially ordered this networking chaos. **Common carriage** refers to the nonbinding agreement among stations establishing a core schedule on Sunday, Monday, Tuesday, and Wednesday nights. During the hours of 8 to 10 P.M. (with time zone delay feeds), PBS fed those programs most likely to attract the largest audiences. In turn, stations committed themselves to airing the PBS core offerings on the nights they were fed, in the order fed, and within the prime-time hours of 8 to 11 P.M.

For several years the common carriage arrangement worked well. The typical "core" program received same-night carriage on more than 80 percent of stations. Core slots thus took on a premium quality; underwriters and producers, looking for favorable treatment for their programs, began to insist they be assigned a time slot within the core period. Maximum carriage was thought to mean maximum audience size. With more core

quality programs on their hands than available hours in the eight-hour core period, PBS programmers were forced in the early 1980s to move some long-standing core programs (*Mystery* and *Great Performances*, for example) outside the core period to make room for other programs in the hope that the stations would still carry them on the feed night.

This move was partially successful; even though same-night carriage for the rescheduled programs fell, it was only to about 55 percent for these noncore programs. Station programmers took these moves by PBS as a sign that core programs could be moved around at will. Station independence began to reassert itself. By the 1985–86 season, same-night carriage of the core itself had slipped to 73 percent. PBS, concerned with complaints from national underwriters that "their" programs were not receiving fair treatment, moved to bolster same-night carriage. In fall 1987, PBS began a new policy of **same-night carriage** by which selected, broad-appeal programs would be designated for carriage the night they were fed. This policy had little effect, however, because PBS did not strictly enforce it.

In 1995 PBS once again attempted to get control of unpredictable station scheduling. Wanting to encourage new corporate underwriting because Congress had reduced federal funding, a committee of its board presented the stations with a new **common carriage agreement**—this time with financial penalties. Some 40 stations refused to sign the agreement until the penalties were removed. The toothless new agreement went into effect in September 1995, "requiring" stations to carry certain programs within prime time on the feed night (see the programs identified in 7.2). The agreement promised that PBS would designate no more than 350 hours per year for common carriage, of which stations could choose up to 50 hours *not* to carry on feed night, a provision allowing local programming flexibility. Within these limitations, the agreement stated a goal of 90 percent carriage or better for designated programs.

Most programs tagged for common carriage were receiving the requested carriage by at least 90 percent of stations as of 2001. As for "untagged"

7.2 2000 PRIME-TIME SCHEDULE

Week of: OCTOBER 22 – OCTOBER 28, 2000 **PREPARED: 7/14/00**

	Sunday 22	Monday 23	Tuesday 24	Wednesday 25	Thursday 26	Friday 27	Saturday 28
8:00 2000	NATURE Wild Horses of Mongolia with Julia Roberts NTSC Letterbox/ Widescreen where available % +	ANTIQUES ROADSHOW % +	BUILDING BIG Dams (4/5) DVS % +	ALASKA'S GOLD RUSH TRAIN % +	THE LIFE OF BIRDS BY DAVID ATTENBOROUGH Fishing for a Living (5/10) % +	WASHINGTON WEEK IN REVIEW % + WALL STREET WEEK % +	PBS DARK
9:00 2100	EXXONMOBIL MASTERPIECE THEATRE Oliver Twist	THE AMERICAN EXPERIENCE The Rockefellers	NOVA Lincoln's Secret Weapon DVS % +	EXXONMOBIL MASTERPIECE THEATRE'S AMERICAN COLLECTION Langston Hughes' "Cora Unashamed"	MYSTERY! Hetty Wainthropp Investigates 4 "A Minor Operation" DVS % +	THE AMERICAN EXPERIENCE The Rockefellers (rpt)	AUSTIN CITY LIMITS (PBS Plus) ((surround sound)) %
10:00 2200			FRONTLINE		RUNNING MATE		
	(3/3) % +	(2/2) DVS % +	% +	(1/1) DVS % +	% +	(2/2) DVS % +	
11:00 2300			CHARLIE ROSE (PLUS) % +				PBS DARK
12:00 2400	% STEREO	+ CLOSED CAPTIONS					

Reprinted by permission of PBS.

shows, program managers often tape-delay them outside of prime time, using the vacated evening slots for other programming. Carriage on feed night typically averages less than 90 percent for untagged programs.

PBS RESPONSIBILITIES

Since its founding, PBS has had two key responsibilities: *to accept or reject programs* and *to schedule those accepted.* The program acceptance/rejection responsibility is grounded in technical and legal

standards established by PBS during the 1970s. The technical standards protect stations from Federal Communications Commission violations and maintain high levels of video and audio quality. By their very nature, they can be applied with reasonable consistency. As the steward for underwriting guidelines, PBS maintains stringent rules for on-air crediting of PBS program funders to prevent violations of FCC underwriting regulations and to ensure against public television's appearing "commercial." The legal standards protect stations from libel and rights infringements and alert them to

equal time obligations that may result from PBS-distributed programs.

PBS warns stations in advance of programs containing offensive language or sensitive scenes (nudity or violence) and makes an edited version of programs containing extreme material available to stations. In rare cases, controversial programs such as *It's Elementary* (a documentary on gay issues in grade school) have been canceled or postponed, but in general PBS tends toward airing programs as produced.

Day-to-Day Management

An executive vice-president heads PBS's National Program Service (NPS). This senior executive sets policy for and oversees the content and array of formats within the program schedule, directing long-range development of major programs. Other managers assist in the day-to-day activities of program development, scheduling management, and acquisition of international programs. Content departments within the NPS concentrate on the development of news and public affairs, children's, cultural, and fund-raising programs. PBS Plus and PBS Select offer a menu of "user-pays" programs to supplement local schedules. Other departments deliver programs for adult at-home college education and in-school instruction for children. Interactive and online services, extensions of PBS's programming, were introduced in the mid-1990s —including *Mathline* for students and *PBS Online* on the Internet (*www.pbs.org*). Thus, programming for the station broadcasts is only part of PBS activities.

Satellite Distribution

The broadcast operations department manages the daily details of the national schedule much as a traffic department would at a commercial network. All the pieces of the jigsaw puzzle must be plugged into place across an array of satellite schedules, insuring, for example, that (1) the end of a 13-episode series coincides with the start of another ready to occupy its slot; (2) dramas with profanity have an early edited feed available on another

transponder; and (3) filler is available when, for example, the Saturday morning schedule of how-to programs runs short in the summer.

PBS now delivers instructional and general audience services via direct-to-home satellite channels. The regular national programming feed provided to PBS member stations is retransmitted by two DTH services, DirecTV and DISH (Echostar), but delayed by 24 hours to protect the member stations. In late 1999, PBS launched two more satellite program services, PBS Kids (children's programming) and PBS You (adult learning service for college credit).

Fund-Raising Assistance

The Station Independence Program (SIP), a division in PBS's National Program Service (NPS), is a very successful station service. The SIP schedules and programs three main on-air fund drives a year, called **pledge drives** (a 16-day event annually in March and two nine-day drives in August and December). Stations wishing to avail themselves of the SIP service (and most do) pay PBS additional fees for it. A key SIP function is acquiring, funding, and commissioning special programs for use during local station pledge drives. Programs with *emotional payoff* tend to generate more and higher pledges, not necessarily those programs with the largest audiences. Self-help programs and inspirational dramas, for example, generally make money for stations, but documentaries on topics such as world economics do not do well. In general, performance events (*Yanni, Three Tenors*) do very well in pledge drives. Miniseries like *The Farmer's Wife* also attract viewers.

TYPES OF STATION LICENSEES

One of the difficulties in describing PTV programming strategies is that the stations are so diverse. The 171 **licensees** (as of 2001) operating 347 **stations** (of which many are unstaffed transmitters) represent many management viewpoints. More stations (i.e., transmitters) than licensees exist

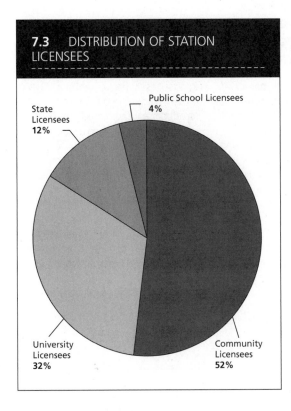

7.3 DISTRIBUTION OF STATION LICENSEES

Public School Licensees 4%

State Licensees 12%

University Licensees 32%

Community Licensees 52%

because in 20 states a legislatively-created agency for public broadcasting is the licensee for as many as 15 separate transmitters serving its state. Also, in several communities, one noncommercial educational licensee operates two television channels. In these cases (Boston, Pittsburgh, and Milwaukee, among others), one channel usually offers a relatively broad program service while the second channel is used for more specialized programming, often instructional material.

Much of their diversity is explained by the varying auspices under which they operate. Licensees fall into four categories: *community, university, public school,* and *state agency,* in the proportions shown in 7.3, and each approaches programming in some different ways.

Community Licensees

In larger cities, particularly those with many educational and cultural institutions but without a dominant institution or school system, the usual licensee is the nonprofit community corporation created for the purpose of constructing and operating a public television station. Because the governing board of such a station exists solely to administer the station (as compared with university trustees who have many other concerns), many feel that community stations are the most responsive type of licensee. As of 2001, 90 such licensees operated in the United States.

Compared with other licensees, community stations derive a higher proportion of their operating support from fund-raising activities (including on-air auctions)—about 26 percent, compared with 21 percent for licensees overall.[5] As a result, on-air pledge-drive programming reflects the urgent need to generate funds from the viewers they serve. Programmers at these stations, therefore, are more likely to be sensitive to a proposed program's general appeal. They will lean toward high-quality production values to attract and hold a general audience. (See 7.4 for an alternative funding idea.) Within the *community* category, several stations stand somewhat apart because of their metropolitan origins, their large size, and their national impact on the entire noncommercial service as producers of network-distributed programs. These flagship stations of the public broadcasting service are located in New York, Boston, Los Angeles, Washington, Chicago, Baltimore, Seattle, and Pittsburgh. The first four are particularly notable as production centers for the nation, originating such major programs as *The Newshour with Jim Lehrer, Nova,* and *Nature.* Although other public stations and commercial entities often participate in their productions and financing, these large, community-licensed producing stations generate most of the PBS schedule.

Community stations, because of comparatively high levels of community involvement and because of a prevalence of clearly receivable VHF channels, tend to attract larger local audiences than do other types of noncommercial licensees. For example, Nielsen reports that more than half of the households in San Francisco, one of the nation's largest media markets, tune weekly to

7.4 THE ADVERTISING EXPERIMENT

Reductions in federal funding for public television during the Reagan administration's first term forced a greater reliance on public donations. Most stations came to rely more heavily on revenue from nonfederal sources in general and on public donations in particular.

Searching for alternative ways to finance public television, Congress authorized a one-year advertising experiment. Ten public television stations, including all types of licensees, were allowed to sell and broadcast advertising from April 1982 through June 1983. Studies showed minimal objection from the public, and some participating stations reported substantial profits (direct cost of sales commissions averaged only 30 percent of gross sales). Advertising revenues are based directly on the size of a station's audience, however, and because public television ratings are comparatively small, gross sales (and profits) provided stations with only a fraction of their annual budgets.

The public television industry could find no cause for enthusiasm in the outcome, and no authorizing legislation resulted. Instead, hoping to stimulate corporate support another way, the FCC loosened their underwriting guidelines to permit, among other things, the display of products and animated corporate logos in program underwriter credits.

The topic of advertising on public television resurfaced in the mid-1990s as new threats by Congress to reduce federal funding (unsuccessfully) appeared as part of the Contract with America agenda. Ervin Duggan, then president of PBS, predicted such changes would result in a network of new non-profit commercial licensees across the country.

community-operated KQED. With such a high level of viewing, more of its audience see its fund-raising appeals and contribute money to the station. WNET, New York's largest public television station, is an exception among community stations. It receives a portion of its funding from state government.

University Stations

In many cases, colleges and universities activated public television stations as a natural outgrowth of their traditional role of providing extension services within their states. As they see it, "the boundaries of the campus are the boundaries of the state,"[6] and both radio and television can do some of the tasks extension agents formerly did in person. Fifty-four licensees make up the *university* group.

Here, too, programmers schedule a fairly broad range of programs, often emphasizing adult continuing education and culture. Some, typically using student staff, produce a nightly local news-cast, and many produce a weekly public affairs or cultural program. None, in recent history, has produced a major PBS series for the prime-time core schedule. University-licensed stations such as WHA (Madison, Wisconsin) and KUHT (Houston, Texas) contribute occasional specials and single programs to the PBS schedule. WUNC-TV at the University of North Carolina in Chapel Hill produced *The Woodwright Shop* series, and other university-licensed stations have supported short-run series aired in the daytime PBS schedule.

As operating costs mount and academic appropriations shrink, some university stations turn to over-the-air fund-raising to supplement their institution's budgets. In doing so they use tactics similar to those of community stations, including airing programs specially produced for fund-raisers. Expanded fund-raising efforts are generally accompanied by broadening program appeal throughout the station's schedule, although the shows target a wide range of small, niche audiences.

Public School Stations

Local school systems initially became licensees to provide new learning experiences for students in elementary school classrooms. From the outset, some schools augmented instructional broadcasts with other programming consistent with the school system's view of its educational mission. By 2001 only seven of these *school licensees* remained. Most of them have organized a broadly based community support group whose activities generate wider interest and voluntary contributions from the community at large. As a result, the average local licensee now draws 7 percent of its income from subscriber contributions.

Naturally, programmers at these stations are heavily involved with in-school programming (instructional television—ITV), but because they desire community support they are also concerned with programming for children out of school and for adults of all ages. Other than ITV series, most rarely produce original entertainment programs for PBS, and they obtain most of their schedules from national, state, and regional suppliers of instructional programming. Of course, they usually carry such general (non-ITV) PBS educational children's programs as *Sesame Street*, too.

State Television Agencies

More than 200 of the nation's 347 public television transmitters are part of state networks operated by legislatively created public broadcasting agencies. Networks of this type exist in 20 states. Most of them were authorized initially to provide new classroom experiences for the state's schoolchildren. Most have succeeded admirably in this task and have augmented their ITV service with a variety of public affairs and cultural programs furnished to citizens throughout their states.

State networks, such as those in South Carolina, Maryland, Kentucky, Nebraska, and Iowa, are very active in the production and national distribution of programs. Their efforts range from traditional school programs for primary and secondary grades to graduate degree courses offered in regions where colleges and universities are few.

These production efforts are the counterpart to the national production centers of the community-based licensees. Although state networks rarely produce prime-time PBS series, they frequently join consortia generating specific programs for series such as *Great Performances*. Others, such as the Maryland Center for Public Broadcasting and the South Carolina ETV Commission, have produced many long-lived PBS series, for instance, *Wall Street Week*.

Although in recent years these state network stations have gotten more foundation, underwriter, and even viewer support, state legislatures still appropriate more than three-fifths of their budgets. This fact, plus the perception of their "community of service" as an entire state rather than a single city, gives programmers at these stations a different perspective.

Similarities Among and Differences Between Station Licensees

It should be evident from these brief descriptions that each category of public television station poses special problems and special opportunities for programming strategies. Each station type is ruled by a different type of board of directors— community leader boards, university trustees, local school boards, state-appointed central boards. Each board affects program personnel differently:

- Community representatives try to balance local power groups.
- University boards, preoccupied with higher-education programs, tend to leave station professionals free to carry out their job within broad guidelines.
- School boards likewise are preoccupied with their major mission and in some cases pay too little attention to their responsibilities as licensees.
- State boards must protect their stations from undue political influences.

All licensees struggle to function with what they regard as inadequate budgets, but there are wide funding discrepancies between the extremes

of a large metropolitan community station and a small local public school station. Significantly, all types of stations have broadened their financial bases in recent years to keep up with rising costs and to improve program quality and quantity. Licensees having the greatest success in securing new funding have, in general, made the strongest impact on national public television programming. In turn, successful public television producer-entrepreneurs are motivated to create attractive new public television programs with broad audience appeal in the hope of securing still more underwriting. Such programs increase viewership and draw more support in the form of memberships and subscriptions. Although this trend has its salutary aspects, it has also diverted noncommercial television from some of its original goals. For example, controversial public affairs programs and those of interest only to specialized smaller audiences—the "meat and potatoes" of public television—do not always receive corporate funding, but instead frequently receive funding from CPB, PBS, and foundations.

PROGRAM PRODUCTION

Early in its history, PBS developed a characteristic schedule of dramatic miniseries and anthologies; documentaries on science, nature, public affairs, and history topics; concert performances; and a few other types, none of which ABC, CBS, Fox, or NBC offer on a regular basis. PBS's marketplace position has thus historically been that of an alternative to the commercial networks. Today, however, several cable networks (including The Discovery Channel, A&E, The History Channel, The Learning Channel, and Bravo) offer some programs similar to PBS's. From time to time, some members of Congress—important critics because Congress supplies public television with 14 percent of PBS's annual revenue—will argue that PBS has become superfluous because it duplicates programming available on cable. The argument lacks merit because 15 percent of U.S. TV households do not subscribe to cable or satellite, while 99 percent can receive PBS. Moreover, fewer cable subscribers actually watch the cable networks that have PBS-like programs; PBS's ratings are two to four times larger.

Program Financing

How a program gets into the PBS schedule contrasts with the process at its commercial network counterparts. At ABC, CBS, Fox, NBC, and most cable networks, program chiefs order the programs they want, pay for them out of a programming budget, then slot them into the schedule. To minimize ratings failures, the networks first pay for the production of pilot programs each year. Additional episodes are ordered of the most promising, and the series receives a place in the schedule.

At PBS, however, program funding is more complex. A program may have a single financial backer or several. More frequently than not, funding comes from a combination of sources, especially when the project runs into millions of dollars. PBS will partially support and, on occasion, fully support a project out of its program assessment funds, but many programs must find their own backing. Producers would, of course, prefer to walk away from PBS with a check for the full amount. Owing to PBS's limited purse, they must usually "shop" a project from one corporate headquarters to the next, perhaps even to foundations and the Corporation for Public Broadcasting. Given the daunting process, producers have been heard to say that they spend more time chasing after dollars than making programs. To streamline this process and significantly increase its effectiveness, PBS and a group of major producing stations formed, in 1997, the PBS Sponsorship Group, a marketing collaborative. By pooling forces, the organization has, through increased cooperation, efficiency, and professionalism, brought about substantial gains in corporate sponsorship.

Program assessment fees, now levied on PBS member stations, were begun in the early 1990s. They represent public television's response to growing cable-network competition for the limited

supply of programs to buy. In 1990 stations voted to streamline the program funding process so that newly offered productions could be snapped up without delays. The first year of program assessment, nearly $80 million was transferred from station hands to PBS's; by FY 2001, the figure had grown to more than $105 million. The chief program executive now handles selected program funding as a centralized responsibility (in contrast to the long-beloved notion that program decision making should be tightly controlled by public television's 171 station program managers). To form this fund, stations are assessed in proportion to their market size. Programs produced either wholly or in part from this fund carry an announcement crediting "viewers like you" because station money is involved, a large part of which comes from viewer contributions.

A program on PBS can have several "fathers," that is, multiple producers. Typically, separate production units shoot film for partners in a co-production deal, as when PBS joins with the BBC to produce a science or nature program. In such an arrangement, both will have usage rights. Sometimes a cable network partners with PBS (although usually only for funding and not actual production). Rather than share a program with a U.S. competitor, public television prefers foreign coproduction over domestic coproduction.

The Major Producers

A very large portion of PBS's schedule comes from series produced by or in conjunction with four major producing stations—WGBH in Boston, WNET in New York, KCET in Los Angeles, and WETA in Washington, D.C. In most years, these producing stations account for well over half of PBS's new shows (see 7.5). Other stations contribute an occasional series or special to the PBS schedule, but most local efforts either focus too narrowly on a topic to be of wide national interest or fall short of national standards for writing, talent, and technical characteristics because they lack sufficient budget. PBS seeks programs equivalent in content and production quality to com-

7.5 MAJOR PRODUCING CENTERS	
Stations	**Program Series**
WGBH, Boston	*The American Experience*
	Antiques Roadshow
	Arthur
	Frontline
	Masterpiece Theatre
	Mystery
	New Yankee Workshop
	NOVA
	This Old House
WNET, New York	*American Masters*
	Charlie Rose Show
	Great Performances
	Live from Lincoln Center
	Metropolitan Opera Presents
	Nature
WETA, Washington, DC	*In Performance at the White House*
	The News Hour with Jim Lehrer
	Washington Week in Review
KCET, Los Angeles	*Adventures from the Book of Virtues*
	The Puzzle Place
	Storytime

mercial efforts, and it is especially interested in programs for children.

British programs such as *Masterpiece Theatre* and *Mystery!* have become staples of American public television because they are high-quality programs available at one-tenth the cost of producing comparable fare in the United States. But they, along with other foreign productions, occupy only a fraction of all PBS programs. PBS programming comes from a mix of foreign producers, international coproductions, commercial independent producers, public television stations, and the producing organizations with traditional ties to PBS, such as Sesame Workshop (formerly Children's Television Workshop). Nearly 90 percent are made in the United States (see 7.6). This pattern

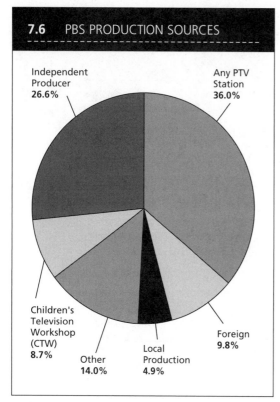

7.6 PBS PRODUCTION SOURCES

Independent Producer **26.6%**

Any PTV Station **36.0%**

Children's Television Workshop (CTW) **8.7%**

Other **14.0%**

Local Production **4.9%**

Foreign **9.8%**

Source: Corporation for Public Broadcasting, "Highlights from the public television survey/fiscal year 1996," in *CPB Research Notes, No. 106* (May 1998), p. 8, Table 1, Historical Trends, Part II.

of sources has been consistent over recent years, although increased competition from cable networks for foreign programs has narrowed PBS's options. The greatest change in funding in recent years has been in the distribution of funds by means of program assessment, not in program sources.

Balance in Selection

Responsibility for acquiring programs falls to one of several "content" managers, including the directors of drama, performance, and cultural programs; children's; news and public affairs; and science and history.[7] They must view sample tapes (demonstrations) and sift through many hundreds of proposals each year. Based on these written proposals or sample tapes (pilot episodes are very

rarely made), the manager decides whether to purchase the program or provide some portion of production funding. In the case of foreign productions, a program can be purchased outright because it is already "in the can" (produced). If the decision on a proposal for a new production is favorable, a small research and development grant is usually the first step, perhaps with a promise of larger amounts to follow. Once production is under way, the content manager will consult with the producer during the production process to guide the outcome toward a satisfactory result. It is important to note that *PBS can order programs to be produced, but it does not itself produce them*.

Through all this, National Program Service executives attempt to maintain balance in the national schedule so that the network doesn't find itself one season with, for example, too many symphony concerts and too few investigative documentaries in the schedule. To better regulate the flow of new productions into the national schedule, PBS established the Public Television Pipeline, a management system for monitoring and coordinating all program development activity from the proposal stage through delivery to PBS. Throughout the year, the Pipeline sends signals to producers about PBS's overall schedule surpluses and shortfalls as well as specific content needs. Proposals are submitted, approval (and perhaps seed money) obtained from PBS, and the final selection process is under way.

Corporate Pressure

Programs occasionally have corporate underwriters who actively participate in program production or acquisition. The executives in charge of underwriting these programs invest not only prodigious sums from corporate treasuries but also personal effort and reputation, and they feel entitled to choice slots in the prime-time schedule. Of course, PBS cannot always fit a program in the time slot the underwriter wants and still maintain a balanced schedule.

Corporate fiscal needs can also affect scheduling. Often, the underwriting corporation requires

that a program be played within its fiscal year—irrespective of audience and schedule needs. PBS program executives attempt to accommodate such cases, knowing that if they do not, the corporation in its pique may refuse future requests for support.

The major producing stations also attempt to influence program decisions at PBS on behalf of their program underwriters. For those stations, financial health depends on corporate support, which pays for salaries, equipment loans, and other production expenses. Were just one major underwriter to withdraw support, the financial effect on a producing station could be devastating.

Station Pressure

Other programming pressures occur. Many stations, for example, *refuse* to telecast a program at the time fed because they decide it:

1. Is not of prime-time quality

2. Contains too much profanity or violence to air in early evening

3. Occupies a slot the station wants for its own programs

4. Has little appeal for local viewers

Although each of these reasons has merit at times, the combined effect of 171 station program managers exercising independent judgment has often left portions of the PBS schedule in a shambles. PBS program executives assembling a schedule must anticipate these concerns to minimize defections from the live feed.

Program Rights and Delivery

PBS programmers must also wrestle with two problems common to both commercial and noncommercial programming: program rights and late delivery. In public television as in commercial television, standard program air-lease rights are set by contract with the producer, who owns the rights. PBS has traditionally negotiated with producers for as many **plays** as possible so that by airing the same program several times, the typically

small (per airing) PBS audience snowballs. Extra plays also fill out the program schedule.

At the same time, the program syndicator seeks as few airings as possible over the shortest time period to retain maximum control and resale potential for a program. A compromise between various producers and PBS permitting four program plays within three years is now the standard rights agreement in public television.

Late delivery has obvious troublemaking possibilities. One year, so many productions were behind schedule that the fall schedule premiered without a single new series.[8] As a consequence, in that extraordinary year, the "second season" premieres in January were so choked with overdue new programs that the popular *Mystery!* series had to be popped out and shelved until the following fall!

Tardy arrival also cripples promotion and publicity efforts. The enormous audience and critical acclaim enjoyed by PBS's *The Civil War* in September 1990 owed much to the producer's early completion of the series. That enabled the production of ample promotion and advertising. Perhaps most important, the series was available for screening by an enthusiastic press during the July press tour of the Television Critics Association, which resulted in a gusher of free and favorable publicity.

SYNDICATED AND LOCAL PROGRAMMING

Because of its role in formal education, public television has had to develop its own unique body of syndicated material to meet instructional television needs. A number of centers for program distribution were established to perform the same function as commercial syndication firms, but on a noncommercial, cooperative basis (see 7.7 for more on these centers).

Noncommercial Syndication

The abundance of ITV materials means that it is no longer necessary to produce instructional programs locally, except where desired subject matter

7.7 NONCOMMERCIAL SYNDICATORS

The Agency for Instructional Technology (AIT) in Bloomington, Indiana, produces series for primary grades, high school, and postsecondary students. Among the best known are *All About You, Mathworks, Assignment the World,* and *Up Close and Natural.* AIT took the lead in developing innovative classroom programs that operate in conjunction with desktop computers, creating the first interactive lessons on DVD.

Great Plains National (GPN) in Lincoln, Nebraska, offers dozens of series for elementary and junior high use along with a great many materials for college and adult learning. Titles in its catalog range from *Reading Rainbow* (for first graders) to *The Power of Algebra, Tombs and Talismans,* and *Truly American* (for high schoolers and adults).

Western Instructional Television (WIT) in Los Angeles offers more than 500 series in science, language arts, social studies, English, art, and history. TV Ontario also supplies U.S. schools with dozens of instructions series, especially in science and technology, including *Read All About It, The Landscape of Geometry,* and *Magic Library.* Even PBS, through its Elementary/Secondary Service, offers a slate of ITV programs, such as *The Voyage of the Mimi, Amigos,* and *Futures with Jaime Escalante.*

1. Works full-time with present and potential users
2. Assists teachers in proper use of the materials
3. Identifies classroom needs
4. Selects or develops materials to meet the specific goals of local educators

More than 1,200 hours of the most-often-selected ITV series for kindergarten through twelfth grade are made available to subscribers by satellite every day, 33 weeks per year. The National ITV Satellite Service (NISS) is coordinated by the SECA regional network. More than half of all public schools make use of ITV. Subscribers include public television stations, state departments of education, regional educational media centers, and other authorized educational entities.

Noncommercial Adult Education

Quality programming for adult learners is now available in quantity to public stations. Beginning in the late 1970s, various consortia began to turn out **telecourses** (television courses) for integration into the curricula of postsecondary institutions. These efforts have centered particularly in community colleges, led by Miami-Dade (Florida), Dallas (Texas), Coastline Community College (Huntington Beach, California), and the Southern California Consortium. With budgets ranging from $100,000 to $1 million for a single course, they have proven sufficiently well-produced to attract casual viewers as well as enrolled students.

Meanwhile, faculty members at other leading postsecondary institutions began developing curriculum materials to accompany several outstanding public television program series distributed nationally through PBS for general viewing. The first of these was *The Ascent of Man,* with the late Dr. Jacob Bronowski, a renowned scholar as well as a skillful and effective communicator on camera. More than 200 colleges and universities offered college credit for that course. Others quickly followed (*The Adams Chronicles, Cosmos, Life on Earth, The Shakespeare Plays*) as programmers discovered that such series furnished the casual viewer

is unique to a community. Local school authorities usually select instructional materials for in-school use, although the public television station's staff often serves as liaison between sources of this material and users. The state may appropriate funds for instructional programs, giving them to public stations within the state, or school districts may contract with a local public station to supply particular ITV programs at certain times. Stations that serve schools usually employ an "instructional television coordinator" or "learning resources coordinator" who:

with attractive public television entertainment and simultaneously served more serious viewers desiring to register for college course credits.

This experience led many public television programmers to realize that too much had been made of the supposed demarcation between ITV and PTV. Too often during earlier years, many program producers would not even consider producing so-called instructional television. The first Carnegie Commission in 1965 strengthened this presumed gap by not concerning itself with television's educational assistance to schools and colleges and by adopting the term *public television* to mean programming for general viewing.

PBS began its Adult Learning Service (ALS) in the early 1980s, offering over-the-air instruction leading to college credit. As of 2001, more than 96 percent of PBS stations have offered this service, which is utilized by more than 1,800 colleges and universities. Enrollment now exceeds 275,000 annually for the 60 or so telecourses offered, which cover arts and humanities, business and technology, history, professional development, science and health, and the social sciences.

Shortly after its launch, ALS received a significant boost from Walter Annenberg, then owner of *TV Guide*, who established the Annenberg/CPB Project. For this project, the Annenberg School of Communications gave $15 million to CPB each year for ten years (1983–93) to fund college-level instruction via television and other new technologies. The project resulted in such high-visibility public television series as *The Constitution: That Delicate Balance, French in Action, Planet Earth, The Africans, War and Peace in the Nuclear Age, Art of the Western World, Discovering Psychology,* and *Economics USA,* with subject matter ranging from the humanities to science, mathematics, and business. The net result of Annenberg's entry into this field was not only an increase in the number of adult instructional programs available through ALS, but also, thanks to their above-average budgets, an increase in production values (quality).

Colleges and universities wanting to offer credit for these telecourses normally arrange for local public television stations to air the series, and all registration, fees, testing, and supplementary materials are handled by the school. Some of the courses use computers, and all are keyed to special texts and study guides. ALS offers programmers one of the most challenging additions to their program schedule. Because such programs require close cooperation with the institutions offering credit, they require a reliable repeat schedule that permits students to make up missed broadcasts.

Experience has demonstrated that ITV and PTV programs can appeal to viewers other than those for which they were especially intended. The Annenberg/CPB series is only one example. Another is *Sesame Street,* initially intended for youngsters in disadvantaged households. Yet one of the significant occurrences in kindergarten and lower elementary classrooms throughout America has been the in-school use of *Sesame Street.* Ironically, *Sesame Street* may also contribute to the gap in knowledge between advantaged and disadvantaged children because it is widely watched (and learned from) by already advantaged children, perhaps making the disadvantaged more disadvantaged.

Commercial Syndication

More extensively tapped sources, however, are such commercial syndicators as Time-Life, David Susskind's Talent Associates, Wolper Productions, Granada TV in Great Britain, and several major motion picture companies including Universal Pictures. Public television stations sometimes negotiate individually for program packages with such syndicators; at other times they join with public stations through regional associations to make group buys. Commercially syndicated programs obtained in this way by PTV include historical and contemporary documentaries, British-produced drama series, and packages of highly popular or artistic motion pictures originally released to theaters. Such programming, because it was designed for general audiences, is thought to bring new viewers to a public station. Many programmers believe those new viewers can then be persuaded, through promotional announcements, to watch more typical PTV fare.

The proportion of commercially syndicated programming in public television station schedules, nonetheless, averages only slightly more than 4 percent of broadcast hours. The number is small partly because those syndicated programs public stations find appropriate are relatively *expensive*; unless the station secures outside underwriting to cover license fees, it usually cannot afford them. Stations now pay as much as $100,000 for an hour of British television that cost as little as $50,000 a few years ago. Another reason is *philosophical*: Although much commercially syndicated material has strong audience appeal, its educational or cultural value is arguable.

Local Production

The percentage of airtime filled with locally produced programming has gradually decreased over the years as both network and syndicated programming have increased in quantity and quality. Owing mostly to its high cost, the percentage of total on-air hours produced *for local use* by public television stations declined from 16 percent in 1972 to just less than 5 percent 25 years later. Moreover, production quality expectations have risen. More time and dollars and better facilities must now be used to produce effective local programs.

Locally produced programs, nonetheless, are far from extinct in public television. A survey of station producers found that, among the 79 licensees responding, more than 3,000 programs had been produced during the past year. Among them were weekly and occasionally nightly broadcasts devoted to activities, events, and issues of local interest and significance. Many stations regularly cover their state governments and legislators. Unlike commercial stations, which concentrate on spot news and devote a minute or less to each story, public stations see their role as giving more comprehensive treatment to local matters. But news and public affairs programs were not the only kinds being produced. The survey found stations turning out a spectrum of content: arts and performance, documentaries, history, comedy, science, nature, and even children's programs.

SCHEDULING STRATEGIES

Nowadays, PBS programmers want to maximize audiences. Gone are the educational television days when paying attention to audience size was looked upon as "whoring after numbers." The prevailing attitude at PBS recognizes that a program must be *seen* to be of value, and that improper scheduling prevents full realization of a program's potential. Member stations now recognize that bigger audiences also mean a bigger dollar take during on-air pledge drives.

Counterprogramming the Commercial Networks

Competition, of course, is a key consideration. The three ways of responding to it are:

1. Offensively, by attempting to overpower the competitor

2. Defensively, by counterprogramming for a different segment of the audience than the competitor's program is likely to attract

3. Ignoring the competition altogether and hoping for the best

PBS has never been able to go on the offensive; its programs lack the requisite breadth of appeal. Prime-time PBS shows average around a 2.0 household rating. ABC, CBS, and NBC regularly collect ratings of 8 and higher (although their figures are much smaller than a decade ago, the result of audience defections to the many cable networks now available).[9]

PBS, then, must duck and dodge, a strategy called **counterprogramming.** By studying national Nielsen data, programmers learn the demographic makeup of competing network program audiences so they can place their own programs more advantageously. For example, a symphony performance that tends to attract well-educated women older than 50 (**upscale**) living in metropolitan areas would perform well opposite Fox's *Family Guy*, CBS's *Everybody Loves Raymond*, or the Paramount

Network's *WWF Smackdown!,* all having **downscale** (lower socioeconomic) audiences. Similarly, in searching for a slot for the investigative documentary series *Frontline,* PBS did not consider for a moment the 8 to 9 P.M. slot on Sundays because football overruns had formerly pushed *60 Minutes* into this slot.

PBS tries to avoid placing a valued program against a hit series in the commercial schedules. PBS also has traditionally avoided placing important programs during the three key all-market audience-measurement periods (sweeps) in November, February, and May—times when commercial television throws its blockbusters at the audience. Because the commercial networks have cut back on sweep blockbusters in recent years (especially costume-drama miniseries, which lure away many PBS viewers), PBS has grown more willing to run an important series through a sweep month. This is clearly a calculated risk, a kind of TV "minefield"; a powerful commercial network special could draw off so many viewers from a weekly PBS miniseries that few would return to see its continuation and conclusion.

Further, because public as well as commercial stations are measured during the sweeps, PBS's stations demand a "solid" schedule, with a minimum of "mission programs." This is a mildly pejorative reference to public television's mission to serve all Americans, specifically referring here to narrow-appeal programs of interest only to some very small groups of viewers. Many programs are "good for the mission" but earn small ratings. Thus the sweeps now display many of PBS's strongest—not weakest—programs.

Stripping and Stacking Limited Series

A standard among PBS's offerings, the limited series includes both *nonfiction* and *fictional miniseries* (continuing dramas with a fixed number of episodes usually ranging from 3 to 12 or more). Some notable examples of limited series in recent years include *Frank Lloyd Wright, The Irish in America,* and *India: Land of the Tiger.* Most limited series appear once a week in prime time, much as weekly series are scheduled on commercial television.

Because short-run series lose viewers across the first few weekly telecasts, however, PBS schedulers have experimented with alternative play patterns in the hope of staunching the dropoff. To borrow jargon from computer technology, they asked whether limited series scheduling could be made more "user friendly." Experiments with the *Holocaust* series and *Shoah* in 1988 showed that limited series having sufficiently engaging material lent themselves to airing on consecutive nights, a practice known in commercial television as **stripping.** This ploy not only attracted at least as many viewers as tuned in to similar programs on a weekly basis but it also encouraged viewers to spend significantly more time watching the series. Moreover, the episode-to-episode ratings dropoff disappeared.

When a limited series has too many episodes for convenient stripping, PBS bunches episodes together, **stacking** two episodes per evening. *The Civil War,* for example, was scheduled in this pattern, thereby limiting the magnitude of nightly commitment on the part of viewers. PBS's practice is to schedule limited series on a maximum of five consecutive nights (although Ken Burns' *Baseball* required nine evenings).

Which limited series receive special treatment and which must air in the usual once-a-week way hinges on a decision about "sufficiently engaging material." This is in part a function of production budget, advance promotion, casting, subject matter, and less well-recognized variables such as timing, quality, and appeal to the public television audience. Such decisions cannot be supported by audience research alone; the programs must be screened (watched) as well. Ultimately, the chief program executive makes the call.

Bridging

Another competitive tactic is **bridging,** illustrated in 7.8. Remote-control "zappers" notwithstanding, most viewers stay with a program from start to finish, thus a lengthy program prevents an audience from switching to the competition's programs at

7.8 BRIDGING THE FOUR FULL-TIME NETWORKS

	PBS	ABC	CBS	NBC	Fox
8:00	Live From Lincoln Center	Ellen	Bless This House	Seaquest 2032	Beverly Hills 90210
8:30		Drew Carey	Dave's World		
9:00		Grace Under Fire	Central Park West	Dateline: NBC	Melrose Place
9:30	Songs of the Homeland	Naked Truth			
10:00		Primetime Live	Courthouse	Law & Order	nonnetwork
10:30					

Note: Wednesday, September 20, 1995.

their start. PBS bridges by scheduling mostly one-hour or longer programs during prime time and sometimes breaks its programs at the half hour, thereby crossing over the start time of commercial half-hour situation comedies on the Big Four commercial networks and some cable channels.

Because the commercial networks usually break every night at 9 P.M. (a key **crossover** point), the PBS schedule normally breaks then, too, in the hope that some "grazers" might come to public television. Were PBS to schedule a pair of half-hour shows opposite one-hour network programs, the second of PBS's half-hour programs would draw away very little of the locked-in audience tuned to the bridging network shows. When PBS broke at 9:30, however (as illustrated in 7.8), it bridged the start of two sitcoms on ABC, two hour-long shows on NBC and CBS, and the early late news on Fox. Of course, in this example, viewers of the second PBS program have to flow out of the lead-in PBS program, *Live from Lincoln Center*, come from

Grace Under Fire (unlikely), or come from homes where the television set had just been turned on.

Audience Flow

Certain PBS series are especially dependent on audience flow from a strong lead-in. New, untried programs especially need scheduling help. *The Ring of Truth*, a six-part series on the scientific method, for example, was not expected to build a loyal following the way a predictable series such as *Wall Street Week* has. Thus it was placed following an established, successful science series, *NOVA*, which regularly draws large audiences (large, that is, for public television) and itself has no need for a powerful lead-in.

Particularly in need of a lead-in boost—on a regular basis—is another PBS staple, the **umbrella series.** These are anthologies of single programs having loosely related content that appear under an all-encompassing title (or umbrella) such as *The American Experience* (history programs) or *Great*

Performances (ballet, plays, operas, orchestral music, Broadway shows, and so forth). Because the material offered under the umbrella changes from week to week, the audience never knows what to expect; clearly, the format works *against* habit formation. Thus, it is essential that a strong audience be introduced to each week's episode, if not by costly media advertising (usually out of public television's reach), then by a substantial lead-in.

Considerations at the Station Level

A public television program schedule is notable for its variety; it is meant to serve the total population over time but not the complete needs of the individual viewer. Although this is also true of commercial stations, it especially applies to public television schedules. Because they usually are so focused in content, PTV programs tend to be watched by small, often demographically targeted population segments. Seeking the most opportune time slot for reaching those target groups is the program manager's challenge.

No PTV programmer ever builds an entire schedule from scratch (unless the station has just signed on for the first time, of course). Rather, the manager's ongoing responsibility is to maintain a schedule while considering

1. *Licensee type*, as each carries its unique program priorities

2. *Audience size and demographics*

3. *Competition* from commercial stations, other public television signals, and cable networks

4. *Daypart targeting*, such as daytime for children's programs and for instructional services, and early evenings for older adults

5. *Program availability*

6. *Tape-machine capacity* (for delaying a program's broadcast)

No single element overrides the others, but each affects the final schedule. Public television programmers seek programs that meet local audience needs and schedule those programs at times most

7.9 TYPES OF PROGRAMMING BROADCAST BY PUBLIC TELEVISION STATIONS

Type of Program	Percent of Total Broadcast Hours
Information and skills	28.5
General children's	19.5
News and public affairs	19.3
Cultural	16.6
Instructional	7.9
Sesame Street	7.7
Other	0.6
Total	100.1

Source: Corporation for Public Broadcasting, "Highlights from the public television programming survey," in *CPB Research Notes, No. 106* (May 1998). Data shown are from 1996 (most recent data). Some overlap in children's programs leads to double-counting.

likely to attract the target audience. Because all audience segments cannot be served at once, the mystery and magic of the job is getting the right programs in the right time slots. High ratings are not the primary objective; serving the appropriate audience with a show they will watch that adds to the quality of their life is. A breakdown of PTV program types appears in 7.9.

NATIONAL PROMOTION

Still another consideration is the importance of national promotion. Fledgling programs and episodes of an umbrella series need extra help for viewers to discover them. Although an effective lead-in program is essential, advertising and promotion can alert other potential viewers to a new program and persuade them to try it. Unfortunately, public television budgets permit little advertising. Only a few underwriters include some promotional allotment in their program budgets.

Still another PBS practice is to carefully schedule on-air promotion announcements for a particular program in time slots where potential viewers of that program (based on demographic profiles) are likely to be found in maximum quantity. Such on-air promotion is crucial as it reaches known viewers of public television, but its effectiveness is somewhat hampered by public television's limited prime-time reach. In one week, a massive on-air campaign promoting one program could hope to reach at best only 20 to 25 percent of all television households.

AUDIENCE RATINGS

Public television must always demonstrate its *utility*. Many contributed to its continuance—Congress, underwriters, viewers. If few watch, why should contributors keep public television alive? Programmers have come to realize that critical praise alone is insufficient; they need tangible evidence that audiences feel the same way. That most convincing evidence comes from acceptable ratings.

Nielsen Data

PBS evaluates the performance of its programs with both national and local viewing data, each having its own particular usefulness in analysis. National audience data are provided by the Nielsen PeopleMeter service (NPM); the Nielsen Station Index (NSI) provides the individual market data (see Chapter 2).

PBS's limited research budget permits the purchase of only one national audience survey week per month. Forty weeks therefore go unmeasured. (The commercial networks, as described in previous chapters, purchase continuous, year-round national data.) NSI's ever-expanding Metered Market service (50 markets in 2001) provides PBS with a comparatively inexpensive proxy for daily national ratings, however, because 66 percent of the country's TV households are within these markets. Slowly, more markets probably will be metered. Except for Boston, the local Metered Market service employs household meters rather than people-meters. Of necessity, then, demographic data on viewers must continue to be collected by the diary method in these markets.

A newspaper program listings service, TV Data of Queensbury, New York, provides a critical form of data for PBS. TV Data compiles station-by-station program schedules 52 weeks a year. To ensure accuracy, the company calls all public stations each week to collect last-minute program changes from the previous week. The resulting program carriage data are delivered to PBS via the Internet, which the network analyzes to understand station usage of PBS programs. The data reveal time zone program shifts as well as delayed carriage patterns. PBS then sends its carriage data to Nielsen, which marries it with meter viewing data to produce the national PBS ratings.

Public stations use the same Nielsen local **diary** surveys (and the resulting rating books) during the four sweeps as do their commercial counterparts. Nielsen surveys a few large markets in October, January, and March, and public stations in those markets can also purchase these reports.

Commercial network programmers, to the irritation of advertising time-buyers, have traditionally inflated affiliates' ratings by **stunting** with unusually popular specials and miniseries during the sweep weeks (see Chapter 4). These higher ratings provide the local affiliates with an opportunity to raise advertising rates. PBS programmers schedule some new product during sweeps, but lack enough truly top-notch programming to stunt for an entire four-week period. PBS does, however, try to schedule a *representative mix* of PBS offerings during each of the national survey weeks. No more than one opera is permitted, for example, nor are too many esoteric public affairs programs scheduled during that week.

PBS itself indulges in stunting during its pledge drives. Just as networks stunt for economic reasons, so too does public television. The difference is structural: Rather than raise revenue by selling advertising time on the basis of ratings, PBS stations raise revenue by direct, on-air solicitation of viewer contributions. Programs specially pro-

duced for the drives to reach the viewers' emotions are scheduled alongside regular PBS series. To an extent, larger audiences mean larger contributions, but a low-rated program may find a small but appreciative audience and prove a lucrative fund-raiser.

Audience Accumulation Strategy

PBS strives for maximum variety in its program schedule to serve as many people as possible at one time or another each week. Unlike commercial network programs, not all public television programs are expected to have large audiences. Small audiences are acceptable so long as the weekly accumulation of viewers is large, an indication that the "public" is using its public television service. And so, an important element in assessing PBS's programming success is its weekly cumulative audience, or **cume.** This statistic, along with **time spent viewing,** constitute the two basic elements of audience data.

The most important data come from the cumes. As explained in Chapter 2, Nielsen defines a cumulative household audience as the percent of all U.S. TV households (unduplicated) that tuned in for at least six minutes to a specific program or time period. (Six minutes is a minimum figure, the "ticket" for admission into the cume. Even if the viewer watches for 50 minutes, or leaves and rejoins the audience five or six times during a telecast, that person is still counted only once in the cume, provided the six-minute minimum has been met.)

The weekly public television national cumes for prime time (8 to 11 P.M., Monday through Sunday) averaged 29.9 percent of U.S. households in 1998–99. When all times of day are included, the weekly cume rises to 55.1 percent of the country's households (but down from nearly 59 percent a few years earlier). The competing "comparison channels" on cable (A&E, The Discovery Channel, The Learning Channel, The History Channel) attract only 60 percent of the total viewers of PBS.

Based on prior experience, PBS programmers apply informal guidelines for what rating levels constitute adequate viewing. Nature and science programs typically attract a cumulative audience of 5 to 7 percent of U.S. households, dramas around 4 to 5 percent. Concert performances typically attract 3 percent, and public affairs documentaries 2 to 5 percent. Because ratings are not the sole criterion by which PBS program performance is evaluated, however, failure to meet these levels never triggers a cancellation. Repeated failure to earn the minimum expected cumes, though, could eventually result in nonrenewal.

Loyalty Assessment

PBS researchers also study audience loyalty (tenacity) as a way of evaluating a program. Using ratings from the 50 metered markets, which Nielsen provides quarter hour by quarter hour, it is possible to plot an audience's course across a single program or across an entire multiweek series. If the audience tires quickly of a program, the overnight ratings will slip downward during the telecast (a fate to which lengthy programs are especially susceptible). If the audience weakened in response to the appeal of competing network programs, such as a special starting a half hour after the PBS show, the overnight ratings suddenly drop at the point where the competing special began. This information tells the programmers (roughly, to be sure) the extent to which the program engaged viewers. Noncompelling programs are vulnerable to competition. Shows failing this test have to be scheduled more carefully when repeated, preferably opposite softer network competition.

The national peoplemeter service, in addition to TV ratings and cumes, provides a different but equally valuable analytical statistic: the number of minutes spent by people (or households) viewing a single program or even a whole multi-episode series. This time-spent-viewing figure reveals how *much* of a production was actually watched, in contrast to the **cume,** which simply tells how *many* watched. As mentioned previously, some miniseries earn higher time-spent-viewing figures when stripped on consecutive nights than when scheduled weekly.

Demographic Composition

Another useful way of evaluating a program is by observing exactly who is watching. If a program is designed for the elderly, did the elderly in fact tune in? When African Americans were the target, did sufficient numbers switch on the program? Although households tuning to public television each week are, as a group, not unlike television viewers generally, audiences for individual programs can vary widely in demographic composition. Programs such as *NOVA*, the *Bill Moyers Specials*, and *Masterpiece Theatre* attract older, college-educated, professional/managerial viewers because these programs can be intellectually demanding. Demanding shows are numerous on PBS, thus its cumulative prime-time audience composition reflects this tendency. Many programs, though, have broader-based followings, among them *Nature* and *This Old House*.

PBS's evening programs have also been found to have an age skew (tendency) favoring adults 35 years of age or older. Few young adults, teenagers, or children watch in prime time. The reason for this skew probably lies in the nature of the schedule, which, despite the occasional light entertainment special, consists largely of nonfiction documentaries. According to CBS's top research executive:

Our analysis shows that over age 35, you get an adult programming taste. Under age 35, you still have a youth orientation. It is only when people reach their mid-30s that their viewing tastes become more like older adults'. . . . And their appetite grows for news and information programming.[10]

Still, public television's overall (24-hour-a-day) cumulative audience demographically mirrors the general population on such characteristics as education, income, occupation, and racial composition, as shown in 7.10. That is partly because it is a large audience, with more than half of all U.S. TV households tuning to public television each week, and about four-fifths tuning in monthly. Another reason for PBS's broad profile is that the overall audience includes the viewers of daytime children's and how-to (hobbies and crafts) pro-

7.10 U.S. POPULATION AND PTV AUDIENCE COMPOSITION

	Total U.S. TV Population (percent)	PTV Audience (percent)
Occupation		
Prof/Owner/Mgr	24.9	25.3
Clerical and Sales	15.7	14.7
Skilled and Semiskilled	28.9	27.6
Not in labor force	30.5	32.4
Income		
$60,000+	29.0	31.8
$40,000–$59,999	19.7	20.2
$20,000–$39,999	26.1	25.4
Less than $20,000	25.2	22.6
Age		
65+	12.5	15.5
50–64	15.2	19.1
35–49	24.3	24.9
18–34	23.9	16.7
12–17	8.6	4.9
2–11	15.4	15.8
Ethnicity		
Non-black	88.2	89.4
Black	11.8	10.6
Spanish origin	8.3	8.2

Source: Nielsen Television Index/PBS, 1998–99.

grams, many of whom are not frequent users of the prime-time schedule.

Public television representatives frequently are called upon to explain a seeming paradox: How can public television's audience duplicate the demographic makeup of the country when so many of its programs attract the *upscale* viewer? The question is second in importance only to that of how many people are watching; it is often tied to charges of elitism in program acquisition, implying PBS is not serving all the public with "public" television.

PBS replies that it consciously attempts to provide *alternatives* to the commercial network offerings; to do so, the content of most PBS programs must make demands of viewers. Demanding programs tend, however, to be less appealing to view-

ers of lower socioeconomic status (as well as to younger viewers). The result is *underrepresentation* of such viewers in certain audiences. This underrepresentation is, however, on balance, only slight and limited largely to prime time, being offset in the week's cumulative audience totals for other programs having broader appeal. Critics often overlook that underrepresentation does not mean no representation. *NOVA,* for example, is watched each week in some 900,000 households headed by a person who never finished high school. Even operas average nearly 300,000 such downscale households in their audiences.

The kinds of audience statistics just cited serve a unique function: justification of public television. Commercial broadcasters and cable operators justify their existence when they turn a profit for their owners and investors; public broadcasters prove their worth only when survey data indicate the public *valued* (that is, viewed) the service provided.

WHAT DEVELOPMENTS LIE AHEAD

Many people in the noncommercial field believe the public television station of today will become the public telecommunications center of tomorrow —a place where telecommunications professionals handle the production, acquisition, reception, duplication, and delivery of all types of noncommercial educational/cultural/informational materials and stand ready to advise and counsel people in the community. In this scenario, existing public television stations will transmit programs of broad interest and value to relatively large audiences scattered throughout their coverage areas; but they will also feed these and other programs to local cable channels and transfer programs of more specialized interest to videocassettes or DVDs for use in schools, colleges, libraries, hospitals, and industry or for use on home video equipment. Because of its high quality, high-definition television may give public broadcasters the special edge they need—if early adoption proves practical.

The coming years pose special challenges, however, to those who hold public television licenses

across the country. To achieve its public service potential and move beyond the limitations posed by broadcast towers into the new video distribution technologies of cable, DBS, home video, and fiber optics, the social value of noncommercial, educational video services must be reaffirmed by American policymakers. Public television cannot make the transition into the new media environment of the twenty-first century without such affirmation. *The public service, and particularly the educational value of this institution, is founded on the principle that a certain portion of the public's airwaves should be reserved for noncommercial, educational use.* Public financing was a key element of that founding assumption, and billions of dollars have been invested in making public television available to the entire nation. To continue as the national resource that it has become in broadcasting, public television must extend its mandate to additional video technologies. The educational role of public television is certain to play a key role in achieving that objective.

A renewed focus on its educational mission will guide PBS's program selection and fund-raising efforts in the future. One of its successes, *Arthur,* targets schoolage children on weekday and Sunday mornings and is the most watched children's program in all of television, among young children. PBS in fact had six of the top ten preschool programs in 2000, including *Barney and Friends, Dragon Tales, Teletubbies,* and others. On the other side, public television is seeking wide-appeal programs, much like commercial networks, that can attract underwriting; one such effort was Ken Burns' *Jazz,* which aired in 2001. These programs may signal directions for the future. By 2005, PBS will still be around, but it may be a smaller force on the national scene because public television faces daunting competition for product and funds. On the hopeful side, PBS's average ratings held steady during most of the 1990s as the major networks suffered a continuous viewing decline, and blockbusters such as *Baseball* more than doubled its usual ratings while winning national acclaim. Additional satellite transponders coupled with digital compression and high-definition pictures,

combined with exciting program ideas, may revitalize the noncommercial television industry.

As with all broadcasters, however, PBS is planning for further increases in competition from new, yet to be launched cable networks. In 2001, some 25 hopeful networks were queued, awaiting an expansion of local cable system capacity that would accommodate their carriage. The operative strategy for broadcasters is *alternative means of program distribution,* including interactive CD- and DVD-ROM disks and the Internet.

One very hopeful move in 2000 was the first-time appointment of a programmer as the president of PBS. Pat Mitchell's years of experience taught her that change is necessary when a program service gets too set in its ways. One of her first moves was to rearrange some of the long-time favorites in prime time to "make for a better natural flow of shows and allow the pairing, for example, of science and nature programs."[11]

SOURCES

Current, weekly Washington newspaper about public broadcasting, 1981 to date.

Facts About PBS. Alexandria, VA: Public Broadcasting Service, July 1995.

CPB Research Notes. Washington, DC: Corporation for Public Broadcasting, May 1998.

Hoynes, William. *Public Television for Sale: Media, the Market, and the Public Sphere.* Boulder, CO: Westview Press, 1994.

LeRoy, David, and LeRoy, Judith. *Public Television: Techniques for Audience Analysis and Program Scheduling.* Washington, DC: Pacific Mountain Network/Corporation for Public Broadcasting, 1995.

Nelson, Anne. Public broadcasting: Free at last? *Columbia Journalism Review,* November 1995, pp. 16–18.

A Report to the People: 20 Years of National Commitment to Public Broadcasting, 1967–1987 and 1986 Annual Report. Washington, DC: Corporation for Public Broadcasting, 1987.

Somerset-Ward, Richard. *Quality Time? The Report of the Twentieth Century Fund Task Force on the Future of Public Television.* New York: Twentieth Century Fund Press, 1993.

Witherspoon, John, and Kovitz, Roselle. *The History of Public Broadcasting.* Washington, DC: Current, 2000. Chapters by Robert Avery and Alan Stavitsky.

Who Funds PTV? A Guide to Public Broadcasting Program Funding for Producers. Washington: DC: Corporation for Public Broadcasting, 1991.

www.pbs.org

INFOTRAC COLLEGE EDITION

Consult InfoTrac College Edition using the password provided with this book. Use boldfaced terms as Key Words and section headings from this chapter for Subject searches.

NOTES

1. *ITV* in this usage should not be confused with *ITV* meaning "interactive television."

2. In one public presentation, Bruce Christensen, former president of PBS, defined public television's goal as "to provide programming that is largely ignored or is uncommon on commercial TV." He was supported by Michael Checkland, director general of BBC, who said, "Public service to us means serving the whole public, not drawing arbitrary lines between majorities and minorities." *Broadcasting,* 13 May 1991, p. 49.

3. Credit for this analogy and other portions of the chapter goes to S. Anders Yocum, Jr., at that time director of program production for WTTW in Chicago, as published in *Broadcast Programming,* Belmont, CA: Wadsworth, 1980.

4. These associations serve not only as forums for discussions of stations' policies and operating practices but also as agents for program production and acquisition. Set up to make group buys of instructional series, the regionals' role has evolved into providing programming for general audiences as well as for ITV use. Distribution is via the public television satellite, traffic over which is managed by PBS.

5. Corporation for Public Broadcasting. "Average revenue profiles for public broadcasting stations, fiscal year 1997." *Research Notes No. 111,* March 1999.

6. This particular expression was coined by President Charles Van Hise of the University of Wisconsin in the early 1900s, but all land-grant colleges espouse similar traditions.

7. The rare exception is news programming, coordinated by PBS but actually produced by stations. For example, PBS worked with NBC on nightly coverage of the 1992 Democratic and Republican conventions, but production was handled by WETA-TV in Washington, D.C. as part of the *MacNeil/Lehrer Newshour*. See NBC to produce conventions with PBS, *Broadcasting*, 5 August 1991, pp. 27–28; Carter, Bill. NBC and PBS to pool '92 convention coverage, *New York Times*, 1 August 1991, p. A6.

8. This was 1981, the year of the writers' strike.

9. On occasion, PBS will offer a program with mass audience appeal. In 1999, the broadcast of the acclaimed Ken Burns miniseries, *New York: Documentary Film* attracted nearly 20 million total viewers and a 2.7 rating, a substantial increase over typical PBS viewing.

10. Quoted in Townsend, Bickley. Going for the middle: An interview with David F. Poltrack, *American Demographics*, March 1990, p. 50.

11. Elizabeth A. Rathbun, "Too Good to Be 2.0," *Broadcasting & Cable*, 130:5, 12 June 2000, p. 14–18.

PART THREE

Cable, Satellite, and Online Strategies

Part Three turns to the newest aspects of television—program services delivered to homes by cable or other multichannel providers such as DirecTV, wireless cable (MMDS), and the Internet. Their strategies differ from those of broadcasting because all are *multichannel technologies;* their programmers must consider broadcast stations, cable-only networks, and online programs in the same competitive arena. For the first 50 years of television, only three networks determined most of what audiences saw, but by 2000, the average household could receive more than 60 channels and watched an average of 13 channels during any given week.

Programming a cable network or a local cable channel superficially resembles programming at a broadcast station. The programmer selects an array of movies and programs to fill a single channel or small group of channels, and then the programmer worries about scheduling positions, ratings vagaries, and promotional imagination. The programming situations of cable and satellite *operators,* however, differ greatly from those of broadcast or cable *network* programmers. For example, a network programmer fills one channel all year round, while a cable operator must fill many channels—typically five dozen or even more because the number of cable systems with 100 or

more channels continues to grow. A broadcaster purchases and schedules individual programs; cable operators buy or produce only specific programs for local channels. Most cable and satellite programming involves obtaining licenses to retransmit whole networks of prearranged and prescheduled nationally-distributed and nationally-promoted programs. A broadcaster with a network affiliation fills up to 70 percent of the station's schedule with one network's programs, and a broadcast station's promotional efforts are generally closely linked to its network's image. The cable operator, however, is connected with several networks—perhaps 50 or more—while also retransmitting the signals of local and distant over-the-air broadcasters, access channels, and any local origination channels. A cable system's image comes from its total package of channels as well as its local origination programming, public relations, paid local advertising, and on-air promotion. A satellite operator is limited to its total package of channels and its public relations to build an image. Lastly, broadcast stations receive most of their income from advertising spots sold within programs; cable systems are supported primarily by monthly fees paid by their subscribers, although advertising revenues continue to grow in the larger cities. Satellite operators have no direct advertising revenue.

Part Three begins with a chapter describing the programming constraints operating on multichannel programmers covering both local system and national satellite services. The following chapter focuses on services from a single program supplier, a basic or premium network. The third chapter looks at the current practices occurring on the web that relate to television and radio programming. Each of these chapters follows the structural pattern used previously, examining program *selection, scheduling, evaluation and promotion* within a particular programming context.

Chapter 8 analyzes strategies for **cable system and satellite programming.** It is difficult to find the boundaries between the "stuff" of this chapter and the topics relevant to the succeeding chapter. Although this chapter deals with "local" cable matters and the next with "national" cable matters, the first chapter also includes satellite services because they are more like cable operators than like cable networks. It is, however, increasingly apparent that local partakes of national, especially in the networking and syndication of some program materials, while national partakes of local, especially in the matter of local advertising inserts. Development of video and audio delivered over telephone lines to home computers, called *networking*, further blurs once sharp lines. Nonetheless, this chapter's task is to explain what happens in programming at the local level and what comes via multichannel operators, and because the technologies are changing rapidly, it devotes considerable space to explaining the newest media. It surveys the profound impacts of developments in cable- and satellite-related technologies, the ways legal requirements affect system and satellite programming at the nearly 12,000 cable systems in the United States, the ways economic considerations influence program decision making, and the types of marketing strategies utilized by cable system and satellite operators. All four sets of factors affect cable and satellite programming in vastly different ways from their effects on broadcast programming.

Chapter 9 focuses on nonpay and pay programming, the nationwide **subscription and premium program services** that may be delivered via cable, satellite, or the web. These program suppliers are part of the nonbroadcast world, but they have adopted many of the strategies and practices of the broadcast networks. The changing patterns of ownership of the program suppliers gives some clues to the newest trends. This chapter outlines the ways the basic and pay cable networks choose their original programs, the unique concerns they have in scheduling those programs, the methods of evaluation used for their audiences (because they are so much smaller than broadcast audiences), and the ways the programs are promoted.

Chapter 10 looks at a wholly new topic, that of **online video and audio programming.** First, the author separates the major arenas of the Internet, isolating the subjects of particular interest to this book on programming. As will become clear, online programming can be defined many ways, although little is known about many of the newest approaches. This chapter discusses the major providers of streaming video and audio currently available online, their strategic considerations, and the unusual aspects of their content selection, scheduling, and promotion. Then the chapter deals with the special case of online audience measurement, and the impact of online programming on the most established media. An especially important aspect of this chapter is its emphasis on comparisons with more familiar media. This chapter includes considerable detail on the individual companies and services that are presently available, so it becomes a baseline for comparison as the online programming situation changes.

Part Three, then, focuses on the special programming circumstances of cable, satellite, and web programmers and the unique constraints that operate in different multichannel programming situations. This part concludes the discussion of television programming. The final section of this book examines issues in commercial broadcast radio programming.

Chapter **8**

Cable System and Satellite Programming

Susan Tyler Eastman
Edward J. Carlin

A GUIDE TO CHAPTER 8

Multichannel programming is caught in a whirl-wind created by new communications technologies. Rapid transformations in federal regulations and revolutionary developments in the technology of communications are making the years from 2000 to 2010 a period of fundamental change in the industries of cable, satellite, telephone, and computing. Cable companies are striving to increase capacity and develop innovative technologies for the home; direct satellite and terrestrial companies are offering attractive alternatives to traditional coaxial cable; and telephone companies are entering the cable and online programming field. All these competing businesses want to be first and most effective in offering connection to the burgeoning sources of information and entertainment on the Internet. Cable wants to avoid being bypassed by telephone companies that bring additional wires into the home. Mergers and buy-ups—that foster cooperation rather than head-to-head competition—seem increasingly likely in the wake of AT&T's purchase of Tele-Communications Inc. and Mediaone. Those purchases made the phone giant AT&T the largest of all the cable operators.

Because communicating via the web may soon consume much of the time once devoted to television viewing, cable operators and telephone companies are rushing to provide high-speed home access to the Internet as well as a wide range of video and audio programming. As one Bell Atlantic executive put it, "The people who will win this game are the folks who provide depth and breadth in programming and knock-the-socks-off customer service."[1] Although many changes may be invisible to consumers, the underlying technology of the multichannel media is altering in ways that will eventually expand national and local video programming options.

The job of cable and satellite programmers is to *select, schedule,* and *evaluate* channels of programs and services from the more than 200 basic and premium satellite services described in Chapter 9 and, for a few local cable programmers, to *select* and perhaps *produce* one or more channels of local cable programs or websites. To do these jobs, multichannel

programmers must operate within technical and legal limits while generating profits for the parent corporation with maximally marketable services.

THE RETRANSMITTERS

Three kinds of program retransmitters coexist, uneasily: terrestrial wired cable systems, terrestrial wireless systems, and direct satellite broadcasters. Not surprisingly, the thousands of cable systems face common problems, as do the surviving terrestrial noncable systems and the major satellite services. They operate according to the same principles and face approximately the same limitations.

Cable Systems

The term *cable systems* refers to geographically-bounded and franchised companies using coaxial cable to deliver dozens of program channels to, collectively, about 68 million homes and offices. Each local cable operator pulls signals off several satellites and broadcast antennas, and then retransmits them via wire to homes and other buildings. There are about 12,000 separate systems in the United States, although their owners are rapidly buying, selling, and exchanging systems to create large clusters to generate economies of scale. Because cable has matured as a business, one manager and office staff can effectively serve a much larger geographic area than the small areas most cable franchises encompass. Thus, swapping systems to create clusters of several adjacent or nearby cable systems under one manager saves large overhead costs and provides about the same level of service, or so the industry claims. **Clustering** is clearly more efficient than operating a patchwork of scattered systems in different counties and different states, and studies show that after the 5-million-subscriber mark, significant economies-of-scale emerge. The definition of cable must also include telephone companies that are gradually merging with cable to deliver television, radio, and Internet signals over wire to the home. The five largest **multiple system operators (MSOs),**

AT&T, Time Warner, Charter, Cox, and Comcast, together serve more than two-thirds of all cable subscribers.

Historically, one of the cable industry's biggest problems has been a lack of channel capacity (and that may still be the case in isolated communities and in some countries), but construction of optical fiber systems throughout the United States in the 1990s expanded cable's capacity enormously. In addition, the ability to compress video signals so that several can share a wedge of bandwidth has further increased cable's capacity. Big portions of that capacity are being used for pay-per-view, however, and much of the remaining capacity is being reserved for future nontelevision services. *Generally speaking, there are about twice as many cable networks vying to get on cable systems as the systems usually carry.* Therefore, basic and pay cable networks, local origination channels, local access channels, and new data and computer services must compete in an aggressive marketplace for carriage. Moreover, the virtually infinite capacity of the Internet suddenly makes 200 or even 500 channels sound inadequate. Full digitalization of cable, accompanied by high-speed online access, is often referred to as the "thousand channel universe" and is expected to mutate into the "million channel universe" in a decade or so.

Wireless Cable

Another retransmitter operating alongside cable companies is **multichannel multipoint distribution service (MMDS),** commonly called *wireless cable*. MMDS operators broadcast multiple channels of local television and cable networks using microwave frequencies from an antenna located on a tower, tall building, or mountain. Homes, apartments, and hotels receive the signals using a small microwave dish, typically about 16 to 20 inches in size. A set-top converter, identical in function to a cable TV box, has to be located near each TV receiver. MMDS most successfully serves portions of large cities where tall buildings are not too numerous to block the line-of-sight microwave signal.

Wireless cable has superior signal quality when compared to wired cable because the signals are not required to go through miles of cable and multiple stages of signal-degrading amplification. In addition, service interruption is significantly reduced as there is nothing to fail between the transmit facility and the receive site. Modern MMDS transmission equipment using digital technology has proven very reliable; frequency-agile equipment can automatically replace a failed transmitter or receiver within seconds, whereas with cable, a truck usually has to go out to repair cable breaks and replace failed amplifiers. With the recent development of digital video transmission and data transfer capabilities, the expansion of channel capacity, and the inclusion of local broadcast channels, wireless cable offers a competitive alternative to the other two broadband delivery systems.

Shortly after AT&T's startling purchase of Tele-Communications Inc.'s thousands of cable systems, MCI WorldCom and Sprint each purchased a significant number of MMDS operators (altogether, about 60 percent of the total MMDS licenses). These properties allow Sprint to offer two-way communication services to almost 30 million households nationwide. MCI WorldCom's wireless acquisitions allow it to reach more than 50 million U.S. households. Sprint and MCI WorldCom intend to use this spectrum as a "last-mile" connection to homes for the provision of high-speed Internet access (see 8.1 on LMDS developments). Many MMDS operators view apartments as significantly underserved by cable operators and thus a possible source of rapid revenue growth. The lack of mobility inherent in wired networks, however—whether provided by cable operators or telephone companies—suggests that MMDS may become the preferred last-mile technology for terrestrial systems of the twenty-first century.

Satellite Systems

Satellite systems refer to three types of distribution methods: (1) low-power C-band **home satellite dishes (HSD);** (2) medium-power Ku-band **direct-to-home (DTH)** satellite systems, such as

8.1 LOCAL MULTIPOINT DISTRIBUTION SERVICE

Another promising development in the wireless industry was the FCC's creation of **local multipoint distribution service (LMDS)** at the turn of the century. At about 17 times the size of regular MMDS frequency bands, LMDS offers plenty of broadband service potential. Yet, propagational restrictions limit the usability of this high-frequency spectrum: (1) signal attenuation by rain and snow; (2) signal attenuation from blockage by buildings and foliage; (3) the need for highly directional receiving antennas; and (4) a limited transmission radius of five to ten miles. In consequence, LMDS systems are configured in multiple cells within the transmission area, similar to cellular telephone systems. Although LMDS licenses can be used for backhaul services, commercial data transfer, and local loop telephony, their most significant application is for mobile high-speed Internet access.

Asia's STAR TV, the former ALPHASTAR, and PRIMESTAR services; and (3) high-power Ku-band **direct broadcast satellite (DBS)** systems, such as DirecTV and DISH. DirecTV has more than 10 million subscribers, DISH about 4 million, and just over 2 million homes receive HSD signals.

The oldest form of satellite program delivery, HSDs, are still commonplace throughout the United States, especially in rural areas not reached by cable television services. HSDs allow consumers to intercept the signals of various broadcast and cable networks as programs are being transmitted via satellite to affiliates and local cable operators. A number of factors, including the high cost of the home HSD equipment (around $2,000), the large size of the dish (10 to 12 feet in diameter), prohibitory city and county zoning laws, and the scrambling of C-band transmissions by angry program providers, have prevented HSD systems from becoming a realistic national alternative to cable

television for multichannel video program distribution (MVPD).

In the 1980s, a few entrepreneurs turned to the underdeveloped medium-power Ku-band to distribute analog satellite signals directly to consumers, with a cable-in-the-sky approach. These companies (Comsat, United Satellite Communications, Skyband, and Crimson Satellite Associates) tried to create new direct-to-home (DTH) satellite program delivery services that would use a much smaller dish antenna than existing HSDs and provide packages of channels to paying subscribers. The initial two advantages of these DTH systems over HSD systems included less interference from other transmissions and reception on dishes just 3 feet wide. Four factors, however, contributed to the failure of these medium-power DTH services: substantial consumer entry costs of $1,000 to $1,500 for home DTH equipment; occasional signal interference from heavy rain and snow; limited channel capacity of just six to 12 channels; and no access to popular cable programming.

Therefore, until the mid-1990s, the primary competition for incumbent cable systems for MVPD service was the costly and inefficient HSD alternative. Three new factors then changed the satellite system landscape: the creation of direct broadcast satellites (DBS) serving the United States in the late 1980s; the passage of the Cable Television Consumer Protection and Competition Act in 1992; and the establishment of a digital video compression standard (MPEG-1) in 1993.

The International Telecommunications Union (ITU), as the world's ultimate authority over the allocation and allotment of all radio transmission frequencies (including radio, television, microwave, and satellite), allocated the high-power Ku-band for multichannel, nationwide satellite-to-home video programming services in the Western Hemisphere. The FCC considered these services DBSs and assigned licenses to eight applicants in 1989. Of these, only DirecTV and DISH are currently providing DBS service to subscribers. The high-power Ku-band allow DBS subscribers to use dish antennas of just one to two feet in diameter. (The Japanese have already begun broadcasting video

and data using an even higher frequency band, Ka, to antennas the size of half dollars.)

The Cable Act of 1992 guaranteed DBS companies access to cable program networks, and it forbade cable television programmers from discriminating against DBS by refusing to sell services at terms comparable to those received by cable operators. This provision, which was upheld in the Telecommunications Act of 1996, provided DBS companies with the program services they needed to compete with cable, attract investors, and entice subscribers.

The third factor—establishment of a digital video compression standard—was then solved by the engineering community in 1993 when MPEG-1 was chosen as the international standard for compressing video. By using MPEG-1, DBS companies could digitally compress eight analog program channels into the space of one transmission channel, thus greatly increasing the total number of program channels available to consumers. (For example, the FCC originally assigned 27 analog channels to DirecTV for its license; using MPEG-1, DirecTV became able to provide its subscribers with 216 channels of programming.) In 1995, DBS companies upgraded their systems to the improved, broadcast-quality MPEG-2.

Like upper-tier cable, DBS programming is decoded in the subscriber's home using a set-top converter box. The required home equipment usually costs between $99 and $299. Like local cable operators, DirecTV and DISH must negotiate with individual program providers (and normally pay for the right) to retransmit cable and broadcast network signals to their paying subscribers.

The cable industry did not ignore the implementation and growth of these DBS companies. In 1994, Continental Cablevision, intent on establishing its own "headend in the sky" for consumers living in noncabled areas of the United States, was able to enlist the support of five other big cable operators (Comcast, Cox, Newhouse, TCI, and Time Warner) and one satellite manufacturer (GE Americom) to launch a successful medium-power Ku-band DTH satellite service. Named PRIMESTAR it transmitted 12 basic cable

channels from GE Americom's medium-power K-1 satellite to three-foot dish antennas. PRIMESTAR offered far fewer channels than any of the cable operators' own local cable systems, so they believed that their cable subscribers would not be interested in PRIMESTAR as a replacement for cable service.

As DirecTV and DISH began to demonstrate that DBS was a viable service in the mid-1990s, PRIMESTAR decided to change its focus and expand by enhancing its offerings to compete directly with DBS. PRIMESTAR converted its 12-channel analog system to a proprietary Digi-Cypher-1 digitally compressed service, eventually delivering about 160 channels. To differentiate itself from the DBS companies, which require subscribers to purchase the home satellite equipment, as well as pay a monthly fee, PRIMESTAR marketed its service just like a local cable TV service by leasing the equipment and programming packages together for one monthly fee. By 1999, however, citing limited opportunities for growth and financial difficulties, PRIMESTAR sold itself to DirecTV, effectively curtailing the only U.S. medium-power DTH service, as DirecTV converted the former PRIMESTAR subscribers over to its high-power offerings.

Waiting in the wings was BellSouth Corporation, a regional telephone company. Working with PRIMESTAR's former satellite partner, GE Americom, BellSouth developed its own 160-channel DTH service for its 14-million phone customers. Beginning in 2002, this DTH service delivered basic and pay-cable channels along with local television stations. If sufficiently successful, BellSouth expects to expand the service to reach as many as 50 million households with several hundred channels of programming and interactive services.

As with cable subscribers, consumers pay a monthly fee for MMDS or satellite service, paying extra for upper program tiers and premium channels. Survival of these services, especially MMDS and DTH services, will depend on their ability to provide high-speed Internet access. As with cable subscribers, consumers pay a monthly fee for MMDS or satellite service, paying extra for upper program

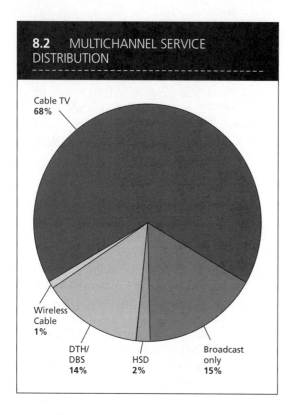

8.2 MULTICHANNEL SERVICE DISTRIBUTION

Cable TV 68%

Wireless Cable 1%

DTH/ DBS 14%

HSD 2%

Broadcast only 15%

tiers and premium channels. Survival of these services, especially MMDS and DTH services, will depend on their ability to provide high-speed Internet access. Out of the 101 million U.S. homes with television, 85 percent are multichannel homes. As 8.2 shows, 68 percent of those have cable, 14 percent have DTH or DBS, 1 percent have wireless cable, and 2 percent have HSD. The remaining 15 percent are over-the-air-only homes reached just by broadcasting.

SELECTION STRATEGIES

The shortage of broadband spectrum has long restricted terrestrial and satellite retransmitters in the kind of programming they can offer. All industries make the case to Congress and the FCC that they cannot provide all the channels of service that are available, let alone additional duplicative broadcast channels (an analog and a digital channel offering

the same programming). At present, some cable and MMDS companies remain particularly disadvantaged by having relatively small capacity compared to satellite operators; meanwhile, satellite and terrestrial services have, until recently, lacked the ability to distribute local broadcast stations. However, the long-term solution is clear to all participants: *rapid transition from analog to complete digitalization of broadcast and cable program providers and retransmitters,* followed by eventual *interoperability.* Digital roll-out is progressing at high speed, and consumer demand is very high.

Three stages relating to spectrum availability affect cable and satellite programming: One is the complete conversion of terrestrial broadcast stations to digital signals; one is conversion of cable systems to retransmit digital broadcast as well as satellite network signals; and one is the step beyond to the interactive services of on-demand video and high-speed Internet access. Although many experts predict conversion to a totally digital on-demand video and information system by about 2010, several conditions create roadblocks that slow the transition. The conditions inhibiting digitalization and conversion to on-demand technologies can be divided into overlapping **technical, legal, economic,** and **marketing conditions** affecting cable and satellite delivery and reception and thus programming strategy. Not all factors inhibit innovation and change, however; some encourage them. Successful programmers juggle all the variables of physical and legal limits, licensing and marketing costs, along with revenue potential, to select the best options for their coverage areas, and the mix of services necessarily varies somewhat from town to town and from one company's footprint to another. At present, the most challenging programming decisions are those arising from the changing nature of new communication technologies.

TECHNICAL PARAMETERS

The precise number of channels (or amount of bandwidth) a system can carry is largely a function of its delivery, compression, and filtering technolo-

gies as well as its flexibility. Because the newest technologies (1 gigahertz) have practically unlimited capacity, cable and satellite systems no longer evaluate capacity by maximum bandwidth capability or by the number of 6 MHz analog channels that can be handled (such as 36 or 120 or 500 channels). Instead, the industry views fiber and amplifier technology in terms of **platforms** or levels of potential capability. A 1 gigahertz platform with appropriate design architecture can be utilized for mixes of analog and digital signals, and the number of functions it performs (and thus services it delivers) can be gradually increased over time. Indeed, the upper levels above 750 MHz are sometimes thought of as "virtual channels," the cable engineering equivalent of "virtual reality." Virtual channels are for streams of digitized information that function as return paths to the cable operator; movement of these digitized streams through a cable (or telephone) system is measured in time and distribution rather than in old-fashioned radio frequencies. The 1 GHz platform is viewed by engineers as practically limitless, but several intervening developments in technology are necessary to fully utilize that capacity. This section on changing technology goes into detail about aspects of **digitalization** (including high-definition, compression, video-on-demand, and fiber optics) and **interoperability** (including addressability, multiplexing, personal communication service, and interactivity).

Digitalization

Digitalization of communications provides tremendous increases in usable bandwidth. It means better quality pictures and, eventually, high-definition television. It means such new interactive services as video-on-demand (VOD) and near-video-on-demand (NVOD). It is likely that in the decades ahead, very few live broadcasts will occur: Eventually, only a few networks will deliver **real-time** sports and breaking news; the rest of television will be **on-demand programming,** operating much the same whether the consumer seeks entertainment or information, and looking the same to the consumer whether the original source was once

called a broadcast, cable, satellite, or online network and whether the programs are watched on the TV set or computer. At present, going digital demands a much more complex infrastructure with expensive technical characteristics that the public will have to pay for.

For cable, the high cost of upgrading systems to all-digital and providing extremely advanced set-top boxes has led the industry to a *phased roll-out* strategy. Cable operators seek to retain as many of their viewers and advertisers as possible and move step by step into digitalization only as economic payback becomes visible. An overnight shift is viewed as impossible because it would involve trashing most existing television sets, and the average consumer owns several sets and VCRs. In consequence, cable operators offer digital signals as an option and slowly introduce more and more capable set-top boxes. Although the theoretical capacity of most cable systems is extremely high, as a practical matter there will be too few channels for all the services that want to get on local systems until digitalization is completed well past 2005. Then, as the Internet becomes part of the television system—and vice versa—subscribers will face the so-called million channel universe.

For satellite companies, digitalization is not an issue. DirecTV and DISH launched their operations as fully digital systems, often touting the quality of their picture and sound in their marketing efforts to consumers. Although each system uses a different digital video compression system, both are able to deliver on their marketing promises. Each piece of equipment, from antennas to set-top boxes, is digital. They are, however, restricted by the number of transmission channels currently licensed to them by the FCC: 46 for DirecTV and 107 for DISH. Using present-day digital compression standards of 12 to 1, DirecTV can transmit more than 500 channels, and DISH can send almost 1,300 to subscribers . . . far more than most cable systems offer. New DBS, DTH, or MMDS systems will also arrive in the marketplace as fully digital systems, limited only by the number of channels allocated to them by the FCC. Currently existing systems of all kinds are converting

to digital transmitters and home receivers, and HSD systems, because they intercept signals, have also evolved technically as cable programmers and broadcast networks have shifted to digital trans-mission to their headends and affiliates.

From the consumer's perspective, digitalization will necessitate the replacement of existing tele-vision sets and VCRs; it will mean a higher pro-portion of discretionary income allotted to subscriber fees; and it will introduce many frustrations as viewers try to select effectively from the million channel universe. Although the cable industry has shifted to the view that *over three-quarters of households will be digital by about 2010, the industry recognizes that not all TV sets will be digital, and the remaining 15 percent of noncable/nonsatellite U.S. households will still require analog signals.* On the VCR front, the public's rapid adoption of digital music and DVD players shows the direction of the near future, but not all home equipment is likely to be readily compatible with subsequent generations of digital set-top boxes. Meanwhile, Hollywood is rushing to play catch-up by digitalizing its enor-mous libraries of old movies and television series.

High-Definition Television

Although **high-definition television (HDTV)** will come to broad audiences eventually, its progress has been slow, in part because emphasis went first to digitalization and interactive programming to access the Internet. HDTV is dependent on special set-top converter boxes and full digitalization at the program provider and retransmitter levels, as well as in the home. Although some of the Big Four broadcast networks were transmitting in versions of HDTV by the turn of the century, and some sta-tions also transmitted programs in HDTV, the bulk of consumers could not access the signals because their cable operators did not deliver the signals in HDTV format. In addition, of course, homeown-ers have to have HDTV sets to take full advantage of the signal, and it seems as if every participant waits for the other participant to do it first.

DirecTV dishes and receivers can handle both the standard compressed NTSC signals from satel-lites and HDTV signals in both **progressive** (scans like computers in 720p HD) and **interlace** (scans like television in 1080i ATSC) **formats.**[2] Indeed, a single satellite receiver can function simultane-ously as a digital television receiver for over-the-air signals and high definition of both kinds (if digitally enabled via a technology like DirecTV PLUS) and provide seamless switching among all channels, accompanied by Dolby Digital surround sound. The flexibility of present-day dishes has great appeal for consumers of high-end equipment, particularly in sports bars and other public places.

Compression

Still another element that has drastically changed how cable, broadcast, and online video operate is **signal compression.** To compress a signal is to re-move redundant information (such as background that does not change for several seconds) and transmit only the changing information. Ad-vanced compression techniques can send between 4 and 12 or more television signals in the 6 MHz bandwidth once required for just one television picture. International telephone and satellite tele-vision signals, as described earlier, have long made use of compression. Video signals on the Internet also utilize compression, and the earliest results were jerky because so much was not transmitted. It is expected that compression rates as high as 20:1 may soon become common with little degra-dation in picture quality.

Video-on-demand

From cable operators' perspective, **video-on-demand (VOD)** is envisioned as a costly change, necessitating the end of analog signals and a com-plete shift to digital transmission and reception. It means realization of the million channel universe, comprising the vast resources of the Internet, as well as all preproduced and recorded video and audio programs, and, less happily, an infinite sup-ply of commercial messages targeted to individual consumer desires. Such a huge change awaits several developments, among them smart set-top boxes and greater standardization of technologies via **open** or **flexible architectures** (infrastructures that can transform any kind of signal into some-

thing the viewer can see and hear). In the meantime, **near-video-on-demand (NVOD)** setups allow local caching of programs so that viewers can watch any of a pool of movies at, say, ten-minute intervals. From the perspective of pay-per-view (PPV) networks and VOD program suppliers, it looks like their dreams are finally coming true.

Fiber Optics

Another element in the conversion to digital systems is **fiber optics.** Cable systems and telephone companies are evolving toward all-fiber communications because of its *much higher capacity* (as much as 1,000 times a comparable thickness of coaxial cable), *better picture quality* (because fewer and different types of amplifiers are required), and *greater reliability* (through redundancy because systems typically use only a portion of capacity and thus have plenty left for backup channels). In most systems, however, fiber installation ends at nodes serving a block or so of homes (**fiber-to-the-node, FTTN**), because installing fiber all the way to individual homes (**fiber-to-the-home, FTTH**) does not appear cost-effective for the foreseeable future. The cable industry claims that most services, including high-speed Internet connection, pay-per-view (PPV), and personal communications services (PCSs), can be adequately provided with FTTN. Users of up-to-date office campuses with fiber all the way, however, commonly notice (and complain about) a significant lessening of speed and reliability at home, compared to their all-fiber offices, dorms, and classrooms, when part of the signal travels via ordinary telephone or cable lines. Whether cable operators or telephone companies will ultimately dominate in bringing high-speed Internet service to tens of millions of homes has been the big money question for the communications industry. One answer appears in the purchase of TCI by AT&T.

Interoperability

What are being constructed nowadays are **broadband** communication systems, not just cable or telephone systems. To take advantage of complex information flows and to seamlessly mix signals coming from many sources, sophisticated digital switching centers that can transfer among signals from computer data, broadcast television, cable television, telephone, banking signals, shopping credit records, fax, and so on are essential to realize the dream of the electronic superhighway. *Interoperability, the ability for two-way video, voice, and data to operate through the same home equipment, however, requires common standards—down to the basics of jacks and plugs—across the entire communications industry.* Widespread adoption of the MPEG-2 standard (the chip language for digital video compression) was one recent step on the way. The next advance from the **Moving Picture Experts Group (MPEG),** the organization in charge of developing standards for compression of video and audio, was MPEG-4 in 1999, the standard for multimedia applications. The quest to bring the consumer the ultimate experience in multimedia entertainment means that the boundaries between the delivery of audio sound (music and spoken word), accompanying artwork (graphics), text (lyrics and printed words), video (visual), and synthetic spaces have become increasingly blurred. New and complex solutions are required to manage the delivery of these different content types in an integrated and harmonized way that is entirely transparent to the consumer of multimedia services. At the same time, different parties have intellectual property rights associated with multimedia content and understandably seek to acquire income from those who make use of their content.

The members of MPEG have thus begun work on a "super-platform," MPEG-21, to encompass all digital media applications. *The scope of MPEG-21 could be described as the integration of two critical technologies: how consumers can search for and obtain content—either personally or through the use of intelligent agents—and how content can be presented for consumption according to usage rights associated with the content.*

Addressability

The technical ability to send customized packages of signals to each home with or without certain

pay channels or a second **tier** or level necessitates two-way service or **addressability.** The operator must be able to address (talk to) the set-top box. Without addressability all channels pass every home (or reach all homes in the case of direct satellite), and pay channels must be **scrambled** (electronically jumbled, requiring a descrambler in subscribing homes) or mechanically **trapped** (defeated at the pole or box) to keep them from entering nonsubscribing homes. Traps can capture only about four channels and must be physically installed and removed with every change in service.

With addressability, in theory, headend computers can add or delete services without sending a technician to the customer's home, can direct different sets of channels to individual homes, and can offer pay-per-view movies and events using impulse ordering (rather than prearrangement by telephone or office visits). Very few cable systems address all subscribers, however; fewer than half of households have **addressable converters**—the much unloved set-top boxes that convert incoming frequencies to an analog channel a television set can handle. Installing addressable converters has big benefits (and some frustrations, see 8.3) for cable and satellite operators because they are outside the FCC's regulations. Operators can charge a monthly rent for the boxes, and their presence encourages consumer use of the unregulated premium services (HBO, Showtime, pay-per-view movies).

Set-top converters are not so advantageous for subscribers, however. Most converters defeat the utility of the television's original remote controls and interact poorly with home video recorders, frustrating subscribers and generating loud complaints. Moreover, subscribers must pay monthly for *each* converter box, raising monthly bills in homes with many television sets (the national average is three and having as many as five or six TV sets and a mix of accompanying VCRs and DVD players is not uncommon). As more digital boxes continue to replace analog boxes, and even incorporate hard drives and other computing functions within them, cable and satellite programmers will face exciting decisions about how to utilize sophisticated capabilities without dis-

8.3 CONVERTER PIRACY

For the cable operators, frustrations lie in signal theft and illegal selling of set-top converters that descramble premium and pay-per-view channels. One cable company president was quoted as saying, "Converters are becoming a cash commodity" and that his company was forced to pay armed guards to protect its warehouses of converter boxes.[3] Pirated converters are often advertised in consumer and electronics magazines for about $350, and the FBI has become involved in seizing illegal converters from independent manufacturers in six states.

Pirated cable signals allegedly cost the industry millions of dollars annually. In addition to grossly illegal practices such as splicing into a neighbor's cable line (thereby degrading the neighbor's picture), some subscribers install fancy electronic chips in their set-top converters, disabling the trapping function to watch unauthorized pay channels. This practice reached such extremes that one cable company "fired an electronic bullet from its headquarters" through all converter boxes in its system that caused illegally installed chips to malfunction. The system urged subscribers with broken converters to bring them in for repair, and then they filed federal suit against several hundred who brought in boxes containing illegal chips.

Whether the next generation of set-top boxes will have sufficient security to defeat piracy is more a question of cost than technology.

rupting service to the many households with only elementary capability.

Nonetheless, *the nation is in a transition period, moving inexorably from limited addressability toward totally addressable digital systems that will eventually require every home to have converters for every set. Some experts expect the conversion to be nearly complete by 2005 (others say 2010). The newest **intelligent boxes** include a cable modem, advanced graphics, greater speed, and a "triple-tuner" archi-

tecture that allow customers to watch television, access the Internet, and talk on the telephone at the same time. Roll-out proceeds in fits and starts because such smart boxes are very expensive, and competing units lack compatibility. The high initial cost of elaborate and sophisticated converter boxes with a million or so circuits delays the implementation of this portion of the electronic highway. Instead, set-top converters evolve and mutate, gaining abilities until they reach the full-service, intelligent two-way platform. Once standardization of the technology is achieved—at some fuzzy date in the future—such converters will probably move inside television sets and DVD recorders, but adoption of such advanced technology will require replacement of all home electronic equipment and thus widespread adoption will be slow in arriving. In the meantime, incorporation of high-definition signals and connections to other digital services must be worked out among industry competitors, further slowing implementation of new services.

Multiplexing

In the mid-1990s, several national cable network programmers began **multiplexing** several channels of entertainment carried by the same signal, which are split into separate channels for subscriber viewing. The premium networks were the first to implement the idea, with HBO delivering three channels of programs and Showtime and Cinemax offering two or three. Three factors inhibited its spread. First, although multiplexed offerings slowed churn, they served more to improve retention than to attract new subscribers to pay channels. Second, the channel capacity crunch, brought on by the need of cable MSOs to find space for newly acquired or created program networks, limited the desirability of multiplexing. Third, the rapid growth of Internet access turned network interest away from separate channels and toward online interactivity. Moreover, from the cable subscriber's perspective, it makes little difference whether hundreds of programs come on different "channels" or from menus under a single brand name (such as

Fox or ESPN, for example). In contrast, on satellite services—because of their greater channel capacity—multiplexing thrives by encouraging such theme clusters as Discovery Health and Discovery People or Encore Hits, Encore Action, Encore Mystery, and so on.

Personal Communication Service

PCS refers to low-power, digital pocket-sized telephones operated by radio connection to the cable headend or other switching center. PCS is expected to become as common as VCRs and fax machines in the coming decade because the units can be very small, totally portable, and convenient. They improve on cellular telephones by having nearby pickups requiring far less power in the user's unit and may soon replace much of today's wired and cellular telephone service. PCS is important to the cable industry because its existing copper and fiber optic infrastructures could be the return system from millions of PCS cells.

PCS is also important to the MMDS industry because it represents a second stream of revenue and an operational synergy. One-way video delivery over MMDS never caught on, and the spectrum largely lay fallow until the FCC allowed two-way digital signals on this band. MMDS's rejuvenation resulted from separate decisions by both Sprint Corp. and MCI WorldCom Inc. to spend more than $1 billion each for existing MMDS licenses in the late 1990s. What provoked such big expenditures? The answer lies in the hidden possibilities of wireless cable. Although MMDS operations are legally authorized to cover up to 35 miles with a single tower, the telephone companies recognized that they could build low-power MMDS transmitters within a few miles of each other, "cellularizing" the coverage area in order to boost carriage capacity. In such a configuration, MMDS became a perfect fit for Sprint, for example, which already had multiple PCS towers covering small cells. The same towers can be reused for wireless cable programming and cellular phone service, thus creating a strong synergy between Sprint PCS and MMDS operations.

Interactivity

On the programming side, program guides, home shopping, and games have been pushing the cable industry toward implementation of secure interactivity. As digitalization and high-speed Internet access arrive nationwide, it is expected that all kinds of programs—from education to cooking to comedies—may eventually avail themselves of the ability to ask viewers to respond in real time. Interactivity will rapidly revolutionize information gathering about audiences and methods of calculating audience size; it will alter the revenues available to cable and satellite companies, and interactivity will alter program content in many ways. For example, with some interactive setups, viewers can tune in to a live sporting event, then choose their own camera angles, select the most recent statistics, or purchase their player jerseys— all by clicking a remote. Imagine watching a favorite popular television show, then instantly ordering the soundtrack or a particular star's dress or sweatshirt. Viewers can even play along with a popular game show or do banking and pay bills without getting up from their living-room chairs —all by clicking a remote.

Such interactive options are already available from a number of cable and satellite operations, such as DISH in the United States; British Sky Broadcasting (BskyB) in the United Kingdom; TPS and Cable Lyonnaise in France; PrimaCom in Germany; Via Digital in Spain; and Galaxy Latin America, the exclusive provider of DirecTV in Latin America. Such operations use OpenTV set-top box software from Sun Microsystems, which enables digital interactive television. OpenTV software has been installed in more than six million set-top boxes worldwide, and it was recently made available by Motorola in the United States.

LEGAL REQUIREMENTS

On the legal side, multichannel operators must adhere to federal law, state law, and municipal agreements. Several long-established policies promulgated by Congress, enforced by the FCC,

and upheld by the courts affect programmers. These policies can be grouped as **universal access** (including the hot topics of must-carry and retransmission consent). At the same time, many **corporate policies** (and associated legal requirements about franchises, syndex, and antennas) go counter to Congress's avowed intentions.

Universal Access

One Congressional policy is the goal of equality for rural and urban users. This goal has a century of tradition in government regulations encouraging and then demanding access to utility and telephone services for all citizens, and it drives many policy decisions regarding television and the Internet. *Above all, communication technologies are viewed as essential to the proper operation of a democracy, for both their informational and their educational capacities.* Thus, **access** for all the public, irrespective of household income or geographic location, is a policy goal. For several decades, requiring the delivery of terrestrial radio and television broadcast signals to all homes was seen as the main method of implementing that goal. Traditionally, Congress viewed cable and satellite services as secondary to broadcast service, though the courts tended to equalize their value. Since 1996, access for all to the Internet has been a goal, but implementation lags behind policy, largely because imposing regulations on the Internet early in its development was widely seen as inhibiting innovation and speedy growth.

Must Carry

The most contentious regulatory issue of the 1990s carrying well into the early twenty-first century is the required carriage of signals. The issue of **must carry** divides the program providers (networks) from the retransmitters (local cable systems) and even more vociferously divides local broadcasters from multichannel operators. Initially, the must-carry question was whether cable operators would be required to carry all local broadcast signals. Without a legal requirement forcing cable systems to carry all local broadcast

stations, cable operators could exclude some stations from easy access to cable viewers because the installation of cable connections usually means over-the-air antennas are disconnected. Cable operators can be expected to be desirous of carrying highly watched network affiliates of ABC, CBS, NBC, Fox, UPN, and WB, but less desirous of carrying small-audience religious, Spanish-language, and shopping affiliates and independents. Shopping channels, for example, may compete for viewers with channels owned by the cable operator or ones with which the operator has a favorable financial arrangement. Any broadcaster who was excluded from cable systems would be at great threat financially because of the loss of audience reach. Congress decided cable "must."

Next, the question shifted to whether satellite services had to carry local broadcast signals. Would DBS have to provide retransmission of all local stations (called **local-into-local service**), eating up considerable bandwidth and necessitating high scrambling costs because their footprints overlapped many markets? On the one hand, direct broadcasters have long sought the lifting of prohibitions against carrying *any* terrestrial broadcast stations; on the other hand, being required to carry *all* stations, irrespective of content is, they say, unworkable. Although a DBS company now has the option of providing local-into-local service, it is not required to do so, but DirecTV and DISH rapidly began supplying local broadcast signals to about half their markets. Nonetheless, they complain that forced carriage of *all* broadcast stations—even low-power signals or stations that are essentially shopping services—eats up a disproportionate amount of its capacity. Even with sufficient capacity, hypothetically, satellite operators offering affiliates of all nine broadcast networks plus a PBS station to all 211 markets would require them to catch more than 2,110 signals, scramble them, and then selectively unscramble ten for each market. Of necessity, satellite operators charge subscribers for local affiliate signals.

Then, after the turn of the century, the contentious issue shifted again. Although federal law requires broadcast stations to shift from analog to digital signals, as long as a significant portion of the public can receive only analog signals, broadcasters must (for economic as well as political reasons) distribute both kinds of signals. Most multichannel operators, however, find it more profitable to increase their channel capacity very gradually, thus they say they lack the ability to provide two signals for every broadcast station (along with a wide range of digital cable networks). Cable and satellite operators also say they lack the spectrum. At the same time, the broadcasters argue that their enormous financial investment will be squandered without **digital must carry.** They also claim that many stations will be driven out of business if they are forced to give back their analog channel before the public moves totally to digital. Until that is accomplished (if ever), broadcasters want to have both their analog and digital signals delivered to homes via cable or telephone video carriers. It must be remembered that two-thirds of homes get television only via cable and another 17 percent from satellite and microwave services, but 15 percent of homes continue to depend on over-the-air signals.

One outcome of digital must carry is the threat to program suppliers. New cable networks (**wannabes** in industry slang) are placed at high risk by the slow pace of cable spectrum expansion, which makes little space for new content services. If cable operators must give space to two broadcast signals for every local station, the spectrum crunch becomes further exacerbated, leaving even less room for new content services. Some older cable services are also at risk: C-Span I and II, the not-for-profit channels that provide congressional and public affairs coverage, were cut from many cable systems in the early 1990s as a result of expanded analog must-carry regulations, and they had not recovered their previous reach a decade later.

Retransmission Consent

In 1992 Congress allowed local television stations to choose between being carried free of charge by cable and satellite systems or negotiating with the systems for some compensation for carrying their signals (**retransmission consent**). After some years

in the courts, the law was upheld, and stations had to give permission for carriage, which most promptly did. In order to deliver local-into-local service, the Satellite Home Viewer Improvement Act of 1999 required DBS companies also to seek retransmission consent agreements with television stations, essentially treating all multichannel suppliers alike. Initially, the broadcast networks exchanged their **owned-and-operated** stations' retransmission rights for cable carriage of such cable channels as MSNBC and ESPN II. By 2000, however, Disney and Fox were aggressively seeking leverage against such major cable MSOs as Cox and Time Warner. Their tactics included requesting more favorable channel placement (lower) on systems for Disney or Fox-owned channels, shifting The Disney Channel on recalcitrant cable systems from pay to basic, or the payment of relatively high monthly per-subscriber fees. To date no cable system has ever paid a broadcaster for rights to its signal, but thousands of eyes watch for the first cable system to cave in.

Corporate Policies

In addition, the policies of the parent corporation may impose restrictions on what a local system can and cannot carry. Some multiple system operators (MSOs), for example, have policies freezing out adult programming; a few have policies favoring access channels. MSOs often sign agreements with program suppliers, the net effect of which is to compel carriage of a particular satellite network on all their systems irrespective of whether it might be the best choice for each market. The cable network naturally wants the largest possible audience and can offer discounts to encourage wide carriage.

Franchises

Every cable system must win a **franchise** (a contract) to operate in the local geographic area from municipal government, generally accomplished by paying a small percentage of revenues into local government coffers. This is called the **franchise fee,** and cable subscribers see it listed on their

monthly bills. Local government justifies charging operators a fee because they are making commercial use of local infrastructure (streets, poles, trees) that belong to the whole community. In retaliation, cable operators list the franchise fee on the bill (typically about 5 percent of the subscriber's monthly statement). Local franchise agreements typically specify that **public, educational, and government access channels (PEG)** and all local broadcast stations reaching the area must be carried.[4] In smaller markets with small capacity systems, carriage for at least one affiliate of each of the major networks (as well as local independents and public stations) is usually what a franchise specifies. Periodic refranchising of local cable operators is a hangover from a previous era, lingering as a momentary hurdle for each cable company every ten years or so. With Congress's acquiescence, local communities have lost the ability to solicit competing applications for a franchise unless they can legally prove inadequate service— a very difficult thing to demonstrate to a court's satisfaction. So cable operators get automatic renewal, while local authorities must strain to negotiate for improvements. However, the probability of the eventual merger of most cable and telephone companies (and even direct-to-home broadcasters) makes refranchising merely a short-term concern. Neither telephone companies nor direct broadcasters are as yet required by law to have franchises.

Syndex

Another area of federal concern has to do with exclusive rights to show syndicated programs. Federal regulations now enforce the **syndicated exclusivity (syndex)** rule, requiring cable operators (but not satellite operators) to black out syndicated programs on *imported* signals (distant stations or satellite networks) if a local station possesses exclusive rights to the program. For example, if both WGN, the Chicago superstation, and a local independent carry rerun episodes of *Roseanne,* and the local station has stipulated exclusivity in its contract with the syndicator (usually for a stiff price), the superstation must be blacked out or covered up with another show in the franchise

area when *Roseanne* is on. Because most local cable systems lack the insertion equipment to cover up one program with another, such superstations as KTLA, WPIX, and WGN have tried to make themselves "syndex proof" by scheduling only original programming or paying for exclusive national rights to syndicated shows. The most valued of syndicated programs are sporting events, because they involve original programming, huge audiences, and big advertising revenue, but the cost for exclusive national cable rights is usually very high.

Antennas

Another bone of contention has to do with regulations about antennas. The FCC's Over-the-Air Reception Devices Rule removes the ability of local governments and property owners to restrict subscribers' ability to receive video programming signals from television stations, wireless cable providers, and DBS systems. The rule prohibits most restrictions that (a) unreasonably delay or prevent installation, (b) unreasonably increase the cost of installation, or (c) preclude reception of an acceptable quality signal. The rule applies to viewers who place video antennas on property they own, including condominium owners and cooperative owners who have an area for their exclusive use (such as a balcony or patio) in which to install the antenna. The rule applies to townhomes and manufactured homes, as well as single family homes, and in essence, greatly increases the number of potential customers for wireless cable and DBS service.

On the legal side, then, federal regulations have generally freed cable and satellite operators to program as they wish, but local franchise agreements and MSO policies place some short-term limits on what can be scheduled on a channel. Once the cable operator has signed a franchise agreement that specifies particular types of services, the cable programmer must place those services on the system before calculating the amount of channel space (or bandwidth) and locations available for other services. For satellite services, regulations have been instrumental in leveling the playing field with cable by eliminating most of the restrictions concerning program access and service availability.

ECONOMIC CONSIDERATIONS

Nearly every aspect of the cable and satellite business involves cost expenditure as well as potential income. *In deciding whether to carry a new channel, operators calculate whether the revenue will outweigh the expenses.* **Revenues** come from monthly subscriber fees, advertising time purchases, and promotional support; **expenses** include the cost of carrying and installing the program services, paying for copyright, and paying for churn. Understanding the basic economics of cable involves knowing who pays who.

Most cable networks require each local cable or satellite operator to pay monthly fees, calculated per-subscriber-per-month for the program service. A very few cable networks come without charge to redistributors (especially brand new or highly specialized services), and a few actually pay the systems for carriage (mostly shopping and foreign-language channels or short-term arrangements by new services). Univision, for example, pays cable operators a small amount per Spanish-surname subscriber (rates vary with the quarter of the year), and Fox paid operators for one year to add Fox Sports to their systems. Shopping services usually pay local cable operators a small percentage of sales as a carriage incentive and may operate as a **barter** network on an exchange-for-time basis, similar to the barter programs discussed in Chapter 3. A distributor, such as Home Shopping Network, presells most advertising spots, although a few local avails may be included as an enticement to carry the channel. Nonetheless, most cable operators pay out hundreds of thousands of dollars each month for the cable networks they carry.

Premium cable networks have a different licensing pattern: The local cable or satellite operator gets about 50 percent (sometimes only 40 percent) of the fee paid by subscribers. This fee-splitting arrangement explains why operators are so anxious for their subscribers to upgrade. One increasingly successful method of gaining shelf space is to offer **equity holdings** (partnership) to cable MSOs and DBS companies. Operators are

then motivated to place the service advantageously on the system because they benefit from its success.

Revenues

Cable operators make money by selling subscriptions and local advertising, whereas satellite companies have only subscription revenues. Fees for minimum service on cable have been kept very low by federal mandate, and **basic service** (the lowest level) usually includes only the over-the-air channels (i.e., retransmissions of local broadcast stations) and local access channels. Typically, additional channels are divided into tiers of programming, and for a subscriber fee, the next tier is provided; for an additional fee, the next tier is provided, and so on. On some systems, it is necessary to add tiers in a certain sequence, omitting none of the lower tiers; on other systems, the additions to basic are more flexible. Finally, virtually all cable and satellite operators provide one or more pay channels (HBO and other pay networks) for an additional monthly per-channel fee, and the larger systems also offer pay-per-view, where the subscriber pays whenever part of the programming is watched.

Cable and satellite operators look two ways for growth in revenues. Because there has been little growth in new cable subscribers for more than a decade, *the two directions for increasing revenues are global expansion into other countries and new interactive services—in particular, high-speed access to the Internet.* In America, new interactive digital services for individuals linked to the web are expected to be the "killer applications" of the next decade.

Advertising

On the positive side, programming costs can be offset in the case of the most popular cable networks because the local operator can sell up to two minutes of spot time per hour (local **avails**) on the most popular channels. Local advertising has become an increasing source of revenue as more and more cable systems join with other systems in a geographic region to distribute advertising messages. Ads are usually purchased only on

such channels as ESPN, CNN, MTV, Nickelodeon, TNN, TNT, and USA Network. (Satellite and wireless cable operators presently lack this option, but as audience size increases, the potential for carriage of local advertising increases.)

Offering spots for local sale is a major bargaining point for cable networks when renegotiating contracts with local cable systems. These spots are, for the most part, deducted from program time rather than network advertising time, so they cost the network little. There is, of course, a practical limit to how much a program can be shortened to allow for advertising. Moreover, advertising spots that cannot be sold (such as spots in less popular programs or in lightly viewed time periods) offer little advantage to a local system.

Promotional Assistance

When cable and satellite programmers are deciding which networks to carry, they also consider how much **promotional support** is provided. On-air promotion as well as print advertising and merchandising are especially valuable for gaining new subscribers, reducing churn, and creating positive images in the minds of current and potential subscribers and advertisers. National networks can supply professional-quality consumer marketing and sales materials, including on-air spots, information kits, direct mailers, bill stuffers, program guides, and other material that the local system lacks the resources to create. In other words, some fees paid to national cable program suppliers are, in effect, returned in the form of advertising avails, co-op advertising funds, or prepaid ads in *TV Guide* and other publications that attract audiences to local cable systems and satellite companies. Major program suppliers also maintain elaborate web sites about key programs, another factor in audience retention.

Expenses

The most powerful factor affecting carriage of most programming is cost to the local system. Operators expend between $3,000 and $6,000 to install a new cable channel, and marketing it adds

another $1 or so cost per subscriber, resulting in a price tag of tens of thousands of dollars in mid-sized and large systems. Cost is directly affected by whether the cable network is advertiser- or sub-scriber-supported, whether the MSO or satellite company owns part of the service, and which additional incentives the service offers the operator. The cable industry is consolidating very rapidly because larger companies can negotiate lower per-subscriber prices for program network. If an operator controls a subscriber base of five or ten million homes—whether terrestrial or satellite—it has considerable leverage with program suppliers in negotiating monthly fees.

The FCC has estimated that, as of 2000, cable and satellite operators collectively were paying $6.1 billion annually to cable networks. The fees per cable network vary from as little as a nickel per subscriber per month to more than $1.50 per subscriber per month, charged by the most popular and profitable of all cable services, ESPN. The fees paid to cable networks become a sizable monthly outlay for a system carrying 50 or more advertiser-supported networks to 10,000 or 20,000 subscribers, as the following equation shows:

$0.10 × 10,000 × 50 services = $50,000 monthly
 cost for 50
 networks

Network contracts often specify even larger fees if the network is placed on an upper tier, it being assumed that fewer people will subscribe to an upper tier or package of channels. To date, no operators have been forced to pay directly for retransmitting terrestrial broadcast signals, but when that day comes, it will alter the economics of the lowest level of service.

Compulsory Copyright

In addition, all cable and satellite systems pay **copyright royalty fees** based on a variable fee schedule, with a base compulsory license fee and then additional fees, ranging from about 15 to 19 cents per subscriber per month, for each distant station or network signal. These added fees particularly raise the cost of carrying superstations:

WGN, KTLA, WPIX, WWOR, and others. These funds are returned, proportionately in theory, to the holders of copyrights, such as the holders of rights for sporting events, music, movies, domestic and foreign television programs, and so on; from the operator's perspective, they are an additional expense.

Audience Churn

Another big problem is audience **churn** or turn-over. Subscribers who disconnect, even if they are replaced, cost the system in hookup time, administrative record changes, equipment loss, and duplicated marketing effort. Cancellation rates of 20 percent or more were common in the 1980s, but cable or another retransmitting service has become a necessity to viewers in communities with poor over-the-air reception. The **churn rate** for any local system or DBS service can be calculated for a year, or any length of time, by dividing the number of disconnections by the number of new connections; all systems keep careful track of their churn.

$$\frac{\text{Disconnects}}{\text{New connects}} \times 100 = \% \text{ churn}$$

For example, a system with 200 disconnects, which added 500 new subscribers, has a 40 percent churn rate. Annual rates higher than 30 percent usually presage financial disaster. Not all cancellations can be prevented, of course, because people move, children grow up and leave home, and local economic recessions cause unemployment and cutbacks on services. College towns normally have lots of cable cancellations at the end of spring semester and lots of new connections in the fall, but minimizing avoidable audience churn is one of the primary responsibilities a service's programming and marketing executives share.

Turnover on premium channels occurs more frequently than with the basic service. The solution has been to institute hefty charges for disconnecting single channels, and those fees have defeated the practice of **substitution,** in which subscribers casually dropped one pay channel to try out another. Operators seek instead to get

subscribers to **upgrade,** to add to their total pro-
gram package. Nonetheless, several pay channels,
such as American Movie Classics, Galavision, and
Disney have devolved from pay to basic services,
and the shaky status of other premium services has
motivated mergers, combined marketing efforts by
HBO and Showtime—once active competitors—
and, finally, probably will result in the disappear-
ance of stand-alone **premium** services. Indeed, pay
cable will rapidly mutate into VOD, and a stan-
dardized pay-per-use system for most computer-
telephone services will be the eventual outcome
of the new digital technologies.

MARKETING FACTORS

After technical limits, legal requirements, and
economic considerations have been evaluated, the
cable programmer weighs a series of marketing
considerations in deciding whether to carry a par-
ticular network and how to position and promote
it. *Cable programmers seek to attract and hold both
the local audience and the local advertiser. To achieve
these goals, they must maximize new subscriptions and
minimize disconnections.* The nature of the local
audience determines what has particular appeal.
National research has established that the cable
audience is younger and made up of larger families
than the noncable audience, but in particular
markets, cable subscribers may differ dramatically
from national norms. One cable system may have
more mid-aged, upscale, urban subscribers with
higher than average income, for example, while
another may have many more large families of
mixed-age members. The upscale households might
want documentaries and sporting events, while
the families might want "G" and "PG" movies
and science programs. Program services have to
be chosen so that every subscriber has several
channels that especially appeal.

Broad and Niche Programming

Cable networks vary on a continuum between
sharply defined **narrowcast services** and those

with **broad-based appeal.** A religious network, for
example, carries a relatively narrow type of content
and appeals to a relatively narrow (defined demo-
graphically) audience. In contrast, TBS Super-
station carries almost as wide a range of programs
as a broadcast network and tries to appeal to all
ages and all lifestyles with a varied mix of pro-
gramming. Networks that carry only a single type
of program, such as The Food Channel or The
Golf Channel, are called **theme networks,** and
they embody narrowcasting in its simplest form.

Defining cable program services is usually not
simple, however, because two intertwined elements
must be separated—the *content* and the *target audi-
ence.* Content may be chosen from a restricted
genre pool or may represent a range of types and
formats; the service may appeal to either the mass
audience or a limited subset of viewers. Four possi-
ble combinations of program content and audi-
ence appeal are shown in 8.4. In one case, MTV
combines a restricted range of content (rock-
related videos, games, and talk) with a narrowly
defined audience (appealing to teens and young
adults). In contrast, USA Network's content ranges
from soaps to sports to sitcoms to movies and
news, and it appeals to the broadest mass audience
by dayparting much as broadcast networks do.

In a third conceptual model, Nickelodeon/-
Syndicated programs a broad range of content,
including off-network fare, movies, cartoons, and
original children's programs, but the service ap-
peals mostly to children and their families. Simi-
larly, Univision carries every kind of program, but
it appeals primarily to Spanish-speaking house-
holds. Lifetime schedules a wide range of health
and exercise programs along with movies and se-
ries, but it appeals almost exclusively to women
(half the total audience, of course). Similarly,
ESPN carries only sports-related programs but
appeals to at least half the population.

In a fourth conceptual model, a narrowly
defined type of content may appeal to a wide audi-
ence. The Weather Channel carries only weather-
related programming, but like CNN and several
other narrowcast services, it may be useful to vir-
tually all households for a few minutes weekly. In

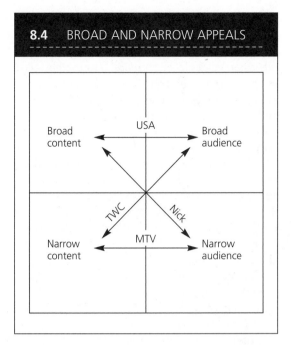

8.4 BROAD AND NARROW APPEALS

Broad content — USA — Broad audience

TWC — MTV — Nick

Narrow content — Narrow audience

other words, this theme network has broad demographic appeal.

Network concept, then, becomes one more element in the programming mix. As many as two dozen networks are clearly established in the public's mind (**branded**), but the programmer must gamble that new cable networks selected for a cable or satellite system (1) will survive to provide programming for a reasonable length of time and (2) will project clear and marketable images to subscribers and advertisers. In addition, the array of programming should reflect **channel balance.** There should be something for all members of all types of households, including family programming, arts and culture, documentaries and science, news and sports, old and recent movies, and so on.

Channel Lift

Some services of particular appeal are considered to have **lift** in that they will attract subscriptions to higher tiers or premium services. Game channels have this impact for households with children aged 10 to 15 years. Lift diminishes as systems add

more and more services, however, leading to **discounting** and **bundling** of services mixing high and lesser appeal in upper-tier packages. Cultural channels are often marketed more for their balancing effect than for any lift they create, and public affairs channels, classified advertising listings, and community access services are carried because they create a positive image for the cable system. One year, HBO intensely promoted its successful series *The Sopranos,* hoping for lift, but found that the expensive marketing effort only temporarily doubled subscribers, and that after a month, most new subs had canceled the service. A further strategy, adopted by the entire industry, has been to locate adult programming only on pay tiers, which makes good economic and political sense because so many people are willing to pay extra for adult fare.

SCHEDULING STRATEGIES

The aforementioned can be considered the technical, legal, economic, and marketing factors that impact the selection strategies of cable and satellite programmers. *Scheduling* on cable and satellite systems has a special meaning in addition to its usual sense of placing programs in an orderly flow. At present, it also refers to locating whole channels of programs on the lineup or digital displays of home television tuners. The channels have to be placed so they meet federal regulations and limits on the technology while maximizing revenue and marketability.

Lineups

Cable and satellite operators normally follow **channel matching** for the three or four nearest VHF network affiliates; in other words, they place them on the same channels on which they broadcast, although they are not required by federal law to do so. Independent broadcast stations, public stations, and imported distant stations are less fortunate, because their channel numbers may be occupied by a local station or, more likely, by a basic or pay service of more direct value to the operator.

For example, superstation WGN, licensed as Channel 9 in Chicago, appears all over the lineup on cable systems outside its secondary Chicago coverage area (and on DBS systems), in part because the number 9 channel may be occupied by other Channel 9 broadcasters, in part because programmers locate popular superstations higher in the lineup to encourage sampling of adjacent channels. Local access channels, which are always part of the lowest level of cable service, can be positioned at virtually any point in the array. And channels in the basic level of service need not be physically adjacent in the frequencies, forcing basic-only subscribers to pass over scrambled and seemingly blank channels to reach all they can view. The **repositioning** of local broadcast stations from the traditional VHF numbers to higher numbers (20s, 40s, and up) threatens station revenues by reducing audience sampling, but it has advantages for cable and satellite programmers in that it encourages subscribers to examine the higher channel numbers.

Clusters

Cable and satellite programmers practice **clustering** (grouping) channels according to their content or appeal on the upper levels of service. Channels can be grouped according to whether they are (1) all alike in content, such as all news or all sports, or (2) all alike in appeals to a particular target demographic group, such as children who watch channels with reruns and cartoons, or (3) have something for every member of the family in a tier or cluster (for which a fee is charged). A cluster might consist of a news channel, a sports channel, a music channel, a movie channel, a superstation, and so on. What defeats effective clustering concepts for cable systems are short-term marketing needs and lack of channel capacity, because to be effective networks in a cluster need to be adjacent on the channel numbering scheme used by present-day remote controls. Electronic program guides can make efficient use of clusters, irrespective of the position of a particular channel in the string of channel numbers. Guides can list all the sports or all the movie channels together, even if the channels carrying the sports (or movies) are scattered on the tuner. Wireless and satellite systems usually employ **thematic clustering** in electronic television guides in such groups, for example, as entertainment and arts, news and information, premium movies, premium sports, adult, music, and pay-per-view. Interactive guides allow subscribers to pick a cluster and view the schedule for just those channels.

As fiber enormously expands capacity and the number of networks and stations carried triples and quadruples, operators are expected to go to menu- or topic-driven systems like Internet portals use. They make channel numbers (and therefore lineup concepts) irrelevant (see 8.5). Just as all channels coming through a VCR are converted to Channel 3 or auxiliary inputs on the TV set, so in the future might digital television sets have only a single "channel" and receive all input from a converter box. Thus, one imminent change is the loss of the idea of *channels*. Digitalization will eventually permit consumers to select the video, audio, and text they want from the full array available without concern for the source of the programming. When Internet convergence and VOD are fully implemented, viewers have individual web agents that they program with their own likes and dislikes. All programs will be nominally available without distinction between sources, and channel placement will be irrelevant. Clustering will then remain important only as a way of scanning options on-screen.

EVALUATION STRATEGIES

Multichannel services have two evaluation concerns: evaluation of audience size and evaluation of program popularity. These result in very different practices, unique to cable because wireless and satellite systems do not carry local advertising.

Audience Size

Evaluation of cable audiences has been a longtime problem. *The overriding difficulty is that cable*

8.5 UNIFORM LINEUPS

Even within a single Nielsen DMA, having the most popular advertising-supported services on the same channel numbers on all cable systems makes selling advertising easier. Standardization within a market is called a **common channel lineup** to distinguish it from the ideal of consistent positions for services from market to market across the country (called a **universal channel lineup**). Nationwide standardization of channel positions has the particular advantage of making national on-air promotion more effective. The goal of a uniform channel lineup, even for the dozen most popular services, is a long way from realization. The Los Angeles DMA was the first major market in which several cable operators agreed on a common channel array, and in the late 1980s newly constructed systems (new-builds) in Philadelphia and New York adopted uniform channel configurations. The pattern adopted in Los Angeles, however, does not match the one adopted in New York. Moreover, technical considerations limit realization of such plans in many markets with long-established systems.

The real point is that as cable becomes a software-driven system, more like the Internet than like present-day cable TV, then channel *numbers* will become irrelevant, and it will be standardization among menus and search systems that will be the goal. Uniformity makes sense for viewers, cable networks, and cable systems.

program audience shares cannot be compared directly with over-the-air audience shares. As explained in Chapter 2, cable reaches only two-thirds of the homes reached by broadcast television, and each individual channel attracts only a portion of the people watching cable. Typical cable network ratings range from 1 to 2 percent of total TV households rather than the 8 to 10 percent that local broadcast affiliates typically attract. During the height of interest in the Oklahoma City bombing or the O. J. Simpson trial, CNN's ratings reached 12s and 14s, but without disasters or extraordinary events, CNN (and other popular cable networks) usually attract fewer than 2 percent of viewers—and that means 2 percent of the approximately 68,000,000 cable homes, not 2 percent of the more than 101 million broadcast TV households.

Advertisers had little interest in such small numbers of viewers until the cable industry came up with four strategies for increasing the number of people reached simultaneously or making them more salable to advertisers. The first strategy has to do with geographic coverage in portions of a state. Because the geographic area covered by an individual cable franchise is far smaller than the coverage areas of a single broadcast station, the cable industry now links franchises over a wide area (like the center of a state) by microwave or cable to create large **interconnects.** Advertising interconnects are arrangements for simultaneously showing commercials on selected channels. Of course, each operator must purchase expensive insertion equipment for each channel that will have local advertising added. (The ads usually cover up promotional spots sent by the network, and how many and which ones can be covered by local spots is specified in cable network contracts with local cable operators.) Interconnects generally occur in or near large markets, however, leaving thousands of cable systems with unsalable (too small and undefined) audience sizes.

A related strategy is **zoning,** which refers to subdividing an interconnect into tiny geographic areas to deliver advertising, which permits small local businesses to purchase low-cost ads that reach only their neighborhood. A dry cleaner, for example, hardly wants to pay to reach the other side of town where the competition operates but might find two or three zones on its side of town ideal for reaching potential customers.

A third strategy is **roadblocking,** scheduling the same ad on all cable channels at the same time so that the advertiser's message blankets the time period. This can be done nationally by buying the same minutes of time on all major cable networks or handled locally in one market by

inserting the same ad simultaneously on all channels in an interconnect.

A fourth strategy has been to develop criteria other than ratings for wooing advertisers. Cable sales executives generally emphasize the **homogeneity** of viewers of a particular channel, meaning their demographic (age, gender) and psychographic (lifestyle, income) similarity. Viewers of MTV, for example, are alike in age and interests; weekday viewers of Lifetime are mostly women; viewers of The Ski Channel share a common winter activity.

Repetition and Ratings

On the programming side, **program repetition** is another strategy used to increase audience size. Sales executives for cable television will report how many people saw a program *in all its airings*, rather than how many saw it on, say, Tuesday night at 9 P.M., the usual way that broadcast ratings are calculated. *For cable, the size of the cumulative audience is often more salable than the audience for a single time period.*

To deal with advertisers' perception that cable ratings are too low, some cable operators have begun to collect their own data using set-top converter boxes. Garden State Cable TV, a system covering a Philadelphia suburb in the state of New Jersey, uses converter boxes in more than half of its 200,000-subscriber base to collect television ratings data. Older analog set-tops from both General Instruments and Scientific-Atlanta already have some capacity to monitor and take "snapshots" of what channel a TV set is tuned to, a feature typically used in relation to PPV. This information can be utilized to convince local advertisers that sufficient numbers of viewers are tuned to specific channels at some hours.

LOCAL ORIGINATION ON CABLE

At the local level, cable programming means several very different things, with no counterpart on wireless or satellite systems. On one hand, local cable refers to the programming activities of the nearly 12,000 **operators of cable systems.** They may produce their own local channels of information or entertainment supported by advertising. On the other hand, **broadcasters** also make use of some cable-only channels nowadays, filling them with local programming. Much of this programming did not *originate* for cable, however; it is broadcast material being retransmitted—creating a second kind of "local cable." Finally, local cable also refers to the programming activities of several thousand not-for-profit **community access groups** over the cable, the third major category of local cable-only programming. It is the most truly local of all and has flourished in some cities for more than two decades. The Internet, however, is rapidly altering and supplanting this kind of local cable programming.

The first kind of local cable programming— channels provided by cable operators themselves —are normally commercial and intended to supplement a system's profits. When they run local channels—an increasingly rare phenomenon, cable programmers select, schedule, and market an appealing array of programs that carry advertising. Additional revenue streams may come from new commercial services. Just as is true of communications technology nationwide, however, the central characteristic of local cable programming is **convergence.** The sharp distinctions between the sources of programs are breaking down. Over-the-air broadcasters are producing for cable; newspapers are producing for cable; cable is sharing with broadcast stations and with newspapers. Even a telephone giant, Ameritech, has moved into cable system ownership to provide video dialtone service. And access services are beginning to join with schools, hospitals, and other community organizations to cablecast wider mixes of programming. What ties these very different services together—and makes them different from the cable networks discussed in the next chapter—is their predominantly local nature. Wherever their programs come from, their appeal and reach (and means of support) are to the nearby geographic area. The size of that area is growing,

however, to whole regions or states (and sometimes leapfrogging national distribution, becoming "local" in other countries). Although Internet connections have created "virtual" communities of widely scattered people with shared interests, the bulk of email, social service communications, and sales messages via computer appear within small, contiguous geographic areas.

Local cable channels consist primarily of (1) entertainment mixed with infomercials and classified advertising channels or (2) news and sports. When produced and controlled by the cable operator, such channels are called **local origination (LO)** channels, although the *news* channels tend to cover such wide areas that they are referred to as **regional cable.** Local and regional cable-only channels have the long-term benefit of differentiating cable from competing wireless and direct broadcast services and the short-term benefit of generating advertising revenue.

Entertainment Channels

Around the country, a modest percentage of cable systems operate entertainment-oriented cable channels for the purpose of selling advertising. Local ads can appear as crawls across the bottom of a screen, which works well with live programming, or as spot advertising obtained from local or regional advertisers or through an interconnect. About one-third of local cable channels are operated by religious broadcasters, and they typically mix syndicated programs with local and nationally distributed religious programming, including gospel music, discussions of gospels, sermons, and religiously oriented talk. In addition, a few foreign-language cable channels usually have a full spectrum of news, entertainment, and talk in one non-English language.

The remaining local origination channels around the country are mostly either like the news channels described next or are programmed like independent television stations. They can carry nationally syndicated series or movies—very old ones, because they are licensed cheaply as a result of the relatively small cable audiences (compared to broadcast stations). Such programs may be

8.6 TOLEDO'S LOCAL ORIGINATION CHANNEL

Because Toledo has only five local broadcast stations, TV5 has been able to become the WB affiliate for Toledo and to license a great deal of "good" unsold syndication. TV5 carries first-run syndicated shows such as *Extra*, off-network reruns such as *Suddenly Susan, Caroline in the City,* and *The Jamie Foxx Show,* and nightly sports (Cincinnati Reds baseball) or movies. Because the local newspaper *(The Toledo Blade)* owns the local cable company (Buckeye Cablevision) that produces TV5, the channel receives the enormous benefit of a listing at the top of the newspaper's grid, right under the local broadcast stations, instead of burial in the "Ts" as *TV Guide* places it (and similar channels). The combination of national affiliation, having only a few local broadcast stations (only two of which have VHF frequencies), and supportive ownership by the local newspaper places TV5 in the forefront of successful local origination channels that compete directly with broadcast stations.

chosen and scheduled locally but, like syndicated programs on broadcast stations, are not very local. Toledo, Ohio, for example, has a popular LO channel called TV5 that is remarkable for its syndicated series and sports (see 8.6).

On other local origination channels, high school and minor league sports are especially effective in attracting audiences of considerable appeal to advertisers. Local talk programs also provide an ideal environment for both local and national **infomercials.** Major national companies, such as Sears, Bell Atlantic, Ford, General Motors, and Procter & Gamble supply the bulk of direct-selling infomercials to cable systems, and these are supplemented by shorter infomercials from local car dealers, restaurants, pharmacies, home builders, and the like. Many of the local infomercials are lengthy commercials, often three

minutes or so long, produced by cable system facilities (for a fee).

Classified advertising channels, often produced by local newspapers, have been another successful area for local cable, especially when operated in conjunction with a daily paper. Digital insertion equipment permits quick updating of listings and the use of photographs (and some slow-motion video), making real estate, car, and other classified ads as well as Yellow Pages viable as auxiliary revenue streams for cable. Because the Internet provides much the same opportunity for reaching out to viewers, however, religious broadcasters, retail companies, and newspapers are generally operating web sites with the same content they put on local cable channels, and are increasingly favoring the web over cable.

News Programming

News is a powerful environment for advertising messages and thus popular with many commercial entities wanting to reach news consumers and make money. Having hyperlocal services helps systems attract and retain subscribers and keeps them in the good graces of local franchising authorities that grant them their licenses. In the long term, however, regional cable-produced services may even take over the role that local broadcast stations have traditionally played because cable does not use scarce airwaves. Although they are, in turn, likely to be supplanted by Internet sources, someone has to produce the content for online services. For local news content, some cable operators may have a leg up on broadcasters.

News Inserts

One approach to cable has been for broadcast stations to negotiate permission to insert five minutes of local news in every half hour of AOL Time Warner's CNN Headline News. As of 2000, more than 75 television stations had contracts with Headline News to produce such **news inserts,** and their combined reach was likely to exceed 7 million cable households. Most of the TV stations producing local news inserts retain a portion or all of the commercial inventory within the five-minute newscasts.

Rebroadcast Channels

Another strategy has been to replay broadcast newscasts on cable channels. Pittsburgh Cable News Channel, for example, began in 1994 as a **retransmission consent** channel. Federal law requires local television stations to give permission to cable systems for carriage of their signals and allows them to negotiate a fee or other compensation from cable operators in exchange for their broadcast signal. Many stations exacted cable channels of their own in lieu of monetary payment. Most of these are solely **rebroadcast channels,** but a joint effort of WPXI (TV) and cable operator Tele-Communications, Inc., created The Pittsburgh Cable News Channel that carries multiple repeats of the WPXI's newscast accompanied by original news, special events, and a talk show. LIN Broadcasting, a group owner, has been successful with local weather channels started by the company's broadcast TV stations that reach more than 1 million subscribers.

Such commercial channels are effective promotional tools for both the station and the cable operator and hold the promise of revenue sources. The pricing of ads is comparable to that of local ad inserts on CNN and Headline News, and cable systems carrying the channel receive two minutes of ad time per hour. In the case of the Pittsburgh Cable News Channel, all other advertising revenue is split between WPXI and TCI. In the case of LIN Broadcasting's weather channels, the stations get a percentage of ad revenue plus a license fee for each of the 1 million subscribers. By the turn of the century, most large television stations were expected to have cable channels that they programmed alone or in conjunction with the cable operator.

Regional News Channels

Modeled on CNN and its repeating counterpart, Headline News, seven cable-only **regional news channels** have attracted considerable industry attention. Although they required capital invest-

ments of many millions of dollars in equipment, crew, reporters, and studios to get going and have high daily operating costs, their revenue potential is usually much greater than for entertainment channels because they attract more regular viewing. What the services share is their recency and their focus on the neighborhood level of service: Traffic reports are street by street, weather reports describe in detail what is important in the local areas, and "news" moves down to the level of parades, store openings, and city official activities. This kind of information transfers very effectively to online services.

These regional cable-only news services differ from ratings-driven broadcast stations that normally divide their newscasts into half-hour segments, devoting airtime to sensational crimes, fires, and accidents, and including nonlocal stories if they are likely to hold audience interest. That means local events get only a few minutes at most on broadcast stations, and events likely to be of interest to only a few viewers are scrapped. In contrast, hyperlocal cable-only news channels that operate live for several hours daily—increasingly 24 hours as they become established and profitable —can focus on neighborhood events on-the-scene and at length if they might be of interest to a few viewers. Most model themselves on CNN rather than the broadcast network newscasts and carry long, live programming, although New York 1 News is gaining increasing influence with its taped one-hour news wheel. With the luxury of more time to dwell on events, regional networks can spend hours on breaking events and enough time on stories about health, sports, and entertainment events to avoid the taint of sensationalism. Cable news producers' success with audiences and owners comes from an intense focus on local interests and, especially in times of stress, carrying lots of ongoing weather and traffic reportage. The details that emphasize the problems caused for neighborhood residents and businesses appeals to viewers and advertisers and the very low cost of such reportage appeals to cable operators (see 8.7).

In line with keeping expenses minimal, these regional channels take advantage of the newest

roboticized cameras and other automation, which may result in some odd pictures at times but reduces the technical staff necessary to operate (compared to broadcast newsrooms). The reporters tend to be young and inexperienced, often interns or working for nonunion salaries, who carry their own handheld Hi-8 cameras with portable video recorders, eliminating still other staff costs. Using portable tripods a reporter can even tape herself (or himself) "on the scene" of events and interviews. As one reporter for New York 1 News put it, "I do a story every day. I dream it up. I set it up. I produce it. I report it, and I even edit it. I get to do everything."[5] The videojournalist who functions as correspondent, reporter, camera operator, and producer has become the model for inexpensive news gathering.

Although financial support must initially come from a parent corporation with deep pockets and patience, such national advertisers as Coca Cola and Procter & Gamble are getting interested in cable-only news and its online counterparts. Regional news channels can attract advertising from businesses too small to be able to pay broadcast station rates. Rates on New England Cable News are about $500 for a 30-second spot, compared with $3,000 or so on a Boston network affiliate. Although such networks typically average less than a 1 rating for 24 hours, local disasters drive up ratings dramatically. For example, New York 1 News had ratings of about 6 for its live coverage of a winter snowstorm.

The next stage in development of such channels is to add interactivity via the Internet. Viewers' desire to selectively choose among news stories and have news-on-demand is apparent. At present, the same news information can appear simultaneously on a cable channel and online, broadening the current audience and holding down online space as the country awaits media convergence.

New Cable Services

The first arena for expansion of services for most cable operators will probably be telephony—to

8.7 REGIONAL CABLE NEWS SERVICES

The first and best known of the regional all-news ventures on cable continues to be News 12 Long Island. Launched in 1986 by Cablevision, News 12 Networks is a division of Rainbow Media, the programming arm of Cablevision Systems Corp. Rainbow Media has launched localized operations in Connecticut, New Jersey, Westchester, and the Bronx (see www.news12.com News12LongIsland). Each service supplies news about the local region to residents, beginning each morning with a radio-style mix of news, weather, and hyperlocal traffic reports (for example, live from key points on the Long Island Expressway on News 12 Long Island), then continues at a slower pace throughout the day with reports on local community events, live interviews, local news updates, and reprises of national and international news. Its stories include everything from school parades to unsolved murders to reports on issues like garbage dumping and pollution. With a staff of 150 and facilities rivaling those of nearby broadcast stations, an annual budget more than $10 million, News 12 Long Island, the flagship service, attracts enough advertising revenue to make a profit. Interestingly, its highest viewing comes in prime time.

NY1 News is Time Warner's 24-hour news channel in New York City. Available exclusively on Time Warner Cable, NY1 covers the city's five boroughs with more than 25 full-time reporters. Through its web site (www.NY1.com), NY1 also offers news on demand with Real Audio live audio, live image update, and custom newscasts. Its use of comprehensive journalists —who report, videotape, and edit their own stories—structured in taped, one-hour programming wheels, has become a global model for inexpensive news coverage. In addition to advertising, it attracts revenue by charging for consulting about low-budget news for, among others, Telemundo, the Spanish-language broadcast/cable service out of Miami, Florida, a London, England, station called Channel One, and Australian television networks.

NorthWest Cable News (NWCN) began cablecasting in 1995. This 24-hour news network was made possible by successful retransmission consent negotiations between then owner, The Providence Journal Company (PJC) and the cable operators who carried the local programming of PJC's KING Broadcasting. KING Broadcasting consists of KING-TV in Seattle, Washington, KREM-TV in Spokane, Washington, KGW in Portland, Oregon, and KTVB in Boise, Idaho. PJC was acquired by the Belo Corporation on February 28, 1997. Later, in order to promote synergy within its company, Belo announced that NWCN would become a part of its northwestern broadcast division. The number of viewers has grown to more than 2 million and includes Alaska and northern California. NWCN has established itself as a competent news provider, consistently beating CNN Headline News in the ratings. During periods of breaking news and weather coverage, NWCN has emerged as a top viewer's choice—obtaining ratings that beat the other cable channels and, on occasion, the local network affiliates (see www.nwcn.com).

The Texas Cable News (TxCN) is Belo's second regional effort. Although some regional news channels choose to cover a metro area or even a limited part of a metro area, TxCN is following the design of NWCN by opting for coverage of vast regions that include multiple metro markets. TxCN maintains only a tiny in-house editorial staff of the regional cable news services and has no reporters of its own. Its newscasts depend entirely on contributions from its television and newspaper partners, The *Dallas Morning News* and WFAA-TV8 in Dallas. NWCN and TxCN both use half-hour news wheel formats.

Since its launch in 1998, the Florida News Channel (FNC) has provided news for several local cable networks in several Florida markets from its headquarters in Tallahassee. FNC, a multimillion-dollar project, pioneered the use of virtual reality in its distribution and programming efforts. Although virtual reality sets have been around for a few years and have been used by both local

stations and national networks, FNC is their most extensive user in the United States. FNC gathers news from NBC affiliates in several cities statewide under a pure barter arrangement with the channel, as well as from a number of two-person crews sprinkled into the local markets that FNC serves. The initial plan called for NBC stations as owners; now all but one are non-owning "affiliates," providing access to their content in exchange for rights to FNC's video and use of its statewide fiber-optic transmission network. That fiber network was the second major change—originally, a microwave network was planned. The third evolution of FNC was the change from a statewide news channel to individually-produced local channels, all relying on a mix-and-match, digitally delivered package of content from Tallahassee.

As regional cable news channels go, Orange County Newschannel (OCN) in California may be considered a moderate success from a synergy perspective, but from a financial perspective, it has been less successful. Century Communications (purchased recently by MSO Adelphia Communications Corp.) cut OCN's staff by 20 percent from its peak in 1996 and uses its cable sales reps to sell the channel to advertisers as part of the Century package in Orange County. Seeking to further reduce costs, OCN has begun promotional news barter relationships with the

Orange County Register, KCBS (the CBS owned-and-operated television station based in Hollywood), and KNX (the all-news radio station in Los Angeles that is also owned and operated by CBS). KCBS features some OCN material on several of its daily newscasts and grants OCN limited rights to both KCBS and CBS network video. KNX has rights to reuse audio from OCN, which it promotes on-air when using the breaking news content.

The Mid-South News Network, a service of Time Warner Communications and WREG-TV3 in Memphis, operates 24 hours a day, 7 days a week. The Mid-South News Network uses a wheel format to update the latest local news, weather, and sports in Tennessee, Mississippi, and Arkansas. All Time Warner customers can find the Mid-South News Network on Channel 2 of their systems (see www.wreg.com/3msnn.htm).

In Washington, D.C., there is NewsChannel 8 owned by Allbritton Communications. It has appeared on many of the area's cable systems since 1991, supplying regional editions for Maryland, Virginia, and Washington, D.C., residents. Although it came for free for the first five years, beginning in 1996 it charged per-subscriber fees beginning at 28 cents per month, increasing a few pennies annually until the end of current contracts in 2001. NewsChannel 8 carries advertising and gives local operators two minutes per

hour to sell. Its staff of 200 provides three local feeds to different segments of the D.C. area, and its highest viewing is in the morning and evenings. Its annual budget approaches $17 million, the highest of any local cable effort to date (see www.newschannel8.net).

CN8, the 24-hour cable network owned and operated by Comcast Cable Communications, Inc., has launched two regional prime-time daily newscasts. The newscasts—an hour each at 7:00 and 10:00 P.M.—are broadcast to nearly 4 million homes on Comcast Cable in Pennsylvania, New Jersey, Delaware, and Maryland. CN8 News is the region's first cable newscast and only newscast to occupy the 7:00 P.M. prime-time slot; it provides more headlines and weather than any other local station newscast—including weather forecasts every ten minutes during *Weather on the 8's.* The news is broadcast live each weeknight from CN8's state-of-the-art studio in New Castle, Delaware, which recently underwent a $1.5 million renovation. Stories will also be filed from news bureaus in Philadelphia and Harrisburg, Pennsylvania, and Trenton and Union, New Jersey (see www.cn8.com).

Hearst and Continental Cablevision launched what is now called New England Cable News (NECN) in 1992. It has become the largest regional cable news network in the country
(continued)

8.7 REGIONAL CABLE NEWS SERVICES (continued)

serving 2.5 million homes in 530 communities throughout New England. NECN provides news, weather, entertainment, and sports for New Englanders around the clock and has been the winner of many awards, including a George Foster Peabody Award and an Alfred I. duPont/ Columbia University Broadcast Journalism Award for excellence in in-depth reporting. NECN is the only regional news network in history to be given a duPont Award. Other honors include a Scripps Howard National Journalism Award, 19 regional Emmys, and 35 awards from the Associated Press including News Station of the Year in 1999. NECN's newscasts focus on stories of importance to New Englanders, producing documentaries on people, places, and issues. Today, NECN is jointly owned by Me-

diaOne and the Hearst Corporation (see www.necnews.com).

Begun in 1993, Chicagoland Television News (CLTV) carries a heavy dose of Chicago Cubs games and *Chicago Tribune* news coverage. CLTV is the Chicago area's only 24-hour regional news, weather, sports, and information channel, with 1.7 million cable households, making it one of the larger local cable channels in the country. Like CFN 13, another *Tribune* property, CLTV also shares content and people with the local newspaper, the *Chicago Tribune*. The newspaper newsroom now has a 30 foot by 50 foot soundstage and has, in effect, become a televised stage that showcases daily journalism. Several newspaper staffers now coordinate the flow of reporters and editors onto the stage. Both the news-

paper and CLTV are specifically oriented toward the suburban Chicago audience. One goal of the cable channel is to promote the value and expertise of the newspaper reporters, which should, in turn, improve newspaper circulation (see cltv.com).

Noted particularly for its heavy local sports coverage, is Vision Cable of Pinellas County, Florida, which does remotes of arena football, high school basketball, pro beach volleyball, and the Special Olympics. In addition, there are a half-dozen regional channels that carry a mix of highly local news, talk, and sports, supplemented by investigative reports, such as Bay TV in the San Francisco area, Pittsburgh Cable News Channel, Cable TV Network of New Jersey, News 12 in Fairfield County, Connecticut, and the Sunshine

compete with local telephone companies for local business and home service and to offer personal communication services to individuals and companies. Although business services have much greater profitability than do residential services, activities that were once carried out from office buildings, such as word processing, fax, email, and other data communications, can now operate from airplanes, homes, and cars. Cable operators see their wired broadband capacity as ideal for capturing highly profitable portions of this telephone-related business. As one local manager pointed out, gaining 10 percent of the local telephone company's business represents a lot more money to him than giving up, say, 20 percent of his cable

business to a competitor. Subscribers like getting a single bill for both telephone and cable service.

After integrating the technologies, a second integrative stage occurs as marketing functions for cable, wired, and wireless (cellular, PCS) telephony are co-located, probably in shopping malls. One-stop shopping with combined billing are expected to increase revenues for all services. Telephony has two big differences from cable, however, that slow convergence: (1) telephone delivery areas are far larger than cable franchise areas, necessitating mergers and buyouts until cable operators can reach competitively large geographic areas, and (2) about 80 percent of telephone revenues come from 20 percent of the customers. In telephone, the commercial cus-

8.7 CONTINUED

Network, along with some that specialize in state political and economic news such as The California Channel and the Pennsylvania Cable Network.

Central Florida News 13 (CFN 13) is Orlando's only 24-hour local news channel serving the central Florida region. Owned by the Orlando Sentinel Communications (Tribune Media) and Time Warner Communications, CFN 13 features Tribune's formula of newspaper-to-television content provision, frequently showcasing news and reporters from *The Orlando Sentinel.* Sharing branding, management, and reporting staff is something new and different for Time Warner, a company that practically invented the concept of vertical integration. CFN 13 has a live camera in *The Orlando Sentinel* newsroom that is used several times

each day for debriefs from the newspaper's journalists. Like most other Time Warner news channels, CFN 13 operates with one-man-band videojournalists for newsgathering and uses the news wheel for its newscasts. CFN 13 airs 48 half-hour newscasts every day, and a producer individually creates each half-hour newscast (see www.cfn13@orlandosentinel.com).

A latecomer, The Dispatch Broadcast Group launched its 24-hour Ohio News Network (ONN) in 1997, becoming the first statewide news channel in the country. The channel is seen in the following five DMA Markets: Cleveland, Columbus, Cincinnati, Dayton, and Toledo. ONN's goal is to cover each Ohio town and city as well as the regionalism of the entire state. In addition to continuous news,

weather, and sports, ONN offers *Ohio's Talking,* a nightly live interactive talk program featuring newsmakers, opinion leaders, and experts; *On the Square,* which spotlights the state's political landscape; and *On the Hill,* which looks at decisions made by Washington, D.C., lawmakers. On the public safety newsfront, ONN produces *Ohio's Most Wanted,* a crime-fighting segment, which has contributed to the capture of several Ohio felons; *On the Road,* and *Ohio's Missing Children.* In addition, ONN carries the daily *High School Sports Site,* and *Ohio Sports Insider,* along with live coverage of high-school championship games (see www.onnnews.com).

tomers are far more lucrative than the residential customers, whereas in cable the differentiation in rates has been minimal. At the moment, hostility between local and long-distance phone companies has led to separate billing for long-distance (or a charge for the bill), further slowing convergence with cable.

Once converged systems are debugged—and Continental Cablevision in Cambridge, Massachusetts, found interconnection of cable and the Internet far more difficult than anticipated—capital costs for providing broadband communications from homes, office buildings, and public places will be high. Each location needs a network interface device to separate and control the television and telephone signals. Although huge

initial costs will fall as the technology becomes commonplace, it is important to remember that, in the United States alone, there will be more than a billion locations to be connected.

COMMUNITY ACCESS ON CABLE

In dramatic contrast to commercial cable, the access channels operated by community groups are noncommercial and driven by educational, artistic, and public service goals. They tend to operate on the neighborhood and city level, rarely reaching outside county boundaries. Federal law permits local franchising authorities to require cable systems to provide channel space and sometimes

financial support for community access services. Although by law these services divide into three kinds—public, educational, and government (PEG) channels—in practice, they usually operate out of *community access centers*. Such centers are noncommercial and local not just in practice but in active philosophy, and they provide alternative programming that would never be viable on for-profit stations or local origination cable channels. And like commercial companies, they are finding the Internet increasingly effective for reaching their audience.

The community members who were once clamoring to gain local access time for their home videos or local performances can now exhibit continuously on personal web sites, bypassing one of the motivators for public cable access. One striking aspect of the Internet has been the rapid shift of art video and low-budget movies from cable access to the web. Video artists now fill several sites with original films shorts, and the Internet provides places for the videos of birthday parties and church fairs as well as the more serious animation and dramatic films that once characterized local public access cable. Religious groups that once clamored for more time on local access channels also have more freedom to program as they wish on the Internet. Nonetheless, church groups wishing to reach older, downscale constituents that tend to avoid computers still seek a significant portion of time on access television, creating problems for some managers as they see other kinds of traditional access fare fading in quantity.

In many well-wired communities, local governments are finding web sites more effective for the kind of information they produce. Long lists of community events, community service agencies, and government office phone numbers suit menu-driven web sites better than television channels. Users can access the web sites at their convenience and select only the material of particular interest, unlike cable channels that unfold programs over time. Live carriage of public meetings, especially those of municipal government and local school districts, but also including environmental protection committees and councils, planning approval commissions, and other ad-hoc meetings on community issues, continue to remain best suited to local access cable until the accessibility and quality of online video improve.

Educators, once a group seeking large numbers of cable access channels, have also turned increasingly to web sites to provide interaction with students and parents. Homework instructions can go online; e-mail allows personal messages from teacher to student or parent; and the cost of such sites is far less than for effective cable production.

Traditionally, *access* has meant two things to local access centers: (1) access to the means of television production through training classes and arrangements for loans of TV cameras and sharing of editing equipment, and (2) access to an audience by cablecasting locally produced programs. The underlying principles guiding the staffs of access centers are the ideas of free speech for everyone, egalitarian use of the media, fostering and sharing artistic expression, the accessibility of all people to affordable education and instruction, and open and participatory government decision making. The Internet is proving an even more effective vehicle for achieving these goals than cable, however, and as home video equipment falls in price and rises in sophistication, fewer members of the public are seeking the video training that access centers can provide. Thus, the centers focus increasingly on digitalizing their facilities to aid in converging video and computer input and output.

The once-separate local arts centers and local television centers have come together in many communities to become community media centers and are evolving into community communications centers. They involve institutional networks, local libraries, health centers, and schools, and connection to each other, community agencies, and the Internet has become central to their future and their survival. It is not the particular technology (television, broadcasting, books, or computers) that ultimately matters but serving the mission in the community—the mission of public access to the means of communication.

Organization

Although the more than 4,000 access centers in America come in a bewildering variety of organizational setups, many are finding common bonds with farseeing public libraries. As the repositories of printed books and periodicals move into videotape, DVDs, CDs, and computer storage of ideas, their noncommercial, anticensorship, free speech, and open access goals come to resemble those of community access television centers. Many access centers, including one of the oldest in America, Bloomington's Community Access Television, have located themselves within a community public library and receive financial support from the city, county, library (a taxing authority in Indiana), and cable operator.

Nonlocal Programming

Although it was once thought that all access channels would carry only locally produced programs, some regional and national sources are now available to supplement what can be locally made. In addition to public broadcasting, noncommercial services such as SCOLA provide unedited segments of broadcast news from other countries in their original languages. Especially popular in university towns and cities with large foreign-born populations, SCOLA offers news from such varied sources as France, Spain, Mexico, Taiwan, Poland, the United Arab Emirates and Dubai, Germany, Hungary, Italy, Korea, Greece, China, Croatia, Slovenia, Iran, the Ukraine, and the Philippines over the course of a week.

Access TV is, at its best and worst, a forum for community speech and an alternative to commercial television (see 8.8). It is not the same as public broadcasting because the professional licensee makes media *for* the community. Public access inherently means media made *by* community members, not professionals. At the same time, access concepts appear to be leapfrogging nationwide, reaching and fostering the development of local public access in other countries. It is not, however, American access programs that are being dispensed but the ideas and values of community

8.8 DEEP DISH TV NETWORK

Community access centers obtain the Deep Dish TV Network via satellite. It is a not-for-profit, part-time program distributor supported by donations and grants. Independent and community producers create the highly diverse and largely political documentaries Deep Dish distributes on such topics as housing, the environment, civil liberties, racism, sexism, AIDS, the Middle East, and Central America. It identifies itself as "the first national grassroots satellite network" and quotes author Studs Terkel:[6]

The idea of a democracy in this country is based on an informed citizenry, an intelligent citizenry—and you can't be intelligent without being informed. That's what Deep Dish TV is all about.

Deep Dish TV appears unscrambled on commercial satellite transponders, and its programs are carried by 300 or so cable systems and some public television stations. (The name *Deep Dish* refers to parabolic receivers as well as apple and pizza pie!)

access—free speech, localism, egalitarianism, education for democracy, empowerment, and checks on the commercial marketplace.

In the rapidly changing media environment, three things appear to be central to the long-term success of public access. One of these is reconceiving the access mission broadly to include all kinds of communication, from arts to television training to health to education, via all kinds of media—television, radio, computers, newsletters. Another is charging for services such as teacher-training workshops, taping of fairs and festivals and sports, and equipment training. And finally, developing collaborations, partnerships, and affiliations is essential to the survival of public access centers. They must join with city government and community and regional groups, both commercial and noncommercial, to find advocates and constituencies. Despite the fact that religious groups use as much as 4 percent of airtime nationally, they have

not generally been advocates for public access. Seeking out constituencies interested in protecting and fostering free speech and the arts and in having alternatives to commercial programming and open political and cultural debate is the only direction that will result in adequate financial support over the long haul. In addition, because the federal government is returning many responsibilities to the states, local groups must increasingly seek their financial support at regional and statewide levels. Cable operators have become highly reluctant to pay for access operating expenses, but at the same time cities have great need of franchise fees for other expenses. Paragon Cable recently regained control of 20 underutilized access channels because local government could make use of the Internet and gain from a substantial increase in franchise fees once the channels carried cable networks.

WHAT LIES AHEAD

As new nontelevision services (banking, shopping, security) become widely available and heavily utilized, it behooves cable and satellite operators to offer as many specialized services as possible. Viewers will reach these new services via elaborate menus, preprogrammed selections, and nonlinear voice-activated searching shortcuts. *Ease of use will be critical to viewer acceptance and use.* Having **transparency** in technical processes will be a paramount concern to operators. Because the software and hardware behind such apparent simplicity will be enormously costly and difficult to make work reliably from network to network and service to service, *standardization in all communications technology becomes eventually inevitable* (**convergence**). At present, the cable and satellite industries compete with each other and traditional broadcasting, while the Internet group grows, making a period of intense competition amid confusing, incompatible systems.

Search Agents

On the reception end, the industry awaits improvements in **search engines** for personalized

online programming. Consumers need effective methods of becoming aware of entertainment programs, news stories, and other messages they would probably like to see. At first, this will involve elaborate online program guides, preview channels, and complex menu-driven selection systems, but over time, it is envisioned that mass guides will evolve into personal search engines (**agents**). The selection side of choosing and finding content will evolve rapidly from button-pushing preprogramming to far more elaborated personalized systems. People will gradually, over a lifetime, program and reprogram a personal agent who will select—from the huge sea of entertainment, news, and commercial messages—those pieces of content that will have maximum appeal or fulfill expressed needs for the individual or group. Agents for each individual will notify them of specific content on request based on their previously expressed preferences or current wants. (Of course, such marketing tricks as fee reductions for watching commercial messages will probably surface right away.)

The process of reprogramming an agent (by voice or perhaps merely by what is frequently chosen or requested) will eventually become transparent to users, and over decades, agent-programs should become the equivalent of semi-sentient computers in science-fiction. Agents will eventually mutate into **avatars** (virtual selves) having virtual bodies that can interact with other avatars on the Internet, far beyond the static cartoon representations that exist today.

Convergence

One of the factors inhibiting a swift conversion to a **video-on-demand (VOD)** universe is the current profitability of local broadcast stations. Although the big networks can see themselves as survivors in a VOD universe, local broadcast stations can readily see that most must fall by the wayside. Nonetheless, under congressional mandate, they are spending large amounts of money to convert from analog to digital and want to ensure that they stay in business long enough to

satisfactorily recoup those expenditures. One immediate effect of technical convergence is strong pressure to form larger and larger groups of broadcast stations (as well as cable systems). Larger units have several advantages: They can negotiate more advantageous prices for programs, and they can share resources, thus cutting costs. The larger the group, the less its survival depends on the viability of individual stations. Nonetheless, heretical as it sounds to the current broadcast industry, many experts predict the collapse of most of the present over-the-air broadcast system in as short a time as a decade or two. Instead of a dozen or more broadcast stations serving one market, a single local news and sports gatherer (who could operate directly through local cable or the Internet) would survive.

Because marketing and programming are intimately connected in the retransmitter business, mergers and consolidations will increase to thrust well-known brand names into the public eye. It is presumed that consumers will be more likely to try out costly new services if they recognize the brand name. Thus, marketing and programming, through the process called **branding,** are intimately connected in cable, wireless, and satellite-delivery businesses. As digital convergence increases, the focus of operations for multichannel programmers will shift away from scheduling manipulation to promoting and informing subscribers.

It is important to remember that both operator-controlled and community-controlled channels necessarily compete for some of the audience's attention with broadcast stations, national cable networks, and international Internet programming. Although the total number of people in America rises, it does so slowly, so the more options viewers have, the fewer that may go to any one programming source. Because advertising revenues are based largely on the size of audiences, having too many competitors cuts the audience pie into slivers too small to measure. Thus, large numbers of channels dilute viewership from the perspective of cable and satellite programmers.

When terrestrial broadcasters complete their conversion to digital signals, however, a great deal of bandwidth will be freed up and returned to the federal government who can then reallocate some of it to direct-to-home broadcasters. It is likely DBS would get enough of that bandwidth to keep them competitive with terrestrial cable. Continued congressional support of direct satellite is probable because there are national defense advantages to redundant nationwide communication systems.

In sum, *television should now be thought of as just one way to produce communication,* just as oil paint and carved stone are two of many ways to produce art. And *traditional distinctions between local and nationwide retain meaning only in consideration of specific content, not in the means of distribution.* Indeed, the means of distribution of all kinds of signals in the near future will be digital, and mixing sources will become the way of producing, consuming, and using communication media. Before long, it will be possible to hold a conversation with a friend, primarily in audio as one would on the telephone, but introduce video from a home camera of self or objects and text from paper into the conversation. The impediments to such media mixes are falling rapidly. One widely recognized implication is that television viewers, cable subscribers, and "Interneters" are really *communication users*, who will necessarily vary in their need for and sophistication of use of communication media.

SOURCES

Broadcasting & Cable. Weekly trade magazine covering all aspects of broadcasting and cablecasting. Washington, D.C., 1931 to date.

Cable Strategies. Monthly trade magazine concentrating on the operations and marketing of local cable services. Denver, CO, 1986 to date.

Cable Television Business (formerly *TVC*). Biweekly trade magazine covering cable system management. Englewood, CO, 1963 to date.

Grant, August E. (ed.), *Communication Technology Update*, 7th ed. Boston: Focal Press, 2000.

Osso, R. (ed.) *Handbook of Communication Technology.* Boca Raton, FL: CRC Press, 1999.

Multichannel News. Weekly trade newspaper. New York, 1979 to date.

INFOTRAC COLLEGE EDITION

Consult InfoTrac College Edition using the password provided with this book. Use boldfaced terms as Key Words and section headings from this chapter for Subject searches.

NOTES

1. Kenneth Van Meter, president of Bell Atlantic Video Services' interactive multimedia platform division, speaking before Kagan Services' Interactive Multimedia Forum, 18 August 1994, New York.

2. High-definition television (HDTV) contrasts with standard definition (SDTV) and other lower-definition systems. Standard-definition television (SDTV) has 520 lines of resolution and uses interlace scanning. The HDTV system called 1080i has 1080 lines of resolution and displays images using a form of interlaced scanning that first transmits all the odd lines on the TV screen and then the even lines. This system of HDTV is supported by CBS and NBC. The competing HDTV system, called 720p, offers 720 lines of resolution and displays images using progressive scanning, which

means it transmits each line from top to bottom. This system provides image quality close to that of 1080i. Moreover, when transmitted at 24 frames per second instead of the usual 60 frames per second, cable operators can squeeze more HDTV channels into their lineups. This system is, not surprisingly, supported by cable operators, as well as ABC and Fox. Then, there is a third option, 480p, with 480 lines of resolution scanned one after another progressively on the screen. It allows for transmission of either multiple programs in the space of one channel or data services such as Internet access. It is, quite logically, supported by Microsoft and various computer companies.

3. Berniker, M., quoting Barry Rosenblum, president of Time Warner Cable of New York City. Cable thieves undaunted by new technology. *Broadcasting & Cable,* 10 July 1995, p. 36.

4. Similarly, the FCC has imposed public interest obligations on DBS companies. They must set aside 4 percent of their channel capacity exclusively for noncommercial programming of an educational or informational nature, and the DBS companies cannot edit program content but must merely choose among qualified program suppliers. Commonly, DirecTV, for example, offers nine channels to fulfill this public-interest obligation: Clara+Vision, C-SPAN, EWTV, Inspirational Life, NASA TV, PBS You, StarNet, TBN, and WorldLink TV. DISH Network offers slightly different choices.

5. Seligmann, J. Covering the neighborhood. *Newsweek,* 13 December 1993, p. 6.

6. From the brochure cover for Deep Dish TV Network in New York, 2000.

Chapter 9

Subscription and Premium Programming

Douglas A. Ferguson

Cable program services are no longer limited to cable systems. Direct-to-home (DTH) satellite services and other broadband carriers offer a full array of channels that originally surfaced as cable channels (as was discussed in Chapter 8). Indeed, these channels are owned by the same companies that first offered cable services in the United States. As competition abounds in the new millennium, new "cable" channels are proliferating.

THE NONBROADCAST WORLD

The terms *network, channel,* and *program service* are interchangeable. Many of the companies that provide nationwide programming have adopted these terms in their names, occupy a single channel on cable and satellite systems, and possess the primary characteristics of a network in that they (1) are centralized, (2) distribute simultaneous programming, advertisements, and adjacencies— if advertiser-supported, and (3) are retransmitted to cable and other multichannel subscribers.

Before 2000, it was easier to delineate the various program services. Previous editions of this book quite logically followed the broadcast/cable scheme because the two worlds were clearly separate. Broadcasters' main revenue stream was advertising, so they gave away their programming to create target audiences that they could sell to advertisers. Cable operators' main revenue stream was subscriptions, so they packaged the broadcast channels along with program services that they helped create. Broadcast programming was broad, expensive, and new. Cable programming was narrow, cheap, and retread. Broadcast stations were either affiliated with one of the Big Three networks or became independent stations. Cable program channels were either part of the basic service for one price or tiered into premium packages. Other delivery systems and newer networks were ancillary.

In the 1990s, the appearance of many new broadcast networks made it difficult to talk about purely independent stations anymore; a parallel situation has arisen with the explosion of new

cable and DTH satellite and Internet channels. Although online services deserve separate attention for their relative novelty (see Chapter 10), this chapter brings together the once-separate worlds of basic and premium networks.

In this chapter, program services designed for multichannel delivery are occasionally called "cable channels" or "cable networks," but before long a new name will be needed. Growing numbers of people are getting their "cable" from a satellite dish or through their computer. The term **subscription channels** seems a good choice to encompass all forms of delivery (see 9.1).

Competition Among Services

What is the real difference between CBS and the USA Network? Both target a broad audience, both carry a mix of rerun and original shows, both carry live sports, both have theatrical and first-run movies, and both have sitcoms and game shows. The main difference, aside from news programming, lies in the 98 percent reach of a broadcast network versus the 85 percent reach of cable and satellite networks. As that gap eventually closes, another conceptual sea change will roll in.

At one time, the big difference between broadcast and cable was the amount of money spent on *original* programming, but that difference is diminishing as cable channels spend more money for big stars, big movies, and big series (and miniseries), while broadcast networks cut costs by filling prime time with more and more game, reality, and news programming that costs less than $500,000 per episode.

Premium television is an umbrella term for a group of specialized entertainment services that, for an optional fee, provide special or "premium" programming to subscribers that costs over and above some basic fee. These services primarily offer unedited movies and original productions in a commercial-free format. The premium television field divides into three distinct components:

1. Pay-cable services, charging viewers a monthly subscription "premium"

9.1 TOP 20 SUBSCRIPTION CHANNELS

Network	Subscribers	Systems
TBS Superstation	78,000,000	11,668
The Discovery Channel	77,400,000	N/A
USA Network	77,181,000	N/A
ESPN	77,115,000	N/A
C-SPAN	77,000,000	7,047
CNN	77,000,000	11,528 cable
TNT	76,800,000	10,637
Nickelodeon	76,000,000	11,788
Fox Family Channel	75,700,000	13,818
Lifetime Television (LIFE)	75,000,000	11,000 (cable systems in the United States)
TNN	75,000,000	N/A
A&E Television Networks	75,000,000	12,000 (United States and Canada)
The Weather Channel	74,000,000	12,763
MTV: Music Television	73,200,000	9,176
CNN Headline News	72,446,000	7,039
QVC (shopping)	72,175,994	7,511
The Learning Channel	72,000,000	N/A
CNBC	71,000,000	5,000 (United States and Canada)
AMC (American Movie Classics)	71,000,000	N/A
VH1 (Music First)	68,300,000	5,040

Source: www.ncta.com/glance.html, September 2000.

2. Pay-per-view (PPV) services, charging on a program-by-program basis

3. Video-on-demand (VOD) services, charging similarly to PPV but offers more viewer control and sometimes VCR-like functionality

The key difference to consumers is that pay television means buying a *group of movies* over a month, whereas **pay-per-view (PPV)** and **video-on-demand (VOD)** mean purchasing *just one program* at a time. Most of the top PPV programs are special events rather than movies (see 9.2). Premium channels may be distributed several ways to homes, bars, and hotel rooms, including:

- Cable systems

- Beamed directly (DBS) to a home satellite dish (HSD or DTH) or to hotels
- Satellite master-antenna television installations (SMATV)
- Microwave distribution systems (MMDS or "wireless cable")
- Online video servers

The content of a multichannel system's offering of premium services derives mainly from a handful of national pay-TV services and dozens of pay-per-view services, each distributing a program schedule to local cable systems (or directly to homes in the case of DTH channels) by satellite. Each pay-TV service offers several channels.

9.2 TOP 20 PAY-PER-VIEW EVENTS, 1990–99

Rank	Provider	Event	Date	Buys
1	SET	Tyson vs. Holyfield II	6/97	1.99M
2	SET	Tyson vs. Holyfield	11/96	1.60M
3	SET	Tyson vs. McNeeley	8/95	1.58M
4	SET	Tyson vs. Bruno	3/96	1.40M
5	TVKO	Holyfield vs. Foreman	4/91	1.36M
6	TVKO	De La Hoya vs. Trinidad	9/99	1.25M
7	SET	Tyson vs. Ruddock II	6/91	1.23M
8	TVKO	Holyfield vs. Lewis	3/99	1.10M
9	SET	Douglas vs. Holyfield	10/90	1.06M
10	SET	Tyson vs. Seldon	9/96	1.00M
11	SET	Tyson vs. Ruddock	3/91	0.96M
12	TVKO	Holyfield vs. Bowe	11/92	0.93M
13	TVKO	Holyfield vs. Bowe II	11/93	0.92M
14	SET	Chavez vs. Whitaker	9/93	0.90M
15	TVKO	De La Hoya vs. Whitaker	4/97	0.86M
16	TitanSports Inc.	*WWF WrestleMania XV*	3/99	0.85M
17	SET	Tyson vs. Botha	1/99	0.77M
18	TitanSports Inc.	*WWF WrestleMania VII*	3/91	0.76M
19	SET	Chavez vs. Camacho	9/92	0.69M
20	TitanSports Inc.	*WWF WrestleMania VI*	4/90	0.68M

Source: Showtime Event Television estimates.

Another form of monthly pay service is known as **minipay service.** Such services (e.g., Flix) usually offer older product and fewer special events than regular monthly pay services at a much lower monthly fee. The home subscriber pays a basic fee, with additional monthly charges for the regular pay and minipay channels, and per program charges for each pay-per-view movie or event.

Video-on-demand (VOD) is a system of pay-per-view movies *without a defined program schedule*, usually delivered by newer distribution systems such as high-speed telephone lines and online via the Internet. Some PPV providers such as In-Demand (formerly the distributor Viewer's Choice) offer **NVOD (near-video-on-demand)** in which the same program is offered every ten or 15 minutes. Like pay-per-view, the subscriber orders movies and special events from a menu. Unlike traditional PPV, the programming is continuously available, eliminating the scheduling function for the programmer.

The Structure of Subscription and Premium Services

One way to understand the multichannel programming business is to consider the wholesaler-retailer analogy: National cable and other multichannel programming services are like coast-to-coast wholesalers in that they sell their product—*programming* —to regional and local outlets, the wired (or wireless) cable system operators (or satellite programmers). Multichannel providers are like retailers, because they sell their product—*television*

9.3 COMPARATIVE PREMIUM SUBSCRIBERS, 2000			
	Subscribers* (in millions)		Subscribers* (in millions)
Pay-TV		**PPV**	
HBO	26.7	In Demand	29.0
Cinemax	14.8	BET Action	10.0
The Disney Channel**	1.0	Hot Network	8.0
Showtime	13.6	TVN Digital Cable	5.0
The Movie Channel	8.0	Spice	13.0
Flix	0.9	Spice 2	10.3
Movieplex	9.5	Playboy	11.3
Starz Encore	22.3	ESPN Extra	1.0
		Erotic Network	2.0
		Pleasure	0.3

*Cable and satellite combined
**Primarily a basic service

Source: www.cvmag.com/database.

programming services—to consumers, home by home and subscriber by subscriber. The wholesaler's four functions are:

1. Licensing existing shows or financing original programming created by Hollywood's studios or independent producers, or in conjunction with international joint-venture partners

2. Packaging programming in a form acceptable to consumers (by providing interstitial promotions such as wraparounds, titles, on-air hosts, and graphics)

3. Delivering programming by satellite to cable or other multichannel provider operators

4. Supporting their products with national advertising and promotion and by supplying advertising materials and co-op dollars at the local system level

The cable or DTH operator as retailer must decide how best to market the channels of programming within the local system's inventory (**shelf space**). Just as a supermarket manager has to allot shelf space to products, deciding to display some more prominently than others, a multichannel provider must decide which premium and basic cable services to offer and promote to subscribers. In making these marketing decisions, the local manager considers channel capacity, the demographics of the subscribership, the program distributor's pricing and level of promotional support, and the number of local broadcast stations that are carried. Many programming decisions are made by the MSO for all or most of its systems rather than by local operators.

Shelf space varies greatly among the nearly 12,000 U.S. cable systems.[1] Premium services compete with one another (and with advertiser-supported subscription channels) for a share of the shelf space on local cable systems by offering financial incentives as well as promotion and advertising support. (Local systems promote their premium services extensively to increase **lift** and thus revenue from subscriptions.) Premium subscriberships as of 2000 are shown in 9.3. Note that these are *not* **reach** but actual paying subscriber rolls.

The licensing of many American television programs and movies follows a pattern beginning with the most profitable U.S. markets and ending with international distribution. Basic cable networks bid directly against local broadcast stations for the rights to popular movie packages and off-network television series. Because of the way original contracts for most series are written, program services pay much lower **residuals** than broadcast stations do. Residuals, as discussed in Chapter 4, are payments to the cast and creators every time the program is shown. Licensing fees for cable networks can be as much as $100,000 per episode, but lower than for broadcast stations.

As a result, basic cable television has become a key **aftermarket** in the progression of sales of movies and programs, generating hundreds of millions of dollars in profits for U.S. and foreign program distributors. Since the late 1980s, the largest cable networks have consistently outbid broadcasters for first rerun rights to newly available hour-long adventure and drama series and even some half-hour situation comedies. (As discussed in Chapter 3, in syndication, hour series are less useful to broadcasters, and even some successful action series such as *NYPD Blue* underperform half-hour sitcoms.) A few theatrical films have gone straight from theaters to basic cable, and many European television series go directly to cable. Basic cable also has become a **foremarket** for some programs that later appeared on U.S. broadcast stations. For example, *Politically Incorrect* migrated from Comedy Central to ABC in 1996.

SELECTION STRATEGIES

To fully understand programming strategies, it is first necessary to grasp the economic fundamentals of multichannel service. *Unlike the broadcast model of maximizing the audience size, the multichannel model seeks to maximize subscriber revenue.*

Economics

After years of slow growth, the cable/satellite channel universe has expanded to hundreds of program services. The change came with regulation, rebuilt cable systems, and digital compression. Another impetus was the Internet, which promises to deliver its own set of program services (see Chapter 10). With multichannel programmers finally realizing the expansion of the "cable" universe, the key to maximizing revenue in the two primary **revenue streams** (subscriptions and advertising) is understanding ways to generate the greatest value. *In the case of cable subscriptions, the path to enhanced value is through tiering.*

Tiering, grouping basic cable channels in stair steps with increasing monthly charges, has the dual advantage of helping viewers find specific channels (convenience) and providing additional money for cable operators (economics). At the same time, tiering poses a threat to the advertising revenues of such broad-appeal (foundation) services as USA Network and TNT while holding out promise of channel space for theme-oriented networks. Successful niche and microniche services that aggressively attract targeted viewers lift the entire group of channels with which they are packaged. Less-defined channels, however, become vulnerable when tiered as they lose identity unless they have high-profile programs. Consequently, tiering has led some cable networks to compete for recent off-network series and led others to increase their efforts in producing or purchasing original programming and undertaking aggressive promotion and marketing. Gone are the days when cable was merely recycled programming. The number of subscribers (more than 85 million homes) justifies more and more original programming.

Advertising is one main revenue stream. Agencies base their decisions on reach, frequency, selectivity, and efficiency. Cable is highly selective but it lacks universal reach. It is ironic that cable networks stole away the broadcast audience by offering so many choices, because the new constellation of channels works against the kind of mass audience viewing that supports big-dollar advertising. Targeting specific audiences is great, but the efficiency lost in smaller and smaller groups of viewers produces diminishing returns in selectivity. As more cable networks launch, find distribution, and

ultimately, acquire broader household penetration, cable program services have begun to feast on themselves in the same way that they consumed broadcast network share.

Most basic subscription networks are advertiser-supported and bundled in tiers by multichannel systems to subscribers (see Chapter 8). Basic services come either as part of the system's standard service (**basic**), grouped (in an **expanded basic** or new product tier), or are sold separately (**a la carte**). After calculating actual viewers, most of these newer networks do not attract an audience large enough for buys by most major advertisers, but cable's abundance of narrowly targeted programming appeals to the nation's niche marketers. These smaller, specialized advertisers, once restricted to print or an occasional broadcast special, now have the opportunity to reach a broader audience through cable networks. Thus, national cable networks offer advertisers, in the words of one observer, "a rifle shot versus a shotgun blast [of broadcast]."

Besides advertisements, carriage fees are the main support for cable networks. In most arrangements, the cable operator pays a monthly license fee to the program supplier, and these fees normally expand in each contract renegotiation. So that large systems with more potential viewers pay more than small systems, cable network license fees are usually structured as per-subscriber per-month charges to the cable operator. The monthly fees range from about 10 cents per subscriber for services such as Court TV and The Weather Channel to about 55 cents per subscriber for more popular services such as CNN and TNT (the high price of sports contracts has driven up the cost of channels that bid high for the telecast rights). For advertising-supported networks, there is a tension between getting the national penetration necessary to pass along to the advertisers and keeping the carriage fee high enough to pay the bills. Many new channels pay **launch fees** and offer free carriage to appeal to potential cable operators. For example, E! Entertainment offered $7 per subscriber and free carriage when it launched The Style Channel. In 1996 the Fox News Channel paid $10 per subscriber to be added to DirecTV's lineup. By

1998, DTH providers were charging new networks an average $6 per subscriber.

Fox Sports Network 1 carries a rate of 90 cents to $1 per subscriber, per month, while its second network charges 45 cents to 55 cents. ESPN's charges have rocketed to about $1.20. At 20 cents, A&E's license fee would be on par with that of Lifetime Television, which is also owned by Disney and Hearst. Sources said Lifetime's rate card is in the 18- to 19-cent range. Even at 20 cents, A&E's rate would be way below that of a service such as Turner Network Television, for example. TNT's rate card is between 50 and 60 cents.

On the pay channels, feature films are licensed to pay-television networks in one of two ways: per subscriber or by flat fee. *Per subscriber* means that the film's producer or distributor negotiates a fee per customer for a specific number of runs within a fixed period, the number varying with the presumed popularity of the film. Such a fee is based on the actual number of subscribers who had access to the film (though not necessarily the number who actually saw it). In a *flat-fee* arrangement, the parties negotiate a fixed payment regardless of the number of subscribers who have access to it.

Once the pay-cable networks grew large enough to pay substantial amounts for the pay-television rights to a movie, they usually abandoned the per-subscriber formulas and negotiated flat-fee arrangements with the program suppliers. The flat-fee method is also used for acquiring original programming. In pay-per-view, however, the cable operator pays a per-subscriber fee to either the studio or PPV service provider.

Program Types

Just as there are different types of nonbroadcast channels, there are various types of multichannel programs. Signature programs and vignettes characterize the cable and satellite universe.

Signature Programs

Tough competition for viewers drives most cable networks to strive for **signature programs,** unique programs or a pattern of programs that distinguish

a network from its competition. *Signature programs create a well-defined image for the network and breed a set of expectations for both audiences and advertisers.* These expectations, whether positive or negative, help viewers select which channels to watch and lead advertisers and their agencies to expect that advertisements on some channels will or won't be effective. A lack of program definition, or absence of signature programs, killed off several early cable services.

Four major types of signature programs appear on cable program services. The first consists of *original movies or series* not shown elsewhere, also called made-for-cable movies and programs. Although they are expensive to produce, they are highly promotable and attract new viewers more than repeat programming. A second type of signature programming consists of *narrow theme genres,* such as all live nightclub comedy or all shop-at-home or all instructional programs. BET's *Comicview* is an example of the comedy nightclub genre. A third type consists of programs for a *niche audience,* or viewers with a narrowly defined set of interests or within a targeted demographic group. For example, USA Network seeks a young male audience with *Strip Poker.* The fourth, and least common type of signature programming, consists of the *cable exclusive,* programs shown once or twice on the broadcast networks but not shown before on cable.

Vignettes

Another common genre in cable consists of vignettes, or **interstitials.** This type of short-form programming, traditionally a staple of pay services and used between movies that end at odd times, has found its way onto basic program services. Comedy Central spends about three minutes per hour on interstitial programming, including *Topicals,* quick skits on the day's news, and *Pipeline,* clips from stand-up comics. *Although the primary purpose of vignettes is to promote branding, they also serve as "back-door pilots."* Nickelodeon saw interstitials as a way to boost the network's brand name and began putting more money into vignette development, realizing that they are far cheaper to produce than half-hour pilots. Moreover, vignettes

can be aired repeatedly to gauge viewer interest. Nickelodeon's *The Adventures of Pete and Pete* series started in short-form, and the network's preschool block used interstitials to test the waters for a new Muppet show.

Many cable networks use interstitials even though the airtime could be sold to advertisers. For example, *Perspectives on Lifetime,* a series of editorials and interviews tied to issues such as breast cancer awareness or events such as Black History Month, contributes to the overall mosaic of the channel. Lifetime has even experimented with live hosting between programs to achieve a seamless look with no commercials on the hour or half hour, thus keeping viewers away from their remote controls. Turner Classic Movies (TCM) shows vintage filler called *One Reel Wonders* between featured movies.

Originals

Despite the continued use of off-network programming, the dominant trend for cable networks is toward more commissioned, coproduced, or solely produced original programming. The shift began in the early 1990s when the USA Network and Turner Broadcasting's TNT made a commitment to original movies. By the early 1990s, about three-quarters of cable programming overall was original to cable or "first run" of some sort. Most were of the low-budget variety, but in recent years cable networks have increased their budgets for original programming.

One result of the increase in cable's original programming is that conventional distinctions among broadcast network, syndicated, and cable program services have faded. *Cable networks use original programs to distinguish their programming from that of their competitors.* The issue of **branding** —defining and reinforcing a network's identity— has become more important as the multichannel universe expands. Not surprisingly, the 20 or so foundation services are leading the charge in original programming, while the newer niche services are a bit more cautious about spending at a rapid rate.

Basic Channels

It is useful to examine cable programming networks in terms of their content and audience appeal because competition for shelf space on cable systems and advertisers occurs largely among similar services (see 8.4 for graphic display). Some basic services such as the USA Network consist of a broadly appealing mix of program forms similar to those of broadcast television; these are the broad-appeal networks (or **full service**) and they include **superstations.** Superstations are typically independent broadcast television distributed by satellite to cable systems across the country or within a given region. As previous discussions have suggested, most program services—and especially the newer and proposed services—are niche (or theme) and microniche (and multiplexed subniche) services that focus on a particular type of program content or target a specific demographic group.

The top 20 cable networks were listed in 9.1. Several national program services daypart in a manner similar to the broadcast networks by offering a broad program array targeting a mass audience. These broad-appeal services—TBS, TNT, USA Network, The Family Channel, and WGN (superstation)—are among the most popular of all program services. Nearly every kind of program seen on a broadcast network has been tried by these full-service cable networks, although not all have proved successful. Despite the shift to more original cable programming, off-network syndicated hours such as *Law & Order, ER,* and *NYPD Blue* remain very popular with audiences of broad-appeal networks.

Broad-appeal networks generate income for the sale of commercial time because they reach the same mass audience sought by the broadcast networks. Of course, the cable networks reach far fewer viewers, so the price of commercials is less. In some cases, advertisers use the lower rates charged by the cable networks to negotiate for lower rates from the broadcast networks. If the **cost-per-thousand** (homes reached) is too high for broadcast networks, many advertisers spend less for over-the-air networks and supplement their audience reach by purchasing spots from the cable networks.

DTH Services

Through a small (18-inch) dish, subscribers to direct broadcast services have access to hundreds of channels, including basic cable networks, pay movies, PPV events. After an industry shakeout in the late 1990s, only two DTH companies remain in the United States: DirecTV and DISH (Echostar). The selection strategies for DTH have benefited from the immense shelf space of satellite capacity (see Chapter 8). *Programmers need not choose as carefully because there's room for so much programming.* Even so, the finite allotment of transponders and the limits of video compression keep the number of services well under 600 channels.

Premium Channels

Every cable system in the United States carries at least one premium service, and more than 90 percent carry two or more monthly pay services. Pay-per-view is available nationally using addressable technology (see Chapter 8). Because it is expensive, cable systems offer pay-per-view services. As of 2000, the addressable pay-per-view universe approached 50 million homes, and nearly all of the 68 million cable subscribers had access to some form of pay-per-view, with 35 million with access to digital cable. The newer direct-to-home services like DirecTV and DISH are able to offer more PPV channel capacity through the use of digital set-top converter boxes. Cable systems have begun the conversion to digital set-top boxes to remain competitive.

Microsoft, AOL, and Yahoo! are major Internet players who want to share the revenue bonanza expected from pay television. Many strategic alliances were formed around the turn of the century, and it will be interesting to see which ones hold up. AOL stands the best chance because of its purchase of Time Warner, but don't count Microsoft out.

If a system has only one pay channel, the odds are very high that it is Home Box Office (HBO). HBO achieved its leading position through its early entry into pay TV in 1972 and early adoption of satellite delivery in 1975 (Showtime began

9.4 CHANNEL SPINOFFS

A&E
Biography Channel
History Channel International

BET
BET Soundz R&B
BET Gospel
BET World Music Beat
Rap/Hip Hop

Discovery
Civilization
Home & Leisure
Kids
Science
Wings
Health
en Español
People

E! Entertainment
Style

Encore Media Group
Starz! Family
Starz! Cinema

HBO
HBO Family
HBO Comedy M
HBO Zone

Multimax: ActionMAX
Multimax: ThrillerMAX

HGTV (Home & Garden)
Do-It-Yourself

International Channel Network
International Channel
ART (Arabic)
RAI (Italian)
The Filipino Channel
Zee TV (Indian)
TV ASIA (South Asia)
CCTV4 (Chinese)
TV5 (French)

Liberty CANALES
Canal 9
CBS TeleNoticias
Cine Latino
Fox Sports Americas
Box Exitos
Box Tejano

Lifetime
Lifetime Movie Network

Rainbow Media
AMC—American Pop
Bravo—World Cinema

Showtime Networks
Showtime Beyond
TBD (Gen-Y emphasis)

Viacom's "The Suite from MTV Networks"
MTV:
 M2
 MTV "S"
 MTV "X"
 VH1 Country
 VH1 Smooth
 VH1 Soul
Nickelodeon:
 Noggin
 Games & Sports (GAS)
 Nick Too

The Weather Channel
Weatherscan
Weatherscan Local
Weatherscan Radar
Weatherscan +
Weatherscan + Traffic
Weatherscan Español

in 1976 and moved on the bird in 1978). These early leads were then consolidated through aggressive national marketing campaigns in the 1980s that competitors could not afford with their smaller audience bases. Relatively few systems carry just Showtime, Flix, or one of the other pay services. With HBO in the primary role, the competition among the others focuses on securing shelf space as the second or third (or even fourth) service

provider on the local cable system's menu of premium offerings.

HBO's main competition comes from Cinemax, The Disney Channel, The Movie Channel, Showtime, Flix, and Starz/Encore. All of the services have spun off additional services to take advantage of increased shelf space using newer digital delivery systems with compressed video. Many of these spinoffs are listed in 9.4.

Selection strategies for pay channels differ from basic channels. Because viewers pay a premium, they have higher expectations of the programming on premium channels.

Multipay Environments

The idea of multipay subscriptions—the sale of multiple premium channels to a single cable household—had its most rapid growth in the early 1980s, only to quickly level off in the face of consumer irritation over duplication of film titles and the ready availability of videocassettes. A decade earlier, most cable experts thought subscribers would be willing to pay for one or, at the most, two premium channels. A ceiling effect on total cable bills was assumed. One view was that subscribers would resist paying more for cable than they did for their telephone bills (around $30 per month on average for upper-income families at the time). Later many cable systems found that the more pay-per-view channels they had, the higher the **buy rates** (number of purchases of individual events) among subscribers. The 1990s brought forth the further multiplication of pay and pay-per-view channels called **multiplexing** (see Chapter 8). Some movie networks adopted a **time shifting** strategy to achieve staggered start times; Disney placed different programs and movies on its second feed.

Selling subscribers additional premium services has proved an easier task than keeping them. Three patterns in pay **churn** occur. As the initial excitement of signing up for cable services wears off, some subscribers naturally decide to keep only those premium channels they watch and enjoy the most (**downgrading**). Other subscribers, believing that the programming offered by the major movie services is too much alike, cancel those where duplication of movie titles seems the highest or where the perceived value of the entertainment declines. A number of other subscribers migrate from service to service (**spin**). When a new premium service is marketed in a cable system with a long-established lineup of premium services, subscribers tend to cancel one service in favor of a new one (**substitution**). This happened in several

communities when the adult-oriented Playboy Channel and, at the other end of the spectrum, the family-oriented Disney Channel was introduced. Many subscribers substituted them for their existing pay services rather than adding them to their current subscriptions.

Pay-cable programmers have adopted strategies focusing on image and programming to combat churn. They try to develop a unique identity or image for a service through advertising and promotion (**differentiation**), and they create unique, original programs and pay high prices to license the **exclusive rights** to movie titles. Those services competing with HBO—particularly Showtime—target their movies to more carefully defined audiences and directly counterprogram HBO's lineup. Differentiating program content through acquisition of exclusive rights to hit movies and developing appealing and promotable original shows has become key to the pay services' competitive strategies.

Economic considerations come strongly into play when a local system is deciding which premium networks to carry. Cable systems charge their subscribers about $8 to $12 more than the basic monthly cable bill to receive a premium channel. The local system operator sets the exact monthly charge, usually within a range negotiated with the program supplier. The revenue for a premium channel is distributed between the *programming service*, which licenses the programming and is responsible for delivering it to the cable system **headend** (its technical distribution facility), and the *cable system operator*, who receives the satellite signal, delivers it by coaxial cable to subscriber homes, and then bills them for the service. Though subject to negotiation, about 50 to 60 percent of the monthly revenue usually goes to the program service, while 40 to 50 percent goes to the cable operator.

Pay-per-view services, which sell individual programs, operate somewhat differently from pay services. In general, the distributor and the operator divide sales revenue either 50/50 or 60/40 (in favor either of the pay-per-view packages or the cable operator). The **revenue split** often varies

from title to title, however, depending on the *program licensing fee* involved and the *potential audience size*.

Video-on-demand (VOD) is sufficiently similar to pay-per-view that the same strategic considerations exist. Furthermore, VOD and NVOD are not limited to cable and satellite television. Any multi-channel provider (e.g., the phone companies) can offer menu-based services. Indeed, even conventional broadcasting stations can be part of this brave new world through online services, second channels negotiated from cable operators in return for retransmission consent, and multiplexed digital channels using spectrum set aside for HDTV.

Not everyone is wildly optimistic about widespread video-on-demand in the near future. For one thing, it may not make much sense to invest a lot of money to create complex media options when most viewers are interested in the latest Hollywood releases. Few people go to the video store to rent anything but the most popular movies. The number of options is less important than the ready availability of hot movie titles.

As of this writing, it is not clear what audiences want, even to them, because not all of the options are clear or tested. When sufficient numbers of VOD users subscribe to such services, the cost for each requested program will decline. It is the classic chicken-or-egg situation: Which will come first, the technology at a low price or the programming content? And the next question is, how fast will the Internet bring streaming video to TV viewers?

Movies

The staple of both pay cable and pay-per-view remains the Hollywood feature film, aired soon after theatrical release. *The rapidity with which a film can be offered to subscribers is central to establishing a premium service's viability and value*. Speed is of particular importance to the pay-per-view services, which generally present top movie titles 6 to 9 months after their initial domestic theater distribution—still usually a few weeks after home video. In contrast, the usual exhibition window for the monthly premium channels is 12 to 15

months after theatrical release, with the broadcast networks following at 18 months to 2 years. Enough money can change the pattern, however, as when CBS premiered ten Universal films prior to pay cable in the 1990–91 season.

None of the national premium services as yet carry commercials. With rare exceptions, films are shown unedited and uninterrupted, including those rated PG-13 and R (containing strong language and behavior normally censored on broadcast television). The pay-per-view services and at least Cinemax on the pay side also run films in the NC-17 category (formerly X-rated).

Entertainment Specials

In addition to theatrical films, several monthly pay-cable services offer original movies, series, and high-gloss entertainment specials created expressly for their subscribers. Other programming formats include original documentaries, magazine series, and blends of entertainment and documentary styles. A few made-for-cable series employing soap opera or situation comedy formats have been created, and a rare few former broadcast series (off-network) have been licensed to premium networks for new episodes.

Selecting performers to star in original pay-cable specials and choosing properties to adapt to the television medium requires an in-depth examination of subscribers' expectations. Because the major broadcast networks can offer opportunities to see leading entertainers, either on specials or daily talk/variety shows, premium programmers are forced to seek fresher, more unusual entertainers and material. Among their options are:

1. Using performers who are well-known but who appear infrequently on broadcast network television

2. Using performers often seen on broadcast television but who rarely headline their own programs

3. Developing programs and artists unavailable on broadcast television

Unlike the typical broadcast network special, every effort is made by pay-cable producers to preserve the integrity of a complete performance,

without guest stars, dance numbers, and other window dressing used to widen the audience base of most broadcast network variety shows. At their best, these shows are vivid reproductions of live performances. Pay-television's time flexibility also permits nightclub acts and concerts to run their natural lengths, whether one hour and 11 minutes or one hour and 53 minutes. The private nature of pay-television viewing also allows for telecasting adult-oriented comedy and dramatic material unsuitable for airing on broadcast television.

Sports

The third major component in pay programming is sports. HBO and Showtime schedule major, big-ticket, national sporting events in prime time. Sports programming creates a divergence of opinion, however, in the pay-television community, with some programmers arguing that sports blur a movie service's image. In consequence, neither The Movie Channel nor Cinemax carries sports.

Because of the broadcast networks' financial strength and audience reach (and a general consensus that certain events like the Super Bowl should stay on over-the-air television), ABC, Fox, CBS, and NBC still manage to acquire the rights to most major sporting events. Premium networks often have to settle for secondary rights or events of lesser national interest. Nevertheless, an audience can be found for some sports that broadcast television does not adequately cover, such as middle- and heavyweight boxing, regional college sports, track and field, swimming, diving, soccer, and equestrian competitions.

Big-ticket boxing and wrestling have been programming staples for pay-per-view packagers for many, many years. In the mid-1980s, the relatively *small number of headline events* and the relatively *small universe of pay-per-view-equipped homes* took PPV out of contention for major events. The rapid expansion of the number of homes with pay-per-view in the late 1980s, however, combined with the success of such events as *Wrestlemania* and championship boxing, rekindled cable operator and subscriber interest in pay-per-view sports. In addition, several regional pay-per-view sports

channels became successful as PPV technology and marketing improved.

In the late-1990s, major PPV boxing matches on cable and National Hockey League games on DirecTV not only achieved record **buy rates** and revenues but helped fuel publicity for PPV itself. The key to success apparently lies in having strong local and national marketing efforts.

PPV and VOD

Interactivity is one way to enhance original PPV offerings. For example, Playboy Television has had so much success with its call-in show *Night Calls* that a spinoff *Night Calls 411* has been spawned. Neither program is expensive to produce, but both generate significant revenue (and thousands of phone calls). Because cable operators get 70 to 80 percent of the $8 per program cost for adult programming (compared to 50 percent of the $4 cost for typical movies), premium television is banking on adult fare.

Jack Trout has written a business-strategy book called *Differentiate or Die*. The message is that businesses cannot survive unless they are unique in some way. Along these lines, some believe that one way to differentiate local cable from other multichannel providers is to offer community programming on a pay-per-view basis. In the future, having eight to ten movies on a server won't be enough.

Launching a Network

Nowadays, launching a network into the multichannel environment requires careful strategy by would-be programmers. On one hand, increased capacity on cable and satellite systems creates greater opportunities. On the other hand, most multichannel services have maximized what can be reasonably passed along to the consumer, especially with political pressure to slow the rising monthly cost of cable-TV.

The first strategy is to pay a **launch fee** to the cable system, typically $5 to $9 per subscriber. Another method is to allow large MSOs to become a partner in the venture. With all the mega-mergers of media industries at the turn of the century,

fewer players are controlling larger pieces of the multichannel universe.

Another way to facilitate distribution is not to charge cable systems for carriage. Some cable networks have launched by reversing the traditional model of carriage, paying MSOs to carry them. Because of excessive start-up costs, there have always been difficulties launching a new cable network. Start-up costs typically vary from $40 million to more than $100 million.

Sheldon Altseld, a TV show producer and founder of The Silent Network, a service for the deaf and hearing-impaired, is an adviser to would-be cable networks. He conducts seminars around the country on how to start a new program service and has an online book and web site, *How to Start Your Own Cable TV Network* (www.cablemaven.com/). His advice to network entrepreneurs includes four key ideas:

1. At least five people have the same idea as you. Success depends on execution

2. Start small, a two- or three-hour programming block somewhere. BET (Black Entertainment Television) started out as a Friday late-night portion of USA Network

3. Network for financing through sources such as those one meets at Chamber of Commerce functions or look to overseas investment firms for support

4. Aim for a particular audience, then reach out to community representatives in that group

Altseld has been surprised by the number of people anxious to start a network. He believes that all the hype over the information superhighway has encouraged people to try anything.[2] Unfortunately, most have no idea how to get started. Altseld's views on the essentials for network survival are listed in 9.5.

Cable networks, mostly those with MSO support, have used various strategies to launch and market themselves. Many unique efforts stand out in the crowded field of hopefuls. For instance, The Game Show Network and FX visited towns and toured malls with various kinds of stunts. *BET on*

9.5 NETWORK STARTUP "SURVIVAL KIT"

Start-up network needs, in order of importance:

- Distribution
- Stable regulatory environment
- Carriage and infrastructure expansion incentives
- Deep pockets
- A la carte distribution
- A well-constructed business model
- Clear niche programming agenda
- Aggressive brand marketing
- Experienced employees

Source: *Cablevision,* 25 July 1994, p. 35.

Jazz and Ovation cosponsored entertainment festivals and concerts. Home & Garden Television personnel visited flower shows and music festivals.

Incubation strategies have become more traditional (and successful) among new cable networks. These refer to such approaches as sheltered launches that help new networks establish themselves before moving full speed ahead. Americana Television, a 24-hour country lifestyle channel, got its start as a part-time service on Nostalgia Television. Viewers could watch a *BET on Jazz* program on BET before Jazz Central launched. Turner Classic Movies (TCM) showed up on TNT, and Cable Health Club was initially part of The Family Channel. To gain sampling, newer networks such as Game Show Network, The Golf Channel, Sci-Fi Channel, TCM, and The Cartoon Network have also turned to DTH for distribution. One final strategy, and a solution to low distribution for new networks, is **piggybacking** or sharing a channel with another service. NewsTalk Television launched with 4 million part-time homes as well as 3 million full-time homes. Romance Network was thus given a slot on American Movie Classics (AMC) on Sunday afternoons. American Pop is

another example, having been incubated on AMC on Saturday nights.

Regardless of shelf space, a high mortality rate will continue among new services. No matter what a network's programming entails, limited distribution into America's subscription households will make it difficult to cover operating costs. Thus, three basic ingredients are needed to survive: a good (programming) idea, smart people behind the idea, and money.

In addition, new program services need to be flexible with tiering, pricing, and packaging. At least two major outcomes will result from this potentially overcrowded cable environment: First, cable operators will remove older foundation services that have become stale in favor of new services; and second, and more common, start-up services will sell out to other (larger) networks. Due to the high cost of maintaining a single network infrastructure in general and of programming in particular, a service that is comarketed with several other networks simultaneously reduces sales, marketing, and engineering/production costs. Further, it helps to be able to lose money through sister companies.

SCHEDULING STRATEGIES

Subscription and premium channels need to follow the same general practices outlined in Chapter 1: conservation or resources, habit formation, and so on. Until the day when viewers truly can choose anything, anytime, the job of the programmer will be crucial to the success of the program service.

Basic Channel Scheduling

The so-called basic channels, almost all carrying advertising and appearing on the lower tiers of cable systems, have unearthed several program scheduling ideas that appeared for a short time on broadcast services but better suit the special needs of cable program suppliers. These include program marathons and alternatives to ratings to build their appeal to advertisers.

Marathons

Marathons, or all-day, all-night continuous program scheduling of the same series, often are used by cable networks to counterprogram major broadcast events like the Super Bowl. Marathons are also scheduled during holidays, protracted bad weather periods, or any time viewers are likely to turn into "couch potatoes." There have been plenty of examples: Leading up to and on Mothers' Day, WTBS gave viewers a *Leave It to Beaver* marathon that included Beaver's mother June Cleaver (Barbara Billingsley) as the host; Nick at Night provided a week-long "Marython"—the return of *The Mary Tyler Moore Show*. During a Super Bowl, The Family Channel ran 14 hours of *Bonanza: The Lost Episodes*, while Nostalgia Television ran 14 hours of *Family*, a 1970s drama, and A&E offered 13 hours of *Masterpiece Theatre's Jewel in the Crown*. Marathons can generate exposure for a newly acquired show as well as remind viewers that a popular show appears on the network. Because the networks promote marathons heavily, they usually perform well—even better than their average programming—which can lead to increased advertising sales.

Homogeneity and Zoning

Cable has developed criteria other than ratings for selecting and scheduling national and local services and for attracting advertisers. Cable executives generally emphasize the demographic or psychographic **homogeneity** of viewers of a particular service. Viewers of MTV, for example, are alike in age and interests; viewers of Lifetime are mostly women. A second and related strategy is **zoning,** dividing an **interconnect** into tiny geographic areas to deliver advertising, which permits local businesses to purchase low-cost ads that reach only their neighborhood. Advertising interconnects are arrangements for the simultaneous showing of commercials on ad-supported services. Although interconnects are cable's primary strategy for increasing the size of salable audiences, they generally occur only in and near large markets, which leaves thousands of cable systems with unsalable (too small and undefined) audience sizes.

Roadblocking

Another strategy is **roadblocking,** scheduling the same ad on all cable channels at the same time so the advertiser's message blankets the cable interconnect (see Chapter 8). Roadblocking, in theory, keeps grazers from using their remote controls to avoid commercials, although noncommercial channels are available. Nonetheless, viewers often quickly give up surfing when the same commercial message appears on channel after channel.

Cable networks are analogous to radio stations in a single market: numerous and fragmented. No one can deny their media reach, but few can figure a way for each individual program service to compete with any of the individual broadcast networks. In some sense, cable programmers must focus their strategies on hard-to-reach audiences, just as radio programmers do.

Pay Channel Scheduling

Rotation scheduling is a major area of difference between pay-cable and broadcast television. Most pay services offer a range of 20 to 100 movies per month, some first run and new to the schedule (**premieres**), some repeated from the preceding month (**carryovers**), and some returning from even earlier (**encores**).

In the course of a month, movies are scheduled from three to eight times on different days and at various hours during the daily schedule. Different movie services offer varying numbers of monthly attractions, but all services schedule most of their programs more than once. (Programs containing nudity or profanity, however, rotate only within prime time and late night on most networks.) The viewer, therefore, has several opportunities to watch each film, special, or series episode. These *repeat showings maximize the potential audience for each program.* The programmer's scheduling goal is to find the various complementary time slots delivering the greatest possible audience for each attraction during the course of a month, not necessarily in one showing.

Unlike the monthly pay-cable networks, pay-per-view services rotate *rapidly* through a short list

of top-name Hollywood hit films. The same movie may air as few as four or as many as ten times in a day. This occurs because pay-per-view programmers market "convenience viewing." Pay-per-view networks either rotate two to four major movie titles a day, some across multiple channels, or run the same movie continuously all day. As the number of channels available to pay-per-view increases, the trend is to assign one movie per channel, thus emulating the "multiplex" theater environment.

Title Availability

Balancing the number of major films and lesser known but promotable titles every month, then adding a handful of encore presentations, is one of the key challenges a premium movie programmer faces. A crucial factor in preparing the lineup is title availability. Most films with good track records at the box office are obtained from major film distributors, but an increasing number can be purchased from a wide variety of independent distributors and producers.

Theatrical films distributed by major studios are typically available to pay-per-view services six to nine months after their initial theatrical release, and available to monthly pay services six months after their pay-per-view release. Usually it does not make economic sense for studios to hold a film in theatrical release for more than a year, but video sales have disrupted this pattern and delayed the availability of some big films. The home video **sell-through** is a film priced to be bought rather than rented by consumers. (For rentals, the studios receive revenues only from the initial purchase of each tape by the retailer.) Successful sell-throughs of extremely popular films, even at much lower wholesale prices, are a distributor's dream—and the studios maximize revenues by delaying pay television release.

Time constraints on the use of films also affect steady product flow, including *how long* and *when* a film is available to pay services. Commercial broadcast television buyers, for example, traditionally had the financial clout to place time limitations on distributors' sales of films to premium services. The broadcasters would seek early telecast

of key films to bolster their ratings during Nielsen ratings sweeps, shortening the period of time during which the films were available to premium networks. The number of such key films of interest to the broadcast networks has been dropping, however, as their ratings deteriorated because of increased home video and pay cable penetration.

Some desirable films are unsuitable for broadcast sale altogether, increasing their pay television staying power. Films such as the *Emmanuelle* series, although not recent, crop up again and again because they never enter **broadcast windows.** A film such as *Something About Mary* would require such massive editing for broadcast television that it would be destroyed in the process. Therefore, distributors allow premium networks to schedule them as many times as they like for as long as they like.

Occasionally, the major pay-movie services disagree about whether to schedule a movie *after* it has already had a commercial broadcast network run. HBO and Showtime have found a pay-cable following for these movies when they are shown unedited and without commercials. Some survey research even demonstrates viewer support for reshowing films that have been badly cut for commercial television presentation or that have exceptionally strong appeal for repeat viewing. Almost all pay services show selected off-network movies, often drawing sizable audiences.

Exhibition Windows

Distributors create a **distribution window** for a film's release when offering it to the premium services. In this arrangement, premium programmers negotiate for a certain number of first-run and second-run plays during a specific time period, generally 12 months. For example, a given film may be made available to a pay-cable service from April to March. It might premiere in April, encore in August, and then play again the following March to complete the run. Programmers must project ahead to see that the scheduled play periods for similar films from different distributors do not expire at exactly the same time. Generally, pay services don't want to waste their scarce resources by running five blockbusters, four westerns, or

three Kevin Costner films in the same month. Such clustering can be advantageous, however, when the films can be packaged and promoted as special "festivals."

Broadcast television's scheduling practices, organized around the delivery of commercial messages, differ broadly, resulting in the weekly series, the daily soap opera, and the nightly newscast. In most cases, an episode is shown only twice in one year, and the largest possible audience is sought. Some premium networks have adopted the short-length formats of broadcast television, such as episodes of *Beggars & Choosers* on Showtime and *Sex in the City* on HBO. The shorter length (not to mention the provocative content) helps these first-run shows get sold internationally and later into syndication. Most pay programs, however, run to their natural lengths, ending when and where the material dictates rather than running in fixed segments to accommodate commercials. Even with series programs, frequent repetition and rotation throughout the various dayparts set premium program scheduling apart from broadcast scheduling. Also, *broadcasters set their schedules for an entire season—pay and pay-per-view set them one month at a time.*

Monthly Audience Appeal

Another major contrast between broadcast television and the premium programming services lies in their revenue-generating strategies. To maximize ad revenues, commercial networks and broadcast stations program to attract the largest possible audiences every minute of the programming day. Premium cable networks, as explained in Chapters 2 and 8, try to attract the largest possible cumulative audiences over the period of a month.

The lifeblood (read *daily operating revenues*) of a pay service is its direct subscriptions. Pay-per-view services must satisfy their customers movie by movie, event by event, or night by night. Pay-television services must satisfy their subscribers month to month, throughout the year, forestalling disconnections. A premium service's success is not determined by the audience ratings of its individual programs but by the general appeal and

"satisfaction levels" of its overall schedule. Insofar as quantitative measures such as ratings reflect that appeal (especially for one-shots like boxing matches or a live Madonna concert), they are useful in gauging response. In cable, however, where subscribers must be persuaded to pony up month after month, qualitative measures take on greater importance.

Another quantitative measure is subscriber turnover. Because both schedules and subscriber billings are arranged by the month, viewers tend to evaluate programming in month-long blocks. Subscribers will most likely continue the service for another month, if:

1. They use their pay service two or three times a week

2. They see benefits in its varied viewing times

3. The service runs commercial-free, uninterrupted program content

4. The service runs unique entertainment programs and theatrical feature films

The pulse of pay-per-view success is measured by the **buy rate.** Careful matching of buy rates and titles offers both the pay-per-view distributor and the system operator a tool for fine-tuning scheduling and promotion plans.

Discontinuing a month-to-month pay service seldom reflects dissatisfaction with one or two individual shows. When viewers disconnect, they feel that the service *as a whole* is lacking. Customers repelled by violence, for example, may disconnect a movie service if a large number of a particular month's films contain a great deal of violence. A family may determine that its desire for wholesome, G-rated fare is not being filled by the programming mix of one particular movie service and so will cancel after a trial month or two.

This process also works in reverse. Favorable word of mouth remains the most potent method of attracting new customers, particularly in nonurban communities. As such, a handful of individual programs each month makes the difference between success or failure when a premium service is new in a community and the local operator lacks

a large and stable subscriber base. Having one or two blockbuster films undoubtedly attracts new subscribers to a service and holds current subscribers even if their reaction to the balance of that month's schedule is negative. Such blockbusters are also essential in the marketing practice known as "free previews," in which basic cable subscribers receive a premium service free for a couple of days.

Movie Balancing Strategies

Selecting programs that will appeal to different target audiences through the course of a month becomes the challenge for most pay programmers. For example, if a particular month's feature films have strong appeal to teenagers and men 18 to 49, the obvious choice for an entertainment special is a show that appeals to women. Pay-television programmers break down their audiences according to:

1. Urban-rural classifications

2. Age groups of 18 to 24, 25 to 49, and 50+

3. Gender

By scheduling programs each month that will appeal to all these groups, the programmer creates a "balanced" schedule.

Films subdivide into several groups with overlapping appeals. The major audience attractions for that month are the premieres—that is, the films that were recent box-office hits and are being offered for the first time on that premium service. These films may be G-, PG-, or R-rated by the movie industry.

The second group of films placed in the schedule are the major G- and PG-rated films. This establishes a strong pattern of family and children's appeal in the schedule. The third group of films have varied adult audience appeals. Films without notable box office success usually fall into this category. They are repeated slightly less frequently than premieres and G-rated hits.

Other films that were not major theatrical hits may still rate as important acquisitions for pay-television services. Viewers may value seeing a film on television that they might not be willing

to pay $3 to $6 to see in a movie theater. Foreign films fall in this group.

Also, if a pay network feels that a particular film has appeal to a segment of its audience, it doesn't matter if it was originally made-for-home video or made-for-broadcast television; films in both categories increasingly show up on pay schedules. Another growth category is film classics.

Film Placement

General rules of thumb for film scheduling include beginning weeknight programming at 7 or 8 P.M. and starting final showings (of major offerings) as late as 11:30 P.M. to 12:30 A.M. Those networks concentrating on the overnight daypart employ still later final showing schedules. For most of the premium movie services, an evening consists of three to five programs, depending on individual running lengths. Entertaining short subjects, elaborate animated titles, and promotional spots for other attractions fill the time between shows. All-movie networks especially favor movie-oriented shorts, such as interviews with directors or location tours.

The premium services no longer **frontload** their films (that is, schedule most of them at the start of the calendar month). Using 16 or more new films each month (not counting carryovers of the previous month's late premieres) usually means scheduling *four premieres each week*, gradually integrating first-, second-, third-, and up to sixth-run presentations week by week so the viewer has a constantly changing lineup of material from which to choose—and new movies appear every week.

Counterprogramming broadcast network schedules is another strategic consideration. For example, on Monday nights when *Monday Night Football* is a strong ABC attraction, premium networks tend to schedule films with female appeal. Preceding or following a popular broadcast network show with a program of the same genre on pay cable creates a unified programming block for viewers (requiring channel switching, an easy move in cable homes with remote controls). Beginning programs on the hour as often as possible—especially during prime time from 8 to 11 P.M.—makes it convenient for viewers to switch to and from pay cable.

Films and specials containing mature themes are usually scheduled at later hours than G-rated films, even though pay television is not bound by broadcasting's traditions. PG features are offered throughout premium schedules. Monthly program guides have encouraged parents to prescreen all films rated PG, PG-13, or R early in the week to decide which are appropriate for their children to watch on subsequent airdates.

Ironically, all rules with regard to mature themes can vanish during *free preview* promotional periods. Some parents who manually delete unsubscribed pay channels from the electronic tuner on their television sets have discovered that enterprising youngsters learn to key in the channel number to watch R-rated movies during the free showings of premium channels.

EVALUATION

Audience evaluation remains a problem in the cable industry. Inadequate viewing data hampers many national advertiser-supported networks in selling time—especially the newer niche services. Although *the total number of a system's subscribers is always known more or less accurately,* and the most popular services are rated by A. C. Nielsen, how many subscribers view the less popular nonpay channels cannot now be accurately measured on most systems.

Comparison Problems

Cable penetration has experienced some growth in the mid-1990s. Although many observers believed that cable had stopped at a plateau of about 60 percent of households in America, cable service exceeded 68 percent by 2001 and has continued to grow slowly. In addition, cable penetration in foreign countries was bounding ahead. Individually, however, audience ratings for most cable networks (excluding the top ten services) have only occasionally exceeded 1 percent of television households at a time. In fact, the very top services celebrate a 4 rating in prime time (about the same

as a 2 among all 101 million television households). Although the combined audience for cable-only channels frequently exceeds that of the broadcast channels, the broadcast business is still very healthy. Advertisers traditionally buy one channel at a time, however, so combined ratings are not much comfort to them.

Cable Ratings

As discussed in Chapter 2, ratings for cable networks really represent three audience measurements. One measure is the audience watching a *particular program at a given time*, measured by AQH ratings and shares as in national broadcast ratings. A second measure is the cumulative audience that watches a *given program in all of its showings*, because some program services repeat shows. When all viewers of repeat showings of a program (such as a movie) are summed, the audience for that one program may exceed a competing broadcast station's audience. The third and perhaps most important measure to cable networks is the *cumulative audience for a channel*. Although peoplemeters have benefited the established cable networks by increasing their reported share of prime-time viewership, they reveal little about the viewing of less popular advertiser-supported services. Cable networks must commission their own research to understand viewing by such demographic subgroups as children, teens, and ethnic minorities.

The overriding problem in evaluating cable program audiences is that local audience shares cannot be compared directly with local over-the-air audience shares. As 9.6 shows, cable **franchise areas** differ in size and shape from markets defined according to broadcast station coverage patterns (DMAs). This type of map prevents advertisers from comparing cable's effectiveness with that of broadcasting and other media in one market.

Currently, Nielsen requires a channel to be available in about 3.3 percent of U.S. TV households (about 3.4 million homes) to qualify for its national cable TV ratings report, the Nielsen Cable Activity Report (NCAR). Further, to show up in the report, the channel has to generate at least a 0.1 rating in their coverage area (the number of households a channel is carried in).

Although total cable-originated programming averaged a 25.5 Nielsen prime-time rating in 2001, most viewers apparently watch the established services. The weekly cumes still favor the broadcast channels (see 9.7). Despite gains in basic cable network ratings, it remains to be seen whether they can score consistently good ratings with original programs, especially series. Further growth in the number of channels will make ratings increases difficult. Cable programmers and consultants are divided over how to best increase ratings. Some believe that heavy series production is necessary (USA Network); others argue for original movie production, heavy promotion, and more effective scheduling (TNT).

The cable industry reports its own ranking of top shows, according to "cable ratings," which are based on multichannel homes, not all television homes. The rankings in 9.8 are based on cable ratings, but the ratings shown in the table are household ratings. Apparently it's possible for Sunday night wrestling on USA to have a larger cable rating than a corresponding total household rating.

CABLE NETWORK PROMOTION

Like the broadcast networks, all subscription and premium networks have economies of scale that can support sophisticated marketing. Although some newer networks strive to acquire new viewers, the usual strategy is retention of existing viewers while developing new services. Above all, promoting **brand identity** (e.g., Lifetime—Television for Women) is the key marketing goal.

The subscription channels with the largest number of regular viewers still use mass-market advertising to reach the audience, but the trend is toward highly-targeted marketing using customer database information about needs and wants, family income, and demographics. Armed with special lists, multichannel marketers use direct-mail to zero in on the right customer.

9.6 MAP OF BROADCAST MARKET SHOWING CABLE FRANCHISES

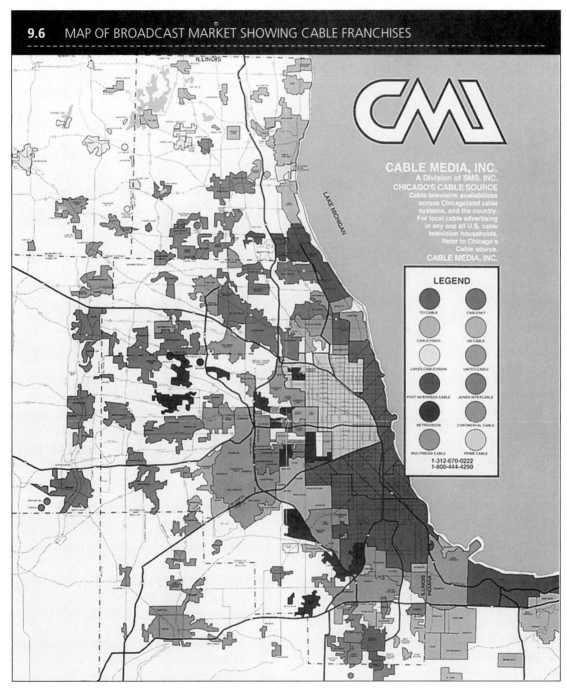

Source: Courtesy Cable Media, Inc. Used with permission.

9.7 NIELSEN CABLE ACTIVITY REPORT

Broadcast Affiliates	Average Weekly Cume %
NBC	84.9
ABC	84.6
CBS	84.1
Fox	75.9
Ind*	69.4

Cable Networks	Average Weekly Cume %
TBS	44.8
USA	41.7
TNT	40.9
DISC	34.1
A&E	33.3
NICK	32.5
LIFE	31.3
ESPN	29.7
TLC	26.4
CNN	25.0
FAM	24.8
TWC	24.8

*Nielsen currently includes UPN, WB, Univision, Telemundo, and Pax with independent stations in this report.

Source: Nielsen Media Research Cable Activity Report first quarter, 1999.

One promotional strategy is to differentiate marketing between nonsubscribers who never have subscribed (**nevers**) and those who have discontinued the service (**formers**). It is easier to sign up the ones who were former subscribers. Treating the different prospective groups separately simplifies the marketing plan and reduces wasted effort.

Premium channels seek greater **buy rates** by promoting specific events or signature programs (e.g., *The Sopranos* on HBO) through all available promotional vehicles. They also send special mailers to those who discontinued their pay channels. Anticipating and meeting customer expectations creates **brand loyalty** that is difficult to dislodge.

Specific tactics used by multichannel services include on-air **tune-in** and **cross-channel promotion.** Tune-in promotion encourages viewers to stay with the channel for upcoming programs. Cross-channel promotion allows regular viewers of one cable or satellite channel (or web site) to learn about the shows on another program service. Most of these efforts are accomplished using automated equipment with **insert capability** that can introduce one channel's promos into another channel's program lineup in predetermined time slots.

Premium channels develop sophisticated campaigns to market their programs year-round, using slogans, giveaways, and special package rates. The actual promotion vehicles include mass media advertising, reminders in monthly bills (**statement stuffers**), and coupons left at homes in plastic bags (**door hangers**). When trying to expand subscriptions in a local area, they may temporarily unscramble their signals to give cable viewers a taste of what they are missing.

Regardless of the method, programmers must get closely involved with the promotional and marketing effort on-the-air, in print advertising, and on related web sites. These days, the job of acquiring and scheduling content is tied to making sure that an audience will be there when the program is shown.

THE CHANNELS

The abundance of program services is astonishing to those who remember just three broadcast networks and then, slowly, 20 or so cable networks. Between 1998 and 1999, for example, the number of cable channels grew from 174 to 214. With a myriad of premium movie channels, the 500-channel universe foreseen years ago is finally at hand. Even the smaller digital cable networks boast the following:

1. Approximately 150 nationwide basic networks that carry advertising

2. More than 40 premium networks (pay-per-channel) that do not carry advertising

9.8 TOP CABLE SHOWS, JUNE 2000
NIELSEN RATINGS FOR WEEK OF 6/19/00 TO 6/25/00

Rank	Program	Network	U.S. Rating	Day
1	*WWF Entertainment*	USA	5.0	Monday
2	*WWF Entertainment*	USA	4.1	Monday
3	*NASCAR: Save Mart Kragen 350*	ESPN	3.6	Sunday
4	*Real World IX*	MTV	2.7	Tuesday
5	*Rugrats*	NICK	2.3	Saturday
5	*Rugrats*	NICK	2.3	Tuesday
7	*WCW Monday Nitro Live!*	TNT	2.3	Monday
7	Movie: *Desert Heat*	USA	2.3	Tuesday
7	*Hey Arnold*	NICK	2.3	Tuesday
7	*SpongeBob SquarePants*	NICK	2.2	Saturday
7	*Rocket Pocket*	NICK	2.2	Tuesday
12	*Rugrats*	NICK	2.2	Sunday
12	Movie: *Danielle Steel's The Ring, 2*	LIFETIME	2.2	Sunday
12	*South Park*	CMDY	2.2	Wednesday
15	*WWF Sunday Night Heat*	USA	1.8	Sunday
16	*Rugrats*	NICK	2.1	Sunday
16	*SpongeBob SquarePants*	NICK	2.0	Saturday
16	Movie: *Abduction of Innocence*	LIFETIME	2.0	Saturday
16	*Rugrats*	NICK	2.0	Monday
16	*Wild Thornberrys*	NICK	2.0	Monday
21	*WCW Thunder*	TBS	2.0	Wednesday
21	*Rugrats*	NICK	2.0	Monday
21	*Rugrats*	NICK	2.0	Saturday
21	*WCW Monday Nitro Live*	TNT	2.0	Monday
21	*Hey Arnold*	NICK	2.0	Wednesday
21	*Catdog*	NICK	2.0	Saturday
21	*Rugrats*	NICK	2.0	Tuesday
21	Movie: *Crimes of Passion*	LIFETIME	1.9	Sunday
21	*Rocket Power*	NICK	1.9	Tuesday
21	Movie: *Murder of Innocence*	LIFETIME	1.9	Saturday
21	Movie: *Blue Sky*	LIFETIME	1.9	Monday
21	*Road Rules IX*	MTV	1.9	Monday
21	Movie: *Danielle Steel's The Ring, 1*	LIFETIME	1.9	Sunday
21	*Flintstones*	TOON	1.9	Tuesday

Source: *Broadcasting & Cable*

3. About seven superstations

4. Dozens of pay-per-view channels

5. About 15 promotional guide channels and interactive services

6. Some 60 regional services

In addition to these existing services, many more proposed networks are poised in the wings. Some channels defy classification. For example, The Disney Channel is a premium channel on a few systems but a basic channel in most markets. The master channel list shown in 9.9 demonstrates

9.9 CABLE AND SATELLITE NETWORKS AVAILABLE IN 2001

Name	Type	DirecTV	DISH	Parent	Description
3 Angels Broadcasting Network	Religion		Religion		
A&E Television Networks (A&E)	Foundation	Ent/Arts	Variety		
All News Channel	News	News/Info			24-hour news service consisting of continuous 30-minute newscasts produced in Minneapolis/St. Paul by Conus Communications
AMC (American Movie Classics)	Movie	Ent/Arts	Variety		
AMC's American Pop!	Lifestyle			AMC	First digital entertainment network to offer convergence programming unified content for the web, digital cable, and broadband services
America's Voice	News	Ent/Arts	News/Info		24-hour television network and Internet site that turns talk into action on today's political and social issues
ANA Television	Foreign				Arab-Net provides news, public affairs, and educational and entertainment programming in Arabic and English
Animal Planet	Foundation		Family	Discovery	
ART (Arab Radio & Television)	Foreign				Wide selection of Arabic cultural and Islamic general entertainment programs
Asian American Satellite TV	Foreign				Chinese-language daily news, television dramas, movies, sports, and educational and entertainment programming
BBC America	Foreign	Ent/Arts	Variety		Best of British television to the United States including classic and contemporary dramas, comedies, documentaries, and the latest world news
BET (Black Entertainment TV)	Foundation		Variety		
BET Action Pay Per View	Movie			BET	
BET Gospel	Music			BET	Gospel music through music videos, exclusive in-depth interviews, concert performances, and inspirational speakers and programming
BET Movies	Movie			BET	
BET on Jazz: The Jazz Channel™	Music			BET	
Biography Channel, The	Foundation	Ent/Arts		A&E	Spin-off of the signature program on A&E
Bloomberg Television	News	News/Info	News/Info		
B-Movie Channel, The	Movie				B-movie originals and classic films from all over the world, including short films, unique animation, and award-winning student productions
Boomerang	Childrens	Ent/Arts			Classic Hanna-Barbera cartoons
Box Music Network, The	Music				Interactive, all-music television network that lets viewers select from a list of more than 300 available music videos of all music genres
Bravo Cable Network	Foundation	Ent/Arts	Variety		Best of documentary programs, studio and international film, and theater, dance and music presentations
Canal Sur	Spanish				Retransmitting live daily newscasts and the most popular shows from the leading broadcasting networks of Latin America
Canales	Foreign				Programming needs for the United States' Latino community's strong sense of heritage and cultural identity
Cartoon Network	Childrens		Family		
CCTV-4 (China Central Television)	Foreign				
Celtic Vision	Foreign				Entertainment and current affairs programming from Ireland, Scotland, and the entire Celtic world

Network					Description
Cine Latino	Spanish	Foreign			
Cine MoreMAX	Movie	Premium	Movies		
Cinemax	Movie	Premium	Movies	Cinemax	
Classic Arts Showcase	Niche	Ent/Arts			
CMT (Country Music Television)	Music	Ent/Arts	Music		
CNBC	News	News/Info	News/Info		
CNET, Inc.	Niche	News/Info			News, information, and resources related to computers and digital technologies
CNN (Cable News Network)	News	News/Info	News/Info	CNN	
CNN Headline News	News	News/Info	News/Info	CNN	
CNN/Sports Illustrated	Sports	News/Info			
CNNfn—the financial network	News	News/Info	News/Info	CNN	
CNNI (CNN International)	News	News/Info	News/Info	CNN	
College Entertainment Network	Niche	Ent/Arts			
Comedy Central	Foundation	Ent/Arts	Variety		
Court TV	Foundation	News/Info			
Crime Channel, The	Foundation	News/Info			Crime-related programming, meant to help improve law enforcement's image
C-SPAN	News	News/Info	News/Info		
C-SPAN EXTRA	News	News/Info	News/Info	C-SPAN	
C-SPAN2	News	News/Info	News/Info	C-SPAN	
CTN—The Chinese Channel	Foreign	Foreign			
Deep Dish TV	Niche	Niche			Educational programming distributed to PBS and public access channels
Discovery Channel, The	Foundation	Ent/Arts	Family	Discovery	
Discovery Civilization Channel	Foundation	Ent/Arts		Discovery	
Discovery en Español	Spanish	Spanish			
Discovery Health Channel	Foundation	Ent/Arts		Discovery	
Discovery Home & Leisure	Foundation	Ent/Arts		Discovery	
Discovery Kids Channel	Childrens	Childrens			By kids, for kids, age 7 to 14
Discovery People	Foundation	Ent/Arts	Variety	Discovery	
Discovery Science Channel	Foundation	Ent/Arts		Discovery	
Discovery Wings Channel	Niche	Niche		Discovery	
Disney Channel	Childrens	Childrens	Family		
DIY (Do-It-Yourself)	Lifestyle	Ent/Arts		HGTV	Lifestyle programming with a major focus on home, gardening, food, crafts, and decorating categories. The network has a companion web site to provide viewers with additional information
Dream Network, The	Lifestyle	Lifestyle			
E! Entertainment Television	Foundation	Ent/Arts	Variety		
ECOLOGY Communications	Lifestyle	Ent/Arts			Current trends, news, fiction, and nonfiction about the environment in a variety of entertainment-driven formats
Empire Sports Network	Sports	Pay Sports			
ENCORE Thematic Multiplex	Movie	Premium	Movies		
ESPN	Sports	Ent/Arts	Variety		

9.9 CABLE AND SATELLITE NETWORKS AVAILABLE IN 2001 (continued)

Name	Type	DirecTV	DISH	Parent	Description
ESPN Classic	Sports	Ent/Arts	Variety	ESPN	
ESPN Extra	Sports		Variety	ESPN	
ESPN Full Court	Sports	Sports		ESPN	
ESPN GamePlan	Sports	Sports		ESPN	
ESPN Now	Sports			ESPN	
ESPN2	Sports	Ent/Arts	Variety	ESPN	
ESPNEWS	Sports	Ent/Arts		ESPN	
Eternal Word Network (EWTN)	Religion		Religion		Documentaries, music, drama, live talk shows, animated children's shows, and special church events from around the world
FamilyNet	Foundation		Family		
Filipino Channel, The	Foreign				
Flix	Movie				
Food Network	Foundation	Ent/Arts	Variety		
Fox Family Channel	Foundation	Ent/Arts	Family		
Fox Movie Channel	Movie	Ent/Arts			
Fox News Channel	News	News/Info	News/Info		
Fox Sports (Regionalized)	Sports	Sports			
Fox Sports Latin America	Sports				
Fox Sports World	Sports	Sports			
Fox Sports World Espanol	Spanish				
FoxNet	Foundation				
FREE SPEECH TV (FStv)	Niche				Programming from independent video artists and activists who address cultural, social, and political issues and showcase experimental media
FX (Fox Basic Cable)	Foundation	Ent/Arts	Variety		
FXM: Movies from Fox	Movie			Fox	
Galavisión	Spanish	News/Info			
Game Show Network	Foundation	Ent/Arts	Variety		
Gay Entertainment Television	Lifestyle				Variety, talk shows, and movies with gay themes and subject matter
GEMS International Television	Spanish				Spanish-language cable network designed specifically to empower, educate, and entertain women
Golden Eagle Broadcasting	Religion				Contemporary Christian programming, it features more than 11 ministries, children's programming, outdoor, home, sports, and women's shows
Golf Channel, The	Sports	Sports			
GoodLife TV Network	Lifestyle				Programming for the baby boomer and older audience
Gospel	Religion		Religion		
Gospel Music Television	Religion		Religion		
Great American Country (GAC)	Music				
HBO (Home Box Office)	Movie	Premium	Movies		

Network					Description
HBO Comedy	Movie	Premium	Movies	HBO	
HBO Family	Movie	Premium	Movies	HBO	
HBO Plus	Movie	Premium	Movies	HBO	
HBO Signature	Movie	Premium		HBO	
HBO ZONE	Movie			HBO	
Health Network/Web MD, The	News	News/Info			
History Channel International	Foundation	Ent/Arts		A&E	
History Channel, The	Foundation	Ent/Arts	Variety	A&E	
HGTV (Home & Garden)	Foundation	Ent/Arts	Variety		
Home Shopping Network, The	Shopping	Shopping	Shopping		
Home Shopping Spree (Spree!)	Shopping				
Home Team Sports	Sports	Sports			
Hot Choice	Sex				Action-adventure and selected adult appeal movies, plus specials
HTV	Music				24-hour, all-Latin, all-music service. No VJs
Idea Channel, The	Niche				Uninterrupted discussions 20 to 40 minutes in length, featuring two or three leading scholars on a wide variety of subjects
iN DEMAND	Movie				
Independent Film Channel, The	Movie	Premium			
Inspirational Network (INSP), The	Religion				
International Channel	Foreign				
Knowledge TV	Niche		Niche		Useful, personally relevant news and information with programming on health, money, and technology
KTLA	Superstation		Superstn		
KWGN	Superstation		Superstn		
Ladbroke Racing Network	Sports				
Las Vegas Television Network	Niche				
Learning Channel (TLC), The	Foundation	Ent/Arts	Family	Discovery	
Lifetime Movie Network	Movie				
Lifetime Television (LIFE)	Foundation	Ent/Arts	Variety	Lifetime	
Locomotion Channel, The	Niche				The best international productions created specifically for audiences between 18 and 35 years and specializing in the animation genre
Madison Square Garden	Sports	Sports			
MBC Network, The	Religion				24 hours of family value programming from a spiritual perspective offering family-oriented programming aimed at a diverse audience
Midwest Sports Channel	Sports				
Military Channel, Inc.	Lifestyle				The worldwide military experience—from original documentary series and classic war movies to service academy sports
MLB Extra Innings	Sports	Sports			
MLB/ESPN Shootout	Sports	Sports			
MOVIEplex	Movie				Recent favorite movies, all without commercials with no R-rated movies, and PG-13 movies shown only in the evenings
MSNBC	News	News/Info	News/Info		

9.9 CABLE AND SATELLITE NETWORKS AVAILABLE IN 2001 *(continued)*

Name	Type	DirecTV	DISH	Parent	Description
MTV "S"	Music			MTV	
MTV "X"	Music			MTV	
MTV 2	Music	Ent/Arts	Music	MTV	
MTV Latin America	Music				
MTV: Music Television	Music	Ent/Arts	Music	MTV	
MuchMusic USA	Music	Ent/Arts			
MultiMAX: ActionMAX	Movie			HBO	
MultiMAX: MoreMAX	Movie			HBO	
MultiMAX: ThrillerMAX	Movie			HBO	
Music (audio)		31	24		
My Mind and Body TV	Lifestyle				Television and news media services to people affected by addictions and other behavioral health problems
My Pet TV	Niche				Original and acquired programming for America's 60 million pet owners
NASA Television	Niche		News/Info		Lift-off-to-landing shuttle mission coverage, press conferences, and public affairs events. News feeds, educational and informational programming
National Jewish Television	Religion				Relevant, enlightening, interactive family-based programming on the unique Jewish way of life, religion, and people
NBA League Pass	Sports	Sports			
NBA.com TV	Sports	Sports			
New Encore®, The	Movie				Recent big hit, first-run movies from the major studios, plus the great movies viewers know and love, uncut and commercial free
New England Sports Network	Sports	Sports			
Newsworld International	News	News/Info			24-hour international news from countries around the world
NFL Sunday Snap	Sports	Sports			
NFL Sunday Ticket	Sports	Sports			
NFL Sunday Ticket Extra	Sports	Sports			
NHL Center Ice	Sports	Sports			
Nick at Nite's TV Land	Foundation	Ent/Arts	Variety	Nickelodeon	
Nick Too	Childrens			Nickelodeon	
Nickelodeon GAS	Childrens		Family	Nickelodeon	Games and sports network
Nickelodeon/Nick at Nite	Childrens	Ent/Arts			
Noggin	Childrens	Ent/Arts	Family	Nickelodeon	Kids' thinking channel. Designed to reach kids 2 to 12 in distinct dayparts, commercial-free programming lineup
Oasis TV, Inc.	Lifestyle				Internet, broadband, and cable/satellite/broadcast TV platforms with branded programming targeting the holistic "New Age" lifestyle market
Odyssey	Foundation	Ent/Arts			Family programming from Henson and Hallmark
Outdoor Channel, The	Lifestyle		Variety		Outdoor lifestyle programming: hunting, fishing, camping, hiking, and so on
Outdoor Life Network	Lifestyle	Sports			Outdoor recreation, conservation, wilderness, and adventure

Network					Description
OVATION—The Arts Network	Lifestyle	Ent/Arts			All of the arts, including arts news from around the world and children's arts programs
Oxygen Media, Inc.	Foundation	Ent/Arts			Empowering and educating women. By women, for women. Founded by Geraldine Laybourne, Carsey-Werner-Mandabach, and Oprah Winfrey
Pax TV	Foundation	Ent/Arts	Family		
PBS Kids	Childrens	Ent/Arts			Programs kids love, parents trust, and educators endorse
PBS National Feed	Foundation	News/Info			
PBS YOU	Foundation	News/Info			
Playboy TV	Sex	Adult			Adult
Pleasure	Sex	Adult			Adult pay-per-view network that airs high-quality, exclusive (nonduplicative) movies and programs, with traditional editing standards (fully edited)
Praise Broadcasting	Religion		Religion		
Praise Television	Religion		Religion		Family entertainment network with an emphasis on music
Product Information Network	Shopping				Short-form and long-form advertising
Proto x	Lifestyle				Exclusive programming by and for 18 to 34 audience (independent film, provocative series, alternative animation, music videos, news coverage
QVC	Shopping	Ent/Arts	Shopping		Home shopping
RAI International	Foreign	Ent/Arts			Italian TV
Romance Classics	Movie	Ent/Arts			
Scandinavian Channel	Foreign			AMC	
Sci-Fi Channel	Foundation	Ent/Arts	Variety		
SCOLA	News				TV news retransmitted from approximately 40 countries to more than 8,000 schools, colleges, and universities throughout the Americas
Shop at Home	Shopping		Shopping		
Short TV	Niche				Solely dedicated to airing the short films produced and directed by today's emerging filmmakers
Showtime	Movie	Premium	Movies		Showtime
Showtime Beyond	Movie	Premium	Movies		Showtime
Showtime Extreme	Movie	Premium	Movies		Showtime
Showtime Three	Movie	Premium	Movies		Showtime
Showtime Two	Movie	Premium	Movies		Showtime
SingleVision					
SkyView World Media	Foreign				Foreign language ethnic programming, available in Russian, Arabic, Italian, Filipino, Greek, Chinese, Asian, Vietnamese, and Ukrainian
Soapnet	Foundation	Ent/Arts			Soap opera news and same-day telecasts of popular soap operas
Speedvision Network	Sports	Sports			Beyond traditional event programming, providing in-depth and authoritative automotive, marine, aviation, and motorcycle coverage
Spice 1	Sex				
Spice 2	Sex				
STARZ!	Movie	Premium	Movies		Starz
STARZ! Cinema SM	Movie		Movies		Starz
STARZ! Family SM	Movie				Starz
STARZ! Theater	Movie	Premium	Movies		Starz

9.9 CABLE AND SATELLITE NETWORKS AVAILABLE IN 2001 (continued)

Name	Type	DirecTV	DISH	Parent	Description
style	Niche			E! Channel	The world of style, fashion, and design, and the people and events shaping these businesses
Sun TV	Spanish				Original programming from the Caribbean, Central and South America (news, sports, entertainment, sitcoms, soaps, talk shows, and tourism)
Sundance Channel	Movie	Premium	Movies		The best, new independent films including features, documentaries, shorts, animation, and international cinema running uncut and commercial free
Sunshine Network	Sports	Sports			
TBN—Trinity Broadcasting	Religion	News/Info			
TBS Superstation	Foundation	Ent/Arts	Superstn		
Telemundo	Spanish				Spanish programming
TeN (The Erotic Network)	Sex				
TMC (The Movie Channel)	Movie	Premium	Movies		
TNN (The Nashville Network)	Foundation	Ent/Arts	Music		
TNT (Turner Network Television)	Foundation	Ent/Arts	Variety	TBS	
Toon Disney	Childrens	Ent/Arts	Family	Disney	Disney Company's vast animation library
Travel Channel	Foundation	Ent/Arts	News/Info		
TRIO	Foreign	Ent/Arts			Top-rated shows from the UK, Canada, Australia, New Zealand, and South Africa
Turner Classic Movies (TCM)	Movie	Ent/Arts	Variety	TBS	
TV 5—La Television Internationale	Foreign				International, French-speaking network with programming from France, Switzerland, Belgium, Canada, Quebec, and French-speaking Africa
TV Asia	Foreign				
TV Games	Sports				Live horse racing plus interactive home wagering
TV Guide Sneak Prevue	Foreign				
TV JAPAN	Foreign				
TVN Entertainment Corporation	Movie				32 digital channels of pay-per-view movies, sports, concerts, and special events, plus 40 digital music channels and an interactive program guide
Universal Torah Broadcasting	Religion	News/Info			The Divine guidance of the Torah, the blueprint for living
Univision	Spanish				
USA Network	Foundation	Ent/Arts	Variety		
UVTV/KTLA	Superstation				
UVTV/WGN	Superstation				
UVTV/WPIX	Superstation				
ValueVision	Shopping	News/Info	Shopping		Home shopping television service
VH1 (Music First)	Music	Ent/Arts			
Video Catalog Channel	Shopping				Antique and collectible home shopping
WAM! America's Kidz Network	Childrens				Commercial-free children's channel dedicated to providing kid-friendly, socially responsible programming 24 hours a day for 8- to 16-year-olds
WB Pay-Per-View	Movie				

Weather Channel, The	Foundation	News/Info	News/Info	
WGN Superstation	Superstation	Ent/Arts	Superstn	
Wisdom® Television	Lifestyle			Programming includes holistic health, self-development, and the mind-body connection
WNBA Season Pass	Sports	Sports		
Word Network	Religion	News/Info		
WorldJazz	Music			Jazz for national and international enthusiasts
WorldLink TV	News	News/Info		
Worship Network, The	Religion		Religion	
WPIX	Superstation		Superstn	
WSBK	Superstation		Superstn	
WWOR	Superstation		Superstn	
Z Music Television	Music			Christian videos
ZDTV (Your Computer Channel)	Niche	News/Info	Family	Anything and everything about technology and the Internet

that some channels can be described in different ways. Regardless of classification by the multi-channel providers, there are other ways to divide the services.

Foundation and Niche Services

In 2001, the number of U.S. homes with fiber or coaxial cable television stood at 68 percent. This household penetration grew to 80 percent with cable and satellite homes combined. Cable and satellite distribution of programs is a $40 billion business with annual programming expenditures for the subscription channels at $8 billion.

Why do people subscribe? For the abundance of basic choices, usually without much attention to the other businesses that have come along: cable modems, cable telephony, and so on. John Malone, chairman of TCI before the AT&T merger, used to call basic "plain vanilla cable"—now over-shadowed by digital offerings. Sanford Bernstein & Co. media analyst Tom Wolzien sees the number of basic subscribers declining in the near future. Wall Street investors expect more out of their cable stocks because the prices are 17 to 19 times cash flow—considerably more than the 10× rates of the 1990s.

National subscription networks can be differentiated in terms of how established they are and who they target. **Foundation networks**—generally the earliest entries, most firmly established, and most popular—reach about 85 million subscriber homes each. The largest (CNN, ESPN, and TBS) reached over 200 million homes worldwide. Some of them began life as **theme networks** and grew into channels that serve more than a niche. Comedy Central is an example of a theme network that has become a foundation network.

True **niche networks** usually have either a single program content type (all music, all shopping) or target a defined demographic group (just children, just Spanish-speaking) with a mix of program types. Another type of niche network is the **branded niche network,** which is the product of further specialization within a theme network. For example, the concept of the Cartoon Channel has

proliferated into specific cartoon channels by animators, like Boomerang (Hanna-Barbera) and Toon Disney. **Microniche services** target a population subgroup (the hearing impaired or foreign language speakers) or provide programming that is a further differentiation of a niche service (women's sports or independent films). Currently, microniche networks include Asian American Satellite TV, The Independent Film Channel, and The Filipino Channel.

The trend with niche program services is toward greater competition. In almost every category or genre, the dominant service has many challengers. ESPN and CNN have been the premier channels of their type, but Fox Sports and Fox News are starting to make a dent in the audiences of the established services. This section lists the various channels devoted to the main program categories.

Finally, and not to be confused with microniche services, are **subniche networks,** where basic and pay services subdivide into even more narrowly targeted channels that are managed and owned by one parent company or network. Most notably, Discovery Communications, which operates The Discovery Channel (foundation) and The Learning Channel, launched several subniche services, and other services are beginning to follow their lead. As newer technologies permit the proliferation of channels, the strategy of **channel spinoffs** is becoming more commonplace. See 9.4 for a list of channel spinoffs as of 2001.

Subniche services are made possible by cheaper satellite time resulting from digital compression. As outlined in Chapter 8, **digital compression** encourages a process called **multiplexing,** distributing several different channels simultaneously, usually 12 digital channels squeezed onto one old analog channel. In some cases, the "new" services run the same programs scheduled at different times. In other cases, programs are subdivided by target audience, and each channel focuses on one target audience. Although satellite-delivered programming is already digital, cable systems have been busy updating their own analog channels to digital channels that can take advantage of compression.

Most of the newer and proposed program services fit into the niche, microniche, and subniche categories. Very few seek broad appeal. According to one cable programmer, these newer services will function like radio station formats, targeting a specific audience segment with demo-specific talent, promotions, and programming.[3]

The 13 Categories of Programming

What are the various formats and genres found on subscription and premium television? Previous editions of this book have gone into considerable detail on each channel. That made sense when there were 20 or 30 channels that almost everyone received, but now the landscape has grown immense and complex. This section looks at the various services available in 2001 by dividing them into 13 general types. Basic channels have been lumped together with premium channels to complete the list, with the latter services listed in italics as needed.

Foundation

With the exception of a few brand-new services, these channels are found on nearly every multichannel service in the United States, so it is likely that the reader is already quite familiar with the content on many. For the rest, please consult the master chart in 9.9 for a capsule description.

A&E Television Networks (A&E)

Animal Planet

BET (Black Entertainment Television)

Biography Channel, The

Bravo Cable Network

Comedy Central

Courtroom Television (Court TV)

Crime Channel, The

Discovery Channel, The

Discovery Civilization Channel

Discovery Health Channel

Discovery Home & Leisure

Discovery People

Discovery Science Channel

E! Entertainment Television

FamilyNet

Food Network

Fox Family Channel

FoxNet

FX (Fox Basic Cable)

Game Show Network

History Channel International, The

History Channel, The

HGTV (Home & Garden Television)

TLC (Learning Channel, The)

Lifetime Television (LIFE)

Nick at Nite's TV Land

Odyssey

Oxygen Media, Inc.

Pax TV

PBS National Feed

PBS YOU

SCI FI Channel

Soapnet

TBS Superstation

TNN (The National Network)

TNT (Turner Network Television)

Travel Channel

USA Network

Weather Channel, The

Children's

For a while, only one or two channels targeted to children found their way onto the cable/satellite lineups. Nowadays, several choices are available. Noggin is Nickelodeon's answer to PBS programming, right down to the use of the Sesame Workshop as a supplier.

Boomerang

Cartoon Network

Discovery Kids Channel

Disney Channel, The

Nick Too

Nickelodeon GAS (Games & Sports)

Nickelodeon/Nick at Nite

Noggin

PBS Kids

Toon Disney

WAM! America's Kidz Network

Foreign

Until the availability of digital channels, the only way to receive foreign channels was to live in a very large city or stay at a Disney hotel. Dozens of options have found their way onto the lineups of both satellite services and some cable MSOs in very large metropolitan areas. Many of these networks have high production values and provide Americans a chance to learn about other cultures.

ANA Television

ART (Arab Radio & Television)

Asian American Satellite TV

BBC America

Canales

CCTV-4 (China Central Television)

Celtic Vision

CTN (The Chinese Channel)

Filipino Channel, The

International Channel

RAI International

Scandinavian Channel

SkyView World Media

TRIO

TV5—La Television Internationale

TV Asia

TV JAPAN

Lifestyle

Lifestyle channels are the niche and subniche channels that instantly remind viewers that they

are not watching regular broadcast television. The content is very specialized, but so are the advertising and viewers.

AMC's American Pop!
DIY (Do-It-Yourself)
Dream Network, The
ECOLOGY Communications
Gay Entertainment Television
GoodLife TV Network
Military Channel, Inc.
My Mind and Body TV
Oasis TV, Inc.
Outdoor Channel, The
Outdoor Life Network
OVATION—The Arts Network
Proto x
Wisdom® Television

Movies

A look at the list of channels suggests that multiplexing and NVOD are alive and well in today's multichannel universe.

AMC (American Movie Classics)
BET Action Pay Per View
BET Movies
B-Movie Channel, The
Cine MoreMAX
CinemaEnt/Arts
Cinemax
ENCORE Thematic Multiplex
Flix
Fox Movie Channel
FXM: Movies from Fox
HBO (Home Box Office)
HBO Comedy
HBO Family
HBO Plus
HBO Signature

HBO ZONE
iN DEMAND
Independent Film Channel, The
Lifetime Movie Network
MOVIEplex
MultiMAX: ActionMAX
MultiMAX: MoreMAX
MultiMAX: ThrillerMAX
New Encore, The
Romance Classics
Showtime
Showtime Beyond
Showtime Extreme
Showtime Three
Showtime Two
STARZ!
STARZ! Cinema SM
STARZ! Family SM
STARZ! Theater
Sundance Channel
TMC (The Movie Channel)
TCM (Turner Classic Movies)
TVN Entertainment Corporation
WB Pay-Per-View

Music

Channels that offer different music formats have grown beyond the limited MTV/VH1/TNN option of the early 1990s. For example, there are five different variations of the trailblazing MTV service.

BET Gospel
BET on Jazz: The Jazz Channel™
Box Music Network, The
CMT: Country Music Television
Great American Country (GAC)
HTV
MTV "S"
MTV "X"

MTV 2

MTV Latin America

MTV: Music Television

MuchMusic USA

VH1 (Music First)

WorldJazz

Z Music Television

News

What was once CNN and CNN Headline News has now expanded to several options. The financial services enjoyed a growth spurt during the heyday of the 1990s stock market.

All News Channel

America's Voice

Bloomberg Television

CNBC

CNN (Cable News Network)

CNN Headline News

CNNfn—the financial network

CNNI (CNN International)

C-SPAN (Cable Satellite Public Affairs News)

C-SPAN EXTRA

C-SPAN2

Fox News Channel

Health Network/Web MD, The

MSNBC

Newsworld International

SCOLA

WorldLink TV

Religion

The number and variety of religion channels has grown in the past decade. Some of these channels sign leases to pay for their space on subscription services.

3 Angels Broadcasting Network

Eternal Word Network EWTN

Golden Eagle Broadcasting

Gospel

Gospel Music Television (Dominion Video)

INSP (Inspirational Network, The)

MBC Network, The

National Jewish Television

Praise Broadcasting Network (Dominion)

Praise Television

TBN—Trinity Broadcasting Network

Universal Torah Broadcasting Network

Word Network

Worship Network, The

Sex

Soft-core pornography still abounds on multichannel services. Social norms that used to discourage the proliferation of such services are eroding, especially with reformers' attention focused on hard-core Internet pornography.

Hot Choice

Playboy TV

Pleasure

Spice 1

Spice 2

TeN (The Erotic Network)

Shopping

Home shopping channels continue to attract viewers, but the number of services has leveled off in the past decade. Again, competition from the Internet has drawn away some customers.

HSN (Home Shopping Network, The)

Home Shopping Spree (Spree!)

Product Information Network (PIN)

QVC

Shop at Home

ValueVision

Video Catalog Channel

Spanish

Instead of the "foreign" category, this programming reflects the mainstream Hispanic or Latino viewer in the United States. Advertisers are keenly interested in this growing population segment.

Canal Sur

Cine Latino

Discovery en Español

Fox Sports World Español

Galavisión

GEMS International Television

Sun TV

Telemundo

Univision

Sports

ESPN and ESPN 2 are still the main purveyors of cable sports, but they get plenty of competition from Fox Sports and from the many regional sports channels. The most recent trend is to differentiate each channel by the sport itself, rather than a league or channel owner. As men are a difficult-to-reach advertising target, the revenue potential is very high. On the other hand, rights fees continue to sky-rocket (see Chapter 5).

CNN/Sports Illustrated (CNNSI)

Empire Sports Network

ESPN

ESPN Classic

ESPN Extra

ESPN Full Court

ESPN GamePlan

ESPN Now

ESPN2

ESPNEWS

Fox Sports (Regionalized)

Fox Sports Latin America

Fox Sports World

Golf Channel, The

Home Team Sports

Ladbroke Racing Network

MSG (Madison Square Garden)

MSC (Midwest Sports Channel)

MLB Extra Innings

MLB/ESPN Shootout

NBA League Pass

NBA.com TV

NESN (New England Sports Network)

NFL Sunday Snap

NFL Sunday Ticket

NFL Sunday Ticket Extra

NHL Center Ice

Speedvision Network

Sunshine Network

TV Games

WNBA Season Pass

Superstations

Local stations with sports and movies can get national attention. Most originate from very large cities.

KTLA

KWGN

KTLA

WGN

WPIX

WGN

WPIX

WSBK

WWOR

The preceding lists of channels by type are what springs to mind when someone mentions "cable network," but a growing number of subscribers get their "cable" from satellite channels.

Direct-to-Home Satellite Programming

As discussed in Chapter 8, satellite operators (including **HSD** for **home satellite dishes, DTH** for **direct-to-home,** and **DBS** for **direct broadcast satellite**) had a growth spurt between 1997 and the early 2000s, at the expense of cable. For example, in 1998 the percentage of the pay-TV market held by cable dropped from 85 the previous year to about 80 percent. Cable responded to the challenge with a satellite-overlay service called HITS²Home (Headend in the Sky), which seamlessly brought up to 140 digital channels (via satellite) to analog subscribers in small systems where the capital costs of headend conversion were deemed too expensive.

By mid-2000, DTH operators had discovered how to bring mainstream local TV stations to subscribers, something that had been a disadvantage vis-à-vis conventional cable. This technique, called **local-into-local,** requires the retransmission consent of these local stations located in large population centers. Penetration estimates for DTH have been set at 25 to 30 million homes by 2005 (thereby doubling in five years), but media analyst Tom Wolzien predicts growth only through 2002, when Internet delivery of pay-per-view begins to take off (see Chapter 10).

DirecTV is the dominant DTH supplier in the United States. It linked with Blockbuster in 2000 to offer co-branded PPV service on DirecTV. It was projected that 6 million of Blockbuster's 40-million base would get DTH by 2004.[4] DirecTV is noteworthy for its promotional efforts. In 2000, it began offering new subscribers two free months of 32 movies channels and 25 sports networks. It also offers upper tiers of service, launching its Family Pack, which included newer channels: The Biography Channel, Boomerang, Discovery Kids, Do-It-Yourself, Odyssey, Oxygen, PBS Kids, and SoapNet.

If DirecTV is the Hertz, then DISH (aka Echostar) is the Avis of DTH. It has cast itself as the underdog, complaining that DirecTV and RCA colluded to keep DISH out of big-box retailers Best Buy and Circuit City.

With the benefit of digital compression, DTH offers hundreds of channels via satellite. The shelf-space limitation described in Chapter 8 is tied to the economics of offering 500 or more channels. A master list of the services offered by schedule for the two DTH services is shown in 9.10, with an indication of how the channels are **tiered.** *In general, the foundation channels appear on the lowest levels, and the newer niche services are offered on the higher tiers.*

Digital Cable

Although DTH boasts better picture quality than conventional analog cable, the real reason that many people began signing up for DirecTV and DISH in the late 1990s was the sheer abundance of channels: more than one hundred on DTH versus 50 or 60 on analog cable TV. Cable's response, which has been slow and expensive to accomplish, was to convert its analog systems to digital so that more channels could be offered. Digital cable also makes NVOD (near-video-on-demand) a reality. From a programmer's standpoint, more services can be offered without as many shelf-space considerations.

The problem is cost. By 2001, many cable system operators had capped the number of basic analog channels, forcing new channels to go onto digital tiers. Even DTH programmers realized that the economics of continually adding channels to a basic service (e.g., DirecTV "Total Choice" at $31.95) did not make sense. Moreover, launch fees for new channels do not cover the eventual cost-per-subscriber costs of so many channels.

Still, a **digital tier** lets cable collect about $9.95 per month for an additional 30 or so channels using 10:1 video compression, where one analog channel carries ten digital channels. Time Warner Cable launched such a digital tier (branded "DTV") and projected 100,000 subscribers by 2002. It included 30 new channels, several premium multiplexes (e.g., HBO, HBO Plus, HBO Signature), and four near-video-on-demand channels.

9.10 DTH PROGRAMMING

DISH

DISH Channel Lineup	Package		
	Top 150	Top 100	Top 70 Top 40 A La Carte
America's Voice	x	x	x
American Movie Classics	x	x	x
Angel One (Sky Angel 100 Ministries)	x	x	x
Animal Planet	x	x	x
Arts & Entertainment	x	x	xx
BBC America	x	x	
BYUTV	x	x	x
Biography	x		
Black Entertainment Television	x	x	
Bloomberg Information Television	x		x
Boomerang	x		
Bravo	x	x	
C-SPAN	x	x	xx
C-SPAN2	x	x	xx
CD-70sSongbook	x	x	x
CD-Acoustic Crossroads	x	x	x
CD-Adult Alternative	x	x	x
CD-Adult Contemporary	x	x	x
CD-Adult Favorites	x	x	x
CD-Big Band Era	x	x	x
CD-Blues	x	x	x
CD-Classic Rock	x	x	x
CD-Concert Classics	x	x	x
CD-Contemporary Christian	x	x	x
CD-Contemporary Instrumentals	x	x	x
CD-Contemporary Jazz Flavors	x	x	x
CD-Country Classics	x	x	x
CD-Country Currents	x	x	x
CD-Easy Instrumentals	x	x	x
CD-EuroStyle	x	x	x
CD-Fiesta Mexicana	x	x	x
CD-Hot Hits	x	x	x
CD-Jazz Traditions	x	x	x
CD-Jukebox Gold	x	x	x
CD-KidTunes	x	x	x
CD-LDS Radio Network	x	x	
CD-Latin Styles	x	x	x
CD-Light Classical	x	x	x

9.10 CONTINUED

DISH Channel Lineup	Package		
	Top 150	Top 100	Top 70 Top 40 A La Carte
CD-Modern Rock Alternative	x	x	x
CD-New Age	x	x	x
CD-New Country	x	x	x
CD-Non-Stop Hip Hop	x	x	x
CD-Power Rock	x	x	x
CD-Reggae	x	x	x
CD-Urban Beat	x	x	x
CNBC	x	x	xx
CNN Financial/CNN International	x	x	
CNN/Sports Illustrated	x		
Cable News Network	x	x	xx
Cartoon Network, The	x	x	xx
Comedy Central	x	x	xx
Country Music Television	x	x	xx
Court TV	x	x	x
DELLL	x	x	x
DISH Info	x	x	x
DISH Info 1	x	x	x
DISH MUSIC—50'S & 60'S HITS	x		
DISH MUSIC—70'S HITS	x		
DISH MUSIC—80'S HITS	x		
DISH MUSIC—ALL THAT JAZZ	x		
DISH MUSIC—BEACH PARTY	x		
DISH MUSIC—BROADWAY & HOLLYWOOD	x		
DISH MUSIC—CLASSICAL AMBIENCE	x		
DISH MUSIC—COUNTRY MUSIC ONE	x		
DISH MUSIC—EXPRESSIONS	x		
DISH MUSIC—HITLINE	x		
DISH MUSIC—HOLIDAY	x		
DISH MUSIC—HOT FM	x		
DISH MUSIC—ITALIA	x		
DISH MUSIC—LOVE SONGS	x		
DISH MUSIC—MOODSCAPES	x		
DISH MUSIC—NEW ORELANS JAZZ	x		
DISH MUSIC—PIANO & GUITAR	x		
DISH MUSIC—R&B REVUE	x		
DISH MUSIC—TROPICAL BREEZES	x		
DISH MUSIC—URBAN ADULT	x		*(continued)*

9.10 DTH PROGRAMMING *(continued)*

DISH Channel Lineup	Package		
	Top 150	Top 100	Top 70 Top 40 A La Carte
DISH-On-Demand	x	x	x
DISH-On-Demand 2 Promos	x	x	x
DISH-On-Demand All Day Ticket	x	x	x
DISH1 Inside DISH Network	x	x	x
Discovery Channel, The	x	x	xx
Discovery Civilization	x		
Discovery Health	x	x	
Discovery Home & Leisure	x		
Discovery Kids	x		
Discovery People	x	x	
Discovery Science	x		
Discovery Wings	x		
Disney Channel (East)	x	x	xx
Disney Channel (West)	x	x	xxx
Do-It-Yourself	x		
E! Entertainment Television	x	x	xx
ESPN	x	x	xx
ESPN Alternate	x	x	x
ESPN Classic	x	x	
ESPN2	x	x	xx
ESPN2 Alternate	x	x	x
ESPNEWS	x	x	xx
Empire Sports	x	x	
Encore (West)	x		
Encore Action/Adventure	x		
Encore Love Stories	x		
Encore Mysteries	x		
Encore True Stories	x		
Encore WAM/America's Kidz Network	x		
Encore Westerns	x		
Eternal Word Television Network	x	x	xx
FX	x	x	x
Fox Alternate 1	x	x	
Fox Alternate 2	x	x	
Fox Alternate 3	x	x	
Fox Family Channel	x	x	xx
Fox Movie Channel	x		
Fox News Channel	x	x	

9.10 CONTINUED

DISH Channel Lineup	Package		
	Top 150	Top 100	Top 70 Top 40 A La Carte
Fox Sports Arizona	X	X	
Fox Sports Bay Area	X	X	
Fox Sports Chicago	X	X	
Fox Sports Cincinnati	X	X	
Fox Sports Detroit	X	X	
Fox Sports Florida	X	X	
Fox Sports Midwest	X	X	
Fox Sports New England	X	X	
Fox Sports New York	X	X	
Fox Sports Northwest	X	X	X
Fox Sports Ohio	X	X	
Fox Sports Pittsburgh	X	X	
Fox Sports Rocky Mountain	X	X	
Fox Sports South	X	X	
Fox Sports Southwest	X	X	
Fox Sports West	X	X	X
Food Network	X	X	XX
Free Speech TV	X	X	X
Galavisión	X	X	
Game Show Network	X	X	X
Golf Channel, The	X		X
Good Samaritan Network	X	X	X
HITN	X	X	X
Headline News Network	X	X	XX
History Channel International	X		
History Channel, The	X	X	XX
Home & Garden Television	X	X	XX
Home Shopping Network, The	X	X	X
Home Team Sports	X	X	
Lifetime	X	X	XX
LinkMedia	X	X	X
MSNBC	X	X	X
Madison Square Garden	X	X	
Midwest Sports Channel	X	X	
Movie Channel 2, The (West)	X		
Movie Channel, The (West)	X		
Music Television	X	X	XX
Music Television 2	X	X	*(continued)*

9.10 DTH PROGRAMMING *(continued)*

DISH Channel Lineup	Package		
	Top 150	Top 100	Top 70 Top 40 A La Carte
NASA	x	x	x
Nashville Network, The	x	x	xx
New England Sports Network	x	x	
Nickelodeon/Nick at Nite (East)	x	x	x
Nickelodeon/Nick at Nite (West)	x	x	xx
Noggin	x	x	
Northern Arizona University/University House	x	x	x
Outdoor Channel, The	x		x
Outdoor Life	x		
Pax TV	x	x	
PBS YOU	x	x	x
QVC Shopping Network	x	x	xx
Research Channel	x	x	x
Romance Classics / Independent Film Channel	x	x	
Sci-Fi Channel, The	x	x	xx
Shop at Home	x	x	x
SoapNet	x		
Speedvision	x		
Sunshine Network	x	x	
TV Games Network	x	x	xx
TV Land	x	x	xx
The Learning Channel	x	x	xx
Toon Disney	x	x	
Travel Channel, The	x	x	xx
Trinity Broadcasting Network	x	x	x
Turner Broadcast System	x	x	xx
Turner Classic Movies	x	x	x
Turner Network Television	x	x	xx
Turner South	x	x	
USA Network	x	x	xx
University of California	x	x	x
Univision	x	x	
VH1	x	x	xx
Value Vision	x	x	x
WGN	x	x	x
Weather Channel, The	x	x	x
Ziff-Davis TV	x	x	

9.10 CONTINUED

DirecTV

DirecTV
Channel Lineup

100–800	DirecTV Channels
200, 594	BIG EVENTS
201	Customer News from DirecTV
250, 600	INSIDE DirecTV™
100, 500	MOVIE SHOWCASE™
220, 603, 699, 753	Sports Schedule
212, 601, 700	This Week ON SPORTS™
101–199	DIRECT TICKET Pay-Per-View Movies & Events
200–340	Entertainment & Arts
265	A&E Network
254	American Movie Classics (AMC)
282	Animal Planet
264	BBC America
266	Biography Channel, The
329	Black Entertainment Television (BET)
297	Boomerang
273	Bravo
296	Cartoon Network
202	CNN
205	CNN/Sports Illustrated
249	Comedy Central
327	Country Music Television
203	Court TV
278	Discovery Channel, The
313	Discovery Health Channel
294	Discovery Kids Channel
290	Disney Channel, The (East)
291	Disney Channel, The (West)
230	Do-It-Yourself
236	E! Entertainment Television
206	ESPN
209	ESPN2
207	ESPNEWS
208	ESPN Classic
231	Food Network
311	Fox Family Channel
258	Fox Movie Channel

DirecTV
Channel Lineup

248	FX
309	Game Show Network
204	Headline News
269	The History Channel
229	Home & Garden Television
240	Home Shopping Network
280	Learning Channel, The
252	Lifetime
253	Lifetime Movie Network
331	MTV
333	MTV2
339	MuchMusic
325	The Nashville Network
299	Nickelodeon/Nick at Nite (East)
300	Nickelodeon/Nick at Nite (West)
298	Noggin
312	Odyssey Network
251	Oxygen
255	Pax
295	PBS KIDS Channel
317	QVC
260	Romance Classics
244	Sci-Fi Channel
262	SoapNet
247	TBS Superstation
245	TNT
292	Toon Disney
233	Travel Channel
315	TRIO
256	Turner Classic Movies
301	TV Land
242	USA Network
335	VH1
307	WGN Superstation
350–399	News and Information
386	ABC East*
387	ABC West*

(continued)

9.10 DTH PROGRAMMING *(continued)*

DirecTV
Channel Lineup

364.	All News Channel
353	Bloomberg Television
380	CBS East*
381	CBS West*
358	CNNfn/CNN International
355	CNBC
350	C-SPAN
351	C-SPAN2
388	Fox East*
360	Fox News Channel
404	Galavisión
368	The Health Network
356	MSNBC
382	NBC East*
383	NBC West*
366	Newsworld International
384	PBS (National Feed)
377	PBS YOU
372	Trinity Broadcasting Network (TBN)
402	Univision
370	ValueVision
362	Weather Channel, The
373	Word Network
375	WorldLink TV
354	ZDTV
500–550	Premium Movies
512	Cinemax East
513	Cinemax MoreMAX
514	Cinemax West
532	Encore Action
526	Encore East
528	Encore Love Stories
530	Encore Mystery
531	Encore True Stories
533	Encore WAM!
527	Encore West
529	Encore Westerns
547	FLIX
501	HBO

DirecTV
Channel Lineup

507	HBO Family
508	HBO Family West
502	HBO Plus
505	HBO Plus West
503	HBO Signature
504	HBO West
550	Independent Film Channel (IFC)
544	The Movie Channel East
545	The Movie Channel West
537	SHOWTIME East
542	SHOWTIME Extreme
539	SHOWTIME Three
538	SHOWTIME Two
540	SHOWTIME West
520	STARZ! East
522	STARZ! Theater East
523	STARZ! Theater West
521	STARZ! West
549	Sundance Channel
595–599	Adult
595	PLAYBOY TV
600–799	Premium Sports
626	Empire Sports Network
780–793	ESPN FULL COURT
770–779	ESPN GamePlan
649	Fox Sports Arizona
654	Fox Sports Bay Area
639	Fox Sports Chicago
638	Fox Sports Cincinnati
636	Fox Sports Detroit
634	Fox Sports Florida
647	Fox Sports Midwest
620	Fox Sports New England
624	Fox Sports New York
651	Fox Sports Northwest
637	Fox Sports Ohio
628	Fox Sports Pittsburgh
645	Fox Sports Rocky Mountain
630	Fox Sports South

9.10 CONTINUED

DirecTV Channel Lineup	
643	Fox Sports Southwest
652	Fox Sports West
653	Fox Sports West 2
613	Fox Sports World
605	Golf Channel, The
629	Home Team Sports
621	Madison Square Garden
641	Midwest Sports Channel
754–768	MLB EXTRA INNINGS℠
794–799	MLB/ESPN SHOOTOUT
720	NBA.com TV
721–733	NBA LEAGUE PASS
623	New England Sports Network
703	NFL SUNDAY SNAP
704–717	NFL SUNDAY TICKET™
701	NFL SUNDAY TICKET EXTRA
740–750	NHL CENTER ICE
608	Outdoor Life Network
607	Speedvision
632	Sunshine Network
721–725	WNBA SEASON PASS
800–899	Music
824	Music Choice '70s
823	Music Choice '80s
817	Music Choice Alternative Rock
805	Music Choice American Originals
838	Music Choice Atmospheres
830	Music Choice Big Band

DirecTV Channel Lineup	
841	Music Choice Blues
813	Music Choice Channel X
829	Music Choice Classic Country
819	Music Choice Classic Rock
836	Music Choice Classical Light
834	Music Choice Classical Masterpieces
843	Music Choice Contemporary Christian
812	Music Choice Dance
833	Music Choice Easy Listening
842	Music Choice Gospel
822	Music Choice Hit List
840	Music Choice Jazz
839	Music Choice Jazz Light
816	Music Choice Metal
804	Music Choice New Releases
818	Music Choice Progressive
811	Music Choice R&B Hits
814	Music Choice Rap
802	Music Choice Showcase I
831	Music Choice Singers and Standards
821	Music Choice Soft Rock
825	Music Choice Solid Gold Oldies
806	Music Choice Sounds of the Seasons
828	Music Choice Today's Country
808	Music Choice World Beat
	*Timed duplicate feeds

Another consideration is the expense of video servers to feed the programming to homes in some of the more ambitious trials. Analysts project that in-home video servers (i.e., DVRs like **TiVo** and **Replay**) will gain acceptance faster than digital cable and digital TV sets, probably reaching 25 percent household penetration by 2003. Both cable and satellite system operators have been deploying set-top boxes (i.e., cable converters) that have integrated DVRs to provide video-on-demand.

Unlike the big promotions for signature and special programming on established cable networks, the newer digital channels are primarily clones of parent services, but with lower-cost shows plus filler from the programming vaults. Such a strategy is another example of conservation of resources.

Given a choice, subscription channel programmers would still rather be on the analog tier because of the greater household penetration. On the digital tiers, it's difficult to sell advertising because the reach is still small.

Pay Networks
HBO
Cinemax

Owned by AOL/Time Warner, HBO encompasses several pay channels: HBO, HBO Plus, HBO Signature, HBO Family, HBO Comedy, HBO Zone, Cinemax, MoreMAX, ActionMAX, ThrillerMAX, HBO en Español, HBO Ole and Brasil, HBO Asia, and HBO Central Europe. (The sole focus of Cinemax is on movies.) The company also owns 50 percent of Comedy Central.

HBO is not the movie channel that began in the 1970s. It differentiates itself from other "movie" channels by scheduling critically acclaimed original programming. HBO has won dozens of Emmys for such programs as *The Sopranos*, stealing the limelight from the Big Three broadcast networks.

The Disney Channel

Although The Disney Channel barely qualifies as a premium channel anymore, some of its sister channels are on pay tiers. Toon Disney is a basic tier channel with Disney animation.

In 1997 only 7 percent of the programs on The Disney Channel were made-for-cable. Three years later, the percentage leapt to more than 50 percent. Clearly, The Disney Channel is trying to keep its programming fresh.

The Movie Channel
Showtime
Flix

Viacom/CBS owns Showtime and its movie-only channels Flix and The Movie Channel. Viacom also owns the MTV Networks listed earlier, The Nashville Network, Country Music Television, Midwest Sports Channel, Home Team Sports, and Sundance Channel.

Showtime's strategy is to make major studio deals, having learned a tough lesson in the 1990s when other premium channels kept it from getting new, big-draw theatrical movies. The channel's other strategy is to compete with HBO for the top boxing draws.

Showtime also will be the first programmer to feature Ipreview, which inserts **interactive promos** using the TiVo DVR. A small thumbs-up icon will appear in the corner of the movie promo allowing viewers to set the DVR to record Showtime with a single click.

Starz Encore

AT&T Broadband & Internet Services (Liberty Media tracking stock) owns Starz Encore, which comprises 25 channels of cable and satellite-delivered premium movie channels. The cornerstone of Starz Encore's programming strategy is to lock in studio release of theatrical movies for several years. For example, in February 2000 Starz signed a $1.7 billion 200-movie deal with Sony Pictures to take effect in 2005 when HBO's deal with Sony expires.

An example of how Starz markets its channels is the Super Pak, featuring 12 channels for $12 (actually two feeds creating a 24-screen option).

Pay-Per-View

Digital video compression has led to new kinds of television systems that are menu-driven rather than schedule-driven. In Chapter 1, the food analogy was introduced as a way to think about programming. Until recently, the restaurant metaphor for delivery of programming was the cafeteria. The "food" is scheduled by the opinions of the programmers, but there is no menu from which to order. Most of the history of television programming existed in a cafeteria with three large buffet tables managed by ABC, CBS, or NBC. With the coming of cable, there were many more choices, but it was still very much a controlled choice: "Our specials tonight are the following," but there was still no menu.

Video-on-demand and near-video-on-demand allow the viewer to create schedules, traditionally one of the functions of programmers. When the video provider supplies an unlimited number of choices, the viewer receives *video-on-demand*. When the number of options is controlled by the provider ("No substitutions please"), the system becomes *near-video-on-demand*. NVOD is an intermediate step before the technology for "true" VOD finds its way into viewers' homes.

True video-on-demand systems offer the viewer the option to "pause" the movie, using the storage capabilities of the off-site video server or taking advantage of in-home video servers like TiVo and ReplayTV. NVOD, which schedules a movie continuously at staggered start-times on multiple channels, has been a transitional method of delivering programming using more primitive technology, until the number of users (and amount of available bandwidth) justifies improved distribution (see discussion of technology in Chapter 1). VOD bridges the computer and television worlds because it is part of online programming (see Chapter 10).

Subscriber video-on-demand (**SVOD**) is one of the most recent wrinkles on VOD offerings. It combines monthly pay services (the *S* is for subscription) with VOD and was the brainchild of John Sie at Starz Encore. Some operators worry, however, that SVOD will cannibalize their existing analog pay-per-view revenues.

The essential difference between conventional cable television and the more advanced DTH is that the latter boasts more choices, higher quality digital signal (especially desirable for viewers with large-screen home theater receivers), and the potential to reach any home with an unobstructed view of the southern sky. Cable, whether it is the older coaxial style or the newer fiber optic version, has the advantage of true interactivity or two-way communication.

The demographics of premium-channel subscription are interesting. Among those with cable, penetration is 83 percent among African Americans, 52 percent among Hispanics, 45 percent among whites, and 43 percent among Asians.

9.11 MAJOR PPV COMPANIES IN 2001

DirecTV	Hughes
InDemand	AT&T, Comcast, Cox
PRIME CINEMA	
TVN	
Intertainer	
AMERICAST	
ON SET	
DISH	

Pay-per-view went through a transformation between 1999 and 2001, placing it closer to NVOD and eventually VOD. Before 1999, **PPV events** were static programs where the viewer made an appointment to watch. With digital compression, the pay business changed by offering fewer choices at more frequent intervals: movies starting every 30 minutes on multiple channels. Some expect the PPV name to survive the transition to VOD, but lose all of the differentiation in the process.

The nationally distributed pay-per-view cable services as of 2001 were InDemand (formerly Viewer's Choice and Request Television), Spice, Spice 2, Playboy Television, BET Action Pay-Per-View, TVN Digital Cable, ESPN Extra, Hot Network, Erotic Network, and Pleasure Channel (see 9.3 for comparative subscribership as of 2000). On the direct-to-home satellite front, distributors include DirecTV and DISH. These services were responsible for the strong growth of pay-per-view in the late 1990s, because they offered so many different channels and start-times.

As pay-per-view continues to grow, there has been a tension between home video (a $15 billion-a-year business) and pay-per-view (a $2 billion-a-year) with regard to windows. By 2000, some moves were being made to make the PPV window coincide with the home video window (which was typically 50 days earlier). The Video Software Dealers Association lobbied the film industry hard to maintain the status quo, but the PPV steamroller

9.12 VIDEO-ON-DEMAND

Hardware Services

VOD hardware services are companies that supply hardware, software, programming, a customizable navigator, billing interface, and other support services. This array of services is sometimes referred to as an end-to-end solution.

Diva (www.DIVAtv.com)

Diva specializes in two-way hybrid fiber coaxial cable systems. At a cost of $350 per home, the lowest cost in the industry in 2001, Motorola DCT set-top boxes are installed in viewing homes. Using a remote control, subscribers order programming through their set-tops that signals the server and enabling hardware and software that reside at the cable headend. Software on the server tracks on-demand purchases and manages billing.

Diva boasts 2,000 new movie releases, titles and specialty programs from Warner Brothers, Disney, Sony, Universal, 20th Century Fox, and Dreamworks, as well as from HBO, ESPN, and Discovery. Diva has more experience with commercial rollouts than either of its major VOD competitors. In 1999 tests, two-thirds of the buys were for current film releases and the rest were adult movies, with higher prices and more generous revenue splits.

SeaChange (www.schange.com)

Recognized for its video servers, SeaChange has developed an on-demand service that provides hardware, software, programming, billing, and technology support. The programming includes movies, sports, news, and nonvideo services such as home banking and stock market trading. The service is available through operators using digital set-top boxes, including those manufactured by Scientific-Atlanta, Pioneer, Nokia, and General Instrument. The cable system's server responds to requests from subscribers, using basically the same technology currently used for impulse pay-per-view. The cable operator determines the charge. Some on-demand services such as movies are likely to be charged on a per-event basis, while others such as news may be sold on a subscription basis.

The technology was being tested in 2001 in seven cities served by six MSOs, including Time Warner Cable in Austin, Texas, Rogers Cable Systems in Toronto, and TeleWest in London. Program content comes from all the major studios and programmers.

was hard to stop. By 2001, the number of PPV homes rose above 50 million. Paul Kagan Associates predicts PPV/VOD revenues to be a $9 billion business by 2009. The movie studios are interested because they get at least 45 percent of the PPV dollar, compared to 20 percent (at most) of the home video rental revenue for guaranteed titles.

Direct-to-home is pushing the transition. Cable operators, after 15 years of deploying analog addressability, still offer pay-per-view to only 44 percent of all cable homes. Satellite and cable distributors both have a wide array of companies from whom to buy movies and events (see 9.11).

It is interesting to note some patterns in the audience appeal for PPV events. For example, only 1 percent of basic households account for 48 percent of a typical cable systems' PPV buys. Furthermore, 50 percent of the buys are from the adult-PPV category.

Showtime Event Television (SET) is the dominant producer of PPV events, many of which are still boxing and wrestling events. PPV music events began to take off in 1999 (e.g., Woodstock '99, Backstreet Boys, and *NSYNC) with revenues topping $30 million. One reason why movies take a backseat to events is because of the higher relative price ($19.95 for single concerts and $39.95 for boxing). In fall 2001, a former HBO executive launched Broadway Tonight (four shows for $79.95) to be shown on pay-per-view.

VOD was in the toddler stage in 2001. The industry was comprised of **hardware services** and

9.12 CONTINUED

Programming Services

In addition to such traditional PPV services as InDemand, DirecTV, and DISH, a variety of other services were showing up on the 2001 radar screen. All of these companies split revenues with their program suppliers. The field will certainly consolidate in the foreseeable future.

Intertainer (www.intertainer.com)

Intertainer provides on-demand entertainment, interactive advertising, and e-commerce. Programming includes movies, music videos, concerts, children's shows, and special interest programs. The system is menu-driven and uses either the Motorola DCT 5000 digital set-top plus Scientific-Atlanta's Explorer 2000 in TV homes or the PC platform in online homes.

The company has industry partners (13 percent: Comcast, Sony, Intel, NBC, and US West) and more than 60 suppliers, including ESPN, Columbia TriStar TV, Warner Brothers, Sony Music, Showtime, Cinar, Dreamworks SKG, MGM, Buena Vista, Poly-Gram, PBS, The Disney Channel, and 20th Century Fox.

Intertainer differs from other VOD services that distribute movies, TV shows, music, video games, and short-form programming on-demand by offering e-commerce and interactive advertising. It "remembers" what a consumer tends to order and begins making suggestions about what to watch; it also sends targeted advertising. Intertainer's dual focus on PC and TV users will probably broaden its base of users quickly.

TVN (www.tvn.com)

TVN has developed a video-on-demand service that is currently being tested by the company. It delivers movies from a library of 40 titles per month and anticipates adding events and e-commerce. TVN's VOD is accessible through General Instrument's DCT line of digital set-tops and compatible with Scientific-Atlanta's Explorer 2000. Subscribers order movies by pressing a button on a remote control, which signals the set-top to download the movie instantly from a video server at the cable headend. TVN delivers movies, a viewer's guide, and management software to the video server by satellite. TVN's video-on-demand was being tested in 2001 at Strategic Technologies' Valencia, California, system.

programming services, and some hybrid entities, which are outlined in 9.12.

PROGRAM GUIDE SERVICES

To provide the schedules of basic and pay cable channels to viewers, cable systems have three options: (1) provide a printed guide or provide schedule information to a channel listing service; (2) generate an electronic guide; or (3) contract for a video guide channel, called a **barker channel.** Because of the cost, printed guides are more common than electronic guides except in large capacity systems. *TV Guide*, which includes local stations and both broadcast and cable networks, continues to be one of the best-selling sources of program information.

Printed Program Guides

Three types of printed program guides are available: *single-channel guides*, *generic multichannel guides*, and *customized guides*. HBO sells its guide, the most widely circulating single-channel guide, to systems for inclusion in their subscribers' monthly statements. The HBO guide costs the cable system about 5 cents per subscriber. Discovery and A&E merge their program guides with their magazines and sell them directly to viewers. Few other basic services can afford to develop program guides.

Generic program guides cover several cable networks, usually the most widely distributed premium services and the top 20 basic cable networks. Generic guides carry advertising, and the same guide can be sold to many systems. These guides emphasize prime-time listings and, of course, omit local cable and broadcast programming. Some guides provide detailed descriptions of program content and include feature articles; others are bare bones. *Cableview* and *Premium Channels*, two of the most widely available generic guides, have about 30 to 60 pages and cost the cable operator between 50 cents and $1 a copy (plus mailing costs). Two other printed guides are *Cable Connection Magazine* and *Cablewatch*; each costs subscribers about $1.50 a month.

Customized guides can serve as important vehicles for value-added promotions (games and contests) and can be supported largely by advertising. Although TVSM's *The Cable Guide* provides only cable program network listings, its *Total TV* provides broadcast as well as cable listings. These guides have more than 100 pages of daily grids, features, and advertisements and cost the cable operator between $1 and $2 per subscriber (plus mailing costs). An inherent problem with customized printed program guides is that the greater the number of channels, the more listings: To be complete, all programs on all channels must be listed half hour by half hour (or hour by hour), and guides become difficult to read and awkward to use. Creators of customized guides face a difficult dilemma: Should the broadcast stations that are carried on the system be included? If they are not included, viewers must use *TV Guide* (the granddaddy of customized guides), newspaper supplements, or other program guides. Including over-the-air channels greatly increases the number of listings, however, making the guides even more unwieldy, and they then duplicate information available elsewhere.

Electronic Guide Channels

Electronic guides tend to be used by subscribers (and to a lesser extent, by cable systems) as supplements rather than stand-alone services. Program information appears in alphanumeric form with some graphic elements. Unfortunately, at the current time, video screens display only 20 to 22 lines of copy at one time. The shift to digital television is eliminating this ruinous limitation, but old-style electronic guides exist as stop-gaps until the real thing comes. The combination of digitalization and computers (in smart TV sets) will permit both immense complexity and user-friendly simplicity through menus and indexing.

Some services allow cable systems to place the names of important films in a heading on another text channel such as news or weather. Other cable systems dedicate a full channel to alphanumeric listings of program titles that continuously scroll, displaying a full day's programming, half hour by half hour. Because of the immense number of program titles appearing on most systems, listings typically include only the titles of featured films and specials on pay channels, and they exclude the descriptive material that is so popular with viewers in printed guides.

The most widely distributed barker channels come from Prevue Networks. They include Prevue Channel, a full-service promotion channel with more than 40 million subscribers; Sneak Prevue, a pay-per-view promotion service with 25 million subscribers; Prevue Express and Prevue Gateway, interactive program guides; Movievue, a pay TV/multiplex service; Interactive Program Data, a service for set-top converters; and EPG, a program listing service. TV Guide On Screen merged with the Prevue Channel in the late-1990s to form the largest guide channel. Another service, StarNet, is a cross-channel promotional service for both basic and pay programming; StarNet produces The Barker, the first all-digital pay-per-view promotion channel (see 9.13).

AUDIO SERVICES

In addition to video programming and data, cable systems can provide subscribers with audio and radio services. Like video services, cable audio

9.13 ELECTRONIC PROGRAM GUIDES
AS OF 2000

Service	Affiliates	Subscribers
The Barker	250	10,000,000
Screen TV	1,200	38,000,000
Starnet	1,000	22,000,000
TV Guide On Screen*	1,874	53,000,000
TV Guide Interactive	800	2,300,000
WorldGate	14	15,005

*Gemstar International bought *TV Guide* for $14.3 billion in 2000.

and radio come in both basic and pay forms and are both locally and nationally distributed. In local cable radio, nearby stations are distributed to cable subscribers, usually free. In national cable audio, basic nonpay services exist; some carry advertising, and some do not. There are also pay services that charge subscribers a monthly fee for a series of specialized music channels, which are collected by the local cable operator and shared between the two entities.

Cable operators are skeptical about the size of cable audio's potential as a revenue stream. The buy rate for all digital audio services is about 15 percent of basic cable television subscribers, and marketing plans generally target the 40 percent of cable subscribers who have CD units. On the positive side, consumers have become more sensitive to audio quality since CDs became common and surround sound and other television/audio receiver advances were developed. This new awareness and appreciation of audio should spur the cable audio business.

Basic Audio

Several national services provide audio programming. The AEI Music Network features six satellite-delivered music channels that include classical, country, light rock, light jazz, current hits, and easy listening instrumentals. This is the leading

service in foreground music for businesses. The Cable Radio Network promotes cable programming and provides adult contemporary music, talk, and specialized shows. This service is used as an audio component for character-generated channels, cable FM, and telephone "hold" music. AEI's music is CD quality. C-SPAN supplies C-SPAN Audio 1 and C-SPAN Audio 2. The former service provides international news and public affairs programming in English from Japan, Canada, China, Germany, and many other nations. The latter service provides live transmission of Great Britain's popular BBC World Service— 24 hours of news, music, programs, entertainment, and cultural information. KJAZ Satellite Radio provides mainstream jazz with a strong emphasis on jazz education. The service contains advertising.

Moody Broadcasting Network provides religious programming in a variety of formats including music, drama, education, and national call-in programs. SUPERAUDIO Cable Radio Service offers six FM music formats—classical, light rock, new age/jazz, country, classic hits, and soft sounds for background music for text channels. The service also carries three entertainment and information formats, including a reading service for the visually impaired (the In-Touch Network), the Business Radio Network, and Minnesota Public Radio. Yesterday USA is the national radio voice of the National Museum of Communication of Irving, Texas. The service provides old-time radio shows and vintage music free of charge without commercials. Finally, WFMT-FM from Chicago is considered a radio superstation that airs fine arts and arts talk 24 hours a day. The station is sold as a premium service by some systems and allows nonlocal advertising.

Premium Audio

The two leading premium services are Digital Music Express (DMX) and Music Choice (MC), formerly Digital Cable Radio. DMX provides up to 76 channels of continuous CD-quality music for both residential and commercial cable subscribers. MC, like DMX, is a commercial-free service of

9.14 MAJOR AUDIO SERVICES		
Service	Affiliates	Subscribers
C-SPAN Audio Network	112	6,600,000
C-SPAN Audio Network II	50	3,200,000
Cable Radio Network	250	13,000,000
DMX	947	4,000,000
Moody Bible Institute	14	146,097
Music Choice	362	11,600,000
Superaudio	334	5,000,000
WFMT	77	456,318

CD-quality music. MC is offered as both a basic and premium service and features 30 channels of various music genres.

DIRECTIONS FOR THE FUTURE

The last 20 years have seen dramatic changes in basic and premium services. The advertiser-supported networks have proliferated into chains of niche program services, many of which are intended to reach subscribers beyond the U.S. borders. Expanded international distribution is the primary means of growth for cable and satellite programmers. Hundreds of millions of potential subscribers in such countries as India and China have become a powerful lure for U.S. cable program suppliers, who can clearly see the pie at home being split in smaller and smaller portions by increasing numbers of hungry new services. Increasing access to potential viewers in the once-inaccessible countries is, however, fueling experimentation with new types of niche services and providing hope to wannabees who envision a world market of sufficient size to support their programming.

On the premium front, while HBO, the leading premium network, has continued to dominate the marketplace, the number two service, Showtime, wrestles with strategies to build its market share. HBO turned to national consumer marketing and

"triple-plexing" of both HBO and Cinemax, further raising its profile with America's viewing public. Meanwhile, Showtime forged exclusivity of movie product into a primary weapon and further differentiated itself through substantial investment in original programming. Pay-per-view networks entered the picture, offering movies and entertainment on an a la carte basis.

The wider availability of top-name movies on pay-per-view and through both sell-through and rental videocassettes and DVDs, however, reduced the overall attractiveness of theatrically released film titles, pressing the movie-based pay networks into producing even more exclusive and original product. HBO's competitors are likely to pursue stronger creative and financial links, perhaps even partnerships, with program suppliers and cable operators. Carrying advertising is another option for marginal pay services.

As cable systems continued to expand the quantity of their program offerings, raising the price of basic service in the process, the pay cable customer's average monthly bill was starting to approach $60 by 2001. As a result, premium services have come under increasing pressure to reduce their retail prices to bring them better in line with customer expectations and spending patterns. A *low-price, high-volume* strategy seems likely to replace the retail pricing strategy that has been endemic to pay-television since its beginning.

As pay-per-view services increase their market penetration, offering the early release pattern for movies that was once the exclusive province of pay cable, more pay-cable services may evolve into "super basic" channels on many cable systems, functioning to provide lift for a second or higher programming tier. Such has already been the case to a large extent with former pay channels American Movie Classics, Bravo, and The Disney Channel. Encore is intended for such a tier. The practice of discounting to operators to gain more subscribers encourages such new packaging strategies.

As compression allows for greatly increased channel capacity and impulse technology becomes standard for cable converters, a wide range of possibilities opens up for cable operators and program-

mers alike. Increasing numbers of cable subscribers can now order a pay-per-view movie, concert, or sporting event in an instant and, increasingly, they will avail themselves of the opportunity. Projections of 50 million PPV homes in the early 2000s will entice Hollywood's studios to release movies to pay-per-view services closer to their theatrical release date, truly creating a "home box-office" bonanza for movie makers and event organizers.

One caveat lies in the rapid spread of online programs that allow viewers with high-speed online connections to watch pirated movies. In July 2000, the case of Napster being used to steal copyrighted music was vastly overshadowed by emergence of another rogue program called DivX (even the name was pirated from a legitimate company). Like the music industry with pirated music, the Hollywood studios were forced to re-examine their business models.

The clearest direction for the future is that joint ventures, mergers, and buyouts will increasingly integrate cable program suppliers with the companies that distribute their wares and with broadcast services because of efficiencies in cross-promotion and reuse of original programming in multiple media. The trend toward building media conglomerates that reach across media technologies and once-rigid legal boundaries, as well as across international borders in distribution, is undeniably accelerating.

SOURCES

Altseld, Sheldon I. *How to Start Your Own Cable TV Network.* www.cablemaven.com/Introduction/index.html

Broadcasting & Cable. Weekly trade magazine. New York: Cahners Publishing Co., 1931.

Cable Television Developments. Published an average of three times per year by the National Cable Television Association's Research and Policy Analysis Department. NCTA: Washington, D.C.

Cable Television Developments. Washington, D.C.: National Cable Television Association, annual.

Cable World. Weekly trade articles on national cable programming. Denver, Colorado, 1988 to date.

Cablevision. Monthly trade magazine covering the cable industry. Denver, Colorado, 1975 to date.

Cablevision's Blue Book. New York: Chilton Publications, 1999.

Cablevision's New Network Handbook. New York: Chilton Publications, 1999.

Electronic Media. Weekly trade publication coverage of electronic media news. Chicago: Crane Communications.

Multichannel News. Weekly trade publication. New York: Chilton Publications, 1980 to date.

The Pay TV Newsletter. Weekly trade analyses of the pay and pay-per-view market from Paul Kagan Associates in Carmel, California. 1983 to date.

Trout, Jack, with Steve Rifkin, *Differentiate or Die: Survival in Our Era of Killer Competition.* New York: John Wiley, 2000.

Wolzien, Tom, Media Merger Concepts. IRTS Faculty Seminar, 23 February 2000.

www.ncta.com

www.cabletvadbueau.com

www.ctam.com

INFOTRAC COLLEGE EDITION

Consult InfoTrac College Edition using the password provided with this book. Use boldfaced terms as Key Words and section headings from this chapter for Subject searches.

NOTES

1. NCTA's web site, www.ncta.com, lists just 10,400 cable systems as of 2000, whereas Nielsen estimates the number of cable headends at 11,197. As the number varies with mergers and buyouts, "nearly 12,000" is a handy rounded total.

2. Applebaum, Simon, How-to-Launch. *Cablevision,* 9 May 1994, p. 48.

3. Cooper, Jim, Little Big Fights. *Cablevision,* 5 July 1995, p. 10.

4. McClellan, Steve, DirecTV linking with Blockbuster. *Broadcasting & Cable,* 15 May 2000, p. 26.

Chapter 10

Online Video and Audio Programming

Douglas Ferguson

Online video and audio, also known as **multimedia,** sometimes referred to as **interactive** media, officially arrived in the early part of this century. For a while, the prospect of a monumental new communication medium had the NASDAQ stock index making record-breaking increases. The comic strip *Doonesbury* parodied how easy it was to parlay an idea into an empire with no worry of showing a profit. Former cable MSO MediaOne (now owned by AT&T Broadband) coined the phrase, "This is broadband. This is the way," which baffled most people who read the slogan on billboards. And now the new online media have their own chapter in a programming textbook!

With the official debut of broadband culture, some observers were reluctant to foresee any merger between the two worlds, broadcast and computer, because of the inherent differences between watching TV (passive) and using a computer (active). On the other hand, one bold prognosticator (Richard Baskin of Intertainer) predicted in 2000, "Five to 10 years out, there won't be a difference between a television and a PC. You'll have intelligence, network and display, and it will be all over your house, and you'll watch some things on the TV, some on the PC."[1]

THE ONLINE WORLD

What is broadband? **Broadband** is the high-speed delivery of digital information: video, music, text, data, and so forth over wires, cables, and through the air. In many ways, digital information has changed the media world. For example, global online advertising is projected to overtake global TV advertising spending by 2005, when U.S. online spending alone is expected to reach $32.5 billion.

Multimedia is a word commonly used for digital forms of interoperable media. The world of live and recorded information and entertainment is influenced by newer forms of multimedia, like email, video games, **instant messaging** (a live form of email), and group discussions (**chat**).

Streaming is the digital distribution of audio or video in near real-time. Also known as **webcasting,** streaming differs from broadcasting because the connection is one-to-one, rather than one-to-many, even though anyone with a computer and a connection to the **web (World Wide Web,** or **www)** can receive pictures and sound. Many web sites provide streamed content, live or recorded, using Real Player, QuickTime, or Windows Media standards.[2]

The streaming technique is based on a time-delay called **buffering,** which prevents slight delays from interrupting the flow of the program. Buffering is less than perfect, sometimes resulting in jittery video in a very small frame on the computer screen. However imperfect, though, it is **video-on-demand:** what you want, when you want it, almost in real-time (see Chapter 9).[3]

In addition to webcasts, broadcast networks have developed synchronized interactive links between their evening news broadcast and web sites. Every sports event has an **enhanced viewing** online feature and a logo in the corner of the screen to remind viewers that they can access game statistics or enter contests. Even syndicated game shows offer play-at-home online enhancements.

Flash animation is a low-frame rate technique friendly to slow connection speeds and compressed video. Notwithstanding the growth of broadband, **made-for-online** video has needed to capitalize on low frame-rate, as with flash animation. One of the reasons *South Park* episodes were so easy to download off the Internet in the late 1990s was because the animation was so crude (not to mention the writing). The creativity of online programs that emulate the *South Park* style of edgy humor is important to building an audience base while the web waits for unbuffered real-time streaming.[4]

A CONCEPTUAL FRAMEWORK

When an innovation comes along that fundamentally changes the way people view the world, the term *discontinuous change* is used. At first glance, the use of online technology to distribute radio and television programming appears merely an extension of broadcasting, another way to receive the content, as with cable and satellite. The key

10.1	STRENGTHS AND WEAKNESSES OF MEDIA DELIVERY SYSTEMS

	Reach Limited by	Revenue Streams	Bandwidth	Interactivity
Broadcast	Geography	1. Advertising	High	One-way
Cable/Satellite	Channel capacity	2. Ads, plus subscriptions	High	Mostly one-way
Online	Bandwidth	3. Ads, subs, plus merchandise	Low	Two-way

difference, however, is the **interactivity** between the user and the programmer, creating a sea change from the past. The seemingly infinite number of choices is another important difference. By 2001, there were more than 100 million **Internet hosts** (comparable to channels).

Previous chapters in this book have been structured around *strategies* for selecting, scheduling, and promoting programs and evaluating audience response. With the "a la carte" nature of program offerings on the Internet, however, many of the programmer's tasks go out the window.[5] Instead of schedules of limited choices, the online audience has an abundant menu of near-limitless choices. Every listener and every viewer constructs his or her own media landscape. Even those audience members not online (or too distracted to schedule their own options) are able to use **digital video recorders (DVRs)** as program-seeking robots, where automatically recorded shows can be played back in any order, at any time (including while they're being recorded!). In this content-on-demand world, nobody spends the same time enjoying the same program as anybody else.

Although it is safe to define **online programming** as *media content available through a computer screen or speaker that displaces or substantially supplements the use of noncomputer media content*, it is easier to say what online programming is not. It is not a web page that promotes programming delivered over conventional channels, nor is it those archived sound bites and video clips found on journalism sites. It is not limited to live and taped shows, described previously as **streaming content,** but can represent virtual events such as chat rooms and event simulations. It is not **repurposed** content that has already been seen, although it may be **simulcast** material that is shown live on another medium.

Conceptually, online programming compares to other programming as shown in 10.1. The list of differences is nonexhaustive but helpful in framing the relative position of online distribution. Although these distinctions may seem peripheral to *how* programming is strategically scheduled, these conceptual differences are crucial for programmers' understanding of *why* new media are fundamentally unlike the old familiar media.

Geography

Ordinary over-the-air radio and television are limited by geography. Networks were developed to link together stations to create a national service. Multichannel media (cable and satellite) became collections of networks, limited by shelf space to about 500 digitally compressed channels (see Chapter 8). Online is free of geography and channel capacity, but limited by the small pipe (**bandwidth**) through which programming must flow. Bundled fiber cables are gradually replacing old-style coaxial cable and telephone lines. Cable and **high-speed digital subscriber lines (DSL)** pushed delivery speeds beyond 300 kilobits per second by 2000, and DTH satellites offered 400 kilobits per second by 2001 (although television-quality distribution requires several megabits per second to achieve true broadband). Faster speeds produce better video and audio quality. Figure 10.2 illustrates the tradeoffs between speed and quality.

10.2 BIT RATE VERSUS QUALITY			
Quality	Frames per Second	Transmission Method	Bits per Second
Television	30	Satellite, copper cable, high bandwidth Internet (LAN)	1.5 megabits
Film	24	Satellite, copper cable, high bandwidth Internet (LAN)	1.5 megabits
High-Quality Internet	15	Medium-high bandwidth Internet T1 connection (LAN); DSL; cable modem	384 kilobits
Medium-Quality Internet	8	Low bandwidth digital Internet ISDN connection (phone line)	80 kilobits
Low-Quality Internet	3	Modem (phone line)	28.8 kilobits

Revenue Flow

The very essence of programming strategy is linked to how revenue flows from consumer to program producer, with the programmer as middleman. The key distinction between broadcasting and multichannel distribution has been the number of revenue streams: Over-the-air radio and TV stations rely almost entirely on *advertising* while cable/satellite services have dual income from advertising *and* subscriptions. Online programming added a third stream from merchandising that allows point-and-click purchasing of items related to the media content. Such products and services once could be sold only in the commercial breaks within the shows.

Tradeoffs

All three forms of media programming in 10.1 and 10.2 have offsetting benefits and drawbacks. Although it has only one revenue stream, the "free" element of broadcasting allows nearly complete audience penetration: 98 percent of U.S. homes receive broadcast radio and TV stations. Thus, broadcast advertising is so much more efficient than advertising on cable or the Internet, which means broadcasters can charge more for their commercials. Cable/satellite programming attracts more revenue than all of broadcasting, but the splintered channels and lower household penetra-

tion (about 85 percent) make multichannel media less likely to compete for advertising—or so it was at the onset of broadband programming.

In addition, online programmers are limited by low bandwidth in the quality of programs: Streaming audio and video were initially restrained by tiny video windows and audio reception hiccups caused by slow connect speeds. Furthermore, the ability to attract subscribers (except for content not readily available elsewhere, like pornography-on-demand) is limited by the "free" nature of the Internet. Users expect to get everything free on the Internet, even copyrighted materials. Web providers who charge must compete with those who are totally advertiser-supported (and with the pirate services that share their content with everyone for free).

Finally, the online household penetration is only about 60 percent, although the long-term trend is away from television viewing. According to trade reports, the average adult devoted about 3,500 hours to consumption of consumer media in 2000. At the same time, about 45 fewer hours were spent watching broadcast television in 2000 compared with the year before. Moreover, time spent online increased by 33 hours. Such shifts in audience activities have been held responsible for a slowing in the growth of conventional television advertising—and a concomitant annual 40 percent growth rate for online commercials.

Despite broadcasting's continued domination of media, *there are some highly positive features to being an online program supplier*. There is no license required, as with broadcasting, nor any FCC regulation. No one *owns* the Internet, so being online erases *location* as well as *time and space*. There are no networks and no syndicators; everything is *local* (but received worldwide). Moreover, the distinction between *distribution* and *content* is tenuous, because there are very few distributors: Content *really is* king. There are no bricks and mortar. The staff size is much smaller than in a broadcast station. Most crucial to this book, the job of programmer becomes the job of librarian. There is not much "scheduling" because everything is available all the time. Whether listeners and viewers prefer to create their own media landscapes remains to be seen, but the online world is not a particularly friendly place to middlemen (like distributors, packagers, and *programmers*) because, by its nature and design, it has no middle. Unlike media companies, there's not much to prevent immediate consumption following the creation step. Programmers online are better known as **content providers.**

Aesthetically, online programming is dissimilar from the nature of what it imitates. Until radio, the mass media (magazines and newspapers) had only sight to rely upon. After adding sound, cinema and television elevated the experience to sight, sound, and motion—the most dynamic media the world had seen. For fifty years, television (both broadcast and multichannel) has reigned supreme, even though it lacks interactivity.

Analog broadcasting, however, is both expensive and difficult to manipulate. Online audio and video is wholly digital, making it much less expensive and easier to integrate with other forms of media. The hourly cost of online usage fell to 41 cents in 1999 from $2.27 in 1998, going from one of the most expensive media to one of the least expensive in just six years. For the user, getting connected to online media is less expensive than subscription television and is sometimes even *free* from advertising-supported web portals.

Interactivity

Interactivity is key to the online world, for better or for worse (see 10.3). Some who have examined the online world have chosen to think solely in terms of interactivity. It would be useful to look at one of these frameworks.[6] The interactivity model has five categories:

1. Internet-on-TV
2. Digital TV (DVRs such as TiVo and ReplayTV)
3. Interactive program guides or navigators
4. Enhanced TV
 - E-commerce
 - Interactive advertising (t-commerce)
 - Impulse sales
 - Ancillary program information
5. Video-on-demand (VOD)

By 2004, industry experts anticipate that more than $60 billion will be generated by interactive applications, organized by the first, second, and third revenue streams introduced in this conceptual model. When it became obvious to mainstream media that interactive technologies were here to stay, most of them got busy diversifying their distribution. Consultants advised them to look at the creation process as a one-time affair, and the exhibition process as utilizing multiple venues.

THE CONTENT PROVIDERS

Who is behind all of this media convergence? Microsoft, for one. Bill Gates sees a big future in video and was eager to invest $5 billion in AT&T Broadband to further his WebTV service. The WebTV $299 boxes designed for DISH (owned by Echostar) were configured with 6.8-gigabyte hard drives to allow video downloads. In 2000, Microsoft also launched a new interactive satellite-TV service with DirecTV called UltimateTV, featuring a $499 set-top box with dual-tuners capable of recording 30 hours of video while tuned to

10.3 THE DARK SIDE OF INTERACTIVITY

How can anything named **cookie** be a threat to privacy? Online access is interactive, thus two-way. It's two-way on *both* ends, however, meaning that users are being watched by the content providers. How? First, each unique address is traceable. Forget about the anonymity of watching TV or listening to the radio. Second, most web browsers let the sites leave a "cookie" behind on the visitor's hard drive. This cookie tracks the user's online behavior and can be accessed by giant marketing databases (much like the way purchases are tracked at the grocery stores by those little plastic cards they encourage shoppers to use).

Some people are not concerned that marketers gather such information. After all, it is aggregated into impersonal data sets that don't care who individuals are (or what they do) so long as trends can be spotted. Such data collection could become pernicious if it is used against individuals. If you are worried, learn how to get rid of those cookie files. It's as easy as finding a file named "cookie" or "cookies.txt" on your hard drive and deleting it. (Don't be surprised if you have to repeat this procedure on a regular basis.)

another channel. The second tuner also let the user download other kinds of computer data (e.g., email, stock prices) while watching TV.

AOL entered into an agreement to make DVR-maker TiVo its programming service. The $200 million agreement set the stage for a $249 set-top box similar to the Microsoft device. The companies' hope is to drive new revenue streams, using a remote control and a keyboard. AOL is well-positioned to provide web content, having bought Time-Warner in 2000.

AOL is one of the three giant **portals,** also known as *walled gardens*, where content is kept somewhat separate from the rest of the Internet (which brings solace to parents of young children).

Microsoft's MSN and Yahoo! are the other major portals. Ironically, the two major television networks (ABC and NBC) that tried to become major portals were unsuccessful; after investing heavily in 1999, they withdrew in 2001, leaving AOL, MSN, and Yahoo! as the dominant entry points. These sites combine start pages with browsers, navigation tools, and search engines.

The Major Players

If the online world were already a mature medium, there would be little need to explore the growth of tiny companies vying to become major players. For radio and television, and even cable and satellite, the major players are already known, with occasional reconfigurations from mergers and buyouts. But a clear picture of who would be the major online players had not quite emerged by 2001.

What about streaming media? At the NATPE convention in 2000, the major players were Microcast, Sandpiper, Akami (which later bought Intervu), and iBeam. A summary of big players in interactive television as of mid-2000 appears in 10.4 but is likely to evolve considerably in the next few years.

One problem with discussing start-up companies in the same breath as established companies is that many of these companies will be acquired by others or go bankrupt before the ink is dry on this page. Nevertheless, it is useful to see what companies were up to in the wild and woolly early days of online media.

Shakeouts

The major media corporations, especially NBC, were quick to jump on the interactive bandwagon, even before the turn of the century. Wall Street reality set in early in 2000, however, and the big shakeout began. NBC Internet shed its other brands (Snap.com, NBCi.com, Xoom.com, and Videoseeker) and portal activities, focusing instead on MSNBC.com and CNBC.com, as well as its program promotion on NBC.com. Some attributed the downturn to television's inability to drive

10.4 INTERACTIVE TV PLAYERS*

Content Provider	URL	Description
Walled Gardens and Content Providers		
ACTV	www.actv.com	Regional interactive-TV sports programming nets
America Online	www.aol.com	Walled garden and content provider
Broadcom	www.broadcom.com	"Generation Y" content focus with extreme sports show
CableSoft	www.cablesoft.com	Develop systems in conjunction with Motorola set-top cable boxes
Excite@Home	www.excite.com	Largest cable modem service in U.S., and one of the largest in the world
Future TV	www.futuretv.com	Web access, home banking, and t-commerce features, plus smart-card and debit-card applications
ICTV	www.ictv.com	Distribution
Intertainer	www.intertainer.com	Match interactive TV with video-on-demand. The interactivity side of this ledger includes t-commerce, interactive/personalized ads, and facts to find as you pursue on-demand viewing
Liberty Digital	www.libertymedia.com	Liberty has a deal with AT&T Broadband for distribution of up to 12 ITV channels
Meta TV	www.metatv.com	Develop interactive applications for cable operators, concentrating on home shopping as well as other t-commerce services and advertising
Metabyte Networks	www.mbtv.com	Best of two worlds—interactive electronic program guide and personalized video instrument à la TiVo or Replay TV. The more cable subscribers use this interactive guide service, the more personalized it gets for them, as "thumbprint" software embedded in the format automatically directs users to their favorite content
NDS	www.nds.com	Subscribers play director of the games they view. Other content forays include home banking, multiplayer games, and interactive ads
Net For All	www.iecommerce.net	Latino interactive-TV marketplace. Multilingual (English/Spanish/Portuguese) service has plenty of features, including web access, email, news/stock ticker, play-along games, and email.
NTN Communications	www.ntn.com	Interactive games via restaurants and sports bars nationwide, looking to break into cable
Peach Networks	www.peach-networks.com	Owned by Microsoft
Source Media/ Interactive Channel	www.sourcemedia.com	Interactive program guide and local/national information services. Source also has VirtualModem, a patented product that delivers high-speed web and multimedia content to TVs without a modem or PC, all from digital cable hardware
Transcast International	www.transcast.net	

10.4 CONTINUED

Content Provider	URL	Description
Tribune Media Services	www.tribune.com	Interactive program guide via Zap2it Services
TV Guide Interactive	www.tvguideinc.com	Leader in interactive program-guide field
TVN Entertainment	www.tvn.com	Video-on-demand, e-commerce, healthcare, games, education, and investment-service applications
Twin Entertainment	www.twinentertainment.com	Games service
WorldGate Communications	www.wgate.com	Internet TV service, complete with channel hyperlinking capabilities, has 20,000 subscribers and eight MSOs deploying it in the U.S.
ZapMedia	www.zapmedia.com	Hopeful mainstream provider, in league with former cable operator Gannett

Operating Systems and Middleware

Canal Plus U.S. Technologies	www.canalplus-technologies.com	Set-top boxes bundling Wink Communications' e-commerce tech with its wares. Company also partners with Concurrent Computer to add VOD functionality
Emperor Systems Software	www.tvlinux.com	Linux as set-top operating system
Liberate Technologies	www.liberate.com	Liberate positions itself as the Microsoft operating system alternative, and has investments from several cable operators, including Comcast and Cox
Microsoft	www.microsoft.com	Set-top operating system along the lines of Windows
OpenTV	www.opentv.com	Translate OpenTV's global success into domestic deals
Power TV	www.powertv.com	Set-top boxes
Spyglass	www.spyglass.com	Partner with OpenTV
Sun Microsystems	www.sun.com	Java language in cable set-tops

Infrastructure and Tools

Accelerate TV	www.acceleratetv.com	Be-all interactive-delivery mechanism
Cisco Systems	www.cisco.com	Equipment maker, wannabe content provider
Extend Media	www.extend.com	Distributing interactive TV across a variety of platforms, including wireless devices, by using advanced multiformat publishing systems
Intellocity USA	www.intellocity.com	Content development, developer tools, and infrastructure design
Mixed Signals Technologies	www.mixedsignals.com	Hardware and software are used to create and encode complex interactive TV, such as enhanced versions of *Jeopardy!* and *Wheel of Fortune*
Telecruz Technologies	www.telecruz.com	Provide platforms
Universal Electronics	www.uei.com	Work wireless keyboards, remotes, and Palm-type devices into every cable operator interactive-TV rollout

10.4 INTERACTIVE TV PLAYERS* *(continued)*		
Content Provider	URL	Description
Video Propulsion	www.videopropulsion.com	Digital video products are this new-to-cable firm's specialty, good for enabling email, shopping, and Web browsing on the tube
Wink Communications	www.wink.com	E-commerce/info delivery service is available to 200,000 cable subscribers in 20 markets

Source: *Cablevision,* June 2000.

business to the web, and others to some big players' focus on the consumer sector rather than on the more lucrative business-to-business sector.

What happened to webcaster DEN makes a good case study. DEN raised $62 million in venture capital in six months and burned $5 million a month. Its content was truly extreme, which led to very strong appeal. One critic compared it to the Golden Age of Sitcoms, but its downfall stemmed from a lesson explored in Chapter 1: *good, fast, or cheap—you can only have two of them.* DEN tried to do all three and became an overnight failure.

Another path to failure lies in overconfidence. ABC had a disastrous experience with its go.com web site, which attempted to become a portal. Despite the network's tremendous promotional resources, the online experiment lost out to Yahoo! and AOL, which specialized in the online world, where ABC only dabbled.

STRATEGIC CONSIDERATIONS

If program strategists are middlemen, and the Internet has no middle, then what is the role of program strategy? Considering the strategic themes outlined in Chapter 1 leads to the conclusion that *selecting* online programs is radically different from selecting in the old media environment. There are, however, enough similarities to discuss how programmers can make the transition from a time-bound broadcast world to the a-la-carte online world.

Daypart Compatibility

The utility of this strategic theme was considerably weakened for broadcasters with the advent of theme cable channels in the 1980s and 1990s (e.g., Game Show Channel, Cartoon Network). *The true goal of dayparting is to target groups of people,* however; the use of a time segment is only a means to an end. Online programmers who select programs for a given web site certainly can match their content to a *compatible* audience.

In the earliest days of streaming video, the distribution of materials was a novelty, so targeting was minimal. Streaming was done because it was possible, not because there was any market demand. Mainstream formats from television, for example, could not be expected to warrant the users' effort to download because it was easier just to watch TV.

The typical early online user was a young male. Programmers needed "edgy" content that met the sensibilities of pleasure-seeking youth. The most successful programs became iconoclastic cartoons like *The God and Devil Show,* which was reminiscent of *South Park* humor. Of course, the most extreme form of early program content for online programming was pornography, which has been a driver of early adoption of all kinds of new media innovations, from old wooden stereopticons, right through the 8mm film and Polaroids, up to the first VCRs and CD-ROMs.

In August 2000, the majority of online users officially flipped from male to female. Nowadays, the typical online user is no different than the typ-

ical television viewer. Thus, the strategy used by the cable theme channels will find a new home online, with the key difference being the user's ability to select from a list of options (**online menu**). *The programmer, as always, must construct an online menu that is compatible with the desired visitor to the web site.*

Habit Formation

Freed from time constrains, the web can show anything, anytime. Programmers must count on first-time visitors being so impressed with the online content that they will **bookmark** (save the address of) the web site. Present studies of **web site repertoire** already note that users have a limited number of favorite sites (so much so that the idea of "web surfing" has become outdated). Major sites (**portals**) like Yahoo!, MSN, and AOL function as *networks*, in the broadcast sense of the word. Different categories (called **links**) of content are presented on a main screen menu, sorted by interest area: news, sports, weather, travel, shopping, and so on. Many users go first to these sites as a jumping-off location for finding what they need to know or want to see. One strategy for programmers is to align themselves with a portal. Or, in the case of Time-Warner and AOL, allow one's empire to be bought by a portal.

Another strategy for content providers is to be an *independent web site*, not unlike the old independent television stations. Here the programmer must rely on the second kind of major site, the **search engine,** such as AltaVista and Infoseek. Even those users who first visit a portal will often try a search engine, too. *Programmers must decide whether to offer their content via major sites or to go it alone, hoping to be found by the search engines.* The job of habit formation falls to making a first favorable impression, such as being the best weather radar site or the best online auction site, an evaluation that will surely have appeal to the "programmers" of search engines.

Audience Flow

When it comes to the notion of audience flow, most online sites, once again, follow the cable

television model for specialized theme channels. As discussed in Chapter 1, the main strategy is to invite audience flow in and out.

On the other hand, online programmers can **cross-promote** content by including new offerings on the same page as the established content. If surfing (the online world's answer to *grazing*) is really less common nowadays than in the beginning, new services will need a programming strategy, beyond promotional support, to attract an audience. The **spinoff** approach and the **tie-in** approach used by broadcasters should work well for online content providers. Some examples of these approaches are discussed toward the end of this chapter.

Conservation of Program Resources

Just as broadcast and cable programmers recycle material to optimize its value, online programmers put as much material onto their online menus as possible. Unlike schedule-bound programmers, the online content providers are not forced to rotate or rerun offerings because everything is continuously available.

One unusual consideration may influence some providers to limit the availability of their material: Many programmers believe that *perceived scarcity* makes content appear more valuable to the public. For example, Disney carefully limits accessibility to its old classic films on videocassette and DVD to make them seem more special when they briefly become available in stores. If online content becomes too common or too readily available, the perceived worth of the products (as compared to premium materials) may be diminished. One reason why cable viewers spend so much of their time watching HBO is because they pay extra for it, and the extra use justifies the cost. The lesson for web site program services seeking subscription fees is to keep the content "special" and original.

Breadth of Appeal

Online content is not immune to being categorized as broadcasting or narrowcasting, even though the term *webcasting* does not differentiate. So far, the size of the online audience for broadband

entertainment and information is not large. Thus the strategy has been to *narrowcast unique content* (avant-garde films and edgy cartoons) and to *broadcast mainstream content* (sports, weather, news, commerce).

The number of web users who would be willing to watch streamed video is presently limited by connection speeds. *Until the rate of transfer problem is finally resolved, programmers must emphasize short-length materials.* Given the ever-decreasing attention span of adults, the online environment is well-suited for delivering brief programs. Even so, the speeds are getting faster and the competition between cable modems and DSL, like the competition between cable and satellite, has driven down the cost of broadband connections.[7]

SELECTION STRATEGIES

Those who toil in the programming business should take heart that regardless of the technology and distribution, *content remains king.* Programs have to have broad (or narrow) appeal to meet the consumers' needs and wants. Even if the audience starts paying more for entertainment and less comes from advertising, the nature of the product will remain the same: Comedy, drama, and human interest will prove enduring appeals.

As for specific online programming strategies, experts know as little about what works and doesn't work in this new medium as "experts" did during television's inception, or about radio in its early days. Many honestly thought radio would be used for education!

Although it is too early to pass along any tried-and-true methods, John Gaffney at *Revolution* magazine interviewed some key players in the online world about whether the web would grow up to be like TV.[8] Several good strategic points were made about a medium in which a Victoria's Secret webcast drew 2 million users and in which a small webcaster (AtomFilms) was making big deals at the Cannes film festival:

1. *Short is good.* Programmers should create online content that will download quickly. Perhaps content providers can benefit from the ever-shortening attention span of the audience.

2. *Generation Y is the unknown, otherwise the potential is small.* Thus, the near term is not threatening, much in the way cable TV was not a big bother to broadcast during the early years. To reach Generation Y, the primary audience for this textbook, old strategies will need to give way to new strategies. Multitasking is the ability for people to attend to several media activities at once. Young people have it, while their parents often do not.

3. *Speed must improve.* This may seem too obvious. The trick is to ramp up the quality wherever possible. Online video is fighting to catch up with NTSC video, standardized way back in 1941. Drawing even with the newer ATSC digital video standards must seem impossible without greater bandwidth (larger pipes) and faster speeds.

4. *Innovations take time.* Progress is incremental, and innovation happens on its own schedule. For programmers, the lesson is *do not overpromise.* The public is smarter than one thinks, as ABC learned with go.com and NBC discovered with its snap.com web site.

5. *Games have the best growth potential.* Online games, contests, gambling, and competition are probably the "next big thing" in terms of interactive program content. This area has been previously unexploited by the media, simply because the media were not yet interactive. Furthermore, the unregulated online world can more readily run lotteries than other media can.

SCHEDULING STRATEGIES

As discussed earlier, **dayparting** is a minor consideration for online channels because, as with the case of cable and satellite channels, the choices for users are plentiful. Radio and television stations have *one* channel, so it makes sense to target the *one* demographic group most likely to be

watching at a particular time of the day or day of the week—by age, gender, or lifestyle. Online shows exist in nearly limitless cyberspace, where shelf space is endless. Similarly, **flow** is not very important for online programming. Digital media can be ordered without regard to time or space. Even old media can be rescheduled to meet the tastes of the viewers, when filtered through a digital video recorder.

Tiering is one scheduling strategy that successfully makes the transition from the analog to the digital world. It is likely that consumers will purchase more of their programming as they do premium multichannel programming (see Chapter 9). Indeed, much of premium multichannel programming (e.g., HBO, Showtime, Encore) has already moved to a random-access schedule with the advent of digital set-top boxes and DVRs.

PROMOTIONAL STRATEGIES

The practice of online program promotion is still very young, but it is already clear that content providers need to promote their products and services using a mix of mass marketing and an abundance of online advertising (the equivalent of "on-air" in broadcasting and cable). The traditional media's interest in all things Internet also provides many opportunities for **publicity** (unpaid promotion).

Moreover, interactive media frequently generate email lists and more sophisticated demographic databases of potential audiences for other services. Nearly all web sites that offer content will require the user to sign up for the service, even if it is free. Then that user's email address becomes available (most sites ask permission) for updates. Instead of reaching merely *potential* users (as radio does with outdoor advertising), online services reach *actual* users, past and present, with their messages. Present users can also be encouraged to provide names of others who might be interested in the site, sometimes with a reward for the referral. In this way, online content providers can send messages directly to their subscriber base, without postage costs.

Even with no-cost opportunities, online promotion planners should budget money for paid advertising. The traditional media of print, radio, and TV supply enormous potential audiences for online entertainment and information (although many adults still avoid online content). At the same time, the newer online medium of **banner ads** reaches small targeted groups of online users. Despite the greater efficiency of online advertising, the reach of older media is important to build a base of users. It needs to be combined with a targeted online approach.

Interactive media can follow the promotion guidelines discussed in Chapter 9. Motion pictures will likely be released to PPV immediately following their theatrical runs, assuming that video stores become less effective in distributing movies. Mass marketing that once said, "Now on VCR and DVD," will shortly say, "Now on PPV." Other pay events carried online will require the same kind of promotion used in the past by cable operators and DTH satellite companies.

MEASUREMENT

As outlined in Chapter 2, Nielsen//Netratings and Media Metrix measure the size of online audiences, using two different methods: **online panels** and **server-side audits.** Both methods report mostly **cumes.** Measuring total reach is a good tactic when a "channel" has not yet attracted a substantial audience. When convergence of the media takes place in the next dozen years, ratings and shares will then prove useful tools for the kinds of online programming that garner a large core of regular users. Until that time arrives, some crucial things are known about the choices made by audience members in spending their time with media, especially the cable and broadcast channels in a new online media environment. In particular, although the number of TV/cable channels available to the average U.S. household had increased from 41 channels in 1995 to 62 in 2000 (an increase of 48 percent), the number of TV/cable

channels viewed had only increased from 10.4 to 13.1 (an increase of 25 percent). Thus, over a four-year period, *the number of channels had increased nearly twice as fast as the number of channels actually viewed or used by viewers* (the topic of **channel repertoire** is covered in Chapter 1). This trend suggests that viewers' usage of growing channel variety is not even coming close to keeping pace with the rapidly increasing number of available channels.

The implication for TV programmers is clear: Attracting and keeping an audience for a specific channel or the programs on that channel has become increasingly difficult. Like diners in their favorite restaurants who generally order the same few items, viewers tend to stick with previous choices that have proved rewarding and adequate to meet their needs.

Just as the increase in available channels brought about by cable had a major impact on the existing broadcast channels, the Internet is now having an even greater impact on how viewers use their cable/satellite/broadcast channels. Again, there is a parallel trend to be found in people's choices of web sites used versus the number of available web sites. Data indicate that although the number of web sites has shown enormous growth, the number actually used by Internet customers has increased only marginally. Web users have begun to reach a comfort level where they usually access the same sites each time they go online. Perhaps an occasional new site is added or even accessed regularly, but the core number has remained rather small and consistent. Whatever lure that "surfing" held in the first few years of the World Wide Web, the most recent research indicates that habit formation is at work.

How web use affects viewing and listening to traditional media is not entirely clear. Early audience surveys of web users showed that to accommodate web use, they cut back on some of the time ordinarily spent watching television. Later research has shown that heavy web users spend even more time with traditional media than light web users.[9] Studies also found that many heavy web users are using other traditional media at the same time as the web. Interestingly, overall household use of both television and radio continues to go up despite the competitive presence of the Internet. Although the number of web users had topped 60 percent by 2000, average daily household TV viewing had increased to an all-time high of 7 hours and 24 minutes. Average time spent listening to the radio had risen to 21.5 hours per week among those 12 years of age and older.[10]

Although the overall time spent with traditional media may not have been affected by the presence and use of the Internet, how people use traditional media in fact has changed. Network television audiences continue to shrink as a percentage of the total audience watching television in all dayparts, most notably in prime time where the number of total TV viewers is highest, and for news and information programming.

The Pew Research Center surveyed the national news audience at the turn of the century. Among the many findings, several are relevant to programmers for the emerging online world. They are summarized on the first page of the Pew report:

Traditional news outlets are feeling the impact of two distinct and powerful trends. Internet news has not only arrived, it is attracting key segments of the national audience. At the same time, growing numbers of Americans are losing the news habit. Fewer people say they enjoy following the news, and fully half pay attention to national news only when something important is happening. And more Americans than ever say they watch the news with a remote control in hand, ready to dispatch uninteresting stories. To some extent, these trends are affecting all traditional media, but broadcast news outlets—both national and local—have been the most adversely affected.[11]

Beyond news and information content, the Internet has changed the face of television. It has changed how audiences use television and how they think about what television represents as a communications medium. Nielsen's *Home Technology Report* has described how and why some of these changes have occurred and continue to occur.[12] The report observes that fundamental changes have taken place in terms of (a) the content itself; (b) the content delivery means (e.g.,

cable modems, satellites, wireless networks); and (c) the content receiving tools (e.g., TV sets, hand-held wireless devices, monitors). Content receivers include the TV set now being used to deliver Internet content, PCs being used to deliver TV programming, and special purpose devices for specific Internet applications.

Like the national/local ratings for broadcast, cable, and radio, Internet audience measurement has proven to be a very difficult and complex process. Companies are refining the process and constantly testing to find new and better ways to measure web audiences; the task is daunting. Nielsen's *Home Technology Report* describes some major complications that make accurate measurement very difficult. For example, because of increasing interactions happening with users on their PCs, information collected at the web site level is less and less clear about how content is actually being consumed. In this case, PC users may access a web site and perform other operations while keeping the web site online. Such uses may be widespread and varied but would be considerably different from the user who went to a site, used it, and then closed it.

The Online Audience

Who are the users of web site content? Who watches (or listens to) online content? Is it just a bunch of college kids with high-speed connections? The United States had 78 million web surfers in April 2000, with equal numbers of men and women. The Internet, once the toy of young people, has become dominated by adults in their 40s. Only 21 percent of homes with incomes less than $15,000 were on the web, but 77 percent of those with combined family incomes of more than $75,000 had Internet access. Only about 9 percent had connection speeds higher than dial-up 56kps. Broadband connections in 31 percent of homes were anticipated by the end of 2003.

Another clue to the activities of the audience for web programming is clear from overall online usage. The 1999 statistics in 10.5 show a substantial percentage increase in Internet activity and spending.

It appears that the audience for online programming is not much different than the audience for other types of programming. Having a high-speed connection favors young males in 2001, so that explains most provocative content on streaming sites. But not everything is experimental or crude. As more people come online, and as more get faster connections, the web looks more like a mainstream medium.

Internet Behavior

The average Internet user in 2000 was on the net 19 times per week for an average of 30 minutes per session, visiting an average of only 11 unique sites. Time spent per site was about 53 minutes, and time spent on the net was about 9.5 hours per week. Altogether, the web consisted of 2 billion sites in 2001 and continues to grow daily. Each user has quickly become very selective in relying on a very small number of sites for normal use. An ineffective site (one that presents obstacles to users) is only a mouse click away from disappearing from the screen, a behavior similar to that of TV viewers who, remote in hand, are ready to change channels when the program fails to maintain their interest.

A study by Ferguson and Perse found that web surfing was not exactly a substitute for television viewing (although it was seen as being just as diversionary), primarily because online activity is less relaxing.[13] ABC's executive vice-president of Internet media Dick Glover contrasts the difference as the *lean-back experience of TV* versus the *lean-forward experience of online media*.[14]

Nonetheless, the big television networks are creating online content to complement their prime-time and sports schedule. What makes the networks think that computer users will be watching television while they are online? It is because 44 million web users, according to a 2000 Gartner survey, report using their online browser at the same time they watch TV. The number was projected to grow to 52 million by 2001.

A February 2000 report from Statistical Research, Inc. (SRI), suggested that, when it comes

10.5 CONSUMER MEDIA USAGE, 1998–99

	Hours per Person				Spending per Person		
	1999 (Estimated)	1998 (Actual)	Percent Change		1999 (Estimated)	1998 (Actual)	Percent Change
Total TV	1,579	1,573	+0.4	Total TV	$188.55	$168.78	+11.7
Broadcast TV	840	884	−5.0	Broadcast TV	—	—	—
Network-affiliated stations	660	708	−6.8	Network-affiliated stations	—	—	—
Independent stations	180	176	+2.3	Independent stations	—	—	—
Subscription/video services	739	689	+7.3	Subscription/video services	$188.55	$168.78	+11.7
Basic networks	632	582	+8.6	Basic networks	NA	NA	NA
Premium channels	107	107	0.0	Premium channels	NA	NA	NA
Radio	1,037	1,050	−1.2	Radio	—	—	—
Recorded music	288	284	+1.4	Recorded music	$ 63.07	$ 61.54	+2.5
Daily newspapers	154	156	−1.3	Daily newspapers	$ 51.85	$ 51.39	+0.9
Consumer magazines	81	82	−1.2	Consumer magazines	$ 39.51	$ 38.30	+3.1
Consumer books	94	95	−1.1	Consumer books	$ 88.73	$ 84.35	+5.2
Home video*	57	56	+1.8	Home video*	$ 97.51	$ 92.14	+5.8
Movies in theaters	13	13	0.0	Movies in theaters	$ 32.18	$ 31.16	+3.3
Videogames	48	43	+11.6	Videogames	$ 21.01	$ 18.45	+13.9
Internet	97	74	+31.1	Internet	$ 39.89	$ 30.78	+29.6
Total media**	3,448	3,426	+0.6	Total media	$622.31	$576.90	+7.9

NA = not available
*Playback of prerecorded tapes only.
**Not all columns add up to totals, due to rounding.

to web activity, the average Internet user is not always an explorer. It reported that 34 percent of visitors to an average web site returned to the same site every day, and that 62 percent of those visitors had the site bookmarked in their browsers. In addition, 85 percent of web users reported visiting just one or two sites during a typical three-hour daypart (web site repertoire). The SRI report also reflected Internet users' adventurous side, however, with surfers reporting searching the Internet (57 percent) and looking for product information (46 percent) more often than any other activity except email.

Just as demographics have evolved, so will behavior. In the 1950s when television was new, people would watch *anything*. Later they became more sophisticated and predictable. *The challenge for online programmers is to stay current with the desires of their audience.* Although this is true for other media, it is especially important for media in their infancy.

IMPACT ON THE MAINSTREAM MEDIA

For someone operating from within the established media, staying informed about trends in online programming is important to maintaining audience share. More important, mainstream

media can spot new opportunities by following the new developments in the online world. The flip-side of opportunity is threat, so it also pays to know what looms over the horizon. This section recounts some of the threats (and opportunities within) the status quo.

Video

The arena where the biggest money has been spent is that of video. Online video represents different levels of threat to the more established media.

Network Television

The major networks all developed web sites to promote prime-time programs and provide archived clips, but it wasn't until near the turn of the century that they got really creative and produced made-for-online programming.[15] In 2001, Warner Brothers debuted a new animated comedy series, *The Oblongs*, online before its subsequent network debut on The WB. Potential viewers of this edgy comedy could tune in 25 original 30-second animated sketches produced separately for a Theoblongs.com web site. In another example, The Anteye Network, at www.anteye.com, bet $600,000 that the web is a good testing ground for pilots. After a contest where web surfers voted on content, six winners were awarded production deals worth up to $100,000 each, to create pilots that Anteye would help shop to TV studios.

Testing new prime-time shows online also came into vogue about the same time. For example, in late 1999, Fox Entertainment commissioned a new TV series that would spend months on the fox.com site before moving to the Fox broadcast network. The creator and producer for the show previously did the movie hit *The Blair Witch Project.*

But the first real signal that prime time was being influenced by online programming was NBC's animated series *God, The Devil, and Bob*, which briefly aired in March 2000. The program was based on a popular online animated series called *The God & Devil Show* at the www.entertaindom.com web site. Apparently, the bawdy content of the site made the online series more appealing than

the toned-down version that was given an ill-fated tryout on NBC. It became obvious that online success with youth audiences did not necessarily translate to the mass audience of prime-time television.

Enhancing existing series is another way for broadcasters to use online content. For example, Fox decided in March 2000 to stream ten-minute webcasts a half hour before the last six episodes of *That '70s Show* of the prime-time season. Such tie-ins are a way to promote shows that have been on the air a while. The arrival in prime time of hit game shows like *Who Wants to Be a Millionaire?* and reality shows like *Survivor* also gave networks a chance to hold the audience's attention even after each episode had ended. The final episode of the first *Survivor* series in the summer of 2000 joined the list of all-time hit series episodes, up there with the top Super Bowls, with a rating of 28.6 and audience share of 51.7. That means 72 million people watched some part of that episode, and it also boosted the CBS.com site usage enormously, almost doubling it from the previous week's half million visitors, according to a Nielsen// Netratings online press release.

Sports content is another arena of television content that lends itself to an online component. To expand the reach of live NFL Football telecasts to Austria, the Netherlands, and Singapore, the events were sold to broadband users as part of a pay-per-view package. In the United States, viewers were receiving "Enhanced TV" on ABC's *Monday Night Football.* In 1999, between 50,000 and 90,000 viewers were logging on to each game's online simulcast. In terms of **stickiness,** a measure of time spent with a web site, the viewers were averaging 40 minutes of connect time, motivated by access to live statistics, trivia polls, and an online game that let them win points by predicting the next play. Surprisingly, only 2 percent of the users were young males—60 percent were aged 26 to 45.

The National Basketball Association also got on the **convergence** bandwagon, bringing computers together with television. The NBA showed multiple webcam coverage of the All-Star Game

10.6 ONLINE ANIMATION WEB SITES

The "Pure Animation" Sites:

www.entertaindom.com
www.mondomed.com
www.joecartoon.com
www.atomfilms.com
www.bde3d.com
www.doodie.com
www.level13.net
www.staytooned.com
www.shockwave.com
www.spunkyproductions.com
www.ifilm.com
www.cartoonnetwork.com

Aside from these, other mixed-content webcast sites existed in June 2000. These sites generally feature short films made by avant-garde filmmakers just getting started. Occasionally sites will put on old, public-domain films and TV shows just for the sake of having content.

www.dreadnought.com
www.shorttv.com
www.thebitscreen.com
www.pseudo.com
www.playtv.com

10.7 WHERE IN THE WORLD IS TUVALU?

Most people have never even heard of the small Pacific island Tuvalu, but they can appreciate the significance of its two-letter country code: TV. Every nation has an Internet code that routes incoming connections, like .br for Brazil and .it for Italy. An enterprising California start-up company called dotTV and its parent Idealab agreed to pay the Tuvalu government $50 million over 10 years for the rights to the .tv domain name. So instead of going to www.microcast.com, you can visit www.microcast.tv instead. Each company that adopts the domain name pays $1,000 a year for a creative address like FrasierCrane.tv or up to $100,000 for names like news.tv or sex.tv.

on www.nbc.com, where viewers could choose camera angles. Nielsen//Netratings revealed in June 2000 that a WWF "King of the Ring" promotion boosted visits to its web sites by 64 percent in one week.

Political coverage of the summer 2000 conventions was scaled back for the traditional network news operations and vastly expanded on their online counterparts. Nearly 100 web sites covered and webcast parts of the proceedings. AOL used a skybox cam 24 hours a day, one of many such setups. The viewer had the capability of communicating directly with floor correspondents of the dozens of e-journalism web sites. Although this proved less popular with television and web users than hoped, it signals the likely direction of future convention coverage.

Network Imitators

Among the streaming media sites emulating the offerings of broadcast networks are EYada, Laugh, ClickMovie (featuring dozens of classic TV shows), and Entertaindom (best known for the animated *The God & Devil Show*). The animation sites seem to attract larger audiences. Flash animation continues to be a favorite method for these sites because it looks good but does not require much bandwidth. Net animation houses such as Spunky, Mondo Media, and JoeCartoon.com are not based in Hollywood, but they aspire to be big studios. Even users with slow modem connections can enjoy these sites, many of which are provocative (see 10.6). *South Park* creators Trey Parker and Matt Stone were lured to produce flash animation for Shockwave. (Most web cartoon sites rely on Macromedia's Shockwave Flash.) Mainstream producers also took note. The Carsey-Werner-Mandabach production firm (*Roseanne, 3rd Rock from the Sun*), for example, opened an animation division.

Local Television

Individual stations got into the act of webcasting with repackaged and simulcast local news content

10.8 DIGITALCONVERGENCE.COM

DigitalConvergence.com is a company that set its sights on selling local broadcasters, advertisers, retailers, and others a way to deliver enhanced content from the television to the PC, rather than the other way around. Unlike Wink and ACTV who offered programming and commercial enhancements via digital set-top boxes, DigitalConvergence.com's technology was available to anyone with a television and computer within 20 feet of each other. The company's proprietary technology—**:CRQ,** a phonetic acronym for "See Our Cue"—was based on an audio cue encoded into the vertical blanking interval of the broadcast signal. This allowed the system to work with video delivered over the air, cable, or satellite, even recorded video.[16]

The audio cues sent the user directly to the particular web page that coincided with the TV message or could be stored for later. Because the audio cue was in-band and could not be stripped out, the system worked with other enhanced services. It used technology that has near 100 percent penetration: basic free television, according to the company executives. No special cards or set-top boxes were required. The only limitation was the number of homes with Internet connections, then about half of the United States.

DigitalConvergence.com had also developed a print application—:CAT (keystroke automation technology)—based on the same concept as :CRQ. A scanning device, built to look like a cat and to split off the cable running into the PC's mouse portal, read a code on a printed page and delivered Internet addresses to the computer. Once installed, the :CAT read codes from practically anything—from printed news to UPC codes on packaged goods. Two enhanced spots per half hour is the limit set by DigitalConvergence.com, but stations had unlimited use of cues for content and promotion. Another limitation Digital-Convergence.com imposed was that only two stations within any local market could license the technology.

from such programmers as Zatso, BroadcastAmerica (*NewscastNow.com*), SeeItFirst.com, and Microcast.tv, among others. One of their innovative ideas is described in 10.7. The real potential for local stations is for **t-commerce,** which markets online products via over-the-air TV commercial links. Similar to **e-commerce,** which exists solely online, t-commerce is in the survival plans of many television broadcasters.

Local broadcasters are always looking for ways to use their spectrum to create new revenue streams, beyond advertising. One idea is to send information from the television to the personal computer (see 10.8). A different idea is for companies like Broadcast Digital Cooperative, iBlast, and Geocast to help local stations provide content to personal computers via over-the-air broadcasting, using part of the digital spectrum set aside for HDTV. The bandwidth of a broadcast signal is much wider than broadband or DSL, so the opportunity to have real-time streaming is exciting. Either method enhances a local station's ability to get started with t-commerce. Rather than have only one revenue stream (advertising), local stations could sell subscriptions for a second stream and facilitate the sale of merchandise for a third stream.

Cable/Satellite

Cable operators have a two-pronged approach to online programming. First, they sell high-speed connection via cable modem through services like Excite@Home and RoadRunner. A list (see 10.9) of cable modem services shows the number of subscribers in early 2000. Second, they (and DTH companies) provide programming content that competes with (or complements) online viewing. DTH satellite is offering high-speed Internet access

10.9 CABLE MODEM SUBSCRIBERS

Cable Modem Services	Affiliates	Subscribers
Charter Pipeline	N.A.	N.A. (4/00)
Convergence.com	N.A.	5,518 (4/00)
Excite@Home	60	1,500,000 (4/00)
HSA	80	16,099 (2/00)
Internet Ventures	4	1,700 (2/00)
ISP Channel	67	10,044 (4/00)
Optimum Online	2	31,474 (4/00)
Power Link	30	37,000 (3/00)
Road Runner	44	730,000 (4/00)

Source: www.cvmag.com.

(with a telephone line return loop because DTH is one way).

Oxygen always wanted to be an established cable channel but had its first incarnation as a web channel because streaming media presents an opportunity for wannabe cable networks to audition their content. MeTV was the opposite situation: a web-page first and then a pay-per-view service (streamed movies for $5 with a $200 set-top linked to a PC).

HBO introduced fans of its *Oz* drama program to new **webisodes** at its www.hbo.com/oz site in advance of the telecasts on HBO in the 2000 fall season. And Showtime borrowed a page from the broadcast networks in 1999 when it simulcast a high-draw telecast, the Tyson-Norris boxing match, with interactive camera angle selection by the subscriber (at a higher fee than the usual Showtime subscription).

After 20 years, CNN started to see its ratings decline in 2000, partly because so many people were getting their information online. If you can't beat 'em, join 'em (they say), so Turner Broadcasting invested $1.2 billion over five years to develop handheld-wireless online access to CNN. Its goal is to maintain CNN in the dominant position as a news provider anytime, and now, anywhere.

Video-on-demand (VOD, see Chapter 9) became a reality for cable operators who did online interactive trials using set-top boxes from Motorola and Scientific-Atlanta. Some of the **platforms** (computer operating systems) included Liberate, MicrosoftTV, OpenTV, and PowerTV. The actual program services came from these companies (some of which are listed in Chapter 9): Intertainer, Diva, ICTV, Wink, and RespondTV.

The pay movie services have been cautious about Internet PPV, wanting to be sure that the rights they buy *include* Internet rights. On the other hand, Playboy Television was one of the first cable premium channels to push online PPV, back in 1998, in a deal with MindSpring. Encore got creative in its multibillion-dollar 1999 licensing deal with the Disney studios, when it unveiled a service called **SVOD** (see Chapter 9). Subscription VOD uses a video file server to store and deliver pay movies whenever a subscriber wants them, with full VCR functionality.

The primary advantage of **Internet VOD** over conventional pay-per-view is that the former can be completely automated. Subscribers get their content played as if they had put a dollar into a jukebox. For a movie to download in five minutes or so, however, even at the high compression rates used in most software, the end-user must be equipped with access lines supporting throughput of about 3 megabits per second. Someone with a typical digital subscriber line or cable modem line running at a few hundred kbps (see 10.2) would require the better part of an hour to download a feature-length film. **Real-time streaming** is faster, but such technologies were new and untested in 2001. Hollywood was likely to wait until they were ready. In the meantime, there would be a place in the **window,** probably after films are shown on free broadcast TV, because then they have been fully exploited.

Program Guides

TV Guide and other companies have online guides to broadcast, but by 2000 only two companies (Yack and Channelseek) offered comprehensive Internet program guides. Yack.com later ac-

quired Channelseek in a multimillion-dollar stock deal. Channelseek had published the first printed guide to streaming media, which was stuffed into mailers sent by broadband and DSL providers.

Interactive television lends itself to better methods of searching for content, especially if the viewer is cruising along the web. Some observers predict that "smart TV" receivers will use artificial intelligence to anticipate audience desires, based on past viewing habits. This author predicted back in 1997 the need for a "something else" button on remote controls that would allow viewers to change broadcast and web channels without ever going back to a previous choice (during a single sitting).[17] A few years later, such a forecast should be revised to a "give me what I like" button that would be the viewer's last resort after giving up on finding anything good without the set-top box's help.

Audio

Streaming audio content has become commonplace on the web. At the same time, web audio has also profoundly affected the music recording industry.

Radio

Survey research by Cyber Dialogue, Inc. showed that more than 40 percent of Internet users in 1999 accessed some music-related content, with more than one-third visiting sites operated by radio stations and more than one-quarter downloading music.[18] Several web sites offer their visitors an opportunity to be disc jockeys by modifying music playlists for themselves and like-minded web surfers. These included Launchcast.com, TuneTo.com, and Live365.com, to name just three.

MSN offers an assortment of simulcast and Internet-only radio stations (see 10.10). Kerbango.com is another source for connecting to online radio. Although the simulcasts extend the reach of stations to interested listeners in other markets, the local stations in those markets get some unwanted competition for listeners. Arbitron does not yet measure such listening, however.

Aside from music, sports radio got some competition from NFL audiocasts in the 2000–01

season. NFL teams agreed to create an NFL Internet Network to provide free audio for every game not covered by a local radio contract. Major League Baseball also announced a similar plan to audiocast its games.

Music Recording Industry

Their names are Gnutella, Scour.com, and Napster, but Napster got all the attention in 2000, when a controversy arose about a program (written by a 19-year-old) that enabled owners of digital-quality CD music to "share" their music with like-minded youths (or old people). Unlike neighbor-to-neighbor sharing, however, these copyrighted files were being traded across international borders instead of picket fences. Some universities blocked access to Napster because so many undergrads (and grads) were tying up the campus digital backbone with pirated music files, typically requiring 5 megabytes per song.

Journalist Steven Levy said it best: "Napster allows you to search for almost any song you can think of, finds the song on a fellow enthusiast's hard drive, and then permits you to get the song for yourself, right now. For the unbeatable cost of free, nada, gratis, bupkes, zero."[19] He also noted that this controversy follows a long history of similar concerns: Both VCR and audiocassettes were supposed to kill intellectual property rights but did not. Maybe this time the difference was the ease with which illicit copying could be done online.

Lawsuits threatened to shut down Napster eventually. With some newer systems, however, the searching is done in a distributed manner, so it cannot be stopped. Unlike Napster, Gnutella was used to exchange not just music files but any files. Freenet is another, more radical approach because it randomly distributes encrypted, copyrighted material.

Film

Each of the major Hollywood studios has its own dot.com, exploring the streaming video world, not sure where it is leading them. They fear, with some justification from the Napster imbroglio,

10.10 MSN ONLINE RADIO

allDANZradio Swing (Internet only)	GMN.com (32k stream) (United Kingdom)
AndHow Web Radio—Jazz and Blues	Homestead.com Jazz X/theDial (Internet only)
(Internet only)	Homestead.com Soul Kitchen/theDial
Areaguides.net Jazz X/theDial (Internet only)	(Internet only)
Areaguides.net Soul Kitchen/theDial (Internet only)	Jazz FM 102.2 FM (United Kingdom)
audiohighway.com Jazz (Internet only)	JAZZ Radio 106.8 FM (Poland)
BluesBoyMusic.com (Internet only)	JazzManMusic.com (Internet only)
BluesBoyMusic.com (Internet only)	JazzManMusic.com (Internet only)
cablemusic.com Smooth Jazz (Internet only)	J-WAVE 81.3 FM (Japan)
ChoiceRadio.com Jazz (Internet only)	KBON 101.1 FM (Eunice, LA)
ChoiceRadio.com Jazz (64k stream) (Internet only)	KHIH 95.7 FM K High (Denver, CO)
ChoiceRadio.com Smooth Jazz (Internet only)	KOAZ 97.5 FM The Oasis (Tucson, AZ)
CrossOver 105.1 FM (Philippines)	KPLU 88.5 FM Pacific Lutheran University
cyberradio2000.com Ratpack Plus (Internet only)	(Tacoma, WA)
cyberradio2000.com Blues Trip (Internet only)	KSDS 88.3 FM Jazz88 (San Diego, CA)
cyberradio2000.com Night Grooves 1	KUNR 88.7 FM (Reno, NV)
(Internet only)	KWSJ 105.3 FM The Oasis (Wichita, KS)
cyberradio2000.com Night Grooves 2 (32k stream)	KZSP 95.3 FM Love 95.3 (South Padre Island, TX)
(Internet only)	mediAmazing.com Blues (Internet only)
cyberradio2000.com Soul Patrol (Internet only)	mediAmazing.com Jazz (Internet only)
cyberradio2000.com Swing Dream (Internet only)	NetRadio.com Café Jazz (Internet only)
cyberradio2000.com Zydeco Ave (Internet only)	NetRadio.com Divas (Internet only)
DiscJockey.com BluesLine (Internet only)	NetRadio.com Jazz Rock (Internet only)
DiscJockey.com Guitar Wars (Internet only)	NetRadio.com Lounge (Internet only)
DiscJockey.com Modern Swing (Internet only)	NetRadio.com Quiet Storm (Internet only)
DiscJockey.com Progressive Jazz (Internet only)	NetRadio.com Smooth Jazz (Internet only)
DiscJockey.com Smooth Jazz (Internet only)	NetRadio.com Acid Jazz (Internet only)

that a little application program written by a 19-year-old in a dorm room could steal their intellectual property and eliminate copyright royalties. Even encryption schemes may fail, if someone is clever enough to remove the digital fingerprint from a purchased copy.

Undaunted, two producer giants, no less than Steven Spielberg (Dreamworks SKG) and Ron Howard (Imagine Entertainment), teamed with partners to create a *pop.com* site that featured short pieces of filmmaking. Initial capitalization was set at $50 million, but pop.com quickly died. Other start-ups are shown in 10.11, but a coherent list of major players has not yet merged.

Online is not just carrying short films, either. In January 2000, MGM became the first Hollywood studio to get serious about online pay-per-view when it made a multiyear deal with Blockbuster Video. The arrangement included streaming of movie trailers, old MGM television series such as *Flipper* and *Green Acres*, and feature-length films on a trial basis. In the same year, Miramax signed a similar deal with SightSound.com to present 12 feature-length PPV movies online. Viewers would pay about $2.95 per title.

Blockbuster sees such new film technologies as a threat to its video rental business. Forming another strategic alliance in 2000 (to position itself against possible change in the future), Blockbuster

10.10 CONTINUED

One.net Jazz X/theDial (Internet only)
One.net Soul Kitchen/theDial (Internet only)
Phoenix Radio Network Phx Jazz (Internet only)
Radio Free Virgin Absolutely Live (Internet only)
Radio Free Virgin Absolutely Live (56k)
 (Internet only)
Radio Free Virgin Absolutely Live (96k)
 (Internet only)
Radio Free Virgin Jazz (Internet only)
Radio Free Virgin Jazz (56k) (Internet only)
Radio Free Virgin Jazz (96k) (Internet only)
Red FM 88.1 FM (Mexico)
Relax 92.4 FM (Germany)
RhythmRadio Blues (Internet only)
Salon.com Jazz X/theDial (Internet only)
Salon.com Soul Kitchen/theDial (Internet only)
Shibuya FM (Japan)
Softwave (Russia)
Softwave (64k stream) (Russia)
Sporting News Jazz X/theDial (Internet only)
Sporting News Soul Kitchen/theDial (Internet only)
The Basement (Australia)
Tubemusic Jazz and Blues (36k stream) (Korea)
TuneInNow Jazz (Internet only)
WCLK 91.9 FM Clark University (Atlanta, GA)
WDRR 98.5 FM Dream 98.5 (San Carlos Park, FL)
WFSJ 97.9 FM Smooth Jazz 97.9 (Jacksonville, FL)

WiredKingdom Radio (32k stream) (Canada)
WLVE 93.9 FM Love 94 (Miami, FL)
WNYC 93.9 FM (New York, NY)
Women.com Jazz X/theDial (Internet only)
Women.com Soul Kitchen/theDial (Internet only)
WOV Radio 990 AM (Otisville, NY)
WWBZ 98.9 FM (Charleston, SC)
www.com Avant-Garde (Internet only)
www.com Blues (Internet only)
www.com Blues Rock (Internet only)
www.com Bop (Internet only)
www.com British Blues (Internet only)
www.com Classic Blues (Internet only)
www.com Classic Jazz (Internet only)
www.com Crossover Jazz (Internet only)
www.com Fusion (Internet only)
www.com Hard Bop (Internet only)
www.com Jazz (Internet only)
www.com Modern Blues (Internet only)
www.com Modern Jazz (Internet only)
www.com Post Bop (Internet only)
www.com Smooth Jazz (Internet only)
www.com Instru Pop (Internet only)
www.com Jazz Cafe (Internet only)
www.com Lounge Lizard (Internet only)
www.com Pop Jazz (Internet only)

joined in plans to develop a VOD service for TiVo subscribers. This particular service would allow Blockbuster customers to reserve movies through their special TiVo remote control. In return, Blockbuster would promote the TiVo digital video recorder at its 4,000 stores nationwide. In many ways, the online video inroads affect the studios and the networks equally. As distribution of materials moves online and to subscription services, the penetration of homes may grow to the point that over-the-air broadcasting becomes a novelty.

A good strategy for the film studios, and the other impacted "old" media, is to adapt to the new environment. An **adaptive strategy** has to be viewed from the standpoint of the established

media and their "old" business models. For example, how does local television adapt to increased online competition? How do the program distributors (networks) adapt to new forms of delivery? By gradually changing over to the new methods. When TV replaced prime-time radio, radio didn't die. It changed. If digital viewing technologies wrest the control away from programmers, they too will have to change. Even so, the old way of packaging shows in arranged schedules won't vanish completely, right away. Most revolutions tend to be hyped evolutions. Many businesses adapt by changing their business model or product. When the telephone industry saturated its growth potential by the 1980s, it looked to other information

10.11 HOLLYWOOD DOT.COMS

Site	Company	Content
Entertainment Destinations		
Pop	Dreamworks/Imagine	Short films/videos/games
Distantcorners	ex-Disney film chief	Horror/science fiction
Thethreshold	Threshold Entertainment	Games/comedy
Wirebreak		
Z	Basic Entertainment	
Entertaindom	Warner Brothers	
Station	Sony	
Movies-Online	Leo Films	
Go	Disney	
Portals		
Atomfilms		Short films/animations
Ifilm	CNET/E! Online/Fox	Site for budding filmmakers
Sightsound		Music/film
Dfilm		
Bijoucafe		
Medium4		
The bitscreen		
Pseudo		
Business-to-Business		
Filmbazaar		Forum for filmmakers
Reelplay		Forum for filmmakers
Mediatrip		
Alwaysif		

entities, like cable. When Kodak saw the impending doom of its film business in the 1990s, it got into the digital photography business.

WHAT LIES AHEAD

An article in *Electronic Media* tried to answer some important questions about streaming video, following the early demise of a few companies in that business.[20] The important question was whether consumers really want to watch streaming video. If so, when will full-motion, full-screen video

streaming be a reality? The first answer was yes, with an asterisk. As of 2001, streaming video is only truly accessible and viewable in closed, controlled, corporate environments. It will be at least until 2005 before enough people have fast connections to online materials.

In response to another question—Can entertainment streaming video sites actually make money?—the answer was "not in the near future." Even then, revenue will need to flow in many streams: advertising, sponsorships, transactions, and commerce. Obviously, the pay-per-view model works well, but it is hard to get people to pay for

things that others are giving away. As for advertising, it may work best when it is personalized—something called **one-to-one** marketing, where share of customer is more important than share of market. Privacy is also an issue, and a sufficient base of potential consumers must exist to make the extra marketing effort worthwhile.

Bandwidth considerations make streaming video look substantially different from regular video. To accommodate bandwidth limitations, programs keep movement to a minimum, and motion effects are discouraged. The audience for online programming is willing to be somewhat patient with the glitches inherent in a new medium, not unlike the situation with early film audio and early television color, but eventually streaming video and audio will have to at least match the quality of home video.

Faced with the announcement of big changes in store for old media in a new media world, some people wonder aloud whether people really want to interact with their TV sets. One should consider that the same question was asked about the personal computer, which was originally designed for doing such office work as spreadsheets, word-processing, and databases. The answer proved to be *yes*. Will people be just as enamored with interactivity from their TV as from their computer? It is likely, given the right tools and applications.

Do people want to watch video over the web on their computers? No, not if it duplicates entertainment video already available on broadcast or cable, and certainly not if it looks worse than the picture on the TV set out in the garage. But people *will* want to watch informational videos, such as virtual tours at real estate sites or displays of car models. They want conveniences that make their lives easier. Gary Lieberman, analyst for Morgan Stanley Dean Witter, made pithy predictions about the future of online, among them are the following 11:[21]

1. Once the tools and applications are in place, the revenue potential is huge.

2. Watching QVC, if you have a "buy" button on your remote, will be hard to resist.

3. Set-top boxes will not succeed unless they cost $300 or less.

4. Obsolescence will become the same problem for set-top boxes that it is now for computers.

5. Thin applications will be more successful than fat ones.

6. DVRs are like power windows on your car: Once you have them, you can never go back.

7. The first step will be video-on-demand.

8. The "killer application" will be a surprise, likely dreamed up in a dorm room.

9. Interactive TV will land in the middle of the PC and TV experience: You won't lean back as much as you once did, but you won't lean forward as much as you do with your computer.

10. Brand names will continue to be important.

11. Compatibility is a must.

According to Paul Kagan Associates, Internet pay-per-view will be a $5 billion a year business in 2005, up from $460 million in 2000. And here's one final forecast, this time from Strategy Analytics: By 2005, 91 percent of U.S. homes will be online. About 90 percent of them will use a PC, but 73 percent will also have interactive TV or other Net device. Sales of interactive TV appliances, such as online digital TV set-top boxes and advanced games consoles, will reach $2.4 billion in 2000, an increase of 107 percent. Sales will peak at $4.8 billion in 2003 but will decline to $4.2 billion in 2005. Shipments, however, will reach 7.4 million units in 2000 and rise at an average growth rate of 44 percent a year, reaching 26.4 million units a year by 2005.

If 91 percent of America is online by 2005, then the ubiquity of the broadcast world will no longer be so wonderful. It is hard to imagine that consumers might download their favorite shows while channel-surfing through thousands of channels or letting a DVR robot download programs for them while they are away, but such change seems likely in the coming years. Whoever designs the kind of remote control Americans use will have a tough job. Will a trackball replace the mouse?

Will voice-recognition do away with the lap keyboard no one will want to use? The answers will demand careful thought and planning. Can the public afford to pay individually for each show? Will product placement within sitcoms and dramas be enough to pay the stars' salaries? If the economics are wrong, the old mass audience ways will last much longer. If the new media demassify the audience, however, there may be no turning back. You will live in interesting times.

SOURCES

Broadcasting & Cable. Weekly trade magazine. New York: Cahners Publishing Co.

Miles, Peggy. *Internet World Guide to Webcasting*. New York: Wiley, 1998.

Novak, Jeannie, and Markiewicz, Pete. *Web Developer.com: Guide to Producing Live Webcasts*. New York: Wiley, 1998.

Revolution: Business and Marketing in the Digital Economy. Monthly magazine. New York: Haymarket Management Publications. www.revolutionmagazine.com.

Swann, Phillip. *TV dot Com: The Future of Interactive Television*. New York: TV Books, 2000.

www.atomfilms.com.

www.entertaindom.com.

www.intertainer.com.

www.microcast.tv.

INFOTRAC COLLEGE EDITION

Consult InfoTrac College Edition using the password provided with this book. Use boldfaced terms as Key Words and section headings from this chapter for Subject searches.

NOTES

1. Kerschbaumer, Ken. Interactive television: Fulfilling the promise. *Broadcasting & Cable*, 10 July 2000, pp. 22–30.

2. The first regularly scheduled, TV-quality Internet newscast was **streamed** on September 27, 1999. The show (SamDonaldson@ABCNEWS.com) airs daily at 12:30 ET, and viewers can participate. Programs are archived in case viewers miss one.

3. Anyone can start an online radio station for less than $5,000, compared to the usual $100,000 start-up cost for the smallest broadcast station. ScreenGenie is a portable television device that allows a programmer to create streamed content with all the video production capabilities of a television studio. In 2000 ScreenGenie retailed for $16,999, compared to the multimillion start-up cost of an over-the-air television station (the streaming software and hardware are just a small part of that cost).

4. The first regular live comedy webcast debuted on June 25, 1997, on the Microsoft Network. The show, *This Is Not a Test,* was the brainchild of the producers of *Saturday Night Live*. The first original episodic comedy webcast came along in 1999 with a fall debut of 26 ten-minute episodes of *Scottland* on the ComedyNet.com web site, now www.scotland.com.

5. At times, *literally* "out the window": TiVo, maker of PVRs that allow viewers to control their own viewing schedules, featured a television commercial in the summer of 2000 that showed a television program executive being thrown out a window.

6. Haley, Kathy. Finding your way to interactivity: Two-way TV. *Broadcasting & Cable*, 6 September 1999, p. 18.

7. A group of designers at Agilent Technologies have developed a palm-sized device capable of speeds of 10 gigabits or 10 billion bits a second. Called a transceiver, it uses a new souped-up version of the old Ethernet format, delivering transfer rates at 10 times those available on high-speed connections in 2001. The cost of 1-gigabit transceivers is expected to fall below $5 by 2004, following the same declining cost curve that drove the semiconductor industry.

8. Gaffney, John. Will the web grow up to be like TV? *Revolution: Business and Marketing in the Digital Economy*, July 2000, pp. 52–53.

9. Arbitron, 1999.

10. Gunzerath, David J. Audience research trends. Paper presented at the Broadcast Education Association convention, Las Vegas, 8 April 2000. Available online at www.Beaweb.org/research/indtrend_files/v3_outline_collapsed.htm.

11. Pew Research Center. Biennial survey of the national news audience, June 2000. Available at www.people-press.org/media00rpt.htm.

12. Nielsen Media Research. *Home Technology Report* (2000)

13. Ferguson, Douglas A. and Perse, Elizabeth. The World Wide Web as a functional alternative to television. *Journal of Broadcasting & Electronic Media*, 44(2), summer 2000, pp. 155–174.

14. Tedesco, Richard. Back to the future: Internet TV. *Broadcasting & Cable*, 31 January 2000, p. 24–26.

15. The first simultaneous complementary TV broadcast and online webcast of a prime-time taped sitcom aired on November 17, 1999. Of the 17.6 million viewers watching *The Drew Carey Show*, nearly 2 million visited the show's web site, and 650,000 live media streams were sent out.

16. Sullivan, Steve. Media matchmaker. *Broadcasting & Cable*, 10 July 2000, pp. 44–46.

17. Ferguson, Douglas. The future of broadcast television. In James Walker and Douglas Ferguson, *The Broadcast Television Industry*. Boston: Allyn & Bacon, 1998, p. 196.

18. Clark, Don. With web radio, anyone can be a DJ, but special software confuses users. *Wall Street Journal*, 15 November 1999, p. B8.

19. Levy, Steven. The noisy war over Napster. *Newsweek*, 5 June 2000, pp. 46–53.

20. Whitney, Daisy. Six burning questions. *Electronic Media Online*, www.emonline.com/resourceGuide/, July 2000.

21. Kerschbaumer, Ken. For Lieberman, it's all about perspective. *Broadcasting & Cable*, 10 July 2000, pp. 52–56.

Although radio stations far outnumber television stations (more than 12,000 to about 1,600) the combined revenues of commercial radio stations fall below those of television stations. For several years, however, radio listening levels have reached three and a half hours per person each day—only one hour short of the average amount of individual television viewing time. Radio is a local medium with lower production costs and correspondingly lower revenues. But the sheer number of stations gives radio programming a major industry role and creates thousands of jobs for programmers. FM has long been the dominant radio medium, getting most of the listening by virtue of its higher quality sound. Most of the 100 FM channels (parceled into about 5,300 commercial and 1,800 noncommercial stations) are successful in attracting listeners and advertisers or underwriters, but most AM stations have been forced to try new strategies to survive.

By the early 1990s, the Federal Communications Commission had made strides toward reviving AM radio by approving AM stereo, allowing simulcasting of AM and FM, and reducing congestion and interference on the AM dial. Reduced congestion was achieved by increasing the number of AM channels to 117 (540 kHz to 1700 kHz) to allow existing stations to move to uncrowded dial posi-

tions and to allow daytimers to expand to 24-hour service. Altogether there are about 5,000 commercial AM stations across the country, although many are only marginally successful. To survive, many AM stations have entered local marketing agreements (LMAs) in which two stations share programming, staffing, and commercial time sales functions, much like the joint operating agreements characterizing the newspaper business. In addition, changes to ownership rules in 1996 allowed owners of radio stations to buy out their competition within markets and operate several stations within one market to achieve operational efficiencies.

Nearly 90 percent of radio stations pull in some programming from satellite transmissions. As the main sources of nonlocal material, networks play a major role as suppliers of information programming to music, news, and talk stations. About 60 percent of commercial stations affiliate with a network to obtain national and international news items, and some networks act as feature resources to stations that otherwise originate most of their own content. While music format syndicators supply geographically scattered, automated-music stations with a complete programming schedule, many syndicators also supply informational content, breaking down the once-clear distinctions between the sources of content. Although these

chapters focus on broadcast audiences, it is important to recognize that more than 40 percent of radio stations also reach listeners on local cable FM and as background to text-only channels. Listening to these sources is unmeasured and assumed to be insignificant at present, but these options hold potential for growth in the future.

Part Four of this book covers programming strategies from the perspectives of national radio program suppliers and local radio stations, subdivided by the kind of content that is provided. The first chapter emphasizes music programming, the second information programming, although, as the authors readily acknowledge, the distinction is often hard to draw.

Chapter 11 focuses on **music radio programming.** Music-oriented stations outnumber all other formats combined by a ratio of better than 90 to 1. To illustrate music programming strategies, this chapter describes a hypothetical radio market into which a new station is introduced, step by step. Choosing a commercially viable format for any given market shows how radio programmers are restricted and the methods they adopt for operating within those constraints. The author reports the process of implementing a new music format, looks at the common types of radio personalities that fit the various dayparts, and explains typical advertising and promotional practices for radio. The author also points out the constraints that the federal government imposes on radio stations and discusses the kinds of music programming that come from the major networks and music syndicators.

Chapter 12 examines the locally and nationally programmed **information station,** including *all-news, all-sports, all-talk* and combined formats. The chapter also includes a substantial section on *noncommercial public radio.* Although information-oriented stations occur much less frequently than music-oriented stations, they occupy an important media role in times of local emergencies and national history-making events, and virtually all stations carry some information content. The chapter covers the high degree of specialization required for a commercial all-news operation that can only be supported economically in mid-sized and large markets. It shows how the news/talk format is freer to shift direction toward entertainment or news as external events require. Although most information formats occur on AM stations, while music formats appear on FM because of its technical superiority in sound, this pattern appears to be altering. Moreover, many of the concerns of the information programmer apply equally to three-minute hourly interruptions inside music formats as well as to more lengthy newscasts. The chapter also contrasts commercial and public radio stations and their typical programming strategies. Out of the thousands of radio stations, about one-tenth are noncommercial and one-third of those are public stations—and nearly all are FM broadcasters. The author discusses the six formats that dominate public radio and shows how stations may be affiliated with one or more public networks or may remain independent.

Part Four completes this book's overview of programming. Radio programming may not seem complex when compared to broadcast television or cable, but these chapters demonstrate that radio programming strategy is highly developed within music and information formats and that radio networks and syndicators play increasingly important roles in an essentially local medium.

Chapter 11

Music Radio Programming

Gregory D. Newton

In the early days of radio when there were fewer stations, it was easy to appeal to a broad-based audience. By definition, "Top 40" stations appealed to everyone—from kids to adults of all ages—by featuring the most popular music of the day. A top 40 station played a little bit of everything and adjusted the rotation by times of day (**dayparting**) to cater to the available audience. In the midday (considered the "housewife" time), it might have played love songs and beautiful ballads. In the evenings, when teens and young adults were listening, the rotation usually included more up-tempo songs. Over time, as the prime-time audience moved to television and the number of stations and the competition for listeners increased, it became impossible to be all things to all people. Radio stations found it necessary to fine-tune their formats to target a specific audience (**segmentation**) 24 hours a day. Segmented formats included not only contemporary hit radio (CHR, or top 40) but also adult contemporary (AC), country, album-oriented rock (AOR), and urban.

Today, each of the major formats has several subdivisions, or niche formats, each aimed at specific demographic and psychographic groups. For example, country has split into at least three subgroups: traditional country, young (or hot) country, and country gold. Adult contemporary now includes hot AC, mainstream AC, soft AC, and NAC/Smooth Jazz (new adult contemporary). Oldies has splintered between stations focused on music of the '60s with some '50s thrown in and stations whose library core comes from the '70s. Urban music is subdivided into urban contemporary, urban AC, and urban gold (an oldies variation rooted in Motown and '70s R&B). Album-oriented rock (AOR) is generally just referred to as rock nowadays, and it includes a number of niche formats: alternative, adult album alternative (AAA, which some might characterize as almost an AC format), active rock (hard rock/heavy metal), and classic rock. CHR also includes a variation called rhythmic or Churban (a blend of CHR and urban). Hispanic formats are among the most rapidly growing choices. In addition to these formats, big band,

adult standards, contemporary Christian, classical, progressive, beautiful/easy listening, and numerous other niche and hybrid formats fill the airwaves. Yet very little in radio is really new. Most programming remains a variation of the tried and true formulas that have worked in the past (and so it is important for programmers to know and understand the history of the industry—what worked, what didn't, and why).

Nationally, AC is the most listened to music format (see 11.1),[1] but tastes vary from region to region and among markets in a region. For example, the most listened to station in Los Angeles is a Regional Mexican format, and three of the top ten stations are Hispanic. Up the coast in San Francisco, News/Talk leads the market, AC is the top music format in terms of total listening, and a classical station is among the top music stations. Because of the differences in the sizes of ethnic populations between the markets, the Hispanic stations are ranked in the lower part of the top 20 stations in San Francisco. Such strong differences mean that a smart program director always tailors a station's programming to the target audience within the market it serves.

CHOOSING A FORMAT

The program director's job is essentially a continuous cycle of *analysis, design,* and *implementation* (see 11.2). The first step in analyzing a market is to evaluate its stations and their current programming. This information can then be used to modify or replace existing program formats or to decide which property to buy and what to do with it after purchase. Such an evaluation takes into account: (1) the technical facilities as compared to those of the competition, (2) the character of the local market, (3) the delineation of a target audience, (4) the available budget, and (5) the potential revenue. Once completed, this evaluation will determine which music format is commercially viable and can win in the ratings in a given market.

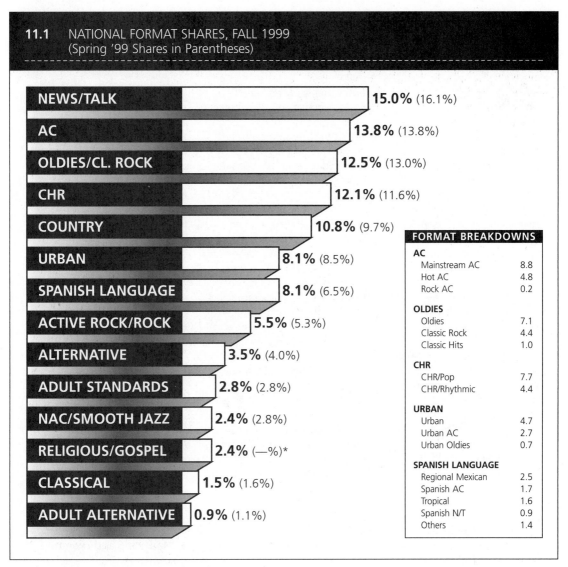

11.1 NATIONAL FORMAT SHARES, FALL 1999
(Spring '99 Shares in Parentheses)

	
NEWS/TALK	**15.0%** (16.1%)
AC	**13.8%** (13.8%)
OLDIES/CL. ROCK	**12.5%** (13.0%)
CHR	**12.1%** (11.6%)
COUNTRY	**10.8%** (9.7%)
URBAN	**8.1%** (8.5%)
SPANISH LANGUAGE	**8.1%** (6.5%)
ACTIVE ROCK/ROCK	**5.5%** (5.3%)
ALTERNATIVE	**3.5%** (4.0%)
ADULT STANDARDS	**2.8%** (2.8%)
NAC/SMOOTH JAZZ	**2.4%** (2.8%)
RELIGIOUS/GOSPEL	**2.4%** (—%)*
CLASSICAL	**1.5%** (1.6%)
ADULT ALTERNATIVE	**0.9%** (1.1%)

FORMAT BREAKDOWNS

AC	
Mainstream AC	8.8
Hot AC	4.8
Rock AC	0.2

OLDIES	
Oldies	7.1
Classic Rock	4.4
Classic Hits	1.0

CHR	
CHR/Pop	7.7
CHR/Rhythmic	4.4

URBAN	
Urban	4.7
Urban AC	2.7
Urban Oldies	0.7

SPANISH LANGUAGE	
Regional Mexican	2.5
Spanish AC	1.7
Tropical	1.6
Spanish N/T	0.9
Others	1.4

Remaining formats take up 0.6% of listening
©2001 Radio & Records, Inc. Reproduced with permission.
*This format was not listed separately before.
Source: *R&R Directory,* Vol. 1. 2000.

Comparing Technical Facilities

The best facility has the best chance to succeed. For AM stations, *power, frequency* (lower in the band is better), and any *license limitations* (reduced power or eliminated night service and directional requirements) are the key factors. For FM stations, *power* and *antenna height* are the crucial considerations. Generally, these elements determine signal quality. A clear, undistorted signal is less tiring to the listener than one that is distorted, faint, or accompanied by natural or artificial interference. All other qualities of similar formats being equal, the

11.2 THE SEVEN HABITS OF HIGHLY EFFECTIVE PDs
(Based on *The 7 Habits of Highly Effective People*, by Stephen R. Covey)

*M*ike McVay is president of McVay Media, a full-service broadcast consultancy, serving adult contemporary, oldies, country, contemporary hit radio, rock, sports, and news/talk. McVay's 30 years of broadcast experience include stints as a general manager, program director, account executive, and air personality.

Compiling this list required quite a bit of soul searching, contemplation of the navel, a national study, and countless interviews with program directors and general managers. First I took the 50 highest-rated radio stations in the United States and talked with people who either worked for or with said program directors. The second part of the study was created and executed by Critical Mass Media. CMM contacted management at every radio station in the top 100 markets. Managers, program directors, or promotion managers at 256 stations offered their opinions and insights into what makes an effective program director.
 Program directors did a better job of grasping the concept of what the study was all about than general managers did. Many general managers described skill sets that were more suited for sales managers or

business managers than PDs. For instance, many GM's noted "being cost-conscious," "understands the importance of the advertiser," and "figures out how to say yes to the sales department versus always telling them no."
 PDs, on the other hand, were self-effacing in how they described themselves as being obsessive-compulsive, driven, sometimes maniacal, and succumbing to mercurial mood swings. The best program directors are able to multitask, talk on a cellular phone while listening to the radio and reprimanding the children in the backseat, awaken in the middle of the night to the sound of dead air on the radio, coddle the fragile ego of a morning talent, and manage upward to the boss so that they get what they want while creating the illusion with their manager that that individual is getting what he/she wants.
 These similarities could sometimes be considered more trait than habit, but there were striking similarities among the responses.

1. Creative. This is the intangible trait. This trait has to include passion, show biz, and the ability to hear it in your head and

get it on the air. Creative programmers think like a listener. They use the strength of creativity to help sales get on the "buy" and the best PDs do it without harming the product. Although creativity is a trait, it is a habit with successful PDs because they actually schedule time into their agenda to be creative. Think about it for a second. Air talents are individuals who sit in a room, by themselves, talk into a piece of metal, and are convinced that there are people listening. A program director directs those people.

2. Understanding and knowledge. It is necessary to have knowledge of the industry, a sense of history, follow the trades, be well read, understand the rating services, and be familiar with the most important of the FCC rules. The habit formed here is one that requires you to read business books, understand the technical aspect of radio stations, and continually work to further your knowledge.

3. Marketing and promotional savvy. To understand how to get to the listeners, you must understand who the listeners are and then market to that audience specifically. Marketing inside a competitive situation, or

station with the best signal will be the listener's choice. Emotional fatigue unconsciously sets in after a period of straining to hear a program with a noisy, uncomfortable signal.

An FM station with 100,000 watts of effective radiated power (ERP) with its antenna assembly mounted on a 1,000-foot tower is a much better facility than a station with the same power but

inside your own cluster of stations, is becoming a greater challenge since consolidation. The last thing the intelligent programmer should do is put two competing marketing tactics on their radio stations. Why cancel out your sister station? Becoming opportunistic is a habit to be developed. The sharpest and most effective program directors are ready to throw away preplanned promotions and create new ones at the drop of a hat. When opportunity knocks, answer the door.

4. Manages people well. General managers who were interviewed noted this as an important strength. However, some of the most successful PDs who were surveyed manage people well but may not be considered by their employees to have "good people skills." Managing is telling someone what you want them to do in a way that makes them believe it is what they want to do. Managing up is as important as managing down. Picking and choosing battles comes into play when one focuses on managing up. The most important part of management comes down to leading by example. Be an exemplary leader.

5. Organized. Program directors who win big generally have strong organizational skills. Although this is not true of all successful PDs, the more organized individuals tend to create the most enjoyable environment in which their employees can work. Time management, multitasking, the ability to be accessible, understanding how to prioritize, being system-oriented, and creating systems for uniformity in the station's programming are all traits that require religious-like commitment in order to become habits. One cannot be occasionally organized.

6. Vision. Knowing exactly where your station is, at all times, in its product life cycle is important. I am not sure that this could be considered a habit or a trait, but it is perhaps more intuition than anything else. The routine of habit can come into effect when program directors are disciplined enough to be conscious of trends and focused on the future by reading every periodical or current magazine they can get their hands on. Watch the big hit TV shows. Watch the news programs. Videotape those shows you don't have time to see and watch them at a later time. Don't lose sight of the lowest common denominator. Understand programming in a multiopoly/consolidated world

and how various formats play off of each other. Vision, the ability to know what is going to happen next, can be developed.

7. Driven. The most effective PDs we have come across, without exception, are driven individuals. They are energetic, all consuming, and competitive. The attitude is "if it is on the air, then you are responsible for it and you have to listen to it to be a winner." One program director suggested the "ability to survive sleep deprivation is a good trait." Another PD put it simply, "Don't give up. Don't ever give up."

Finally, it is important to keep in mind that these seven points are actually too few to be totally accurate. Another that kept coming up throughout our research project was "the ability to adapt," and that skill is also reflected in many of the traits mentioned. The most fun response we received came from a general manager in the west who noted, "In this day of regular ownership changes, the most successful PDs need to be colorblind. This allows them to remain focused no matter how many times their paychecks change color."

with the antenna mounted on a 500-foot tower. The AM station with a power of 50,000 watts on a clear channel (820 kHz) is a much better technical facility than a station with 5,000 watts of power at 570 kHz. *Usually the low-power station is at the mercy of the higher power station.* A 5,000-watt facility with a talk or news format may be

very vulnerable to a same-format station broadcasting at 10,000 or 50,000 watts.

This rule of thumb does not hold in all cases. For example, a 5,000-watt facility at 1,600 kHz might easily fall victim to a 1,000-watt station at 710 kHz.[2] In AM, both power and dial position are important. The lower the frequency, the greater the range of the AM signal. A 1,000-watt AM station at 710 kHz might easily reach a bigger population than a 10,000-watt station at 1600 kHz.

In FM, tower height and power are the principal considerations, and antenna height is generally the most important (a station with a higher antenna utilizing lower power will generally cover more area than a station with more power but a much lower antenna). There are three broad classes of FM stations, although there are also sub-classes and not all stations utilize the class maximums. Class A stations are permitted a maximum of 6,000 watts—or 6 kw—effective radiated power (ERP) with a maximum antenna height above average terrain (HAAT) of 100 meters, providing a signal radius of approximately 18 miles. Class B stations (located in the more densely populated eastern United States) have a maximum ERP of 50 kw and HAAT of 150 meters. Class C stations are located primarily in the western United States and are permitted up to 100 kw and have a maximum HAAT of 600 meters. These stations may have a signal radius of 60 miles or more. Dial position is much less technically important in FM, although the center of the dial gets more sampling. An FM station at the upper fringe of the band (the lower portion from 88 to 92 mHz is reserved for noncommercial stations) needs an advertising and promotion blitz when altering its format. *Always, having the best or one of the best facilities in the market is crucial to beating the competition.*

For many years AM was the king of radio. AM stations were tops in ratings, regardless of format. Beginning in the 1970s, FM began to replace AM as the music format champion. Music simply sounded better on FM because of the technical differences between the two bands. Furthermore, FM doesn't fade under bridges or inside urban skyscrapers, or suffer from weather interference the way AM does. To survive, AM turned toward full-service programming, including elements of news, talk, sports, satellite or syndicated programming, and ethnic (Hispanic or black) and religious (preaching and gospel music) content. The station's technical facility plays an important part in the initial decision to enter music programming competition. It would be aesthetically foolish and economically disastrous to pit, say, an AM against a full-power FM in the contemporary rock field.

It is likely that **digital audio broadcasting (DAB)** will replace both AM and FM analog broadcasting in this decade and improve the sound quality of each. In the United States, the efforts have been directed at creating an *in-band on channel (IBOC)* system that would operate in the current AM and FM spectrum allocations and be compatible with existing AM and FM systems. Most other countries, including Canada and the United Kingdom, have adopted a digital radio system that uses a different portion of the spectrum and is therefore not compatible with existing radio. Once IBOC is approved, broadcasters will add DAB to their existing facilities and transmit simultaneous analog and digital signals during a transition period. As new radio receivers are manufactured with the appropriate chips to decode the DAB signal, consumers and stations would eventually replace the obsolete analog system with DAB.

Meanwhile, new services beyond the AM and FM bands have emerged to provide radio-style programming and are attempting to gain a foothold in the market: Internet broadcasting **(streaming)** and satellite-delivered **digital audio radio services (DARS).** Internet broadcasters have the advantage of potentially global reach but have been limited so far by the lack of portability (the scarcity of wireless Internet service), the lack of sufficient high-speed bandwidth at the consumer end necessary to deliver high-quality audio and video, and the absence of the kind of audience research that advertisers expect. As the technologies for wireless Internet access continue to develop, so too will devices to allow listeners to access their favorite streamed audio (and video)

11.3 DARS PROGRAMMING ALLIANCES (AS OF MAY 2000)

Sirius	XM Satellite Radio
BBC	ASIAONE
Classic Radio	BBC World Service
CNBC	Black Entertainment Television
Hispanic Radio Network	Bloomberg News Radio
Kennedy Center for the Performing Arts	CNNfn & CNN/Sports Illustrated
League of American Theaters	C-SPAN
National Public Radio	Hispanic Broadcasting Corporation
Outdoor Life	NASCAR
Public Radio International	One-on-One Sports
Playbill Magazine	PBS (News Hour with Jim Lehrer)
Speedvision	Radio One
SportsByline USA	Salem Communications
USA Networks (Sci-Fi Channel)	USA Today
We Media	The Weather Channel

without having to be hooked to a wire. High-speed Internet services like **cable modems** and **digital subscriber lines (DSL)** are being rolled out, more rapidly in some areas than others. And as research firms develop the ability to reliably measure the audiences for streaming, more advertisers will be willing to support the programming.

DARS provides a national (or regional) signal via high-powered satellites that require only a small receiving antenna similar to that of a car phone. Sirius, formerly CD Radio (www.siriusradio.com) and XM (www.xmradio.com) are the two competing providers who have been licensed by the FCC so far. Like most large radio companies today, both are publicly traded corporations. They began providing up to 100 channels of subscription-based audio service nationwide in 2001. Approximately half of the channels are dedicated to various music formats. The rest offer news, information, and other special programming. In 2000, they agreed to develop a single technical standard in order to better promote the growth of the new service, because one radio would then be able to receive either company's service. Each has signed

deals for programming with a substantial roster of providers (see 11.3) in addition to their own in-house programming, as well as agreements with consumer electronics manufacturers and retailers, and vehicle manufacturers.

Defining the Competitive Market

In deciding on the potential of various radio formats, *the first step for a prospective station owner is to review the competition thoroughly.* A demographic profile of each station, and each ownership group, in a bar graph will show what percentage of each of the six standard demographic groups each has. The bars in such graphs display the age "leaning" of a station's audiences, suggesting the industry name of **skew graphs. Arbitron** (www.arbitron.com) and **AccuRatings** are the principal sources of these data. The 6 A.M. to midnight, Monday through Sunday page of a ratings book breaks out the individual demographic groups. Any audience analysis service providing demographic separation, however, has the necessary information. Skew graphs

11.4 STATION SKEW GRAPH SAMPLES: KAAA-FM AND KIII-FM

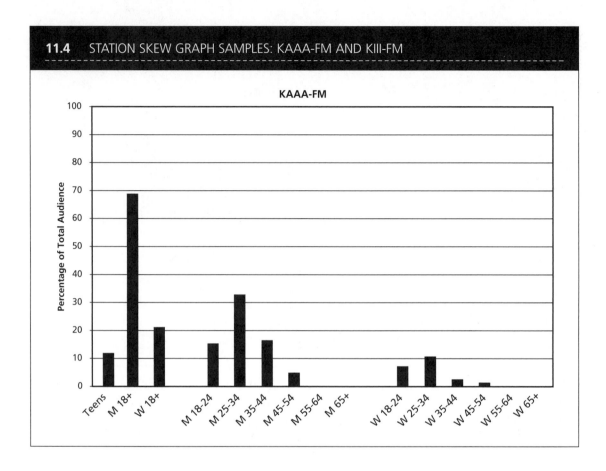

for two stations in the hypothetical market considered in this chapter are shown in 11.4.

With skew graphs of all stations laid out, program strategists can quickly analyze which demographic groups are best served by which stations and groups, and therefore which stations represent major competition. Compare the examples from a hypothetical market in 11.4. KAAA, a rock station, is skewed male (nearly 70 percent) and young (more than half the audience is younger than 35 years of age). KIII, a soft AC, is nearly the opposite. Their audience is nearly all female and older (almost 60 percent between 35 and 64).

Figure 11.5 presents graphs for the Big Sky and RadioEast station clusters. Not only do their individual stations vary, but group patterns emerge here. Both groups skew male overall but Big Sky

more so. There are also significant differences in the age breakouts. RadioEast is strongest for 35 to 54, while Big Sky's stations appeal to younger listeners. These differences reflect the existing formats of the stations in each group, but more importantly, they provide important strategic information about the marketplace for a potential new entrant (including any reformatted station within one of these groups). It is essential to not only look at the formats of individual stations but to consider how the programming and audiences for each station fit together in the group in order to maximize the advantages of group ownership. Different groups will try to leverage different audience segments. One may focus on capturing the female audience across several age categories, another may try to dominate a specific age demographic for both men and women.

11.4 CONTINUED

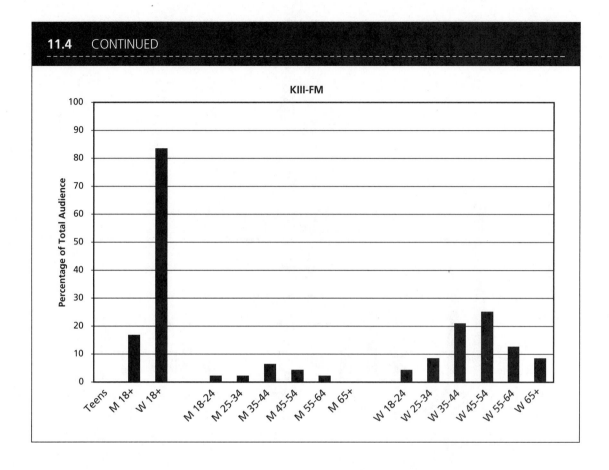

Identifying Target Audiences

It is not enough to study population graphs and other research data about a market's radio listeners. *Radio is essentially a lifestyle medium*. Listeners choose stations, at least in part, because the station's image reflects their self-image: their tastes, their values, and their interests. It is important to go into the community to find out specifically what people are doing, thinking, and listening to. It is helpful to observe lifestyles by visiting restaurants, shopping centers, gas stations, discotheques, bars, taverns, and other places where people go to have a good time. Don't think of this as a task reserved for times of change, however. Being active in the community, and especially in the areas of most importance to the audience, is not a one-time or occasional effort but an ongoing process to keep

programmers in touch with listeners and all aspects of their lives.

Personal interaction with the members of the audience and community is important and can provide valuable insights, but programmers should be careful not to generalize too much from that kind of anecdotal evidence (and should never assume that their personal tastes reflect the general audience's taste). Therefore, formal research utilizing careful sampling procedures should supplement personal investigation. Most cities have research firms that can be hired to make special studies, and national firms such as The Research Group (www.theresearchgroup.com) and Coleman Research (www.colemanresearch.com) specialize in broadcast station research. Other well-known radio consulting firms include Bolton Research

11.5 RADIOEAST AND BIG SKY

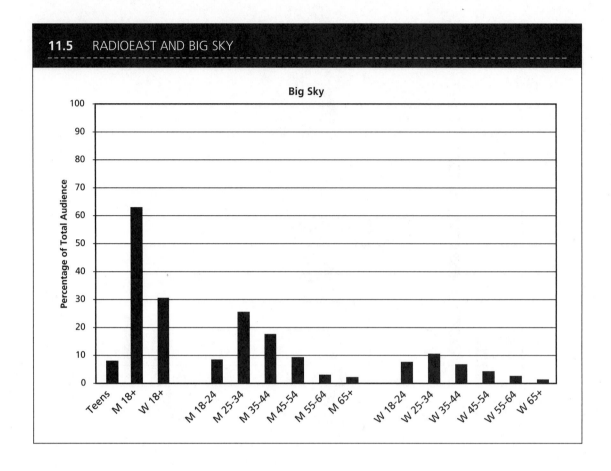

Big Sky

(www.boltonresearch.com), McVay Media (www.mcvaymedia.com), and E. Alvin Davis & Associates (www.ealvin.com). Psychographic profiles (listener lifestyles and values) can provide additional invaluable information for a programmer about the target audience. A study assessing current formats in the market using lengthy, in-depth telephone interviews might get interesting responses: too many commercials, bad commercial production, too much unfamiliar or repetitive music, obnoxious contests, can't win contests, or DJs who talk too much. A station getting answers like these is ready for a major overhaul (or is vulnerable to new competition).

As an example of the kind of findings that prove useful, a station may identify its typical listener as male, 30 to 35 years old, earning $50,000 to $60,000 a year, driving a BMW or other upscale car, drinking imported beer, going out at least twice a week with a date to a good restaurant, and playing tennis. The station can sell this audience description to advertisers and to listeners. Promotional material would stress this lifestyle to those who listened to this particular station.

Knowing the Available Budget

In addition to a **program director (PD),** the usual hit music operation requires six to eight disc jockeys (or air talents), along with a production director and, perhaps, a music director. Salaries vary widely, even within market classes, and are a function of the station's results (ratings and ad revenue), the individual's job history, and negotiating skill.

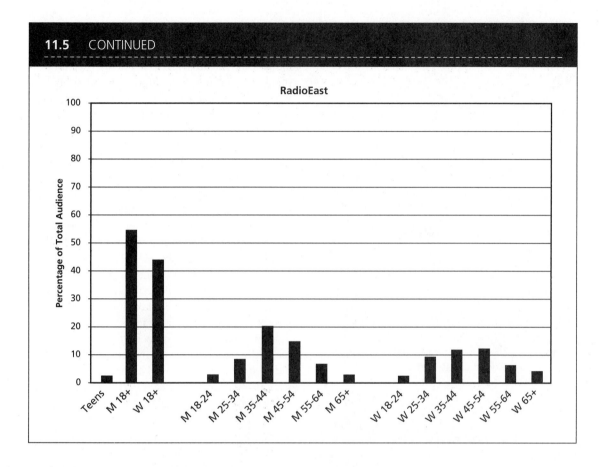

In a medium market of 500,000, the program director may earn as much as $50,000 a year, more if she also handles an air shift. The morning DJ probably gets $50,000 to $80,000, and a popular afternoon drive DJ may get up to $40,000. The production director's salary is probably between $30,000 and $50,000 per year, and the other five or six jocks fall in a somewhat lower range. In the top ten markets, stations would likely have to double or triple these salary figures to get the required talent. Top morning show talent for a large market can easily run into six figures or more, with superstars receiving between $250,000 and $1 million in a major market. Successful PDs can likewise command six-figure salaries in a major market.

In addition to staff salaries, management must expect substantial ongoing costs for promoting and advertising (see 11.6).

A station may employ legal, technical, management, personnel, and sales as well as programming consultants—all of them may be useful at one time or another. Consultants are available to advise on every conceivable aspect of operations. Some are practically required on an on-going basis, such as a communications law firm in Washington, D.C., to handle proceedings with the FCC and keep the station advised of changes in the requirements for operation, for example. Engineering consultants with experience before the Commission are necessary when applying for a new license or any time subsequently that the station makes a change to its facilities requiring FCC approval.

11.6 ADVERTISING THE STATION

Station promotion takes two forms: on-air and off-air. On-air promotion is suited for retaining current listeners through reinforcing their positive image of the station, or extending the amount of time they listen through contesting or other incentives. Attracting new listeners requires a significant investment in off-air promotion, often in conjunction with on-air promotion events. Off-air alternatives include billboards, television, direct mail, or telemarketing. In a medium-sized market (500,000), television and billboard advertising might run $25,000 a month for good exposure. It may cost five times that in a Dallas- or a Chicago-sized market. Not only are unit prices higher in large markets but more territory must usually be covered. A set of painted billboards reaching the whole population in one market may require 35 billboards, for example, although a similar showing in Dallas would require 125 billboards at an average cost of $2,000 each per month. Television advertising is even more expensive, but often necessary to launch a new format and can help generate the kind of top-of-mind awareness among the audience that drives ratings.

Programming consultants can provide important insights on a regular or occasional basis by finding market voids and spotting competitors' weaknesses (or your own). They may even assemble a staff to work up a specific format. Consultation is expensive, however. An engineer may charge $700 a day plus expenses; a programmer may charge $3,000 a month on a three-to-six-month contract. For a complete station overhaul, consultants range from $400 to $1,000 a day. Nevertheless, a neophyte licensee may be literally unable to start up without using one or more consultants. A great deal of highly specialized knowledge and experience must be brought to bear immediately once the Federal Communications Commission has given the licensee authority to start operations.

Estimating Potential Revenue

Television, cable, and newspapers compete with radio for the same advertising dollars. The increasing number of stations, including cable and satellite channels, has fragmented the available audience, making survival more difficult. As market shares shrink, those stations that have high debt service to pay may struggle. During the early to mid-1980s, radio station values skyrocketed following deregulation. Investment money was easy to acquire, and radio stations sold for as high as $82 million (the price, for example, of KVIL, Dallas, in 1987). When investment money disappeared, station sale prices declined. A low-rated FM station in Dallas sold for merely $9 million in 1991, whereas the same station might have sold for $15 to $20 million in the mid-1980s. Prices escalated again in the mid-1990s following relaxation of ownership rules, however, particularly after passage of the Telecommunications Act in 1996, which eliminated the national caps on ownership and permitted group owners to control as many as eight stations in a single market. This has increased the value of stations. That same station that sold for $9 million in 1991 might easily be worth $40 to $50 million in 2000.[3]

All the media compete intensely for local advertising revenues. In any area, advertisers most desire the 25- to 54-year-old audience (although most stations count all listeners over age 12). In radio, the audience subdivides into 10- to 15-year segments that specific formats target. Following Arbitron's pattern, most radio audience segments end in a 4. *If particular advertisers are not seeking all listeners 25 to 54, then they want a subset of the baby boom generation, now ages 25 to 54;* some seek subgroups of 25 to 34, 25 to 49, or 35 to 54. Selected advertisers may seek the audience aged 55 to 64 or younger audiences. For example, many nightclubs and other entertainment venues target 18 to 24 or 18 to 34 audiences. Although banking and financial institutions and packaged vacations appeal to older people who are generally set in their buying habits, they are regarded as saving money rather than spending it, having bought about everything they are ever going to buy. The perception is not

necessarily accurate, as people are living longer and healthier, more active lives. Nonetheless, many advertisers are most interested in the large population bulge represented by the baby boomers. They see that market as having money, responding to advertising, and receptive to buying, even if it means going into debt. Stations have tended to track the boomer generation and adjust their music formats to continue to appeal to this group as it ages. This has resulted in continued heavy play of late '50s, '60s, and '70s music (oldies or classic rock, as well as AC formats that featured plenty of songs from that era), capitalizing on the hit songs of the baby boom's teen through twenties years. As that generation begins to pass into the age range where most advertisers haven't been interested, *the question for radio programmers is whether advertisers will lose their aversion to people over 55 and continue to follow the population bulge, or will more radio stations be forced to compete for younger (and somewhat smaller) audiences?*

STEP-BY-STEP SELECTION PROCESS

Format strategy can be examined by working through a hypothetical market—say, a metropolitan area of slightly more than 1 million people, with 19 commercial stations licensed to the city or nearby suburbs. The market also includes four noncommercial stations: three public radio stations affiliated with colleges and a contemporary Christian station. (The different nature of noncommercial operations was discussed in Chapter 7.) See 11.7 for a list of stations in the market.

The market is typical of most medium and large markets, with three significant group-owned station clusters. The remaining commercial stations in the market are owned by small groups whose additional properties are located in other markets. Of the three groups, HugeCo controls the most stations in the market and is one of the biggest national station groups, with several hundred stations covering all market sizes. Big Sky is also a major group with around 200 stations nationally, primarily in medium and a few large

markets. RadioEast is a relatively small company, family-controlled with fewer than 20 stations, most in medium and small markets. This is their largest cluster and second largest market.

After a period of rapid consolidation in the late 1990s, programming and station rankings in the market have been fairly stable for the past couple of years. The last station acquisition took place two years ago when RadioEast bought into the market. The last format change (KIII's move to soft AC from alternative) took place at about the same time. There is relatively little competition within formats; KDDD-FM, KAAA-FM, KOOO-FM, and KKKK-AM have generally been the ratings leaders for quite some time.

Station facilities are remarkably equivalent. Of the AMs, only one station is a daytimer (KNNN), although KHHH does have a restricted nighttime pattern. In the FM band, all are high-powered class Cs with the exception of Big Sky's KBBB and KSSS, both of which are class A stations licensed to nearby suburbs of the metro city. Most of KSSS's programming is simulcast on KSSS-AM as well as four other AM stations around the state (billed as the Sports Monster Radio Network), and Big Sky recently added a translator for KBBB on the opposite side of the metro area to improve coverage.

Even taking into account the relatively poor nature of its facility, Big Sky believes KBBB is underperforming in its present NAC/smooth jazz format and is considering a format change. Given the makeup of the market, what are the best options? Is there a format that could improve Big Sky's overall competitive situation? What groups are unserved in the population? Figure 11.8 describes the population distribution in the hypothetical market.

First, let's look at the competitive structure of the market. Big Sky's existing primary strength is in the male demos, with the number one station (KAAA) among men 18 to 34 and 25 to 54. Between the rock and sports stations, they have nearly 35 percent of the 18 to 34 male demographics and a 20 percent share of men 25 to 54. With classic rock and oldies formats, RadioEast is also strong in the male demographics, but with an older audience (remember the skew graphs?).

11.7 LIST OF STATIONS, FORMATS, FACILITIES, OWNERS, AND RATINGS (6 A.M.–MIDNIGHT MONDAY–SUNDAY)

Station Format	ERP/HAAT Frequency	Owner	12+ Share Cume (00)	M 18–34	W 18–34	M 25–54	W 25–54
KAAA-FM Rock	97kw/375m 100.7	Big Sky	8.2 1475	24.6 559	8.4 329	12.6 558	3.9 309
KBBB-FM Smooth Jazz	6kw/100m 98.1	Big Sky	2.3 446	0.8 41	0.8 39	2.7 147	2.7 156
KCCC-AM Variety	1kwD/1kwN 1320	HugeCo	1.3 309	1.4 63	2.0 79	1.1 70	1.2 97
KDDD-FM CHR	100kw/300m 102.9	HugeCo	10.9 2268	10.5 443	18.5 575	5.4 434	11.5 692
KEEE-FM Classic Country	100kw/250m 93.5	OK Ltd.	4.4 730	3.3 86	1.7 78	4.1 186	2.9 174
KFFF-FM AC	100kw/400m 104.3	RadioEast	5.4 1201	3.4 149	7.9 268	4.0 285	9.2 500
KGGG-AM# Oldies	50kwD/50kwN 1490	RadioEast	1.4 392	0.2 21	0.1 14	1.4 92	0.6 67
KGGG-FM# Oldies	100kw/275m 92.7	RadioEast	5.8 1156	1.4 86	2.4 82	6.2 351	6.9 387
KHHH-AM Religious	2.5kwD/.5kwN 780	Faith	0.9 252	0.2 21	0.5 11	0.8 69	0.8 63
KIII-FM Soft AC	100kw/425m 94.9	HugeCo	3.9 918	1.3 97	3.8 174	2.6 219	7.1 389
KJJJ-FM Classic Rock	100kw/300m 107.7	RadioEast	6.5 1199	7.7 258	4.3 180	12.4 584	6.1 359
KKKK-AM News/Talk	5kwD/5kwN 1010	HugeCo	6.5 1207	2.0 77	1.4 65	5.3 329	3.5 254
KLLL-FM Hot Country	100kw/425m 102.1	HugeCo	6.1 1249	6.6 223	11.1 334	4.6 301	7.9 412
KNNN-AM Urban	1kwD 1110	Hometown	3.7 513	4.1 90	5.5 129	2.5 104	4.5 166
KOOO-FM Country	98kw/350m 96.3	HugeCo	7.6 1401	5.0 162	6.6 256	6.8 326	8.1 441
KPPP-FM Hot AC	100kw/325m 99.1	Big Sky	5.6 1423	7.6 329	10.7 409	5.6 379	6.7 465
KRRR-AM Talk	5kwD/5kwN 910	HugeCo	1.1 359	0.1 10	0.1 11	1.3 90	0.5 43
KSSS-AM* Sports	1kwD/1kwN 620	Big Sky	1.5 386	2.9 89	0.1 9	3.2 217	0.4 39
KSSS-FM* Sports	6kw/90m 105.1	Big Sky	1.7 401	3.8 120	0.4 31	4.0 263	0.4 52

*Simulcast approximately 75 percent
#Simulcast approximately 90 percent

11.8 SELECTED POPULATION AND DEMOGRAPHIC ESTIMATES

Total metro population: 861,000
Total DMA population: 1,300,000

DMA Racial/Ethnic Population Estimates

White	77.0%
Black	10.0%
Hispanic	5.0%
Asian	3.0%
Native American	5.0%
Women	51.4%
Men	48.6%
Teens 12–17	10.5%
18–24	11.3%
24–34	16.5%
35–44	18.7%
45–54	16.4%
55–64	10.6%
65+	16.0%

has carved out its own audience niche, and no single station seems to have a segment large enough to further subdivide. Moreover, the two most successful country stations are owned by HugeCo, and their combined promotional and programming strength would represent a substantial barrier for any new competitor to overcome. Big Sky should look elsewhere.

The situation in AC is similar, except that no owner has more than a single station in the format. KFFF, KIII, and KPPP represent a combined 15 share (and a whopping 23 share among the primary target audience, women 25 to 54), and their formats are spread across the range of AC programming. A fourth station would be competing head to head with one and to some extent with all three plus CHR KDDD (which, like many CHR stations, sounds more like an AC format during weekdays in order to better capture at-work adult listeners). The competition from these stations, although indirect, is most likely a significant factor in KBBB's current low ratings. Moreover, we certainly want to avoid potentially cannibalizing our existing female audience on KPPP.

In the rock category, Big Sky is dominant (KAAA). Oldies and classic rock belong to competitors, but those are generally one-to-a-market formats (although an oldies hybrid might be a possibility). Combining the sports stations (KSSS) with KAAA, Big Sky has very strong male numbers. Perhaps it would be possible to further increase our younger male demographic power with an alternative format or add some older listeners with a AAA format? The rock audience will generally accept alternative music on their station, although the reverse is generally not true, and KAAA plays some alternative music. Most likely, moving KBBB to alternative would simply take audience from KAAA leaving little or no net gain.

There are some possibilities, however. One option would be an older-skewing music format like adult standard. This audience is not well served by existing programming, but that is because an older audience (55+) is often difficult to sell to advertisers. Another possibility is urban, currently

Meanwhile, because of their size, HugeCo has effectively covered the full age range on the female side. Big Sky has only one female skewing station, hot AC KPPP, which is a distant third among women 18 to 34 behind HugeCo's CHR KDDD and hot country KLLL. Among women 25 to 54, KPPP is seventh, also trailing HugeCo's mainstream country KOOO, RadioEast's AC KFFF, and oldies KGGG.

Given that overview, let's look at potential format holes in the market. We can eliminate the news and talk formats right away. They're expensive to program, requiring large staffs, and with two stations covering that territory there are already enough stations in the market providing that programming. Plus, an FM station seems more suited to a music format.

We can also eliminate country off the top. Although this is a strong market for county music, there are already three stations in the format, with a combined 18 share of persons 12+. Each station

available only on an AM daytimer with poor facilities. According to Census data, the market has a substantial minority population (approximately 10 percent black and 5 percent Hispanic), and the format can also have substantial appeal for white ethnic audiences. Finally, there's CHR, currently represented by the 12+ market leader KDDD. That big share of the audience is a tempting target, and the opportunity for Big Sky to strike at the market's biggest group is a battle many program directors would relish. Moreover, the CHR (or the urban) audience would be a good fit with KPPP with some minor tweaking of its format, potentially strengthening Big Sky's relatively weak overall female numbers without simply stealing from KPPP's existing audience (although there would undoubtedly be some sharing).

Thus, an urban hybrid (rhythmic CHR or jammin' oldies) looks to be the best opportunity in the market. Census data indicates a substantial younger population, 57 percent within the target age range for contemporary music (28 percent in the core demographic between 18 and 34 years of age, plus 11 percent 12 to 17, and another 18 percent 35 to 44; slightly more women than men in all ages). Most of this audience is currently served by relatively few stations because the majority of stations chase the mid-adult demos. The existing urban station would not be a significant competitor because of its facility. In addition, picking rhythmic CHR rather than true urban (*Churban*) would allow the new KBBB to attract listeners from the large KDDD audience and potentially turn them into listeners whose first preference is KBBB ("P1" in rating terminology, the core listeners of a station).

IMPLEMENTATION

A format change will necessitate a new station identity (new call letters, requiring an FCC application, and a slogan), new music, and possibly new air talent. Moreover, the work will have to happen quietly, behind the scenes, in order to avoid tipping off the other stations (and media reporters)

in the market. That means some (or even all) of the work must be done away from the station or at times when few, if any, other staff are around. The program director's first step is to settle on the station's target audience and identity. Branding and positioning are complicated matters, but in simplest terms, *the station needs to create an image in the audience's minds that matches their self-image.* In other words, *the station should fit into the listeners' desired lifestyle in all regards, from the music to the logo and slogan to the DJ patter between songs.* Who is the typical listener, the highly valued P1? In this case, imagine a young (20- to 30-year-old) adult, most likely female; working in a professional or technical field; who enjoys music (with a danceable beat), clubs, movies, and sports; drives a small, sporty car; is interested in fashion; dines out several times a week; exercises regularly; and enjoys traveling.

Next, we'll need to consider, in consultation with the general manager and other corporate executives, whether current Big Sky personnel (at KBBB or perhaps KPPP, or another station outside the market) are suited to the new format. If so, those people may be quietly brought into the process as needed. If not, there will be that much more work for the PD and the one or two other managers who are aware of the impending change at this point. Air staff can be hired prior to the debut, but doesn't have to be. Some stations change format, then gradually add air talent as they can be located and hired. In the interim the station operates either without DJs or by utilizing **voice tracking** (where the air talent records the material for an entire show beforehand, and the voice tracks are then inserted between songs via automation).

Building the station's music library is another task to be accomplished before the format goes on the air. Getting current CDs is fairly easy for stations in larger markets and others that report their airplay to one of the major trade journals such as *Gavin* or *Radio & Records*. There are also several specialized trade journals, such as *Hitmakers* or *Friday Morning Quarterback,* and reporting airplay to those magazines can also be a way to ensure music service. Developing rapport with record company

promoters helps also. When the music director or program director makes contacts with friends in the record business, the station gets on their call schedules and mailing lists. This ensures that the station will receive all the current material promptly, in many cases prior to the actual release date. To prepare a new format, the station needs the previous 6 to 12 months of releases. Performance licenses (in the form of annual royalty fees) should be obtained from both **ASCAP** (www.ascap.com) and **BMI** (www.bmi.com). The license grants the station the right to play nearly all popular music, a necessary expense for virtually all music stations. The rights organizations then distribute most of the money to the music's copyright holders, based on surveys reporting the amount of airplay. Classical stations also need to contact **SESAC** (www.sesac.com) to obtain foreign and other specialized music performance rights, although in recent years SESAC has also attempted to build a roster of popular music artists. Some formats, AC or oldies in particular, may also need a performance license from that organization.

Someone will have to dig for the recurrents and the gold—especially the latter.[4] Because of their age, many of these recordings are scarce. Promoters and distributors are often out of stock, and in some cases pressings are no longer being made. It may take months to build the gold library, and these recordings should be kept under lock and key to forestall avid collectors among staff members. Many stations use "gold services" such as TM Century's Gold Disc™ Library (a complete oldies library on compact disc). Although it is an additional programming cost to the station, a purchased library offers time savings and convenience. Each disc may have as many as 20 songs on it. Furthermore, many companies offer CD jukeboxes that contain an entire library kept under lock and key. Only the music director and the program director have access to the discs.

Another option is to purchase a complete (or nearly complete) library as part of a digital automation system. Companies that provide programming software and hardware such as Computer Concepts (www.ccc-dcs.com), RCS (www.rcsworks.com), or

Scott Studios (www.scottstudios.com) can deliver the music for most popular formats (for an additional charge, of course) either already on the hard drive of a new system or as separate audio files for existing systems.

Digital automation systems utilizing hard-drive audio storage and playback for songs as well as commercials and other spots are becoming more common (and more affordable as the cost of technology drops). However, most stations still play compact discs on the air. A few still use **carts** (audio cartridges) or even, on special occasions, old-style vinyl **records.** In smaller markets, compact discs are becoming standard as old equipment is replaced and will soon eliminate carts and records entirely.

The program director needs to temporarily act as the music director to structure the music, and later one of the jocks can take over the music duties as well as audience research. In a typical setup, the music director works for the program director, doing research, taking calls from record company promotion reps, and preparing proposed additions and deletions to the playlist. The program director has the right to make the final call, but the music director does the background work.

To recruit experienced air talent, Big Sky will place ads in trade publications and on the web sites of state and national broadcast associations of which they are a member. Management will also look for referrals within the company. Small market stations, or others with entry-level jobs, also send announcements of openings to nearby colleges and universities.

THE MUSIC

No one "right way" to program a radio station exists. Moreover, what works in one format or market may not work in another. Good research is one key to success, and it encompasses all formats. Nonetheless, to show how music is categorized and tracked, this chapter presents a model for a hit music system that combines aspects of systems used by radio stations across the country. This

system represents one plan for programming a rhythmic CHR station designed to achieve maximum attractiveness to the 18 to 34 demographic target. The system has five major music categories: power, current, recurrent, power gold, and gold. Other stations or formats might have additional categories. Some programmers might further divide the categories by tempo, style, or genre, or—in the case of formats with substantial gold libraries —by era. Any contemporary popular music station can use this basic formula, whether CHR, rock, AC, country, or urban. It would require significant modification, however, to work for an oldies, classical, or news/talk format.

1. Power. This category contains approximately ten top songs, played at the rate of four to seven each hour. (The rotation would be slower, one to three each hour, in most non-CHR formats). Rotation is controlled so that the same song is not played at the same time of day on consecutive days. Rotation time—the time that elapses before the cycle of 11 songs begins again—varies from as little as 75 to 90 minutes in some dayparts in our rhythmic CHR format to as much as six or seven hours in some AC or rock formats. The exact rotation is decided by the program director. The songs in this category are the most popular of the day and receive the most airplay. They are selected weekly based on:

- How they test during call-out research with the station's audience
- Their rankings and audience test scores in national trade magazines such as *Billboard, Radio & Records,* and the *Gavin Report*
- Local sales (to a lesser degree)

Area record stores are contacted weekly for sales information, which they record by bar code. Once upon a time, stations also used telephone requests as a barometer of song popularity. However, because of the inadequacies of the system and the ability of a few people to make a lot of phone calls for their favorite song (hence, stuffing the ballot box), this method is seldom used nowadays. In bigger markets, telephone or auditorium testing is used instead. A sample audience will hear part of a song and be asked to evaluate it. In smaller markets, rankings of sales and airplay in trade magazines often play the biggest part (see the section on research).

2. Current. This category contains the remaining 20 or so currently popular songs. They are played at the rate of three or four per hour (in an hour with no commercials, five might be played). Some stations subdivide this category by tempo, placing slow songs in one group and fast ones in another; other programmers subdivide by popularity, grouping those moving up in the charts separately from those that have already peaked and are moving down in the charts. The same research methods used to determine the power songs determine those in the current category. Together, the powers and currents form the station's current playlist of about 30 songs.

3. Recurrent. This category contains songs that are no longer powers or currents but that have been big hits within the last two years. (Some stations keep songs for up to three years in the recurrent section.) These songs get played at the rate of two to four per hour, depending on commercial load and desired rotation time in the first two categories. Some stations limit this category to 30 records played at the rate of once an hour; others may have as many as 100 songs, playing them twice an hour. Songs usually move into this category after being powers or currents, but a few would be dropped from the music list: novelty records that are burned out (listeners have tired of them) and records that "stiffed" (failed to become really big hits). These songs should be tested periodically by telephone call-out or web-based research.

4. Power gold. This category contains records that were very big hits in the past three to ten years. There may be from 100 to 300 of these classics, and they are played at the rate of two to three per hour, depending on commercial load. The songs are recycled every few days. These are the "never-die" songs that will always be recognized by the target audience and immediately identified by them as classics. They greatly enhance the format,

because listeners get the impression that the station airs a broad range of music. Because there are so many of them, auditorium research is the best way to test these songs for desirability, recognizability, and **burnout** (listeners have tired of them) but they may occasionally also be rotated through call-out or web tests.

5. Gold. The gold category contains the rest of the songs from the past 10 to 15 years that are not in the recurrent or power gold categories. This group of 200 or so titles is played at the rate of one to two an hour, depending on format and commercial load. Songs in this group are carefully researched, usually in auditorium tests, to make sure they appeal to the station's target demographic group and are not suffering from burnout. Stations can extend their gold categories by not including every song that meets their criteria for airplay in the active library. Rotating songs in and out of the active gold library every few weeks—or creating subcategories that rotate at different speeds—can increase the audience's sense of musical variety on the station while maintaining a consistent sound.

A final category, **oldies,** may complete the record library for some formats (although CHR stations omit it entirely). Oldies comprise the largest group because it covers the greatest span of time—all the hit songs from the 1950s up to ten or 15 years ago. As many as 600 songs may be in the group, and they are played at the rate of one to two per hour in some formats. The commercial load and the number of older listeners the station wants to attract will determine how many oldies get played. Songs in this group had to be hits at the time they were released and must continue in popularity. Programmers for AC and oldies stations subdivide songs in this category according to the dates the songs were originally hits. The year categories listed here roughly parallel major shifts in the style of popular music:

- Mid-1950s to 1964
- 1965 to 1972
- 1973 to 1980
- 1980 to ten years ago

A song that is a huge hit in one market can be a dismal flop in another. These songs will be auditorium tested for signs of burnout in the specific market and could also occasionally be part of web testing.

Controlling Rotation

Regardless of format, music stations must control **rotation** *(the frequency of play of different kinds of songs).* For many years, stations used a flip card system. Each song was placed on a 3×5 card in a file box (perhaps separated into different categories of music). DJs were instructed to play the next available and appropriate song and place the flip card at the back of the stack.[5] A flip card system, however, leaves the disc jockey rather more discretion than may be desired about what's played and invites the playing of "favorites" (a programmer's nightmare!).

Most stations use computers to keep track of what song is played where and what kind of restrictions apply. Computers can be programmed with a host of restrictions to maintain the exact rotation and balance among songs the music director desires. By combining airplay data with ratings information, programmers can track how the music flow impacts audience flow as well as how frequently the audience is really hearing a song. Computers can be used to:

- Follow a category rotation
- Restrict some songs to particular dayparts
- Balance up-tempo and down-tempo songs
- Avoid scheduling two songs by the same artist closely together
- Prevent songs from playing close to the same time every day
- Prevent adjacent songs of the same type (such as two old school songs or two rhythm and blues songs)

Adherence to such restrictions leaves most of the control in the hands of the program director rather than the on-air personality, whose focus should be on his or her performance between songs

rather than on selecting music. DJs as well as the program and music directors can get printed lists of all the songs to be played, although it is more common to display the log on a computer monitor in the studio. Broadcast software can integrate the music log with the traffic log to present the air talent with a single seamless schedule, and the screen may even include scrollable live copy or other performance notes for the air talent.

When setting up the rotations for various music categories, *it is important to keep the relationship between the number of songs in the category, the rotation speed, and the clock structure in mind.* The program director must make sure the categories are not cycling in time frames that are multiples of each other, which would lead to categories synchronizing and the same songs playing together in a pattern. In the example of our hypothetical Churban station, the power category is set to turn over every 90 minutes. Thus, the current category should be rotated at a pace to avoid turning over at 3 or 4.5 hours (which would synchronize to the second or third power rotation at 90 minutes). Good choices would be 3.5 or 5.5 hours, keeping given songs in the categories out of sync for substantial lengths of time. Gold and recurrent categories generally have enough titles and slow enough rotation that synchronization is not a major issue, but programmers should still be aware of it.

The Hot Clock

One of the program director's major responsibilities has been to construct **hot clocks.** A hot clock is a design, looking like the face of a clock or a wheel, in which the formula for producing the planned station "sound" is visualized. It divides an hour into portions for music (by category), weather, news, promos, and commercials. Hot clocks tell the DJs where to place the elements that make up the programming for a given hour. The program director devises as many hot clocks as are needed: one for an hour with no news, another for an hour with two newscasts, another for an hour with one newscast, another for an hour with 10 commercial minutes (or 12 or 14 or however many the station

allows and could sell). Hot clocks are examples of dayparting—that is, estimating who is listening at a particular time of day and what their activities are, and then programming directly to them.

Stations that use computers to program their music embed the hot clocks in the computer software. The computer "knows" that at six minutes after the hour it should play the next power song. Because the computer plans ahead, it will adhere to the usual restrictions, making sure, for example, that another song by the same artist has not played recently and is not scheduled too closely in the future.

Typically, morning clocks include news and heavy doses of information (traffic and weather in particular). Clocks for the remainder of the day will not include news in most music formats, but will generally offer traffic and weather in the afternoon. In all, there may be as many clocks as hours in the day, with a completely different set for weekends (where weather is the key information element).

Besides structuring information (news, weather, traffic), promos, and commercials, the hot clock also structures the music for a given hour. The music portion of an hour depends on the number of commercials to be aired. A commercial-free hour, for example, requires many more songs than an hour with 14 spots. A basic morning-drive hour designed to handle one newscast and 13 minutes of commercials appears in 11.9. This leaves room for up to 10 or 11 songs, depending on how much the DJ talks. The music for this morning hour might consist of four powers, two currents, two or three recurrents, one power gold, and one gold. The service elements—news, weather, traffic—are spaced more or less evenly throughout the hour. As is typical of a contemporary music station, news has been placed in the middle of a quarter hour. Station imaging, promotion, and identification elements, either recorded or voiced live by the air talent, occur between every song.

The clock in 11.10 is intended for an early evening show. The music selection contains 12 songs, made up of six powers, two currents, two

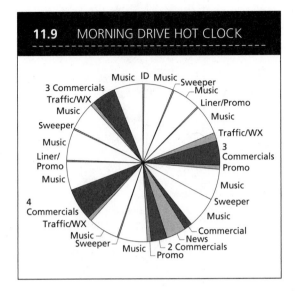

11.9 MORNING DRIVE HOT CLOCK

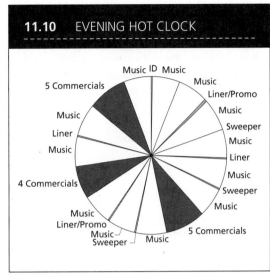

11.10 EVENING HOT CLOCK

recurrents, one power gold, and one gold. Note the long music sweep from before the top of the hour until approximately 20 or 22 minutes past. This selection fits a CHR or urban contemporary station but would be different on a rock or mainstream country station (where the rotation of currents would be slower and more golds would be played). A midday clock might look similar to this one but with more golds and recurrents scheduled to slow down the current rotation a bit so at-work listeners aren't hearing the same song four or five times. The rotation pace in the currents would then pick up again during afternoon drive and evening.

No single set of clock formulas will drive a station to the top of the market. Other possible clocks might include more longer music sweeps (stations may adopt a "more music" image, promising six, eight, ten, or more songs in a row), or even commercial-free hours. Remember that a change in one area will also change other aspects of the clock, however, and there are many factors to balance. Longer music sweeps will generally mean longer commercial clusters, which may damage advertising sales and drive away listeners at those times once they figure out the pattern. The program director will have to negotiate the number of **commercial avail-**

abilities (the number of spots, commonly referred to as **avails**) in an hour as well as the maximum number of avails in an individual break with the general manager and the sales manager. Most program directors will argue for a limited number of commercial minutes, but the recent trend at most stations has been to increase the amount of commercial time in most hours.[6]

Music Research

The key ingredients in designing a successful format are careful planning, ongoing local research, and a willingness to adapt to changing audience tastes and competition. Although music tastes within a format tend to be more homogenized nationally today than in the past, because of cable video music channels, the mobility of the population, and other factors, successful programmers are always aware of—and take advantage of—market-specific variations. Music stations may employ one or more people to handle call-out research and assemble statistics. A rock station's music researcher compiles the list of the top-selling titles based on local record store sales. The researcher also keeps tabs on records the station does not play but that are selling due to airplay on other stations and

nightspot exposure. The researcher may be employed full or part time and usually works for the music director. The more objective information the researcher gathers, the easier it is for the programmer to evaluate the record companies' advertising and sales. Record promoters will naturally emphasize their products' victories, neglecting to mention that a record died in Los Angeles or Kansas City. The station must depend on its own research findings to rate a piece of music reliably. Figure 11.11 illustrates the common method of creating a list of top hits.

As explained in Chapter 2, **call-out research** gets reactions directly from radio listeners. Two versions of the technique are used—active and passive. In active call-out research, the names of active listeners are obtained from contest entrant lists. The passive version selects names at random from the telephone directory. In either case, respondents are asked to listen to excerpts (hooks) from the songs being researched or to lists of titles and to rate them on a scale running from 1 to 5 as follows:

> 1 = "Hate it."
>
> 2 = "Dislike it."
>
> 3 = "Don't care."
>
> 4 = "Like it."
>
> 5 = "My favorite record."

Research will also assess the extent to which a record might be burned out, by asking listeners if they are "tired" of hearing the song (a high burnout percentage tells a PD that the song might need to be retired from the active library, either temporarily or permanently). When a sample is completed (100 calls is typical), the votes for each number on the scale are tabulated. The various totals are then manipulated to obtain interpretations in terms of ratios or percentages. (See the weekly *Callout America* report in the CHR section of any issue of *Radio & Records* for an example of this research.)

For example, assume 100 listeners are called within a week, and 30 records are discussed. Twenty-four listeners say they like song number five, and

11.11 MAKING A TOP HITS LIST

Trade publications such as *Billboard, Radio & Records,* and the *Gavin Report* (and others that specialize in a single format) are studied when adding new music to a playlist. Each week the researcher compiles a chart of the top 30 songs from each magazine and averages them to get composite ratings. Analysis of chart movements of newer songs and news regarding airplay in other areas are also helpful in choosing the "adds." Some programmers will track more than one chart, and the hypothetical rhythmic CHR station in this chapter is a good example. In this case, all urban and CHR charts will provide valuable information. Another example might be a market where country wins in the ratings. The country music charts can suggest crossover songs for a pop/mainstream CHR or AC station.

To derive this chart, the music director compares the top songs on the current playlist to the rankings in *Radio & Records, Billboard,* and *Gavin.* If a song is number one in *Radio & Records,* it gets 30 points. If it rates number two in *Billboard,* it gets 29 points; a rating number three in *Gavin* gives it 28 points, and so on. After charting each song against the major trade publications, the researcher divides the total by the number of publications to get the average ranking. Local sales figures are tabulated in a similar manner. The figures are averaged and combined with other research to create the station's chart. Trade publication rankings are based on data supplied by hundreds of reporting stations. If the researcher finds from the weekly call-out test that number five seems to be burning out locally but was nevertheless still running in the top three or four nationally, the song might be retained but assigned a lower rotation position pending further analysis.

36 say it is their favorite record; 11 said they didn't like it, six didn't care, and nine hated it. Fourteen had never heard it before (a very high

recognition rate of 86 percent). Song number five thus has a total score of 325 and an average response of 3.78—this song is scoring very well with your core audience. It should definitely be high in the playlist, and depending on its age, trend, and the scores of other current songs, it might qualify for the power category.

When doing caller research of any kind, it is crucial that the questions be asked in the right manner. Contest entrants, for example, listen to your station and will tend to answer what they think you want to hear (after all, they are pleased with the station at the moment!). It is important to make them understand that they are being asked to help determine the station's music selection. Because the station is their favorite, they should be pleased to have the opportunity to shape its programming even more to their liking. During a music interview, contest winners can also be asked to comment on other things they like or dislike about the programming. This requires a sympathetic ear on the part of the researcher.

When calling people randomly selected out of the telephone book, the first step in an interview is to qualify the person—that is, make sure the person is in your target demographic and listens to, or prefers, the kind of music the station plays. The second step is to ask about song preferences.

Another method of radio research (mentioned in Chapter 2), primarily for the gold and recurrent parts of the library, is **auditorium testing.** Several companies specialize in this kind of audience research. Typically, they bring a test group to a large room and ask them to evaluate music as excerpts are played. As many as 300 songs may be tested, with the audience writing their responses on special forms or punching in responses electronically. The tabulated results will be broken down demographically, usually providing valuable information to programmers on which songs to play in which dayparts, and which songs may be wearing out for the target audience. Additional questions can be asked, such as "What station do you listen to most?" "Second most?" "Who has the best news/the best sports/the best personalities?" "What is the most irritating?" and so on.

One relatively recent development in music testing is the emergence of **web site-based systems** that are less expensive and more accessible to small and medium market stations than traditional telephone or auditorium testing. The process begins similarly to active call-out telephone testing. Stations recruit a sample of audience members willing to participate in testing (in this case, via on-air announcements or their own web site). Once the panel is assembled, the program director will upload the song hooks to the web site weekly (or even more frequently if needed) and then send out an email to the sample announcing that the music is ready for their assessment. The listeners then complete the testing at their convenience, and the results are available immediately to the program director and music director.

NEWS

News has always been a problem on rock and roll stations. Adult-oriented stations must provide information to their audiences, especially during morning drive. Stations targeting younger listeners, however, often do not want to carry news, feeling that their listeners are bored with it, but think they must provide news to satisfy unwritten FCC requirements.

Do listeners want news on music stations? Early studies by consultants concluded that a large percentage of rock listeners were "turned off" by news. These same listeners also hated commercials, **public service announcements (PSAs),** and anything else not related to music and fun. Some studies found, however, that everybody wanted lots of news on their music stations. Organizations such as the Associated Press, which is in the business of selling news services to radio stations, are not likely to publish studies indicating that young listeners do not want to hear news. Consultants, however, are in the business of finding out what is wrong with radio stations and have a vested interest in finding things wrong that can be fixed. More contemporary views hold that the task for programmers is to find news and information that

is relevant to the target audience because it will provide an important component in the overall station identity. *Listeners do value information—but only if they understand how it is relevant to their life right now.*

Some thinking on news scheduling hinges on the habits of some listeners and Arbitron's diary method of surveying listeners. The idea is to hold a listener for at least five minutes in any quarter hour by playing some music so the station will get credit in a listener diary even if the listener tunes away at news time. On popular music stations, news is therefore often placed in the middle of one or two 15-minute periods each hour. This strategy assumes that a significant number of listeners are turned away by news. Music stations, especially those targeting younger listeners, have generally eliminated newscasts except in morning drive.

Journalistic Content

Having decided where to put news, the programmer must then decide how to handle it—whether to go the low road, the high road, or—increasingly —somewhere in between. On the low road, jocks (or sidekicks) **rip and read** news wire copy as it comes out of the machine. Some low-roaders satisfy the need for local news by simply stealing from the local newspaper or *USA Today* (the news itself cannot be copyrighted, although specific versions of it can be).

On a more elevated level, there are now local news services available that will provide local and regional news (including traffic and weather) for any station willing to pay for the service. The best known of these is Metro, a service of Westwood One. The advantage to the station is the ability to deliver timely and valuable local information at a cost less than hiring a news staff. The disadvantage is the loss of any exclusivity. The same reporter filing the story for your station on the downtown fire and resulting traffic jam at 3:05 p.m. may well be on your competition at 3:08 (or 3:03).

Another option is to enter into a joint agreement with one of the local television stations. The local evening television news anchor or sports

reporter may be a valuable addition to the radio station's morning show, and the teaming has promotional advantages for each station. Some clustered stations have adopted a variation of this cross-promotional approach if the cluster includes a news or news/talk AM station—the FM music stations get their morning news from the AM station news staff. Opinions are divided about the advisability of identifying the anchor as from the FM or the AM station during an FM newscast; some stations believe that maintaining a single brand identity is crucial to the station's image and success, while others trade on the legitimacy associated with the news station by identifying the anchor as being from that station.

Programmers who set the highest goals for themselves do well to hire at least two persons to staff the news operation. One staffer does the air work in the morning while the other develops local stories, mostly over the telephone. The two news staffers reverse their roles in the afternoon, or both can be in reporting mode. The morning person leaves **voicers** (stories recorded by someone other than the anchor-person with a short introductory script for the anchor to read) for use during the afternoon newscasts (if there are any), and the afternoon person leaves them for use early the next morning. This news operation would be extremely luxurious for a music station, however. The typical full-time news staff in radio stations throughout the country is only one person. And even at stations that have a news staff, they are most likely serving multiple stations in a market.

Nonentertainment Programming

The deregulation of radio in the 1980s substantially eased FCC-imposed requirements for nonentertainment programming on radio stations. Minimum amounts of nonentertainment programming for AM and FM stations have been abolished, as have the Commission's formal ascertainment requirements, although a licensee is still required to "informally" ascertain the problems, needs, and interests of the community, and to provide programming that addresses those issues. A quarterly

list of programming the licensee has broadcast to meet those needs must be placed in the station's public file.

News, public affairs, and "other" nonentertainment programming create a flow or continuity problem for the formula format. The complaint is, "we have to shut down the radio station to air that junk." Junk, of course, is any programming not directly related to the music format. However, that assumes that all nonentertainment content must be long form. Nonentertainment material may be effectively woven into any format. Much important information, from traffic and weather reports to upcoming events in the community, can be dished out in 60, 30, or 10 seconds. Public service announcements are both nonentertainment and community-oriented programming, and a station can make significant contributions to the community welfare with an aggressive PSA policy. The key for programmers is to be as careful and deliberate about the choices they make with this material as they are with their music. Make sure these elements are timely and relevant to the lives of the target audience. The morning jock shouldn't be wasting several minutes rehashing the weekend on Monday morning—he should be letting the audience know whether to grab their umbrella or their sunglasses as they struggle to get out the door and off to work on time. On Thursday and Friday, the afternoon drive talent should be focused on events coming up that weekend as well as helping the audience avoid the overturned semi at the airport freeway exit.

Radio will probably always be a service medium, and broadcasters will always differ on what constitutes community service. In a competitive major market served by a number of communications media such as newspaper, cable, television, radio, MMDS, LPTV, and DTH, the FM radio station that plays wall-to-wall rock music is doubtlessly providing a service, even though it is solely a music service. In information-poor markets, owners may elect to mix talk shows with music, air editorial comments on community affairs, and in general, provide useful information to the community. The services

and information provided should be based on competitive market factors, the owners' and managers' personal choices, and a realistic understanding of the role a radio station can play in the particular market situation.

AIR PERSONALITIES, DAYPARTING, AND VOICE TRACKING

In contemporary radio, there are SCREAMERS!!! trying to wake the very young, and the shock jocks, the adult-male-oriented personalities courting FCC retribution daily. And there are very laid-back jocks who just talk conversationally when they open the microphone switch. Then, there are those "friendly" jocks who fall somewhere in between the screamers and the laid-backs. Once there was also the big-voice-boss who told the listener this was a Big DJ, a know-it-all, but this style faded in the early 1970s.

Dayparting is one of the major strategies of the music station programmer. The programmer's challenge is to make each daypart distinct and appropriate to the audience's characteristic activities and at the same time keep the station's sound consistent. The most important ingredient in making daypart distinctions is the personality of the jock assigned to each time period, followed by appropriate adjustments to the music rotation and other programming elements. *Nevertheless, neither the PD nor the air talent should lose sight of the fact that consistency is the primary goal.* Under a strong program director, a kind of "sameness" can develop among all the jocks in a specified format without the drabness or dullness normally associated with sameness. *Sameness* here means predictability. Listeners tuning in to the station at odd hours hear the same "sound" they heard while driving to work in the morning or home in the afternoon (consistency). That kind of familiarity and predictability will contribute to more regular listening.

Morning

By and large, modern morning jocks are friendly, funny, and entertaining. They "relate" to the target audience. Morning jocks, for example, probably will talk more than air talent on other dayparts because their shows are especially service-oriented. Morning drive air talent are more than mere jokesters—*they provide the day's survival information to the audience:* how cold (or hot) it will be, whether it will rain (or snow), what time it is, frequent updates on traffic problems that will keep them from dropping the kids at daycare and getting to work on time, and so on. Reports of a pile-up on one expressway give listeners a chance to switch their commuter routes—and the station a chance to earn a Brownie point.

Traditionally, morning drive lasted from 6 to 10 A.M., and it is still defined that way by Arbitron. For PDs and morning jocks, however, the reality is different. People are spending more and more time in their cars as the suburbs surrounding many large urban areas continue to sprawl outward. Commutes take new forms (suburb to suburb rather than suburb to city), and people's work schedules have changed to incorporate flex time or just earlier (or later) shifts. As a result, the real "drive time" has extended. In many markets, traffic builds to significant volume by 5:30 or even 5 A.M. Therefore, many major and large market stations begin their morning shows at those earlier times. Some also end earlier, getting to their midday programming by 9 A.M.

Morning jocks are often paired in teams of a lead DJ and a sidekick, someone to bounce jokes off, or a co-anchor who can add to the act, commonly a male plus a female. On most stations, the morning jock is the only performer permitted to violate format to any appreciable extent (the "morning zoo" approach). Normally, morning drive-time personalities are also the most highly paid. They have a greater responsibility than other jocks because the audience is bigger in the time period than at any other time of day. For most stations, "If you don't make it in the morning drive, you don't make it at all."

Midday

The midday jock is frequently conversational in style, warm and friendly. Incidental services (requiring talk) during this daypart are curtailed—although not eliminated—in favor of longer music sweeps. Music rotations may be slowed and more recurrents, golds, and oldies added so as not to seem too repetitious to the all-day audience. Although there is considerable out-of-home listening in the 10 A.M. to 3 P.M. period, Arbitron data show that the majority of listeners are at home or at work. Many midday jocks capitalize on the dominantly female audience by using **liners** (brief continuity between songs) having special appeal to women, and by talking about what the listener might be doing at home. At-work listeners may also be targeted through daytime-specific promotions (giving away lunch to everybody in the office after entrants have mailed in business cards or faxed in requests, for example). Noon time may lend itself to special programming as people leave the office or take a break from work, such as the all-request "diner" hours popular on many country, AC, oldies, and rock stations.

Afternoon

The afternoon jock (3 P.M. to 7 P.M.) is more up-tempo, as is the music rotation in this period if the station is dayparting. Teens are out of school to listen to CHR stations, and adults are driving home from work for the AC stations. In small markets, this necessitates a delicate balance between teen-oriented music and music suiting the moods and attitudes of the going-home audience. Again, weather and traffic are important in this period (especially traffic), although perhaps not quite as much as in the morning. Information is more likely to take the form of the afternoon jock alluding frequently to evening activities—about how good it must be to finish work and to look forward to whatever events people in your audience will be a part of that evening—a concert, a ballgame, a movie sneak preview, and so on. By Thursday, and certainly on Friday, weekend plans usually become a focus.

Evening

More teens than adults are available to listen at night, making this daypart strong for CHR stations. Evening jocks may be screamers with a special appeal to teens. The ability to use listener phone calls on the air, juggling the phones along with music and everything else, is an essential ingredient of many CHR evening jocks' shows. They may open the request lines and play specific records for specific people, get listeners to introduce songs or play along with pranks, or engage in short funny bits (usually edited before playback). In major markets, and even in many middle-sized ones, this practice creates problems for the telephone company. In Mobile, Alabama, WKRG-FM asked the phone company to make a record of calls that did not get through to its four request lines. In one week, there were 65,000 such unsuccessful calls. Imagine what the number might be in Los Angeles or New York! Telephone companies in some markets have appealed to stations to stop promotions that involve extraordinarily high volumes of listener call-ins.

Because the majority of adults are doing something other than listening to the radio (most often watching television, renting videos, and so on), AC stations and other adult formats may try slightly altering their programming in the evening to attract an audience. Syndicated programs such as Broadcast Programming's *Delilah* or AMFM Networks' *Rockline* offer programming that is different yet similar enough to have broad appeal for the AC or rock audience.

All-Night

In the all-night period, from midnight to 6 A.M., the jock's attitude is usually one of camaraderie. "We're all up late tonight, aren't we? We have to work nights and sleep days." This jock must commune with the audience: the taxi drivers, revelers, police officers, all-night restaurant and grocery store workers, insomniacs, parents up giving babies two o'clock feedings, shift workers at factories, bakers, and the many others active between the hours of midnight and 6 A.M. The commercial load is almost nil during this period, so the jock can provide listeners with a lot of uninterrupted music. Many stations will run network or syndicated material here to save on costs, or use some of this time period to beef up their public affairs programming.

The Voice-Tracking Question

As investors, and therefore corporate executives, continue to demand ever greater earnings from each station in a group, the pressure mounts to cut costs in order to pass those savings to the bottom line. One obvious method is the elimination of some, most, or all local air talent, but a successful station can't play just music and commercials. Radio needs personality to succeed—otherwise, the listener is just as likely to play a cassette or CD so as to skip the commercials altogether.

Technology has provided one solution to this dilemma for broadcast managers. Automated systems allow talent to **voice track** (prerecord) their segments, which are then played back at the appropriate time between songs. One or two people can voice track an entire day's programming on a station before going off to do production or engineering or sales; or one air staff can provide voice tracks for many stations in a local or regional group, perhaps in addition to a live shift on one station. Using ISDN lines or the Internet, it is technologically easy for the air talent to be in Dallas and upload voice tracks to stations in Michigan, Florida, and Oregon. Not only can this provide budgetary savings for the local station, but it offers the opportunity to use better quality air talent than would otherwise be affordable in many small and medium markets.

The downside is the potential to lose what radio is best at—being local and immediate. If a station is voice tracked from a distant source and has competition that is well programmed, live, and local, history says unequivocally that the nonlocal station will lose. If management decides to use voice tracking, it would be best to limit it to off-peak hours (overnights, weekend mornings, and nights) to the extent possible, and to make every effort to

ensure the talent localizes the content. Ideally, the voice tracks should be recorded as close to the actual air time as possible in order to provide the most up-to-date information.

ADVERTISING AND PROMOTION

The modern radio station pays almost as much attention to advertising and promotion as to programming. They are essential to keep a station from simply disappearing in the crowd. Nowadays, stations use television, newspapers, billboards, bumper stickers, bus cards, cab tops, and other graphic media. Promotional stunts are the special province of pop radio, involving the cooperation of programming personnel. If this chapter's hypothetical station were trying to break into a large market, as much as $2.5 million might be needed the first year for promotion. Many hit music operations, seeking a general (mass) audience with emphasis on the 18- to 49-year-old group, commonly give away as much as $500,000 every year in cash!

Station promotion can have three possible goals: to *build audience share* (by extending the listening of the current audience); to *build cume* (by attracting new listeners); or to simply *enhance the audience's expectations* of the station without an immediate ratings goal (positioning). In any case, it is essential that the promotional effort be focused on the listener if it is to succeed. Too often, promotions happen because of advertiser or economic concerns rather than through a focused attempt to achieve one or more of these three goals. In addition, stations should concentrate their efforts on one promotion at a time. Multiple concurrent promotions simply dilute the impact of each and may confuse and frustrate listeners.

Contesting

The traditional promotional stunt is the contest, but the industry favors the word game. Many people think they cannot win contests, but they like to play games. For many stations, a contest approach emphasizes a superprize of $25,000 or more. Such amounts can be offered only a few times each year (during the Arbitron survey sweeps). And because a station cannot afford to risk losing the big prize on the first day of the game, winning has to be made difficult.

People are more likely to think they can win a small prize than a $25,000 treasure hunt or open a safe containing $50,000. With a superprize one person is made happy, but thousands are disappointed. Consequently, it is better to break up the $25,000 prize into $250 or $25 prizes and scatter them through a more extended period. **Direct mail** contesting is now widely used to increase listening in specific geographic areas, based on the zip codes of target listeners.

Currently popular games include birthdays (announce a date on the air, and the first to call with that birthday wins a prize) and cash call (make one call-out per hour and give the jackpot to the person naming the exact amount in the jackpot at the time). Cash call involves a small prize, added to each call until the correct amount is guessed. The DJs ballyhoo the contest before it starts to generate excitement, sometimes for days and days (precontest hype). Then they finally hold the contest.

Jock:	Is this Mary Jones?
Listener:	Yes.
Jock:	Well, this is Jocko at station KPPP, and if you can tell me the exact amount in our KPPP jackpot, you'll win!
Listener:	Mmmmmm. Last I heard it was $1,950.
Jock:	That's right! You win! You're right. Mary Jones, you've just won yourself $1,950!
Listener:	Oh, wow! I can't believe it.
Jock:	What are you going to do with the money, Mary?
Listener:	Oh, wow . . . oh, wow . . . I can't believe I won! I don't know . . . I think I'll go to Cancun and lie on the beach.

Jock: Mary, who plays the most hit music
 and gives you cash?
Listener: KPPP!

The more exaggerated the winner's response to
his or her victory, the better the programmer likes
it. Hyperbole is the element sought. Later the sta-
tion will air promos in which each winner's response
is repeated and repeated (postcontest **hype**). Jocks
should remember to ask such questions as, "What
are you going to do with the money? What will
your husband/wife say?"

Cash call is but one of many games. The peo-
ple's choice gambit can work with direct mail or
telephone games. This variation provides a variety
of prizes and allows the contestants to identify
ahead of time the prizes they want if they win.
Studies have determined that cash, cars, and trips
are the most desired prizes. Prizes and contest rules
should be carefully targeted to appeal to the exact
age, sex, and economic groups the station wants
to listen.

The growth of huge national groups has added
an interesting twist to promotional contests. Those
group-owned stations pool resources and jointly
run a contest with larger daily or weekly prizes
than would be possible for a single station or single
market cluster. Thus, instead of giving away $102
(or whatever number corresponds to their dial po-
sition) in the birthday game, a station may award
several thousand dollars to the one hundredth
caller. The catch is that same prize is being offered
simultaneously by the morning jocks on 100 or
more stations across the country and the odds
of winning are therefore infinitesimal, although
many in the local audience may not realize it.

There are three steps to properly promoting a
contest: (1) Tell 'em you're gonna do it: "It's com-
ing, your chance to win a zillion dollars!" (2) Do
it: "Listen every morning at 7:20 for the song of
the day. When you hear it played later in the day,
be the first caller at 555-0000 and win the money!"
(3) Tell 'em you did it: "KPPP congratulates Mary
Jones of your town, winner of a zillion dollars in
the KPPP song of the day game." It is important
to avoid exact addresses on the air. The station

might have legal culpability if a robbery or other
crime occurs. Also, many DJs do not use last names
of callers on the air to discourage possible un-
pleasantness for their listeners.

Exercise caution in recording and airing tele-
phone conversations. Stations have shifted to call-
in rather than call-out games because the law
requires that the person being called (by the sta-
tions) be informed immediately off-air, "This tele-
phone conversation will be broadcast or recorded."
Then the dialogue can begin: "I'm Jocko from
KPPP." It is a troublesome law that ruins many
such calls because, once informed, the listener
does not respond spontaneously. Listeners who
call in, however, are assumed to be aware that
their voice may go out on the air. Management
should seek legal counsel on call-out questions
and should write specific instructions to program-
ming personnel on how call-out calls are to be
handled (see 11.12).

Community involvement projects are as impor-
tant as contests in programming and promoting
a successful radio station. The station must be
highly visible at local events to gain a strong, posi-
tive, local image. The event should be one that is
of significant interest for the station's target audi-
ence and that fits their lifestyle and the station's
image. The following are community promotions
that, depending on the format and market, might
benefit both the station and the community:

- The station's van (customized to look like a
 boom box, complete with disc jockey, albums,
 bumper stickers, and T-shirts) shows up at the
 entrance to the hall that features a concert
 that night

- Two or three jocks take the van and sound
 equipment to the beach (or any public park)
 on the Fourth of July to provide music and
 "freebies" to listeners and friends

- The station runs announcements, and then helps
 collect clothing and other items to benefit the
 victims of a recent tornado by letting people
 drop off goods to DJs with the station van at
 different collection points in the community

11.12 PROGRAMMING, PROMOTION, AND REGULATORY CONSTRAINTS

Radio broadcasters have to be aware of myriad rules, regulations, and guidelines. To keep up with them, radio programmers read trade journals, retain legal counsel specializing in communication law, and join the National Association of Broadcasters (NAB) as well as state broadcast organizations. Programmers have to be aware of legal constraints that may limit their ingenuity. Illegal or unethical practices such as fraud, lotteries, plugola, and the like can cost a fine, a job, or even a license.

Contests and Games

The principal point to remember about on-air contests and games is to keep them open and honest, fully disclosing the rules of the game to listeners. Conniving to make a contest run longer or to produce a certain type of win-

ner means trouble. Perry's newsletter, *Broadcasting and the Law,* is useful for flagging potential difficulties.

The perennial problem with many brilliant contest ideas is that they are lotteries by the FCC's definition, and advertising lotteries is explicitly prohibited in some states but not in others. If a contest includes "prizes, consideration, and chance," it is a lottery and probably illegal.[7] Consult the station's lawyers or the NAB legal staff if there is the slightest question.

At least one large group has also run afoul of the Federal Trade Commission's (FTC) rules regarding deceptive advertising practices in the way they conduct national contests across multiple stations in the group. The stations were accused of misleading listeners about the

nature of the contest and their chances of winning by failing to make the multimarket, multistation nature of the contest sufficiently clear in the rules (which must be broadcast several times each day during the run of the promotion) and broadcasting the winners' comments without identifying them as residents of other markets (thus implying they were local residents).

Sounds that Mislead

Similarly, opening promos or commercials with sirens or other attention-getting gimmicks (such as "Bulletin!") unjustifiably cause listeners to believe they are about to receive vital information. Listener attention can be gained in other more responsible ways that do not offend FCC rules or deceive listeners. Monitoring locally produced commercials or promos

Commercial Load

More arguments arise over commercial load than any other aspect of programming a music format. Before the 1970s, FM stations had few commercials because they had few listeners. Early top 40 formats on AM stations had many spots, frequently almost alternating songs and commercials on the hot clock. Researchers began hearing listeners say, "I like so and so because they don't play commercials" or "because they play so much more music than other stations." Lights flashed and bells rang throughout the industry. Listeners hate commercials! Schulke and Bonneville, two of the early radio programming syndicators, began to employ the strategy of music **sweeps** and **stopsets.** A music sweep is an uninterrupted period of music; a *stopset* is an inter-

ruption of the music to air commercials or other nonmusic material such as news headlines.

Herein lies conflict. Sales personnel must have commercial availabilities (unsold spot time) if the station is to make money. Programmers rightfully argue that if the station is to score big in the numbers, it must limit its commercial load. The answer is compromise. Salespeople agree to raise rates, and programmers agree to provide 10 or 12 commercial minutes per hour instead of the full 18 the sales department wanted. (In 1982, the FCC stopped expecting radio stations to adhere to the now-defunct NAB radio code that specified a maximum of 18 minutes of commercials per hour except during political campaigns and other local, seasonal events when increases were permissible.)

11.12 CONTINUED

for misleading production techniques is especially important. Similarly, hoaxes perpetrated by air talent, even in the name of entertainment, can result in FCC penalties. For example, a station in St. Louis was cited for airing a phony emergency alert (on April Fool's Day) claiming the United States was under attack. Particularly offensive in the Commission's view was the DJ's use of the actual emergency alert tone at the beginning of the bit to heighten the realism.

Plugola and Payola

Announcers who "plug" their favorite bar, restaurant, or theater are asking for trouble for themselves and the licensees (plugola). Similarly, a jock who accepts a color television set from a record distributor in exchange for air play of a record is guilty of pay-

ola. The big payola payoffs usually come in drugs, though, conveniently salable or consumable so they rarely leave evidence for the law. Nonetheless, such practices eventually surface because talk gets around, leaving the people concerned subject to prosecution. Drugs make station management very nervous; the legal penalties can include loss of the station's license, a $10,000 fine, and jail. Certainly, any tainted jock is likely to be fired instantly. Most responsible licensees require air personnel to sign statements once every six months confirming that they have not been engaged in any form of payola or plugola; some require drug tests for their employees.

Program Logs

Any announcement associated with a commercial venture

should be logged as commercial matter (CM), even though the FCC has done away with requirements for program logs per se. Program logs have many practical applications aside from the former legal requirement, including billing for advertising, record-keeping, format maintenance, and format organization. Common sense dictates a continuation of the old method. Advertisers demand proof of performance, and an official station log is the best evidence of whether and when spots were aired. If a station is challenged on the number of PSAs or the amount of nonentertainment programming it has aired, an official station log provides the best evidence of performance.

Spot loads vary considerably by format. News and talk operations carry the heaviest spot loads, as many as 18 or 20 minutes per hour. Popular music stations carry generally carry 10 to 12 minutes per hour, perhaps slightly more in morning drive, scattered in breaks between songs. Just as earnings demands are forcing stations to look at ways to cut costs, however, one way they can increase revenues is to increase the number of avails in an hour. Recent reports have many music stations running up to 16 minutes an hour. The strategy may work if everybody in the market follows along. The risk is that a heavier than normal spot load opens a station up to attack by a "more music" competitor.

Not only do many successful rock operations run a reduced commercial load, but they also

often program (and promote) commercial-free periods (see 11.13). Further, the quality of commercial production is critical. Commercials must complement the format rather than clash with it. Many rock stations refuse to advertise funeral homes, intimate patent medicines such as hemorrhoidal creams, and other products and services they believe will offend their listeners or not mesh with their format. Those that will take any spot, so long as it's paid for, risk alienating their audience and failing in the long run.

One key to understanding radio programming strategy is to compare stations in the number of commercial spots per break (**load**) *and the number of breaks or interruptions per hour* (stopsets). Too many spots in a row creates clutter, reduces advertising

11.13 COMMERCIAL-FREE HOURS

Listeners tune in in droves, at least in major markets, when a new station (or old station with a changed format) announces it will play "commercial free" for days or even weeks. Stations have been known to zoom to the top of the ratings charts after a month of commercial-free play, and fall into the pits when commercials are introduced. There is a painful irony in stations boosting the fact of no advertising when advertising is what supports the station. Of course, the cost of commercial-free play to a new station is initially low, as few advertisers leap to purchase time on stations without a ratings history. But instituting commercial-free hours generates an unfortunate tension between the conflicting goals of on-air and sales staffs, and worse, it conveys a naively negative attitude toward advertising messages to listeners, even though it is those messages that keep the station on the air. A substantial amount of research suggests that it isn't commercials that listeners object to so much as bad commercials, spots that are poorly written and produced or that aren't compatible with the format and audience. Stations are better served by making an effort to ensure that every element they air, including the commercials that pay the bills, is of the highest quality and meets the audience's expectations of the station.

impact, and encourages listeners to push buttons. Conversely, too many interruptions destroy programming flow and encourage listeners to migrate to other stations or to their own recorded music. Because advertising is necessary, management must establish a policy reflected in hot clocks and stick to it.

In the past, stations have kicked off new formats with no commercial load whatever. They typically offer huge prizes to listeners to guess the exact time and date the first commercial will be aired. Another popular audience-holder is the five-, six-, eight-, ten-in-a-row concept, with the announcer saying, essentially, "We've got ten in a row coming up without interruption." The longer the listener stays with the station, the more the station's quarter-hour shares are improved. A listener staying through a ten-song sweep will have been tuned in for 35 to 45 minutes, or three quarter hours. The tradeoff is a four- to six-minute commercial break that follows, and a second long stopset that will come up after just one or two more songs. The station still needs to sell a certain number of commercials at a given price in order to be profitable. Longer music sweeps and fewer stopsets mean longer stopsets with more commercial units in each. Nevertheless, this programming technique is commonplace in music formats and will likely continue until advertisers or the audience reject it. A tension will continue to exist between the number of commercials and the number of interruptions that can be tolerated.

Call Letters

Gordon McLendon, early innovator of the top 40 format, was one of the first broadcasters to recognize the value of sayable call letters. His first big station was KLIF, Dallas, originally named for Oak Cliff, a western section of the city. The station call was pronounced "Cliff" on the air. Then there is KABL ("Cable") in San Francisco, KOST ("Coast") in Los Angeles, and KEGL ("Eagle Radio") in Fort Worth. These call letters are memorable and distinctive noms de guerre and get daily usage. Today, nearly every city has a "Magic," a "Kiss," and a "Mix." More recent variants include names like "Alice" (KALC, a Hot AC in Denver). When the Belo Corporation in Dallas developed a new format for WFAA-FM, the historic letters were changed to KZEW, and the station became known as "the Zoo." (Gagsters used to try to pronounce WFAA, and it came out "woof-uh.")

FM stations often combine their call letters and dial position in on-air identifiers—especially if they are rock stations. In Indianapolis, rocker WFBQ calls itself Q95, and rhythmic CHR WBBM

in Chicago is B96. This practice generally involves rounding off a frequency to the nearest whole number (102.7 as 103, or 96.9 to 97). The increase in stereo receivers with digital dial displays, however, has discouraged the use of rounding off. More stations now give their actual dial location on the air, such as Rock 100.5 ("Rock One Hundred point Five"), KATT in Oklahoma City.

Jingles, Sweepers, and Liners

The day of the minute or half-minute singing **jingle ID** is gone. Nowadays, having a chorus of singers praise the station for a minute or half-minute is out of the question. That would take time away from the music that the audience tuned in for in the first place. Most stations keep jingles very short and to the point, and they are available in a wide variety of music types and styles to fit specific formats (although some formats, particularly rock, eliminate them entirely as inconsistent with the station image). Companies like JAM Creative Productions (www.jingles.com) and TM Century (www.tmcentury.com) specialize in radio IDs and jingles that consist of a few bars of music with the station call letters and identifying slogan sung over them. Producers will create several versions for use between songs of different tempos and in different dayparts.

Many stations also use **sweepers** between songs during music sweeps (thus, the name). These are short, highly produced imaging elements that include call letters, an identifying slogan, or air talent ID. They move the audience from one song to the next while reminding them of the station they're listening to (for diary purposes) and reinforcing the station's image, often by making aural connections between other elements of popular culture and the station. These are most often created locally by the station's production director, although many stations use outside talent that specializes in station imaging to provide the voice tracks for these important pieces.

Liners serve a similar purpose but are simple scripted voice tracks or live reads without music or effects. They can be used to promote upcoming station events, music ahead after the break, or for general station imaging. To be effective, however, liners must be kept fresh, constantly rewritten, and replaced.

NETWORK AND SYNDICATED PROGRAMMING

For economic reasons or other factors, stations may not wish to locally program 24 hours a day, 7 days a week. Thanks to CDs and satellite technology, national or regional programming is easily available from either a **network** or a **syndicator.** Both offer similar types of programming, but they can be distinguished by the nature of the relationship between the program supplier and the local station. Networks provide an integrated, full-service product (music, news, air talent, national spots, other features) that airs simultaneously on all affiliated stations, while syndicators provide one element (a single program, a music service, and so on) to individual stations that may air the material at different times.

National and regional programming can be divided into three categories: short form, long form, and continuous music formats. A program of sufficiently broad appeal can run in more than one format (thus increasing the odds that the supplier will be able to sell the program in most markets). Stations use short-form programs as spice in the schedule, airing most longer syndicated fare on weekends or at night (some network material may air in other dayparts). Short-form formats include individual network newscasts as well as syndicated programs and series (for example, the weekly 60-minute *King Biscuit Flower Hour*, nearing its thirtieth year in distribution, or the *House of Blues Radio Hour* from United Stations). Familiar long-form programming includes shows that run several hours on a daily or weekly basis, for example, ABC's *American Country Countdown* with Bob Kingsley or *American Top 40* with Casey Kasem from AMFM Networks.

11.14 SYNDICATORS

Selected Major Syndicators	Selected Programs
ABC	*Tom Joyner, Doug Banks, ESPN Radio, American Gold, Rock & Roll's Greatest Hits, American Country Countdown*
AMFM	*Rockline, American Top 40, The Dave Koz Radio Show*
Broadcast Programming	*Delilah, Neon Nights*
Premiere	*Rick Dees, Entertainment Tonight, Top 25 Countdown, After Midnite, Club Country Live*
United Stations	*House of Blues Radio Hour, Dick Clark's U.S. Music Survey, Sonrise, JazzTrax, Drew Carey's HiFi Club*
Westwood One	*Out of Order, Superstar Concert Series, The Beatle Years, In the Zone, Superstars of R&B, BBC Classic Tracks, Loveline*

Continuous music formats are just what the name suggests—24-hour, seven-day-a-week music selections. Until the late 1970s, stations programmed their own music or purchased long-form all-music programming tapes from syndicators such as TM and Century 21. As indicated in 11.14, syndicated formats are available from a number of companies, with or without voice tracking from the syndicator. The increased availability of satellite delivery in the 1980s brought a new type of national music programming service—the full-time, live network radio format. Modern satellite-delivered networks supply the combined services of a traditional network (news and advertising) and a formatted program service (music and entertainment programs). Satellite Music Network (SMN) was the first provider of real-time satellite radio in ten different music formats, including two versions of country, two rock formats, two adult African-American targeted formats, two adult contemporary formats, one version of nostalgia, and one version of oldies. That service was eventually consolidated with ABC Radio (www.abcradio.com). Other major full-time network providers include Westwood One, whose offerings were originally the Unistar and Transtar networks (www.westwoodone.com), Radio One (www.radioonenetworks.com), and Jones, which

offers both network formats under the Jones name and syndicated formats through its Broadcast Programming (www.jones.com).

Music Formats

The decision to go with one of these services instead of locally generated programming can reduce operating costs by one-half. About half of all commercial stations use at least some national or regional radio programming, from overnight filler to 24-hour "turnkey" operations. Although local programming is desirable, nationally programmed song selections are based on the kinds of professional research that smaller local stations find difficult to afford. Using a network or syndicated format package, a small-market station can achieve a consistent "big-market" sound with a recognized appeal to audiences and advertisers.

Network formats offer a complete package that includes practically everything but local commercials. Syndicated formats, like those from Broadcast Programming, at their most basic provide only music that is intended for use on fully automated stations. A station running a syndicated format may choose to run without air talent, may use local air talent, or for an additional fee the syndicator may also provide voice-tracking service. Unlike

11.15 24-HOUR FULL-SERVICE NETWORK FORMAT COMPARISON

AC	Country	Oldies	Urban	Rock	Hispanic	Other
ABC: StarStation Lite 2000	**ABC:** Coast-to-Coast Real Country	**ABC:** Pure Gold Classic R&B	**ABC:** The Touch			**ABC:** Stardust Rejoice Radio Disney
Jones: Adult Hit Radio NAC Soft Hits	**Jones:** CD Country Classic Hit Country US Country	**Jones:** Good Time Oldies		**Jones:** Rock Classics	**Jones:** La Bonita La Buena Z Spanish	**Jones:** Music of Your Life
Radio One: Choice AC	**Radio One:** Go Country			**Radio One:** Rock Alternative		
Westwood One: Bright AC Soft AC	**Westwood One:** Mainstream Country Hot Country	**Westwood One:** Oldies Channel Groovin' Oldies		**Westwood One:** Adult R&R		**Westwood One:** Adult Stds CNN

networks, format syndicators traditionally do not sell commercial time or produce newscasts.

Network formats (see 11.15) are generally available on a barter basis (two minutes per hour is the norm), although stations in unrated markets or brand new stations may be required to take the service on a cash-plus-barter contract. Full-time satellite programming eliminates the need for large staffs, large facilities, and large equipment budgets. In the most extreme form, current digital automation systems allow stations to replace a complex of air studios, production studios, and a programming/production staff of several people with a small production studio (for local commercials, weather forecasts, and so on), an on-air computer, and a staff of one or two. In smaller markets, going with such a service may allow a reformatted station to break even in less than a year.

Like a locally produced format, the network or syndicated service operates from a hot clock, each hour following a set pattern of music sweeps, some combination of mandatory and optional stopsets, and perhaps other material (jingles, sweepers, and so on). Figure 11.16 shows a typical network clock that might be used in the daytime for an oldies or AC format. There are 11 minutes of avails in three stopsets, two minutes for the network (the first minute in each mandatory break) and nine for the local station. Also note the long music sweep (or two long sweeps if the local station doesn't take the optional break at about :35), and note the opportunities for *localization* (liners to be recorded by the network air talent as well as things that can be done within the station breaks). Local stopsets and other content are triggered at the local station by a network command using sub-audible tones (different tones can be used to trigger different local elements). After the three- or four-minute break, the station's automation system then seamlessly rejoins the network at the appropriate point. For liners, the network channel is kept open, so the liner plays over the music as a song fades or the intro begins. In the late 1990s, many of the networks and syndicators settled on a single technological standard for satellite receivers provided by Starguide Digital

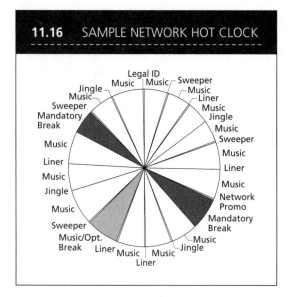

11.16 SAMPLE NETWORK HOT CLOCK

(www.starguidedigital.com). At each mandatory break, the local station must fill the time with local content, such as commercials, promos, PSAs, weather, and traffic. The network then uses this time to send important information (last-minute changes in the network air talent lineup or the network spot log, for example) or other material (such as copies of the network commercials for use in hours where local stations are not using the full network feed) to the affiliate stations using their regular channel. In an optional break, the network will program a precisely timed song so stations that don't have local spots scheduled there can continue music. It's a system that can be a bit awkward at times for the network PD—after all, how many songs are there in a particular format that remain popular (this is generally a secondary gold or oldies position, because you wouldn't want to miss playing a top current hit in your rotation) and run exactly 3:30?

The key to successfully operating with a satellite-delivered format is effective **localization**—*making the station sound like a part of the community even though the programming isn't locally produced.* Networks offer major-market quality personalities, thoroughly tested and carefully scheduled music,

and (sometimes) network news. Another part of their service is aimed at helping stations localize the product, but it is always up to the local station to direct the effort. At the request of the local station, network talent will record local station IDs, liners, and other voice tracks (intros to weather or news, contest wraps so that the tenth caller sounds like she's talking to the network DJ, and so on). These are then sent to the local station for insertion in the programming. For example, most stations will put the call letters or slogan, voice tracked by the appropriate network talent, at the start of every break or between songs leading into a song **intro** or **backsell** (telling the audience what music is coming up or what just played) by the network DJ so that it sounds to the listener like the DJ is at the station. Most of this process is really common sense and involves little more than the kinds of things a programmer would do if the air talent was at the station (for example, having the air talent use the call letters or slogan coming out of music every time, so the station and music are associated in the listener's mind). But it's surprising how many stations fail to follow through and wind up sounding like a satellite station because they create localizing material too infrequently or irregularly. Others make the mistake of completely eliminating local programming and production personnel, leaving account executives to write and produce commercials and the receptionist to voice track a weather forecast a couple of times a day, employees who are often without the training or talent to effectively execute those tasks.

Local information remains important—regardless of the market, people still want the weather forecast, they want survive-the-day information like traffic in the morning and afternoon drive times, and they expect the local radio station to provide it. Many network-affiliated stations adopt a middle-ground approach, running local in morning drive and perhaps one or two additional shifts during the day while using the satellite primarily at night and on weekends. Most networks require the affiliate stations to air the scheduled network spots, however, even during hours when the station is not airing the network programming.

One downside to running full-service satellite-delivered music programming is relative to the lack of control at the local station. Sometimes the network personality talks too much or makes inappropriate comments. One station became upset when the network DJ (in Dallas) told Christmas listeners to "avoid the crowds and stay in today," which was then followed by local commercials asking people to do exactly the opposite! By choosing a format syndicator, a station may exert more control because the music and all other program elements (especially DJ tracks) can be located (and therefore altered or eliminated as needed) at the station. The price of such control, however, is paying someone to mind the format, to handle voice tracking, and so on. For locally controlled stations, this is not a huge concern, and format syndication works well. For an automated station with a distant owner and a skeleton staff, however, the network format is a better option.

Concerts and Specials

Special music programs have long been popular with both stations and advertisers. Concerts command premium prices because they provide exclusive access to top-ranked music in a live setting. Some acts are particularly valuable because they cross over a variety of station formats (for example, from soft rock to country), making it fairly easy for some music shows to air on at least one station in most markets. Since the mid-1990s, however, only a few musical megastars have been able to attract audiences on the scale necessary to meet national production and distribution costs, and justify local stations' preempting regular programming by filling high-priced advertising time. (Access to these rare concerts and major performers remains beyond the financial reach of most local stations on an individual basis.)

Syndicators capable of recording such shows generally offer them to stations on a barter or cash-plus-barter basis at prices from $25 to $50 per hour in small markets to several hundred dollars per hour in large markets. Networks may include these music specials as part of the full-service network programming of music, news, and sports. Networks can also go into the syndication business, offering music specials on a station-by-station basis.

Advertisers will pay a premium rate for music concerts and specials, because the commercials in these shows are fixed, allowing the advertiser to target the commercials to the exact demographics of the affiliates clearing a music special. The advertiser also gets the bonus of being associated with a major musical event.

As with any other type of network program, *the key to revenue for a music special or concert series is the size of its cleared audience.* Fitting a particular concert or series of concerts to a demographic category matching a salable number of affiliates is very difficult. Most of these programs target either the youth demographic, aged roughly 18 to 34 (it may include teens), or the adult demographic, aged 25 to 54. Each group presents programming problems, and local stations can be understandably reluctant to preempt programming that they know will deliver a given audience and amount of revenue for an unknown. Stations will expect a careful fit between special programs and their regular formats. Contemporary radio listeners have many choices and are ready to push a button if the sound or voices are too staid, too serious, or otherwise perceived as "not for them."

For a network seeking musical concerts and specials, three alternative strategies exist:

- Produce many shows of varied appeal to capture fragments of the youth or adult audiences

- Concentrate on the relatively small number of stars that appeal across the broadest format spectrum

- Buy or produce programs that have unique, broad appeals

The third strategy is often the most economically efficient, although many national programmers also follow the first strategy to at least some extent. For example, countdown shows such as *American Country Countdown* with Bob Kingsley (from ABC) or *Rick Dees' Weekly Top 40* (from Premiere Radio Networks) target specific groups

who will listen to a wide variety of music over the course of the show. Countdown shows succeed best as regularly scheduled weekend features, and audiences tend to seek them out. These unique music programs tend to clear the broadest range of affiliates (*Country Countdown* airs on around 600 stations, Dees on 350), making them potentially the most profitable syndicated programs and competitive with top-rated radio sports.

Feature Syndicators

Syndicated feature programs range from daypart packages such as *Sports Shorts* or Sunday morning religious programs to brief inserts such as the 90-second *Medical Journal* or interviews with star performers (for example, *Off-the-Record* from Westwood One). Stations producing their own programming include short features to add spice and variety to a stretch of recorded songs and use the longer programming to fill unsalable or low audience time periods. Radio broadcasters may use features to attract a specific target audience during evenings or weekends, frequently subgroups of the station's overall target demographic group.

Syndicated features are as varied as their producers, which include many of the companies previously mentioned in this chapter—ABC, AMFM (www.amfm.com), Jones, Premiere (www.premrad.com), United Stations (www.unitedstations.com), and Westwood One are among the biggest. A few major market stations also syndicate their talent (for example, KLOS in Los Angeles offers morning duo Mark & Brian to stations in other markets).

One of the most important types of feature programming today is the syndicated morning show. Several successful major market morning shows have made the transition to national syndication, including Tom Joyner (Dallas, syndicated by ABC), Rick Dees (Los Angeles, syndicated by Premiere Radio Networks), and Bob & Tom (Indianapolis, syndicated by AMFM). Perhaps the best known (or most infamous) is Howard Stern, whose show originates at WXRK in New York. As with the other programming discussed in this section, a syndicated morning show can offer small and

medium market stations talent that would otherwise be far beyond their reach, albeit at a still significant cost in cash and avails. There are a wide range of styles available, from Bob & Tom's Midwestern, occasionally risqué humor to the outrageous and frequently offensive "shock jock" style of Howard Stern. As with all choices, programmers should be aware of the tastes and interests of their audience and market when selecting a syndicated morning show. All of them can point to significant ratings successes; most, including Stern, have also failed in some markets where they were on the wrong station or the market itself was not appropriate for their style.

Many companies that syndicate long-form format packages also supply short features that fit within their long formats and provide other **prep services** for local air talent (entertainment news, joke services, other short items that can be used on the air). The short features are also made available to other stations in the same market on a **format-exclusive** basis. If a feature is format-exclusive, that same short feature can be sold to more than one station in a market if their formats differ, but only one rock or one country or one talk station can license the program. This arrangement assumes nonduplicated listeners.

RADIO AND THE INTERNET

For most of the 1990s, radio paid little attention to developments in the online world. Most of the scant interest there was came from sales people who made dot.com companies one of the fastest growing categories of radio advertising toward the end of the decade. Programmers made only tentative and usually half-hearted, poorly funded forays into the new media environment. Although slow to react to the growth of the Internet, by 2000 radio stations and associated companies like Arbitron were racing each other in a furious game of catch-up, fearing that the window of opportunity to attract the new media audience might close before they developed a serious presence in that environment.

At first, even those stations that were online did little more than put up rudimentary web sites or perhaps offer the listeners the ability to email requests to the station. The majority of these were simply the product of one poorly equipped staff member at the station or done as a **tradeout** (a service or good provided in return for advertising time on the station) by the station's Internet service provider. The results generally gave listeners little reason to visit once, let alone return. Moreover, stations and listeners were often frustrated by technological problems (primarily insufficient bandwidth) that made it difficult to deliver high-quality content. Stations that delivered programming online often found that it was an expensive way to reach only a few listeners, and all too often with poor audio-quality programming. Yet, as the online world accounted for a rapidly increasing portion of the public's media consumption, it became clear that radio would have to adapt to that environment to survive. In order to not only survive, but to flourish, radio would have to offer compelling content online and be able to sell the audiences attracted to that content to advertisers.

Several online programming strategies have developed. The simplest approach, taken by many stations, networks, and syndicators, is to merely repurpose their broadcast programming by streaming it online. As more stations streamed programming (and Internet-only stations emerged), the appearance of **content aggregators** was almost inevitable given the inherently decentralized nature of the World Wide Web and the attendant difficulties in promoting programming to that diverse audience. These companies provide a centralized location for a variety of online programming services, thus making it easier for programmers and target audiences to connect in the vast universe of cyberspace. Broadcast.com, one of the earliest and most successful aggregators, developed a sizeable roster of radio stations from around the world as well as Internet-only audio services and other specialized content before it was sold to Yahoo!.

Some groups, such as CBS/Infinity, refused to webcast their stations because they saw little opportunity to generate significant revenue online

and feared further diluting their broadcast audience in an increasingly competitive marketplace. Although further fragmentation of the audience was and is a fact of life for radio as new, competing services continue to develop, several opportunities emerged to improve the online revenue picture.

For stations who simply stream their existing programming, **ad insertion technology** offered stations twice as much inventory to sell if they offer a streamed version of their broadcast programming. Stations using this technology from Real Networks (www.real.com), and other companies providing broadband services have the ability to insert different ads in the streamed programming and the broadcast programming simultaneously.

The best stations go beyond rudimentary web sites and develop very aggressive and elaborate online strategies. Their content-rich web sites include numerous features of use or interest to the audience, from playlists (the most common listener question at many stations, "What was that song I just heard," or its more frustrating variation, "What was the song you played last Thursday right after the weather forecast" can now easily be answered online) to local community information to coupons from local merchants to online-only promotions. For those who are not content to merely stream existing programming, stations can offer Internet-exclusive programming options. These online sister stations can take several forms, including subniche formats designed to superserve one or more fragments of the broadcast station's audience, or even listener-customizable audio streams. Taking a page from the publishing industry, stations have developed online classified advertising. Affiliate relationships with Internet service providers or local retailers can provide additional revenue for stations that aggressively reach out to the online audience. E-commerce opportunities (such as providing a virtual mall for local retailers) provide an additional incentive to visit the station web site by providing a valued service to both listeners and advertisers.

Radio stations have repeatedly adapted to technological change and increased competition for the audience and advertisers. The Internet is

merely the latest in a long line of challenges facing programmers searching for a big enough piece of the audience pie. In the 1990s, radio still enjoyed several advantages, most importantly portability, over early attempts to distribute programming online. New technologies and services will continue to emerge, which will minimize or negate those inherent advantages. The development of wireless Internet services and portable appliances designed to play Internet audio (some of which also receive traditional radio signals) removes the portability problem. *To maximize their audience and the value of their programming, smart programmers will leverage their existing audience goodwill and brand recognition along with the available technological tools to aggressively court the Internet audience while not forgetting the traditional (and larger) broadcast audience.*

What Lies Ahead for Radio?

At no time in the past has the future for radio seemed more uncertain. As Mike McVay pointed out in 11.2, perhaps the most important trait for a contemporary programmer is the ability to successfully and repeatedly adapt to change. Taking out the crystal ball in this environment, where even the most experienced industry veterans are uncomfortable making prognostications about three to five years down the road, is risky business.

It is probably safe to say that music will remain the main course in radio with 75 to 80 percent of the total audience share, although news/talk is now the largest single format in terms of total listening thanks to its strong appeal among the baby boom generation and older adults (see 11.1). For the FM music audience, stations targeting the baby boom generation with AC, rock, and country formats will remain the dominant players in most markets. As that audience continues to age beyond the point where they are of interest to the biggest advertisers, however, station groups will spread the formats of their stations in a market to cover a wide demographic range in order to maximize their appeal to advertisers. With the exceptions in some markets of big band, oldies, or traditional country—formats with appeal to an older audi-

ence willing to listen to AM—spoken-word formats are the present and future of AM radio (talk programming will also succeed on some FM stations). News, talk, sports, and business will be the primary alternatives for AM radio. Time-brokered programming, most commonly targeting specific ethnic or religious groups not served by other stations in the market, is another possibility for AM.

The effects of industry consolidation since 1996 can hardly be overstated. Satellite-delivered nationwide digital audio service began in 2001, and the switch to digital transmission for terrestrial broadcasters is coming. Alongside these changes, any discussion of radio's future must take into account the opportunities and challenges presented by the emergence of broadband service. The ability to broadcast over the Internet to audiences using high-speed connections via DSL, cable modem, or wireless service offers yet another potential group of competitors to existing stations and potential outlets for creative programming.

Multistation clusters within a market have fundamentally altered the strategies and economics of radio programming, along with the day-to-day nature of the work the employees of those groups perform. Owners are no longer looking for a slice of a market segment but rather to dominate one or more market demographics and to leverage that dominance into ever-greater percentages of the market's ad dollars. The radio ad market remains strong. Radio revenues are growing, both in total dollars and as a percentage of all ad spending, lending support for the strategy. Most markets are controlled by two or three ownership groups, and those that aren't yet eventually will be, although the pace of consolidation has slowed as the largest groups devoted more effort to making the previous deals pay off. Having six, seven, or eight stations in a market allows a cluster to reach nearly all of the listeners in one or more demographic or psychographic segments. The 2000 merger of AMFM and Clear Channel Communications meant that, for the first time, an individual radio owner could deliver nearly the same size audience to an advertiser as a national television network did (and better in some cases). Although revenues will

continue to grow, owners will also be looking to trim costs—thus greatly increasing earnings and pleasing the Wall Street investment community—by extending the productivity of programming and production staffs. Although there will still be stations with air talent live in the local studio, more groups will take advantage of available technologies such as ISDN and the Internet to use a single, centralized air staff to provide voice tracks in many or all dayparts for stations throughout a market cluster, a multimarket group of stations, or even stations in a multistate region.

Further exacerbating the drive for higher earnings, competitive pressures will increase as not only broadband services (which radio can actually leverage as an additional revenue source) but also Sirius and XM begin to provide a substantial challenge to broadcasters (although at a cost to consumers of about $10 a month). The two satellite DARS companies are well funded; have negotiated content agreements with a multitude of successful, experienced program providers; deliver many commercial-free services with both niche and mass market appeal; and offer a significant improvement over previous national programmers like DMX (cable audio): They are mobile. The major auto and truck manufacturers began providing receivers in their lines in 2001. In the long run, there may be some question about the ability of the market to sustain competing DARS services offering similar programming, and as with satellite TV services consolidation seems likely.

In any case, terrestrial broadcasters still retain one significant competitive advantage over the new services: localism. Local service has always been the soul of successful radio, and radio stations will best be able to fend off the challenge from satellite and broadband audio by emphasizing their local commitment, the cost differential to the audience, and (eventually) similar digital quality. However, they'll have to do it with limited local staffs and tight budgets.

This chapter touched on only the more obvious strategies involved in the fascinating art of programming a modern music station. To the uninitiated, all radio music formats may seem much the same. In actuality, each is replete with subtle and not-so-subtle variations. To program successfully in today's competitive market requires never-ending ingenuity, insight into your audience, and professional growth. The name of the game is change, but it must be accomplished by consistency in the on-air sound. Radio programming is constantly evolving, and for those who enjoy innovation, it offers a rewarding challenge.

SOURCES

Albarran, Alan B., and Gregory G. Pitts. *The Radio Broadcasting Industry*. Boston: Allyn and Bacon, 2001.

Beyond the Ratings, monthly newsletter. Laurel, MD: Arbitron Ratings Company, 1977 to date.

Billboard. Weekly trade magazine for the record industry, 1884 to date.

Duncan, James H. (ed.). *Duncan's Radio Market Guide.* Kalamazoo, MI: Duncan's American Radio, annual with supplements.

Hausman, Carl, Benoit, Philip, and O'Donnell, Lewis B. *Radio Production: Production, Programming, and Performance.* Belmont, CA: Wadsworth, 2000.

The Journal of Radio Studies, Washburn University, 1991 to date.

Keith, Michael C. *The Radio Station.* Boston, MA: Focal Press, 2000.

Lotteries & Contests: A Broadcaster's Handbook. 3rd edition. Washington, DC: National Association of Broadcasters, 1990.

Lynch, Joanna R., and Gillespie, Greg. *Process and Practice of Radio Programming.* Boston, MA: University Press of America, 1998.

MacFarland, David T. *Future Radio Programming Strategies.* Hillsdale, NJ: Lawrence Erlbaum, 1997.

Norberg, Eric G. *Radio Programming Tactics and Strategy.* Boston: Focal Press, 1996.

Radio Ink. Bi-weekly magazine for radio managers. 1998 to date.

Radio & Records. Los Angeles: Radio & Records, Inc. Weekly newspaper covering the radio and recording industries. 1973 to date. Also available online at www.rronline.com.

Radio And Internet Newsletter (RAIN). Available online at www.kurthanson.com.

RadioWeek. Washington, DC: National Association of Broadcasters. Weekly newsletter.

Warren, Steve. *Radio: The Book*. Washington, DC: National Association of Broadcasters, 1997.

INFOTRAC COLLEGE EDITION

Consult InfoTrac College Edition using the password provided with this book. Use boldfaced terms as Key Words and section headings from this chapter for Subject searches.

NOTES

1. News/Talk has a larger share of listeners nationally than any music format. It is also worth noting that this sort of ranking is cyclical. At the time of previous edition's publication, the top five formats were country, AC, news/talk, oldies/classic rock, and CHR. Spanish formats accounted for barely a 2 percent share. Five years from now, things will have changed again.

2. In the United States, the AM band runs from 520 kilohertz to 1710 kilohertz with station allocations spaced at 10 kHz intervals. The FM band runs from 88 to 108 megahertz with allocations spaced every .2 mHz beginning with 88.1 (then 88.3, 88.5, and so on through 107.9). However, interference concerns will prevent assignments of stations on adjacent frequencies within a market.

3. Radio station prices are based on multiples of cash flow. A station with a strong history and good facilities in a large market might sell for as much as 20 times cash flow. The extent of consolidation in a market, station facilities and condition, current ratings, retail sales, and advertising expenditures in the market all contribute to determination of station value.

4. Recurrents are songs that are generally less than two years old, that were big hits but are no longer on the charts, and that are still popular enough to deserve airplay. Eventually, recurrents may become gold, songs that are older hits (from more than two years in the past) that still merit airplay because of their continued popularity.

5. The gold book preceded the flip card system. The programmer listed all songs in a book, numbering the days of the month beneath each song. When a song was played, the DJ marked out the number of the day on which it was played, each DJ using a different color marker. Because a new book was used every month, at the beginning of the month listeners often heard songs that had recently been played.

6. Thirty years ago, some top 40 stations sped up their turntables (so that 45 r.p.m. records played at 47 or 48 r.p.m.) thereby increasing the tempo and energy level, and gaining enough time to squeeze in another commercial or two each hour. Digital technology now allows talk stations to speed up audio material without altering the pitch in order to create more avails in an hour.

7. *Consideration* refers to payment of some kind—including both money and extraordinary effort—to be allowed to participate in a contest.

Chapter **12**

Information Radio Programming

Joseph G. Buchman

A GUIDE TO CHAPTER 12

Is information radio primarily about *entertaining* or *educating* its audience? Some broadcast industry analysts believe *all radio is information radio*. Sound extreme? Consider that about one out of ten radio stations in the United States is programmed as full-time talk, news, or sports. Another 10 percent are programmed as religious stations offering a kind of information programming intended to educate the faithful and to create converts. Of the remaining 80 percent, many are full-time talk, news, or sports at night, during drivetime, and on the weekends. Even the most highly targeted "all music" stations provide information to their audiences—in the form of earthy philosophy or "what's hot"—fashionable, trendy, and the latest in slang among the listener's cohort group. Pure music-only stations are extremely rare, and none dominate in revenues or ratings. To succeed in the ratings, the most successful "music" stations also offer substantial news and other information especially during drivetime blocks.

Then consider that more than one-fifth of the average commercial radio station's airtime is set aside for advertising and promotion—forms of information. Even commercial-free public radio offers large blocks of news (*Morning Edition* and *All Things Considered*), comedy (Garrision Keillor's *Prairie Home Companion*) and talk (*Car Talk*) as well as an ever-increasing number of enhanced underwriting announcements.

The on-air signal is only part of a radio station's business strategy in this new century, however. Most radio stations offer extensive web sites packed with information about their music offerings, local news, weather radar, live audio streaming, personality biographies, and the like. Some stations and many syndicated talk programs publish monthly newsletters targeted to their core audiences. Other hosts have authored books (such as Howard Stern's *Private Parts*, Rush Limbaugh's *The Way Things Ought to Be*, Paul Harvey's *For What It's Worth*, and Laura Schlessinger's *Parenthood by Proxy: Don't Have Them if You Won't Raise Them*).

INFORMATION VERSUS ENTERTAINMENT RADIO

For many media consultants all radio is seen as providing a form of *information*, on the other hand, other industry analysts and consultants see *all radio* as *entertainment* radio. Even news programming, these analysts suggest, can only dominate in ratings and revenue when it is programmed as a form of audio entertainment. Understanding this perspective is the key to insight into how the best news, talk, and sports programmers achieved unprecedented ratings and revenue success in the past decades. The most successful news/talk/sports programmers require their air talent to remain focused on the entertainment value of their presentations.[1] Radio history is full of examples of spoken-word radio personalities who took themselves too seriously, abandoned their focus on the *entertainment* value of their presentations, and suffered irreversible revenue and ratings decline.

At a recent radio industry conference, a panel of news/talk programmers clearly explicated the entertainment value of their programming. One programmer summed it up this way, "All highly rated radio is, first, entertaining and in radio there're only two ways to entertain an ear—with spoken words [as in] news/talk or with music. When we got our staff to realize their spoken words had to be as entertaining as the music down the street, or the movie on HBO, we started to have success."[2]

The most successful information radio programmers do not focus on the information their stations provide; they focus on the entertainment value they deliver. They see their competition as far more than just the other radio stations in their markets. They program their stations to compete against all other forms of entertainment, including television, movies, local concerts, sporting events, outdoor recreation, and so on. These programmers view all radio (really all media) as vehicles for entertainment and nothing more. They have learned from experience that unless talk, sports, and even

news *entertains* its audience, ratings and revenue success will be elusive at best.

One personality who suffered from this lack of focus on the entertainment value of her show was Dr. Laura Schlessinger. Her increasingly strident antihomosexual rhetoric resulted in censure in 2000 by the Canadian Broadcast Standards Council, a loss of several key U.S. affiliates, and the loss of several national advertisers, including Procter & Gamble, which withdrew support from her proposed television show.

In 1980, only 75 radio stations in the USA offered full-time talk or news programming. By 1985, that number had grown by only 25, to 100. By 2000, more than 1,300 full-time talk radio stations were in operation—an increase of more than 1,500 percent in only 20 years. An analysis of market dominance reveals *those stations with the highest ratings and revenue shares employ a combination of spoken-word and music programming.* Music stations use talk to build interest, just as talk/news/sports stations use music to enhance their spoken-word delivery. Because much or all of information radio is delivered as a form of entertainment, and much or all of music radio can be seen as a form of information, there's no clear-cut line of distinction between information radio and entertainment radio formats. Talk formats incorporate music; music formats incorporate talk. From information radio to entertainment radio is not an interval or a dichotomy; it is a continuous scale with most successful stations nearer the middle than either of the ends.

Identifiable Personalities

Among dominant spoken-word formats, the talk is almost always live, delivered by **identifiable personalities,** and peppered with music. Many "talk" shows offer not only musical bumpers going into and coming out of commercial breaks, but also full-length cuts of popular songs or custom-produced musical parodies. The one common element of success for both spoken-word radio and music radio is the identifiability of its personalities.

There are two primary reasons for the importance of having easily recognized personalities in radio, especially spoken-word radio. First, research has repeatedly shown that the most loyal radio listeners seek feelings of pseudofriendship or imagined personal relationships with media personalities. These relationships are evidenced by unexpectedly intense emotional love/hate reactions to talk hosts such as Howard Stern, Rush Limbaugh, Laura Schlessinger, G. Gordon Liddy, Dr. Joy Brown, Bob & Tom, Rollye James, and Phil Hendrie. *An emotional connection, whether expressed in positive or negative emotional valences, has been shown to be absolutely necessary for sustained listener involvement and long-term ratings and revenue success.*

The second reason for the importance of identifiable personalities in today's radio environment comes from the way ratings information is collected. In most metropolitan areas, the call letters, formats, and even the total number of available stations changes constantly. Most radio listeners are unaware of the call letters of a station, its slogan, or its dial position even when they listen regularly. Research by Arbitron shows that diary-keepers often mistake one station's promotional slogan or call letters for another's, just as battery purchasers often mistake the bunny that never stops for Duracell. (The bunny is the icon for the Eveready Battery Company.) The only method that gets station listening recorded accurately is by having extremely identifiable personalities. While diary-keepers may confuse KXXX 96.3's more music format with KYYY 100.7's classic hits, it's hard to imagine they would think they were listening to Howard Stern when it was really Dr. Joy.

AM Radio's Perceived Limits

Prior to the introduction of television and FM radio in the late 1940s, all radio was AM, and almost all of that was spoken-word driven. News, soap operas, prime-time radio drama, science fiction, and mystery dominated the air. By the late 1950s, many AM stations were bankrupted as listeners migrated to television. Those few FM stations that were on the air tended to serve university

communities, public schools, or charitable organizations, but the combination of Top-40 program formats and the introduction of rock and roll drove audiences back to their old AM radios, especially during daytime hours. The AM technical standards, however, which had been developed in the 1920s, were very limiting for music. FM was waiting to capture AM's music audiences, and only the slowness of the introduction of FM radio receivers, especially into cars, allowed AM music stations to thrive in the 1960s and early 1970s.

AM stations are limited in practice to about 8,000 hertz of dynamic range. This is sufficient for spoken words as the limits of the deepest- to the highest-pitched human voice fall easily within that range. But the human ear has a dynamic range of about two and a half times that amount, or up to 20,000 hertz. Because that's what the human ear can hear, that's also what musical instruments can produce. Nothing inherent in the technology of AM (Amplitude Modulation) or FM (Frequency Modulation) makes one or the other better for music. The uneven limitations or advantages of AM and FM are simply a result of decisions made by regulators more than 60 years ago. Some hope that new proposals for a single digital radio band will level the playing field for all stations within the next decade.

FM does have the advantage of not being affected by natural interference from lightning, or humanmade interference from car engines, electric motors, and the like. Early regulators also authorized more dynamic range to FM (about twice that of AM) and later authorized a system for FM stereo. (AM stereo standards came far too late to help music-formatted AM stations.)

Even more important than the technical differences are the *perceptions* of radio audiences. *The first rule of marketing any product or service is that the customer's perception of reality is all that matters*. If the customer thinks the shirt is whiter, the color is brighter, the taste is richer, the smell is fresher, the fabric is softer, or the *sound is better*—then, for that customer, it is.

By the late 1970s, radio listeners, especially younger listeners, perceived FM stations as superior, as part of their new generation. AM was old, haggard, poor quality—a leftover from an older generation. By the mid-1980s, these listener perceptions were so entrenched that no AM stations could attract a viable audience with music programming alone.

Nonetheless, the playing field between AM and FM stations was still relatively level for spoken-word programming. The result of AM's dilemma was the emergence of information radio, which falls into three major categories: all-news, news/talk, and sports/talk. Few stations can be placed entirely within one of these categories. For example, a station that is predominantly all news may program a few talk shows, particularly on weekends. Similarly, a sports/talk station may also carry such syndicated programming as *The Rush Limbaugh Show* as part of its regular programming.

NEWS PROGRAMMING

Radio did not become a primary source for news coverage until World War II when the technology of radio was still relatively new to many households. Although Edward R. Murrow, William Shirer, and the other great war correspondents offered listeners the sounds of battle and bombing, most radio newscasts devoted far more time to commentary than to actual reporting—a tradition that continues to this day. From Walter Winchell to Paul Harvey, from Heywood Hale Broun to Howard Cosell, radio generated instantly recognizable voices that captured the nation's imagination. Don Imus, Howard Stern, Rollye James, and Rush Limbaugh are not so different from their predecessors, except in two ways: They go on at far greater length, and they make no claim to be journalists. Over time on many stations news became more about promotion than about real news. Newscasters began to focus on "human interest" stories at the expense of hard news.

Human Interest as "News"

Human interest in radio news is often expressed in station advertising and on-air promotion slogans as "news you can use." This means putting a local angle into every story. Only those newscast stories that have a simple, clear internal answer to the question, How does this affect our target listeners? are to be aired. The highest-rated radio news stations emphasize "news" about motion picture celebrities, television stars, famous athletes, listener victimization, local tragedies, and sex scandals (with increased permission for these sorts of stories created by the hard-news gloss of the Lewinsky/Clinton sex scandal). The presence of an "exemplar," a human affected by the news story, greatly enhances listener recall about the story. For these reasons, stories about international relations, macroeconomic policy, scientific discovery—news that cannot easily be put directly into a human context—is seldom covered. This trend toward human interest coverage in radio news can be seen as early as 1953 in the *Programming Policy* book of the Trinity Broadcasting Company (see 12.1).

12.1 1953 GUIDELINES ON DOING THE NEWS INTERESTINGLY

A lot of stories . . . just disinterest, bore, and/or confuse listeners. These stories are in the following categories, by and large:

> Repatriation commission hearings
> Central European political developments
> The day's activity . . . at the UN.
> Localized Korean fighting . . .

"These are, roughly, the type of stories that will in short order kill any newscast . . . (Instead) find stories of human interest like this . . .

Marilyn Monroe denies she is marrying Christine Jorgensen . . .

Play down all confusing or uninteresting stories —stories without human interest.

Source: *Trinity Programming Policy Book,* as reproduced in David R. MacFarland, *The Development of the Top 40 Radio Format,* Arno Press, New York, NY, 1970.

Newscasters as Entertainers

Increasingly, radio news is not delivered as a separate program element, but seamlessly integrated into the entertainment presentation by the local DJ or talk-show host. A talk programmer put it this way, "All of our shows have some news content. Liddy will sit there and read newspaper articles for 45 minutes . . . our listeners get informed from . . . hearing Stern and Liddy talk about the news."[3] In essence, AM radio is following the model of cable television. Unlike the days of broadcast-only television, when every network had a news department, television viewers today do not expect to see news on The Discovery Channel, TV Land, or UPN, and today's radio audience doesn't expect news to be delivered by every radio station. Unlike the 1960s, when a few AM program directors decided the mix of news, music, sports, and talk for networks of thousands of stations, in the current radio environment, listeners become their own program directors, choosing their own unique mix by switching stations.

The Demise of Network-Delivered Newscasts

Most large-market stations are now so tightly formatted that they want a newscast more tailored to their format than any network can provide. In response, radio networks have become less newscast delivery services and more sources of original sound bites. Stations then use the network sound bites to craft their own custom newscasts. Increasingly, network news material is not delivered by a local anchor or as part of a traditional newscast, but by a sidekick to the station's drivetime personality. One model for the newscaster as sidekick is Robin Quivers who began as a newscaster but who now is, in effect, one of the team of co-hosts of *The Howard Stern Show.* Using members of the

whacked-out morning team as "newscasters" may make traditional journalists shudder, but the practice has increased program consistency, reduced audience turnover, and resulted in increased ratings. As local stations have modeled their formats after Stern/Quivers or Imus/McCord, such entertainment environments have become the primary sources for local and national radio news. Ironically, what were once the great radio network news departments assist by passing along sound bites of everything from presidential addresses to Hollywood stars pushing their latest productions.

Randall Bloomquist, program director of WBT-Charlotte puts it this way: "My audience doesn't want NPR-style news . . . they want the stories to be about their lives. Our listeners don't care that another 19-year-old drug dealer has been shot. The place where that happens might as well be in another dimension. But if the city is holding a hearing on putting more retail into a development where our listeners live, we'll carry that hearing live. News is what happens where our listeners live, not some shooting in Shitsville."[4] When actual breaking news events do occur (such as the Gulf War, the O. J. Simpson chase, or the Clinton impeachment trial), radio stations increasingly rely on the audio portion of television newscasts, rather than on radio networks.

In smaller markets and on less successful stations in larger markets, network newscasts can still be heard in their entirety. Because these stations have much smaller audience sizes, the radio networks could not survive financially if these were the only audiences the radio network advertisers could reach. Network affiliation contracts require stations that choose not to carry the newscasts in full to at least broadcast the commercials that were included within the newscast. Stations receive private feeds of the commercials from the networks for local recording and insertion into local programs. They also receive schedule information from the network. They must then schedule the network's commercials in time periods equivalent to when they would have aired in the newscasts. After these replacement commercials air, station personnel produce affidavits for the

networks affirming the times and dates the network spots ran.

Music in Spoken-Word Formats

The most successful radio news, talk, and sports shows incorporate music into almost every element of their formats. Most play extended **bumper music** (lead-in bars), sometimes even entire songs, going into, coming out of, or even in the middle of news and commercial breaks. Other talk-oriented shows present custom-produced musical parodies of popular music with political, social, or cultural/current event-inspired lyrics. Rush Limbaugh, Howard Stern, Phil Hendrie, and others have even marketed CDs and tapes of music aired on their "talk" shows.

If the evolution of music television is an accurate model for the future of music-based radio, audiences can expect more spoken-word/information programming on what have traditionally been music-based stations. MTV and VH1, for example, have enjoyed their greatest ratings success in recent years following an emphasis on biographies, game shows, and music-related news. Some traditional album-oriented rock (AOR) and other youth-formatted stations in top-ranked metro areas are programming sex advice, sports talk, and radio trivia shows (audio versions of *Who Wants to Be a Millionaire?*).

THE RISE OF THE SPOKEN WORD

Aside from the social/cultural influences that have contributed to an interest in spoken-word radio, several technological, economic, and policy changes have also played a role. The six key factors are summarized in 12.2.

Cost Decline

It is doubtful that the shows of Rush, Dr. Joy Brown, Bruce Williams, or others would be available today without the dramatic drop in the cost of distributing broadcast quality audio over long

Because of this, few station owners were willing to take the risk of programming anything more controversial than the blandest kinds of talk. Rather than risk complaints at renewal time, it was easier to avoid all controversy.

At the height of deregulation, under the Reagan administration, the Fairness Doctrine was abandoned by the FCC. The Fairness Doctrine was merely an FCC policy that had not been written into law, so the FCC could simply decide to drop it. Although many members of Congress and some lobbyists fought to write the Fairness Doctrine into law, each of three subsequent attempts ended in failure. After several years, it became clear that the Fairness Doctrine was not likely to return. Subsequently, broadcasters felt increasingly free to engage in even the most outrageous forms of talk programming.

By the early 1990s, it was clear that radio talk hosts had more freedom to advocate one view of controversial issues and ridicule opposing points of view than ever before allowed. Show hosts could take one side of an issue and demean opposing perspectives, often with tremendous success in audience ratings. Audience ratings showed that such talk was much more interesting than talk that tried to be fair or equal to both sides. Despite complaints of extremism, the FCC decided to rely on the marketplace to provide fairness. In theory, if one station took one side of an issue, other stations in the market would program opposing views to attract the disaffected audience. *Overall fairness would be found across the dial, rather than forced on each individual station* as had been the case before. Time will tell whether this policy of relying on marketplace forces to ensure overall fairness across stations will work in practice.

12.2 FACTORS IN THE RISE OF TALK RADIO

1. Decline in distribution cost due to satellite technology
2. Governmental repeal of the Fairness Doctrine in 1987
3. Cultural/societal freedom to discuss formerly taboo topics
4. Cellular phones
5. Migration of music-oriented audiences to FM
6. Attractiveness of spoken-word environment to advertisers (commercials seen as an interruption to music formats, but as a continuation of information radio programming)

distances that occurred in the early 1980s. Prior to that time, radio network operators were forced to pay premium fees to the telephone monopoly for land-based distribution. This created the "chicken and egg" question common to most new technologies: Which will come first, the hardware or software? Automobiles or roads to drive them on? Nationally distributed radio personalities or the expensive distribution system? By the mid-1980s, thanks to the much lower costs of satellite distribution, national syndication of unproven programming, such as the midday talk show offered by Rush Limbaugh, was for the first time economically feasible.

The Abandonment of the Fairness Doctrine

Prior to 1987, the FCC's Fairness Doctrine required radio stations to cover all sides of controversial public issues equally. In application, this severely limited the topics aired on talk radio as station owners feared lawsuits or complaints at license renewal time by those who felt they were treated "unequally." Often both sides of a controversial issue would claim less than equal treatment.

Embracing Formerly Taboo Topics

Although the elimination of the Fairness Doctrine removed most government-imposed restrictions on the nature of talk programming, several social/cultural events in the 1990s appeared to give the public's permission to broadcasters to push the

lines of what is considered acceptable on radio to the breaking point. Talk topics considered taboo in even the most prurient venues a few years ago are now considered mainstream radio programming. What had been confined to the seamier sections of porn magazines, Internet chat rooms, and X-rated movies, was by the late 1990s suddenly fair game. Media frenzies such as the O. J. Simpson trial, Jon Benet Ramsey murder, and Clinton impeachment hearings encouraged on-air listener venting of reactions to topics as intense as murder, sexual child abuse, and oral sex. Perhaps Edward R. Murrow would have found a way to avoid discussion of the most grisly details of a double homicide or the relevance to his impeachment of presidential semen on an intern's dress, but his journalistic descendants certainly showed no hesitation. Once such topics became mainstream news, not much, if anything, was left as taboo for even the most polite social discussion.

Mobile Phones

Just as talk was becoming more interesting on radio, a new technology emerged to allow easier participation by listeners. *The highest level of radio listening occurs in morning and afternoon drive, difficult times to conduct talk programming prior to the introduction of cell phones.* By the 1990s, the ability of broadcasters to offer free cell phone calls to the station's talk numbers (in return for running advertising for the cellular service), made easy participation by listeners possible at any time of day. Research showed that listeners were more likely to continue listening when they had the ability to call in, even if they were unlikely to actually call.

Migration to FM

When the Fairness Doctrine was abandoned and cell phone and satellite technology emerged, many AM stations faced financial pressures unseen since the advent of television. In the largest markets, audiences began abandoning AM stations for FM stations in the early 1970s. By the late 1980s, it was clear no all-music format could survive on the AM band. Those music formats that proved successful on an AM station were quickly duplicated by FM competitors. *When AM and FM stations offer similar music programming, the bulk of the audience will choose to listen to the FM stations,* leaving the AM station struggling for advertisers and revenue.

By the mid-1980s, with a nothing-left-to-lose philosophy, AM stations, even in large markets, were willing to gamble on unknown syndicated talk personalities. These visionary talk syndicators initially offered the programming for free (in exchange for carrying the commercials), and local AM station owners were able to cut the expense of paying a local personality. Although almost no one in the industry believed daytime talk programming on AM could succeed, much less draw back audiences from FM, there really were no other viable programming options.

Synergistic Advertising Environment

Spoken-word radio provides an environment uniquely attractive for radio advertisers. Music stations, especially those that promote a "more music, less talk" format, in effect, invite their listeners to tune out during commercials. On a spoken word formatted station, commercials are less of an interruption. A higher percentage of listeners stay tuned during the commercial breaks, and some research indicates they are more attentive to the commercial messages. Thus, given equally sized audiences on both a talk and a music station, advertisers are willing to pay a higher price to place their commercials on the news/talk/sports station —because more of the listeners will stay tuned during the commercial breaks.

TALK FORMATS

In the fall of 2000, when all spoken-word formats were summed, news/talk radio reached a 20 share of national radio listening, a full seven share points above the next most-listened-to format. Music format station shares declined, including

12.3 TOP TEN SPOKEN-WORD RADIO FORMATS

1. **Heritage Talk** Traditional news/talk formats, mostly on AM band. Broad appeal with mix of news, sports, talk, health, and financial features

2. **Sports Talk** Making a transition to "guy talk." Usually has contracts with major league football, baseball, basketball, and hockey

3. **Hot Talk** Younger demographic appeal, is sexually oriented, and usually found on FM stations, often with Howard Stern

4. **Success Radio** Formerly Money Talk or Business Radio. A mix of investment and personal advice for financial success. May include upscale travel, recreation, and relaxation talk

5. **Urban Talk** or Black talk. Tends to be in urban areas, similar to Heritage Talk but with Black/African American appeal

6. **Faith Talk** or "religious radio." Formerly exclusively Christian, but now characterized by a growing multitude of faiths

7. **All News** Is like CNN Headline News, local weather and traffic. High repetition. No long-form programming or play-by-play sports

8. **Foreign Language Talk** Primarily Spanish. One of the fastest growing formats in medium-sized markets

9. **Public Radio** Primarily delivered by NPR

10. **Internet Talk** Initially limited to audio discussion of web-based issues, is likely to broaden topics with time

drops for country, Top 40, classic rock, and R&B. An important exception to the decline in music format ratings was among Spanish-language stations. With more than one-fifth of national radio listening, it is clear that there is more appeal to talk radio than can be found in any single talk/news format. Moreover, the number and type of talk radio shows continue to change. Traditional talk has fragmented to include hot talk, advice talk, business, sports, success talk, and other niche formats. All variations of talk radio are different in approach, sound, and "attitude." Most consultants now identify at least ten different spoken-word entertainment formats, which appear in 12.3.

Heritage Talk

Heritage talk stations typically are 50,000 watt clear channel stations that have included at least some talk programming for 40 years or more (see 12.4). Twenty years ago, these were classified as full-service stations with a mix of news, talk, sports, and midday music. Increasingly these stations have moved to an all-spoken-word format with emphasis on local news, weather, traffic, sports, and local talk. They are also able to attract the highest rated of the nationally syndicated talk programming. These stations typically carry heavy commercial loads, often up to 20 minutes an hour.

Sports/Guy Talk

Sports/guy radio is a rising star in spoken-word radio. Just a few years ago, only a handful of stations dedicated their formats to sports programming. Today, more than 100 commercial sports/talk stations are on the air, with some major markets supporting two sports/talk stations. The vast majority of these stations are AM, but a few FM sports/talk stations exist as well. Some of the leading stations in this genre include WFAN-AM, New York, WMVP-AM, Chicago, and WIP-AM, Philadelphia.

The growth of sports/talk has been fueled not only by the overall success of information formats, but by the format's success in drawing men in the 25 to 54 or 18 to 34 age groups, demographics much sought after by advertisers. Another factor

12.4 · HERITAGE NEWS AND TALK

In the mid-1960s, the foundation for all-news radio was laid by two major broadcasting groups. The first was Group W, the Westinghouse Broadcasting Company, which converted three AM stations—WINS (New York) and KYW (Philadelphia) in 1965, and KFWB (Los Angeles) in 1968—to an all-news format. CBS followed suit with several of its owned-and-operated AM stations, first at WCBS (New York), KCBS (San Francisco), and KNX (Los Angeles), and later at WBBM (Chicago), WEEI (Boston), and finally WCAU (Philadelphia).

By the mid-1990s, hundreds of stations, mostly AM, were identifying themselves as all-news or news/talk stations, and the format was spreading beyond major cities into smaller markets. Although the all-news format is dependent on local programming, network affiliation provides coverage most local stations cannot supply. In addition, a growing number of syndicators are supplying both affiliated and nonaffiliated stations with news services and programs.

The term *talk station* was generally adopted when KABC in Los Angeles and a few other major-market stations discarded their music formats around 1960 and began airing information programming featuring the human voice. KABC started with a key four-hour news and conversation program, *News/Talk*, from 5 to 9 A.M. KGO in San Francisco later adopted the name of that program to describe its overall format. KGO used news blocks in both morning and evening drivetime and conversation programs throughout the balance of the day. KABC focused on live call-in programs, interviews, and feature material combined with informal and formal news coverage. KABC first promoted itself as "The Conversation Station," but *news/talk* stuck as the generic industry term for stations that program conversation leavened with news during drivetimes.

in sports/talk's success is its use of a growing number of ex-athletes as hosts, including such former stars as Pete Rose and Tom Seaver.

Stations programming a sports/guy talk format usually feature a variety of programs. Of course, play-by-play coverage of games is an important element, but other popular sports/talk staples include scoreboard shows, interview shows, and talk programs with a sports slant. Sports programmers agree that a successful sports/talk station is more than just the games. What makes the format work is a combination of the games and celebration of the lifestyle that goes with it. Just like the fun of a football game is far more than just in going to the game. The game becomes an excuse for a day-long or weekend-long party with tailgating, road trips, and barbecuing. In sports radio, it is the lifestyle of the sports fans on the air that really makes this format work. The broadcast of the games serves as the catalyst for the overall format of guy talk.

Although most sports/talk stations create some of their own programming, a growing number of syndicated programs help them fill the broadcast day. This is particularly important to smaller market stations, which do not have the resources to produce a great deal of original programming or hire high-profile hosts.

Hot Talk

AM talk shows tend to focus on politics, welfare reform, and gun control, while FM talk shows often explore topics such as sexual conquest, drug use, and other "indecorous" subjects. Many FM talk programmers feel FM spoken-word entertainment listeners are looking for a "rock and roll" attitude without the music. It will come as no surprise that Howard Stern is one of the most successful hosts of talk radio with a "rock and roll" attitude (see 12.5).

12.5 THE KING OF ALL MEDIA

In a career that in some respects closely parallels that of Rush Limbaugh, shock jock Howard Stern has become a powerful voice in information radio. Beginning with a morning drivetime program in New York, *The Howard Stern Show* found success in major markets across the country. Like Limbaugh, Stern's radio success led to two best-selling books and a television program (on the E! Entertainment cable network). Stern has also hosted successful pay-per-view cable specials and appeared in a film based on his first book, *Private Parts*.

The road to success has not always been smooth for the self-proclaimed "King of All Media." In 1995, Stern's employer, Infinity Broadcasting, agreed to pay the FCC fines totaling nearly $1.7 million for alleged violations of the Commission's indecency standards. Despite this controversial action by the FCC, Stern's popularity continues unabated—his program wins the crucial morning drivetime slot in many markets in which he is heard, while advertisers pay top dollar to be heard during the program. Although the subject matter of Stern's program may be of questionable taste, he is an undisputed money-maker for some stations on which he appears.

In Los Angeles on Friday afternoons in the late 1990s, car headlights were often seen blinking on and off like the landing lights at LAX. In the last hour of the last day of each work week, FM talk host Tom Leykis of KLSX ritually asks his male listeners to flash their headlights as a signal to female listeners in other cars to flash their breasts. Financial pressures to pay off mountains of debt from radio consolidation has pushed new owners to find new ways to increase revenues. Aside from the increased audience size bawdy talk attracts, it also allows for an additional six or seven minutes of commercials over what could be successfully programmed on all-music formats.

Most FM spoken-word entertainment programming is targeted toward younger listeners, especially younger males. One general manager described the ideal FM spoken-word listener as "male, professional, 33, two kids, political, growing out of rock 'n' roll."[5] According to Tom Leykis, for a talk show to attract this ideal listener, it must focus more on personal relationships than on conventional chat-radio topics like politics or the economy. And that approach leads to a voyeuristic prodding into the sex lives of the listeners. Whether the content is a male listener describing his sexual conquest of the night before, or a female relating her conflicted feelings about sharing the details of a sexual affair she had with one of her bridesmaids with her husband, such talk tends to repel older people while attracting those who thought they were "music-only" listeners.

Syndicated Talk

While television offers greater visibility, and motion pictures greater stardom, radio remains a gold mine for the talented entertainer. By mining daytime AM radio, which many considered a dead medium, Rush Limbaugh amassed a financial fortune both personally and for those stations wise enough or lucky enough to carry his show from its launch. By 2000, Limbaugh was making more than $22 million a year. In 1997, Laura Schlessinger sold her daytime, mostly AM station show, to the Premiere Radio Networks for more than $71 million. And advertisers are willing to pay the freight. A one-minute spot on the Limbaugh show, which cost $3,200 in 1993, was up to $14,000 in 2000.

It is possible that high-dollar national syndication deals for superstars will leave talented newcomers no place to develop their skills on local radio. Michael Harrison, publisher of *Talkers* magazine said, "It's really sad that so much money will go to the superstars and so little to the new talent."[6]

Many industry analysts are now beginning to feel radio has entered a second Golden Age. The first was during and shortly after World War II in the 1940s. The second Golden Age may just be getting underway. Radio revenues overall climbed

steadily through the last decade of the twentieth century but exploded for syndication services. United Stations Radio Networks president and CEO Nick Verbitsky says, "In more than 30 years in this business I've never seen anything as good as today's [syndication market]. Advertiser appetite is strong because they know syndicated radio does things efficiently . . . we produce things that they could never afford to do for themselves locally."[7]

The growth of syndicated radio in the 1990s has blurred what was once a clear line of distinction between traditional network radio and syndicators. According to some syndicators, there is *no* difference. When a single personality such as Rush Limbaugh or Dr. Joy has hundreds of stations as affiliates, that's very much a network regardless of what it is called.

In the 1980s, the established networks returned to long-form entertainment programming—most notably talk shows. ABC's Talkradio, Mutual's *The Larry King Show,* and NBC's TalkNet combined overnight long-form talk and interview programs. Recent years have seen an explosion in the popularity of talk shows, and syndicated talk programming, in particular, has been especially hot throughout the 1990s. In fact, many smaller market station owners credit *The Rush Limbaugh Show* alone with making the difference between profitability and bankruptcy.

In 1988, *The Rush Limbaugh Show* debuted on 56 stations in the United States. By 2000, Limbaugh was carried on more than 650 stations, most of them AM. There is evidence that Limbaugh has brought new listeners to the AM band, helping many stations in smaller markets to remain profitable and on the air. Limbaugh positioned himself as the voice of the conservative right and helped to propel talk radio into the center of American politics during the 1990s (see 12.6).

Talk Listeners

Many industry observers have noted the relationship between the age of the target market for talk radio and that demographic's history of social activism. Michael Packer, a Detroit-based consult-

12.6 THE RISE OF RUSH

After a relatively nondescript career including various jobs as a radio personality and a stint in the advertising office of the Kansas City Royals' baseball team, Rush Limbaugh found his voice as the host of his own syndicated program. Beginning in 1988, and buoyed by Limbaugh's considerable skills in promotion, *The Rush Limbaugh Show,* with its decidedly conservative political stance, quickly found an audience at stations across America. Limbaugh's devoted listeners call themselves "dittoheads," ditto being shorthand for the praise that initially began each caller's remarks.

Limbaugh's radio success has spread to other media. By the mid-1990s, the radio host was the author of two best-selling books and the host of a syndicated television program. He also produces a newsletter and occasionally pops up on such television programs as ABC's *Nightline* and NBC's *Meet the Press.* While Limbaugh often takes a provocative view of the issues of the day—as with his notable quote, "The most beautiful thing about a tree is what you do with it when you chop it down" —he is firmly entrenched in American popular culture and widely imitated.

ant, cites the aging of the baby boom as the key to the success of talk radio: As the baby boom generation rediscovered its power to protest, high-tech style, instead of marching in the streets, they picked up their phones and called talk radio stations. They rediscovered the power of free speech through talk radio. A profile of common characteristics of talk listeners appears in 12.7.

Some talk shows have somewhat skewed demographic appeals. For example, Howard Stern and many sports talk, or guy talk hosts, have a higher percentage of young males listeners. Also breaking news events and prolonged national scandals such as the O. J. Simpson trial or Monica Lewinsky/Bill Clinton tryst have been shown to dramatically

increase the short-term ratings of news/talk stations. Other talk programming may be characterized by seasonal trends. Sports talk programming typically has higher numbers in the fall ratings especially among those stations carrying baseball's World Series and the National Football League.

THE CONTENT INFRASTRUCTURE

Most information radio formats are constructed to showcase different types of content during different dayparts. Heritage Talk stations, for example, schedule a heavy load of news during the morning drivetime daypart (from 5 to 9 A.M. or 6 to 10 A.M.) and again during afternoon drivetime (from about 4 to 6 P.M. depending on the market). The rest of the program day is devoted to various kinds of talk programs, often including some type of sports programming. Although play-by-play coverage is important to sports/talk stations, talk programs abound in their schedules, along with newscasts, although these are heavily dosed with sports news and game scores.

All-news stations air continuous newscasts, usually in 20- or 30-minute segments, for 24 hours each day. An example is WBBM-AM (Chicago), whose slogan is, "Give us 20 minutes, and we'll give you the world." Some all-news stations, however, break away from their news cycles to carry live sports, interview programs, or overnight talk programs.

Although news and talk stations are often seen as similar because their spoken-word formats are so distinct from music stations, they are in fact very different from one another. All-news formats, because they repeat news cycles over and over, tend to attract listeners for short periods of time, just long enough to hear one or two of the cycles. Talk-oriented formats develop very loyal listeners who often stay with the station for long periods of time (many hours to all day).

Because the appetite for news and such surveillance features as traffic and weather is greatest in the morning, all-news station listenership is typically largest during morning drive. Because listeners to all-news formats typically listen for short periods, all-news stations have short **time spent listening (TSL)** and must constantly recruit new listeners to replace those who tune out. Talk stations, however, do a better job of holding listeners through midday and evening hours.

These audience flow characteristics affect how various spoken-word formats are sold to advertisers and promoted to both current and potential listeners. All-news is a *high cume, low TSL* format: It depends on high cume ratings to counteract low average-quarter-hour numbers. Because of this, the locally produced all-news format is usually limited to larger markets, those with enough overall radio listenership to generate the needed constant audience flow to the station. To reach this station's audiences, advertisers, programmers, and station promotion executives must schedule sufficient spots, program elements, and promos to reach the constantly changing audience. While station managers and air talent will get "sick of hearing the same thing over and over and over," the typical listener, who tunes in for perhaps 20 minutes a day, will just begin to be sufficiently exposed to create recall. Research in this area is called **effective frequency.** *For a promo, advertisement, or program element to reach the average listener, it must be scheduled 7 to 10 times the station's audience turnover.* For an all news station, audience turnover can be as high as 40 times per day or more.

The all-news programmer oversees the equivalent of a single program airing 24 hours a day, whereas news/talk and sports/talk programmers deal with diverse blocks of programming lasting

from one to four hours. The talk programmer must also consider the gratifications desired by various kinds of talk listeners. Some are attracted by the personality of the hosts, such as Howard Stern, Laura Schlessinger, or Rush Limbaugh. Others use talk radio primarily as a way to gather information. Still others listen to hear viewpoints that differ from their own.

The programming infrastructure, usually created on a computer, forms the skeleton on which hang the sections of hard news, features, talk programs, game coverage, sports commentaries, editorials, and so on. At all-news stations, newscasts are repeated in 20-, 30-, 45-, or 60-minute sequences, although most stations prefer the shorter 20-minute cycles. Cycle length affects spot and headline placement, time, traffic, weather, and sports scheduling, major news story development, and feature scheduling. Advantages and disadvantages are inherent in all lengths; which cycle a programmer chooses depends on local market conditioning to the format, staff capability, editorial supervision, and program content.

Typically, each hour on an information station contains 12 to 18 minutes of spot announcements programmed in 8 to 18 commercial breaks. Spoken-word formats will accept a larger commercial load than music stations because the spots are less intrusive than on music stations. *Long-form talk programming typically has fewer breaks per hour, with more spots within the break.* All-news stations, especially those with frequent news and traffic updates, may run as few as one or two spots in breaks coming every 5 minutes or less.

News Scheduling Priorities

Because the programming of all-news stations is based on repeating cycles, scheduling considerations tend to be tighter than for talk stations. On the average, news occupies about 75 percent of airtime on an all-news station. The basic elements at an all-news station include:

- Hard news copy
- Recapitulations of major stories (recaps)

- Question-and-answer material from outside reporters
- Results of public opinion polls
- Telephone (actualities)

Earthshaking news developments on a global or national scale are not necessarily uppermost in the audience's notion of what is news. During morning drivetime, weather and traffic reports should be emphasized as they will determine how listeners start their day. A typical urban schedule runs in this way: Time announcements at least every 2 minutes; weather information (of the moment and forecast) no more than 10 minutes apart; traffic information every 10 minutes; plus, interspersed, allied information such as school closings, major area sports events, and so on. In other words, the top priority in any all-news format is local, **personal service programming.** Item repetition slows during the midday, as average listener TSL increases, and is stepped up during evening drivetime (4 to 7 P.M.). Predictability is important in news programming, because the audience will get used to coming to the station at specific times for program elements such as time, weather, and sports. Effective news management means carefully watched story placement, creative rewriting of leads, and precisely calculated lifespan for individual stories.

The important question is, how much soft (as opposed to hard, fast-breaking news) material is available? When? How often? What kind? Most soft material based on an audience's natural interest in medical and health information, the entertainment industry, or leisure time material attracts listeners. Local audiences vary, of course, in what they need and will accept. The balance between entertaining the overall audience, increasing TSL, and serving listeners seeking fast credible news is a bit like trying to run a McDonald's and a three-hour fine-dining experience out of the same kitchen.

News Headlines

Headlines are an important element in attracting listeners to a news segment. Normally programmed

at the top of the hour and at the half hour, headline presentation style and substance must be determined carefully.

Time and Traffic

Once the spots and headlines are set, personal service elements such as time, traffic, weather, and sports can be keyed in. Time and traffic announcements gain in importance during certain dayparts, especially morning drivetime. Determining length is a pivotal decision, as is frequency. And when time lags occur between on-site observation and actual broadcast, inaccurate traffic information seriously undermines the credibility of an information station.

Arrangement of personal service components should be extremely flexible within the program schedule. At times, of course, weather and sports become major hard news stories in and of themselves, such as during a big blizzard or when a local team wins a championship or fires its coach.

Weather and Sports

Accurate weather information is an invaluable asset to any information station, particularly in prime programming periods. If a professional meteorology service is used, the station gains credibility. Drivetime weather reports are usually short, covering only immediate-area conditions. An occasional forecast can be added to tell commuters what to expect going home and for the night to come. When a significant number of boaters, private pilots, or farmers are part of the audience, special weather reports are useful at intervals. Special weather reports can run from 30 seconds to 2 minutes and can be tied to a hard news story if conditions warrant. In general, weather is increasingly important as it becomes extreme (affecting commuting), during holidays (affecting travel), and as the weekend nears (affecting leisure plans).

Sports is generally granted the quarter- and three-quarter-hour time slots on all-news stations, with local interest, volume, time of day, and pressure from other news features determining its length. Sports reporting is anchored to scores and

area team activities, but sportscasts are normally expanded on weekends to cover many more games or contests at distant points—after all, in the farthest reaches of Maine and California, Notre Dame alumni associations persist. Although weekday sports segments are usually held to about 2 minutes at the quarter- and three-quarter-hour marks, weekend sportscasts are easily expanded to 10 or 12 minutes. The situation is obviously quite different at sports/talk stations, where sports programming of various types runs throughout the day.

Local Appeal

Until Rush Limbaugh, it was generally held that a talk station must be *locally* programmed throughout the daylight hours to be successful. Prior to the 1990s, most networks and syndicators limited their talk-show offerings to the evening and overnight hours. That premise was shattered by the phenomenal success of *The Rush Limbaugh Show* in 1988, syndicated by EFM Media. The program, usually fed via satellite at noon EST, was an instant success and by 1991 had been acquired by nearly 500 stations. "Rush Rooms" sprang up in restaurants across the nation as diners listened to the program over lunch. Limbaugh mixes humor and production elements with a conservative view of the day's political issues, and his show quickly became the highest rated in midday on most stations that carried it. Limbaugh, more than any other radio talk personality, proved the value of mixing discussion of controversial issues with elements of entertainment (music, parody, hyperbole).

HOSTS, AUDIENCES, AND GUESTS

Conversation program hosts are often generalists, as are most broadcast journalists. They have developed the ability to grasp a subject's essence. The host of a general interest talk program will discuss world and local affairs, politics, medicine, economics, science, history, literature, music, art, sports, and entertainment trivia—often on a single program. It thus becomes a vital part of the

host's daily preparation to keep abreast of current events and to have at least some familiarity with a wide range of topics.

Callers and Listeners

On shows without call screeners, research has shown that *the typical on-air caller is quite different from the average listener*. Some studies show that callers have lower income levels, less education, and are lonelier than radio listeners in general. Callers represent only a small fraction of the audience, however, and they differ from one another depending on the nature of the program. Most important, they are inherently different from listeners to the same programs. According to surveys by the Times Mirror Center for the People and the Press, only 11 percent of Americans say they have attempted to call a talk radio program; of these, only 6 percent report that they made it on the air.

Talk listeners, unlike callers, have higher than average spendable income and savings account balances; they take more than the average number of trips by air, buy more luxury cars, and so on. Callers do not reveal an accurate profile of listeners, but station personnel frequently become so focused on calls that they forget about the audience—which should be their prime concern. Switching the emphasis to the listening audience usually makes ratings go up.

Commercial Interests

Of all radio formats, the talk format is the most vulnerable to unscheduled commercial matter. **Payola** and **plugola** have been associated with the music industry, but the talk format offers the greatest opportunities for such abuses. An hour of friendly conversation presents endless opportunities for the on-air host to mention a favorite resort or restaurant or to comment on a newly acquired automobile. Moreover, the program host is often in the position of booking favored business acquaintances as guests. The on-air personality therefore receives many offers, ranging from free dinners to discounts on major purchases. Policies aimed at preventing violations must emphasize

that management will severely penalize violators. Most stations require their on-air talent and producers to sign affidavits showing that they understand the law on these points, and some stations hire independent agencies to monitor programs for abuses. More than one station has reinforced this message by billing on-air performers for time if their casual conversations become commercials.

However, guests representing commercial enterprises may certainly appear on the station. It is appropriate, for instance, for a local travel agent to discuss travel in mainland China or for the proprietor of a health food store to present opinions on nutrition. And, obviously, many personalities on the talk-show circuit have something to sell—a book, a movie, a sporting event, a philosophy, and so on. Some mention of the individual's reason for appearing is appropriate because it establishes the guest's credentials. An apt reference might be, "Our subject today is solar eclipses, and our guest is Dr. Mark Littmann, author of a new book entitled *Totality*."

ON-AIR TALK TECHNIQUES

Call-in programs are the backbone of talk radio. They can also be complicated to produce, especially if a program has a dozen phone lines to deal with. To help the on-air personality run a smooth show, the call screener (or producer) has become a vital part of the talk radio staff. As described by one talk host, the screener is a "warm-up artist" for the host, building up the caller's enthusiasm and excitement so that it comes through in the caller's interaction with the host.

Telephone Screeners

Screeners add substantially to station budgets, but a station can control its programming only through careful screening. Airing "cold" or unscreened calls is comparable to going out on a date with the first person you see in a parking lot at the mall. Some talk hosts, such as Jim Bohannon of the Mutual Broadcasting System, prefer the spon-

taneity of unscreened calls; Bohannon asks his screener to indicate only the call's city of origin.

The screener for a talk program functions as a gatekeeper, exercising significant control over the information that reaches the air. Screeners constantly manipulate the lineup of incoming calls, giving priority to more appropriate callers and delaying or eliminating callers of presumably lesser interest. The screener asks each caller a series of questions to determine whether the call will be used: "What topic do you want to talk about? How do you feel about it? Why do you want to speak on the air?" At the same time, the screener determines if the caller is articulate, if their comments are likely to promote the flow of the program, and if they possess some unique quality that the host and audience will find appealing.

Philosophies on exactly what constitutes the ideal caller vary from market to market. According to a talk radio programmer in Los Angeles, for example, calls that are in vehement, rational (or sometimes even irrational) disagreement with the program host are to be expedited and cherished. This executive feels that the conflict such calls produce can serve as a shot of adrenaline to the program, increasing listener interest.

The screener filters out the "regulars" who call the station too frequently, as well as inebriates, people with thick accents, and others unable to make a coherent contribution. Callers thus dismissed and those asked to hold for long periods often complain of unfair treatment, but the screener must prevail, insisting on the right to structure the best possible conversational sequence. Effective screeners perform their jobs with tact and graciousness.

When screeners must dump a caller, they say something like, "Thank you for calling, but I don't think we'll be able to get you on the air today." Most stations prohibit the use of the caller's full name to forestall such imposters from identifying themselves as prominent people in a community and then airing false statements to embarrass the individuals they claim to be.

When a program depends on callers, what happens in those nightmare moments when there are none? For just this emergency, most talk-show hosts maintain a clipping file containing newspaper and magazine articles saved from their general reading to provide a background for monologues when no calls come in. Another strategy is the expert phone list, a list of 10 or 20 professionals with expertise in subjects of broad appeal. Resorting to the list should yield at least one or two able to speak by phone when the host needs to fill time to sustain a program.

Screening Systems and Delays

Various systems are used for the screener to signal to the on-air host which incoming call has been screened and is to be aired next. Most talk stations now utilize computer software they have developed themselves or a commercial product. Using computers places greater program control in the hands of the on-air host. The computer display indicates the nature of the calls prepared for airing; the host can then alter the complexion of the program by orchestrating call order. The information displayed for the host usually includes the first name and approximate age and sex of the caller, and may specify the point the caller wishes to discuss. The display frequently includes material of practical conversational value, such as the current weather forecast. Hosts often use a timer to monitor call length. Many hosts cut a caller off, as politely as possible, after 90 seconds to 2 minutes to keep the pace of the program moving. Occasionally, a guest will get more airtime if he or she is particularly stimulating or is a celebrity or well-known authority on a topic.

All talk stations use a device, usually an electronic digital delay unit, that delays the programming about seven seconds to allow the host or audio board operator to censor profanity, personal attacks, and other unairable matter. The on-air host generally controls a "cut button" that diverts offensive program material, although the engineer should have a backup switch.

Because the program is delayed, the screener instructs all callers to turn off their radios before talking on the air. Failing this, callers hear their

voices coming back at them on a delayed basis and cannot carry on a conversation, causing the host to exclaim, "Turn your radio down!" Listening only on the telephone, callers hear the real-time program material and can talk normally with the host.

Controversy, Balance, and Pressure

Although talk radio programmers get many opportunities for creative expression, they also must devote considerable time to administration. Because the station deals almost constantly with public affairs issues, its programmers spot-monitor the station's programs for compliance with such FCC rules as equal time for political candidates and to avoid legal pitfalls such as libel. A programmer, however, having many other duties as well, rarely knows as much about the minute-by-minute program as heavy listeners do. Therefore, backup systems must be established.

Talk stations frequently find themselves the targets of pressure groups, activist organizations, and political parties trying to gain free access to the station's airtime. Although most partisans deserve some airtime (in the interest of fairness and balance), management must turn away those seeking inordinate amounts of airtime.

Political parties are well aware of the impact of talk stations and have been known to organize volunteers to monitor programs and flood incoming phone lines with a single point of view. Politicians seeking airtime have sometimes misused the idea of fairness, confusing it with the equal-opportunity provision for political candidates—sometimes through ignorance, at other times to confuse the program executive.

Because an effective talk station frequently deals with controversial issues, management can expect threats of all kinds from irate audience members. A provoked listener will demand anything from a retraction to equal time and, on occasion, someone will threaten legal action. Potential lawsuits usually vanish, however, when management explains the relevant broadcast law

to the complainant. When the station is even slightly in the wrong, it is usually quick to provide rebuttal time for an overlooked point of view.

Listeners will tune out a poor phone call on a talk station just as they would a weak record on a music station. Therefore, station programmers must control the on-air subject matter and the flow of program material rather than letting callers dictate the programming. Nationwide, the talk stations with the highest ratings have adopted the strategy of focusing on the *needs of the listeners*, not the *wants of the callers*. The talk host who in the past had generated telephone calls because of an argumentative personality or an "over-the-back-fence" nature may be replaced or redirected toward informational or entertaining radio programming.

A primary ingredient in the recipe for success in any talk format is commitment at the top— at the station management level. A timely and innovative music format can catapult a station from obscurity to the number one ranking during a single rating period. Talk stations and all-news stations, however, generally take years to reach their potential. Once success is achieved, however, the talk station enjoys a listener loyalty that endures long after the more fickle music audience shifts from station to station in search of the hits. High figures for time-spent-listening and long-term stability in cumulative ratings demonstrate audience loyalty.

The talk station producing a significant amount of local programming generally is more costly to operate than a music operation. Good talk personalities are often higher paid than disc jockeys, and they must be supported by producers, call screeners, and frequently, extra administrative personnel. Salaries of talk hosts vary a great deal, of course, from city to city. Some, in smaller markets, earn $20,000 to $30,000, but major-market personalities are paid as much as $600,000. Screener and producer positions are often entry-level jobs paying the minimum wage or just above, but they offer an opportunity to enter the industry and acquire experience.

THE SPOKEN WORD IN PUBLIC RADIO

Talk shows are among the most popular programs on public radio. Shows such as *Car Talk* and *A Prairie Home Companion* attract large, loyal audiences. In 1997, Pacifica Radio, a public radio organization based in California, developed a five-year strategic plan that admonished stations to be aware of increasing pressures to commercialize as a result of increasing costs and decreasing federal support. Another factor is the increasing popularity of many public radio programs. The potential for earning commercial revenue from these shows is tempting to many public radio owners.

One precursor to this trend toward commercialization has been the conversion of what had been commercial-free religious radio. More than two-thirds of religious radio stations (mostly Christian) are now commercial, and for every public radio station on the air in the United States, there are at least three religious stations.

Public stations are explicitly committed to serving as an alternative to commercial broadcasting, providing programs for specialized, small audience needs. In 1999 the FCC adopted rules creating a new, noncommercial low power FM radio (LPFM) service. The new service consists of stations with maximum power levels of just 10 watts reaching areas with a radius of between one and two miles and some with 100 watts reaching areas with a radius of approximately 3.5 miles. Most of these stations emphasize talk and music programming aimed at small populations of minority and non-English-speaking populations.

Programming strategies for public radio must consider the relationship between a station's philosophy toward its audience and its fund-raising capability, its degree of localism, and its integrity. As in public television, the nature of the licensee determines many of the goals of the station. About 60 percent of public radio stations have colleges and universities as their licensees, while about one-third are licensed to independent community organiza-

tions, 6 percent to local school districts or local governments, and 4 percent to state governments.

One ongoing, even acrimonious, controversy within public radio concerns target audiences. This has two aspects. First of all, more than 80 percent of Americans do not listen to public radio. Those who do tend to be professional or managerial, hold college degrees, earn more than $30,000 per household, value information very highly, and are socially conscious individuals. Second, most public stations today target adults, not children.

The all-news and public affairs format, although seemingly a natural for public radio, has been less used than might be expected. The apparently endless appetite of radio listeners for news now supplies public radio with a new opportunity for success. In the early days of public radio, it was nearly impossible to raise money for news programming, but it has now become easier to generate revenue for news than for classical music and arts programs.

National Public Radio (NPR) is the leading supplier of public radio news. *Morning Edition* and *All Things Considered* are the best known and most used news programs in public radio. At least one station in every public radio market carries both programs. Recently, however, **Public Radio International (PRI)** began distributing competing national and international news programs from diverse production sources. *Marketplace*, the first daily half-hour news program to originate from the West Coast, is a highly successful business news program produced by KUSC. PRI also distributes the *BBC World Service*, CBC's *As It Happens, The World*, and two daily news programs produced by the *Christian Science Monitor, Monitoradio* (evenings) and *Early Edition* (mornings). NPR has concentrated on the development of major national news programs, while PRI focuses on developing major international news programs. The increased quality and diversity of news programs for public radio is providing stations and listeners with more outstanding choices for news.

The Pacifica stations—WBAI-FM (New York), WPFW-FM (Washington, D.C.), KPFT-FM (Houston, Texas), KPFA-FM (Berkeley, California), and

KPFK-FM (Los Angeles)—pioneered the news and public affairs format for noncommercial public radio. The Pacifica Foundation, licensee of the stations in this group, has a specific social and political purpose that influences its approach to news and public affairs. The listener has little difficulty recognizing the bias, and Pacifica is open about its philosophy. These stations were especially successful during the late 1960s and early 1970s when the nation was highly politicized over Vietnam and Watergate. They demonstrated the vital role of broadcasting that is free from commercial restraints in their reporting of that war and the surrounding issues. They played a similar role for the brief time of the Persian Gulf War.

News and public affairs programming has become increasingly viable in public radio because an information society demands high-quality news programs. The extraordinary popularity of the nationally distributed news programs, NPR's *All Things Considered, Morning Edition,* and *Weekend Edition,* along with the BBC's *The World, Marketplace, Monitoradio,* and *Early Edition* (distributed by PRI), has bolstered audiences for news programs on public radio. These programs have won many awards for broadcast journalism, and they provide a prestigious base for local station newscasts and supply sufficient national and international coverage to support expanded news programming in all public radio formats.

These news programs now attract large amounts of private and corporate financial support. News programming was uniformly difficult to underwrite locally or nationally until NPR pioneered a fundraising strategy—the News & Public Information Fund—that enabled corporations, foundations, and individuals to invest jointly. This fund in turn supports individual news programs.

About 40 percent of public radio airtime consists of network or syndicated programs, mostly national and world news and radio drama. Although NPR has had long visibility as the national noncommercial service, other radio networks emerged in the 1980s to compete for public radio affiliates, the most successful of which was PRI. These newer networks have been aided by the switch to satellite distribution, which has increased program availability.

National Public Radio

Nearly one-third of noncommercial radio stations are members of NPR. This system of more than 400 nonprofit radio stations broadcasts to communities in 48 states, Puerto Rico, and the District of Columbia. Each station, itself a production center, contributes programming to the entire system. Each station mixes locally produced programs with those transmitted from the national production center. A private nonprofit corporation, NPR distributes informational and cultural programming by satellite to member stations daily. Funds for the network's operation and for the production, acquisition, and distribution of radio programs come from corporate underwriting, private foundations, government agencies, and member stations.

NPR programs news, public affairs, art, music, and drama to fit into whatever formats member stations choose. The news and information programs already discussed—*Morning Edition, All Things Considered,* and *Weekend Edition*—are its most distinguished trademark and the core of its program service. NPR also has provided leadership in music and arts programming for the public radio system, such as *Performance Today, The World of F. Scott Fitzgerald, Jazz Alive, NPR Playhouse* (featuring new radio dramas), and live broadcasts of musical events from Europe and around the United States. It has also provided stations with in-depth reporting on education, bilingual Spanish news features, and live coverage of Senate and House committee hearings. Satellite distribution of the NPR program service has meant better quality transmission of existing programs and distribution of up to a dozen stereo programs simultaneously. The high quality of national programs frequently entices stations to use NPR programs.

During the Persian Gulf War, NPR provided extensive, round-the-clock coverage of events, but such an unusual effort proved costly. As a consequence, member dues increased again in 1991. Meanwhile, state support dropped in many areas.

Gulf Crisis coverage cost NPR about $300,000 more than its monthly $1.2 million budget, and although the war ended quickly, it was followed by rising costs for coverage of the Soviet coup. During such news crises, NPR usually goes from 18 to 24 hours a day and adds an extra, 5 A.M. feed of *Morning Edition* and a late-night feed of *All Things Considered*.

Public Radio International

In 1982 a group of five stations formed a second national radio network called American Public Radio (APR), later renamed Public Radio International (PRI). Minnesota Public Radio, KUSC-FM in Los Angeles, KQED-FM in San Francisco, WNYC AM/FM in New York, and WGUC in Cincinnati initially joined together to market and distribute programs they produced and to acquire other programming to distribute to affiliates. The name was changed in 1994 to help end the commonplace public confusion between APR and NPR and also to underline the network's interest in building imports and exports of radio programming in the international marketplace.

The most successful program PRI distributed in its first year (1982) was *A Prairie Home Companion*, produced by Minnesota Public Radio. When host Garrison Keillor left *Prairie Home* in 1987, Minnesota Public Radio created several less-successful replacement programs before the eventual return of Keillor and his show in the 1990s. The majority of PRI's schedule consists of original performances by orchestras, soloists, and ensembles, and it programs a daily concert series. PRI also offers the BBC's *World News Service, The World, Monitoradio, Marketplace,* and *As It Happens,* but its programming emphasizes classical music.

OTHER NONCOMMERCIAL SOURCES

WFMT's Beethoven Satellite Network, U.S. Audio (formed by Eastern Public Radio), Audio Independents, and the Longhorn Network began in the 1980s. Like PRI, these networks and syndicators market and distribute programs nationally. A variety of station programming consortia also emerged in public radio, paralleling those in public television, commercial broadcasting, and cable. The Public Radio Cooperative, a joint venture of individual public radio stations largely in the northeastern United States, supplies programs to stations that pay a broadcast fee. Member stations produce many of the programs; the rest come from commercial syndicators. The appetite for more programming than NPR can supply is strong.

Public radio also supports several regional groups that distribute programs and consults on station operation. These include Southern Educational Communications Association, Eastern Public Radio, Public Radio in Mid-America, West Coast Public Radio, and Rocky Mountain Public Radio. In the United States, government agencies operate two noncommercial radio enterprises: The National Oceanic and Atmospheric Administration broadcasts local weather information over 550 NOAA stations in the 160 megahertz band, and state governments operate numerous Highway Advisory Radio stations (HAR) within the AM broadcast band (see 12.8 and 12.9.)

WHAT LIES AHEAD FOR INFORMATION RADIO

Several years ago, Arbitron began tracking Internet usage and found that about one out of every five Americans has listened to radio delivered via the Internet. The amount of time spent listening via the Internet grows annually because the technical challenges of receiving the audio stream have become simple for the casual computer user. Many observers note that at first Internet radio listening was strikingly similar to radio listening in the 1920s: In those days, the effort of building a receiver, tuning in stations, and listening to scratchy audio on a pair of headphones were much more challenging than installing audio streaming plug-ins now, such as RealAudio or QuickTime.

12.8 NOAA WEATHER RADIO

NOAA Weather Radio is a nationwide network of radio stations broadcasting continuous weather information direct from a nearby National Weather Service office. NOAA Weather Radio broadcasts National Weather Service warnings, watches, forecasts, and other hazard information 24 hours a day.

Working with the Federal Communications Commission's new Emergency Alert System, NOAA Weather Radio is an "all hazards" radio network, making it the single source for the most comprehensive weather and emergency information available to the public. NOAA Weather Radio also broadcasts warning and post-event information for all types of hazards—both natural (such as earthquakes and volcano activity) and technological (such as chemical releases or oil spills).

Known as the "Voice of the National Weather Service," NOAA Weather Radio is provided as a public service by the Department of Commerce's National Oceanic & Atmospheric Administration. The NOAA Weather Radio network has more than 550 transmitters, covering the 50 states, adjacent coastal waters, Puerto Rico, the U.S. Virgin Islands, and the U.S. Pacific Territories. NWR requires a special radio receiver or scanner capable of picking up the signal. Broadcasts are found in the public service band at these seven frequencies (MHz): 162.400, 162.425, 162.450, 162.475, 162.500, 162.525, 162.550.

Nowadays, because spoken-word programming does not require the fidelity of music programming, the Internet and talk radio are made for each other.

AM talk stations may have been great-granddad's medium, but talk radio today is at the cutting edge of Internet delivery. The Internet is becoming a vital part of talk radio, with a significant percentage of station and syndicators' promotional budgets being dedicated for online audio streaming as well as station and host web sites. One of the largest U.S. radio networks, Premiere, has created web sites for each talk-show host it syndicates. Premiere's highest-rated host, Rush Limbaugh, is reported to receive an average of 10,000 emails per day. This kind of interactivity and perceived intimacy with the host is key to listener loyalty. Internet streaming also allows fans to listen to local programming while out-of-town, to listen to archived copies of past programs they may have missed, and to listen to programs from almost anywhere on earth. For example, in the summer of 2000, one could listen in an Internet café in Ulaanbaatar, Mongolia, to *The Rollye James Show* from Philadelphia 12 time zones away for less than $1 an hour.

In a sense, the Internet allows even the most local of local radio to be international in delivery. The increasing ease of audio streaming over the Internet also allows nearly every business, organization, or individual to be able to have an international radio talk show. Michael Harrison of *Talkers* magazine explains, "Every Rotary club will have a talk show. Talk shows will be part of the culture of being in business."[8]

Most on-air broadcast radio stations have been slow to develop their online presence. One notable exception has been KPIG. In late 1999, Arbitron's Internet rating system estimated twice as many listeners were tuned to KPIG online as were listening over-the-air. Unfortunately Arbitron's system at that time was incapable of tracking the geographic location of Internet listeners, but other studies have shown a majority of Internet radio listening occurs within the station's coverage area, mostly by listeners at work.

12.9 HIGHWAY ADVISORY RADIO

Highway advisory radio broadcasts up-to-the-minute advisories to motorists on the AM radio band over a four-to six-mile radius.

In 1992 the New Jersey Turnpike Authority introduced a Highway Advisory Radio System. Located at 1610 AM (south) and 590 AM (north) on the radio dial, the Highway Advisory Radio provides motorists with the latest, up-to-the-minute reports on road and traffic conditions along the entire length of the roadway.

The Highway Advisory Radio (HAR) remains on the air 24 hours a day, seven days a week, 365 days a year providing the following information:

Current traffic conditions

Travel restrictions

Notices of events throughout New Jersey

Directions to popular tourist attractions

General safety information

Nine fixed and two portable transmitting sites comprise the Highway Advisory Radio Network. Special HAR informational signs have been placed strategically along the roadway and are equipped with special flashing lights. The lights are activated to alert motorists that an urgent message is being broadcast. Whenever possible, traffic conditions of surrounding roadways and facilities are also broadcast.

Portable highway advisory radios can be deployed immediately to the scene of chemical or haz-mat spills, auto accidents, detours, construction and work zones, weather related incidents and disasters, and so on, providing area residents and motorists with the safety information they need.

Although advances in the technology of the mass media are often amazing, their ultimate impact depends on the way listeners choose to interact with them. In the end what matters more than the quality, speed, or mobility of the technology is its *content*. The history of the mass media, and the history of marketing in general, provides numerous examples of the degree to which consumers will go to seek what they want. The ability to creatively entertain, inform, and engage audiences has repeatedly proven to transcend technical change. Even in a world of digital wireless Internet delivery of every possible audio stream, the creativity, localism, and feelings of pseudofriendship with radio personalities are likely to survive.

SOURCES

Bell, Art. *The Art of Talk*. New Orleans, LA: Paper Chase Press, 1998.

Chinn, Sandra. *At Your Service—KMOX and Bob Hardy: Pioneers of Talk Radio*. St. Louis: MO: Virginia Publishing, August 1997.

Davis, Michael P. *Talk Show Yearbook 2000: A Guide to the Nation's Most Influential Television and Radio Talk Shows*. Washington, DC: Broadcast Interview Source, 2000.

The Directory of Talk Radio 2000, Longmeadow, MA: *Talkers* magazine.

Goehler, Richard. *NAB Media Law Handbook for Talk Radio*. Washington, DC.: National Association of Broadcasters. April 2000.

Hilliard, Robert L., and Keith, Michael C. *Waves of Rancor: Tuning in the Radical Right*. Armonk, NY: M. E. Sharp, 1999.

Hutchby, Ian. *Confrontation Talk: Arguments, Asymmetries, and Power on Talk Radio*. Mahway, NJ: Lawrence Erlbaum, 1996.

The Journal of Radio Studies. Broadcast Education Association, Washington, DC.

Laufer, Peter. *Inside Talk Radio: America's Voice or Just Hot Air?* Secaucus, NJ: Carol Publishing Group, 1995.

Looker, Tom. *The Sound and the Story: NPR and the Art of Radio*. Boston: Houghton Mifflin, 1995.

Milam, Lorenzo. *The Radio Papers: From KRAB to KCHU*. San Diego: Mho & Mho Works, 1986.

Sabo, Walter. The State of FM and Younger Demo Talk Radio. Paper presented at the New Media Seminar, New York City, 29 April 2000.

Sadow, Catherine, and Sather, Edgar. *On the Air: Listening to Radio Talk*. Boston: Cambridge University Press, 1999.

Talkers Magazine: The Bible of Talk Radio and the New Talk Media. Longmeadow, MA, 1990 to date.

INFOTRAC COLLEGE EDITION

Consult InfoTrac College Edition using the password provided with this book. Use boldfaced terms as Key Words and section headings from this chapter for Subject searches.

NOTES

1. For the purposes of this chapter, *success* is defined as station dominance in local revenues and ratings.

2. Personal communication from Rollye James, talk-show host and radio consultant, Philadelphia, PA, May 2000.

3. International Radio-TV Society Conference, New York, February 2000.

4. New Media Seminar, New York, 29 April 2000.

5. Mark Kiester, general manager of KJFK-FM in Austin, Texas, quoted by John Lippman, FM stations dump rock for risque talk. *Wall Street Journal*, 29 October 1998, p. B1.

6. Personal communication from Michael Harrison, 27 April 2000.

7. Merli, John. Radio's making waves. *Broadcasting & Cable*, 30 August 1999, p. 19.

8. Harris, 27 April 2000.

Abbreviations and Acronyms

Boldfaced terms are explained further in the Glossary.

AAA — Association of Advertising Agencies
AC — **adult contemporary**
ACE — **awards for excellence in cable programming**
ACT — Action for Children's Television
ADI — **area of dominant influence**
AFTRA — American Federation of Television and Radio Artists
AIT — Agency for Instructional Technology
ALTV — Association of Local Television Stations (formerly INTV)
AMC — American Movie Classics
AOR — **album-oriented rock**
AP — Associated Press
AQH — average quarter hour
ARB — Arbitron Research Bureau
ASI — **market research company**
ASCAP — **American Society of Composers, Authors, and Publishers**
BEA — Broadcast Education Association
BM — **beautiful music**
BMI — **Broadcast Music, Inc.**
CAB — **Cable-Television Advertising Bureau**
CAT — keystroke animation technology
CATI — computer-assisted telephone interviewing
CATV — community antenna television
C-band — low-power communications satellites
CBC — Canadian Broadcasting Company

CD — **compact disc**
CEN — Central Educational Network
CHN — Cable Health Network (now Lifetime)
CHR — contemporary hit radio
CM — commercial matter
CNN — Cable News Network
CPB — **Corporation for Public Broadcasting**
CPM — cost per thousand (used in advertising)
CRQ — See Our Cue
CRT — Copyright Royalty Tribunal
C-SPAN — Cable-Satellite Public Affairs Network
CSRs — customer service representatives
CTAM — Cable & Television Association for Marketing
DAB — **digital audio broadcasting**
DARS — Digital Audio Radio Services
DBS — **direct broadcast satellite** (also direct satellite services)
DJ — **disc jockey**
DMA — **designated market area**
DMR — Digital Media Report
DSL — digital subscriber line
DSS — Direct Satellite System (RCA trademark for DBS)
DTH — **direct-to-home**
DVD — Digital Versatile (or Video) Disc
DVR — Digital Video Recorder
EEN — Eastern Educational Television Network
EEO — **equal employment opportunity**

ENG	electronic newsgathering		NAACP	National Association for the Advancement of Colored People
EPG	electronic program guide		NAB	National Association of Broadcasters
ERP	**effective radiated power**		NAD	National Audience Demographics (Nielsen report)
ESF	**expanded sample frame**		NARB	National Association of Radio Broadcasters
FCC	Federal Communications Commission		NATPE	National Association of Television Program Executives
FTC	Federal Trade Commission			
FTTC	fiber to the curb		NCAR	Nielsen's Cable Activity Report
FTTN	fiber to the node		NCTA	National Cable Television Association
GPN	Great Plains National Instructional Television Library		NET	National Educational Television
			NFLCP	National Federation of Local Cable Programmers
HAAT	Height Above Average Terrain			
HBO	Home Box Office		NHTI	Nielsen Hispanic Television Index
HDTV	**high-definition television**		NISS	National ITV Satellite Service
HHs	**households having sets**		NOW	National Organization of Women
HP	**homes passed**		NPPAG	National Program Production and Acquisition Grants
HSD	**home satellite dish**			
HUTs	**households using television**		NPM	Nielsen PeopleMeter
IBOC	In-Band On Channel		NPR	**National Public Radio**
ID	station identification		NPS	National Program Service
ITNA	Independent Television News Association		NSI	Nielsen Station Index
ITV	**instructional (or interactive) television**		NSS	National Syndication Service (Nielsen report)
Ku-Band	high-power communications satellite frequency		NTI	Nielsen Television Index
			NTSC	**National Television Systems Committee** (U.S. TV Standard)
LIFO	last in, first out			
LMA	local marketing agreement		NVOD	**near video-on-demand**
LO	**local origination**		O&O	**owned-and-operated**
LOP	**least objectionable program**		PAF	Program Assessment Fund
LPTV	**low-power television**		PBS	**Public Broadcasting Service**
LULAC	League of United Latin American Citizens		PCN	personal communication network
MFTV	**made-for-TV**		PCS	Personal Communication Service
MMDS	**multichannel multipoint distribution service**		PDG	Program Development Group
			PEG	**public, educational, and government access channels**
MNA	Multi-Network Area Report			
MOR	middle-of-the-road		PG	movie code: parental guidance suggested
MOW	movie of the week			
MRA	Metro Rating Area		PPM	portable peoplemeter
MSA	Metro Serving Area		PPV	**pay-per-view**
MSO	**multiple system operator**		PRI	**Public Radio International**
MTV	Music Television			

PRSS	Public Radio Satellite System	SRA	Station Representatives Association
PSA	public service announcement	SRI	Statistical Research, Inc.
PTAR	**prime-time access rule**	STV	**subscription television**
PTR	Persons Tracking Report (Nielsen report)	SVOD	subscriber video-on-demand
PTV	**public television**	TCI	Tele-Communications, Inc.
PURs	**persons using radio**	TCM	Turner Classic Movies
PUTs	**persons using television**	TNN	The National Network
R	movie code: restricted	TNT	Turner Network Television
RAB	Radio Advertising Bureau	TSL	**time-spent-listening**
RADAR	Radio's All Dimension Audience Research	TSO	**time-spent-online**
RCD	remote control device	TvB	Television Bureau of Advertising
ROSP	Report of Syndicated Programs	TVHH	television households
RPC	Radio Programming Conference	TVPC	Television Programmers' Conference
RTNDA	Radio Television News Directors Association	TvQ	**television quotient**
SDTV	**standard definition television**	TVRO	**TV receive only**
SECA	Southern Educational Communication Association	**UHF**	ultra high frequency
SESAC	Society of European Songwriters, Artists, and Composers	URL	Universal Resource Locator
SIN	Spanish International Network	USA	USA Network
SIP	Station Independence Program (fundraising service of PBS)	VBI	vertical blanking interval
SMATV	**satellite master antenna television**	VCR	**videocassette recorder**
SMN	Satellite Music Network	**VHF**	very high frequency
SMPTE	Society of Motion Picture and Television Engineers	VIP	Viewers in Profile (Nielsen report)
SNAP	Syndication/Network Audience Processor (computer software)	VJ	**video jockey**
		VOD	**video-on-demand**
		VSAT	very small aperture terminal
		WCA	Wireless Cable Association (MMDS operators)
		Wrap	Windows Ratings Analysis Program

Glossary

This list includes **boldfaced terms** in the text and other vocabulary but excludes phrases boldfaced in text for emphasis only. Acronyms appear under their spelled-out definitions. *Italicized words* in the definitions indicate other glossary entries.

AC Adult contemporary, a soft rock music format targeting the 25 to 54 age category.

access Public availability of broadcast time. In cable, one or more channels reserved for noncommercial use by the community, educators, or local government. See also *access time*, *community access channels*, and *prime-time access rule*.

access time The hour preceding *prime time* (usually between 7 and 8 P.M. EST), during which the broadcast network affiliates once could not air off-network programs. See also *prime-time access rule*.

ACE Awards sponsored by the National Cable Television Association for local and national original cable programs.

actuality An on-the-spot news report or voice of a news maker (frequently taped over the telephone) used to create a sense of reality or to enliven news stories.

adaptation A film or video treatment of a novel, short story, or play.

addressability Remote equipment that permits the cable operator to activate, disconnect, or unscramble signals to each household from the cable *headend*. This technology provides maximum security and is usually associated with *pay-per-view* channels.

ad hoc networks Temporary national or regional hookups among radio or television stations for the purpose of program distribution; this is especially common in radio sports.

adjacencies A commercial spot next to a program that can be sold locally, especially spots for station sales appearing within (or next to) network prime-time programs.

affiliate A commercial radio or television station receiving more than ten hours per week of network programming, but not owned by the network. This also applies to cable system operators contracting with *pay* or *basic cable* networks, or occasionally to public stations airing noncommercial programming from the *Public Broadcasting Service*, *National Public Radio*, or *Public Radio International*.

affiliation agreements Contracts between a network and its individual affiliates specifying the rights and responsibilities of both parties.

aftermarket Syndicated sales of programs to a different industry than the one for which they were originally produced, as in sales of broadcast programs to cable and original cable programs to U.S. or foreign broadcasters or video rental or sales.

agent A representative, either a person or software that acts for someone else.

aging an audience A strategy for targeting slightly older viewers in the early fringe daypart, starting with children in the afterschool time period and moving toward adult male viewers for the early evening newscast. Colloquially called "aging your demos." Also used during prime time.

aided recall In survey research supplying respondents with a list of items to stimulate their memory.

air-lease rights Permission to broadcast a program.

a la carte Programs chosen separately by viewers, as items on a menu. See also *video-on-demand*.

American Society of Composers, Authors, and Publishers (ASCAP) An organization licensing musical performance rights. See also *Broadcast Music, Inc.*

amplifier Electronic device that boosts the strength of a signal along cable wires between telephone poles.

amortization The allocation of syndicated program series costs over the period of use to spread out total tax or inventory and to determine how much each program costs the purchaser per airing; a station may use straight-line or declining value methods.

ancillary markets Secondary sales targets for a program that has completed its first run on its initial delivery medium. Also called "backend" or *aftermarkets.*

ancillary services Revenue-producing services other than the main broadcast or cable programming, as in data.

anthology A weekly series consisting of discrete, unrelated programs under an *umbrella* title; these may be a playhouse series consisting of dramas by different authors or a sports program consisting of varied sporting events (often in short segments) and related sports talk. This technique is used by over-the-air networks for packaging unused program *pilots.*

AOR Album-oriented rock, a rock music format appealing to a strongly male audience, aged 18 to 34, consisting of less well-known songs by avant garde rock artists and groups as well as their most popular works.

appeals Elements in program content that attract audiences, such as conflict, comedy, nostalgia, suspense, and so on.

Arbitron Information on Demand (AID) A computerized service that identifies the best times for airing station promotional spots after factoring in program sequence, network promo content, target audience, and so on.

architecture In communications, the design of a channel or technical platform.

Area of Dominant Influence (ADI) One of more than 200 geographical market designations defining each radio market exclusive of all others. It indicates the area in which a single station can effectively deliver an advertiser's message to the majority of homes. ADI is Arbitron's term; Nielsen's comparable term is *Designated Market Area (DMA).*

ascertainment Determining a community's needs, interests, and problems to file a report with the FCC showing how a station responded to these needs with programming. The method of collecting information is determined by the station.

ASI Market Research Los Angeles–based company specializing in program and commercial testing using invited theater audiences.

Association of Local Television Stations (ALTV) Professional trade association of stations not affiliated with ABC, CBS, or NBC, formerly the Association of Independent Television Stations (INTV).

audience flow The movement of audiences from one program or time period to another, either on the same station or from one station to another; this includes turning sets on and off. Applied to positive flow encouraged by similarity between contiguous programs.

audimeter Nielsen's in-home television rating meter, used until 1987. See also *peoplemeter.*

audition tape A demonstration of an anchor, host, disc jockey, or other personality's on-air abilities and appearance or sound; in radio, this may include short clips of interviewing or song announcing. Also called a *demo tape.*

auditorium research In radio, mass testing of song *hooks* to measure their popularity.

automation Use of equipment, usually computerized, that reproduces material in a predesignated sequence, including both music and commercials. This produces a log of airings acceptable to advertising agencies. Also used for traffic and billing and in some television production processes.

avail Short for a sales *availability.*

availability Commercial spot advertising position (*avail*) offered for sale by a station or a network; also, syndicated television show or movie ready for station licensing. See also *inventory* and *program availabilities.*

avatar In computers, a virtual self in humanlike form who carries out its person's wishes.

average quarter hour (AQH) Rating showing the average percentage of an audience that tuned in a radio or television station.

backfeed line A line from the production site or studios to the cable *headend* for the purpose of delivering programs.

backsell On radio, telling the audience what songs just played.

backstory The previous history of characters in a series.

bannertracking Tracking the amount of viewing and clicking of banner ads.

barker channel A cable television channel devoted to program listings; this may include video as well as text listings.

barter Licensing syndicated programs in exchange for commercial time (*inventory*) to eliminate the exchange of cash.

barter spot Time in a syndicated program sold by the distributor.

barter syndication The method of program distribution in which the *syndicator* retains and sells a portion of a syndicated program's advertising time. In *cash-plus-barter* deals, the *syndicator* also receives fees from the station licensing the program.

basic cable Those cable program channels supplied for the minimum subscriber rate, including most local broadcast stations, some noncommercial channels, and assorted advertiser-supported cable networks. See also *basic cable networks*.

basic cable households The number or percentage of total television homes subscribing to cable service.

basic cable networks Those cable program services for which subscribers do not pay extra on their monthly bills; they are usually supported by advertising and small per-subscriber fees paid by the cable operator. Contrast with *pay-cable networks*.

beautiful music (BM) A radio format emphasizing low-key, mellow, popular music, generally with extensive orchestration and many classic popular songs (not rock or jazz).

Big Seven studios The major Hollywood studios: Columbia-TriStar, Walt Disney Studios, MGM-UA, Paramount, 20th Century Fox, Universal, and Warner Brothers.

billboard In radio promotion, either an outdoor sign or an on-air list of advertisers; in television promotion, either an outdoor sign or an on-screen list of upcoming programs in text-only form.

bird A satellite.

blackout A ban on airing an event, program, or station's signal; this is often used for football games that have not sold out all stadium seats. Also FCC rules for blocking imported signals on cable that duplicate local stations' programs for which *syndicated exclusivity* has been purchased.

blanket licenses Unlimited rights to plays of all music in a company's catalog by contract; this applies especially to music used by radio and television stations.

block booking Licensing several programs or movies as a package deal.

blockbusters Special programs or big-name films that attract a lot of attention and interrupt normal scheduling; these programs are used especially during *sweeps* weeks to draw unusually large audiences. They normally exceed 60 minutes in length.

blocking Placing several similar programs together to create a unit with audience flow.

block programming Several hours of similar programming placed together in the same daypart to create audience flow. See also *stacking*.

blunting The strategy of airing a program of the same type that another source carries in order to share the audience.

bookmarking A process for saving *URLs*.

branding Marketing a program channel as a targeted product separate from the changing shows carried; also defining and reinforcing a network or service's identity so that it becomes widely recognized as synonymous with a product or service.

break averages Ratings for the breaks between programs, usually calculated by averaging the ratings for the programs before and after the break.

breaks Brief interruptions within or between programs to permit station identification and other messages; usually two or two and a half minutes long.

bridging Beginning a program a half hour earlier than competing programs to draw off their potential audiences and hold them past the start time of competing programs.

broadband Having a wide bandwidth capable of carrying several simultaneous television signals; used for coaxial cable and optical fiber delivery.

broadcasting Fundamentally, spreading a modulated electromagnetic signal over a large area by means of a transmitting antenna; more precisely, the industry consisting of unlicensed networks and licensed radio and television stations regulated by the *Federal Communications Commission*. These are *over-the-air* stations and networks, which distinguishes them from wired, *cable-only* or *online* networks, and from *direct-to-home* satellite transmissions.

Broadcast Music, Inc. (BMI) A music-licensing organization created by the broadcast music industry to collect and pay fees for musical performance rights; it competes with the *American Society of Composers, Authors, and Publishers (ASCAP)*.

broadcast window The length of time in which a program, generally a feature film that was *made-for-pay* cable, is made available to broadcast stations in syndication. See also *pay window* and *window*.

broken network series Canceled network series revived for *syndication*, mixing *off-network* and *first-run* episodes of the series; usually a *situation comedy*.

buffering A time-delay technique, using temporary local digital storage, that prevents interruptions in the flow of a streamed program.

bumping Canceling a showing.

bundling Grouping several cable services on a pay *tier* for a single lump monthly fee; also, grouping radio programs on a network for a single fee. See *unbundling*.

buying Renting programs from *syndicators*. See also *license fee* and *prebuying*.

buy rate Sales per show, or the rate at which subscribers purchase *pay-per-view* programs, calculated by dividing the total number of available *pay-per-view* homes by purchases. For example, if 50 of 100 *pay-per-view* households ordered one movie, the buy rate would be 50 percent; if 50 of 100 *pay-per-view* households ordered two movies, the buy rate would be 100 percent.

cable audio FM radio signals delivered to homes along with cable television, usually for a separate monthly fee; same as *cable radio* or *cable FM*.

cablecasting Distributing programming by coaxial cable as opposed to broadcast or satellite microwave distribution; also, cablecast refers to all programming a cable system delivers, including local cable, *access*, and *cable networks*, except *over-the-air* signals.

cable franchises Agreements between local *franchising authorities* (city or county government) and cable operators to install cable wires and supply programs to a specific geographic area; usually involves payment of a franchise fee to the local government.

cable network National service distributing a channel of programming to satellite and cable systems.

cable-only Programming or services available only to cable subscribers; also, *basic cable* and *pay cable networks*

that supply programming to cable systems but not to noncable households.

cable penetration The percentage of households subscribing to *basic cable* service.

cable service Same as *cable network* or *cable system* or both; also including local offerings such as an *access* or *local origination* channel and alarm or security signals.

cable subscriber A household hooked up to a cable system and paying the monthly fee for *basic cable* service.

cable system One of nearly 12,000 franchised, nonbroadcast distributors of both broadcast and cablecast programming to groups of 50 or more subscribers not living in dwellings under common ownership. See contrasting *SMATV* and *DTH*.

cable operator The person or company managing and owning cable facilities under a franchise. See *MSO*.

cachetrack Measurement system for tracking page views stored by browser programs.

caching The storing of digital program information.

call-ins People telephoning the station.

call letters FCC-assigned three or four letters beginning with *W* or *K*, uniquely identifying all U.S. broadcast stations. (Stations in other countries are assigned calls beginning with a different letter, such as *X* for Mexico and *C* for Canada.)

call-out research Telephone surveying of audiences initiated by a station or research consultant; used extensively in radio research, especially to determine song preferences in rock music. Contrast with *call-ins* referring to questioning listeners who telephone the station.

call screener Person sorting and selecting incoming calls on telephone call-in shows and performing other minor production functions as assistant to a program host.

camcorder A portable video camera and videotape recorder in one unit.

captive audience Television programming for viewers who have few options other than viewing, such as standing in supermarket checkout lines, waiting in airports, or viewing in classrooms as part of school lessons.

carriage charges Fees paid to a cable network or, hypothetically, to a television station for the right to carry specific programming.

carryovers Programs repeated from the preceding month.

cart machine Automated radio station equipment that plays cartridges of music, commercials, *promos*, jingles, and *sweepers*.

cash call Radio giveaways requiring listeners merely to answer the phone or call in.

cash flow Operating revenues minus expenses and taxes, or cash in minus cash out.

cash-plus-barter A syndication deal in which the station pays the distributor a fee for program rights and gives the *syndicator* one or two minutes per half hour for national advertising sale; the station retains the remaining advertising time.

casting tape A videotape showing prospective actors in various roles; used especially for proposed *soap operas* and live-action children's programs.

CATV The original name for the cable industry, standing for "community antenna television" and referring to retransmission of broadcast television signals to homes without adequate quantity or quality of reception.

C-band The frequencies used by some communications satellites, specifically from 4 to 6 gigaHertz (billions of cycles per second). See also *Ku-band*.

channel balance Carrying several cable services having varied appeals.

channel capacity The maximum number of channels a cable system can deliver.

channel matching Locating *over-the-air* stations on the same cable channel number as their broadcast channel.

channel piggybacking Two cable networks time-sharing a single channel.

channel repertoire The array of television channels a viewer usually watches, on average thirteen.

charts Music rankings as listed in trade publications.

checkerboarding Scheduling five daily programs alternately, one each day in the same time period; that is, rotating two, three, or five different shows five days of the week in the same time period.

cherrypicking In cable, selecting individual programs from several cable networks to assemble into a single channel (as opposed to carrying a full schedule from one cable network).

CHR Contemporary hit radio, a format that plays the top songs but uses a larger *playlist* than the top 40.

churn Turnover; in cable, the addition and subtraction of subscribers or the substitution of one pay-cable service for another. In broadcast network television, shifting of the prime-time schedule. In public broadcasting, changes in membership.

churn rate A cable industry formula that accounts for when a subscriber connects, *disconnects*, *upgrades*, and *downgrades*.

classic rock Radio music format consisting of older ('50s, '60s, '70s, '80s, even '90s) songs.

clearance Acceptance of a network program by affiliates for airing; the total number of clearances governs a network program's potential audience size.

clear channel An AM radio station the FCC allows to dominate its frequency with up to 50 kilowatts of power; usually protected for up to 750 miles at night.

click-through An e-commerce measurement of the use of a link to assist another web site.

clipping Illegally cutting off the beginning or end of programs or commercials, often for the purpose of substituting additional commercials.

clipping file A collection of newspaper and magazine articles saved for some purpose, such as background and fill-in material for talk-show hosts.

clocks Hourly program schedules, visually realized as parts of a circular clock. See also *wheel*.

clone A close copy of a prime-time show, usually on another network. Compare with *spinoff*.

closed captioning Textual information for the hearing impaired—transmitted in the vertical blanking interval —that appears superimposed over television pictures.

clustering Grouping channels on a cable system for marketing and pricing purposes; operating multiple cable systems in adjacent geographic areas to achieve economies of scale.

clutter Excessive amounts of nonprogram material during commercial breaks; includes credits, IDs, *promos*, audio tags, and commercial spots.

coding In radio, classifying songs by type or age of music and play frequency.

commentary Background and event interpretation by radio or television on-air analysts.

commercial load The number of commercial minutes aired per hour.

common carriage Airing prime-time PBS programs simultaneously on many public stations.

common carriers Organizations that lease transmission facilities to all applicants; in cable, firms that provide superstation signal distribution by microwave and satellite. They are federally regulated.

common channel lineup Identical service arrays on cable channel dials/tuners/converters on most cable systems within a market.

community access channels Local cable television channels programmed by community members, required by some franchise agreements.

community service grants Financial grants from the *Corporation for Public Broadcasting* to public television and radio stations for operating costs and the purchase of programs.

compact disc (CD) A small digital recording read optically by a laser; it may be used for computer data, visuals, or sound.

compensation A broadcast network payment to an affiliate for carrying network commercials, usually within programs (but sometimes radio affiliates carry only the commercials embedded in a local program).

compensation incentive Usually a cash payment by a network or syndicator to encourage program clearance.

composite week An arbitrarily designated seven days of program logs from different weeks, reviewed by the FCC in checking on licensee program performance versus promise (until 1982 for radio).

compression Technical process for reducing the necessary bandwidth of a television signal so that two, four, or more signals can fit in the same width of frequencies. Used on satellites and cable.

compulsory licensing Federal requirement that cable operators pay mandatory fees for the right to retransmit copyrighted material (such as broadcast station and superstation signals); the amounts are set by government rather than through private negotiations. See also *copyright*.

concept testing Research practices asking audiences whether they like the ideas for a proposed program.

consideration Payment of some kind (usually money or extraordinary effort) to be allowed to participate in a contest. The combination of consideration, chance, and prize is considered to be a *lottery* by the *Federal Communications Commission*.

contemporary FCC radio format term covering popular music, generally referring to rock and broken out into the subcategories of adult contemporary (AC), contemporary hit radio (CHR), and urban contemporary (UC).

content providers Term commonly used for companies and individuals supplying programming for the Internet.

continuity acceptance Station, network, or system policies regarding the technical quality and content claims in broadcast advertising messages.

continuous season Network television scheduling pattern spreading new program starts across the September to May year rather than concentrating them in September/October and January/February. In other words, having program starts scattered from September to April, and perhaps even year-round.

Conus A nationwide news service for licensing television stations using satellite delivery of timely news stories from all over the country.

convergence Technological melding of separate communication devices (TVs, computers, telephones) into one system.

converter An electronic device that shifts channels transmitted by a cable system to other channels on a subscriber's television set.

cookie Software that attaches to the user's hard drive and provides evidence of web sites accessed.

co-op Shared costs for advertising.

cooperation rate In ratings, the percentage of contacted individuals or households agreeing to participate in program or station/network audience evaluation, such as by filling out a diary or agreeing to have an electronic peoplemeter installed in the home and attached to TV sets.

coproduction An agreement to produce a program in which costs are shared between two or more companies (studios), stations, or networks.

copyright Registration of television or radio programs or movies (or other media) with the federal Copyright Office, restricting permission for use.

copyright fee In general, a fee paid for permission to use or reproduce copyrighted material; in cable, a mandatory fee paid by cable operators for reuse of broadcast programs; in online, fees paid for reuse of any printed and video content.

copyright royalty fee Money paid for permission to use copyrighted material.

core schedule In the early 1980s, two hours of programs fed to PBS member stations for simultaneous

airing four nights a week, ending in 1986. The term now loosely refers to prime-time programs tagged for same-night showing on public television stations. See *same-night carriage*.

corporate underwriters National or local companies that pay all or part of the cost of producing, purchasing, or distributing a noncommercial television or radio program; they may fund programs on PBS, NPR, or local public broadcast stations. See also *underwriter*.

Corporation for Public Broadcasting (CPB) A government-funded financial and administrative unit of national public broadcasting since 1968.

cost per episode The price of licensing each individual program in a syndicated series.

cost per point The amount an advertising agency will pay for each ratings point.

cost per thousand (CPM) How much it costs an advertiser to reach a thousand viewers, listeners, users, or subscribers.

counterprogramming Scheduling programs with contrasting appeal to target unserved or underserved demographic groups.

coventure Shared program financing and production among two or more stations, networks, cable systems, or other programming entities.

CPB-qualified stations Public radio stations receiving *community service grants* from the *Corporation for Public Broadcasting (CPB)*. The prerequisites for qualification include a large budget, paid staff, strong signal, and so on.

crawl Electronically generated words that move horizontally across the television screen.

crime dramas Hour-long television series with main characters who are detectives, police, district attorneys, lawyers, and so on; these series are usually aired first in *prime time*.

critical information pile A quantity of important news breaking simultaneously that causes massive alterations in planned news coverage.

crossmedia ownership Owning two or more broadcast stations, cable systems, newspapers, or other media in the same market. This was prohibited by the FCC unless an exception was granted (temporary or grandfathered) until ownership rules loosened somewhat in 1992 and again in 1996.

crossover Temporarily using characters from one program series in episodes of another series. Compare with *spinoff* and *clone*.

crossover points Times when one network's programs end and another's begin, usually on the hour and half hour, permitting viewers to change channels easily (although a long program such as a movie may bridge some hour and half-hour points).

crossover songs Music (or performers) that fits within two or more radio formats (for example, songs played by country and AC disc jockeys).

crossownership rules FCC rules limiting control of broadcast, newspaper, or cable interests in the same market.

cume A cumulative rating; the total number of different households that tune to a station at different times, generally over a one-week period; used especially in commercial and public radio, public television, and commercial sales.

cybercasting Using the Internet and other online services to transmit live audio and video.

cycle Span of news flow between repeat points in all-news radio.

daypart A period of two or more hours, considered to be a strategic unit in program schedules (for example, morning *drivetime* in radio, 6 to 10 A.M., and *prime time* in television, 8 to 11 P.M.).

dayparting Altering programming to fit with the audience's changing activities during different times of the day (such as shifting from music to news during *drivetime*).

daytimer An AM radio station licensed to broadcast only from dawn to dusk.

deficit financing Licensing television programs to the broadcast networks at an initial loss, counting on later profits from syndication rights to cover production costs. This practice is employed by the major Hollywood studios.

delayed carriage Airing a network program later on tape.

demographics Descriptive information on an audience, usually the vital statistics of age and sex, possibly including education and income.

demo tape Demonstration tape of a program, used for preview without the expense of producing a *pilot*.

Designated Market Area (DMA) Nielsen's term for a local viewing area. See also Arbitron's *Area of Dominant Influence (ADI)*.

diary An instrument for recording hours of listening or viewing of a station or cable service. Used by Arbi-

tron, Nielsen, and other research firms, it is filled out by audience members.

differentiation The perceived separation between networks, stations, or services by the audience and advertisers, generally based on programming differences and promotional images.

digital Technology that utilizes the binary code (on/off) of computers as opposed to continuous signals (analog).

digital audio broadcasting (DAB) A proposed system for *over-the-air* broadcasting utilizing *digital* encoding and decoding.

digital audio radio service (DARS) Satellite-delivered multichannel digital radio.

digital compression A technology that eliminates redundant information in a television picture or radio sound to reduce the bandwidth needed for transmission; missing information is recreated at the receiving end.

digital delay unit An electronic device to delay programs for a few seconds between studio and transmitter to permit dumping of profanity, personal attacks, and other unairable material. This is commonly used on *call-in* programs.

Digital Media Report (DMR) A web-tracking service.

digital subscriber line (DSL) Telephone lines capable of handling the high-speed digital signals needed for video streaming.

digital versatile (video) disc (DVD) Rented and purchased discs carrying video of whole movies or other programs to be replayed on special DVD players.

digital video recorder (DVR) Playback or recording machine for a DVD.

direct broadcast satellites (DBS) Special satellites intended for redistribution of high-powered television signals to individual subscribers' receiving dishes, requiring only small home or office receiving dishes; recently called *direct-to-home* transmission.

direct-to-home (DTH) Television signals distributed by satellite to receivers on individual homes and office buildings, bypassing *over-the-air* stations and cable systems.

disc jockey (DJ) A radio announcer who introduces music.

disconnects Cable subscribers who have canceled their service.

dish Receiving or sending antenna with a bowl shape, intended for transmitting satellite signals; also called *earth station*.

distant signals Broadcast station signals imported from another market and retransmitted to cabled homes; usually independents. See also *superstations*.

distribution window A period of time in which a movie or television program is available to another medium. See also *window*, *pay window*, and *broadcast window*.

docudrama A fictionalized drama of real events and people.

documentary A program that records actual events and real people.

double jeopardy When shows with small audiences attract less committed viewers, which in turn lowers the chance of improving the ratings.

double running The practice of showing additional episodes of a successful show on the same day.

downgrading Reducing the number or value of pay services by a subscriber (reverse of *upgrading*).

downlink Satellite-to-ground transmission path, the reverse of *uplink*; refers also to the receiving antenna (*dish*).

download Transmission and decoding signals at the receiving end; used for satellite program (and computer) signals.

downscale Audience or subscribers with lower than average socioeconomic demographics, especially low income. See also *upscale*.

downtrending A pattern of declining ratings/shares over time (reverse of *uptrending*).

drama A prime-time series program format, usually one hour long, contrasting with *situation comedy*. It includes action-adventure, crime, doctor, adult soap, and other dramatic forms.

drivetime In radio, 6 to 10 A.M. (morning drive) and 4 to 7 P.M. (afternoon drive).

drops Individual household hookups to cable wires, running from the street to the house or apartment.

dual format A public radio format consisting of two unrelated formats, usually news and jazz or news and classical, attracting different audiences.

duopoly rule An obsolete FCC rule that limited ownership of stations with overlapping coverage areas.

duplicator dilemma The problem of having the same NPR programs on more than one public station in a

market because affiliations and program rights are not exclusive.

early fringe In television, the locally programmed period preceding the early news, usually 4 to 6 P.M. See also *fringe*.

earth station Ground receiver/transmitter of satellite signals; when transmitting it's called an *uplink;* when receiving it is a downlink. In television or radio, its purpose is to redirect satellite signals to a broadcast station or to cable *headend* equipment. It is also used to receive signals directly at homes or offices without a broadcast or cable intermediary via receive-only stations, also called antennas or *dishes*.

eclectic A mixed radio format applied to varied programming in radio incorporating several types of programs; a recognized format in public radio.

e-commerce Online sales of products and services.

editorials In broadcasting, statements of management's point of view on issues.

educational programs Television programs for schools, at home children, or at-home adults that have instructional value. See also *telecourses*.

effective radiated power (ERP) Watts of power measured at receiving antennas on average; it is used to measure the strength of signals.

electromagnetic spectrum The airwaves, including AM, FM, UHF, VHF, and microwave used by radio and television, as well as ultraviolet, X rays, gamma rays, and so on.

electronic newsgathering (ENG) This refers to portable television equipment used to shoot and tape news stories on location.

electronic program guide On-screen program listings to promote more viewing and aid subscribers in choosing programs.

encore In *pay-cable*, repeat scheduling of a movie or special in a month subsequent to the month of its first cable network appearance.

enhanced viewing Logos and other on-screen methods of linking web sites to broadcast programs.

endbreaks Commercial breaks following a program's closing credits.

end-to-end Refers to the entire commercial digital communication process from source to receiver, including hardware, software, programming, and billing.

episode One show out of a series.

episode testing Studies of audience reactions to plot changes, characters, settings, and so on while the show is in production.

equal employment opportunity (EEO) Federal law prohibiting discrimination in employment on the basis of age, race, or sex.

equal time An FCC rule incorporated in the Communications Act of 1934 requiring equivalent airtime for candidates running for public office.

equity holdings A financial interest from part ownership of a business; it is the same as "equity interest" or *equity shares*.

equity shares Ownership shares offered as compensation or incentive to cable operators for making *shelf space* for a cable network, especially newly introduced networks such as shopping services.

ethnic Programming by or for minority groups (for example, Spanish-speaking, Native Americans, or African Americans).

exclusive cume Total audience of individuals listening only to a certain radio station.

exclusive rights The sole contractual right to exhibit a program within a given period of time in a given market. See also *syndicated exclusivity rule*.

expanded basic tier A level of cable service beyond the most basic *tier,* offered for an additional charge and comprising a package (or *bundle*) of several cable networks —usually advertiser-supported services.

expanded sample frame (ESF) The base unit for a sampling technique that includes new and unlisted telephone numbers.

extraneous wraps Reusable closings for radio news, prerecorded by an announcer or reporter for later on-air use; often used around wire service stories.

Fairness Doctrine A former FCC policy requiring that *stations* provide airtime for opposing views on controversial issues of public importance. This requirement ended in 1987.

feature Radio program material other than hard news, sports, weather, stock market reports, or music; also called *short-form* programs. In television and cable, this is generally short for theatrical feature films.

feature film A theatrical motion picture, usually made for theater distribution, followed by *home video* sales, *pay-per-view*, and *pay-cable* play; some are aired by the *over-the-air* networks. Feature films occupy about one-fifth of the total syndication market.

feature syndicator Distributor of short, stand-alone programs or series, as contrasted with *long-form* (continuous) programming; used mostly in radio, less in television and cable.

Federal Communications Commission Government agency that regulates communications.

fiber optics Very thin and pliable glass cylinders capable of carrying wide bands of frequencies. See also *optical fiber*.

Financial Interest and Network Syndication Rules
FCC regulations prohibiting broadcast networks from owning an interest in the domestic syndication rights of most television and radio programs they carry; modified to increase the number of hours a network can produce for its own schedule in 1991; eliminated in 1995.

Fin-Syn Industry shorthand for *Financial Interest and Network Syndication Rules*.

first refusal rights The legal right to consider a program proposal until deciding whether to produce it; this can stymie a program idea for years.

first-run The first airing of a television program (not counting the theatrical exhibit of feature films).

first-run syndication Distribution of programs produced for initial release on stations, as opposed to the broadcast networks. Compare with *off-network syndication*.

flash animation A low frame-rate technique for compressed video using slow speeds.

flat fee A method of payment involving a fixed lump price; contrasts with a sliding scale (usually based on number of viewers).

flip card A filing system for record rotation at radio stations.

flipping Changing channels frequently during programs. See *grazing*.

focus group A research method in which people participate in a joint interview on a predetermined topic.

foremarket The migration of a cable-originated program to a broadcast network. See *aftermarket*.

format The overall programming design of a station, cable service, or specific program, especially used for radio and cable program packages.

format-exclusive In radio, syndicating of programming to only one station with each format in a market.

format programming Program ideas sold to other countries to be implemented in local languages with local actors.

formula The set of elements that define a format.

foundation cable networks In cable, the earliest established and most widely carried *cable networks;* those most cable operators think essential to carry.

franchise area A license granted by local government to provide cable service, based on the local government's right to regulate public rights of way. The franchise agreement delineates a geographic area to be wired.

franchising authority The local governmental body awarding a franchise to build and operate a cable system involving wires that cross city streets and rights of way. A fee is charged to cable operators, based on the principle that the public should be reimbursed for use of its property in a commercial business.

free-form A talk radio *format* in which callers' interests set the program's agenda; also called "open-line" talk.

free-form community stations A public access radio format, begun in the 1960s most notably by Lorenzo Milam.

frequency In advertising, the number of times the audience was exposed to a message. Also, the portions of the electromagnetic spectrum used for AM, FM, and television broadcasting, cable distribution, and satellite *uplinks* and *downlinks;* a channel number is shorthand for an assigned frequency. See *C-band* and *Ku-band*.

fringe The television time periods adjacent to *prime time*—from 4 to 7 P.M. and 11 P.M. to midnight or later (EST). *Early fringe* means the time preceding the early local newscast; late fringe starts after the end of late local news, usually at 11:30 P.M.

front- and backend deal A program licensing agreement in which the *station* pays a portion of the fees at the time of the contract and the remainder when the program becomes available; see *futures*.

frontload In pay television, to schedule all main attractions at the beginning of the month.

futures Projected episodes in a series that have not yet been produced; typically, network series programming intended for syndication that may be purchased while the series is still on the network for a negotiated price that accounts for the purchaser's risk.

genre Type of program, as in sitcom, drama, news, and reality.

geodemographic A segment of the population identified by lifestyle.

global brands Brand names recognized around the world, such as Disney, Coca Cola, and Microsoft.

gold A hit song or record generally with lasting appeal; in sales, a song selling a million copies, an album selling 500,000 copies.

Gold Book A list of *gold* (classic) records for use in radio programming.

grandfathering Exempting situations already in effect at the time a new law is passed.

graphics Titles and other artwork used in programs, newscasts, *promos*, or commercial spots.

grazing Checking out many television channels using a remote control.

gross rating points In advertising and promotion, a system for calculating the size of the delivered or anticipated audience by summing the rating points for all airings of a *spot*.

group The parent corporation, owners of several broadcast stations or cable systems.

group-owned station A radio or television station licensed to a corporation owning two or more stations; a cable system owned in common with many other cable systems. See also MSO.

group owner An individual or company having the license for more than two broadcast facilities. Compare with MSO.

guides Program listings, presented in printed or electronic form.

hammocking Positioning a weak program between two successful programs to support a new or less successful program by lending their audiences to it.

hard news Daily factual reporting of national, international, or local events, especially focused on fast-breaking events. Compare with *soft news*.

headend Technical headquarters for receiving and transmitting equipment for a cable system where signals are placed on outgoing channels.

heterogeneity Audiences consisting of demographically or psychographically mixed viewers or listeners. Compare with *homogeneity*.

hiatus A period of weeks or months in which a program is pulled off the air, usually for revamping to improve its ratings when it returns to the air, although many series never return.

high-definition television (HDTV) Various technical systems for distributing video with higher quality and a wider aspect ratio than standard television broadcasting, generally using a greater *bandwidth* in the spectrum and more scanning lines. See also *aspect ratio*.

hit list Names of controversial programs avoided by an advertiser.

homemade programming Amateur video.

homes passed (HP) The total number of buildings cable wires pass, irrespective of whether the occupants are or are not cable subscribers.

home satellite dishes (HSD) Low-power C-band dish antennas serving a house or apartment building.

home video The movie and television program sales and rental business.

homogeneity Audiences composed of demographically or psychographically similar viewers or listeners.

hook A plot or character element at the start of a program that grabs audience attention; also, in radio research, a brief song segment characterizing a whole song.

horizontal documentaries A multipart treatment of a news subject spread over several successive days or weeks. Compare with *vertical documentaries*.

horizontal scheduling *Stripping* programs or episodes across the week. Compare with *vertical stacking*.

host A personality who moderates a program or conducts interviews on radio, television, or cable.

hot clock See *wheel* or *clocks*.

households having sets (HHs) A ratings industry term for the total number of homes with receiving sets (AM or FM radio, UHF or VHF television, or cable hookups); that is, the total potential audience.

households using television (HUTs) A ratings industry term for the total number of sets turned on during an *average quarter hour*; that is, the actual viewing audience to be divided among all stations and cable services in a market.

hyping or hypoing Extended promotion of a program; stunting or airing of special programs to increase audience size during a *ratings period*.

ideal demographics The theory that a particular age and sex group should be the target of prime-time network television programs.

impulse ordering Technology that permits a cable viewer to punch up and purchase a *pay-per-view* program or merchandise using a hand-held *remote control*.

incentive An enticement to make a deal or sign a contract. Examples include additional local *avails* offered to stations or cable systems by a syndicator or network or payments for clearing a program; also, discounts and prizes offered to lure potential cable subscribers.

incubation strategy Launching a new network by sheltering the new service under an existing network (a.k.a., sheltered launch).

indecency A subcategory of the legal definition of obscenity, enforced by the FCC. Generally it refers to prohibited sexual and excretory language and depictions of such behavior.

independent A commercial television broadcast station not affiliated with one of the national networks (by one FCC definition, carries fewer than 15 hours of network programming per week in prime time).

independent producers Makers of television series, movies, or specials who are legally separate entities from the Hollywood movie studios.

infomercial A long sales pitch disguised as a program, called a "program-length commercial," usually lasting from 15 to 30 minutes or more and presented on cable channels or stations in less popular time periods.

infotainment A mix of information and entertainment.

inheritance effect A research term for an audience carried over into a subsequent program's audience. See also *lead-in*.

in-house Programs produced in the station's own facilities as opposed to network or syndicated shows; also shows such as *soap operas*, newscasts, and public affairs that the broadcast networks produce themselves. Also called *house shows*.

insertion news In local cable, short commercial newscasts provided by broadcasters for inclusion on local cable channels.

instant messaging Live e-mail.

instructional television (ITV) Programs transmitted to schools for classroom use by public television or radio stations.

instructional television fixed service (ITFS) A television distribution system delivering programs by line-of-sight microwave to specific noncommercial and commercial users within a fixed geographic area; the usual means for delivering instructional programming to schools by public television stations.

in-tab Diaries actually returned to the ratings service in usable form and counted in the sample.

intelligent boxes Television converters that give access to multiple media activities at one time on a shared channel, as in watching television, accessing the web, and telephoning simultaneously.

interactive Media that permit users to send signals to the program source as well as receive signals from that source.

interactive cable Two-way cable that permits each household to receive one stream of programming and also to communicate with the cable *headend* computer.

interconnection grants Funds from the *Corporation for Public Broadcasting* for public television stations to cover satellite transmission costs.

interconnects Transmission links among nearby cable systems permitting shared sales and carriage of advertising spots.

interdiction In cable, a recently developed technology for interrupting unwanted (not paid for) television signals outside the household, such as on a pole or the side of a building.

interoperability The ability for two-way video, voice, and data to operate through the same home equipment.

interstitial programming Short programs intended to fill the time after an odd-length program is completed. Also called *shorts*.

inventory The amount of time a station has for sale (or the commercials, records, or programs that fill that time).

Iris Awards for outstanding local programming given by NATPE.

jock See *disc jockey* and *video jockey*.

joint venture A cooperative effort to produce, distribute, or market programs.

kiddult Television programs appealing to both children and adults.

kidvid Television programs for children.

Ku-band Frequencies used for transmitting some high-powered satellite signals, the band between 11 and 14 gigaHertz (billions of cycles per second), which require smaller receiving *dishes* than *C-band*. Compare with *C-band*.

large-market stations Broadcast stations in markets 1 to 25, as defined by the ratings companies. Compare with *mid-market stations*, *small-market stations*, and *major market*.

late night Television daypart from 11:30 P.M. to 1 A.M.

lead-in A program preceding others, usually intended to increase *audience flow* to the later programs. Called *lead-off* at the start of *prime time*.

lead-off See *lead-in*.

leased access Channels available for commercial lease, occasionally required by a cable franchise agreement, sometimes voluntarily offered by large-capacity cable systems.

least objectionable program (LOP) A theory holding that viewers select not the most appealing program among those available at one time but the one that offends fewest viewers watching together; it presumes that channel switching requires an active effort occurring only when the channel currently being viewed presents something new and objectionable.

legs Trade slang meaning a program will provide dependably high ratings, as with *blockbuster* off-network television series.

licensees Entities legally holding broadcast licenses.

license fee The charge for the use of a syndicated program, feature film, or network service.

lifespan In television, the number of years a series stays on network television.

lift Added audience gained by combining popular with less popular cable services in marketing.

limited series A television series having only a few episodes for airing.

liners Brief scripted comments by *disc jockeys* between records on music radio without music or effects.

links Navigational connections to other parts of the site or other web sites.

live Not prerecorded, or in the record industry, recorded as performed, not edited.

live assist Programming combining *disc jockey* chatter and automated music programming on tape.

live feed A program or insert coming from a network or other interconnected source without prerecording and aired simultaneously.

local-into-local A technique by which satellite operators can retransmit the appropriate local television stations within each market of their footprints.

localism An FCC policy encouraging local ownership of broadcasting and community-oriented programming.

local marketing agreements (LMAs) Contracts for sharing the functions of programming, staffing, and commercial time sales largely entered into by economically weak AM stations, much like newspaper joint operating agreements within a market.

local origination (LO) Programs the cable system produces or licenses from syndicators to show locally, including access programs, as contrasted with programs from *basic cable* networks or *pay-cable* networks.

log The official record of a broadcast day, kept by hand or automatic means such as tape, which notes opening and closing times of all programs, commercials, and other nonprogram material and facts. Once mandated by the FCC, it is now used as proof of commercial performance.

long-form In television, longer than the usual length of 30 minutes for sitcoms and 60 minutes for *dramas* or *specials* (for example, a 90-minute fall season introduction to a new prime-time *series*) or playing the entire two or three hours of a *feature* film in one evening. It also refers to a *miniseries* of ten hours or more. In radio, it is nationally distributed programming using a single musical *format*, as in automated beautiful music or rock, as opposed to syndicated features or *short-form* news.

long-form nights Evenings on which a two-hour movie or *special* is scheduled by a network.

loss leader A program (or *format*) broadcasted because management thinks it is ethically, promotionally, culturally, or aesthetically worthwhile rather than directly rewarding financially; in cable, carrying cultural channels used as image builders.

lotteries Contests involving the three elements of prize, *consideration*, and chance. Prohibited by the FCC for broadcast stations except occasionally and prohibited on broadcast stations by law in some states.

low-power television (LPTV) A class of broadcast television stations with limited transmitter strength (usually covering less than ten miles), generally assigned in areas where a full-power signal would interfere with another station using the same channel.

made-for-cable Movies produced specifically for cable airing; when financed by the *premium networks*, it's called *made-for-pay*.

made-for-online Programs, usually short films, made specifically for video streaming on the web.

made-for-pay Programs, usually feature films, produced for *pay-cable* distribution; they may later be syndicated to broadcast stations.

made-for-TV (MFTV) A movie feature produced especially for the broadcast television networks, usually fitting a 90-minute or two-hour format with breaks for commercials.

magazine format A television or radio program composed of varied segments within a common framework, structurally resembling a printed magazine.

major market One of the 100 largest metropolitan areas in number of television households by FCC definition.

mandatory licensing A nonvoluntary arrangement requiring cable operators to pay fees for the right to reuse copyrighted broadcast programming; the fees are returned by CRT to rights holders, also called *compulsory licensing*. See also *copyright*.

market report An Arbitron or Nielsen ratings book for a single market.

matching In cable, assigning the same cable channel number as a station's *over-the-air* channel number. See also *repositioning*.

merchandising Selling products, generally related to programs or media company brands, over the air or online.

metered cities The largest markets in which the stations pay Nielsen to provide overnight ratings from metered households.

Metro Area The most densely populated center of a metropolitan area, defined by Arbitron and Nielsen for rating a geographic subset of a market.

microniche services *Theme networks* targeting a population subgroup such as the hearing impaired or foreign language speakers. This is not to be confused with multiplexed *subniche networks*.

midband Channels on a coaxial cable falling between broadcast channels 6 and 7, requiring a converter, cable-ready TV set, or VCR to tune.

mid-market stations Broadcast stations in markets 26 to 100, as determined by the ratings companies. See also *large-market stations* and *small-market stations*.

minicam A small, portable television camera. See also *electronic news gathering* and *camcorder*.

minidoc A short news documentary.

mininetworks Regional, special purpose, or part-time networks formed to carry a limited program schedule, such as news reports, a holiday *special*, or sporting events. See also *ad hoc networks*.

minipay service A basic cable network that charges cable systems a small amount per subscriber per month for its programming.

miniseries Prime-time network television *series* shorter than the traditional 11 episodes.

mixed format Radio formats that use a common name but differ from station to station in the song lists they play (AC, soft rock). Compare to *pure format*.

movie libraries Those *feature films* under contract to a *station* or cable network with *plays* still available.

movie licenses Contracts for the right to play a movie a fixed number of times; currently, contract lengths average five years.

movie repetition Repeating movies on a cable network.

movie rotation Scheduling movies at different times of the day and on different days of the week on a cable network.

multichannel multipoint distribution service (MMDS) A form of pay television also called *wireless cable* that distributes up to 33 channels (and more with compression) in a market using microwave to rooftop antennas.

MPEG A series of digital video standards used for compression.

multimedia Programs, presentations, or facilities combining computerized video, audio, and data; used especially in educational and business training applications.

multipay A cable environment with many competing premium services; also, cable subscribers taking more than one pay channel.

multiple franchising Licensing more than one cable company to wire the same geographic area and compete for subscribers; this occurs very infrequently. See *overbuild*.

multiple networks In radio, several co-owned services such as ABC's six radio networks or Westwood's five networks.

multiple system operator (MSO) Owner of more than one cable system. See also *group owner*.

multiplexing Simultaneously transmitting (via subcarriers) one or more television (or radio) signals in addition to the main channel; utilizes *digital compression* to fit a 6 megaHertz NTSC signal into a narrower band; in radio, carries RBDS signals.

music sweep An uninterrupted period of music on music radio.

must-carry rule An FCC requirement that cable systems have to carry certain qualified local broadcast television stations.

narrowcasting Targeting programming, usually of a restricted type, to a nonmass audience, usually a defined demographic or ethnic group. This is used when either the programming or the audience is of a narrow type.

National Association of Broadcasters (NAB) Primary trade association of the radio and television industry.

National Association of Television Program Executives (NATPE) Main trade association of broadcast programmers.

National Public Radio (NPR) The noncommercial radio network service financed primarily by the *Corporation for Public Broadcasting* (CPB); serves affiliated *public radio* stations.

national representative See *station rep(resentative)*.

National Television Systems Committee (NTSC) The system of television (named after the group that developed the standard) prevalent in the Western Hemisphere until the introduction of *high-definition television*.

near video-on-demand (NVOD) Meaning that the viewer gets almost any program requested from a video library but is limited to the most-requested titles. See *video-on-demand*.

net net The final revenue figure for a syndicated (or local) program after all program costs, commissions, and unsold time estimates are subtracted.

network An interconnected chain of broadcast stations or cable systems that receive programming simultaneously. This also refers to the administrative and technical unit that distributes (and may originate) preplanned schedules of programs (for example, ABC, CBS, NBC, Mutual, PBS, NPR, HBO, ESPN, Showtime).

network compensation Payments by broadcast networks to affiliated stations for airing network programs and commercials.

network parity Equality in network audience sizes, usually calculated by comparing the number of affiliated stations in large, middle, and small markets. See also *parity*.

new-build A recently constructed residential area in which cable wires pass all houses.

new connects Newly built homes with cable hookups.

news block Extended news programming. In radio, the time immediately before and after the hour when stations program news; in television, the period between 5:30 and 7:30 P.M. (varies with market).

news cooperatives Joint arrangements between radio and television stations and cable systems for co-producing news.

niche networks Cable networks carrying a single type of programming, usually targeting a defined audience; also called a *theme network*.

nonclearance Written refusal to carry a particular network program by an *affiliate*.

noncommercial educational broadcasting The system of not-for-profit television and radio stations, and the networks that serve them and operate under educational licenses. These include public broadcasting, public access stations, and many religious and state- or city-operated stations.

nonduplication An FCC policy that prohibits airing the same program material on two co-owned radio stations (such as an AM and FM) in the same market (exceptions are granted in some very small markets, in *grandfathered* cases, and in cases of financial need).

nonentertainment programming News and service information such as weather and traffic reports.

nonprime time In network television, the hours outside of *prime time*, especially morning, day, and late night; nonprime-time programming sometimes excludes news and sports because they are handled by separate network departments and may schedule programs within *prime time*.

nontraditional scheduling Putting news or other programs in time blocks other than the ones normally used by network-affiliated stations.

novelas Spanish-language serials resembling *soap operas* but concluding in six months or one to two years. They generally have specific educational goals but are presented in the guise of entertainment.

off line Use of program elements as they are fed from a network or other source; also, not connected to a web portal.

off-network series Former broadcast television network show now syndicated.

off-network syndication Selling programming (usually *series*) that has appeared at least once on the national networks directly to stations or cable services.

off-premises equipment In cable, traps and converters installed on telephone poles or the sides of buildings outside the subscriber's home.

off-season For the broadcast networks, the 12 weeks of summer (the season went to 40 weeks in 1996).

online Transmitted from an Internet company, originally by telephone wire; connected to a web portal.

online networks or services Usually a web *portal* or a broadcast or cable network operating multiple web sites.

open architecture A flexible technical infrastructure that transforms a variety of signals into viewable or listenable content.

operating income A company's profits before taxes and interest payments are deducted.

optical fiber Very thin strands of glass capable of carrying hundreds of video signals and thousands of audio or data signals; used in cable television to replace coaxial cable trunk and feeder lines, and in telephone to replace telephone trunk wires.

output deals Preselling of not-yet-produced programs by producers, usually to other countries.

overbuild A second cable system built where another firm already has one. See also *multiple franchising*.

overmarketing Persuading people to subscribe to more cable services than they can readily afford.

overnight Radio airtime from midnight to 6 A.M.; television programming from 1 or 2 A.M. to 4 or 6 A.M.

overnights National television *ratings* from metered homes in major cities available the following day to network programmers.

over-the-air Broadcast, as opposed to delivered by a wired service such as cable television.

owned-and-operated (O&O) station Broadcasting station owned and operated by one of the major broadcast networks.

page views Documents requested by online users, also called page impressions.

parity Audience equivalence; in network television, having equal numbers of *affiliates* with equal *reach* so that each network has a fair chance to compete for *ratings/shares* based on programming popularity. Also applied in comparing VHF and UHF stations and broadcast stations with and without cable carriage. See also *network parity*.

passive meter An electronic meter recording viewing (or listening) and channel tuning that requires no action by viewers, such as pushing buttons. See also *peoplemeter* and *passive peoplemeter*.

passive peoplemeter A new generation of passive television meters incorporating an automatic camera with a computer recognition system (which matches viewer silhouettes with stored demographic information) to record viewer demographics. See also *passive meter*.

passive viewing Watching television without actively consulting all the competing program options.

pay cable Cable television programming services for which the subscriber pays an optional extra fee over and above the normal monthly cable fee. See also *pay television*, *premium networks*, and *pay-per-view*.

pay-cable households Number or percentage of total television households subscribing to a *premium* cable service.

pay-cable networks National satellite-distributed cable programming for which subscribers pay an extra monthly fee over and above the monthly fee for *basic cable* service. See also *premium networks*.

pay channel *Pay-cable* and *pay-per-view* channels supplying mostly movies, sports, and specials to cable subscribers for an optional extra monthly or per program fee.

payola Illegal payment for promoting a recording or song on the air.

pay-per-view (PPV) Cable or subscription television programming that subscribers pay individually for; purchased per program viewed rather than monthly.

pay radio Premium *cable FM*, cable networks available to subscribers for a monthly fee.

pay run Length of a movie's license (*rights*) on a cable network.

pay television An umbrella term for any programming for which viewers pay a fee; includes *pay cable*, *subscription television*, *pay-per-view*, MMDS, DBS/DTH, and TVRO packages.

pay window A period of time in which a program, usually a *feature film*, is made available to *pay cable*, generally from 6 to 12 months. See also *broadcast window* and *window*.

penetration *Reach*; in a given population, the percentage of households using a product or receiving a service.

peoplemeter An electronic meter attached to TV sets measuring both tuning and audience demographics; it requires viewers to push buttons to identify themselves. See also *passive peoplemeter*.

Personal Communication Network (PCN) A system of very small, portable telephones connected by radio signals to cable wires within a building, and from there connected by cable to the public telephone network.

personal video recorders (PVRs) Home digital equipment that can record automatically and while being viewed, with instant content access.

persons using television/persons using radio (PUTS/PURS) Measurements utilizing individual audience member's viewing and listening habits instead of household data; especially important to radio and sports programs where much listening and viewing takes place away from homes.

pilot A sample first program of a proposed television *series*. Often longer than regular episodes, it introduces characters, set, situations, and program style and is generally accompanied by heavy promotion before it is aired.

pilot testing Comparing audience reactions to a new television program under controlled conditions prior to the program's appearance in a *network* schedule.

platform A computer operating system with a certain level of technical capability.

play A showing or *run* of a program. Also, one to two showings of each episode of a program until all rights are exhausted as specified in a licensing agreement.

playlist Strategically planned list of recordings to be played on music radio.

plugola Inclusion of material in a program for the purpose of covertly promoting or advertising a product without disclosing that payment of kind was made; penalties for violating *payola* or plugola regulations may be up to a $10,000 fine and a year in prison for each offense.

pocketpiece An abbreviated version of weekly national ratings, available to network executives, covering prime-time broadcast and larger cable network programs.

population All homes with television sets or radios; cable population is all the homes with cable service. See also *universe*.

portal Company providing comprehensive access to the Internet, as in Yahoo! or AOL.

positioning Making the audience believe one *station* or cable service is really different from its competitors; especially important for *premium channels*, television stations, rock music radio stations, and cable shopping services.

prebuying Financing a movie or television series before production starts to obtain exclusive future telecast rights.

preemption Cancellation of a program by an *affiliate* after agreement to carry the program, or cancellation of an episode by a *network* to air a news or entertainment *special*. This is also applied to cancellation of a commercial sold at a special preemptible price to accommodate another commercial sold at full rate.

premiere week Start of the new fall prime-time season.

premium networks In television and radio, pay services costing subscribers an extra monthly fee over and above *basic cable*; in cable, called *pay cable* and *pay-per-view*. It also includes STV, SMATV, MMDS, and DBS/DTH services. In radio, called *pay radio* or premium *cable FM*.

prep services Brief content items supplied by radio syndicators for use on-the-air by DJs.

prerun Showing before network television air date (usually on pay television).

presold Series episodes or film idea sold before being produced (generally related to the high reputation of the producer). See also *buying* and *prebuying*.

primary affiliate A station that carries more than 50 percent of a network's schedule. See also *multiaffiliates*.

prime time Television *daypart*; in practice, 8 to 11 P.M. (EST) six days a week and 7 to 11 P.M. Sundays. Technically, any three consecutive hours between 7 P.M. and midnight.

prime-time access rule (PTAR) FCC rule forbidding network *affiliates* from carrying more than three hours of network programs and *off-network* reruns (with some exceptions) in the four hours starting at 7 P.M. EST. The rule was eliminated in 1995.

production fee License fee that the broadcast networks pay for new programs.

program availabilities Syndicated programs not yet under contract in a market, therefore available to stations for license.

program intensive A medium that uses up a lot of programs.

program log A station's record of all programs, commercials, *public service announcements*, and *nonentertainment programs* aired.

Program Practices Department Network department that clears all programs, *promos*, and commercials before

airing and is responsible for administration of network guidelines on such subjects as nudity, sex, race, profanity, and appropriateness for children. Also called "standards and practices" or "continuity acceptance department."

promo A broadcast advertising spot announcing a new program or episode or encouraging viewing of a *station's* or *network's* entire schedule.

promotion Informational and persuasive advertising of programs, *stations*, or *networks*.

promotional support *Network* or *syndicator* assistance with promotion in the local market, consisting of *co-op* funds, *ad slicks*, or other aids to increase viewing of a specific program.

protection In radio, a form of *exclusivity* in which the network supplies a program to only one *station* in a market, even if the network has affiliates whose signals overlap.

psychographics Descriptive information of the lifestyles of audience members, which includes attitudes on religion, family, social issues, interests, hobbies, and political opinions.

Public Broadcasting Service (PBS) The noncommercial, federally supported interconnection service that distributes programming nationally to member *public television* stations. It also serves as a representative of the public television industry.

Public, educational, and government (PEG) Access channels on cable television.

public radio The noncommercial radio stations in the United States qualifying for grants from the *Corporation for Public Broadcasting*, mostly FM licensees.

Public Radio International (PRI) A not-for-profit radio network serving public radio stations.

public service announcement (PSA) Noncommercial spot advocating a community event or a not-for-profit charity, or public service activity.

public station Television or radio station receiving a grant from the *Corporation for Public Broadcasting*; prior to 1967 they were called educational stations. These stations are licensed by the FCC as noncommercial educational broadcast stations.

public television (PTV) Overall term replacing "educational television" to describe federally funded noncommercial television.

pure format A radio format appealing to an easily definable demographic group who like the same music

and announcing style (AOR, country). Compare with *mixed format*.

qualitative research Systematically gathered information on broadcast and cable audiences and program viewing other than *ratings* collected by the industry; also used in sociological research to contrast with other quantitative research methods.

Radio Broadcast Data Systems (RBDS) A recently developed radio technology using FM subcarriers to *multiplex* a visual display (such as an automatic station ID) and limit electronic scanning of stations to those with a prespecified *format*.

rankers Jargon for lists of stations in a market ordered by some criterion, such as daypart audience, cume audience, and so on.

rankings In radio, lists of songs and albums by popularity, commonly published in trade magazines. In television, share rankings are lists of television shows with highest to lowest percentages of homes watching (out of homes using television).

rate structure Arrangements for revenue paybacks or licensing rights between cable operators and cable program suppliers.

rating An audience measurement unit representing the percentage of the total potential audience tuned to a specific program or for a time period.

ratings period Usually four sequential weeks during which local television station *ratings* are collected, reported week by week, and averaged for the four weeks, called a *sweep*. Four *sweeps* are conducted annually—in November, February, May, and July. In radio, this may refer to as many as 48 continuous weeks for larger markets, fewer weeks for smaller markets. In network television, it may refer to only one week in a *pocketpiece*.

reach Cumulative audience or total circulation of a station or service.

reality shows Low-budget television series using edited tapes of real people in contrived situations or at their jobs (supplemented by on-camera interviews and reenactments), especially police, and fire crews, and emergency workers.

real-time Live, as broadcast, cablecast, or webcast.

rebroadcasts Repeats of newscasts or programs, commonly used for broadcast station newscasts reshown on local cable channels.

rebuilding Redesigning and reconstructing a local cable system.

recaps Recapitulation of news events or news stories.

recurrents Songs that have been number one on *playlists* in the recent past; this is used in scheduling songs on popular music stations.

relay communications satellite A satellite that retransmits cable, telephone, and other signals to *earth stations* (for example, the Galaxy and Satcom cable satellites).

release cycles Pattern of availability of new feature films.

remote Live production from locations other than a studio (such as football games and live news events).

remote control A handheld, infrared-operated device for tuning television channels, turning sets on and off, muting sound, controlling VCR and DVD player operations, and other functions.

repackaging Grouping sets of television shows or movies to run as a tribute to a performer or to create a theme.

repertoire The number of channels or sites regularly accessed.

repositioning Moving *stations* and *networks* to different positions on a cable channel array; this generally refers to moving broadcast stations away from channel numbers corresponding to their *over-the-air* channel numbers. Compare with *matching*.

repurposing Using content originally produced for one medium in another medium.

rerelease Second round of theater showings of a recently made movie.

rerun Repeat showing of a program first aired earlier in the season or in some previous season. Commonly applied to *series* episodes.

resale rights Permission from wholesaler to offer copyrighted material for retail sale, republication, or retelecasting.

reselling Offering a program to the public for purchase as in the videocassette and DVD rental and sales business. See also *resale rights*.

reserve price The minimum acceptable bid for a syndicated television program.

residual rights Royalty payments for reuse of shows or, in the case of radio, voiced announcements, news features, and other content.

response rate The number of persons who order an item.

rest The length of time a *feature film* or other program is withheld from cable or broadcast syndication (or local station airing) to avoid overexposure.

resting Shelving a movie or *series* for a period of time to make it seem fresh when revived.

retransmission consent Control by originating station of the right to retransmit that station's signals for use by cable systems. Also, a proposal to require agreement from copyright holders (probably for a fee) before programs can be picked up by resale carriers (*cable systems, common carriers*). This issue particularly affects *superstations*, cable operators, satellite carriers, and writers/producers. It cannot be implemented without giving up *mandatory licensing*.

reuse fees Royalties for replay of recorded material.

revenue split Division of pay revenues from subscribers between cable operator and cable network (usually 60/40 or 50/50).

revenue streams Sources of income, as in advertising, subscriptions, and merchandise sales.

rights Legal authority or permission to do something, especially with copyrighted material.

rip-and-read The simplest form of newscasting; the announcer rips copy from the wire service and reads it on the air.

roadblocking Simultaneously airing a program or commercial on all three networks to gain maximum exposure for the content (for example, presidential addresses, political campaign spots, and commercial spots).

rocker Colloquial term for a radio station with a rock music *format*.

roll out The period for developing, producing, and scheduling new programs. Also applied to a new network's multistage plans for filling *prime time*.

rotation In radio, the frequency with which different types of songs are played.

rotation scheduling In television, repeating programs (usually movies) four to six times during a month on different days and often in different *dayparts* to encourage viewing, creating a cumulatively large audience. This technique is used by *pay-cable* and *public television* services. In radio, it is the pattern of song play.

royalty Compensation paid to copyright holder for the right to use copyrighted material. See also *copyright* and *compulsory licensing*.

run The play of all episodes of a *series* one time or play of a movie.

run-through Staging a proposed show for preview by program executives; this often replaces a script for game shows.

safe harbor Late-night time period in which children are not likely to form a large part of the viewing audience.

same-night carriage An agreement between PBS and *public television* stations to air *tagged* programs on the day and time they are delivered by PBS.

sample size The number of people surveyed (in radio or television, asked to fill out a diary or have a meter installed). See *in-tab*.

sampling frame The population from which a ratings sample is drawn.

sandwich For affiliate news, splitting the local news into two sections placed before and after the network newscast. In promotion, standardized opening and closing segments of a *promo*.

satellite master antenna television (SMATV) Also called master antenna television (MATV); this is satellite-fed television serving multiunit dwellings through a single satellite *earth station*. The service is distributed within a restricted geographic area (private property) not requiring a *franchise* to cross city streets or public rights-of-way. Otherwise similar to cable service, charging a monthly fee and usually delivering a mix of satellite-distributed pay and basic networks.

scatter Advertising time purchased on an as-needed basis.

schedule The arrangement of programs in a sequence.

scrambling Altering a television transmission so that a proper picture requires a special decoder to prevent unauthorized reception.

screener An assistant who preinterviews incoming callers or guests on participatory programs; also called *call screener*.

screening In research, locating individuals fitting specific age or gender criteria.

seamless transition An *audience flow* scheduling strategy that cuts all interrupting elements at the break between two programs to move viewers smoothly from one program into the next. This is difficult to achieve because most contracts with producers require playing closing and opening credits, and the advertising time at breaks between programs is especially valuable.

search engines Software that classifies and makes accessible portions of databases.

second season Traditionally the 11 to 13 weeks of episodes (of new or continuing programs) beginning in January.

segmentation Subdividing formats to appeal to narrow target audiences.

sellout rate The percentage of advertising inventory sold.

sell-through The potential of a movie on videocassette or DVD to attract purchase rather than solely rental in video stores.

semipilot A sample videotape version of a proposed game show with audience and production devices (such as music) but no finished set.

series A program that has multiple *episodes* sharing a common cast, plot line, and situation.

servers Hard drives, especially very large ones used by *portals* and *search engines*.

service information Hourly reports (in some *dayparts*) on weather, traffic, school closings, sports scores, and other matters of practical value to local listeners.

share A measurement unit for comparing audiences; it represents the percentage of total listening or viewing audience (with sets on) tuned to a given station. The total shares in a designated area in a given time period equal 100 percent.

shared time slot A time period for which two or more short series are scheduled sequentially, first one complete series, then another complete series.

shelf space Vacancies on the channel array of a cable system.

shock jocks Talk-show *hosts* and *disc jockeys* who attract attention with controversial material; this is generally targeted to adult males with off-color patter and jokes, usually in major markets.

shopping services Cable networks supplying merchandise for purchase as *long-form* programming.

short-form Program material in less than 30-minute lengths on television; typically one to five minutes long for radio. This also refers to *miniseries* that are four to six hours long. Compare with *long-form*.

shorts Very brief programs, usually five minutes or less in length. See also *interstitial programming*.

signal-to-noise ratio The relationship between the amount of transmission noise in a signal and the intended sounds or data.

signature programs Key programs that give identity to a *network* or *station*.

simulcast Airing simultaneously on two or more channels.

sitcom See *situation comedy*.

situation comedy (sitcom) A program (usually a half hour in length) in which characters react to new plots or altered situations.

skew graphs Bar graphs showing the percentage of each of six demographic groups a station reaches; they are used to compare all stations in a market.

skewing Tending to emphasize one demographic group.

slow-builders Programs acquiring a loyal audience only after many months on the air.

small-market stations Broadcast stations in markets 101 to 211, as defined by the ratings companies. See also *large-market stations*, *mid-market stations*, and *major market*.

small sweeps July *ratings* period. See *sweeps*.

SNAP A third-party processor of Nielsen ratings.

soap opera A serial drama generally scheduled on broadcast networks during weekday afternoons. Advertisers (such as laundry detergent manufacturers) that target homemakers dominate advertising time.

soft news Opposite of *hard*, fast-breaking news; consists of features and reports that do not depend on timely airing (for example, medical reports, entertainment industry stories, leisure, health, and hobby material).

soft rock A radio music *format* consisting of current hits but without heavy metal and other hard rock songs.

source/loss report Measurements of the flow in and out of a web site.

special One-time entertainment or news program of unusual interest; applied to *network* programs that interrupt regular schedules.

spin In *pay cable*, the migration of subscribers from one pay service to another; also called *substitution*. See also *spin research*.

spinoff A *series* using a secondary character from another series as the lead in a new prime-time series, usually on the same network. Compare with *clone*.

spin research SRI's method of testing what station time periods work well for a particular show.

spot A commercial advertisement usually of 15 or 30 seconds in length, or a period of time in which an advertisement, a *promo*, or a public service announcement can be scheduled.

stacking Sequential airing of several hours of the same kind of programs; similar to *block programming*.

standard definition television (SDTV) Characterized by 6 megaHertz bandwidth and 2:1 interlace, used by traditional UHF and VHF stations.

standard error A statistical term accounting for unavoidable measurement differences between any sample and the population from which it was drawn.

Standards and Practices Department See *Program Practices Department*.

station A facility operated by licensee to broadcast radio or television signals on an assigned frequency; it may be affiliated by contract with a *network* (for example, ABC, NPR) or *independent* (unaffiliated), commercial or noncommercial.

station rep(resentative) Firm acting as the sales agent for client station's advertising time in the national market.

staying power A *series* idea's ability to remain popular year after year.

step deal An agreement to supply funds to develop a program idea in stages from expanded concept statement to scripts to *pilot* to four or more *episodes*.

stickiness The measure of time spent at a web site, comparable to *time-spent-listening* in radio.

stockpiling Preemptive buying of syndicated programs for future use that also keeps them off the market and unavailable to competitors. See also *warehousing*.

stop set Interruption of music on radio to air commercials or other nonmusic material.

streaming Digital distribution of audio or video in near real-time, also called *webcasting*.

stringer A freelance reporter paid per story rather than by the hour or the month.

stripping Across-the-board scheduling; putting successive episodes of a program into the same time period every day, five days per week (for example, placing *Star Trek* every evening at 7 P.M.).

strip run/strip slot See *stripping*.

stunting Frequently adding *specials* and shifting programs in the schedule; also using *long-form* for a program's introduction or character *crossovers*. The goal is to attract audience attention and consequent viewership.

This technique is frequently used in the week preceding the kickoff of a new fall season combined with heavy promotion; also used in *sweeps*.

subniche networks Second and third television program services (*networks*) *multiplexed* with the established signal to capture more of the viewing audience, or may reschedule the established network's movies or programs (*time shifting*) to gain large cumulative audiences for the same programming.

subscription channel A program channel, normally delivered via cable or satellite, carrying audio or video pay programming.

subscription television (STV) *Over-the-air* pay television (scrambled).

substitution Cable subscribers replacing one cable pay service with another. See *spin*.

success rate The percentage or number of programs renewed for a second year.

summer schedules A recently introduced *network* practice of scheduling original *series* in the summer. Compare with *second season* and *continuous season*.

superband Channels on a coaxial cable between the broadcast frequencies of channels 13 and 14 (above VHF and below UHF); they require a converter or VCR tuner.

superstation An *independent* television *station* that has its signal retransmitted by satellite to distant cable companies for redistribution to subscribers (for example, WGN-TV from Chicago).

sweepers Short, highly produced imaging pieces that include call letter and identifying slogans and sounds, used as recurring radio station identification.

sweeps The periods each year when Arbitron and Nielsen gather audience data for the entire country; the ratings base from a sweep determines the *network* and *station rates* for advertising time until the next sweep. For television, the four times are November (fall season ratings are most important because they become the ratings base for the rest of the year); February (rates fall season again plus replacements); May (end-of-year ratings); and July, when a small sweep takes place (summer replacements). Radio sweeps occur at different times and vary from 48 weeks to two to six periods annually depending on market size.

switched video A digital process permitting consumers to select from libraries of program or movie titles for instantaneous viewing, rather like dialing a telephone

number switches the caller to another telephone. See also *video-on-demand*.

switch-in Adding a new cable service to an established lineup (usually involves canceling one existing service).

switch-out Dropping one cable service from an established lineup, generally to replace it with another service.

syndex *Syndicated exclusivity rule* governing syndication of television programs.

syndicated exclusivity rule Called *syndex*, an FCC rule (reinstated in 1989) requiring cable systems bringing in *distant signals* to block out syndicated programming (usually on *superstations*) for which a local broadcaster owns *exclusive rights*.

syndication Marketing programs directly to stations or cable (rather than through a broadcast *network*) for a specified number of *plays*; *syndicators* are companies that hold the rights to distribute programs nationally or internationally. See also *off-network syndication*.

syndication barter The practice in which the advertiser rather than the station buys the rights to a *syndicated* program and barters the remaining spots to stations in exchange for airing its own spots free in the program. Same as *barter syndication*.

syndication window The length of time a program, usually a *feature film*, is made available to broadcast stations, generally ranging from three to six years, but it may be as short as two months for pay television. See also *pay window*.

syndicator A company marketing television or radio programs to *stations* and *cable systems* within the United States and in other countries.

tabloid program Sensationalistic news or entertainment shows resembling supermarket tabloid newspapers (for example, *Hard Copy, Inside Edition*).

tagged Shows identified by PBS for *same-night carriage*.

talk A radio *format* characterized by conversation between program *hosts* and callers, interviews, and monologues by personalities.

tampering Unlawfully influencing the outcome of the ratings; see also *hyping* or *hypoing*.

targeting Aiming programs (generally by selecting appropriate appeals) at a demographically or psychographically defined audience.

t-commerce Over-the-air television sale of online products and services.

teaser A very brief news item or program spot intended to lure a potential audience into watching or listening to the succeeding program or news story; referred to as the "teaser" when used as a program introduction.

telecourses Instructional courses viewed on *public television* or a *cable network*, offered for credit in conjunction with local colleges and universities.

telenovelas Long soap opera–like series in Spanish that have definite endings.

television quotient data (TvQs) Program and personality popularity ratings, typically measuring familiarity and liking, characterized by viewer surveys asking respondents to tell if a program or a personality is "one of their favorites."

television receive-only (TVRO) Referring to owners of backyard satellite *dishes* and the home satellite market. See also *direct broadcast satellites*, *downlink*, and *home satellite dishes*.

tent-poling Placing a highly rated program between two *series* with lower ratings (often new programs) intended to prop up the ratings of the preceding and following programs.

theme networks Cable networks programming of a single type of content, such as all weather, all news, or all sports. Also called *niche networks*.

theme weeks Daily movies grouped by genre or star on television stations and cable networks across several days.

third-party processors Companies that sell reports summarizing, reanalyzing, or redisplaying Nielsen data.

tier In cable, having multiple levels of cable service, each including some channels and excluding others, offered for a single package price. In syndication, having different price levels for different *dayparts*, pricing going up when stations place a syndicated program in a small-audience time period.

tiering Combining cable channels to sell at a package price; may be only basic services or a combination of pay and basic networks.

time-buyers Advertising agency executives who purchase station time on behalf of client advertisers.

time shifting Scheduling programs or movies at alternate hours for the convenience of viewers (as on *multiplexed* channels); also, playing back a home recording of a broadcast or cable network program for viewing at a time other than when it was originally scheduled.

time-spent-listening (TSL) Measure of the minutes radio listeners stay with a particular station.

time-spent-online Measure of the average connect-time for users of an Internet service. See also *stickiness*.

titles Text portion of a program with the name of the program or stars or credits or source.

tonnage Raw audience size (as opposed to demographic subgroups); used in advertising.

top 40 Radio music *format* consisting of continuous replay of the 40 highest rated popular songs; generally superseded by CHR and AC except in the largest markets.

tracking Monitoring a syndicated or local program's *ratings* over time, often in several different markets if syndicated.

track record Performance history, as in how a program rated in previous *plays* on a network or on other stations when syndicated; also, how a writer/producer worked out on past productions.

tradeout Exchange of airtime for a good or service, such as giving spots to a travel agent in exchange for airline tickets to use as a contest prize.

transparency The appearance of simplicity to users despite very complex technical processes.

transponder One of several units on a communications satellite that both receives *uplinked* signals and retransmits them as *downlinked* signals (amplified on another frequency). Some users lease the right from satellite operators to use the entire transponder (40 megaHertz *bandwidth*); others lease only a part of a transponder's capacity. Currently, most satellites have 24 transponders, and *digital compression* of video signals greatly increases transponder capacity.

traps Mechanical or electronic devices on telephone poles or ground-level pedestals for diverting premium services away from nonsubscribing households.

treatment Outline of a new program (applied especially to *soap operas*); describes characters and setting of program (before a script is prepared).

trending Graphing *ratings/shares* over a period of time or on a series of stations to anticipate future *ratings/shares*, especially of syndicated series; same as *tracking*.

tuning inertia A theory that viewers tend to view the next program on a channel without switching until moved by unacceptable programs to actively switch.

turnkey system An arrangement for turning over a responsibility to a second party. In *pay-per-view* cable, ordering and billing may be handled by a special company or the telephone company. Also, arrangements whereby local and regional cable advertising is sold and inserted within programs by a specialized advertising company rather than by the cable operator. In radio, arrangements whereby an automated radio station is programmed by satellite by another entity.

turnover Changes in the number of subscribers, listeners, or viewers; in cable, the ratio of disconnecting to newly connecting subscribers. See also *churn*.

UHF channels Ultra high-frequency television signals having less advantageous positions on the broadcast band than *VHF*, requiring separate receiving antennas in the home. Most public and many smaller commercial television stations are UHF.

umbrella series An *anthology* television (or radio) program of only broadly related content under an all-encompassing title (for example, *Great Performances*).

unbundling Breaking apart previously grouped programs, services, or channels for separate licensing or member purchase; used especially in cable and public radio.

underwriter Foundation or private corporation giving grant money to cover the costs of producing or airing a program or series on *public television* or *radio*.

unduplicated Said of programming that is not available on any other local or imported station signal in a market; said of people counted only once in *cumes*.

uniform channel lineups In cable, having the largest cable networks on the same channel numbers on most cable systems nationwide. Compare with *common channel lineup*.

universal lifeline service A minimal cable service for a low monthly fee available to all subscribers. Also called "economy basic" and other names.

universe In cable, the total population of cable subscribers within all franchises.

upfront Advertising time sold in advance of the new program season.

upgrading Adding pay channels at the request of cable subscribers (reverse of *downgrading*).

uplink Ground-to-satellite path; also the sending antenna itself (reverse of *downlink*).

upscale Audiences or subscribers with higher than average socioeconomic demographics, especially income. Compare with *downscale*.

uptrending A pattern of increasing *ratings/shares* over time (reverse of *downtrending*).

URL Universal resource locator, an Internet address.

value-added promotion Contests, games, and other promotions offering more publicity to the advertiser than just spot advertising on radio, television, or cable.

V-chip An electronic system requiring the broadcast networks to add a code to each television show that indicates the amount of violence, sex, strong language, or mature situations in each individual show. Using TV sets equipped with V-chips, parents can program the set to exclude those programs deemed inappropriate for the family.

vertical documentaries In-depth factual treatment of a subject in many segments broadcast on the same day. See also *horizontal documentaries*.

vertical integration An industry in which the owners of the means of production also own the means of distribution; in media, a concentration of companies owning *cable networks* (producers) and broadcast stations, *cable systems* (distributors), and web portals.

vertical ownership Owning both the program supply and the means of distribution.

vertical scheduling Placing program segments sequentially on one day; also called *vertical stacking*. Used by stations and cable networks in scheduling movies of one type; also used in radio to scatter portions of a taped interview or minidocumentary throughout the day. Compare to *theme* weeks.

vertical stacking See *vertical scheduling*.

VHF stations Very high frequency; the segment of the electromagnetic spectrum in which television channels 2 through 13 fall; the most desirable broadcast television stations.

videodisc Prerecorded digitalized video information on disc for playback only; usually read by laser.

video jockeys (VJs) The announcer/host on rock music programs, corresponding to a radio *disc jockey*.

video-on-demand (VOD) Systems for instantaneously delivering to the home only those programs a consumer wants to see.

videos Taped musical performance *shorts* used for promotion and programming (on MTV and others).

voicers Stories prerecorded by someone other than the announcer or *disc jockey* currently on the air.

warehousing Purchasing and storing *series* and movies primarily to keep them from competitors. See also *stockpiling*.

webcasting Digitally distributing programming only via the web.

webisodes Episodes of a web-only program series.

weighting Statistically matching a sample to the population by increasing the numerical weight given to responses from one or more subgroups.

wheel Visualization of the contents of an hour as a pie divided into wedges representing different content elements; used in radio to visualize a program *format*, showing designated sequences and lengths of all program elements such as musical numbers, news, sports, weather, *features*, *promos*, PSAs, commercials, IDs, and time checks. See also *hot clock*.

window The period of time within which a network or distributor has the *rights* to show a feature film or other program (generally after the first theatrical distribution if the program was not *made-for-pay*); windows vary from a few months to many years. See also *pay window*, *syndication window*, and *broadcast window*.

wireless cable See *multichannel multipoint distribution service*.

www, World Wide Web The most widely accessed portion of the Internet.

zapping Erasing commercials on home-taped video-cassettes. Sometimes used synonymously with *flipping*—changing channels by *remote control* to avoid commercials.

zipping Fast-forwarding through commercials on home-taped videocassettes.

zoning Dividing a cable advertising *interconnect* into tiny geographic areas to allow small businesses to purchase ads reaching only specific areas.

Annotated Bibliography

This is a selective, annotated listing of books, articles, guides, reports, trade magazines, and web sites on broadcast and cable programs and programming published since 1995. The bibliography lists major trade publications, books published, and scholarly research articles in journals about programming theory and practice. Additional citations appear at each chapter's end under "Sources" and "Notes." See also Bookmarks for the World Wide Web and lists of web sites in Chapter 10. For publications prior to 1995, consult the bibliographies to the fifth and previous editions of this book.

Adams, Michael H. *Introduction to Radio: Production and Programming*. Madison, WI: Brown & Benchmark, 1995. A guide to radio programming from a production point of view.

Albaran, Alan B. *Management of Electronic Media*. Second edition. Belmont, CA: Wadsworth, 2002. Textbook for teaching management of new and mature media businesses, including television and radio stations, cable systems, and Internet portals and sites, with special emphasis on news and global markets; incorporates many case studies.

Audience Research Sourcebook. Washington, DC: National Association of Broadcasters, 1991. Beginning handbook on radio and television station research for station executives.

Aufderheide, Patricia. "Why Kids Hate Educational TV," *Media Studies Journal* 8 (Fall 1994): 21–32. Scholarly article on the lack of educational and informational programming for children on commercial TV.

Beyond the Ratings. Laurel, MD: Arbitron Ratings Company, 1977 to date. Monthly trade newsletter on developments in and applications of Arbitron local radio ratings for broadcasters.

BIB Television Programming Sourcebooks. Philadelphia, PA: North American Publishing, 1996–97 edition. An expensive, annual four-volume listing of theatrical and made-for-TV movies, TV series, specials, and miniseries, including information on distributor, running time, cast and plot, ratings/share, and other information, intended for television station and cable programmers.

Billboard: The International Newsweekly of Music and Home Entertainment. New York, 1888 to date. Weekly trade magazine of the record industry.

Brinkley, David. *David Brinkley: 11 Presidents, 4 Wars, 22 Political Conventions, 1 Moon Landing, 3 Assassinations, 2000 Weeks of News and Other Stuff on Television and 18 Years of Growing Up in North Carolina*. New York: Alfred A. Knopf, 1995. An insider's view of television news programming.

Broadcaster: The Magazine for Communicators. 1942 to date. Canadian trade magazine on the radio, television, and cable industries, with special emphasis on news.

Broadcasting. 1931 to date; cable added in 1972; radio and Washington politics dropped in 1992. Major weekly trade magazine of the broadcasting industry; see especially "Special Reports" on cable, children's television, digitalization, high-definition TV, Internet technology, journalism, media corporations, radio, reps, satellites, sports, syndication, and television programming.

Broadcasting and the Law. Knoxville, TN: Perry Publications, 1972 to date. Twice-monthly newsletter and supplements explaining findings of the Federal Communications Commission, courts, and Congress affecting broadcast operations.

Broadcasting & Cable Market Place (replaced *Broadcasting Yearbook* in 1992). Washington, DC: Broadcasting Publications, 1935 to date, annual. Basic trade directory of radio and television stations and support industries; added cable in 1980.

Brooks, Tim, and Marsh, Earle. *The Complete Directory to Prime Time Network and Cable TV Shows: 1946–Present*. Sixth edition. New York: Ballantine, 1995. Annotated directory of most network television programs with details on casts and content for each show.

Bryant, Jennings, and Bryant, J. Alison. (Eds.). *Television and the American Family*. Second edition. Mahwah, NJ: Erlbaum, 2001. A comprehensive treatment of research into families and media use, attitudes, and effects.

Cable Services Directory. Washington, DC: National Cable Television Association. 1978 to date, annual (title varies). Annual directory of information on individual cable systems, including amounts and types of local origination.

Cable Television World. Washington, DC: National Cable Television Association, annual. Yearly trade summary of changes in the cable industry, with tables and charts.

Cable World. Denver, CO: Cable World Associates, 1988 to date. Weekly trade articles on national cable programming and other topics from a managerial perspective.

Clifford, Brian R., Gunter, Barrie, and McAleer, Jill. *Television and Children: Program Evaluation, Comprehension, and Impact*. Hillsdale, NJ: Erlbaum, 1995. Report of scholarly research on the effects of programming on children.

Comm/Ent: A Journal of Communications and Entertainment Law. San Francisco: Hastings College of the Law, 1978 to date. Law journal, published quarterly, containing articles summarizing the law on specific issues, including broadcasting and new technologies.

Community Television Review. Washington, DC: National Federation of Local Cable Programmers, 1979 to date. Bimonthly newsletter of the NFLCP for local cable programmers, covering public, educational, and government access television on cable and local cable origination.

Compaine, Benjamin M., and Gomery, Douglas. *Who Owns the Media? Competition and Concentration in the Mass Media Industry*. Third edition. Mahwah, NJ: Erlbaum, 2000. Authoritative analysis of the structure of ownership in the major media, including various meanings of market competition and concentration. Covers television, movies, radio, and the Internet, as well as print media.

Cooper, Roger. "The Status and Future of Audience Duplication Research: An Assessment of Ratings-Based Theories of Audience Behavior," *Journal of Broadcasting & Electronic Media* 40 (Winter 1996): 96–111. A scholarly article on audience behavior.

Craft, John E., Leigh, Frederic A., and Godfrey, Donald G. *Electronic Media*. Belmont, CA: Wadsworth, 2001. A new introductory text available online as well as in print; integrates the newest media with traditional media history and law, economics and programming, and technology and society, with an applied orientation.

Croteau, David, and Hoynes. *Medi/Society: Industries, Images and Audiences*. Thousand Oaks, CA: Sage, 2000.

Current. Washington, DC: Public Broadcasting Service, 1981 to date. Weekly Washington newspaper focusing on public broadcasting.

C-SPAN Update. Washington, DC: C-SPAN Network, 1982 to date. Weekly newspaper of program content and issues affecting the broadcasting of public affairs on radio and television.

Daily Variety. Hollywood/New York: Variety, 1905 to date. Trade newspaper of the film and television industries. Daily version of *Variety* magazine oriented toward film and television production and programming.

David, Nina. *TV Season*. Phoenix, AZ: Oryx, 1976 to date, annual. Annotated guide to the previous season's commercial and public network and major syndicated television programs.

DBS News. Washington, DC: Phillips Publishing, 1983 to date, monthly. Newsletter covering international regulatory, technical, and programming developments in direct broadcasting.

Dominick, Joseph R., Sherman, Barry L., and Messere, Fritz. *Broadcasting, Cable, the Internet, and Beyond: An Introduction to Modern Electronic Media*. Fourth edition. New York: McGraw-Hill, 2000. Up-to-date edition of this basic text, with several chapters on programming and the Internet.

Duncan, James H., Jr., editor. *American Radio*. Kalamazoo, MI: Duncan's American Radio, Inc., quarterly plus supplements. Industry sourcebook for radio ratings and programming information for all markets, with extensive tables and charts.

Duncan, James H., Jr., editor. *Duncan's Radio Market Guide*. Kalamazoo, MI: Duncan's American Radio, Inc., annual. Companion reference volume on the revenue ratings histories and projections for 170 markets, including market descriptions and many charts and tables.

Eastman, Susan Tyler. (Ed.) *Research in Media Promotion*. Mahwah, NJ: Erlbaum, 2000. An examination of current research on the promotion of television, radio, and web programs, including sports, news, movies, children's programs, and the media branding process.

Eastman, Susan Tyler. "Programming Theory under Stress: The Active Industry and the Active Audience." In *Communication Yearbook 21*: 323–377. Authoritative article covering the history of programming theories, comparing current theories and proposing a model for the current situation.

Eastman, Susan Tyler, Ferguson, Douglas A., and Klein, Robert A. *Promotion & Marketing for Broadcasting and Cable*. Fourth edition. New York: Focal Press, 2002. Text on strategic planning for marketing networks, stations, cable systems, and web sites to audiences and advertisers, with a chapter on promotion and marketing research methods.

Electronic Media. Chicago, 1982 to date. Weekly trade periodical published by Crain Communications covering topical news in broadcasting, cable, and new media technologies. Available online at http://www.emonline.com.

Erickson, Hal. *Television Cartoon Shows: An Illustrated Encyclopedia, 1949 Through 1993*. Jefferson City, NC: McFarland, 1995. Reference material on children's programming.

Ferguson, Douglas A., and Perse, Elizabeth M. "The World Wide Web as a Functional Alternative to Television." *Journal of Broadcasting & Electronic Media* 44 (Spring 2000): 155–174.

Fisch, Shalom M., and Truglio, Rosemarie T. *"G" Is for Growing: Thirty Years of Research on Children and Sesame Street*. Mahwah, NJ: Erlbaum, 2001. A synopsis of the decades of formative and evaluative research conducted as part of the production of this enormously influential children's program series.

Journal of Broadcasting & Electronic Media 39 (Spring 1995): 147–176. Scholarly examination of public TV as a public sphere institution through the case of a programming cooperative contributing to the national PBS schedule.

Grant, August E. (Ed.) *Communication technology update*. Seventh edition. Boston: Focal Press, 2000. Latest in a quickly updated series on the newest media technologies written by academics and media experts in their specialties.

Hausman, Carl, Benoit, Philip, and O'Donnell, Lewis. *Radio Production: Production, Programming, and Performance*. Fifth edition. Belmont, CA: Wadsworth, 2000. Handbook of ways of producing and performing on radio, including programming aspects.

Head, Sydney W., Spann, Thomas, and McGregor, Michael A. *Broadcasting in America: A Survey of Electronic Media*. Ninth edition. Boston: Houghton Mifflin, 2001. Basic reference text on American broadcasting, covering technology, economics, regulation, history, social effects, and programming; newest edition contains three chapters on program strategies, network and nonnetwork programs.

Howard, Herbert H. *Ownership Trends in Cable Television*. Washington, DC: National Association of Broadcasters, annually since 1987. Continuing comparative series on the 50 largest cable multiple-system-operations; tables and charts.

Jankowski, Gene F., and Fuchs, David C. *Television Today and Tomorrow: It Won't Be What You Think*. New York: Oxford University Press, 1995. A view of the future of networks and affiliates, one that predicts a large dose of the past.

Jones, Steve. *Doing Internet Research: Critical Issues and Methods for Examining the Net*. Thousand Oaks, CA: Sage, 1998. Practical handbook on Internet analysis, including methods for measuring online audiences.

Journal of Broadcasting & Electronic Media. Washington, DC: Broadcast Education Association, 1955 to date. Scholarly journal covering research in all aspects of television and radio broadcasting, especially emphasizing those topics with industry impact.

Journal of Consumer Research. Chicago, IL: University of Chicago Press, 1974 to date. Interdisciplinary journal reporting empirical studies and humanistic analyses that describe and explain consumer behavior.

Journal of Mass Media Ethics: Exploring Questions of Media Morality. Mahwah, NJ: Erlbaum, 1986 to date. Essays, reports, and literature reviews about ethical issues of interest to professionals and scholars; published quarterly.

Journal of Radio Studies. Topeka, KS: Washburn University, 1991 to date. Scholarly articles on historical and contemporary radio, including programming.

Keith, Michael C. *The Radio Station.* Fifth edition. Woburn, MA: Focal Press, 2000. Latest edition of the most authoritative and widely used book on the business of running a radio station, covering general management specifics in advertising, programming, promotion, traffic, and billing, as well as the current state and future directions of the radio industry.

Kisseloff, Jeff. (1995). *The Box: An Oral History of Television, 1920–1960.* New York: Viking Press. A humorous amalgam of stories of the early decades of television.

Krugman, Dean M. "Visual Attention to Programming and Commercials: The Use of In-Home Observations," *Journal of Advertising* 24 (Spring 1995): 1–12. Scholarly examination of eyes-on-screen times for both program and commercial viewing.

Lee, Teresa A. *Legal Research Guide to Television Broadcasting and Program Syndication.* Buffalo, NY: W. S. Hein, 1995. Information on the laws regarding programming.

LeRoy, David, and LeRoy, Judith. *Public Television: Techniques for Audience Analysis and Program Scheduling.* Washington, DC: Pacific Mountain Network/Corporation for Public Broadcasting, 1995.

Lin, Carolyn A. "Network Prime-Time Programming Strategies in the 1980s," *Journal of Broadcasting & Electronic Media* 39 (Fall 1995): 482–495. A scholarly article on prime-time television schedules.

Lindlof, Thomas. *Qualitative Communication Research Methods.* Thousand Oaks, CA: Sage, 1995.

Lloyd, Frank W. *Cable Television Law 1995: Coping with Competition and Regulation.* New York: Practising Law Institute, 1995. An annual guide to cable regulation.

The LPTV Report. Butler, WI: Kompas/Biel & Associates, monthly since 1985. Trade magazine that is the official information channel of the Community Broadcasters Association, an organization of low-power television broadcasters.

Lynch, Joanna R., and Gillespie, Greg. *Process and Practice of Radio Programming.* New York: University Press of America, 2000. Text consisting of examples and practices current in the industry, with student exercises.

MacFarland, David T. *Future Radio Programming Strategies: Cultivating Listenership in the Digital Age.* Second edition. Mahwah, NJ: Erlbaum, 1997. An unusual analysis of the values and realities of the present-day radio business and their meaning for radio programming.

Minow, Newton N., and LaMay, Craig L. *Abandoned in the Wasteland: Children, Television, and the First Amendment.* New York: Hill and Wang, 1995. A critical look at children's television programming.

Multichannel News: The Newspaper for the New Electronic Media. New York, 1979 to date. Weekly trade newspaper of regulatory, programming, financial, and technical events affecting electronic media.

NAB Legal Guide to FCC Broadcast Law & Regulation. Washington, DC: National Association of Broadcasting. Regularly updated. Loose-leaf, one-volume compilation of selected FCC broadcasting regulations (many on programming) with analysis and commentary designed for station managers.

NAB News. Washington, DC: National Association of Broadcasters, 1989 to date. Monthly reports during 1989–90 on developments in federal regulation, ratings research, and other matters affecting broadcasters, later becoming a report on the NAB convention.

NATOA News. 1980 to date. Bimonthly newsletter of the National Association of Telecommunications Officers and Advisors and the National League of Cities. Short reports on current events affecting local cable franchise regulation and technology, including legislative updates.

NATPE International Newsletter (formerly *NATPE Programmer*). Washington, DC: National Association of Television Program Executives, 1990 to date. Monthly trade newsletter of the national programmers' association.

Newcomb, Horace, editor. *Television: The Critical View.* Sixth edition. New York: Oxford University Press, 2000. Latest edition of the popular critical/cultural text for students.

New York Times, The. 1850 to date. Daily and Sunday national newspaper covering business and entertainment aspects of broadcasting and cable television.

Norberg, Eric G. *Radio Programming: Tactics and Strategy*. Newton, MA: Focal Press, 1996. A textbook presenting another perspective on radio programming strategy.

Osso, R. (Ed.) *Handbook of Emerging Communications Technologies*. Boca Raton, FL: CRC Press, 2000. Text for students and practitioners on the news media technologies, with contributing authors.

The Pay TV Newsletter. Carmel, CA: Paul Kagan Associates, 1983 to date. Weekly trade summaries of analyses and events affecting premium cable television.

Pringle, Peter K., Starr, Michael F., and McCavitt, William. *Electronic Media Management*. Third edition. Boston: Focal Press, 1995. Text covering managerial issues and functions, including programming, at broadcast stations and for cable systems.

Price, Monroe E. (Ed.) *The V-Chip Debate: Content Filtering from Television to the Internet*. Mahwah, NJ: Erlbaum, 1998. A collection of chapters analyzing aspects of program labeling and rating, including the factors leading to adoption of this requirement and comparisons with other media-rating systems

Producers Quarterly. Port Washington, NY: Producers Quarterly Publications, 1991 to date. Trade magazine for executives in the movie and television production business, covering developments in production technology and animation, production problems and success stories, and interviews with producers.

Radio & Records: The Industry's Newspaper. Los Angeles, weekly, 1974 to date. Trade magazine of the record industry, ranking songs and albums. Available online at http://www.rronline.com.

RadioWeek. Washington, DC: National Association of Broadcasters, 1960 to date. Weekly newsletter on matters affecting radio broadcasters, including proposed changes in federal regulations and standards.

R&R Ratings Report. Los Angeles: Radio & Records, Inc. Semiannual special reports on the state of radio programming.

Religious Broadcasting, 1968 to date. Monthly magazine emphasizing evangelical broadcasting on radio and television, with informal style.

RTNDA Communicator, 1946 to date. Monthly newsletter of the Radio-Television News Directors Association.

Schumann, David W., and Thorson, Esther. *Advertising and the World Wide Web*. Mahwah, NJ: Erlbaum, 1999. An innovative historical and practical analysis of developments in online advertising, spelling out what is unique and what borrows from the traditional media; of value to both students and practitioners.

Smith, Anthony. (Ed.) *Television: An International History*. New York: Oxford University Press, 1995. A history of international television programs.

Spragens, William C. *Electronic Magazines: Soft News Programs on Network Television*. Westport, CT: Praeger, 1995. A guide to early reality programming on prime-time television.

The Television Audience. Northbrook, IL: A. C. Nielsen Company, 1959 to date, annual. Trends in television programming and audience viewing patterns.

Television Digest. Washington, DC: Warren Publishing, Inc., 1945 to date. Weekly trade summary of events affecting the television business.

TV Today. Washington, DC: National Association of Broadcasters, 1970 to date. Weekly newsletter addressing matters of interest to broadcast station members, including developments in technology, regulation, and member services.

Variety. New York and Hollywood, 1925 to date. Weekly trade newspaper covering the stage and the film, television, and recording industries.

Walker, James R., and Ferguson, Douglas. *The Broadcast Television Industry*. Boston: Allyn & Bacon, 1998. A detailed assessment of broadcast television's current economics and industry structure, providing depth in key aspects impractical to cover in other books when cable and radio are included.

Warren, Steve. *Radio: The Book*. Washington, DC: National Association of Broadcasters, 1997. Practical handbook supplying an overview of the radio business from a managerial perspective.

Webster, James G., and Phalen, Patricia F. *The Mass Audience: Rediscovering the Dominant Model*. Mahwah, NJ: Erlbaum, 1997. A penetrating assessment of decades of research about programming theory and audience behavior, demonstrating that the mass audience continues to be a powerful force in network programming and thus in scholarly research.

Webster, James G., Phalen, Patricia F., and Lichty, Lawrence W. *Ratings Analysis: The Theory and Practice of Audience Research*. Second edition. Hillsdale, NJ: Erlbaum, 2000. Text describing and analyzing audience ratings data for industry and scholarly ratings users, covering applications, collection methods, and models for data analysis.

Wimmer, Roger D., and Dominick, Joseph R. *Mass Media Research: An Introduction*. Sixth edition. Belmont, CA: Wadsworth, 1999. Revised text on applied research methods in mass media emphasizing broadcasting; includes survey methods and peoplemeter ratings.

Witherspoon, John, and Kovitz, Roselle. (Eds.) *The History of Public Broadcasting*. Washington, DC: Current, 2000. A useful collection of chapters by scholars and insiders who analyze the funding, technology, and programming over the last four decades.

Zillmann, Dolf, and Vorderer, Peter. *Media Entertainment: The Psychology of Its Appeal*. Mahwah, NJ: Erlbaum, 2000. Scholarly treatise applying psychological theories to the appeal of entertainment carried in a wide range of media.

Bookmarks for the World Wide Web

Please note:

- This list was current for August 2001. It is continually updated on the homepage link for this textbook, searchable from http://www.wadsworth.com

- If you encounter difficulties with any of the addresses, try entering the minimal URL address by deleting any material after the ".com"

- You may also link to a list of bookmarks from the consulting site for one of the authors: http://www.televisionstrategy.com

General Interest Sites

http://tv.zap2it.com
http://www.broadcastingcable.com
http://www.fcc.gov
http://www.nab.org
http://www.natpe.org
http://www.ncta.com
http://www.cabletvadbureau.com
For other media organization and associations, see the list in 1.15 on page 26 of this textbook.

Updates and News Summaries

http://www.broadcastingcable.com
http://www.multichannel.com
http://www.variety.com
http://web.bu.edu/COM/html/comnewstoday.html
http://www.mediacentral.com
http://tv.yahoo.com

Schedules

http://tvlistings.zap2it.com
http://www.gist.com
http://www.clicktv.com

Ratings Research

http://www.arbitron.com
http://www.nielsenmedia.com
http://www.rronline.com/Subscribers/Ratings/Homepage.htm
http://www0.mercurycenter.com/tv/nielsen/nnumbers.htm
http://www0.mercurycenter.com/tv/nielsen/ncable.htm
http://www.katz-media.com/katz/KTVG/TVProg/home.html
http://tv.zap2it.com/news/dailynielsenrankings_headlines.html

Broadcast Networks

http://www.abc.com (http://abc.go.com)
http://www.cbs.com
http://www.nbc.com (http://www.nbci.com)
http://www.fox.com
http://www.thewb.com
http://www.upn.com
http://www.paxtv.com
http://www.univision.com
http://www.telemundo.com
http://www.pbs.org

Cable

http://www.ppv.com
http://www.cabletvadbureau.com/html/
 00NetProfiles.htm \
http://www.aetv.com
http://www.amctv.com
http://www.bet.com
http://www.bravotv.com/
http://www.cartoonnetwork.com
http://www.cbn.org
http://www.cinemax.com
http://www.cnbc.com
http://www.cnn.com
http://www.cnnfn.com
http://www.comcentral.com
http://www.courttv.com
http://dsc.discovery.com
http://www.disneychannel.com
http://www.eonline.com
http://www.foodtv.com
http://www.foxfamilychannel.com
http://www.foxnews.com
http://www.fxnetworks.com
http://www.galavision.com
http://www.hbo.com
http://www.hgtv.com
http://www.historychannel.com
http://www.lifetimetv.com
http://www.msnbc.com
http://www.mtv.com
http://www.nationalgeographic.com/tv/channel
http://www.tnnonline.com/tnn/content.html
http://www.oxygen.com
http://www.playboy.com/pbtv
http://www.scifi.com

http://www.showtimeonline.com
http://soapnet.go.com
http://www.superstation.com
http://www.travelchannel.com
http://www.tbn.org
http://TCM.turner.com
http://www.tnt-tv.com
http://www.usanetwork.com
http://www.vh-1.com
http://www.vvtv.com
http://www.wewomensentertainment.com
http://www.weather.com

Satellite

http://www.directv.com
http://www.dishnetwork.com

Radio

http://www.rronline.com
http://www.gavin.com
http://www.allaccess.com
http://www.npr.org
http://www.abcradio.com
http://www.clearchannel.com

Online

http://www.atomfilms.com
http://www.entertaindom.com
For other animation sites, see the list in 10.6 on
 page 338
http://www.intertainer.com
http://www.microcast.tv
For other interactive television sites, see the list
 in 10.4 on pages 328–330 of this textbook.

About the Contributing Authors

William J. Adams, associate professor in the School of Journalism & Mass Communication at Kansas State University, has a B.A. from Brigham Young University, an M.A. from Ball State University, and his Ph.D. from Indiana University. He teaches, researches, and writes about programming, especially focusing on network television programming for prime time and on motion pictures. He has published extensively as a journalist and scholar. His work includes chapters in the area of television and movie programming in five editions of *Broadcast/Cable Programming: Strategies and Practices* (Wadsworth, 1985 to 2002); on promotion in *Promotion & Marketing for Broadcasting & Cable* (Focal Press, 2002); and on movies in *Research in Media Promotion* (Erlbaum, 2000). He has also published articles in the *Journal of Broadcasting & Electronic Media*, the *Journal of Communication*, and the *Journal of Media Economics*. Professor Adams brings considerable historical expertise in television programming to his analysis of present-day prime-time strategies at the major networks. He can be reached at wadams@ksu.edu.

Robert B. Affe, a television executive, attorney, and teacher, is presently a visiting professor in the Department of Telecommunications at Indiana University. He was educated at Georgetown University (A.B.) and the New York University School of Law (J.D.). After admission to practice before the New York State Supreme Court and the District of Columbia Court of Appeals, he practiced communications law in Washington, DC Drawn to the business of television, Mr. Affe has helped launch or rebrand stations in markets comprising, in aggregate, a tenth of all American television households. He was corporate director of programming for Weigel Broadcasting in Chicago, in addition to his years as a programming executive at WOIO-TV in Cleveland, KDAF-TV in Dallas, WTOG-TV in Tampa-St. Petersburg, and WTXX-TV in Hartford-New Haven. While in Florida, he was an adjunct professor of Mass Communications at the University of South Florida, and he is a frequent guest speaker at colleges and professional organizations. He contributes to industry trade periodicals, has been active in the National Association of Television Program Executives, and serves as a station program and operations consultant. He can be reached at robertaffe@hotmail.com.

Robert V. Bellamy, Jr., associate professor of Media Communication in the Department of Communication at Duquesne University in Pittsburgh, has his B.A. from Morehead State University, his M.A. from the University of Kentucky, and his Ph.D. from the University of Iowa. His teaching and research interests include television programming and promotion, media globalization, media and sports, and the impact of technological change on media industries. He has professional experience as a National Association of Program Executives Fellow and program consultant to KLRT in Little Rock, and a newscast producer for WBKY-FM and WBLG-AM in Lexington, Kentucky, and WMKY in Morehead, Kentucky. He also worked as air talent and engineer for WMKY. He has published numerous articles about network branding, U.S. media economics and institutions, and international media communication. His work has appeared as chapters in several books, including, *Research in Media Promotion* (Erlbaum, 2000); *Television and the American Family* (Erlbaum, 2000); *Promotion & Marketing for Broadcasting & Cable* (Focal Press, 2002); *Media-Sport* (Routledge, 1998); and in such publications as the *Journal of Broadcasting & Electronic Media*, the *Journal of*

Communication, the *Journal of Sport & Social Issues*, and *Journalism Quarterly*. Professor Bellamy is coauthor of *Television and the Remote Control: Grazing on a Vast Wasteland* (Guilford, 1996) and coeditor of *The Remote Control in the New Age of Television* (Praeger, 1993). He can be reached at bellamy@duq.edu.

Joseph G. Buchman, associate professor in the Department of Business Management at Utah Valley State College, also teaches in the Multimedia Communications Technology program there. His B.S. is from Indiana University, his M.S. from Purdue University, and his Ph.D. from Indiana University, where he was a visiting professor in the Department of Telecommunications from 1999 to 2001. He was program director of WNAS-FM, New Albany, from 1974 to 1976, and was an air personality on WQHI and WRKA in Louisville, WTTS and WBWB in Bloomington, Indiana, and WUTK-AM in Knoxville. His teaching and research focus on communication technologies, especially radio news, talk, and promotion. Professor Buchman authored the chapters on commercial radio promotion in two editions of *Promotion & Marketing for Broadcasting & Cable* (Focal Press, 1999, 2002), and in *Research and Media Promotion* (Erlbaum, 2000), and he coauthored two editions of *Broadcast & Cable Selling* (Wadsworth, 1993). He has published primarily in the trade press, including articles on radio, the Internet, and legal issues in *Next* and *Virtually Alternative*. He can be reached at buchmajo@uvsc.edu.

Edward J. Carlin, associate professor and chair of the Department of Communications and Journalism at Shippensburg University, has his B.A. from Heidelberg College and his M.A. and Ph.D. from Bowling Green State University. He teaches, researches, and consults about television, satellite and radio technology, programming, and production. His programming experience includes developing and implementing commercial radio play lists and air shifts and designing noncommercial educational radio and television program lineups. Professor Carlin has presented many conference papers and published several book chapters about the evolving media technologies, especially focusing on direct broadcast satellites in three editions of *Communication Technology Update* (Focal Press, 2000). He also published chapters on DAB and DARS in the *Handbook of Communication Technology* (CRC Press, 1999), and on digital video editing in *Television Field Production and Reports*

(Longman, 1999). Dr. Carlin can be reached at ejcarl@wharf.ship.edu.

Susan Tyler Eastman, professor of Telecommunications at Indiana University in Bloomington, has her B.A. from the University of California at Berkeley, her M.A. from San Francisco State University, and her Ph.D. from Bowling Green State University. She is senior author/editor of six editions of *Broadcast/Cable Programming: Strategies and Practices* (Wadsworth, 1981 to 2002), three editions of *Promotion & Marketing for Broadcasting & Cable* (Focal Press, 1982 to 2002), and *Research in Media Promotion* (Erlbaum, 2000). Professor Eastman has taught about programming and promotion for more than twenty-five years and has published over a hundred book chapters and articles, most of which focus on the structural, content, and industry factors affecting programming and promotion in television, radio, and cable. Her articles have appeared in such journals as the *Journal of Broadcasting & Electronic Media, Critical Studies in Mass Communication*, the *Journal of Communication*, the *Journal of Applied Communication Research, Sociology of Sport Journal*, the *Journal of Sport & Social Issues*, the *Journal of Educational Technology Systems*, the *Journal of Research and Development in Education*, and *Communication Yearbook*. She can be reached at eastman@indiana.edu.

Douglas A. Ferguson, professor and chair of the Department of Communication at the College of Charleston, is a former chair and assistant dean at Bowling Green State University. His B.A. and M.A. are from the Ohio State University and his Ph.D. from Bowling Green State University. Early in his career, he was program director of NBC-affiliated WLIO (TV) and a station manager. In addition, he was program director for a local origination cable channel in Bay City, Michigan, that carried local game shows, children's shows, sporting events, movies, and off-network syndication. He teaches, researches, and writes about programming and promotion on the Internet and other new media technologies. He has authored several chapters on aspects of information technology and media programming. He coauthored *The Broadcast Television Industry* (Allyn & Bacon, 1998) and was coeditor/author of *Promotion & Marketing for Broadcasting & Cable* (Focal Press, 1999, 2002) and the fifth and sixth editions of *Broadcast/Cable Programming: Strategies and Practices* (Wadsworth, 1997, 2002). Professor Ferguson's scholarly work has been published in the *Journal of Broadcasting & Electronic Media, Communica-*

tion Research, Journalism Quarterly, the Dowden Center Journal, and Communication Research Reports. He can be reached at fergusond@cofc.edu.

John W. Fuller, director of research at the Public Broadcasting Service, came to the national public network in 1980 as head of the research department in Alexandria. His B.A. is in Radio-Television from Florida State University, and his M.A. is from the University of Florida. In 1966 he started in television as studio director of WJKS-TV in Jacksonville, Florida, moving to promotion manager in 1968. He then became research director for WRLV-TV in Jacksonville, and soon served as program director as well until 1976. From there he went to Arbitron as research project manager, moving to PBS four years later. Presently, he oversees a seven-person department responsible for program performance analyses, daily tracking of prime-time program audiences, management of market research projects, and collection of national carriage data. He provides research consultation and support for both the network and its member stations, and has contributed to the last three editions of Broadcast/Cable Programming: Strategies and Practices (Wadsworth, 1993 to 2002). He can be reached at jfuller@PBS.org.

Timothy P. Meyer, professor of communication in the School of Information and Computing Sciences at the University of Wisconsin-Green Bay, holds the Ben J. and Joyce Rosenberg professorial chair. He received his B.A. from the University of Wisconsin and his M.A. and Ph.D. from Ohio University. Before joining the University of Wisconsin-Green Bay, he taught at the University of Texas at Austin and the University of Massachusetts, Amherst. He actively consults in marketing and advertising research and works in organizational and management communications. He is coauthor of Advertising Research Methods (Prentice-Hall, 1992) and Mediated Communications: A Social Action Perspective (Sage, 1988) and has published numerous chapters and articles on programming and marketing in edited books and such major scholarly journals as the Journal of Communication, the Journal of Broadcasting & Electronic Media, the Journal of Marketing Research, and the Journal of Advertising Research. He has contributed to the last four editions of Broadcast/Cable Programming: Strategies and Practices (Wadsworth, 1989 to 2002). He can be reached at meyert@uwgb.edu.

Gregory D. Newton, assistant professor in the Gaylord College of Journalism and Mass Communication at the University of Oklahoma, teaches courses in programming, media management, and production, and is the faculty advisor for Oklahoma University student radio station. He has many years of radio station experience, serving as program manager and production director at WAIT-AM/FM, as operations manager and production director at WXET-FM, and as an air talent for these stations and several others with AC, CHR, country, big band, jazz, and news/talk formats. He is completing his Ph.D. at Indiana University and holds an M.A. from Northwestern University and a B.A. from Northern Illinois University. Professor Newton has been associate editor of the Federal Communications Law Journal and has published in the Journal of Broadcasting & Electronic Media, the Journal of Communication, the Journal of Radio Studies, and the Journal of Applied Communication Research. Many of his studies have explored the structural factors affecting the programming and promotion of television programs. He can be reached at gnewton@ou.edu.

John von Soosten, presently general manager and program director of WNSW Radio in New York City, was for many years the senior vice president and director of programming for Katz National Television, part of the nation's largest television representative firm. Before joining Katz in 1984, he was president and program manager of Metromedia's WNEW-TV (now WNYW-TV). Before that, he was production manager at the same station and production technician at WOR-TV (now WWOR-TV). His B.S. is from Ithaca College, and his M.S. from Brooklyn College, and he taught television production for many years at the college level. He now consults for program syndicators and SNAP software and has contributed numerous magazine articles about the business of television and radio. He brings a wide experience with syndicated television programming from the perspective of hundreds of U.S. stations and their foreign counterparts to his chapters on syndication in the last four editions of Broadcast/Cable Programming: Strategies and Practices (Wadsworth, 1989 to 2002). Mr. von Soosten has been president of the National Association of Television Program Executives (NATPE), vice president of the International Radio Television Foundation (IRTS), and secretary of the NATPE Educational Foundation. He can be reached at johnvons@msn.com.

James R. Walker, professor and chair of the Department of Communication at Saint Xavier University in Chicago, has his B.A. and M.A. from Penn State University and his Ph.D. from the University of Iowa. He has many years of experience as a producer and host of a daily consumer affairs program aired on public television. His teaching and research have focused on television programming practices, the effectiveness of television program promotion, and the impact of remote control devices on television viewing behaviors and the television industry. Professor Walker coauthored *The Broadcast Television Industry* (Allyn & Bacon, 1998) and *Television and the Remote Control: Grazing on a Vast Wasteland* (Guilford, 1996) and coedited *The Remote Control in the New Age of Television* (Praeger, 1993). In addition, he has published more than two dozen articles in national and regional journals, including the *Journal of Broadcasting & Electronic Media, Journalism Quarterly, Communications Law Review,* and the *Journal of Popular Culture.* He can be reached at walker@sxu.edu.

Index to Program Titles

This is a guide to specific television, radio, cable, and online **programs** and **movies** mentioned in the text. (Television, radio, and cable **networks** and **online services** appear in the General Index.)

General Index

Definitions and major text references appear in **boldface.**